Modernity in Central Europe, 1918–1945

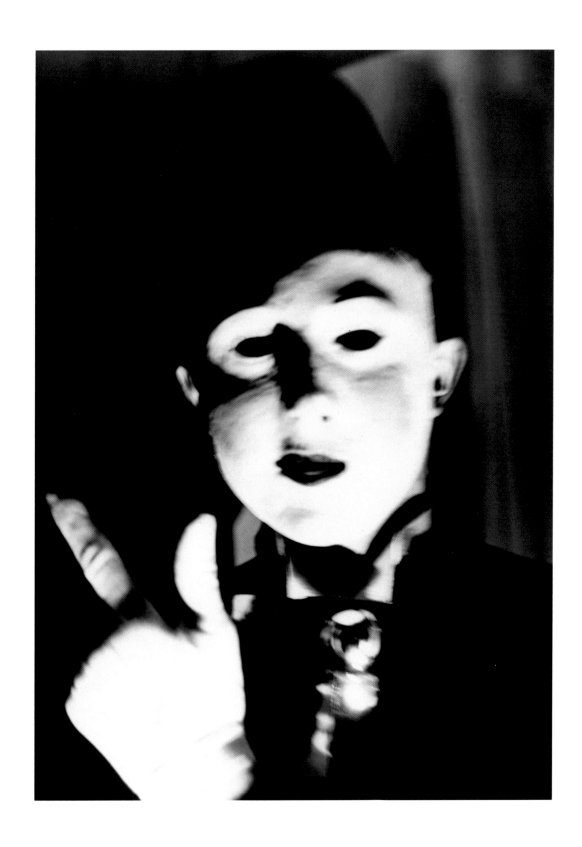

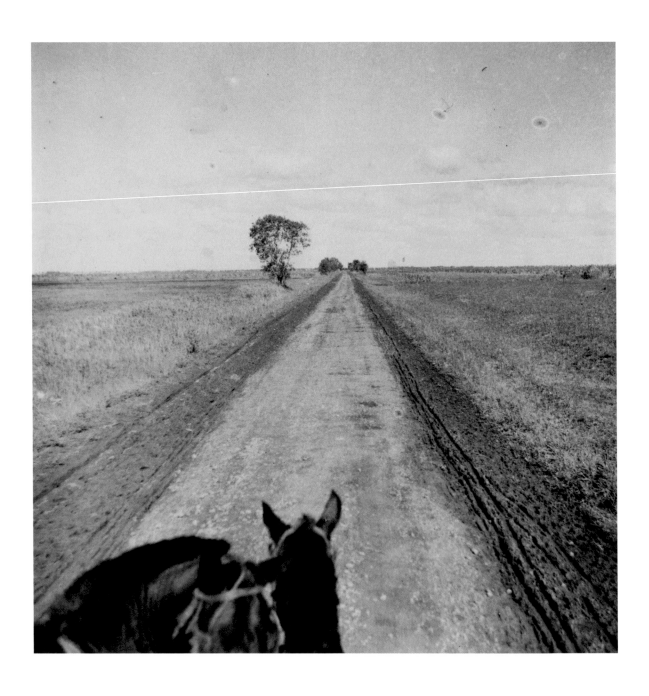

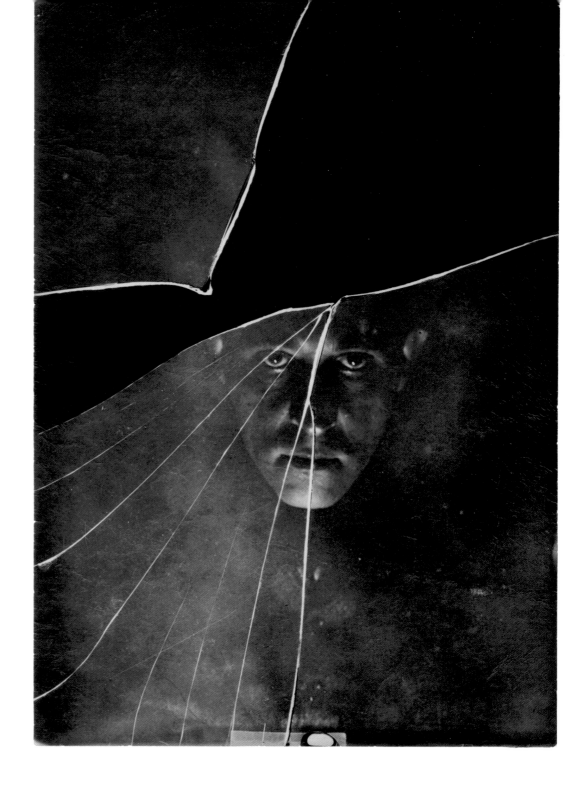

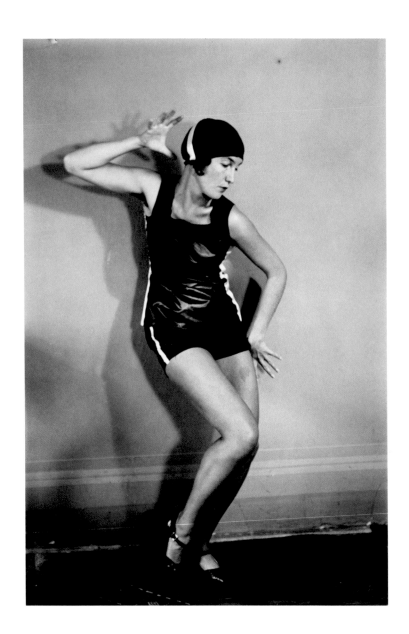

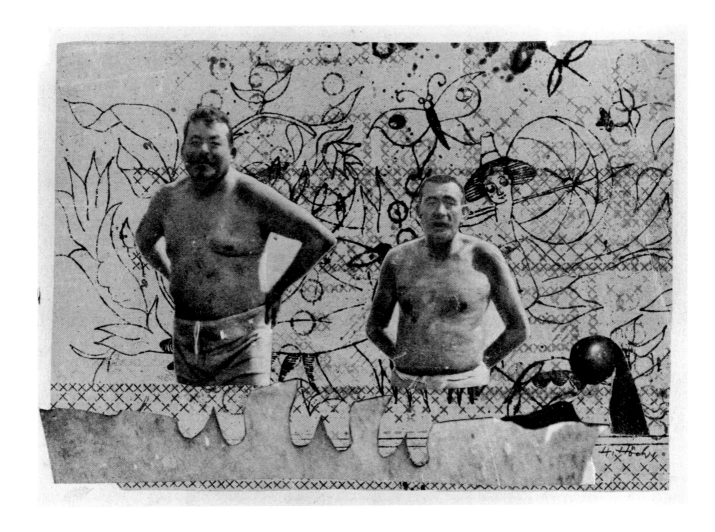

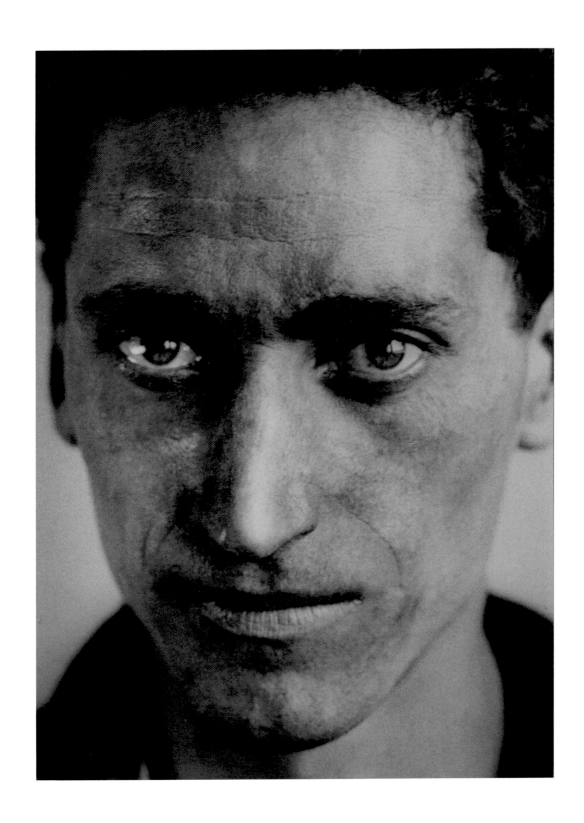

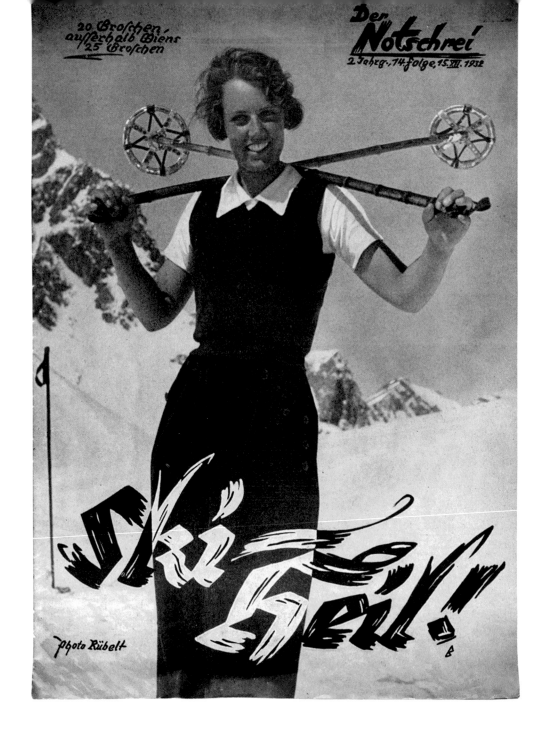

20 Groschen,
außerhalb Wiens
25 Groschen

Der
Notschrei
2. Jahrg., 74. Folge, 15. XII. 1932

Photo Rübelt

Ski Heil!

MATTHEW S. WITKOVSKY

WITH AN INTRODUCTION BY
PETER DEMETZ

NATIONAL GALLERY OF ART
WASHINGTON

foto

Modernity in Central Europe, 1918 – 1945

This catalogue is published on the occasion of the exhibition *Foto: Modernity in Central Europe, 1918–1945*.

The exhibition is organized by the National Gallery of Art, Washington

EXHIBITION DATES

National Gallery of Art, Washington
June 10–September 3, 2007

Solomon R. Guggenheim Museum, New York
October 5, 2007–January 2, 2008

Milwaukee Art Museum
February 9–May 4, 2008

Scottish National Gallery of Modern Art, Edinburgh
June 7–August 31, 2008

Sponsored by the Central Bank of Hungary

The exhibition is made possible by the generous support of the Trellis Fund.

Additional support has been provided by the Trust for Mutual Understanding, the Marlene Nathan Meyerson Family Foundation, and The Robert Mapplethorpe Foundation, Inc.

Produced by the Publishing Office
National Gallery of Art, Washington
www.nga.gov

Judy Metro, *Editor in Chief*
Ulrike Mills, *Editor*
Wendy Schleicher, *Designer*
Mariah Shay, *Production Editor*
Chris Vogel, *Production Manager*

Separations by Robert J. Hennessey
Maps by Tom Willcockson, Mapcraft, Woodstock, Illinois

This book was typeset in Bauhaus and Quadraat Sans CE by Duke & Company, Devon, Pennsylvania, and printed on PhoeniXmotion Xantur.

The paper used in this publication meets the minimum requirements of the American National Standard for Information Sciences — Permanence of Paper for Printed Library Materials, ansiz39.48.1992.

PHOTO ESSAY

page iii: cat. 45; page iv: cat. 148; page v: cat. 4; page vi: cat. 23; page vii: cat. 52; page viii: cat. 85; page ix: cat. 31; page x: cat. 84; page xi: cat. 9; page xii: cat. 127; page xiii: cat. 130; page xiv: cat 150; page xv: cat. 8; page xvi: cat. 152

DIVIDER PAGES

pages xviii–xix: adapted from cat. 64; page xxii: cat. 82; page xxvi: cat. 81; pages 8–9: adapted from cat. 4; pages 24–25: adapted from cat. 13; pages 50–51: adapted from cat. 29; pages 68–69: adapted from cat. 48; pages 88–89: adapted from cat. 61; pages 116–117: adapted from cat. 96; pages 138–139: adapted from cat. 132; pages 158–159: adapted from cat. 142; pages 180–181: adapted from cat. 156; page 204: cat. 91

10 9 8 7 6 5 4 3 2 1

First published in hardcover in the United States of America in 2007 by Thames & Hudson Inc., 500 Fifth Avenue, New York, New York 10110
thamesandhudsonusa.com

First published in hardcover in the United Kingdom in 2007 by Thames & Hudson Ltd, 181A High Holborn, London WC1V 7QX
www.thamesandhudson.com

ISBN: 978-0-500-54337-5 (hardcover edition)

ISBN: 978-0-89468-334-3 (alk. paper, museum edition)

Library of Congress Catalog Card Number: 2006908835

British Library Cataloging-in-Publication Data: A catalogue record for this book is available from the British Library

Printed and bound in Germany by Dr. Cantz'sche Druckerei, Germany

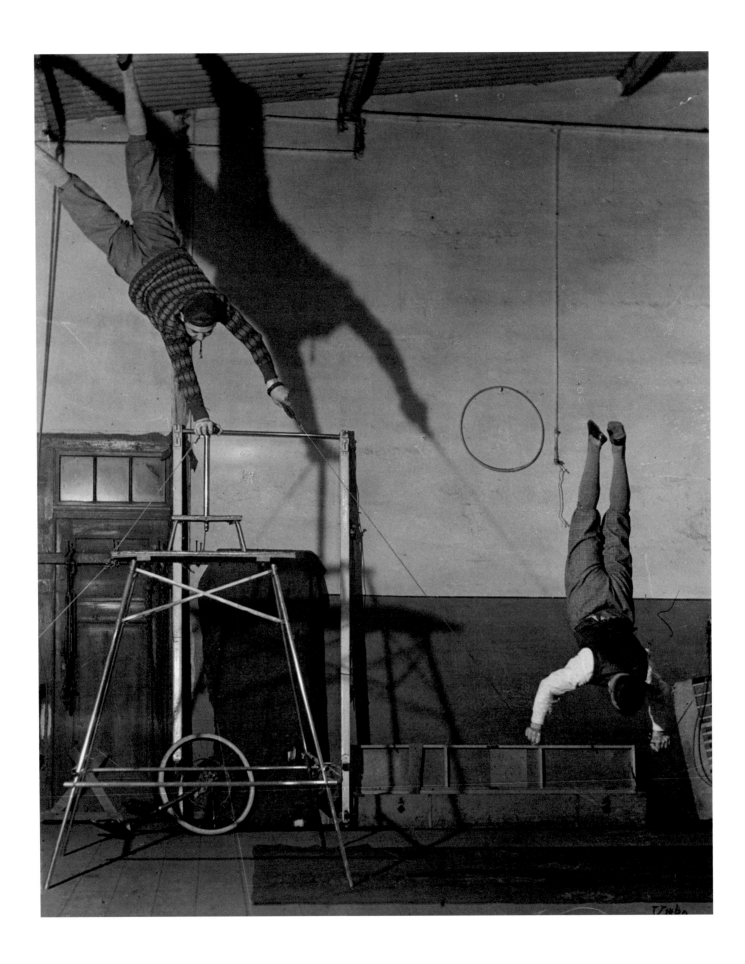

The 1920s and 1930s have a special place in the annals of world photography. In the New Vision era, as it is commonly known, photography became ubiquitous and held all of society in its sway: *photomontage, photojournalism,* and *photobook* are some of the new words coined to convey the ascendancy of the photographic in so many branches of art and communication. A few institutions and individuals from central Europe, such as the Bauhaus in Germany and its Hungarian-born professor László Moholy-Nagy, have gained a secure presence in the history books for their part in this golden age. But the extent to which central European culture as a whole shaped the "new photography," and with it key concepts that would define the history of all photography as we know it today, remains unfamiliar. To recover the crucial role played by photography in the region, and in so doing delineate a central European model of modernity, is the double aim of *Foto: Modernity in Central Europe, 1918–1945.*

Fifty years of totalitarian rule, which divided Europe into East and West, have obscured the cohesiveness of central Europe in the first half of the twentieth century. It was in those pivotal decades that the region came to be fully modern—suddenly, violently, exuberantly, nervously. Photography, which lent itself to the public, educative role expected of all culture in central Europe, became recognized as a creative medium ideally suited to expressing and interpreting modern civilization for a wider audience. The stunning achievements of individuals—across Austria, the Czech and Slovak lands, Germany, Hungary, and Poland—many well known in their day but lost from memory for decades thereafter, attest to a singularly fertile environment. Beyond these personal accomplishments it is the triumph of photography in institutions, from art schools and museums to publishing houses and even government ministries, that gives the true measure of success for this discipline and also best indicates the tenor of modernity in the region.

We are enormously grateful to Dr. Zsigmond Járai, Governor of the Central Bank of Hungary, and to the Central Bank of Hungary for sponsorship of this exhibition. A special thanks is extended to the Embassy of Hungary and to Ambassador András Simonyi for their unfailing enthusiasm for *Foto* and the National Gallery of Art. We would like to express our deepest appreciation to the Trellis Fund for its support of the exhibition in Washington and for its generous ongoing support of photography programs at the Gallery. We also would like to thank the Trust for Mutual Understanding, the Marlene Nathan Meyerson Family Foundation, and The Robert Mapplethorpe Foundation, Inc., for their support of the exhibition.

The National Gallery is fortunate to have in Matthew S. Witkovsky, assistant curator of photographs and curator of the exhibition as well as author of the catalogue, a scholar possessed of the necessary dedication and familiarity with both sides of the former iron curtain to realize this complex project. We are indebted to Professor Peter Demetz, whose writings on central European figures have for decades enriched the history of literature and art, for his evocative introductory essay.

Profound thanks go as well to our colleagues at the Solomon R. Guggenheim Museum, New York, the Milwaukee Art Museum, and the Scottish National Gallery of Modern Art, Edinburgh, for giving the exhibition fresh life in their respective cities. Equally appreciated is the collaboration of lenders public and private, abroad and at home, who have in many cases shared not only treasured works of art but also their time and expertise, and above all their passion for this outstanding period.

EARL A. POWELL III

The present book and exhibition address the phenom-enal success of all things photographic in central Europe, from the collapse of the great intra-European empires through the end of World War II. The character of that success is complex and intimately bound up with the region's experience of modernity. An account of central European photography from c. 1918 to 1945 is thus also an account of "the modern" there—one that, as told in these pages, should cause us to rethink established narratives of modernity in the study of twentieth-century art and civilization. The "new pho-tography," for example, is both new and old-fash-ioned, and emphatically collective and institutional in structure: an academic avant-garde. This photogra-phy effects a radical break with entrenched habits of seeing and conceiving the printed page, the exhibi-tion space, the city and daily life, indeed the world, yet it is also profoundly mindful of history, especially art history, and seeks to engage the public sphere rather than turn its back on communicability or com-mon traditions. To the bohemian rebelliousness of Arthur Rimbaud or the young Pablo Picasso one might oppose the studied polemics of Karel Teige, John Heartfield, or László Moholy-Nagy.

Being or becoming modern in central Europe is not a birthright or natural asset—it is no more guaranteed than place names or political sover-eignty. On the contrary, "the modern" appears alien or artificial, the object of envy, admiration, and unease. From these contradictory sentiments spring, on the one hand, tendencies toward proselytism on behalf of "international" standards, tinged frequently with a perception of belatedness or inferiority vis-à-vis those standards; and on the other, sharp resis-tance (born still more often of insecurity) to all things "foreign," coupled with calls to uphold a perceived national or racial uniqueness. As Foto shows, both impulses, taken separately and in varying combina-tions, should be considered definitional to what made central Europe modern, even though the latter direction runs toward fascism and the Holocaust, too often seen as epilogue to the modernist utopia.

Such characteristics of modernity reveal themselves plainly in photography, a public, popular image medium, but they are discernible in other creative disciplines in this region as well. Similarly, the model of modernity put forth here is not intended—despite the contrast of artists offered above—to stand purely in contradistinction to a Francocentric or other West-ern model. I hope instead that these propositions may refresh our perspective on modernism overall, across media and geographic boundaries.

While all research projects are team efforts, this one—which covers six countries and nearly as many languages—gave rise to an exceptionally extensive and rewarding collaboration. Earl A. Powell III, director of the National Gallery of Art, has guided this collabo-ration, joined by the directors of the three institutions to which the exhibition will travel: Lisa Dennison, Solomon R. Guggenheim Museum, New York; David Gordon, Milwaukee Art Museum; and Richard Caval-coressi, Scottish National Gallery of Modern Art, Edinburgh. Their enthusiasm has made it possible to bring Foto to the widest possible audience, in echo of the great photography surveys mounted in central Europe during the 1920s and 1930s. Sponsorship of the project has been a close partnership as well. To my esteemed colleague, the Honorable András Simo-nyi, his family, and his former and current associates Károly Dán, Zoltán Féher, and Sándor Bognár I extend a special tribute for sharing in the ambition behind this show. Heartfelt recognition is owed to Betsy Karel for her sincere commitment to photography at the National Gallery of Art.

The present exhibition and publication would have been unthinkable without the generosity of experts across countries and continents. The study of photography collections and primary writings in Europe was facilitated in Berlin by Hendrik Berinson, Rudolf and Annette Kicken, Christine Kühn, Thomas Walther, and Peter Zimmermann; in Bratislava by Peter Bagi and Iva Mojžišová; in Brno by Jindřich Chatrný and Antonín Dufek; in Budapest and Kecskemét by Károly Kincses and Magdolna Kolta (deceased); in Cologne

by Bodo von Dewitz and Walburga Krupp; in Essen by Ute Eskildsen and Robert Knodt; in Łódź by Krzysztof Jurecki; in Munich by Ulrich Pohlmann and Dietmar Siegert; in Paris by Anne Biroleau, Annie Le Brun and Radovan Ivšić, and Csaba Mórocz; in Prague by Rumjana Dačeva, Karel Srp, and Eva Willenbrinková; in Vienna by Christian Brandstätter, Monika Faber, and Hans and Monika Schreiber; in Warsaw by Danuta Jackiewicz, Stefan Okołowicz, Anna Żakiewicz, and Joanna Zarżycka; and in Wrocław by Adam Sobota. Travels in the United States benefited from similar openness and hospitality; appreciation goes here to Jaroslav Anděl, Jared Ash, Simon Bieling, Adam Boxer, Julian Cox, Malcolm Daniel, Mia Fineman, Peter Galassi, Howard Greenberg, Cynthia Herron, Corey Keller, Robert Koch, Anne Lyden, Weston Naef, Sandra Phillips, Anne Tucker, Leslie Wakeford, Michal Venera, and Del Zogg. Among these collegial ranks, particular gratitude is owed to Sabine Hartmann, Aurel Hrabušický, Marta Králová (deceased), Bob and June Leibowits, Jan Mlčoch, Jarmila Okrouhlíková, Michaela Pfundner, Attila Pőcze, Miloslava Rupešová, and Josef Seiter. For additional conversations and information I am grateful to Béla Albertini, András Bán, Vladimír Birgus, L'udovít Hlaváč, Krisztina Passuth, Daniel Vojtěch, and Andrzej Turowski. Steven Mansbach and Timothy Benson have been especially thoughtful interlocutors.

Graham Smith, editor of History of Photography, and the contributors to a special issue of that journal devoted to central European modernism brought focus and acumen at a critical moment in the germination of this book. Individual chapters were improved through counsel from Lenka Bydžovská, Hal Foster, Olivier Lugon, and Herbert Molderings. I am especially indebted to Ulrich Keller and Jindřich Toman, who patiently studied the full manuscript. Peter Demetz, who led me to the triangle Prague-Berlin-Vienna years before I undertook this project, has contributed a graceful and engaging introduction. The authors of the biographies provided invaluable guidance on points both small and large, and served as key sources for additional primary materials: Elizabeth Cronin, Stanisław Czekalski, Amanda Hockensmith, Astrid Lechner, Jiří Pátek, and Maciej Szymanowicz. To them goes deep appreciation for their part in this investigative undertaking.

Organizing the exhibition at the National Gallery of Art has been a remarkable experience. Earl A. Powell and Alan Shestack, deputy director, have encouraged the project from its inception, and Elizabeth Driscoll Pochter, administrator, has intervened providently many times on its behalf. D. Dodge Thompson and the department of exhibitions specialize in making the impossible come true; warm thanks go here to Jennifer Cipriano, exhibition officer, and to Kristina Giasi. Registrar Michelle Fondas managed with a practiced hand the intricate coordination of a changing checklist at each of the exhibition's four venues, joined by conservator Bethann Heinbaugh. Principal conservation expertise has been provided, with wonderful camaraderie, by Kimberly Schenck, Constance McCabe, and Marian Dirda. Hugh Phibbs, a man of genius and humor, and Jenny Ritchie and Stephen Muscarella brought off the preparators' complicated assignment. Under the unwavering guidance of Mark Leithauser, a talented team crafted the exhibition installation, including architect Jamé Anderson, Gordon Anson, Lisa Farrell, and Abigail Bysshe. Susan Arensberg and Lynn Matheny distilled the exhibition's guiding ideas in accompanying didactic materials. Working on related events with Faya Causey and Ana María Kozuch in academic programs, Margaret Parsons and Victoria Toye in film programs, and Stephen Ackert and Danielle DeSwert in music programs has been a real pleasure and brought out important dimensions to the history of central European modernity that would have been otherwise impossible to express. Christine Myers, head of development and corporate relations, and associates past and present— Jeanette Crangle Beers, Patricia Donovan, Jason Herrick, and Missy Muellich—have contributed to securing exhibition support with uncommon energy and amiability. Deborah Ziska and Anabeth Guthrie in the press office took up the challenge of trumpeting seemingly unpronounceable names with aplomb.

Work on this book would often have gone astray if not for the benevolent stewardship of Judy Metro, editor in chief, and her able colleagues. I could not have asked for better collaborators than Ulrike Mills, editor, Wendy Schleicher, designer, and Chris Vogel, production manager; together they have made a book that far exceeds its original promise. Sara Sanders-Buell and Ira Bartfield applied themselves to the quixotic task of reproducing photographic images in print; thanks are due as well to photographer Daniel Šperl and to Robert Hennessey, technological visionary whose separations have for years guaranteed the excellence of National Gallery publications on photography. The accompanying Web site is the work of Suzanne Sarraf and Guillermo Saenz. In the department of visual services, headed by Alan Newman, appreciation goes to photographers Lorene Emerson and Ric Blanc, for their abilities and their unflappable

charm. Numerous new and rare publications were acquired for our library thanks to the receptivity of Neal Turtell, executive librarian, and Anna Rachwald; meanwhile, the untiring office of interlibrary loans—Thomas McGill, Ted Dalziel, and Anne Goska—brought in myriad sources for consultation.

This project owes its success at a fundamental level to Sarah Greenough, head of the department of photographs, who has been a mentor, colleague, guide, and confidante at every step in its development. It is an honor beyond words to thank her here, the first time she has not written the acknowledgments herself in a National Gallery photography catalogue. I am grateful to have the comradeship of fellow curators Sarah Kennel and Diane Waggoner, and I know that we are all beholden to the assistants who have kept our office running: Sara Cooling, Brooke Lampley, and Emma Acker over the tenure of Foto. To Emma goes special tribute for her boundless intellectual curiosity and unfailing good cheer. Cameron Shaw, Juliet Baillie, Elizabeth Cronin, and Sonja Simonyi, the research assistants who have steered daily operations over the past three years, deserve exceptional praise. Elizabeth gave to book and show a steady hand and a ready smile—as well as a stellar bibliography—and she, like Sonja, made valuable contributions while working through the manuscript. Sonja in addition curated a remarkable series on central European cinema that provides an inseparable complement to the exhibition. I would also like to thank Gail Maxfield, housekeeping, who has often brightened early mornings in the workplace; Frank Schiavone, printing and duplicating; Minnie Barbour, Barbara McNair, and Juanita Walker, the three muses of telephony; and Darryl Brown at the computer help desk, who is always ready to try.

Many thanks to Richard Lanier and the Trust for Mutual Understanding for facilitating programming and curatorial travel, and to Michael Stout and The Robert Mapplethorpe Foundation for underwriting a portion of the exhibition costs. Crucial support for research assistance has been provided by Marlene Myerson, a woman of admirable energy and dedication, and by Mary and Roy Cullen.

To my smart and warm-hearted counterparts Maria-Christina Villaseñor, Solomon R. Guggenheim Museum, New York; Lisa Hostetler, Milwaukee Art Museum; and Keith Hartley, Scottish National Gallery of Modern Art, Edinburgh, I extend utmost gratitude for their collegial interest and their own stimulating presentations of the exhibition. I have benefited over the years of this project from the friendship of Leah Dickerman, Mark Levitch, Christine Poggi, Jindřich Toman, and Liliane Weissberg. Warmest thoughts go to my family in blood and marriage, and to the family of Josef Jařab, which is practically our own. And to the irreplaceable Janine Mileaf, as ever my closest reader, and our wondrous Thalia.

MATTHEW S. WITKOVSKY

Akademie der Künste, Berlin, Kunstsammlung

Albertina, Vienna

The Art Institute of Chicago

Bauhaus-Archiv, Berlin

Darina and Vladimír Birgus

Buhl Collection

City Gallery Prague

City Museum in Brno

Roy and Mary Cullen

Carla Emil and Rich Silverstein

Ewa Franczak and Stefan Okołowicz

The J. Paul Getty Museum, Los Angeles

The Getty Research Institute

Marcin Giżycki

Howard Greenberg

Ewa Hartwig Fijalkowska

Institut für Auslandsbeziehungen e.V., Stuttgart

Betsy Karel

Kicken Gallery, Berlin

Robert Lebeck

June and Bob Leibowits

Hungarian Museum of Photography

Hungarian National Gallery

The Metropolitan Museum of Art

Moravská galerie, Brno

Museum Folkwang, Essen

Museum of Czech Literature in Prague

Museum of Decorative Arts in Prague

The Museum of Fine Arts, Houston

The Museum of Modern Art, New York

National Museum in Warsaw

National Museum in Wrocław

Muzeum Sztuki w Łodzi

Národní galerie v Praze

National Gallery of Art

National Gallery of Art Library

Österreichische Nationalbibliothek

Prentenkabinet, University Library, Leiden

Prentice and Paul Sack Photographic Trust

Private collections

Rubin Family Collection

San Francisco Museum of Modern Art

Monika and Hans Schreiber

Josef Seiter

Dietmar Siegert

Slovak National Gallery, Bratislava

Staatliche Museen zu Berlin, Kunstbibliothek

Stiftung Hans Arp und Sophie Taeuber-Arp, e.V., Rolandseck

Jindřich Toman

Ullstein Bild

Thomas Walther

Eva Willenbrinková

Yad Vashem Art Museum, Jerusalem

PLACE NAMES

All place names are given in current standard English throughout the body of this book and in the captions for the accompanying plates and illustrations. In the maps on pages xxx–xxxi, however, and in tombstone information for the biographies, localities are referred to in the official language or languages of the time. There are thus certain discrepancies between captions or text and between the maps or biographies. A glossary of city names that harmonizes contemporary English with pre- and post-1918 appellations appears on page xxix. For more detailed information on historical place names, including a list of sources consulted, see the note preceding the biographies on page 217.

TRANSLATIONS AND ORTHOGRAPHY

Original language designations, with accompanying translation, are provided for organizations, art movements, exhibitions, and periodicals in the text, for books and articles in the notes, and for works of art in the captions. Spelling in the original language retains period conventions for proper and common names even when those are at variance with current usage. Translations are not provided in cases where the original may readily be understood by English speakers, or where the text in question is included in the bibliography. Except where noted, all translations from Hungarian are by Sonja Simonyi, and from other languages by the author.

CITATIONS

Full bibliographic citations are provided in the notes once each chapter. Further references in the same chapter mention only the author and most recent year of publication, or, in the case of exhibition catalogues, the city and year of publication. Archival and primary references that have been subsequently quoted or reprinted are cited by year of original creation, followed by a full reference to the more recent publication.

TITLES AND DATES

Titles are provided based on makers' inscriptions or period sources wherever possible. One should bear in mind that photographs of this period often shifted context (moving, for instance, from an illustrated newspaper page to an exhibition wall) and changed titles as a result; titles accrued just as frequently through anecdote or later attribution. For this reason, many works carry additional titles in parentheses. Others are termed "Untitled" to indicate absence of information rather than a deliberate artistic choice. Dates are presumed to apply to both negative and print except where noted.

DIMENSIONS AND MEDIA

Dimensions are given in centimeters, with height preceding width. Brief descriptions are offered here of the principal techniques discussed in this book:

Bromoil Print, Carbon Print, Gum Dichromate Print

The bromoil process involves exposing a sheet of gelatin silver photographic paper through a negative, then treating it with a dichromate salt solution to harden its emulsion in direct proportion to the light it receives. When this sheet is wetted and rolled with lithographer's ink, the unhardened gelatin areas repel the ink while hardened areas receive the ink. A bromoil could be used as a lithographic printing matrix to transfer the ink to a receiving sheet; the result is a bromoil *transfer print*. *Carbon prints* and *gum dichromate prints* also exploit the properties of dichromated salts to create *pigment prints* consisting of pigments in gum arabic or gelatin.

Gelatin Silver Print

A print is made on paper prepared with light-sensitive silver salts suspended in an emulsion of gelatin. The images of early gelatin papers were *printed out*, or made visible through direct exposure to light, in the same manner that *albumen prints* were created. Most of the gelatin silver prints of the twentieth century reveal their images by *developing out* in a chemical solution. Developed-out gelatin silver prints could be manipulated in many ways, such as the partial reversal of tones achieved in the *Sabatier* effect.

Photogram

A photogram is made by placing an object directly on a light-sensitive paper or film and exposing it to light. The resulting image, made without the use of a camera, appears as a light form or silhouette against a dark background. Although photograms may be made using a variety of papers, most photograms from the 1920s and 1930s in central Europe are gelatin silver prints.

Photomontage

A work is made of cut or torn and pasted photographs or photomechanical prints in ink, such as *photolithographs*. Photomontages frequently include hand-drawn or other nonphotographic elements, such as *printed matter*. If a photomontage has been photographed and printed, the resulting object is referred to as a reproduction of a photomontage.

CONTEMPORARY NAME IN ENGLISH	OFFICIAL NAME 1890	OFFICIAL NAME 1930
Belgrade	Beograd	Beograd
Berlin	Berlin	Berlin
Bratislava	Pozsony (Preßburg)	Bratislava
Brno	Brünn	Brno
Bucharest	Bucureşti	Bucureşti
Budapest	Budapest	Budapest
Carlsbad	Karlsbad	Karlovy Vary
České Budějovice	Budweis	České Budějovice
Cologne	Köln	Köln
Dessau	Dessau	Dessau
Dresden	Dresden	Dresden
Essen	Essen	Essen
Frankfurt	Frankfurt	Frankfurt
Gdańsk	Danzig	Danzig
Halle	Halle	Halle
Hamburg	Hamburg	Hamburg
Hannover	Hannover	Hannover
Kaliningrad	Königsberg	Königsberg
Katowice	Kattowitz	Katowice
Kraków	Krakau	Kraków
Leipzig	Leipzig	Leipzig
Linz	Linz	Linz
Ljubljana	Laibach	Ljubljana
Łódź	Łódź	Łódź
Lviv	Lemberg	Lwów
Munich	München	München
Moscow	Moskva	Moskva
Olomouc	Olmütz	Olomouc
Paris	Paris	Paris
Poznań	Posen	Poznań
Prague	Prag	Praha
Rijeka	Fiume	Rijeka
Sofia	Sofia	Sofia
Strasbourg	Straßburg	Strasbourg
Stuttgart	Stuttgart	Stuttgart
Szeged	Szeged	Szeged
Timişoara	Temesvár (Temeschburg or Temeschwar)	Timişoara
Trieste	Triest	Trieste
Vienna	Wien	Wien
Vilnius	Vilna	Wilno
Warsaw	Warszawa	Warszawa
Wrocław	Breslau	Wrocław
Zagreb	Agram	Zagreb
Zakopane	Zakopane	Zakopane
Zurich	Zürich	Zürich

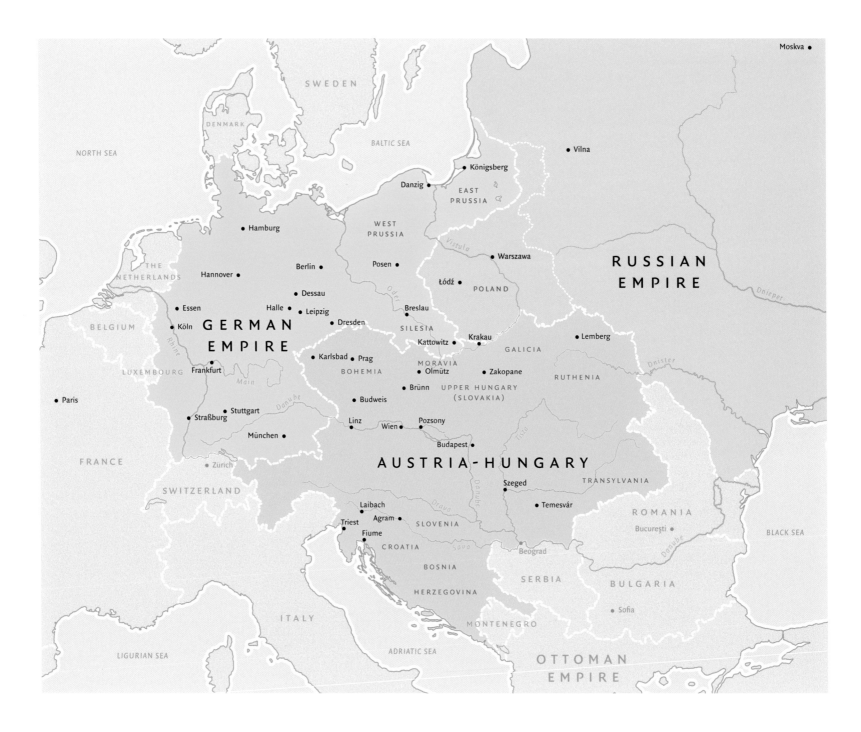

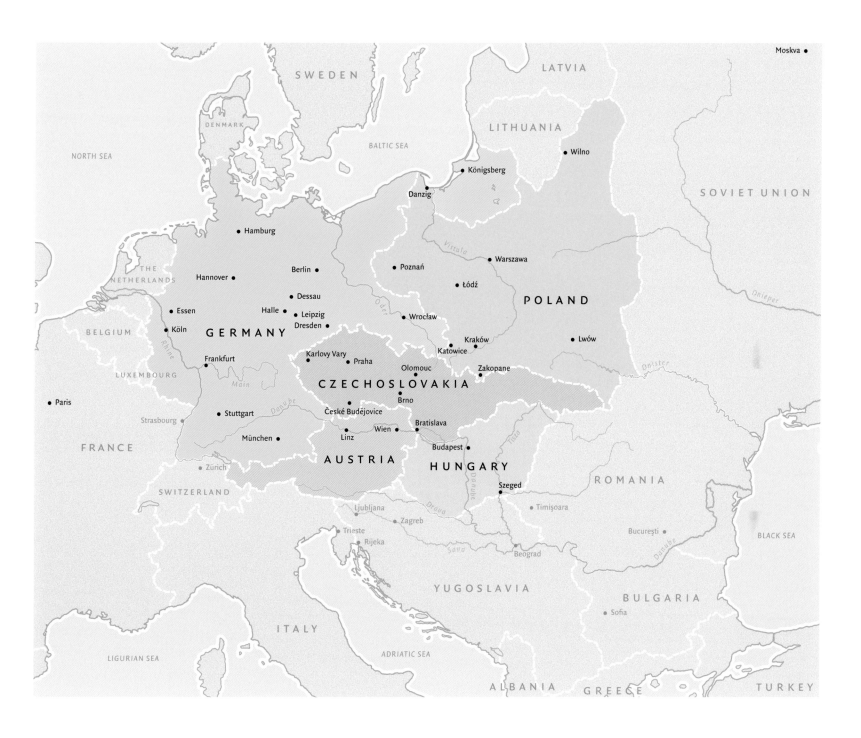

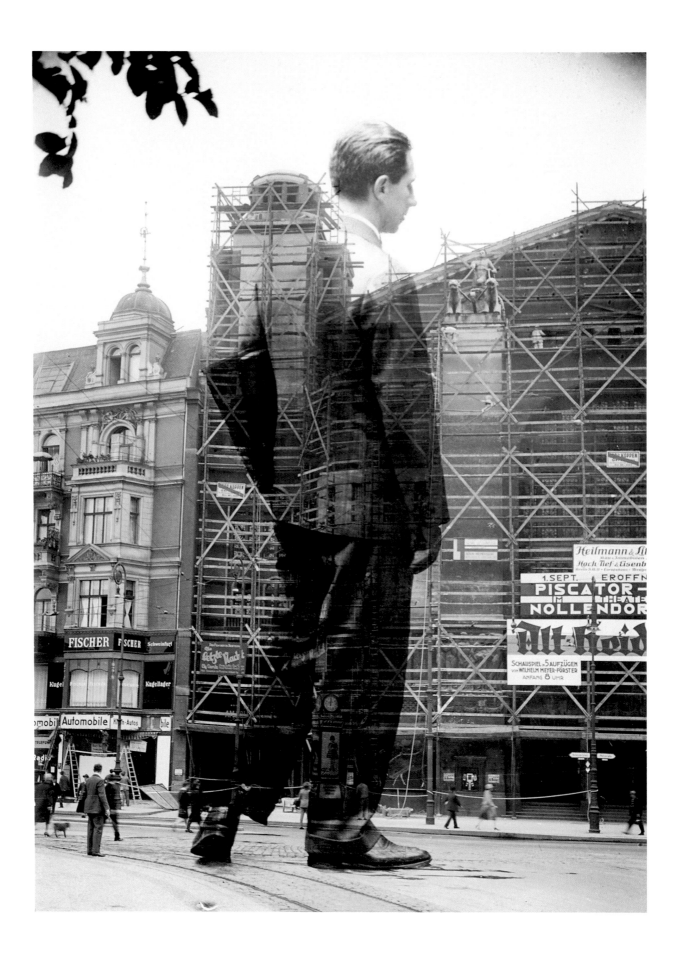

The central European avant-garde did not create its astonishing achievements in a tranquil moment of history. The more radical iconoclasts who opposed rampant nationalism and the cruelties of World War I gathered in Zurich (1915) to establish a cosmopolitan Dada group, and their ideas quickly spread, mocking and subverting heroic commonplaces. Not much later (1917–1918), the dissolution of the grand empires, the Reich of the Hohenzollern, the Austro-Hungarian monarchy, and the fall of the Romanov czars, set in motion unexpected migrations of expressionists, cubists, and the new artists and theoreticians of cinematography. Their liberated energies crystallized (the image was used by Walter Gropius in 1919) in movements and institutions that, defining themselves as late cubist, surrealist, or constructivist, were to dominate the aesthetic experience of the 1920s and 1930s, in spite of Hitler's and Stalin's brutal enmity, or precisely because they struggled to survive it.

Modernity means, above all, a modernization that thrives in the industrial world of the new metropolis, an emancipatory nationalism, and a democratization based on widening suffrage to include women and working people. Industrialization moved undeviatingly from the West to the East, while nationalism, in central Europe, spread from Germany to the East and at times ricocheted from there. The regions of the Hohenzollern were industrialized earlier than those of the Hapsburgs. The Prussian government (sensitive to British developments) began to finance iron and steel production even before the revolution of 1848. It created the Zollverein, an efficient economic organization to ease commerce between the eighteen constituent states of the German Reich. By favoring heavy industry, it made Berlin the principal hub between Moscow and Paris, Copenhagen and Rome. In Hapsburg Austria, industries were built with government funds paid after the 1848 revolution to the land-owning magnates as reimbursement for abolishing peasant labor on their estates, and the aristocrats invested these funds to further their enter-

prises; by 1880, they owned two thirds of all breweries and sugar refineries. In Berlin, the government supported inventive engineers and blacksmiths who concentrated on building locomotives and entire railway systems. As early as 1838 the first train went from Berlin to nearby Zehlendorf; in the 1860s the Berlin horse-drawn bus was replaced by a network of city trains; and in 1870 Germany had more than 18,000 kilometers of track. By 1900, 60 percent of Berlin's population belonged to the industrial working class (38 percent in Paris and 43 percent in London), and industrial giants such as Siemens, Borsig, AEG (electric machinery), and AGFA (Anilin and photographic equipment) dominated the central European market. In Vienna, the princely captains of industry continued to reside in their baroque palaces, each a little court in itself; the Vienna census of 1902 listed only eight enterprises employing more than one thousand. Nevertheless, when the poet Rainer Maria Rilke was ordered to work in the Vienna military archives in World War I, sparing him the front, and commuted to his office in a crowded tram every morning, he nearly fainted from proximity to the sweating working class.

Berlin, a city of four million at the beginning of the Weimar Republic, was the central scene of political and aesthetic changes (though never exclusively the center of German cultural life). It powerfully attracted talented people from the provinces and dissidents from lands eastward, including Hungary and the nascent Soviet Union. As elsewhere in the region, such developments began before the war. In 1910, Herwarth Walden, a gifted musician committed to artistic revolution, started to publish his periodical *Der Sturm*, often printing expressionist drawings or prose pieces by Oskar Kokoschka on the title page. Two years later he opened the Sturm gallery to promote the Blaue Reiter group and the Italian futurists, creating a sensation with the latter show in April 1912 (Walden later joined the Communist Party, emigrated to the Soviet Union in 1932, and died, accused by Stalin's political police of espionage for Hitler, in a Rostov

prison). In the first year of Walden's *Sturm* journal, there were 139 cinemas, of the old-fashioned kind, in Berlin, and a few critics, among them Alfred Döblin, began to take note of the new medium that attracted, as happened also in America, a wide and loyal audience among the poorer classes. By 1913, the first German movies were acclaimed by a few critics, especially *The Student of Prague*, made by Paul Wegener, formerly of the Max Reinhardt ensemble. Feeding on this success, the Bioscope Corporation constructed a functional building at Neubabelsberg that was to house the UFA film production giant of later years.

In Vienna, the voices of the imperial age were somewhat subdued. The screams of the expressionists were missing, and Adolf Loos stood alone in his valiant fight against ornament and architectural epigones. The famous coffee houses, the Griensteidl, the Central, and, after the war, the Herrenhof, were fortresses of individualism, and the police did not seem overly disturbed by the daily appearance of Leon Trotsky among the coffee-house intellectuals of the Left. Even the film industry was modest, turning out court circulars (the emperor, in the mountains, bagging a deer) or operettas financed and elegantly directed, among others, by the feudal landowner and aristocrat Alexander Kolovrat-Krakowsky.

Yet (unknown to many Viennese) modern Vienna had the rare distinction of developing a radical analytical engagement, resolutely probing the fundamentals of experience. Viennese philosophy and psychoanalysis clashed with the Austrian traditions of the baroque, or the idea that private and public behavior was something of a theatrical performance.

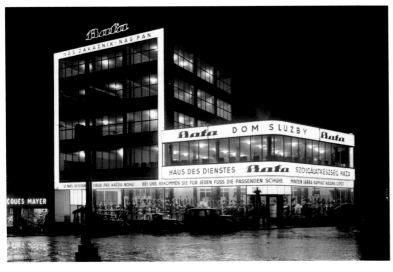

Vladimír Karfík, *Baťa Department Store, Bratislava*, 1930–1931, gelatin silver print (postcard), 9 × 14, Private Collection, Zurich

In their theories of knowledge (increasingly related to the physical sciences and mathematics), the examination of the subconscious, and skepticism about language, one of the most revered forms of expression across all of central Europe, Viennese thinkers left few beliefs intact. Toward 1900, the famous fin de siècle, analytical thought constituted itself in Ernst Mach's and Sigmund Freud's publications. Their critical analysis of language and being was subsequently strengthened by Ludwig Wittgenstein's bold *Tractatus* (1921), positing the logical structure of the universe. In 1928, the Ernst Mach Society changed into the renowned Vienna Circle of Neopositivists, bringing together philosophers, scientists, and mathematicians. Neither waltzes nor metaphysics, the "Mach" continues to be used to measure the speed of supersonic aircraft today.

If individuality and searching self-reflection dominated in Viennese literature and the arts of the imperial age, art history, as a critical and analytic field of inquiry, went its own way after the turn of the century, undergoing changes in its disciplinary perceptions and methodologies. The exemplary art historians of the European tradition, from Giorgio Vasari to Jakob Burckhardt, looked at personal histories and individual genius and tended to distinguish between periods of supreme achievement and years of lesser accomplishment. Alois Riegl, curator of textiles in the Vienna Museum für Industrie und Gewerbe and later professor of art history at Vienna University (1897–1905), in his studies of Christian-era Rome and seventeenth-century Holland defined the work of art as result of a supra-individual *Kunstwollen* that reveals itself in the confrontation with use, raw material, and technique. Riegl, later much admired by Walter Benjamin, aspired to turn art history into a general science of culture. He died early but his work was continued by his Viennese successor Max Dvořák, of Czech background, and the Vienna school of art history attracted increasing intellectual attention and admiration as the century went on.

Hungarian affairs, with their abrupt and belligerent changes, differed considerably from the circumstances in neighboring Austria or Bohemia. Hungarian history resounded with wars, uprisings, and cruel intervention from abroad (the Russian armies of 1848); the compromise of 1867 established a nominal parity between Hungary and Austria in the dual monarchy but did not diminish the edginess of Magyar relations with Romanian, Slovak, Ruthenian, and Croat minorities on their own territories. Far into the 1870s, only 6 percent of the population was entitled to

vote, and 80 percent of the deputies were members of the feudal aristocracy and gentry (still 50 percent in 1910). Yet Hungarians prospered and agriculture was booming; industrial production, often supported by foreign capital, was steadily growing; and more than three hundred Jewish families, active in banking and finances, were granted nobility in appreciation of their contribution to the general well-being. Modern Budapest may have lagged behind Vienna in many respects, but in 1908 the new periodical *Nyugat* (The West) brought together young artists and writers, among them the poet Endre Ady, of the impoverished gentry. It was all high-class cosmopolitan, but Lajos Kassák, a blacksmith by profession, established his counter-periodicals, *A Tett* (The Deed) and *MA* (Today), which looked to Germany and further afield for inspiration; all his life he wanted to be the integral revolutionary, refusing to become a member of the Communist Party. In 1918–1919 the proud Hungarians, who had fought on the wrong side, lost two-thirds of their prewar lands, including the Slovak, Romanian, and Yugoslav territories. A Hungarian liberal republic did not last five months, and the Bolshevik dictatorship of Béla Kun exactly 132 days; in the initial years of the White Terror that followed, under Admiral Miklós Horthy, 5,000 people died, 70,000 were imprisoned, and many of the most gifted liberal and leftist intellectuals went into exile. Among the first were Kassák, who continued his work in Austria and Germany; the critic and philosopher Georg (György) Lukács, a student of German idealism but by 1918 Kun's commissar of education, and one of the most influential Marxist philosophers of the century; Béla Balázs, among the first theoreticians of the cinema; and the polymath artist and theorist László Moholy-Nagy, who taught at the Bauhaus and later established the Chicago Institute of Design (1939). The lively Budapest illustrated newspapers had attracted many talents who now also went abroad, foremost among them Stefan (István) Lorant, a driving force at the helm of the *Münchner Illustrierte Presse* and later founding advisor to *Life* magazine. André (Andor) Kertész, who had started with photo reports from the Italian front, and Robert Capa (Endre Friedmann), later declared the "Greatest War Photographer of the World" (*Picture Post*), were among those who deserted Hungary even after the situation there normalized in the 1920s.

The Czech lands stood out in the old monarchy by their subterranean Protestantism, a strong concentration of industrial manufacturing, and a self-conscious middle class who left it to their historians, composers, librarians, poets (mostly male), and tal-

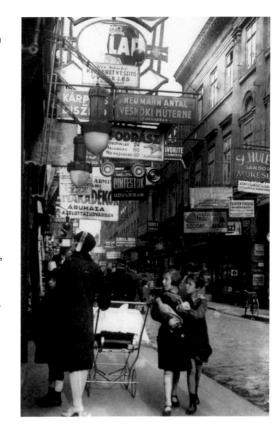

Imre Kinszki, *Király Street in 1929 (A Király utca 1929-ben)*, gelatin silver print, 11.7 × 17.8, Budapest Collection of Metropolitan Ervin Szabó Library

ented novelists (mostly female) to invent a nationalist ideology. As early as 1895, younger Czech writers and critics published a "Manifesto of Modernism," in which they railed against tired realism, imitative decadence, and the subjugation of women. In the arts, the Prague exhibition of Edvard Munch (1905) triggered significant changes. Members of the younger generation pushed aside impressionism and symbolism, and competing groups, including Osma (The Eight, 1907–1908) and Skupina výtvarných umělců (The Group of Fine Artists) inclined to an expressionist and, increasingly, cubist idiom that dominated the decade after 1910, at least until republican independence in 1918. Czech artists exhibited in Walden's Berlin Salons and published in *Der Sturm*—even during World War I —or remained, like the cubist Bohumil Kubišta, close to the Dresden Brücke group. But it turned out that Paris, not Berlin, Dresden, or Vienna, became the lodestar for the Czechs, and not for artistic reasons alone. In their yearning for autonomy if not independence, Czech artists looked to France early, anticipating the future orientation of the Czechoslovak Republic. Cubism also gained a public face early on, whether in debates over a monument to the ancient

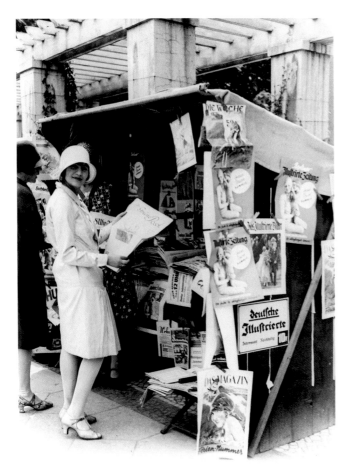

Willy Pragher, *At the Newsstand (Am Zeitungskiosk)*, summer 1929, gelatin silver print, 24 × 18, Private Collection, Berlin

Hussite warrior hero Jan Žižka, or in furniture and tableware designs by the Artěl group. Prague tourists are still surprised today to discover Josef Chochol's bold block of cubist apartments (1913–1914) on quiet Neklanova street.

From the demise of the traditional monarchies that had partitioned the Polish-Lithuanian commonwealth three times toward the end of the eighteenth century, the republic of Poland emerged once again after World War I. Romanticism and nationalism, popular allies across the central European region, had an especially long-established friendship in Polish politics, art, and literature. In three bloody uprisings of 1794, 1830, and 1863–1864, the partisans of resistance confronted numerically superior occupying armies. In the later 1860s and 1870s, thinking Polish patriots changed course (almost as if beginning to agree with the sober Czechs rather than with the dramatic Hungarians), believing that it was more useful to pursue "organic work"—daily effort, rational considerations, and systematic technical and economic self-help—instead of shedding the blood of a genera-

tion of heroes. Each of the occupied regions offered its own opportunities. The Russian czars who controlled the area from Warsaw to Vilnius were, at times, reform-minded and opened vast markets to Polish products. Bismarck's crude policies of Germanization nevertheless left local opportunities for patriotic self-help in Breslau (Wrocław), Posen (Poznań), and the other towns of Silesia, East Prussia, and West Prussia. Austrian-held Galicia, with its capital in Lemberg (Lwów), enjoyed an unusual degree of political autonomy in municipal administration, and many enterprising Jewish families resettled from the poor shtetls further West (the Freuds moved to Moravian Freiberg [Příbor], where Sigmund was born in 1856). Yet romanticism was irrepressible and returned to full force in the Młoda Polska (Young Poland) movement of 1890, competing with new political parties inspired by international socialism and/or populist aspirations.

A modern cultural orientation, strengthened by the inveterate trio expressionism, futurism, and cubism, appeared after 1912, later here than in Hungary or the Czech lands, and created differentiated expectations. In formerly Prussian Poznań, the Bunt group, strongly expressionist, emerged in 1917; in Łódź, the Jung Idysz (Jewish Youth) artists, intent upon asserting their (Jewish) orientation, celebrated Marc Chagall, while in Kraków, the Formiści or formists (1918) at times accentuated folk art (as often happened in the Slavic East, but not only there). In the years of the Republic—including under the quasi-dictatorial Sanacja regime of Józef Piłsudski, who arrived with a military coup in 1926—avant-garde groups continued to assert themselves in individual cities. Polish constructivists operating mostly in Warsaw, and later in Koluszki and Łódź, introduced varieties of abstract painting modeled on the work of Kazimir Malevich (1923). In 1924, Mieczysław Szczuka, Teresa Żarnower, Władysław Strzemiński, Katarzyna Kobro, and others founded the canonical group Blok, with its eponymous journal; Henryk Berlewi, who had recently returned from a lengthy stay in Berlin, marked the event by exhibiting designs for a language of kinetic geometric form in an automobile salon. Polish artists experimented in nonobjective painting, film, architecture, and photomontage, making constructivism there a force of exceptional theoretical and creative coherence.

In the revolutionary transformations of 1917–1918, intellectuals, writers, and artists across central Europe found themselves part of a new scene that radically changed their self-awareness and the scope of their mission. Dadaist Richard Huelsenbeck

returned from Zurich to Berlin to team up with the local radicals, including the brothers Herzfelde (Heartfield) and George Grosz, to issue the first Berlin Dada Manifesto (1919). They later held the *Erste Internationale Dada-Messe*, exhibiting Hannah Höch's inventive photomontages, and Dada branches were established in Paris, Cologne, Zagreb, Bucharest, and elsewhere. The new challenge came from Soviet Russia, where the revolutions of February and October 1917 ultimately brought the Bolsheviks to power. Organizations were formed to proclaim the value of "production art" and constructivism (the term was used from 1920 on); and Vladimir Tatlin, charged by Lenin to take care of Monumental Propaganda, constructed his famous model for a curved tower of iron and glass, possibly inspired by the Eiffel Tower or the oil derricks of Baku and dedicated to the international revolution of the working class. In the years around 1930, central European intellectuals and artists, if they wanted to move on the cutting edge, allied themselves with the many forms of constructivism, surrealism, or social documentation and were constantly confronted with the question whether to ally themselves, and how far, with the Third International.

Central European life in the 1920s and 1930s was, at least in the cities, an experience of sharply contrasting forces clashing within an uncertain scene of inflation, recovery, and economic crisis. The clash was felt most strongly in Germany. Traditional habits there were most sharply confronted by a new rhythm of work and leisure that involved multitudes of people in large offices and on expanding production floors. New movies, such as Fritz Lang's *Metropolis* or Walter Ruttmann's *Berlin: Symphony of a Big City* (both 1927) reflected the threats and exhilaration of the new urban tempo, while the sirens called. People eagerly discussed "Americanization," meaning women's short hair (the *Bubikopf* or pageboy haircut) and even shorter skirts, Charlie Chaplin and movies, Jack Hylton and jazz, the new air transportation, the fabulous Tiller Girls tap dancing en masse; observers did not exactly know whether to admire early imitations of Busby Berkeley musicals or performances of *Ausdruckstanz*, expressive dance, by those who continued to believe in expressing the unmediated stirrings of the soul. Sociologists on the left, but independent of Moscow, challenged the formations and habits of the new society. In 1923, they established an Institut für Sozialforschung (Institute for Social Research) and attracted to their periodical philosophers and intellectuals of the caliber of Siegfried Kracauer—who made white-collar workers into a subject of anthropo-

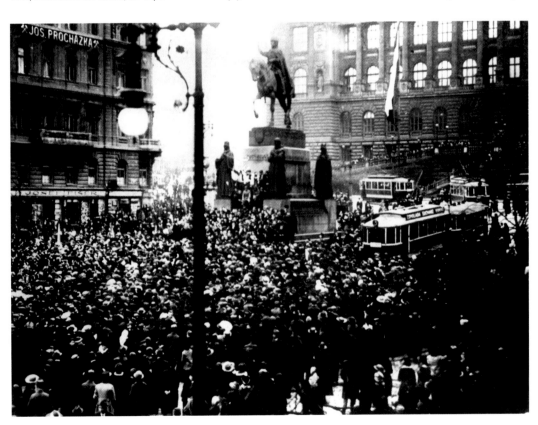

Unknown, *Wenceslas Square, Prague, 28 October 1918, the Day of Czechoslovak Independence*, 1918, gelatin silver print, 36.2 × 26.6, © Topham / The Image Works

logical study—as well as Theodor Adorno and Herbert Marcuse. Only after 1950, when most members of the group returned from their American exile to Germany, did this institution acquire the name "Frankfurt School" and become exemplary for the study of modernity and its many ramifications.

Berlin and the Weimar Republic powerfully attracted expatriates from the East, be they of the gentry as was Vladimir V. Nabokov, or early enthusiasts of Soviet party discipline such as Egon Erwin Kisch, the raging reporter from Prague. All newcomers found shelter, at least before the 1930s, in the many established or newly built mansions of the German avant-garde, foremost among them the peripatetic Bauhaus art school (1919–1933), where Vasily Kandinsky, Moholy-Nagy, and Walter Gropius taught at one time or another.

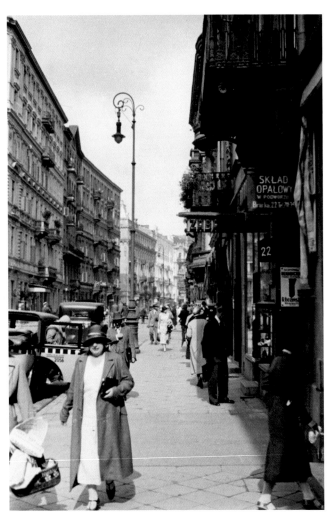

Hajo Rose, *Street in Warsaw* (*Straße in Warschau*), 1931, gelatin silver print, 24 × 15.7, Bauhaus-Archiv, Berlin

Vienna, usually slow on avant-garde projects, planned to resolve the grievous housing problems of its working people immediately after the Social democrats took over the administration of the city in February 1919 (54 percent had voted for them). They defined a program of municipal *Wohnhausanlagen* (housing blocks), including interior courtyards and little parks, and by 1934 more than 61,000 apartments were built. Many progressive architects worked together, among them Josef Frank and Adolf Loos, united by their opposition to the feudal historicism of the imperial Ringstrasse (a Renaissance opera next to a neo-Gothic church) and their unwillingness to submit to a single formula. The result was a tolerant functionalism; there was even a Werkbund settlement (Ober St. Veit) in which each architect was urged to follow his own plans, not those of collective enterprises. When civil war between militant conservatives and socialists erupted in February 1934, the Karl Marx Hof, symbolic center of the settlements, changed, at least temporarily, into a fortress fired upon by government artillery.

In contrast to the wanderings of the Hungarian exiles and the dispersal of the Polish avant-garde across that country's regional cities, Czech progressives were concentrated as always in Prague, with smaller groupings elsewhere, particularly in Brno, the capital of Moravia. The Czechs were fortunate to enjoy a liberal democracy for twenty years. Poets, artists, and critics there, after passing through cubism and a "proletarian" phase, developed their poetism together in the early 1920s, trying once again to reconcile art and life. Vítězslav Nezval, the most gifted among them, admired city lights, boulevards, the new media, circus, love, and the revolution; Karel Teige more pointedly declared constructivism the necessary basis for a flowering of lyrical, poetist creativity. Tomáš G. Masaryk, philosopher and president of the republic, met regularly with important writers, including Karel Čapek, for searching conversations. The Russian linguist Roman Jakobson settled in Prague, providing the avant-garde with a structuralist theory through his work in the Pražský lingvistický kroužek (Prague Linguistic Circle), and Kurt Schwitters and Raoul Hausmann performed in the city to much acclaim.

Yet ideological strains ran deep, and it was difficult to reconcile the simultaneous concentration on pure, playful art and stern revolutionary engagement. Around 1930, poetism gave way to surrealism;

five years later, a small committee of ex-poetists invited French surrealist leaders André Breton and Paul Éluard to Bohemia, and Prague became the central European capital of surrealism, which later went underground and survived the German occupation and the communist regime for decades to come. The protean resilience shown by Marie Čermínová, better known by her invented, unplaceable *nom d'artiste* Toyen, is exemplary in this regard. Toyen paints scenes of jazz and bondage in the early 1920s, claustrophobic abstractions and priapic fantasies in the early 1930s, spectral deserts while holed up in the 1940s, then moves ahead of the communist cloud to Paris, where she works until her death (1980). Yet at the time of the French surrealist delegation, Czechoslovakia was the only liberal and democratic republic left in central Europe. It welcomed not only visitors but also émigrés, principally from Austria and Germany—until its own destruction by Munich and the ensuing German occupation (March 1939).

The German brand of fascism had a double attitude toward modernity. It combined technological advantages in the organization of its media, the building of the *Autobahn* system, and industrial war production with nineteenth-century ideas of state and race, blood and soil. Joseph Goebbels, occasionally a pragmatic minister of propaganda, invited the Italian futurists to an *aeropittura* exhibition in Berlin (where the poet Gottfried Benn addressed Marinetti) in the spring of 1934, but Hitler declared within months that there was, in his state, no place for "cubists, futurists, and dadaists." Yet Nazi Germany was not entirely closed to the world outside; American movies, for example, were shown everywhere until Pearl Harbor. Even Goebbels, who avoided talking about jazz, favored the "rhythmical dance music" of modern times, eagerly played by Czech and French bands in Prague and Paris (and in a few Berlin night clubs), and broadcast to German soldiers (who had their own tastes) by army transmitters, especially in Oslo and Belgrade. German Air Force personnel, too, developed a habit of listening to British and American swing bands in their planes. Few survivors of the avant-garde emerged from the devastations, the camps, and the hiding places of the war, but avant-garde ideas reemerged and were used by Eugen Gomringer (Zurich) and the creators of "Concrete Poetry"; the Vienna Groups, including the Schule des Fantastischen Realismus; and in films by Czech Jan Švankmajer, among others. Perhaps it is not totally misleading to believe that some of the most exhilarating techniques of the old, the historical, avant-garde have been absorbed by the media, film, and advertising, and are all around us now, day and night.

Starting Points

Today's salon clearly demonstrated where the crystal core of new photography is being created. It is the area of central Europe: Czechoslovakia, Hungary, Austria, and Germany. Let us look forward, then, to the next central European salon. JIŘÍ JENÍČEK, PRAGUE, 1933[1]

Historians of modern art today seldom speak in regional terms, and photography historians hardly do so at all. Surveys in photographic history have as a rule been national in scope, or broadly international, following the loftiest rhetoric of many photographers themselves; pictorialists of the late nineteenth century, and after them modernists in the 1920s and 1930s, commonly invoked a worldwide brotherhood for the photographic cause. Four countries are understood today to have led this fraternity in the latter period, only one of which is located in central Europe: France, Germany, the Soviet Union, and the United States. To anyone familiar with the established narrative, then, it must seem surprising to read the claim by modernist proselytizer Jiří Jeníček for central European primacy in "new photography" of his day.

Jeníček, a leader in the amateur movement, placed Germany in the company of Hungary, Austria, and his native Czechoslovakia; the present book includes Poland as well.[2] Over the last thirty years, researchers have unearthed evidence of a terrific level of photographic activity within each of these countries, as well as a vigorous and widespread engagement with modernist ideas and style during the 1920s and 1930s. The sheer number of amateur clubs, avantgarde circles, and illustrated press concerns, as well as exhibitions and publications devoted to photography, gives credence to Jeníček's assertion of a central European photo culture. Yet the enumeration of now unfamiliar organizations and individual talents, taken country by country, does not answer the broadest and most intriguing questions raised by his statement: why would "new photography" take hold especially strongly in central Europe? What factors would cause so many across the region to embrace photography and, beyond that, to seek through photography to articulate a relation to the "new" — that is, to modernity?

To answer those questions involves taking account of the character of modernity in central Europe, which evolved in close and constant dialogue with the West (and in certain influential circles with the Soviet Union) but under fundamentally different circumstances than those prevailing in the West itself. Western modernity commonly designates the state of affairs brought about through industrial development and the rise of consumer capitalism in the early 1800s. In the domain of economics and statecraft, modernity connotes faith in progress and optimism about capitalist, constitutionally elected societies. In the cultural arena, by contrast, modernity stands for a questioning, dissident attitude toward mainstream views and the governing structures of public life. "What defines cultural modernity," Matei Călinescu has written, "is its outright rejection of bourgeois modernity, its consuming negative passion."[3] The critical distance between creative thinkers and society or the state, summarized by Călinescu with hyberbolic radicality, is a hallmark of modern thought as modeled in the West.

Central Europe, or more precisely the area dominated by the Prussian and Austro-Hungarian empires, followed a course of development both tied to and distinct from that in the established western nations. In the later 1800s — decades after France, England, and the United States — the central European lands began in a circumscribed and uneven fashion to develop the bourgeois economy characteristic of industrial modernity. In certain respects, modernization moved with striking speed; Budapest, for example, possessed the second subway line in Europe (1896). Yet the larger economic and social structures in much of central Europe prior to 1914 remained alien to modernity. A relatively small entrepreneurial class, composed furthermore of "outsider" constituencies such as Jews and ethnic Germans, worked to build a bourgeois economy in a region dominated by aristocracy and the institutions of the military, state bureaucracy, and the Catholic church, and served overwhelmingly by peasant laborers. As a result, this region experienced what economic historian Iván

Berend calls a "semifailure," in which belated and fragmentary advances in infrastructure, pegged to western developments, occasioned more than anything a lasting "modernization crisis": "Economic and industrial progress in Central and Eastern Europe during the second half of the nineteenth century was too little to generate radical social change yet too rapid to be socially digestible."[4]

As a result, modernism, meaning the cultural responses to modernity, developed in a notably restricted climate, in which artists retained a highly public, guiding role. Art, even "shockingly" modern art, was not readily dissociated or set against economic and political modernization, for politics and culture advanced together under the sign of a pervasive, often hyperbolic nationalism. In the imperial subject territories, nationalist yearning in the arts expressed defiance toward the ruling powers and compensated for frustrations in the struggle to gain political independence. Creative artists not only in the future states of Poland and Czechoslovakia, but also in the relatively privileged Kingdom of Hungary, took their cues from philologists and historians, eager to establish terms for a common identity not yet sanctioned by modern, international law. Austria, the ruling seat of this vast conglomeration of competing ethnic populations, had its own difficulties in determining a collective image suited to the modern world. Germany, meanwhile, labored under the insecurity of being in some sense too modern; an industrially powerful confederation of states joined together only in 1871, it lacked the lengthy political and cultural continuity that existed in the nation-states of western Europe.

Around 1900, vibrant modernist movements did arise in the region that split declaratively from mainstream thought, including the nationalist fervor then reaching its peak. The new advocates for modernity, however, did not reject history and tradition but sought instead to reactivate them, to explain them in fresh ways. Rather than maintain a critical distance from official circles, cultural progressives likewise frequently stepped into the center of official debate, such that "state modernity" and "cultural modernity"— to revisit the terms used by Călinescu—continued to work in tandem rather than in opposition to each other.[5] The importation of confrontational artistic styles, from cubism, expressionism, and futurism before World War I to purism, constructivism, or surrealism in the 1920s and 1930s, signaled erudition, worldly awareness, social commitment;[6] exactly these inclinations fueled the spread of "new photography" across the region as well.

Concomitantly with this public, historicist turn, elements of modernism exemplary in the western model played lesser or weakened roles here. Dandyism and bohemianism, subcultural tendencies that emerged, respectively, c. 1800 in London and c. 1850 in Paris, took hold in the leading cities of central Europe only around 1890. Similarly, before World War I, central Europe had few examples of key spaces of western modernity, such as department stores or bustling boulevards. Even those locales common to western and central European urban life, such as brothels or slums, failed to provoke in central Europe prior to 1900 the cultural fascination manifested, for example, in the novels of Charles Dickens or in French impressionist painting. The spaces that occupied modern consciousness in central Europe tended to be officious or aristocratic: municipal buildings, banks, spa resorts, "Grand Hotels," private villas.

Following World War I, the two Germanic monarchies crumbled precipitously, yielding a patchwork of more or less ethnically defined nation-states that matched at least outwardly the republican governments of the West, whose universal validity as a model of statehood found symbolic expression in the recently established League of Nations (precursor to the United Nations). This seismic redistribution of geopolitical power within the framework of a new, ostensibly egalitarian world order gave fresh urgency to the question of how and in what ways "to be modern." For Germans, Austrians, and Hungarians, defeat precipitated a grave societal crisis, reflected in violent revolutionary and paramilitary movements that swept those countries in 1918–1920. Poland, Hungary, and the Slovak/Ruthenian half of Czechoslovakia remained overwhelmingly agrarian, with important remnants of feudal society intact.[7] Even in the more prosperous cities of the former Austro-Hungarian and Prussian empires, such as Prague, Lviv, Leipzig, or Wrocław, the leveling effect of capitalist society, in which social rank and tradition count for less than dynamism or acquisitiveness, met with various forms of resistance that conditioned the acceptance of western modernity.

At the same time, the passage from empire to nation-state spurred fervor for change and reform such as had never been seen in the West. For those who had lost the war, becoming modern seemed a guaranteed means to overcome this recent catastrophe, while for those who had achieved independence, modernity went hand in hand with the gains promised by statehood. Modernist reforms in the public sphere were therefore championed across central

Europe by those desirous of giving a real face to the ideal of modernity. Radical modern architecture, theater, design, and advertising, for example, all received state or local patronage in parts of the region. At the same time, the new governments and their leading citizens continued the self-mythifying, ethnocentric attitudes that had incited nationalist causes throughout the nineteenth century. As a result, commemorations of semifictional past events and the veneration of language, religion, and folk culture played a major role in central European modernism during the interwar decades.

Photography offered an ideal medium with which to depict these various aspects of the "problem" of modernity (**fig. 1.1**). Itself a product of industry, it carried an inherent resonance with the "new" that the region's many advocates for modernization found welcome. Because of its reproducibility, it easily served a pedagogical function, providing readers of books and magazines with unifying images around which to consolidate a new consciousness. This desire did not originate with elected public figures. Private citizens of all kinds, from art school professors to amateur enthusiasts and picture editors, welcomed the pedagogical, standardizing effect of a mass turn to photography—and the success of their various endeavors suggests that students, exhibition-goers, and readers of the daily papers did so as well.

Photography also had deep institutional roots in central Europe, a region in which institutions governed much private as well as public life. Beginning in the late 1800s, a number of schools had been established to improve and regulate the quality of professional photography, initially for applied or commercial purposes but soon for creative ends as well. The

Lehr- und Versuchsanstalte (Teaching and Research Institutes) founded in Vienna (1888) and Munich (1900) attracted ambitious talent from a wide geographic area, and practically from their inception both schools offered courses on fine art in their curriculum. In addition to these state-sponsored schools, private institutes such as the Lette-Verein for women in Berlin, with a photography department from 1890, arose to mirror the patrician initiatives common at that time. All of these places, quite importantly, brought enrollment from around the region, part of the much deeper ties that cemented central Europe as a cultural entity even after its political fragmentation in 1918. Not surprisingly, photography instruction surged in the successor states: the Státní grafická škola (State Graphic Arts School) in Prague, founded 1919, or the Staatliche-Städtische Kunstgewerbeschule (State and Municipal Applied Arts School) Burg Giebichenstein in Halle, 1921; art academies and engineering schools in Vilnius, Poznań, Lviv, Brno, and Budapest; courses offered in private art schools or commercial studios such as those of Johannes Itten (Berlin), József Pécsi (Budapest), or František Drtikol (Prague) (**cat. 1**).

Further opportunities for learning about photography in an often artistically ambitious setting came with the amateur clubs that proliferated from the 1890s. While some wealthy amateurs used darkrooms in their own homes,[8] continuing the rarefied tradition of British amateurism begun by William Henry Fox Talbot, scores of dedicated hobby photographers took advantage of facilities and assistants provided by club dues, their aggregate number climbing to several thousand during the 1920s.[9] These clubs additionally created a conduit to publication in nationally distributed monthly magazines, as well as to participation in international, juried salon exhibitions.

The first amateur club of this kind in the region was the Vienna Camera-Club, established in 1887 on the model of an eponymous organization founded in London two years earlier. The Viennese association soon established its "house" periodical, the *Photographische Rundschau*, actually published in Germany, which quickly found imitators in the Czech lands, Hungary, and Poland.[10] In 1891, the Camera-Club held an international, juried exhibition that explicitly made artistic merit the overriding criterion for inclusion. Claims of profession, purpose, and subject matter were discounted here in favor of a far-reaching program of aesthetic reform—a strategy continued by the photographic avant-garde in the later 1920s.

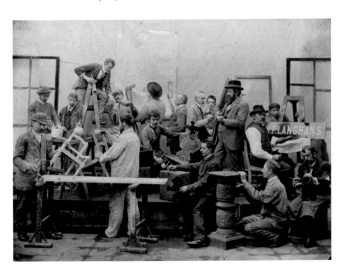

1.1 Unknown, Atelier Langhans, Prague, 1890s, albumen print, 23 × 31, Private Collection

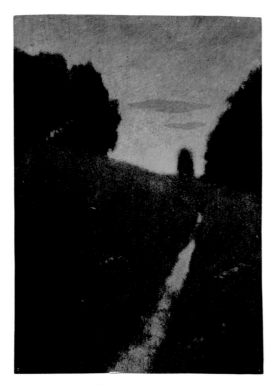

1.2 Heinrich Kühn, *Twilight (Dämmerung)*, 1896, gum dichromate print, 38 × 27.3, Albertina, Vienna

The program furthered by the Camera-Club was known as pictorialism, called "art photography" in the central European countries, and Vienna became a leading center for this far-flung movement as a direct result of the 1891 exhibition.[11] British amateur Peter Henry Emerson had coined the term "pictorial art" in 1889, to describe an expressive, emotionally laden photographic composition liberated from the seeming uniformity of mechanical procedure. Art photographers called for slightly unfocused views and a variety of labor-intensive printing processes that, in Austria and the Czech lands in particular, resulted in brooding, spectral scenes reminiscent of post-impressionist painting **(fig. 1.2)**. With Constant Puyo in France, Alfred Stieglitz in the United States, Heinrich Kühn in Austria, and others, the pictorialist movement represented an intercontinental elite. Kühn and his closest colleagues in the Camera-Club took a particularly highbrow view, dismissing the mass of contemporary amateurs as irredeemable hobbyists. Leading Austrian pictorialists set their sights on the still more exclusive world of secessionist fine art, rather than on initiatives aimed at cultivating artistic abilities among the general population.[12]

This elitist stance turned out to be exceptional in central Europe, and even in Austria proper. The predominantly aristocratic leadership of the Polish pictorialist movement (which expanded much later, blossoming only after World War I) shared some of the disdain for popularizing photography education displayed by the prewar Viennese. The principal figures in Polish pictorialism, such as Jan Bułhak, Henryk Mikolasch, or Witold Romer, nevertheless held positions at engineering schools or universities where proficiency in artistic photography became part of the curriculum during the 1920s. Czechs and Hungarians, meanwhile, disseminated knowledge of pictorialism to a broad middle-class membership, relying on a nationwide network of local clubs formed in the 1890s. In the Czech lands in particular, amateur art photography amounted to a national pastime even before the advent of statehood in 1918.

Tremendous impetus for the popularization of pictorialism came from Germany, the dominant cultural power in this region. Alfred Lichtwark, curator at the Kunsthalle in Hamburg, took an obsessive interest in photographic amateurism as part of a general *Kunsterziehungsbewegung*, or art education movement, sponsoring a series of annual exhibitions to demonstrate the value of cultivating this "sport" seriously and with artistic aspirations. The first of these massive pedagogical undertakings, held in 1893, included more than five thousand entries. Lichtwark wrote tirelessly, explaining the virtues of aesthetic self-improvement in treatises with titles such as *Exercises in Looking at Works of Art* and *The Means and Goals of Dilettantism* (a word divested here of its pejorative connotations).[13]

Beginning in the later 1890s, prestigious studio photographers across the region allied themselves with this promotional campaign, creating a commercial vogue for pictorialist portraiture that made the new aesthetic a household style for the middle classes. Rudolf Dührkoop in Hamburg, Jan Langhans **(see fig. 1.1)** and Vladimír J. Bufka in Prague, Mai Manó in Budapest, and Dora Kallmus **(cat. 2)** in Vienna all helped to popularize aristocratic printing processes and to associate them with what was in 1900 a "modern look," that is, secessionist art and design. Manufacturers of photographic equipment cooperated eagerly in these developments, for the increased prestige and popularity of photography greatly aided sales.[14]

All of this institutional activity prepared the way for the explosion of "new photography" in the 1920s, by making photography into a fashionable means of cultural ennoblement, artistic instruction, and stylistic reform. Although the pictorialist aesthetic espoused in the final prewar decades became anathema to progressives of the postwar era, the model of gargantuan or encyclopedic exhibitions, educative essays, market saturation, and training

2

schools remained firmly in place. So too did the align-ment of ambitious photography with modern fine art, exemplified in the most influential art school of all time, the Bauhaus.

The fact that developments in photography were channeled through registered institutions also gave interwar modernism in this field a decidedly official, public cast. Germany once again took the lead here. The two most common designations for modernist tendencies in interwar photography, New Objectivity (*Neue Sachlichkeit*) and New Vision (*Neues Sehen* or *Neue Optik*) were spread through institutional measures in that country, which transformed individual efforts into a truly popular phenomenon. New Objectivity, a term coined by art critic Gustav Hart-laub in 1925 to describe developments in contempo-rary German painting, mutated into a label for the most modern photography following the publication

of Albert Renger-Patzsch's picture book, *The World Is Beautiful*, in December 1928 **(fig. 1.3)**. Renger intended his book to be a primer in apprehending the modern world, with examples that ranged from forms in nature to industrial landscapes and factory objects. As a corollary to this encyclopedic, instructional vision, Renger and Carl Georg Heise, a museum curator who arranged for the book's publication, insisted on a low price with a high print run. "Thus I would find it one of the worst jokes of our time," Heise explained to influential writer and newspaper critic Kurt Tucholsky, "if the most popular ideas had to be realized in books for snobs, for lack of guts."[15]

In the photophilic environment of central Europe, the influence of colleagues like Heise or Tucholsky and a vigorous publicity campaign by pub-lisher Kurt Wolff were enough to plant the phrase New Objectivity within months on the lips of photog-raphers from Rijeka to Danzig; Polish amateurs, led by Bułhak, even answered this new vogue with their own, artisanally oriented style proudly called *stara rzeczowość* or "old objectivity." Renger suddenly found himself answering a barrage of invitations to speak and exhibit, but above that, to pronounce upon the state of contemporary photography.[16] Indeed, the magnitude of this attention prompted critical warn-ings—even from the artist himself—against "photo-inflation," a devaluing of aesthetic vision suddenly rendered commensurate with the contempora-neous stock market crash and ensuing worldwide depression.[17]

The other great catchphrase of photographic modernism, New Vision, has actually come into wider use only since the end of the interwar period, as an umbrella term for manifold innovations during that time.[18] It, too, has its origins in a book project, with-out doubt the most influential treatise on photogra-phy of its day: *Painting Photography Film* by Bauhaus professor László Moholy-Nagy **(fig. 1.4)**. Published in 1925 and reissued in 1927, *Painting Photography Film* set forth the stunning thesis that camera vision could revolutionize, modernize, all of human perception. From microphotography to X-ray images, from photo-montage and photograms to photojournalism and *typofoto* (combinations of text and photographic image), photographic applications could improve our understanding and extend our aesthetic sense. Detached from the body, the "photo eye" surpassed the limitations of physiology through odd angles, special lenses, or trick photographs, for instance. Dynamism, impartiality, reproducibility, above all a new sense of possibility were now the hallmarks of photography, the truly modern medium.[19]

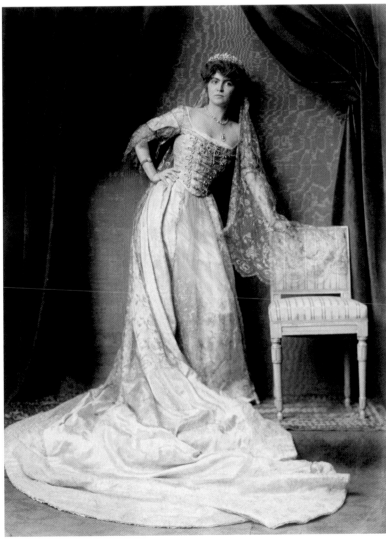

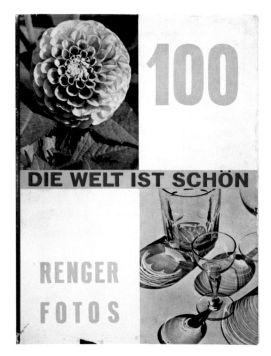

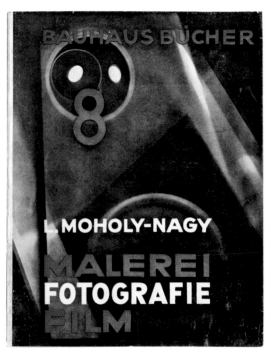

1.3 Albert Renger-Patzsch, *The World Is Beautiful (Die Welt ist schön)* (Munich, 1928), cover by Friedrich Vordemberge-Gildewart, photolithograph, 29 × 21.7, The Getty Research Institute, Los Angeles

1.4 László Moholy-Nagy, *Painting Photography Film (Malerei Fotografie Film)* (Munich, 1927), cover by the author, photolithograph, 17.3 × 20.5, June and Bob Leibowits

Like *The World Is Beautiful,* Moholy's book asserted an encyclopedic role for photography in the modern world. Indeed, *Painting Photography Film* took that assertion further, for it implicitly folded Renger's sober, craftsmanlike aesthetic stance into a panoply of approaches that together constituted the value of photography to modern life. In countless lectures and essays after 1925, Moholy reiterated the ways in which photography could aid humans in recognizing and improving the world. A native of Hungary, he traveled and sent articles with particular frequency to Budapest, and just as often to the nearby cities of Brno and Bratislava, both in Czechoslovakia. These long-term relationships, combined with Moholy's ubiquitous presence in Germany, embedded him deeply within the central European context, a fact obscured by the standard emphasis on his value to a transnational avant-garde.[20]

The breadth and structure of Moholy's explanations, and some of his terminology as well—including the key phrase New Vision—betray the influence of art-historical discourse in central Europe. Indeed, the discipline of art history shaped many guiding personalities of "new photography" in this region: artist-theorists such as Moholy or Karel Teige, who accorded photography an unprecedentedly radical historical mission; cultural critics from Josef Čapek to Tucholsky, Karl Kraus, or Siegfried Kracauer, who penned sophisticated reflections on photography and film for a broad newspaper readership; amateur or professional writers on art, such as Iván Hevesy in Budapest and Franz Roh in Munich, who made their own modern photographs as instructional exercises; collectors on the order of Erich Stenger (Berlin) or Rudolf Skopec (Prague), whose pairing of modern and mid-nineteenth-century photographs of all kinds gave a newfound legitimacy to the field; the museum curator Heise (Lübeck) and university professor Heinrich Schwarz (Vienna), who likewise studied early photographs together with contemporary work, seeking to build public appreciation for the historical continuity of this "inherently modern" creative domain.

The art-historical share in "new photography," endemic to central Europe, is a truly striking feature of photographic renewal in the interwar decades. Teige, for instance, wrote studies on Paul Cézanne and Edvard Munch in high school, then spent one year studying toward a university degree in art history before rebelling to found the avant-garde collective Devětsil in late 1920. Teige's seminal theory of the *obrazová báseň* (picture poem), a form of photomontage explored by many Devětsil members in the mid-1920s, is discussed in chapter 2, along with his crucial early essay "Foto Kino Film" (1922). More than

two decades later, in 1947, Teige, who worked with photographs in book design and photomontages throughout his career, would write a history of photography in Czechoslovakia, also one of the earliest studies of its kind.

Critic and amateur photographer Iván Hevesy followed a comparable if far more modest course of development in Hungary. Hevesy attended art history lectures in his teenage years, but like Teige did not complete a degree in the field. He did, however, publish essayistic studies of impressionism, post-impressionism, futurism, and Dada in the early 1920s, at a time when the latter two movements in particular found an active echo among Hungarian progressive artists. Hevesy deemed contemporary art liberating but elitist and appreciated it only as a transition toward the "truly modern," verifiably popular arts of film and photography. He took up the latter cause around 1930, in step with the times, and began to make his own photographs as well as to preach the modernist gospel. In journal articles such as "The Renaissance of Photography" (1931) and in his 1934 book *Modern Art Photography*, Hevesy characterized photography as a form of expression that, like central Europe itself, had been impelled through historical circumstance to realize its modern potential: "The liberation and self-discovery of photography did not come unexpectedly, just as photography had its profound reasons to get lost before [meaning the pictorialist era]. The most important reasons for this liberation prove to be the new vision of life and art that have developed since the war."[21]

Hevesy's writings and photographs, while largely unoriginal, attest to the force of the central European model of photographic discourse. Photography is seen for the first time there as an innately modern art possessed of a continuous, if aesthetically uneven, historical development. Discussions of the meaning and purpose of photography begin invariably with sweeping historical pronouncements that divide the preceding century into a period of great achievement (1840–1870), followed by one of superficiality and decline. Acknowledged masters such as David O. Hill, Louis-Jacques-Mandé Daguerre, or Nadar (Gaspard-Félix Tournachon), who worked during the earlier decades, are celebrated individually but just as much for capturing the greatness of their time. This is a sharp change from the language of pictorialism, where period consciousness had no place in the hagiography of individual predecessors. Equally novel is the willingness, which finds its culminating example in the writings of Hevesy's one-time

friend Moholy-Nagy, to grant to all forms of photography the status of art. Hevesy follows this democratic line of reasoning with conviction, writing of doctors, passport photographers, and journalists in *Modern Art Photography*: "They care only that an image serve its goal as perfectly as possible. And yet, almost all [of these images] can come close to or achieve that which we . . . call art photography."[22]

For Franz Roh, another populist pedagogue, representational imagery formed just the beginning of photography's claim to the status of a new art form. Roh, whose experimental darkroom exercises match perfectly the culture of "Laboratories and Classrooms" discussed in chapter 3, began to work seriously with a camera in the mid-1920s, like Hevesy after encountering the ideas of Moholy-Nagy. An art historian, Roh studied with and worked for the eminent Heinrich Wölfflin, whose teachings on art history as an "evolution of seeing" then held immense popularity. After publishing his dissertation on Dutch seventeenth-century painting in 1921—significantly transformed from an academic treatise into a picture book with two hundred photographic illustrations—Roh turned his attention to recent and contemporary art.[23] His second book, *Post-Expressionism; Magic Realism, Problems in the Latest European Painting* (1925), applied his mentor's binary terms to distinguish between expressionism and more recent styles in Germany, and it included a chapter as well on "Nature's Own Expression (Art and Photography)."[24]

Roh carried on a massive correspondence with young artists and fellow historians who were continually sending, requesting, or discussing photographic reproductions. The omnipresence of photographic images in his working routine, which included the maintenance of a mammoth slide library, may have impelled Roh toward a more active involvement with camera equipment. He began probably in 1925 or 1926 to play with the camera, testing as if from a recipe book the innovations advocated in *Painting Photography Film*. He also assembled a study collection of diverse nineteenth-century photographs, which may well have included negative prints and shaped prints—common techniques of the mid-1800s—that Roh found particularly appealing for his own work.[25]

Roh thus took up photography with considerable self-consciousness about art history and its relation to vanguard modernist art. In 1928, as general interest in the "new photography" built to a fever pitch in Germany, Roh added to his repertory of public lectures one on "Mechanism and Expression: The Essence and Value of Photography,"[26] publishing his

comments later as the introduction to his iconic picture book, *Photo-Eye* (1930):

the history of photography hitherto shows two culminating periods. the first at the beginning of development (daguerre), the second at the end [1930] (see photos of this volume and many "anonymous" pictures published in illustrated papers). the greatest part of what has been produced between this beginning and end is questionable, because a frank or disguised attempt was made to imitate the charm that belongs either to painting or to graphic art. this of course was a deviation from the proper task of photography....[27]

Printed lower case, in the modern style, Roh's declamation presents with exemplary forcefulness the sweeping historical claims characteristic of the New Vision era. Early and contemporary photography rise like mountainous bookends around a trough of late nineteenth-century "deviation," establishing period parameters that subsume work by well-known names and anonymous makers alike. All approaches, all types of photography belong within the field of expert aesthetic inquiry. Soon afterward, Roh announced the forthcoming publication of an illustrated series, unfortunately never realized, which was to cover by turns "Police Photos, Photomontage, Kitsch Photos, Sport Photos, Erotic and Sexual Photos."[28] This is emphatically not a history of painting, yet it is an aesthetic history of images, and thus inevitably a history of art. Indeed, Roh subtitled his talk "a stylistic history of photography" (*Stilgeschichte der Fotografie*), no doubt tickled to apply the grand terminology beloved of his teacher Wölfflin to this plebeian subject.[29]

The fledgling beginnings of an art history for all photography may be traced, then, to central Europe during the 1920s and 1930s. Photography is described there, for the first time, as a unified and continuously developing *image medium*—an all-embracing, aesthetic qualification of incalculable impact upon later studies in the field. This reconception of photography is in turn profoundly connected to central European anxieties over modernity, understood as a sudden, epochal shift that must imperatively be embraced but also legitimated in historical terms. The enormous institutional mobilization on behalf of photography, from exhibitions and picture books to magazine columns and newspaper commentary, lectures, art-school training, and the like, speaks to a tremendous desire to legitimate the new. Voicing this desire are types unfamiliar from standard accounts of modernism: the public official, the inspired amateur, the classroom instructor, the art historian.[30]

Aesthetic pedagogy does not give the only frame of reference for the new, global image theories formulated in central Europe, nor is every photographer in this region also a professor. One of the most remarkable figures in central European modernism is the Polish polymath Stanisław Ignacy Witkiewicz, also known as Witkacy, who charted an eccentric and largely independent course through the art and literature of his time. By turns playwright, novelist, and painter, Witkiewicz gained aptitude with the camera from an early age, under the guidance of his father, an accomplished amateur who also wrote about photographic aesthetics.[31]

Witkiewicz approached his camera work seriously and methodically, particularly in the many series of portraits he fashioned of those dear to him during the early 1910s **(cats. 3, 4)**. Insisting on the need for multiple images to reveal a person's inner self, he arranged lengthy sessions in which he composed sequences of shots taken in profile, then head-on, both from a distance and from an uncomfortable proximity (the latter involved a manually altered camera with a lens that came exceptionally close to the sitter). These intimate stagings, conducted in an air of pronounced drama and mystery at the family residence in Zakopane, a Galician vacation town, pushed to extremes an aristocratic romanticism associated in Poland with amateur photography, modeled for example on the staged scenes and theatrical portraits of English amateur Julia Margaret Cameron, whose work the Witkiewicz family owned and admired. Yet unlike Cameron, Witkiewicz never attempted to sell or exhibit his photographs. Instead, he accumulated them by the hundreds in albums and stored these at his Warsaw apartment, where they were annihilated along with some 85 percent of the city during the German bombing campaign of August–September 1944.

Witkiewicz repeatedly stated his horror at the concepts of rationality, progress, and self-improvement, and he therefore followed the advance of mainstream modernism with apocalyptic despair. His core treatise on art, *New Forms in Painting and the Misunderstandings Arising Therefrom*, decries the "soulless" contentment that takes dictated, communal happiness as humanity's highest goal: "the first step on the way to total leveling of differences is the standardization of civilization.... Nowadays...even the most individual accomplishments, quite independent of the will of the person responsible for them, add to the growing power of the mob of gray workers fighting for their rights."[32] War had devolved from chivalric bravery to "mechanical, systematic murder," social justice was a delusional dream, the mystery of religion

3
STANISŁAW IGNACY WITKIEWICZ (Polish, 1885–1939), *Arthur Rubinstein (Zakopane)*, 1913–1914, varnished carbon print, 18 × 13, The Art Institute of Chicago, Laura T. Magnuson Endowment

4
STANISŁAW IGNACY WITKIEWICZ (Polish, 1885–1939), *Self-Portrait, Zakopane (Autoportret, Zakopane)*, c. 1910, gelatin silver printing-out paper, 18 × 12.6, Collection of Ewa Franczak and Stefan Okołowicz, Warsaw

would soon be supplanted by superficial faith in scientific clarity, philosophy had been driven to suicide; in sum, everything now tended toward "lulling to sleep our antisocial metaphysical anxiety," the basis of all truly inspired human activity.

Such profound, Nietzschean cynicism, turned against both the West and the new Soviet ideals, cuts against the grain of much that will be presented in this book—yet it is emphatically not a retreat from modernity. Witkiewicz was a fully modern artist. He joined a leading Polish modern art group, the formists, and exhibited with them for years. He pursued forms of abstract painting and revered the work of Kazimir Malevich. In 1921, he was one of the first in the region to respond (albeit vaguely) to the dadaist work of Marcel Duchamp. He gave up oil painting three years later to found a "portrait firm" conceived with sophisticated irony, in which artistic license and subtleties of depiction were formalized in a corporate contract: arms and torsos, but also conventional beauty or even verisimilitude all cost extra, for example.[33] Most important for this account, Witkiewicz returned to the camera, testing multiple exposure, blur, and unusual angles as well as alter egos and extended snapshot sequences in the years around 1930.[34] All this activity bespeaks an abiding, but mistrustful, engagement with modernity as defined in the 1920s and 1930s; a dialectic between the forms of technological, democratized society and habits of thought inherited from landed gentry in the imperial era. Witkiewicz's mastery of this dialectic exemplifies the originality of thought provoked by encounters with modernity in interwar central Europe.

Among their many visionary traits, Witkiewicz's haunting portraits of 1912–1913 prefigure the frank intimacy of much interwar portraiture. Following this thread, chapter 4, "New Women—New Men," focuses on photographic representations of self in a time of rapidly altered social relations. The topos of the New Woman, well-known from German discussions during the 1920s, is extended both to other countries in the region and to the other sex. Women and men alike experienced sudden, far-reaching changes in status as a result of World War I, through the destabilization of imperial pillars such as the Catholic Church, for example, and the establishment of universal suffrage across the region directly upon the war's conclusion. While these changes did not lead to improvements for most women in central Europe—the 1920s and 1930s marked a period of diminishing rights for women there as in the West—

they did give rise to a tremendously visible consumer market aimed at women and driven by images of women in the mass media. The negotiation between selfhood and spectacle, between private identity and public image, constitutes a defining aspect of modernity embodied with singular depth and extent in photography from this region.

The discussion of gender roles leads to the much larger topic of "Modern Living" in chapter 5, the central chapter of the book, which covers the many realms of popular activity infiltrated or redefined by photography since the 1920s. Sports, dance, fashion, movies, city life, and other areas claim consumer attention in this era, all through photographs offered by a burgeoning illustrated press and advertising sector. This is the heyday of photojournalism, when each major city boasts hundreds, if not thousands, of papers and magazines, and even in provincial capitals circulation can climb into the hundreds of thousands; at the epicenter, meanwhile, the world record is reached prior to 1930 with print runs of two million copies for the *Berliner Illustrirte Zeitung*. Photo agencies proliferate, along with freelance reporters, art editors, exhibition designers, and graphic artists conversant with techniques of photographic reproduction. These new vocations, all shaped and managed through institutions (art school degrees, specialized magazines, licensing agencies, professional societies), become so many additional outlets to educate the broadest possible public in what it means to be, or to look, modern.

Serial imagery, bundled into new genres such as the "photo essay" or the "photo story," shift the terms of interaction at this time between word and image on the printed page. Images burst the format of newspaper columns, leap across centerfold spreads, and feature as well in mural-size enlargements at cultural expositions and trade fairs. Ambitious photographers, keen to participate in this image world on their own terms, create another genre, the "photobook"— *The World Is Beautiful* is an outstanding example— monographs in which the expected narrative trajectory is described solely by sequences of photographs. While many of these innovations are tested within the avant-garde art circles discussed in the book's opening chapters, they are also widely visible in popular culture. High and low art invigorate each other particularly during the 1920s, with progressive fine artists seeking to revolutionize the mainstream, and mainstream editors and photographers keenly attentive to progress in the arts. The historical proximity of mod-

ern art to official, public institutions in central Europe yields fantastic rewards in this time that give to the field of photography an unprecedented breadth of possibility and appeal.

Drawing upon the institutions of amateur photography and the illustrated press in particular, individuals in every country except Poland galvanize enthusiasm for "worker photography" or "social photography," as discussed in chapter 7, forging a documentary movement that, while not always truly popular, nevertheless yields a widespread body of dissident work. In Germany, where this movement grows strongest, adherents deride the New Vision for valuing aesthetics over political action. Elsewhere in the region, however, the New Vision, with its international (German) provenance and emphatic novelty, counts as a forceful argument on behalf of modernity, with the result that "worker photography" and "new photography" are often propagated side by side.

An instrumental use of foreign tendencies may be observed to a degree with surrealism as well, discussed in chapter 6, which spreads particularly to cities in Poland, the Czech lands, and Serbia beginning around 1930. Paris is idealized in many Polish and Czech productions, as an argument against Germanness or provincialism and, again, for embracing the internationalist modern world. But surrealism, particularly in the Czech lands, far surpasses that instrumental impulse in the range and quality of its accomplishments. From Prague, the second capital of surrealism after Paris, to the smaller cities of Brno and Olomouc and even the south Bohemian town of České Budějovice, a remarkable variety of work emerges in the 1930s, in all media but particularly in photography: from pseudo-documentary views of "objective chance," to the record of happenings or ephemeral sculpture, to manipulated prints and photomontage. With this work, artists turn declaratively toward private realms of experience, implicitly rejecting the quasi-official, pedagogical framework of central European culture. The force of that rejection, the necessity of which is difficult to understand from a Western perspective, prepares Czech artists to continue surrealist activities apace during the six years of Nazi occupation, while the movement elsewhere falls into a period of relative (some would say terminal) stagnation.

As a counterpoint to the embrace of currents abroad, and particularly to the left-wing documentary described in chapter 7, every country in the region also developed some form of a nationalist cultural movement in which photography figured prominently. Chapter 8 treats this tendency, known variously as *Magyar stílus* (Hungarian Style), *Slovenská moderna* (Slovak *moderna*), and *Heimatphotographie* in Germany and Austria or *Fotografia ojczysta* in Poland (Homeland or Fatherland Photography). In Poland in particular, camera production came accompanied by a rich body of theory on the value of photography to state propaganda. Paeans to the countryside and rural life from this time often carry fascist leanings or outright expressions of fascism. At the same time, images of the land and those living on it reflected competing ideological programs, for many traditionalists wept bitterly over the seizure of their land by the Nazis, who from 1933, their first year in power, took land-grabbing as the major instrument of their foreign policy.

Running throughout are examples of photomontage, a thoroughly modern medium that, in view of its discursive importance as well as its pervasive spread in central Europe, opens and closes the history recounted in this book. Although widely practiced by studio photographers and hobbyists during the nineteenth century, and increasingly common after 1900 in the illustrated press, photomontage reached a new and phenomenal level of visibility in the 1920s and 1930s. This epochal shift was generated by the avant-gardes of the period, and after passing into broader popularity it died with them, marking a meteoric trajectory linked at its start and at its finish with war.

The aftermath of World War I and the Soviet Revolution shaped the early history of photomontage, as shown in chapter 2. Alongside the well-studied movements of Berlin Dada and Soviet constructivism, whose interconnected development sets fundamental terms for photomontage practice, this chapter includes a discussion of important, lesser-known activities unfolding in the Czech lands and Poland. Chapter 9, the final chapter, meanwhile, concentrates on responses to war from around 1930 to 1945. Many of these works were kept strictly private, at first by design but later by force of circumstance. Creation in secret became a necessity during World War II, when formerly outspoken avant-gardists such as Teige or Władysław Strzemiński lived in enforced seclusion. Teige's Jewish compatriot, Jindřich Heisler, created several dozen haunting photographic compositions and mixed-media poems over the years he spent sequestered in various friends' apartments, hiding to avoid deportation. Strzemiński, an abstract painter who had long advocated the value of photomontage, utilized this technique briefly at the war's end to

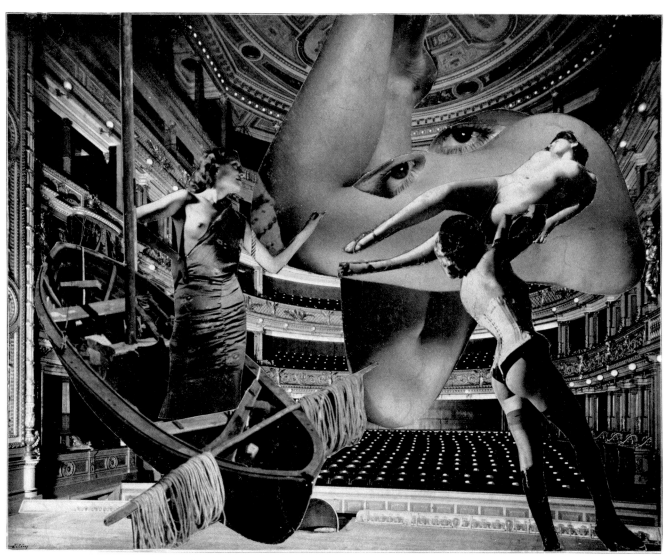

5

5

KAREL TEIGE (Czech, 1900–
1951), *Collage no. 55 (Koláž č. 55)*,
1938, photomontage (printed
matter), 25.5 × 20.4, Museum
of Czech Literature in Prague

create a horrific, poignant homage to those not spared that fate, entitled *To My Friends the Jews*, which he donated to the Holocaust memorial, Yad Vashem, in Jerusalem.

Teige himself began in 1935 to fabricate photomontages in an almost diaristic fashion, producing more than four hundred works that he largely stored at home or gave away to friends **(cat. 5)**. The bulk of his montages date from 1938 to 1945, that is, from the year of the Munich accords that ceded Czechoslovakia to Hitler through the end of World War II. Aggressively erotic, like much surrealist work, Teige's accumulation of photographic reproductions is also uniquely erudite. Art-historical sources of many kinds, from a variety of classical and modern paintings to, above all, the spectrum of recent photography, occupy a highly visible place in Teige's photomontages. Often easy to identify, these many and varied references constitute an illustrated survey, a scholarly treatise in images. The historical turn characteristic of central European modernism recurs here in paradigmatic fashion at a moment when all corresponding possibilities of institutional, public engagement for modernist art have been utterly banished.

Like this introductory first chapter, the eight chapters that follow may be considered a series of starting points, distinct yet overlapping, with which to form a historical and art-historical analysis of modernity in central Europe. The shifting focus from technique (photomontage) to subject matter (gender roles), from the relatively self-contained environment of experimental photography and avant-garde art to the broadly popular movements of "worker" or "homeland" photography, and beyond that to mass-media institutions such as the illustrated press, is intended to suggest ways to apprehend the relation of *foto* to modernity in a somewhat holistic fashion.

As a corollary, while the works shown here have been chosen for their singularity, they also stand in many cases for larger, even vast, quantities of material in the same vein.

That much greater body of photographic work is absent not just for reasons of space: much of it has disappeared. For every happy instance, such as the four hundred extant photomontages by Teige, there are others of tragic loss, such as the annihilation through bombs of Witkiewicz's Warsaw archive, as well as perhaps sixty thousand negatives by Umbo in Berlin and untold thousands of works by Pécsi in Budapest. Many photographers were forced into exile or unemployment by Hitler's regime; some, like Renger-Patzsch and August Sander, chose a state of semiretirement that the Germans would later call "inner emigration" (both photographers, too, lost a good part of their archives during or just after the war). Blessedly few of the figures discussed in these pages suffered death in concentration camps, the fate of Imre Kinszki and Yva, or killed themselves in despair over the Nazi invasion, as did Witkiewicz. Having survived the war, however, the majority of those who stayed in the region had to negotiate a new set of totalitarian regimes, bureaucratic perversions of the left-wing ideals many had defended ten to twenty years earlier. Teige's photomontages have long outlived their maker, who was hounded to death during Stalinist purges in 1951. The lands of central Europe shifted materially and symbolically eastward during that long postwar era. Now, when "old" and "new" Europe have again forged a working unity, it has become easier to reconstitute the "area of central Europe" that made such immediate sense in Jiří Jeníček's day, and to map the terms of a signal engagement with modernity that took place there nearly one century ago.

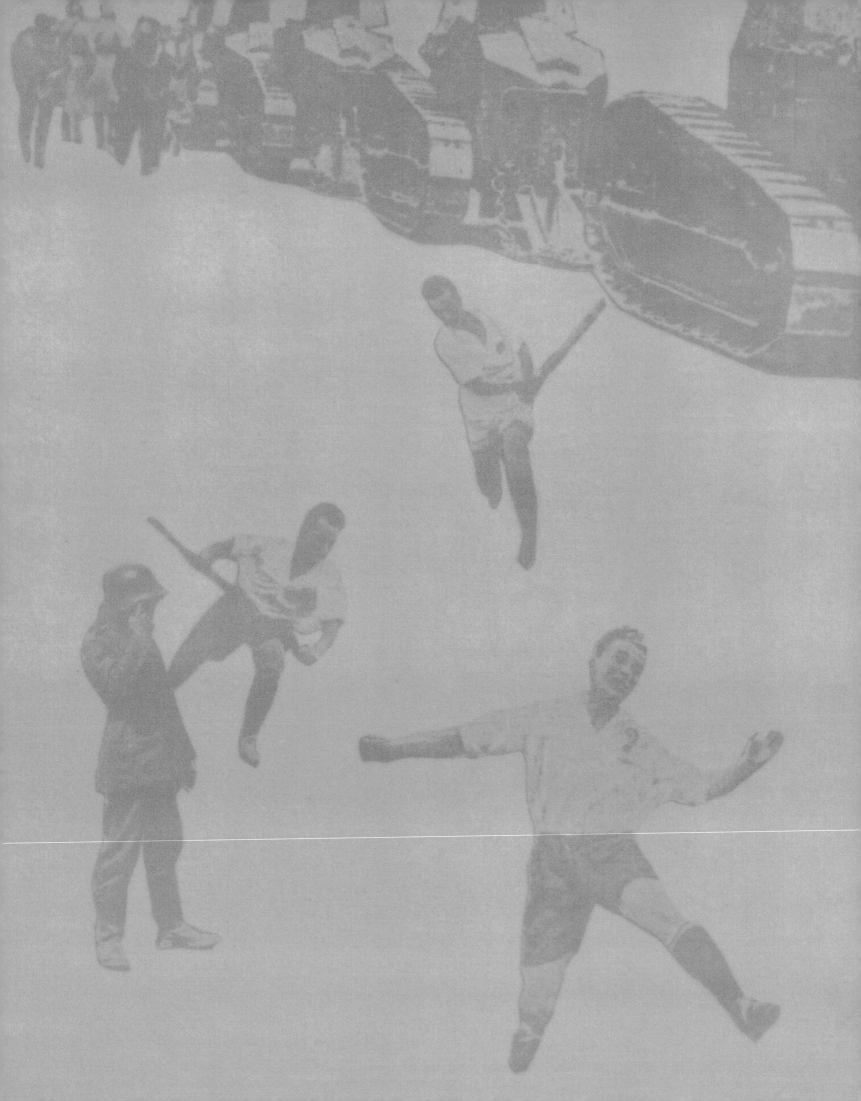

chapter 2

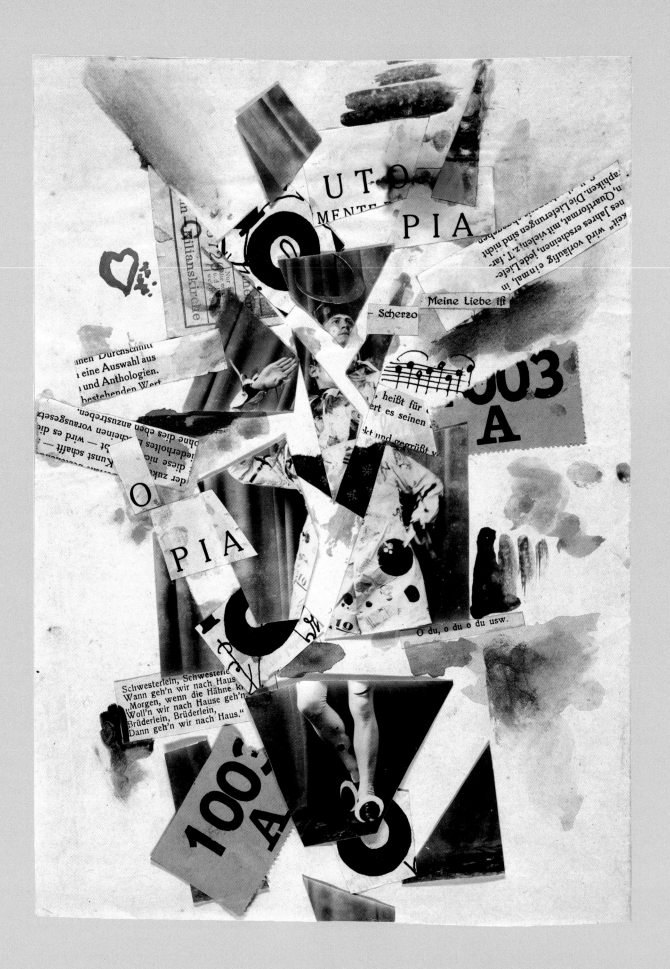

6

RUDOLF LUTZ (German, 1895–1966), *Utopia (Utopia)*, c. 1921–1922, photomontage (printed matter, ink, and gelatin silver print), 29.2 × 21.1, Bauhaus-Archiv, Berlin

Photomontage, a method involving the excision and reassembly of photographic images (whether found or, less commonly, made for the purpose), has a long history in popular and commercial usage across many countries. Its origins as a technique of choice for the avant-garde, however, may be traced to discrete artistic circles in central Europe and Soviet Russia during the years 1919 to 1924, that is, the half-decade of lingering military and economic crisis following World War I. Simultaneously banalized and monumentalized by 1930, a scant ten years after its initial promotion, photomontage returns to the mainstream of visual discourse at an astounding level thereafter, only to wane in popularity once more toward the end of the second interwar decade. Nevertheless, in important instances, photomontage remains an avant-garde technique of choice during the 1930s in the face of new military conflicts—as it will not be for many years after World War II. The trajectory of central European photomontage thus leads in exemplary fashion from war to war, and this subject accordingly begins and ends our account of *foto* and modernity in the region.

Openness to "low" photo culture—commemorative soldiers' portraits touted by Berlin Dada, tourist postcards beloved of the Czech group Devětsil— forms but one aspect of a complex, triangular dialogue by avant-garde photomonteurs with painting, photography, and film. Painting is the discipline in which nearly all the first practitioners of photomontage are schooled, and its recent history to that date includes the crucial reference point of cubist collage, the nearest avant-garde precedent to photomontage in formal terms. Film constitutes for many of these artists an ideal realm; it offers the hope of aesthetic renewal as well as new audiences, thereby resolving the crisis of viewership for truly modern art exemplified precisely by cubist collage.[1] Yet it is in the field of photography that photomontage becomes domesticated, despite widespread resistance from serious photographers and initial ignorance of camera skills within the avant-garde. Indeed, while it is liminal to histories of painting and film even now, photomontage in the 1920s became a cornerstone in the construction of a new,

global history of photography as art that has remained influential ever since.

That photomontage should be privileged in the elaboration of photography's history as art is not entirely surprising, for it equalizes all photographic types and technologies at the level of print reproductions; moreover, the operations of collecting, selecting, excising, and juxtaposing photographs implicitly invite reflection on the photographic image as such and suggest photography as a unified field of production. If this potential is made evident in certain popular forms of photomontage, for instance the April Fools' issues and satirical or fantastic postcards common in central Europe from the late 1800s, it deepens to a profound social and aesthetic (self) analysis in Berlin Dada, the first circle of avant-garde photomonteurs, in 1919–1920. An analytical function, molded by experiments in cinematic montage, likewise propels photomontage creation by the Moscow constructivists, and it structures work by Devětsil, the Blok group in Poland, the Yugoslav Zenitists, and others who respond to Dada, constructivism, and the cubist legacy in 1923–1924. In every case, the production of photomontages is accompanied by theoretical essays that address the nexus of painting, photography, and film from which the new technique emerges. Among the most comprehensive in this regard are Karel Teige's essay, "Foto Kino Film," which surveys the ramifications presented by film and photography for traditional art, and, above all, László Moholy-Nagy's perfectly titled book *Painting Photography Film*.

"Photomontage," a word invented only partway through this initial phase, competes in early writings with alternate terminology: "pasted photographs," "photomontaged pictures," "picture poems," "photoplastics," "poeso-plastic." It is "photomontage" that sticks, however, to describe the outpouring of cut-and-pasted photographic compositions from around 1928 through the later 1930s, the height of interwar photomontage. A popular cultural form, thoroughly reconsidered by the avant-garde, returns for a time to the sphere of popular media culture, infused now with a concentrated desire to analyze and comment on the "medium" of photography and its historical

moment. In that return, photomontage makes evident the instructional bent of central European modernism, latent or manifest to varying degrees in the radical early efforts discussed throughout this chapter. Whether radiating cynical shock or revolutionary beauty, photomontage is an exemplary teaching tool and thus ideally suited to mediate the pedagogically minded engagement with modernity in central Europe.

Nearly all the key participants in German Dada, especially in Berlin, seem to have seized upon photomontage at once, in 1919–1920, as part of a spectrum of liberatory, critical actions in a country rent by assassinations and civil war (cats. 6–10). Although in later years these artists and others spoke of the technique's "invention," Dada specialist Brigid Doherty aptly describes a "transfiguration or transformation" of sources in popular practice and the nascent mass media.² Photographic montage captivated the group,

but other forms were tested as well. Otto Dix stitched together pieces of canvas for his painting *The Match-Seller (Der Streichholzhändler)*, 1920, while Johannes Baader planned a scrapbook consisting solely of press clippings, and Raoul Hausmann read aloud "poster poems" made by printing sequences of letters chosen randomly from a printer's case. A variety of composite procedures—including the all-important method of "team" production—addressed, on the one hand, radical new forms of abstraction, and on the other the subject of mechanized warfare, in which human beings were torn apart, then repackaged into a semblance of fitness through crutches, amputation, prosthetics. Mutilation was a sign of the times.

The earliest published Dada photomontage is a mock tabloid, *Everyone His Own Soccerball (Jedermann sein eigner Fußball)*, which appeared in February 1919 in an edition of hundreds, perhaps thousands, of copies apparently distributed by wagonload around Berlin. The cover paraded a fanfold of leading politicians pasted side by side underneath a competition announcement: "Who is the prettiest?" This initial sally, reminiscent of nineteenth-century newspaper satire, soon gave way to typographically far more dynamic, caustically funny publications, such as *Der Dada* (cat. 7). The journal, which began appearing in June 1919, inserted Dada aggressively into the renascent world of commercial speculation: "Take an ad out with Dada!" "Put your money in Dada!" Another advertisement in *Der Dada* acknowledges in parodic form the massive, tumultuous redistricting of Europe set in motion at the war's end. "Club Dada has established an office for seceding states," reads the mock copy: "Price list for founding states of any size. Here and abroad."³

The new technique reached its peak of visibility in Berlin at the *Erste Internationale Dada-Messe* (First International Dada Fair, June–July 1920), an exhibition whose overall appearance, as well as its constituent works, ferociously advanced principles of montage. Widespread prior usage notwithstanding, cut-and-pasted montages (as opposed to those made in the darkroom) had previously been shown only in print, never in the original, and whether naturalistic or fantastical in appearance, all forms of montage took seamlessness as a standard of achievement. The works at the Dada Fair, by contrast, manifested an insistence precisely upon cuts and rupture, commenting thereby on the state of society in form as well as content: "[the works presented here] proceed from the requirement to further the disfiguration of the contemporary world, which already finds itself in a state of disintegration,

7

7

8

8

of metamorphosis," proclaimed Wieland Herzfelde in the accompanying catalogue.[4]

In later recollections, Herzfelde's brother, John Heartfield, described photomontage as "a conscious technique [developed out of] a politically inflammatory pastime."[5] Interviewed on the subject in 1966, Heartfield mentioned as his initial impulse "glued postcards [that] not only I but also and above all other soldiers often made to get their messages to relatives back home, covertly, so to speak."[6] Heartfield (who also worked as a mail carrier during the war) astutely saw these folk missives as a disruption in the circuits of information flow, temporary subversions of the closely guarded communications network that, while mailed without an envelope and thus made visible to all, nevertheless spoke a secret, subaltern language. He soon assumed the role of amplifying these "messages," in effect redefining his creative role as that of an oppositional town crier **(cat. 8)**.

The intense little self-portrait of Heartfield pictured here, his mouth opened in exasperation and his small-boned hands tensed as if grabbing the lapels of an invisible interlocutor, first appeared in an environment of similarly raucous poster images made by Heartfield for the 1920 Dada Fair **(fig. 2.1)**. Large-scale photographs of the faces of Hausmann, George Grosz, and the artist himself, screaming or looking stern, punctuated this corner of the show's first room,

paired with aggressively humorous, class-oriented slogans: "Unlock your heads at last!" "Dada stands on the side of the revolutionary proletariat!" The snatches of text read like intertitles in silent cinema, while the head shots sandwiched between them echo film stills. The entire installation, meanwhile, resembles the hectic layering that characterizes individual dadaist photomontages. The poster onto which the small photograph of Heartfield was originally pasted, for example, hangs at bottom left on the wall, partly obscured by further works (a photomontage by Grosz and a printer's proof for a Dada group publication, both framed). This violation of elemental rules of picture-hanging levels aesthetic hierarchy and serves to deny the self-sufficiency of the individual pieces, emphasizing instead their inclusion in a larger, patchwork environment.

Within this collective assault on institutions of the bourgeoisie, the proclamation Heartfield is broadcasting carries specific weight. "Photography will one day suppress and replace all painting," reads the utterance, set alongside his picture and attributed to nineteenth-century painter Antoine Wiertz.[7] A threat articulated often since photography's invention in 1839 is called out here as if it were the latest news flash. Yet it is not a matter of simple replacement, as Heartfield's messianic appearance makes

2.1 Robert Sennecke, View of the *Erste Internationale Dada-Messe* (First International Dada Fair), 1920, gelatin silver print, 16.4 × 11.9, Berlinische Galerie, Landesmuseum für Moderne Kunst, Fotografie und Architektur

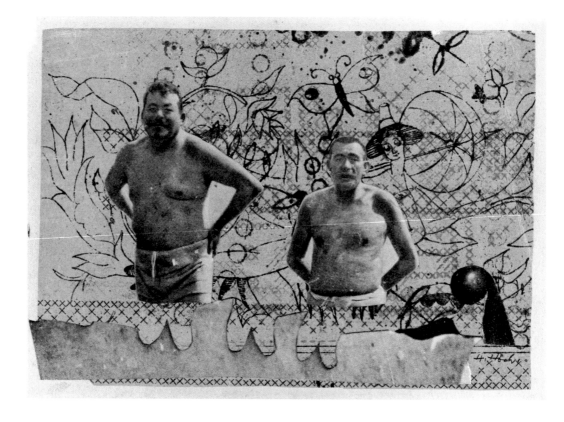

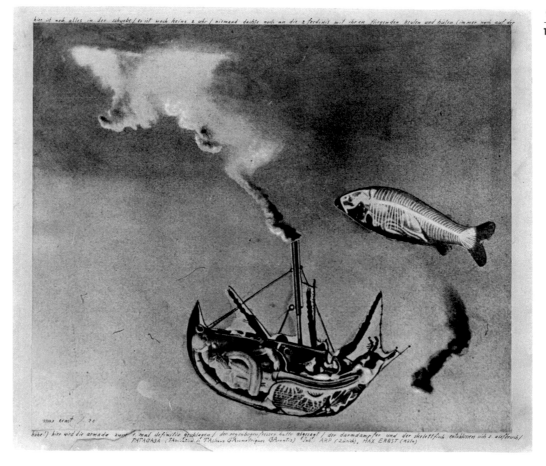

clear. Europe in 1920 has been shattered and cannot be made whole again. Photography, to judge by the works in the Dada Fair, can help explain (better than painting) that situation and the reasons for it, but only by denying its own potential for aesthetic autonomy. Sliced, spliced together, and interspersed with words and objects, the photographic image as suggested by Dada is always and only a composite of fragments, even when, as in this picture of Heartfield, it appears to be single and indivisible.

Subsequent developments in photomontage are punctuated by a series of fundamentally significant exchanges between Germany and the Soviet Union, where the term "photomontage" first circulated, from spring 1923, in the wake of a rich and influential body of work on montage in the cinema.[8] Soviet cinematic experiments, which began directly after the 1917 Revolution, and the intense fervor there to build a new society gave montage, a term derived from engineering and construction, a utopian basis— one that would in turn have an incalculable impact throughout central Europe. As art historian Benjamin Buchloh has argued, the most original current in Soviet photomontage moved quickly from the fabrication of unique works, built up from recycled image fragments and strongly stamped by individual handling, to an impersonal, collective enterprise of assembly involving photography made for the purpose, extended image sequences, and presentation to a mass audience, for example in street posters or kiosk designs as well as in print **(fig. 2.2)**.[9] The locus classicus of Soviet photomontage is found once more in Germany: the Soviet pavilion at *Pressa* (1928), an international exposition of typography and publishing held in Cologne (on a site that included barracks vacated months earlier by occupying British troops).[10] Under the direction of El Lissitzky and Sergei Sen'kin, a team of nearly forty designers assembled a display environment encircled by a "photo fresco" measuring a mammoth twelve by eighty feet, titled *The Task of the Press Is the Education of the Masses* **(cat. 11)**. In an accompanying catalogue statement, El Lissitzky clarified succinctly the road traveled since the 1920 Dada Fair: "Photomontage at its present state of development uses finished, entire photographs as elements from which it constructs a totality."[11]

Many of the ideas for Soviet photomontage, notably collective production and the goal to transform consciousness through simultaneous, mass reception, were first tried in Soviet cinema during the years of civil war in 1918–1921. The directors most

closely connected to practices and theories of montage, including Sergei Eisenstein, Dziga Vertov, and Lev Kuleshov, all worked on the traveling "agit-prop" campaigns, making movies that deployed the close-ups and dynamic editing of D. W. Griffith features to rally support for the Bolshevik cause. The earliest published Soviet photomontages, by Aleksandr Rodchenko, appeared in the constructivist journal *Kino-Fot* from its inauguration in August 1922 alongside

2.2 Gustav Klucis, View of *Dneproges—the great achievement of socialist industrialization (Dneproges—velitshasheie dostijenie sotsialis-ticheskoi industrializatsii)*, completed 1 May 1932, photomontage installation, Sverdlov Square, Moscow, gelatin silver print, 17.4 × 23.4, The Latvian National Museum of Art, Riga, Gift of Valentina Kulagina

2.3 Aleksandr Rodchenko, *Untitled*, for Vladimir Mayakovsky, *About This (Pro Eto)* (Moscow, 1923), photomontage (printed matter), 42.5 × 32.5, State Museum of Mayakovsky, Moscow, from Magdalena Dabrowski et al., *Aleksandr Rodchenko* (New York, 1998)

11

EL LISSITZKY (Russian,
1890–1941) and SERGEI
SEN'KIN (Russian, 1894–1963),
*The Task of the Press Is the Educa-
tion of the Masses (Die Aufgabe
der Presse ist die Erziehung der
Massen)*, from *Catalogue of the
Soviet Pavilion at the Interna-
tional Pressa Exhibition (Katalog
des Sowjet-Pavillons auf der
Internationalen Pressa-Ausstel-
lung)* (Cologne, 1928), photo-
lithograph of photomontage,
20.5 × 15, length 231.5
when extended, June and
Bob Leibowits

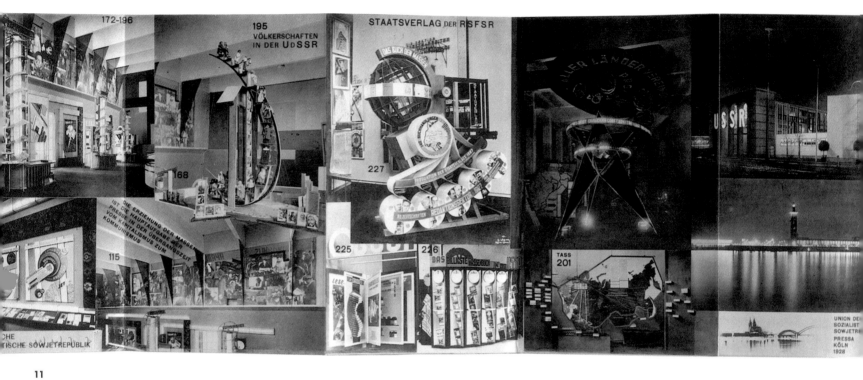

11

articles by Kuleshov, including one that September titled simply "Montage." Together with a "workshop" of student actors, Kuleshov had been testing, as in a laboratory, the properties of splicing isolated shots into larger, rigorously ordered syntactical sequences. "Juxtaposition and interrelationship," Kuleshov declared in an article for the August issue, formed the essence of cinema, superbly demonstrated by Hollywood directors such as Griffith; "authentic cinema," he concluded, "is the montage of American formats, and the essence of the cinema, its method of achieving maximal impression, is montage."[12]

By March 1923, Rodchenko too was writing (in the constructivist organ LEF) about a "new method of illustration…involving the combination of typographical and photographic material on a specific theme," which, because of its inherent "clarity and reality," made graphic illustration senseless.[13] That "new method" would soon find powerful expression in a suite of pictures by Rodchenko—called "photo-montages" in the colophon—for the poem *About This* by Vladimir Mayakovsky, like Kuleshov a veteran of the agit-prop campaigns **(fig. 2.3)**.[14] In their exuberant, page-filling conglomerations of contemporary imagery and their insistent depiction of Mayakovsky himself, Rodchenko's photomontages, the first creations to be so

named, indicate a debt to the vivacious and mockingly autobiographical works of Berlin Dada. Rodchenko had doubtless seen Grosz's book *With Paintbrush and Scissors,* which appeared just as Grosz was leaving for Moscow in the summer of 1922 and contained examples of the hectic, part-drawn and part-pasted compositions he had presented at the Dada Fair—including one stamped ostentatiously "George Grosz constructor" around the margins.[15] Far more than the German creations, however, the eight photomontages in *About This* function, with their individual subplots and thematic coherence, like storyboards in movie scenes. In another context, Rodchenko might have written the intertitles to these scenes as well, a job he had been filling since late 1922 for Vertov's newsreel series *Cine-Truth*—an "illustrated, living magazine," in the words of one reviewer, "which none of the printed illustrated magazines can compete with, since no photographs can replace film stock."[16]

It is instructive to look from this vantage point at another work by Heartfield, made after the demise of Dada in Berlin, which anticipates both the Soviet transformation of photomontage into a mural art and Heartfield's own subsequent career in the 1930s as a master of oppositional propaganda. Heartfield's *Fathers and Sons,* 1924, was created for display in a storefront vitrine to mark the tenth anniversary of the onset of World War I **(cat. 12)**. The work depicts a frieze of skeletons advancing dutifully behind an unswerving General von Hindenburg, bellicose memento mori for the seemingly endless parade of battle-ready children who march forth below them, proud in their uniforms and mock weapons.[17] In its stridency and seamless appearance, this work heralds Heartfield's later, didactic tableaux; Heartfield reused this very image in 1934, embedding a title within it, as had become his trademark (see chapter 9). Yet in its suggestion of directional movement, *Fathers and Sons* is unlike those later works, which are precisely tableaux, or static poses. Of all Heartfield's photomontages, this one comes closest to the newsreels created by Vertov with Rodchenko, and it is tempting to speculate whether, through Grosz or his own contacts with the Communist Party, Heartfield was drawn briefly into the orbit of Russian film during this moment of its initial crossover with still photography in the Soviet context.

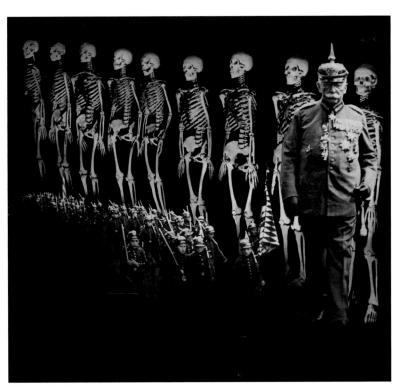

12

JOHN HEARTFIELD (German, 1891–1968), *Fathers and Sons* (*Väter und Söhne*), 1924, gelatin silver print of photomontage, 37.7 × 40.5, Akademie der Künste, Berlin, Kunstsammlung

13

LÁSZLÓ MOHOLY-NAGY (American, b. Hungary, 1895–1946), *Militarism* (*Militarismus*), 1924, gelatin silver print of photomontage, 18 × 12.9, The J. Paul Getty Museum, Los Angeles

The word "photomontage" was first clarified in print later in 1923, in essays by Boris Arvatov and (probably) Osip Brik for the fourth issue of LEF in Moscow. The short statement attributed to Brik presents photomontage as "a combination of snapshots," that is to say, a composite photograph, a description that once again suggests cinematic narration and leaves open the possibility of juxtaposing whole rather than partial images. Interestingly, while the author opposes "the documentary veracity of the snapshot" to the subjectivity of drawing, most of the venom in this text is reserved for "artistic photography"; it is not painting so much as its imitation using a camera that the author finds reprehensible.[18] In this foundational Russian statement on photomontage, as at the Dada Fair in Berlin, we see ex-painters concerning themselves not just with a photographic technique, but with photography as a field of production, and coming to terms with the ruling conventions of this field in the 1920s. Pictorialist photography would likewise form an important foil for Moholy-Nagy in his epochal book, *Painting Photography Film*, which marks the culmination of this initial era in avant-garde photomontage.[19]

Moholy folds photomontage into a global discussion of photography and its possibilities. He counts the camera among mechanical apparatuses, such as the film projector or the gramophone, that have been used heretofore only to capture or transmit preexisting audiovisual phenomena, and thus insufficiently exploited for their ability to generate entirely new sensorial stimuli. Photomontage, "an experimental method of simultaneous representation," augurs such experiential possibilities, which Moholy predicts will improve "with the aid of projections and new printing processes," or, in other words, with increasing mechanization.[20] Photographic montage is but one way, Moholy explains, of making plain the upheaval attendant upon photography's invention: "*We may say that we see the world with entirely different eyes.*"[21] This biological revolution, brought on not by nature but by a mechanical apparatus, is the grandest claim in *Painting Photography Film*, and it forms the basis for Moholy's repeated assertions that photography and film are the ultimate media for modern times.

Moholy offers here his 1924 composition *Militarism*, which he terms a "propaganda poster," along with several other works to illustrate the possibilities for a cut-and-paste technique **(cat. 13)**. He names these pieces *fotoplastiken* or "photo-plastics" and contrasts their creative labor with "the early glued photographic compositions (photomontage) of the Dada-

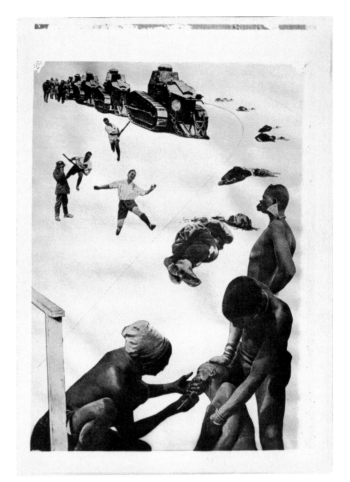

13

ists." The latter works, Moholy implies, lack the rigor of machinic prototypes. Set in parentheses, "photomontage" is bracketed, enclosed within formal and historical parameters that have ostensibly been superseded. "We wish to *produce* systematically," Moholy declares, "since it is important for life that we create *new relationships*."[22] Despite his introduction of new terminology—Polish and Czech avant-gardists had already given proprietary names to their montage techniques—Moholy did not succeed in supplanting "photomontage" in common usage. On the contrary, the term became paradigmatic in the later 1920s, precisely along the lines sketched in his book: as one consummate expression of truly modern photography, the ultimate medium of modern times. By rendering photomontage and other photographic experiments synonymous with modern consciousness, Moholy articulated a rationale for the global dominance of photography (in advertising, politics, entertainment, design, and other fields) that held eminent influence on intellectual currents in central Europe.

As important as *Painting Photography Film* was for avant-gardists from the mid-1920s, a photo-friendly environment, with a special interest in photomontage, had already developed in the region during the extremely fertile period of 1922–1924, particularly in Poland, Czechoslovakia, and Yugoslavia.[23] The groups in these countries who promoted photomontage — Blok, Devětsil, and Zenit, respectively — all adhered to an international circuit of avant-garde movements and stood radically opposed to mainstream or official sentiment. Nevertheless, the optimism in their montages reflects a general postwar exuberance in these newly independent countries, in stark contrast to the situation encountered by Dada in Germany; a delight in revolutionary victories accomplished, moreover, without a revolution, unlike in Russia. The Soviet Union provided a pole of attraction, while Germany stirred deep-seated antipathies, yet it was the conditions of possibility within central Europe that fundamentally determined activity in all three groups.[24]

The three-way dialogue among painting, photography, and film, and the interplay of "high" and "low," which characterize all early activities in photomontage, receive differing, specific inflections in this part of the central European orbit. Members of Blok and Devětsil see photomontage as visual poetry, as optical writing made for the pages of illustrated magazines. Their own journals become a form of poster art, a means to project the space of the book onto the street, whether for purposes of political agitation or lyrical fantasy (or both at once). That sublimated literary impulse, which seeks to replace painting with poetry and poetry with pictures, submits to further interests as well. In the Devětsil movement called poetism, which takes as a principal form of visual expression the photomontage "picture poem," cinema and other modern entertainments are treated

as street theater, an approach inspired partly through Berlin Dada and a dadaist publication by Zenit.[25] In Poland, rich in film theory, experiments with photomontage tend early toward the cinematic, with the singular legacy that photomontage literally becomes a part of experimental film there: photomontages made expressly to be filmed, films that dwell on photomontages, photomontages "screened" in place of films.[26] Although far less visible or numerous than the German and Soviet precedents, early Czech and Polish (and Yugoslav) photomontages more closely anticipate with these interests the role that the technique will play as a truly popular art form from the later 1920s: a means to mediate between the private, singular audience of book readers and the mass spectacle of the street, and to fuse cinema — the great inspiration for Soviet photomontage — with the illustrated magazine culture so important to Berlin Dada.

Blok, its name an evocation of two ideals of solidity — collective unity and simple geometry — was founded in March 1924 as the first constructivist entity in Poland. The group's membership, exceptionally open to women and minorities, included signal representatives of radical art. Among them were painter Władysław Strzemiński and sculptor Katarzyna Kobro, recently relocated from the Russian art school UNOVIS headed by suprematist Kazimir Malevich; Vytautas Kairiukstis (Witold Kajruksztis), a Lithuanian painter similarly schooled in suprematist abstraction; Henryk Berlewi, a graphic designer active in Yiddish modernist circles, who boldly marked the inauguration of Blok by presenting his brand of geometric art, dubbed *Mechano-Faktura*, at a Warsaw automobile show **(fig. 2.4)**; and Teresa Żarnower and Mieczysław Szczuka, likewise Jewish painter-designers who emphasized forms of abstraction suitable for a mechanized world. These last-named artists, the principal force behind Blok and its eponymous journal, are of particular interest here, for they gave photomontage its initial expression in Poland.

Żarnower apparently had the idea, following a pair of groundbreaking art exhibitions in Vilnius and Łódź, to unite avant-garde energies across Poland in a group with its own journal, and Szczuka found the money for this undertaking.[27] The artist-couple therefore understandably held a strong interest in *Blok*, the magazine, as a creative enterprise. From the second issue, which featured a Caterpillar-style tractor on the cover, photographic imagery and photomontage appeared regularly in the pages of *Blok* **(cat. 14)**.[28] Szczuka placed his own photomontages in three issues of the magazine during 1924, making apparent

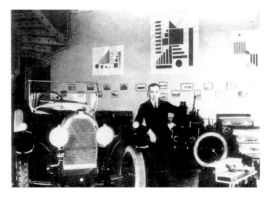

2.4 Unknown, Henryk Berlewi showing his *Mechano-Faktura* at the *Międzynarodowy salon automobilów* (International Automobile Salon), Warsaw, 1924, location of originals unknown, from Andrzej Turowski, *Budowniczowie Świata* (Kraków, 2000)

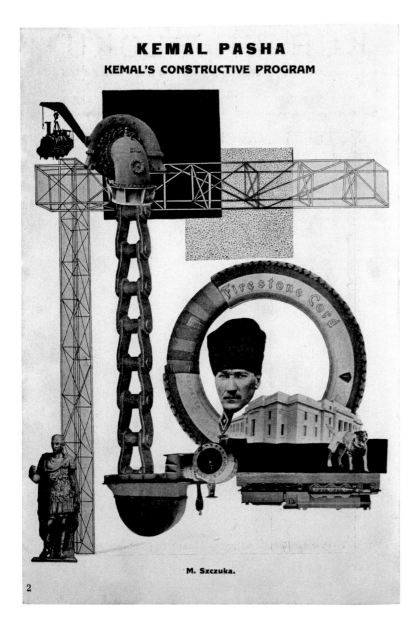

KEMAL PASHA
KEMAL'S CONSTRUCTIVE PROGRAM

M. Szczuka.

2

14

MIECZYSŁAW SZCZUKA
(Polish, 1898–1927), *Kemal
Pasha: Kemal's Constructive
Program*, 1924, in Szczuka and
Teresa Żarnower (Polish,
1895–1950), eds., *Blok*, no. 5
(1924), photolithograph of
photomontage, 23.5 × 15.9,
The Getty Research Institute,
Los Angeles

ture engineers suspended upside-down underneath its paws. These signs of humor, however slight, point to the giddy atmosphere in early postwar Poland, where, as in much of central and eastern Europe, the dissolution of empires brought national independence and a watershed new beginning.

Szczuka called his form of photomontage *poezoplastyka*, a neologism that fuses poetry to visual art, and the most promising compositions of his short career (Szczuka died while mountaineering in 1927) were all connected to books of poetry: covers to *Land on the Left* by Anatol Stern and Bruno Jasieński (1924), and *Smoke over the City* by Władysław Broniewski (1927), along with the outstanding typographic layout for a new edition of *Europa* by Stern, first published in 1925 **(cats. 15, 16)**. While *Europa*, for which Szczuka's companion Żarnower designed the cover, represents his most complex realized work, *Smoke over the City* holds historical interest as the only project by Szczuka extant in maquette as well as in reproduction. Made at a time when he and Żarnower were concentrating on agitational posters, *Smoke* has the size and presence of a street placard, even though it was destined for printing at a modest scale. War and revolution, the context for avant-garde photomontage at its inception, return here with the May 1926 coup d'état by former army marshal Józef Piłsudski. Moved by his past as an architect of Polish independence and an erstwhile socialist, many leftist cultural figures supported Piłsudski's violent takeover: "yet in your victorious song there was entangled / the cry that slipped through prison bars," as Broniewski wrote in his book.

Szczuka provides a distanced view of these events, depicting military victory marches at left and right from a bird's-eye remove. While oblique angles in Soviet montage commonly served a heroicizing function, here the device seems to indicate reserve. The oculus at top, showing what may be a munitions factory floor, is more intriguing but also fearsome; it looks like the barrel of a tank gun trained on the reader. At center, the comically miniaturized figure of a lone soldier is held suspended between two gigantic hands, viewed by photomontage scholar Stanisław Czekalski as a metaphor for Piłsudski's manipulation of the armed forces to land him in power.[29]

With its detail of a "toy" soldier and its squat, nearly ungainly forcefulness, *Smoke* betrays Szczuka's idiosyncratic design sense, which Żarnower shared. Due to his death and the worsening political climate in Poland—Piłsudski hewed mainly to the center, but his Sanacja government "cleansed" political opposition, visiting especial intolerance upon the left—few

an inclination toward Soviet ideas that would soon lead him to concentrate his activities on political agitation. *Kemal Pasha: Kemal's Constructive Program*, titled in English in the original, happily weds geometric abstraction to revolutionary politics and the omnipresent dream of Fordist industry, retracing in condensed form the ideological trajectory of Russian constructivism. Its subject, Mustafa Kemal, had recently ascended to the presidency of the newly autonomous Republic of Turkey on the strength of his military record and his zeal for Westernization. The homage by Szczuka explains Kemal's policy goals succinctly and rather soberly, but like his other early works it contains hints of lyric humor, such as the expectant little dog at lower right, or the locomotive and minia-

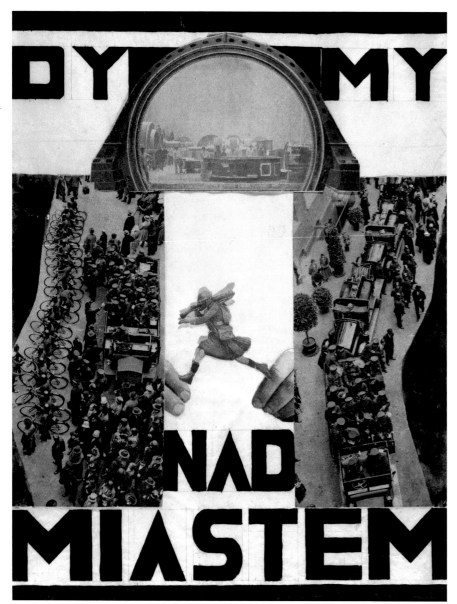

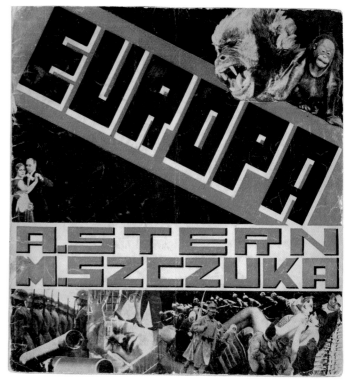

15

16

opportunities came after the publication of *Europa* to develop the formal language of these pioneering years. Nevertheless, in 1942, when an exiled Żarnower collaborated on a book in support of the Polish resistance, she turned anew to the mix of block lettering and newsreel images employed by her and Szczuka in the 1920s **(fig. 2.5)**.

In late 1924, Szczuka printed in *Blok* a telegraphic manifesto titled "Photomontage." Nine simple sentences, each punctuated by an equal sign, present the technique as a means to interweave two and three dimensions, depicting phenomena unobservable by the naked eye with documentary verism and a cinematic sensation of simultaneity. Cinema is, in fact, the only word in this manifesto to replace "photomontage" at the head of one sentence. Szczuka, Żarnower, and Berlewi all published film concepts in *Blok* and took great inspiration from progressive film and film theory internationally. Berlewi adapted in his *Mechano-Faktura* works the cascading rhythms of squares and triangles from the abstract films of Viking Eggeling, which he had reviewed while in Germany in 1922. Film theory advanced at a remarkable rate in Poland as well in the 1920s (although the film industry as such did not).[30] These factors partly explain an ongoing, remarkable interpenetration of photomontage and film in Poland. The first films of Stefan and Franciszka Themerson, for example (see chapter 6), involve sequences filmed from photomontages and other still photographs, while *Beton* (1933) by Janusz M. Brzeski opens with an extended view of a single photomontage.[31] Unlike their counterparts elsewhere, however, no one from Blok commented on photography as a historical field of production, nor did the group's members polemicize with its dominant artistic conventions, meaning those established by the amateur network.[32] Indeed, with rare exceptions such as Themerson or Brzeski, Polish avant-gardists displayed no interest in making actual photographs. The situation in Poland thus evolved in stark contrast to the rest of the region, with institutions of amateurism and the avant-garde remaining almost entirely unconnected.

One reference of special importance to Szczuka was the Czech group Devětsil and its leader, Teige, who counts among the earliest avant-gardists anywhere in Europe to consider photography at the nexus of painting and film. Teige first addressed the subject in the fall of 1922, in a sprawling essay titled "Foto Kino Film," which placed the new media of photography and cinema at the heart of a society revolution-

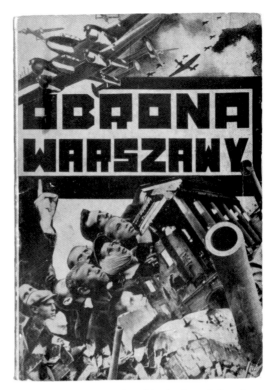

2.5 Teresa Żarnower, cover for Polish Labor Group, *Defense of Warsaw (Obrona Warszawy)* (New York, 1942), photolithograph of photomontage, 20 × 15, National Gallery of Art Library, Washington

ized by proletarization, the ascendancy of industrial standards, and, last but not least, newfound sources of poetic value in popular and media culture. Teige located one ideal of photography in the illustrated newspapers. Taking a page from recent essays by his compatriot Josef Čapek, Teige asserted that what Čapek classed among the "humblest arts" found consummate expression as a record of current events and daily life: "As photography is perfected it increases in beauty, accumulating clarity, realism, [and] documentary value—characteristics that give photography its raison d'être but which common European 'art' photography betrays.... Yes, *in veracity and truthfulness lies the morality of photography....*"[33]

The other apogee in photography, grounded in dialectic contrast to this documentary production, came for Teige with the photograms and pictures of sundry objects made by Man Ray, which he had seen in Paris that summer in the company of dadaist leader Tristan Tzara **(fig. 2.6)**. Teige observes of the photograms that their material composition, while beautiful, "is not of an artistic kind, however, nor can it be fully credited to its author." To this crucial insight on the determining role of chance, Teige adds a broader remark to the effect that photography can in fact

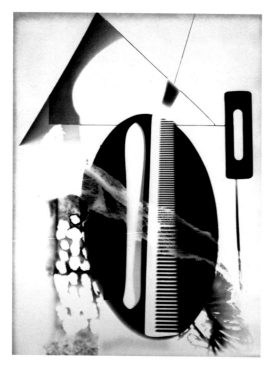

2.6　Man Ray, *Untitled*, from *Delicious Fields (Champs délicieux)* (Paris, 1922), gelatin silver print (Rayograph), 22.9 × 17.1, The Art Institute of Chicago, Julien Levy Collection, Special Photograph Acquisition Fund

claim artistic status, but only in those instances where it insists upon the *disappearance* of phenomenal reality as the precondition for its own pictorial existence. Writing of a simple Man Ray photograph showing an egg in a glass, Teige terms this deliberately banal study "wonderful play and a poem [in] light.... Only this photograph, developed in the darkroom while its real-life subject perhaps no longer exists, can become art." He thus suggests photojournalism and abstract experiment as two core areas of photographic production that advance in tandem, the former taking charge of public life through the mass production and collective consumption of documentary views, the latter providing a revolutionary means to picture individual, private fantasies.

Poetism (*poetismus*), a term invented by Teige and Devětsil poet Vítězslav Nezval, would bridge those poles of public and private, factual and lyrical creation, even as it became for Teige the counterpoint to an increasingly resolute emphasis on pure functionality in creative work undertaken for the public sphere (typography, architecture, design). Arguably the first poetist work of art (arriving some months ahead of the term itself) was the photomontage cover for *Život*, the anthology in which Teige published "Foto Kino Film" **(cat. 17)**.[34] Photomontage (again, not

named as such) makes a brief and entirely negative appearance in that text, where Teige cites unspecified "pasted photographs" by Grosz and Max Ernst as examples of an insufficient rebellion against artistic tradition. "People said this had nothing to do with painting," he comments provocatively—note again the triangular dialogue—"but Man Ray would say that it doesn't have anything to do with photography." Yet the cover to *Život* already suggests a different attitude. Authorship of the piece is credited jointly to Teige, poet Jaroslav Seifert, architect Bedřich Feuerstein, and painter Josef Šíma. This attribution reflects the disciplinary plurality and collective unity embodied in the group name Devětsil, which means "nine strengths" (significantly, *devětsil* also humorously designates an unprepossessing woodland plant [*petasites vulgaris*], called butterbur in English). The Doric column, the automobile tire at its base, and the timeless ocean backdrop all suggest continuity between the ancient past and a very modern present. The fantasy of this vision would be plain to Czech readers, for even with its newly ratified borders their country had neither classical ruins nor a coastline. The automobile tire, meanwhile, symbolized the popular drama of modern life to be staged in Devětsil plays, poems, and above all the photomontages made by members of the group with evident delight over the next several years **(cats. 18–21)**.

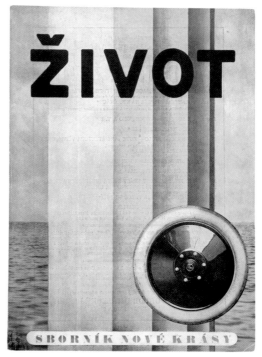

17

JAROMÍR KREJCAR (Czech,
b. Austria, 1895–1949), KAREL
TEIGE (Czech, 1900–1951),
BEDŘICH FEUERSTEIN
(Czech, 1892–1936), and JOSEF
ŠÍMA (French, b. Bohemia,
1891–1971), cover for *Life:
Anthology of the New Beauty
(Život: Sborník nové krásy)* 2
(Prague, 1922 [1923]), Krejcar,
ed., photolithograph of photo-
montage, 25.5 × 18.5, June and
Bob Leibowits

18

JAROSLAV RÖSSLER
(Czech, 1902–1990), *Untitled
(Condensers) (Bez názvu [Conden-
sateurs])*, 1926, photomontage
(printed matter), 17 × 13,
Museum of Decorative Arts
in Prague

19

KAREL TEIGE (Czech, 1900–
1951), *Travel Greetings (Pozdrav z
cesty)*, 1923, photomontage
(printed matter, sealing wax,
ink, and watercolor), 32.5 × 23.3,
City Gallery Prague

Those photomontages belong to a key poetist genre, the picture poem (*obrazová báseň*), proposed by Teige, together with the concept of poetism itself, in December 1923. "The picture is either a poster," he wrote in introducing both terms, "a public art like movies, sports, tourism—then its place is in the street; or it is poetry, purely artistic poetry, without literature—then its place is in a book, a book of reproductions, like a book of poems."[35] Negotiating the juncture of posters and books, the public wall and the printed page, Devětsil affiliates turned, like their dadaist predecessors, to ordinary postcards for inspiration. They too undertook handmade alterations of cheaply produced photographic imagery and showed their composite images in the original, at exhibition, as well as in reproduction on the pages of little magazines. Members of Devětsil did not court incomprehensibility, however, as Hausmann did with his sound poems, nor did they turn on the institutions of art and society with the wrath of Grosz or Heartfield. Furthermore, while they energetically embraced the views of Soviet revolutionaries and shared in a pan-European infatuation with industrial technology, the Czechs developed a rhapsodic view of art in a time of social revolution. "Movies, sport, and tourism," as Teige stated their principal subjects, were all imagined as forms of fairground entertainment, retaining the spontaneity and rough edges of live spectacle with the added montage effects beloved of Hollywood and Soviet directors. Neither a direct attack on media and politics, as in Dada, nor precisely an outgrowth of film theory, as in Soviet or Polish constructivism, the Czech picture poem suggested primarily an improvised theater. The yachts, car tires, condensers **(cat. 18)**, and other objects that show up in these works accordingly function less as commentaries on commodity culture than as props in a fantasy entertainment for reveling postwar masses.

In *Travel Greetings* **(cat. 19)**, one of just two extant works from this early era by Teige, mechanically reproduced and hand-drawn elements combine to suggest an unusually interactive postcard sent home from a vacation abroad. The text to this mailing, which is also its title, seems to unfold from an envelope that Teige really did send to his Devětsil colleague Seifert; the cancellation marks on the stamps nicely echo the double eyepiece of a pair of binoculars glued directly above them. An equation of print and vision, writing and looking, can be inferred both from that juxtaposition and from the overall composition, which substitutes a cartographic itinerary for "literary" descriptions of the trip itself; the one anecdotal

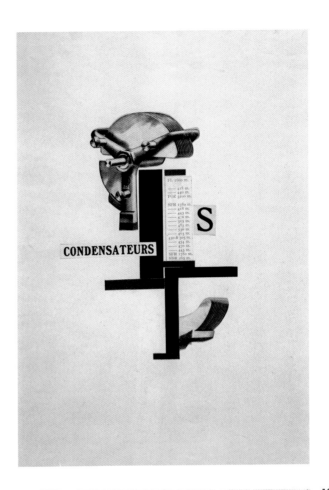

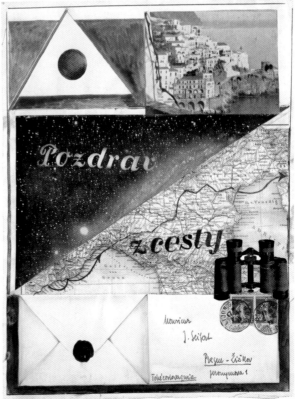

**18
19**

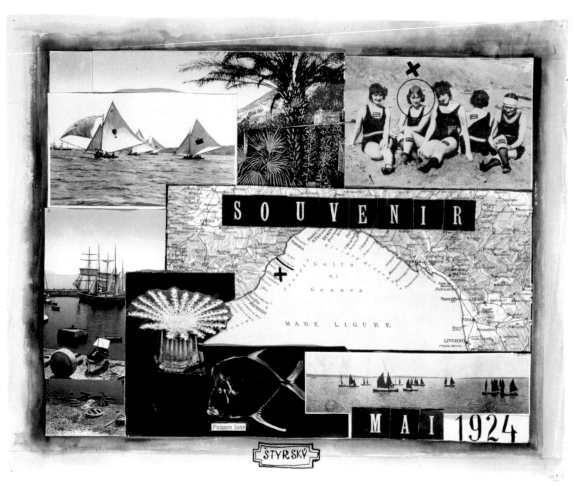

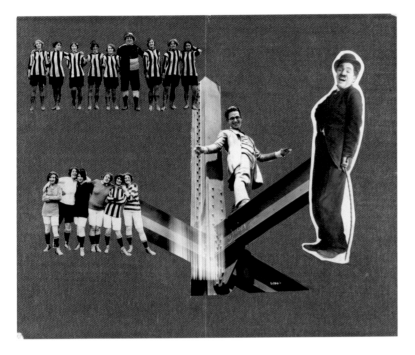

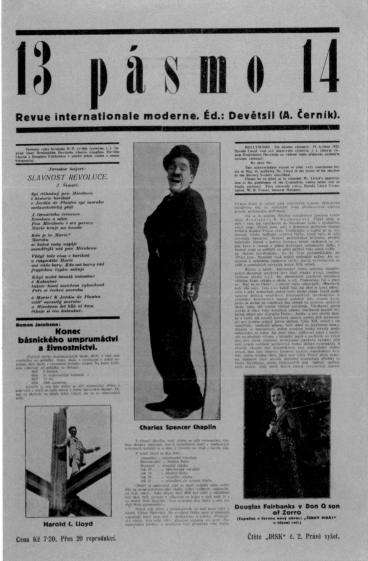

20

JINDŘICH ŠTYRSKÝ (Czech, 1899–1942), *Souvenir (Souvenir)*, 1924, photomontage (printed matter, ink, and pen), 23.9 × 30.2, Národní galerie v Praze, Prague

21

EVŽEN MARKALOUS (Czech, 1906–1971), *Laughter (Smích)*, c. 1926, photomontage (printed matter), 33.9 × 41.5, Museum Folkwang, Essen

22

ARTUŠ ČERNÍK, ed. (Czech, 1900–1953), *Zone (Pásmo)* 1, no. 13–14 (August 1925), photolithograph, 47.8 × 31.6, June and Bob Leibowits

21 | 22

detail comes in the form of a photograph at the upper right, showing a stop along this route in the Italian region of Cinqueterre. This "close-up shot" is balanced by a view of the Milky Way, a cosmic shift of scale that implies an unlimited horizon for personal mobility. Such rapid, unhampered changes of scenery are indicative of the freedoms that Czech and many other central European avant-gardists prized despite the crises that followed the recent war. As Teige phrased it some years later, in a manifesto covering the group's initial rise to prominence: "Those first postwar years… placed us in the middle of the world, a world that became utterly unlike the one in which the previous generation had lived, worked, and grown old."[36]

Painter Jindřich Štyrský, who turned regularly in his career to photography and photomontage, transposed Teige's studious pronouncements into an ecstatic key with his manifesto "Picture." "The most beautiful poem: a telegram and a photograph — economy, truth, brevity," Štyrský declared, "A colored Gauguin = zero as against the perfect color photograph from the tropics."[37] Štyrský's 1924 *Souvenir* **(cat. 20)** is accordingly composed of tropical views arranged in hyperbolic imitation of a tourist postcard, set above a curlicue signature that distinctly recalls Pablo Picasso's ironic collage "masterpieces" of a decade earlier.[38] More than Teige, however, Štyrský indulges in the camp value of this chosen genre, combining glaringly kitschy views (palm trees, yachts on brilliantly sunlit water) with flamboyant notations

regarding the route taken and the girl found along the way (X marks the spot in both cases). At the same time, there is a distinct strangeness to certain passages: letters or symbols apparently tattooed on the bathing girls, or an X-ray view of a moonfish, its name already the sign of a spectral presence. This is tourism in the register of the uncanny, a signal of Štyrský's early interest in dreams and, increasingly, the tenets of orthodox surrealism (see chapter 6).

Devětsil members continued to produce picture poems in the second half of the 1920s, particularly for their journals and books **(cats. 22, 23, fig. 2.7)** but for mainstream titles as well.[39] A selection of original compositions also appeared in the group's two exhibitions, in December 1923 and May 1926. "There are

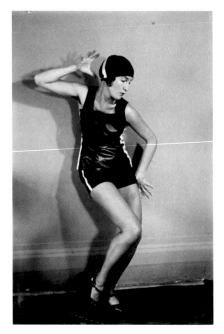

23

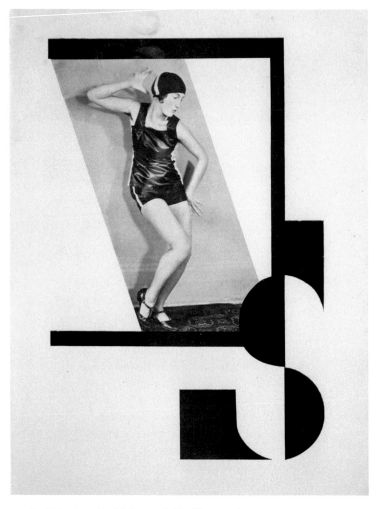

2.7 Karel Teige, Letter S in Vítězslav Nezval with Milča Mayerová, *Alphabet (Abeceda)* (Prague, 1926), photolithograph of photomontage, 35.6 × 24, June and Bob Leibowits

pictures here...glued from bits of postcards...tram
tickets, newspaper clippings, even a real [cigar];
around that a little color, a truncated inscription here
and there or a line of diaristic verse, all artfully folded
together and framed like a picture," wrote reviewer
J. B. Marek on the second occasion, to support his
thesis that Devětsil was hoaxing the public. Marek
ridiculed these photomontages, tellingly, as mere
imitations of the memorabilia soldiers had pasted
inside their luggage during the last war: "[a pastiche]
of everything from mother's photographs and home-
town postcards to Hindenburg and a snazzy dancer
from the Stars Bar." The creation of altered postcards,
a wartime practice cited favorably by the dadaists,
is evoked here with intent to denigrate the new tech-
nique of photomontage rather than legitimate it. In
his review, Marek terms the soldier's collages at least
a "sensitive document...of their time," possessed
of an unqualified truth value. The picture poems, by
contrast, bespeak an age bereft of its moral compass:
"Everyone has his own truth."[40]

In addition to wartime creations, other popular
sources for the picture poems — and indeed for all
avant-garde photomontage — were the April Fools'
magazine issues and related, futuristic postcards
common from the turn of the century **(fig. 2.8)**. These
satirical compositions, widespread in France and the
United States as well, remained ubiquitous in Germany
and the Czech lands through the interwar decades.
Unlike homemade inspirations such as family photo
albums or individually altered postcards, the April
Fools' montages formed part of the commercial print
culture with which dadaists and Devětsil affiliates
were directly occupied. Perhaps because of the prox-
imity of this mass media source to "new" photomon-
tage, most avant-gardists mentioned April Fools'
issues glancingly or not at all.[41] In the case of Berlin
Dada, which remained ferociously oppositional, this
anxiety-provoking influence from the mainstream —
Hannah Höch's employer, the Ullstein publishing
company, put out April Fools' numbers yearly in the
Berliner Illustrirte Zeitung — could indeed be kept at
arm's length. A thoroughly celebratory composition
such as *Metropolis* by Paul Citroen **(cat. 24)** by contrast
bears a distinct debt to such imagery, sharing in the
nervous mix of euphoria and paranoia that character-
izes popular responses to modernity in this region.

Metropolis, which dates from 1923, is the best-
known (and only surviving example) of a suite of per-
haps nine works that Citroen prepared on this theme
mostly in late 1919 and 1920, as a "serious diversion"

from his career as a painter.[42] Friendly with Grosz
and other members of Berlin Dada, Citroen was espe-
cially taken with the group's turn to photomontage,
although he did not share their underlying political
and artistic radicalism. What Citroen retained espe-
cially from his encounters with Grosz was an ebullient
Amerikanismus: boxing, dancing girls, jazz, factories,
cars, and nightlife as expressions of a desperately
needed postwar renaissance. His densely packed col-
lages of tall buildings and street-level bustle offer a
reassuring distance and, despite their seeming chaos,
an orderly overview. Notice how, in *Metropolis*, the
wall of glass and cement is offset just below center
by the swooping view onto a spacious, receding bou-
levard, with a low beaux-arts manor to one side and
bushy trees behind it. The surrounding multistory
buildings and steel bridges acquire by association
a calming, positive valence, although it is hard not
to imagine actual residents feeling hemmed in by
their bristling urban center. This balance between
breathless fascination and fears of asphyxiation
would tip sensationally toward the claustrophobic
in Polish photomontage of the early 1930s, whose
makers doubtless saw Citroen's great work and
openly admired his protégé Umbo.

The afterlife to *Metropolis* is in fact as interest-
ing as the work itself, for it indicates the scope of the
burgeoning image world in interwar central Europe.
Citroen was moved to create his exaggerated montages
partly by seeing dadaist works and, probably, post-
cards like the one illustrated here, but also by his own
activity as a collector of such postcards.[43] The post-
cards he accumulated, like the illustrated newspapers

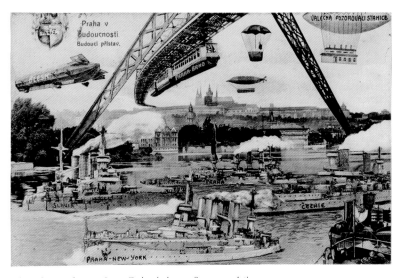

2.8 Unknown, *The Future Prague (Praha v budoucnosti)*, c. 1911, gelatin
silver print of photomontage (postcard), 8.9 × 13.8, Jindřich Toman,
Ann Arbor

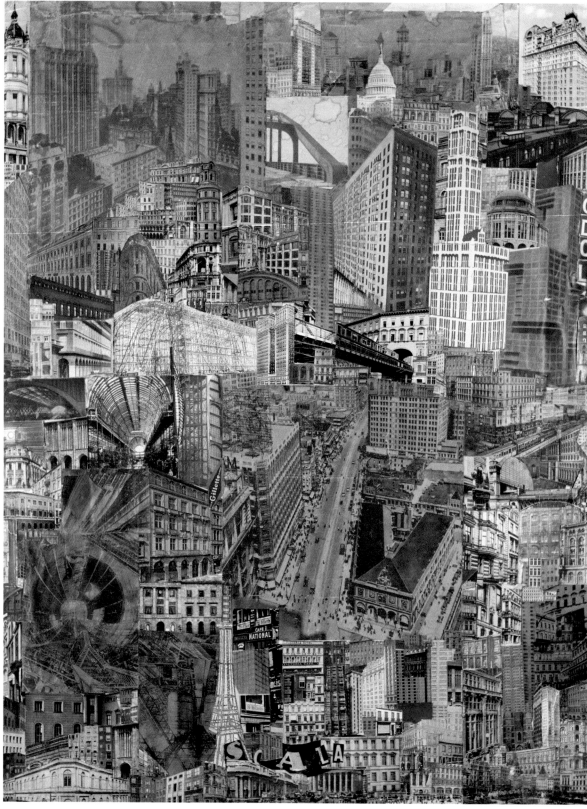

he read, became fodder for cut-and-paste compositions that, in their enormous size and tapestry-like intricacy—*Metropolis* holds close to two hundred pictorial fragments—were flagrantly intended to rival paintings. In marked contrast to all others discussed here, then, Citroen took photographic images out of public circulation with the intention of "elevating" them within a unique, private composition: "*Metropolis*…is, to my knowledge, the first ever photomontage to be made with the intention of achieving an artistically enhanced effect," the artist proudly wrote to one potential purchaser in 1926. Yet what he offered for sale was not the original but an editioned reproduction, and it was as a reproduction that the piece became famous, iconic even. Printed in the Frankfurt *Illustriertes Blatt* in August 1923, on the occasion of an exhibition at the Weimar Bauhaus (where Citroen studied in 1922–1925), it must have become legendary in avant-garde circles; Teige— who visited the Weimar exhibition—named Citroen together with Rodchenko in a short list of photomontage makers in early 1924.[44] In mid-1925, as Devĕtsil fascination with this technique reached its peak, *Metropolis* appeared in an issue of the group's journal *Pásmo* (Zone), nearly simultaneously with its publication in *Painting Photography Film*. Indeed, no fewer than three of Citroen's collages are in the first edition of Moholy-Nagy's book.[45] One of them, *Boxing Match in New York*, brought Citroen's name again into the mass media, this time in the *Berliner Illustrirte Zeitung*, an event that cemented the stature of his collages as paradigmatic modernist expressions.[46] With *Metropolis*— and with this entire series—Citroen thus initially displaced mass-produced images from a sphere of seemingly endless reproduction into the auratic realm of painterly creation, only to watch his work spill back out into public life through the same media that had first served as his source and inspiration.

In December 1925, a few months after the appearance of *Painting Photography Film*, art historian Franz Roh honored *Metropolis* with an illustration and a lengthy encomium in his book *Post-Expressionism*, a survey of recent tendencies in German art. Roh, who would soon take up photography as a form of experimental learning, aligned Citroen's approach to photomontage subliminally with his own disciplinary methodology: "The work of the artist begins with the slow but sure collection of such decisive, interrelating fragments and culminates in their meaningful composition."[47] This exegesis, too, would fuel the understanding of *Metropolis* as an explanatory summation of its era. Roh, like Moholy, placed Citroen's piece within a globalizing discussion of "art and photography" that conveniently sidestepped Citroen's own evident intention to compete with easel canvases in the original composition. By 1926, such a rivalry seemed moot. No matter what its sources, whether in newspapers or film, publicly circulating prints or privately made snapshots, photomontage had become part of a global argument about the value of the photographic image. Photomontage had been claimed for the history of photography, a history that—thanks precisely to advocates such as Roh—became integral to the engagement with modernity in central Europe.

chapter 3

Laboratories and Classrooms

Laboratories and Classrooms

25

JAROSLAV RÖSSLER (Czech, 1902–1990), *Composition with Magic 2 (Kompozice s magickou dvojkou)*, 1922–1923, gelatin silver print, 23.8 × 23.8, National Gallery of Art, Washington, Veverka Family Foundation Fund

Enthusiasts of the "new photography" attached great importance to formal experiment, by which they meant primarily abstraction or artifice achieved through cropping and other darkroom manipulations, staging, and work made without a camera. This shift from "reproductive" imagery to photographic "production," as László Moholy-Nagy phrased it, was by no means confined to central Europe. Man Ray, an American working in France, set a standard in this domain, and original procedures and ideas were tested internationally beginning in the 1910s. Yet excitement at "laboratory" experiments caught on in interwar central Europe as nowhere else, principally in Germany and Czechoslovakia, but also, belatedly, in Hungary and Poland. The popularity of such work arose in turn from its institutional promotion, particularly in art school curricula and at didactic exhibitions. As has been emphasized, modernism in central Europe bore a distinctly pedagogical function; Moholy-Nagy's *Painting Photography Film*, the seminal publication in avant-garde camera experiments, appeared literally as part of a series of professorial treatises issued by the Bauhaus.

Experimental or "avant-garde" photography thus never strayed far from the classroom in this part of the world. A desire for radical originality went hand in hand with the wish to clarify innovation, to submit it to collective testing and systematization — operations that in turn entail the decidedly anti-avant-garde traits of conformity and imitation. Equally surprising, but in keeping with this pedagogical frame of mind, is the demonstrable impulse to explicate "new photography" by reference to historical precedent. Advocates for New Objectivity and the New Vision claimed an exceptional degree of continuity with photographers of the mid-1800s, exhibiting and collecting their works, and echoing or reviving early techniques such as the photogram, negative prints, the daguerreotype, and the cyanotype. "New photography" thus appeared simultaneously as a revolution and a renaissance. More than this even: the theory of

"new photography" implied a historical continuum spanning all branches of photographic production, from the earliest days to the present, marked by the distinctiveness of photography as an *image medium*. Rather than valuing photographs above all as artifacts of technological progress, or differentiating between the creative and the commercial realm, this new theory declared photographs of all kinds and uses — at least in principle — to be part of an ever-modern and inherently experimental field of imagery. The legacy of that global argument from central Europe is the history of photography as it was known for many decades, and in important respects as it is still known today.

Many of the earliest avant-garde "laboratories" were strictly extracurricular operations, although shaped by educational schooling. Jaroslav Rössler **(cat. 25)** took to photographing abstract arrangements in his free time around 1920 while an apprentice in the bustling portrait studio of František Drtikol. El Lissitzky, whose earliest photographic creations date from 1923, when he was living in Germany, had spent three years as an architecture professor at Soviet universities. Those years proved formative not just for his art but also for his team-oriented approach. The student collectives that he and others established in Vitebsk and Moscow operated as microcosms of a new and newly creative society, and the same commitment emanates from several of Lissitzky's initial photographs. His portraits of Hans Arp and Kurt Schwitters in front of Dada journals, the leading examples in print of team initiative in those years; the multiple-exposure, multiple-personage composition *In the Studio* (The Metropolitan Museum of Art, New York); and the combination photogram *Untitled* **(cat. 26)**, featuring Lissitzky with fellow artist Vilmos Huszár, all portray collaboration as the stuff of revolutionary art, just as in the schools where Lissitzky taught. In *Untitled*, Lissitzky and Huszár seem literally to fuse into a twinned pupil distending the cornea of a ghostly eyeball — indwelling visionaries pushing the bounds of sight itself.[1]

For both Rössler and Lissitzky, "earnest play" with photography soon advanced to professional commitments in an experimental vein; Rössler spent a decade photographing advertisements with a "modern look" in Paris, while Lissitzky produced poster, book, and exhibition designs employing photography, most famously for *Pressa* in 1928. Moholy-Nagy likewise undertook photographic design work in the later 1920s, including for exhibitions, although he taught no course on photographic methods per se during his five years at the Bauhaus. Possessing only limited darkroom skills, he encouraged instead the development of photograms, photomontage, and unusual camera angles or subjects outside the classroom **(cat. 27)**. Thus, for example, Marianne Brandt, one of Moholy's favorite pupils and later head of the Bauhaus metal workshop, began to pursue photomontage seriously in 1926, shortly after the publication of *Painting Photography Film* (see chapter 9). The public face of photography for the Bauhaus at this time remained confined to documentation, principally by Lucia Moholy, a professionally trained photographer who broadcast news of Bauhaus architecture and design in reports from or about the school.[2]

A number of Bauhaus affiliates, predominantly women, took up the camera privately during the later 1920s as a means to explore personal identity (see chapter 4). During these years photography also increasingly entered the official Bauhaus curriculum. Painter Josef Albers, who himself made photographic studies of light and texture, integrated photomontage and photo-typographic exercises into the *Vorkurs* or general preliminary course from around 1927.[3] Design professors Herbert Bayer and Joost Schmidt considered work with photographs an indispensable element of instruction. Finally, in the spring of 1929, a surprisingly long time after Moholy's initial promotion of photography—after Moholy himself, in fact, had left the school—Walter Peterhans, a licensed studio operator with a background in engineering and philosophy, founded a photography course within the advertising workshop that continued to be offered until the school's closing in 1932. The comparative study of material, luminosity, and other physical properties with the camera that had developed as an auxiliary to Bauhaus instruction generally became a part of actual photographic discipline **(cat. 28)**. Peterhans, meanwhile, introduced his own understanding of the *Vorkurs* in a series of mesmerizing still lifes **(cat. 29)**, compositions that combine the evident Bauhaus interest in facture with a newfound (for the school) emphasis on technical excellence in printing.

26

EL LISSITZKY (Russian, 1890–
1941), *Untitled (Ohne Titel)*, 1923,
gelatin silver photogram,
17.6 × 23.7, The Art Institute
of Chicago, Mary L. and
Leigh B. Block Collection

27

LÁSZLÓ MOHOLY-NAGY
(American, b. Hungary, 1895–
1946), *Photogram with Eiffel
Tower (Fotogram mit Eiffelturm)*,
1925–1929, gelatin silver
photogram, 29.7 × 23.5,
Staatliche Museen zu Berlin,
Kunstbibliothek

28

THEO BALLMER (Swiss,
1902–1965), *Untitled (Treachery)
(Ohne Titel [Verrat])*, c. 1929,
gelatin silver print with wood
panel, printed matter, and
ink, 29.8 × 42.9, The J. Paul
Getty Museum, Los Angeles

29

WALTER PETERHANS (German,
1897–1960), *Untitled (Still Life
with Flowers, Fabric, and Gauze)
(Ohne Titel [Stilleben mit Blumen,
Stoff, Gaze])*, c. 1928–1932,
gelatin silver print, 22.7 × 28.2,
Bauhaus-Archiv, Berlin

The Bauhaus attracted a noteworthy international enrollment, particularly from Hungary, Poland, and Czechoslovakia.[4] Some foreign students, such as Slovak activist Iren Blüh (see chapter 7), were already immersed in photography, while others, among them Moishe Vorobeichić (Moï Ver), from Vilnius, took up camera work at the school and subsequently used it to reinvigorate familiar subjects in their own countries.[5] In 1928, Hungarian avant-gardist Sándor Bortnyik, who had had indirect contact with the Bauhaus earlier in the decade, founded a private school on the Bauhaus model in Budapest, called Műhely (Workshop). Bortnyik's school soon specialized in graphic design, including the use of photographs, although photography was not taught there in its own right.[6] Hannes Beckmann, who studied at the Bauhaus from 1928 to 1932, worked up a lesson plan in photography for the "Rotterschule," about which little is known, either while studying photography in Vienna (1932–1934) or more likely after resettling in Prague directly afterward.[7] Karel Teige and Zdeněk Rossmann, both Czech, came to the Bauhaus in the late 1920s as well and then disseminated its teachings at home. Teige's journal *ReD*, for example, at that time the most significant interdisciplinary avant-garde magazine anywhere in the region—including Germany—published a special issue on the Bauhaus in February 1930, to which Peterhans contributed an original essay that proved to be his only theoretical text on photography.[8]

Rossmann, meanwhile, went on to join the faculty of the progressive Škola umeleckých remesiel, or ŠUR (School of Applied Arts), in Bratislava, founded in 1928 and known at the latest by 1931 as the "Bratislava Bauhaus."[9] This institute, really an amalgam of exist-

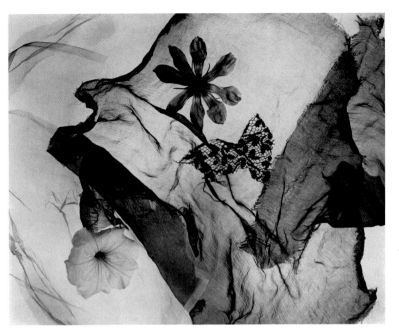

29

28

ing training schools with a new facility that for many years offered only evening courses, bore an eclectic relation to the German prototype. As Bauhaus specialist Rainer Wick observes, the head of the Bratislava school, art historian and ethnographer Josef Vydra, mixed different strains of Bauhaus thinking in his appreciation for both preindustrial craft guilds and industrial manufacturing. Above all, while the Bauhaus aimed at a holistic renewal of society by forming creative generalists, Vydra's school maintained a practical orientation with separate disciplinary tracks, in the manner of a turn-of-the-century arts and crafts institution.[10]

Nevertheless, the ŠUR significantly shifted aesthetic bases in its home country. ŠUR instructors merged the prevalent, regionalist emphasis on folkloric motifs and artisanal skills (ceramics, woodcarving, textiles) with self-consciously internationalist expressions of modernity, for example mass-produced metalwork and functionalist design. Vydra had heard Albers lecture on *Vorkurs* principles in Prague in 1928, and he visited Dessau in person in 1931; Vydra also invited Ernst (Ernő) Kállai, erstwhile editor of the *bauhaus* journal, and Hannes Meyer, former director in Dessau, to lecture in Bratislava, and he tried unsuccessfully to recruit Albers and Bauhaus student Gyula Pap as teachers for his institute.[11]

Another visitor in Bratislava was Moholy-Nagy, whose writings, beginning precisely with the publication of *Painting Photography Film*, appeared regularly in journals in the nearby cities of Brno and Budapest.

3.1 Unknown, László Moholy-Nagy, György Kepes, and others at Škola umeleckých remesiel, Bratislava, 1931, modern gelatin silver print, location of original unknown, Iva Mojžišová, Bratislava

Moholy arrived in March 1931 to deliver a series of five lectures **(fig. 3.1)**, among them one he had developed since 1928 on "New Paths in Photography," and another on typography that likely covered the text-image combinations he called *typofoto*. His audience included Ernő Berda, a teenage art student who had apparently turned to camera experiments after reading *Painting Photography Film*. Berda's captivating miniature depiction of a hand (or is it the hand that is miniaturized?) **(cat. 30)** combines the play in translucency characteristic of photograms with details, such as fingernails, which seem possible to capture only in photography with a camera. The exact technique employed remains difficult to determine, a fitting match for the elusiveness of the image itself. According to anecdotal remembrance, Berda, later a successful painter and graphic artist in Budapest, attracted Moholy-Nagy's attention with such photographs during the latter's 1931 visit.[12] Perhaps more engaging even than the physical appearance of *Hand* is its status as artifact of a pedagogical encounter on a trajectory between Budapest, Bratislava, and Berlin.

Jaromír Funke, who would arrive in Bratislava only after Moholy-Nagy's stay, became the first official instructor of photography at the ŠUR in September 1931.[13] Funke had recently gained attention in Slovakia through Teige's journal *ReD* and work with Brno affiliates of Devětsil for ideas in still life that he had been exploring from around 1924 **(cats. 31, 32)**. Taking pieces of mat board, glass negatives, darkroom flasks, and other materials and equipment used in the photographic process, Funke constructed what he called *Compositions* and, later, *Abstract Photos*, domi-

nated increasingly by the interplay of "flat" areas of darkness and projected shadows.[14] The later works in particular resemble photograms (some appeared in *ReD* with this misnomer), yet they were taken with a camera, and this difference meant everything to Funke. His self-reflexive, quintessentially modernist body of work achieves a remarkable balance between the knowledge of camera technique so highly valued in the amateur movement and the passion for non-mimetic form inculcated in avant-garde circles. The new breed of applied art school, which combined an emphasis on handicraft with openness to abstract art and industrial technology, replicated this balancing act at the institutional level. In this respect, ŠUR made a perfect home for Funke, who left Bratislava in 1935 only to take a position at the similarly structured Státní grafická škola (State Graphic Arts School, or SGŠ) in Prague.

Before arriving in Bratislava, Funke had tried to enroll as a student at the Bauhaus. Responding to the enthusiasm of his friend Rossmann, who was then studying at the school in Dessau and later brought Funke to ŠUR, Funke mailed a set of prints as an entrance portfolio. Peterhans apparently accepted Funke initially, stating his earlier interest in similar subjects, but quickly demurred after learning that one of Funke's compositions actually predated his

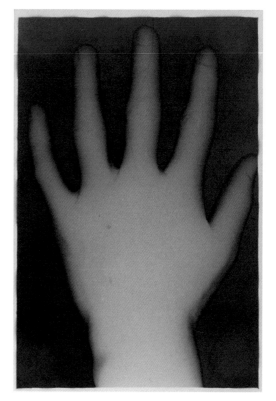

30

30

ERNŐ BERDA (Hungarian, 1914–1961), *Hand (Kéz)*, c. 1931, gelatin silver print, 12.5 × 8.3, National Gallery of Art, Washington, Patrons' Permanent Fund

31

JAROMÍR FUNKE (Czech, 1896–1945), *Abstract Photo (Abstraktní foto)*, 1928–1929, gelatin silver print, 29.9 × 23.5, Moravská galerie, Brno

32

JAROMÍR FUNKE (Czech, 1896–1945), *Abstract Photo (Abstraktní foto)*, 1927–1929, gelatin silver print, 28.7 × 23.5, National Gallery of Art, Washington, Patrons' Permanent Fund

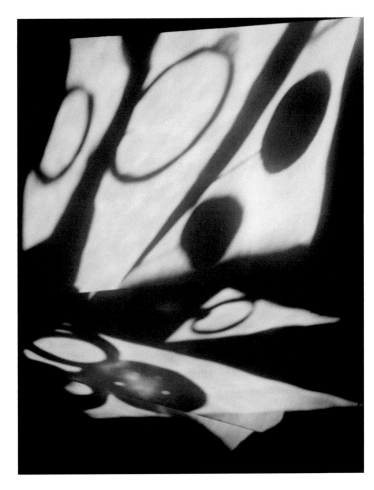

31
—
32

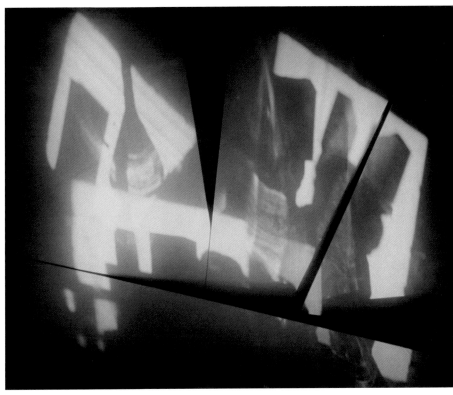

own.[15] This story, transmitted to Funke soon afterward by Rossmann's wife, suggests *in nuce* the conflict that arises when avant-garde originality becomes a subject of classroom study: one possible outcome is, perversely, a room full of teachers.

Although aggrieved by his rejection, Funke nevertheless enthusiastically pursued in his own courses what he took to be the Bauhaus curriculum. "Steps in photographic work from individual material structures to simple spatial compositions of objects" begin the photo course assignments listed in the ŠUR report for the academic year 1931–1932, which progressed, as they did in Germany, with simulated or real layouts for advertising.[16] In 1935, at the close of his first year teaching in Prague, Funke and fellow SGŠ professor Ladislav Sutnar produced an ideal Bauhaus primer, the folio-size picture book *Photography Sees the Surface* **(fig. 3.2)**.[17] With student-made reproductions of "material structures" from the fields of biology, painting, antiques, manufacturing, and philately, among others, the book aimed to demonstrate the key conviction that photography was an encyclopedic medium and thus uniquely suited to picturing the modern world in all its elemental diversity.

3.2 Ladislav Sutnar and Jaromír Funke, eds., *Photography Sees the Surface* (*Fotografie vidí pourch*) (Prague, 1935), cover by the editors, photograph by Jaromír Funke, photolithograph, 29.8 × 21.9, Private Collection

The "new photography" argument for a global photographic vision found its most impressive forum in a series of large-scale didactic exhibitions held across the region from the mid-1920s through the mid-1930s, again with particular success in Germany and Czechoslovakia.[18] These tremendous undertakings aimed explicitly to educate the public about photography, not as a set of technologies or fields of endeavor, but as the total picture of modernity itself. The commingled subjects and purposes presented at these shows dissolved previous distinctions between art and the everyday image, or rather resolved them in favor of art and art history. Photography here triumphed for the first time as a field of modern art, despite the claims for non- or anti-artistic merit often advanced by exhibition organizers.

The first such exhibition, *Kino und Photo* (Kipho), took place in Berlin in 1925. Among subsequent expositions organized along this all-encompassing aesthetic principle are *Neue Wege in der Photographie* (New Paths in Photography, Jena, 1928),[19] *Fotografie der Gegenwart* (Contemporary Photography, Essen, 1929), *Výstava nové fotografie* and its sequel (Exhibition of New Photography, Prague, 1930 and 1931), *I. Wystawa Fotografii Modernistycznej* (First Exhibition of Modernist Photography, Kraków, 1931), and *Mezinárodní výstava fotografie* (International Photography Exhibition, Prague, 1936). Introducing the last-named show, for example, lead organizer Lubomír Linhart proudly mentions the inclusion of Man Ray, by the mid-1930s a touchstone for progressive Czech amateurs; scientific photographs by various "professors" and one "doctor"; an assortment of crime pictures; and photomontages by John Heartfield shown together with images from Soviet reportage collectives. "This international exhibition of modern photography," Linhart declares, "therefore captures the function of modern photography in all its breadth, its characteristic uses and significance within the main fields of human creativity—in art as in science, technology, advertising, print, and in life in general."[20]

The greatest of these many exhibitions was without doubt *Film und Foto* (Fifo), a traveling survey organized by the Deutscher Werkbund with decisive input from Moholy-Nagy and his international colleagues. In Germany alone, *Fifo* traveled, after its May 1929 inauguration in Stuttgart, to Munich, Essen, Dessau, Berlin, and Breslau (Wrocław), its size, shape, and title changing along the way. It also appeared in various versions through 1930 in Zurich, Vienna, Danzig, Zagreb, Tokyo, and Osaka.[21] With such a

33

WERNER GRÄFF (German, 1901–1978), *Here Comes the New Photographer! (Es kommt der neue Fotograf!)* (Berlin, 1929), cover by the author, photolithograph, 25.9 × 18.2, June and Bob Leibowits

widespread presence, it may be fairly said that *Fifo* epitomized *foto* as a key expression of modernity across the central European region and beyond.

In contrast to earlier exhibitions, including those since 1925 conceived in a similar spirit, the organizers of *Fifo* refused to present photographs by specialty, such as portraits, science and industry, or "fine art." In place of such divisions stood a nominally nonhierarchical overview sorted variously by name, country, or professional affiliation, the latter including many press agencies and four art schools: the Bauhaus, Burg Giebichenstein in Halle, the Berlin Lette-Verein, and the Folkwang Schule in Essen. This tactical decision underscored the place of teaching in the "new photography," a position undoubtedly shared by the principal *Fifo* organizer, the Werkbund, itself a (somewhat old-fashioned) institution for apprenticeship and training. Moreover, the exhibition generated complementary publications that read like textbooks in visual perception (**cat. 33**). In a letter to Franz Roh regarding one such book, *Foto-Eye*, Moholy summarized the achievements of *Fifo* with the phrase, "the lessons of the Stuttgart exhibition"—a telling indication that this show had been conceived to displace the dynamics of the classroom into the public arena.[22]

The principal foil in aesthetic terms—for "new photography" advocates and for decades of photography historians in their wake—was the pictorialist

or "art photography" movement, begun around 1890 and still popular worldwide at the time of *Fifo*. In earlier decades, when the pictorialists had argued for their superiority to other branches of photographic production (journalism, criminal or medical documentation, Sunday snapshots), their approach had been by and large to exclude those areas from theoretical consideration. Such a position was inconsistent with the globalizing logic of the New Vision. Instead, pictorialism was labeled a falsification or deviation from "true" photographic principles, an enemy within. Although quite different at the level of theory, this attitude resulted in practice in new forms of banishment. It precluded attention to the hybridization of New Vision and pictorialist "style" already taking place in, for example, the work of Budapest studio photographer József Pécsi (**fig. 3.3**) and Lviv-based amateur Władysław Bednarczuk (**fig. 3.4**). Hugo Erfurth, an éminence grise from the prewar era who remained friendly with the Bauhaus circle, figured at *Fifo* in a marginal way; his less well-connected contemporaries—including some who had been in earlier exhibitions of "new photography"—found themselves excluded altogether.

Also marginalized was Albert Renger-Patzsch, in reality the most popular representative of "new photography" at the time. In Renger's case, the marginality at *Fifo* seems to have been at least partly self-imposed: "I find the exhibition, except for a very few successful things, mediocre and *unsachlich*, to say the least," he wrote to his patron and promoter, museum curator Carl Georg Heise, shortly after a visit to Stuttgart. "The little that's worthy is nearly impossible to discover under the growth of meaningless, technically inept snapshots. . . . Herr Stotz [head of the Deutscher Werkbund] . . . was surprised that I sent him so little . . . [he said] that I must have far more interesting images at home. I replied that, actually, the exhibition seemed to me vastly too interesting, which he didn't get."[23] We see in these wittily phrased comments a resistance to Bauhaus "novelty" on the part of photographers committed to skill and mastery, aesthetic premises inherited from serious amateurs and, in particular, the pictorialist movement. This heritage should not be considered a hindrance. The personification of New Objectivity, Renger was himself considered experimental by mainstream camera enthusiasts, and his book *The World Is Beautiful* attracted lively debate in many amateur and professional circles where *Painting Photography Film* did not even receive a book review.

3.3 József Pécsi, *Untitled (Cím nélkül)*, 1928, bromoil print, 28.6 × 22.2, Richard and Ronnie Grosbard Collection, New York

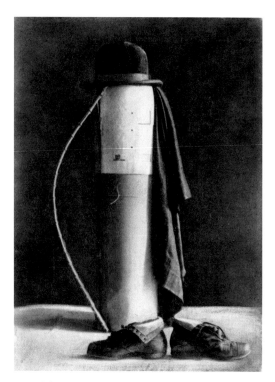

3.4 Władysław Bednarczuk, *Construction (Konstrukcja)*, 1929, bromoil print, 29 × 21.3, National Museum in Wrocław

Fifo's "lessons" were thus not wholly consistent. To give another example, the organizers passed over prominent career photojournalists such as Erich Salomon or Martin Munkacsi, even though they seemed predisposed toward reportage, and in fact used a shot by photo reporter Willi Ruge for the poster in Stuttgart **(cat. 34)**. These idiosyncrasies in no way undercut the force of the exhibition's grand visual argument. *Fifo* consolidated tendencies in "new photography" at an unprecedented level of visibility and inspired a rush of similar projects throughout the region.

Janusz M. Brzeski and Kazimierz Podsadecki, who made their living creating photomontages for the popular press, assembled an overview comparable to *Fifo* in their native Kraków in 1931. This "first" show of modernist photography never had a sequel, and not enough is known of its guiding ideas or contents. Podsadecki and Brzeski, both avid cinephiles, presented film as well as *foto* at the event, including Brzeski's *Cross-Cuts (Przekroje)*, a cinematic montage from preexisting newsreel footage inspired by Walter Ruttmann's *Berlin: Symphony of a Big City* (see chapter 5).[24] Brzeski also created at least two compositions using photograms and combination printing, one of which became the basis for the exhibition poster **(cat. 35)**. Another participant, painter Karol Hiller, presented examples of his *cliché-verre* technique called *heliografika*, which Hiller had developed in response to the photograms of Moholy-Nagy and Man Ray (both featured in the Kraków exhibition as well). These abstract compositions **(cat. 36)**, drawn in tempera on glass or celluloid and then printed actual size on paper, determinedly furthered Moholy's "productive" photography: "I was motivated by the thought," he wrote in 1934, "not to recreate nature's visual manifestations, but rather to create their source directly on the [photographic] plate."[25]

A pair of exhibitions organized in 1930 and 1931 in Prague, by a talented threesome of emerging Czech photographer-filmmakers, has been slightly better documented. "'The world in pictures' would be the most suitable title," wrote neophyte Alexandr Hackenschmied, the leader of this trio, in a perceptive review of the Stuttgart exhibition for the leading Czech amateur journal *Fotografický obzor*: "The intent was to show the breadth of possibilities for utilizing photography. . . . Most of the works on display, however, took artistic expression as their aim. . . . Perhaps the authors of certain works had nothing of the sort in mind. . . . But those who selected the images for exhibition could not forsake their aesthetic viewpoint, and chose more by appearances than by content."[26]

34

WILLI RUGE (German, 1892–1961), *Arno Boettcher*, 1927, gelatin silver print, 18 × 13, Staatliche Museen zu Berlin, Kunstbibliothek

35

JANUSZ MARIA BRZESKI (Polish, 1907–1957), *Untitled (Metal) (Bez tytułu [Metal])*, before 1931, gelatin silver print, 38.8 × 29, Muzeum Sztuki w Łodzi

36

KAROL HILLER (Polish, 1891–1939), *Composition (Kompozycja)*, 1930s, gelatin silver print (*heliografika*), 23.8 × 17.8, National Museum in Warsaw

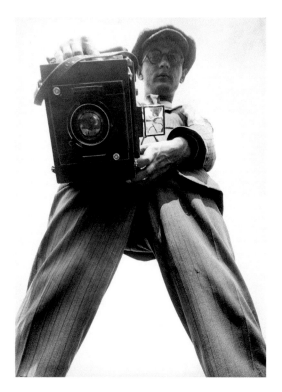

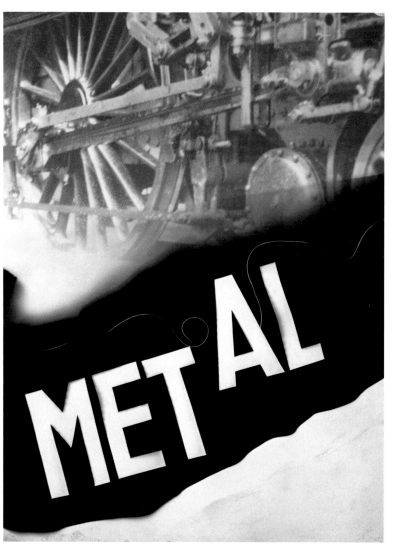

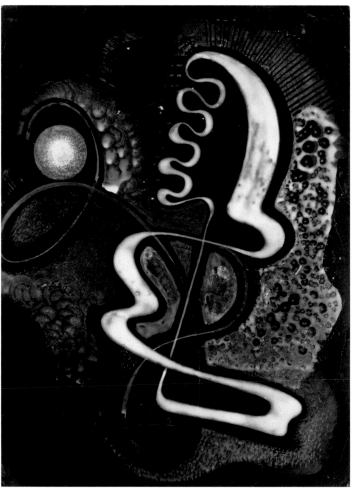

$$\frac{34}{36}\ 35$$

This observation was not meant as a criticism; Hackenschmied and his close contemporaries Ladislav E. Berka **(cat. 37)** and Jiří Lehovec happily participated in the Munich version of *Fifo*, called *Das Lichtbild* (The Photograph). Their own pair of *Výstavy nové fotografie* (Exhibitions of New Photography), meanwhile, offered a Czech-centered, modest parallel to *Fifo*. Scientific photographs and studio portraits hung alongside works in the spirit of "new photography," to make the point that the "photo eye" is all-embracing and oriented toward the photograph as image.[27]

These two shows, the first of which opened in May 1930, also set the work of established modernists such as Funke and Josef Sudek alongside less prominent practitioners of experimental photography. The latter group included Eugen Wiškovský, a high school professor who had just begun to devote himself to photography on an amateur basis, and the timid but amazingly innovative Rössler. Wiškovský, whose academic interests centered on philology and psychoanalysis, gravitated in photography toward the classicist abstraction of Renger-Patzsch. With Funke as his mentor, Wiškovský concentrated initially on architectural views and still lifes, such as the series of stagings with insulators made probably in 1933 **(cat. 38)**. His romantic study of a mass-produced object, twisted out of its ordinary position for emotional effect, reflects Funke's dreamy absorption in shadows as much as it does the closely cropped machine aesthetic from Germany. By around 1930, both sources formed part of a basic vocabulary of experiment for Czech amateurs, although few pursued it with the rigor displayed by Wiškovský throughout the 1930s and after.

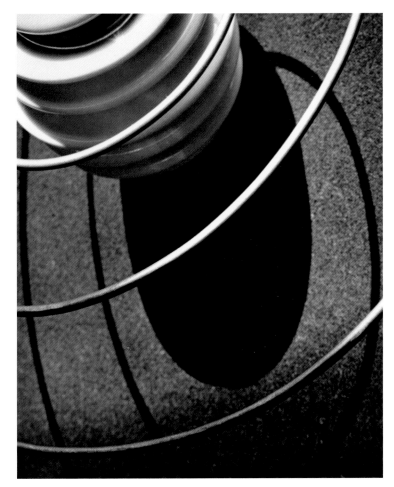

38

Such a vocabulary was not nearly so widespread in 1919–1920, when Rössler began photographing arrangements in the studio of his employer Drtikol. Drtikol, highly sought after as a portraitist and theater photographer, had made a specialty of dancers interacting with abstract stage designs (see chapter 4). It is likely that Rössler furthered Drtikol's interest in the props themselves, for his earliest works concentrated on shapes and space alone. Manipulating cardboard, lighting, and sundry objects, Rössler produced stunningly original studies of surface, volume, scale, and light. Although his works of the early 1920s suggest affinities with a variety of avant-garde art movements, there is only circumstantial evidence for what Rössler saw in those years—he spent time in Belgrade in 1921–1922, where he may have registered work by the avant-garde group Zenit, and he was invited to join the Devětsil collective in 1923—and nothing exists in writing to clarify his motivations.[28] The photographs themselves, such as *Composition with Magic 2* (see **cat. 25**), seem consistently to push

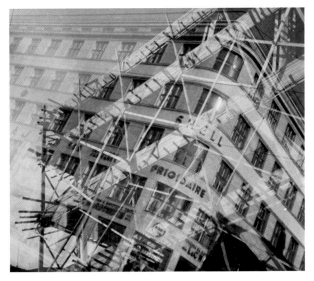

37

37

LADISLAV BERKA (Czech, 1907–1993), *New Construction (Nová stavba),* from the series *Prague Overprinted (Praha v surimpresi),* 1929–1930, gelatin silver print, 12.2 × 14.6, Museum Folkwang, Essen

38

EUGEN WIŠKOVSKÝ (Czech, 1888–1964), *Insulator (Izolátor),* 1933–1935, gelatin silver print, 29.4 × 23.4, Museum of Decorative Arts in Prague

toward a state of immateriality, achieved through the dissolution of forms in space. Although they have frequently been categorized as constructivist, Rössler's early works appear aimed at deconstruction; their enigmatic softness, meanwhile, conjures introspective fantasy rather than socialist revolution.[29]

In many respects—including, significantly, his alternation between gelatin silver and the "fine art" techniques of bromoil, pigment, and hand-colored printing—Rössler's early experiments exemplify the interpenetration of pictorialism and "new photography" that continued throughout the New Vision period. Indeed, their protestations notwithstanding—"against the pictorial conception of photography…against ossified subjects," declared Linhart at the 1936 exhibition in Prague—selection committees for the great "avant-garde" surveys of central Europe had strong precedents in the pictorialist era. Organizers for the second Vienna Camera-Club exhibition of 1891, for example, announced they would judge submissions from science, industry, amateurs, and studio professionals solely on visual merit, via a jury composed exclusively of artists and art historians.[30] Although the resultant selection reflected a partisan aesthetic—as did the "new photography" shows of the 1920s and 1930s—this approach implied at least the principle that all branches of photographic production should be unified on the plane of artistic imagery. Meanwhile, at the 1909 *Internationale Photographische Ausstellung in Dresden (Iphad),* "art photography" was placed in ostentatious proximity to pictures from science, trade, and manufacturing, to suggest the reach of what was not yet called a universal *medium.*[31]

Both pictorialists and advocates for "new photography" displayed enormous ambition as artists, and both generations of photographers sought a place at the forefront of modern art history. If the latter movement can be called avant-garde, this is because it reflected critically on the structure and functions of photography, instead of confining its innovations, as the pictorialists did, to "palette" and print technique. Yet the protagonists of the 1920s also trumped their predecessors in establishing a new art-historical model for photography, one ostensibly independent from the history of modern painting rather than slavishly aligned with it. This strategic development logically entailed an investigation of photographic origins. Experimental procedures, such as the photogram and the negative print, were promoted in the New Vision simultaneously as a revolution and a return to foundational techniques. Sharp focus,

"objective" documentary views, and unretouched prints, all newly in vogue, were likewise credited to the first generation of photographers and thereby granted a legitimacy now denied pictorialist technique.

It is truly striking in how many ways the proponents of "new photography" brought much earlier photography into their discussion. Photography historian Erich Stenger lent increasingly large selections from his vast nineteenth-century collection to *Kipho* in 1925, the *Deutsche Photographische Ausstellung* in 1926, the *Pressa* show in 1928, and *Fifo* in 1929, among several others **(fig. 3.5)**. At *Fifo,* his contributions formed essential illustrative material for a didactic survey installed by Moholy-Nagy in the exhibition's opening room. To emphasize the distinctive, unified development of photographs as images from the earliest days to the present, Moholy-Nagy mixed a selection of Stenger's possessions[32] with newer examples of scientific and newspaper photography under the giant title: "Where Is the Evolution of Photography Headed?" This pseudo-historical layout, seen already in the illustrations to *Painting Photography Film,* led in teleological fashion to the experimental techniques promulgated in New Vision theory.

Stenger's interests in photography leapt from the technological to the nationalistic, and he did not reflect on questions of aesthetics directly.[33] Confronted with the pointedly modern look of "new photography," Stenger found praise only in the reassuring contrast provided by his own pieces. "[The exhibition] was stuck in the most modern picture-making, plunging views, light and shade, objectivity

3.5 Unknown, View of *Pressa,* Cologne, 1928, gelatin silver print, 26.9 × 33, Museum Ludwig, Cologne

and so on," he wrote of *Das Lichtbild*, the Munich version of *Fifo*; "which made my really extensive historical section stand out to even greater effect."[34] For Moholy-Nagy, Franz Roh, and others, by contrast, these nineteenth-century treasures pointed in radical new directions. Roh, who began to think seriously about photography in 1925, may well have begun his own historical collection after seeing Stenger's exhibition contributions. It seems even more likely that his fondness for negative prints and for rounding the edges of his prints **(cat. 39)** derived from looking at nineteenth-century material.

The example of Daguerre legitimated in Roh's mind the abundance of experiment flowing out of the Bauhaus in his own day. A return to origins likewise motivated innovators who would have nothing to do with the Bauhaus. August Sander professed repeatedly his admiration for the daguerreotype and in fact initially contacted Stenger, his first interlocutor in photography, to ask for help in recreating Daguerre's process (see chapter 8). Sander, like Renger-Patzsch a photographer grounded firmly in an aesthetics of technical excellence, also began around 1925 to uphold the early days of photography polemically against the pictorialist era.[35] Renger's two most

important supporters, meanwhile, curator Heise and art historian Heinrich Schwarz, promoted his work together with that of the mid-1800s. Schwarz recommended Renger for shows with the Société Française de Photographie, an institution rooted in the achievements of Daguerre, and with the Royal Society of Photography, devoted to preserving the memory of Daguerre's British contemporary, William Henry Fox Talbot. Schwarz also saw in Renger a worthy inheritor of the legacy of David Octavius Hill, with Robert Adamson a magnificent early practitioner of Talbot's positive-negative print technique, known as the calotype. Just as Heise alerted Schwarz to the merits of Renger's work, so Schwarz inspired Heise to purchase a large group by Hill and Adamson to set beside the even larger holdings by Renger in the Lübeck museum collection.[36]

A similar demonstration of respect for the past from a modernist vantage point emerges from the 1918 essay "Photographs of Our Parents" by the Czech painter and critic Josef Čapek. Čapek did not just disparage pictorialism here and elsewhere: he interpreted photography as a barometer of historical change. This grand approach, closely connected to recent art-historical thinking in his day, shifts the interpretive focus from technology or authorship to

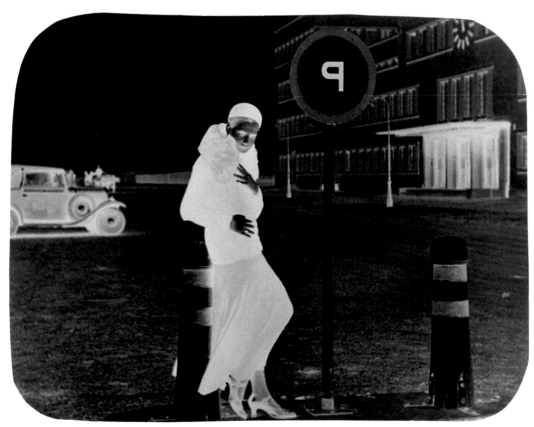

39

39

FRANZ ROH (German, 1890–1965), *Untitled (Negative "P")* *(Ohne Titel ["P" Negativ])*, late 1920s, gelatin silver print, 14.5 × 19.3, Lent by The Metropolitan Museum of Art, Ford Motor Company Collection, Gift of Ford Motor Company and John C. Waddell, 1987

40

WITOLD ROMER (Polish, 1900–1967), *Portrait of My Brother (Portret Brata)*, 1934, gelatin silver transfer print (*izohelia*), 39.8 × 29.9, National Museum in Wrocław

epochal categories—from personal style to period style. "Photography has, or should have, behind it a good-size tradition," Čapek begins, arguing for a medium-specific, historical continuity:

and it's not a bad tradition, for there are quite lovely old likenesses from the years broadly around the 1870s, which convince you of the evil decline that set in later. A person then was a dignified subject, in whom the new miracle [of photography] found meaningful purpose.... The newer period wanted to bring a so-called naturalness to photography, which led to shabby superficiality; the times looked at life in a small and cheapening way.... The older method respected the person more.[37]

This periodizing, humanist standpoint, articulated in 1931 by Walter Benjamin as well—"The procedure itself caused the models to live, not *out of* the instant, but *into* it," he writes of portraits from the age of Hill and Adamson; "during the long exposure they grew, as it were, into the image"—characterizes theory in the "new photography" era. "The most recent literature," Benjamin reports, "seizes on the striking fact that the flowering of photography, the achievement of Hill and Cameron, of Hugo and Nadar—occurs in its first decade. That is the decade which preceded its industrialization."[38] Benjamin's dates are questionable, as are those of Čapek, but what counts is the attempt to correlate dates to aesthetics and, just as importantly, to social possibilities, rather than to the apparently self-improving certainties of technology. The history of photography becomes in these accounts a consummate expression of society at different moments in the era of industrial modernity, its disciplinary development inseparable from the history of the modern *zeitgeist*. Experimental techniques of the 1920s, whether shockingly new (odd angles, abstract details, multiple exposures); revivalist (the daguerreotype); or a hybrid of the novel and the antiquated (negative prints, photograms), all served to bolster this peculiarly historical turn in modernist art.

More traditional applied art schools after 1918, meanwhile, continued to teach "laboratory" experiments, whether out of fidelity to the pictorialist preference for complex print processes, or as part of the testing of chemicals and technical procedures basic to photographic training. A remarkable variety of "novelty" techniques emerged in pedagogical settings in Poland during the 1920s and 1930s, for example, in an atmo-

40

sphere saturated with pictorialist ideas. Pictorialism arrived in the Austrian part of Poland as a Viennese import in 1900–1901, with an exhibition in Lviv of the inner sanctum of Vienna Camera-Club members known as the Trifolium.[39] Henryk Mikolasch, a camera enthusiast with a university degree in chemistry and pharmacology, was elected in 1903 to the presidency of the Lwowskie Towarzystwo Fotograficzne (Lviv Photographic Society, or LTF); the magazine he co-edited, *Wiadomości Fotograficzne* (Photographic News), published the same year a recipe for pigment prints, the hallmark pictorialist technique.[40] Mikolasch began to publish soon after the first photography almanac in Poland, its contents culled from submissions to yearly LTF exhibitions that ran through 1911, and played a crucial role in developing and propagating the inspiration brought from Vienna.[41] The

following year Jan Bułhak, who would become the foremost Polish representative of pictorialist standards in photography, traveled from his adopted hometown of Vilnius for a months-long apprenticeship at the Dresden art center run by Erfurth who, as mentioned earlier, was one of the most prominent adepts of pictorialist technique in pre–World War I Europe.

In 1919, following the reunification of Poland, Bułhak was asked to found an art photography department at the newly reopened university in Vilnius. His teachings, based perhaps partly on his practicum in Dresden and certainly on the theories of French pictorialist Robert de la Sizeranne, created a large and influential following in the 1920s and 1930s. His Galician counterpart Mikolasch became in 1921 the head of photography at the Lviv Polytechnic, while Mikolasch's close associate in the LTF, Józef Świtkowski, founded a workshop for photographic studies that same year at the local university. Institutions of higher education in interwar Poland thus became central to photographic training, while the individuals responsible for them remained pledged to a model of artistically ambitious production dependent on laboratory manipulations.

This state of affairs helps account for the peculiar explosion of "brand-name" printing processes that occurred in interwar Poland. Foremost among these is *izohelia*, a method akin to silk screen developed by chemist Witold Romer **(cat. 40)**. Romer, who began his exhibition career in 1926 with compositions printed in the "modern-pictorial" bromoil technique, showed the first results in *izohelia* in 1931, the year he succeeded Mikolasch as head of photography at the Lviv Polytechnic. *Izohelia* involves making successive contact prints on high-contrast materials, to reduce the light-dark tonal range to a precisely delimited series of gradations, like altitude notations on a map. Romer got the idea observing his father, a prominent cartographer, with the notion that any three-dimensional surface can be represented topographically on flat paper through a "mapping" of differential light intensity. Treating highlights as points of greater elevation and shadows as troughs, Romer turned photography into a branch of hypsometry. His *Portrait of My Brother*, despite its traditional viewpoint and framing, therefore bears an uncanny conceptual affinity with the "new photography" photo essay "The Face as Landscape" (see chapter 5).

Romer's method enjoyed increasing popularity in the 1930s and again after World War II, thanks largely to its inventor's terrific pedagogical enthusiasm. From the late 1950s through the early 1970s, for

3.6 Jan Alojzy Neuman, *Untitled (Bez tytułu)*, 1929, bromoil print, 29.5 × 22.5, National Museum in Wrocław

3.7 Marian Dederko and Witold Dederko, *Cubist Portrait (Portret Kubistyczny)*, c. 1930, gum dichromate print, 25.5 × 20.2, The Art Institute of Chicago, Gift of Alan Koppel in honor of Sherry Koppel PC

example, four *Międzynarodowe Wystawy Izohelii* (International Izohelia Exhibitions) were held in Romer's new residence of Wrocław, where he also founded a new department of photographic technology.[42] Fellow Lviv photographer Bednarczuk, a former student of Mikolasch, was one of several of Romer's contemporaries to adopt *izohelia* in the 1930s. Bednarczuk himself invented a pictorialist technique that he called *fotoryt,* which remains ill-defined but likely required heating the emulsion to produce fine crackling, then retouching further by hand.[43]

Before testing the *fotoryt* and other processes in the early 1930s, Bednarczuk had already won an amateur prize for his 1929 *Construction,* a Chaplinesque arrangement of bowler hat, bent cane, worn shoes, and greasy overcoat surrounding a body made of cardboard cylinders **(fig. 3.4)**.[44] The piece is unusual in the Polish context for its evident artifice and relative abstraction, and for its "little-guy" subject—unlike his peers, Bednarczuk came from a working-class family (see chapter 7). Jan Alojzy Neuman, another Lviv photographer taken with Romer's *izohelia,* likewise created photomontages and studio arrangements of radio equipment, airplanes, and other modern subjects using the bromoil technique **(fig. 3.6)**. Neuman, who worked for a time at the polytechnic as Mikolasch's assistant and later lectured at a secondary-school photographic institute, continued comfortably to make pictorialist exhibition prints while serving as editor for *Leica w Polsce,* a journal for enthusiasts of the 35mm hand-held camera that supposedly signaled the death of "art photography."[45]

Another, polemical innovation in Polish pictorialist circles from the late 1920s is the *fotonit* developed by Warsaw studio operators Marian Dederko and his son Witold **(fig. 3.7)**. This process, which its inventors also named, with self-aggrandizing flair, *fotonizm,* to suggest a full-blown modern "ism," consisted in generating a cubo-expressionist effect by drawing over large parts of the negative. The original image, usually a portrait, would be substantially replaced with a theatrical ground of faceted highlights in charcoal and chalk. Faced with a raging debate over the seemliness of this technique, both on stylistic grounds and in terms of "honesty" vis-à-vis the photographic print, the elder Dederko felt compelled in 1930 to write "In Defense of Fotonizm."[46] Sounding a typical pictorialist note of lament, Dederko declares here his struggle against both the inartistic mimesis of routine photography and the declining standards of pictorialist technique.

Maciej Szymanowicz rightly terms Dederko an aesthetic conservative laboring under the erroneous impression of his own avant-garde status.[47] It is nevertheless worth recognizing the historically determined character of that contradictory stance. Dederko's *fotonit* provides the clearest possible example of a shared basis in reformist aesthetics and pedagogically oriented experiment that united pictorialist and modernist spheres of photographic production in central Europe. Experimental processes were understood to set standards of achievement that might be learned and appreciated by all—or at least by all partisans of the photographic image. It is no coincidence that *fotonizm,* Romer's *izohelia,* Bednarczuk's *fotoryt,* and other "patented" innovations—the *złotobrom* (bromo-gold) toning procedure of Jan S. Dobrzański, for instance, or Bułhak's *wtórnik* (derivate), like *izohelia* a technique using successive generations of contact prints—all arise during the half-decade dominance of the "new photography" in c. 1928–1933. Pictorialism is not so much defeated as trumped by this new movement, outdone in its pedagogical and artistic ambitions by a more self-reflexive and theoretically savvy set of practitioners. It is in these years as well that Bułhak invents an up-to-date name for all of pictorialist "art photography": *fotografika.* Following World War II, the term ironically also comes to designate the radical photography that Bułhak despised. The triumph of "new photography" theory is complete, so much so that it passes unnoticed. Like much else from the intellectual history of interwar photography, Bułhak's term remains in use even today.

chapter4

New Women—New Men

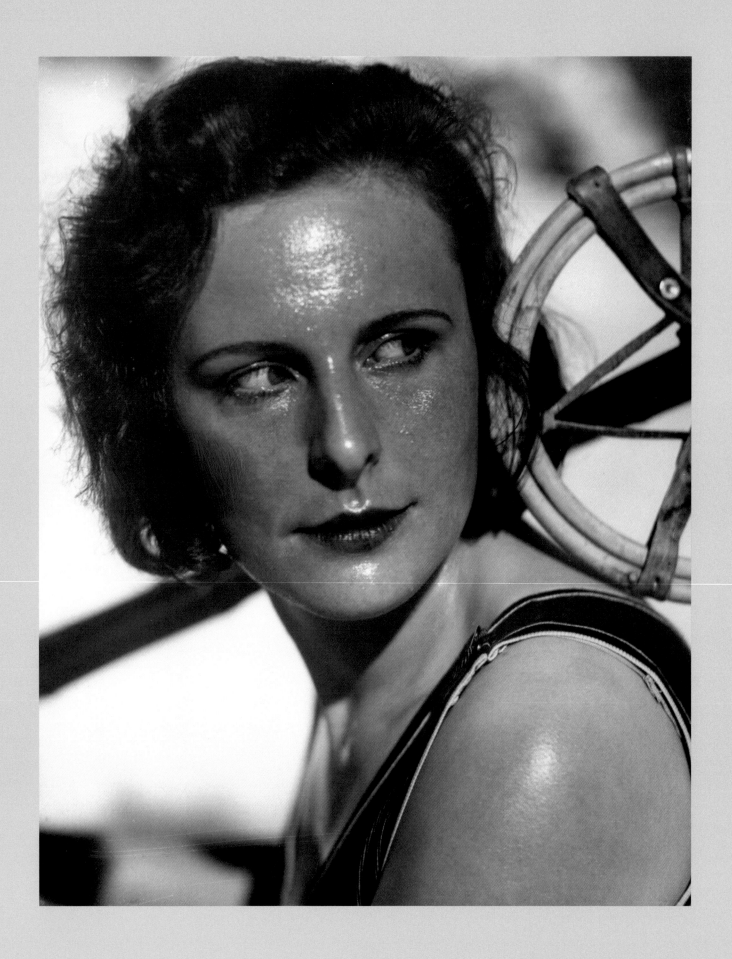

41

41

MARTIN MUNKACSI (American, b. Hungary, 1896–1963), *Leni Riefenstahl*, 1931, gelatin silver print, 29.4 × 23.4, Lent by The Metropolitan Museum of Art, Ford Motor Company Collection, Gift of Ford Motor Company and John C. Waddell, 1987

One of the most visible manifestations of modernity in the interwar years involved a sea change in women's fashions: bobbed hair, vibrant makeup, brassieres instead of corsets, and a slender, lithesome physical ideal. If the *femme nouvelle* of Paris c. 1900 had seemed to be wearing the carpeted salon interior, her "natural" environment, out on the boulevards, the *neue Frau* of Berlin c. 1925 looked shockingly at home on the street — or in the workplace. Although the New Woman lifestyle could truly be enjoyed by just a segment of the female population — young, unmarried urban women from well-heeled families — the persona became a lightning rod for debates over cultural values at all levels of society. Perhaps nowhere did the mixed emotions of elation and anxiety at the prospect of modernity confront each other more clearly than in this realm of personal identity, which concerned men as much as women of the time.

The phenomenon of the New Woman, a close cousin to the American flapper, emerged at the intersection of unforeseen socioeconomic reality and tightly engineered consumer fantasy in the decade following World War I. The war, which in central Europe brought the mobilization of nearly nineteen million men, or one-third of the total male population, leaving some eleven million of them dead or wounded (along with one million civilian dead of both genders), inadvertently galvanized opportunities for women in the political system and, to some degree, in employment as well. Most postwar governments in central and eastern Europe, including those in all the countries surveyed here, had granted women the right to vote and stand for election by 1920. New openings came in the workforce as well, although one cannot speak unequivocally of "advance"; without corresponding adjustments in expectations for home and family or equal pay for equal work, women's employment generally entailed a less than lucrative burden added to ongoing domestic responsibilities. Work outside the house, moreover, served many women in the postwar years only as a means to bridge the gap between high school and marriage.[1]

Although the percentage of employed women did not necessarily increase from prewar to postwar times — in Germany, slightly more than one-third of women held paying jobs, in 1925 as in 1907 — periodic waves of great unemployment for men, coupled to shifts from agriculture into industry and, above all, into the booming service economy, made working women a highly visible epiphenomenon of the new consumerist regime. The salesgirl, the manager's assistant, and the shorthand typist became clichés of the modern age. Moreover, the expanding universe of goods and entertainment targeted precisely women rather than men. The strain on both sexes caused by these macroeconomic trends contributed greatly to the controversy of the New Woman.

This background makes achievements in commercial photography, a field where women did appear alongside men and helped shape the image of their time, all the more remarkable. The decade after World War I saw an unprecedented expansion in the visibility and variety of women behind the camera, which became an "instrument of self-determination," as Ute Eskildsen has phrased it.[2] In Germany, but also in Austria and Hungary, women made it to the forefront of the photographic industry; in Czechoslovakia and Poland, where female photographers were not common, women nevertheless held important positions in cultural criticism. To judge by their writings and their art, the women who came of age around 1925 understood well that the modern image world privileged a practice of self-fashioning, which entailed partly resisting, partly glorying in the consumerist media environment. Not surprisingly, then, the photographers and commentators engaged in marketing the New Woman included many women as well.

It should be emphasized that the larger cultural context for these "revolutionary" changes, which brought photography and the discussion of gender roles to intertwined prominence, remained emphatically traditionalist regarding women's rights. The period after 1920 is generally viewed by scholars of women's history as one of retreat and decline.

Throughout Europe and North America, where the greatest gains had been made prior to World War I, women suffered resurgent restrictions in education and employment, while the civic groups that had advanced women's causes from the middle of the nineteenth century splintered or were otherwise rendered voiceless.[3] In many central and eastern European countries, women were granted the right to vote not out of concern for gender equality, but from a desire to drive "foreign" ethnicities out of office; the more "true" Poles, Hungarians, Czechs, and Slovaks went to the polls, the fewer representatives would presumably be elected from minority groups in these newly constituted nation-states. Gender and national identities were thus largely considered indissociable, and indeed, across the countries surveyed in this book, a majority of women voted for conservative or nationalist agendas during the 1920s and 1930s.[4] In Austria, Hungary, and Poland especially, the dominant women's organizations, and even some of the few women elected to Parliament, tended to side with political parties advocating a traditional place for women in domestic and religious spheres, rather than as independent actors, let alone as agents for social change.[5]

As a sociopolitical reality, then, and also as a field of projection and fantasy, the New Woman and other modern gender roles developed within limitations, flourishing only in the capital cities of central Europe. This chapter is accordingly concerned with these cities alone, and particularly with the region's one metropolis, Berlin, where discussions of the New Woman and possibilities for photographic employment both proliferated during the later years of the Weimar government (roughly 1925–1933).[6] Certainly, the most provocative photographs—pictures showing or suggesting gender reversal, androgyny, and homosexuality—are a German specialty. Nowhere outside of Berlin or the progressive German art milieus were alternative gender identities portrayed photographically in interwar central Europe,[7] and such depictions appeared only rarely even in the most open capitals, such as Paris or New York. At the same time, the coupling of the New Woman and "new photography" specific to Germany during the late 1920s, along with that country's tremendous influence on its neighbors, makes this topic crucial to understanding the larger interplay between *foto* and modernity in that region.

A picture of assertiveness and athletic good health **(fig. 4.1)**, the New Woman figured to some degree as hyperbolic compensation for bodily disfigurations caused so prominently by the war. Machine-

4.1 Kata Kálmán, *Sunbathers by the Pool (Napozó fürdőzők)*, c. 1939, gelatin silver print, 24.2 × 18.4, Hungarian Museum of Photography

age models of womanly beauty disguised like a prosthesis the maiming brought by devices of industrial technology, from machine guns to poison gas to hand grenades; industrial, "manly" fashions for women also masked the anxiety at dismembered masculinity within the defeated countries of central Europe in particular. Leni Riefenstahl, the athlete turned filmmaker, is one of the most famous women to have stepped into this heroic compensatory role **(cat. 41)**. At the same time, the New Woman proved remarkably open to ridicule, distortion, and caricature. Deliberately exaggerated representations of gender in the interwar years, from the humorous kitsch of Atelier Manassé, to numerous meditations on mannequins **(cat. 42)**, and at an extreme the incisive assemblages created by Hannah Höch or Hans Bellmer, all underscore points of unease constitutive of the New Woman image.

As a counterpart to these great shifts in the representation of women, many photographs from the 1920s and 1930s offer an "other than" masculine view of men. Portraits of famous cultural figures by Lotte Jacobi or Trude Fleischmann **(cat. 43)** evidence this new approach, as do views of friends and lovers by many affiliates of the Bauhaus, among them Lucia Moholy and the duo of Grete Stern and Ellen Auerbach, alias ringl+pit **(cat. 44)**. Self-portraiture, an area of particular fascination at this time, is vigor-

42

UMBO (OTTO UMBEHR)
(German, 1902–1980), *Dreamers*
(Träumende), 1928–1929, gelatin
silver print, 21 × 29.2, Kicken
Gallery, Berlin

43

TRUDE FLEISCHMANN
(American, b. Austria, 1895–
1990), *The Hands of the Poet Karl
Kraus (Die Hände des Dichters
Karl Kraus)*, 1930, gelatin silver
print, 13.6 × 8.6, Albertina,
Vienna

44

RINGL+PIT (Grete Stern
[Argentinian, b. Germany,
1904–1999] and Ellen Auer-
bach [American, b. Germany,
1906–2004]), *Untitled (Ohne
Titel)*, c. 1930, gelatin silver
print, 16.1 × 17.4, The Art Insti-
tute of Chicago, Restricted
Gift of the Photograpic Society

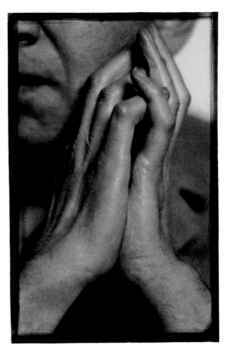

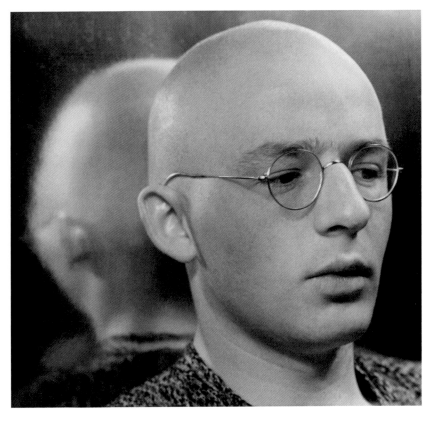

42 43
—
44

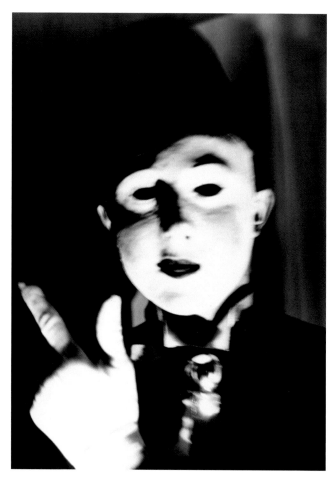

45
—
46

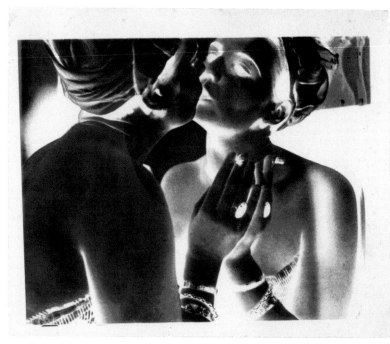

ously made new by women artists, who demonstrate a keen awareness of the importance of masquerade.⁸ Certain male photographers, such as Umbo, Werner Rohde **(cat. 45)**, and several of the Czech surrealists pose before the camera as well, in ways that project a loss of psychic stability and control.

In summary, one may say that the "new" for women and men alike in interwar central Europe entailed a crucial negotiation between selfhood and spectacle **(cat. 46)**. The New Woman and her implications for men existed as a field of institutionally produced imagery for advertising campaigns and the fascinating world of popular press and entertainment that surrounded them. These are the channels through which "new photography" developed, too, like the New Woman a product largely of institutional engagement with the public sphere. Photography and issues of personal identity developed in tandem during the interwar decades, with the camera serving not only as a vehicle for new images of the self, but also as a new form of self-expression in its own right.

The photo story "Lieschen Neumann Wants a Career, or the False Presence before the Camera," by studio photographer Yva, makes an excellent introduction to the New Woman in her archetypal form **(cat. 47)**.⁹ Yva, a Berlin native whose given name was Else Neuländer-Simon, studied photography for a time at the venerable Lette-Verein school, then worked briefly at a movie studio and with a commercial photographer before boldly founding her own enterprise in 1926. A model New Woman herself, Yva rose quickly to prominence, managing a fourteen-room studio in the center of Berlin. One key aspect of her enterprise was an alliance with the Ullstein press empire, which included supplying the Ullstein lifestyle magazine UHU with a series of photographic "picture stories" published between 1930 and 1933: narratives in which photographer, author, and art editor collaborated to produce a sort of illustrated morality play.

"Lieschen Neumann," the first such story, demonstrates with verve the self-reflexive irony common to treatments of the New Woman. The protagonist stands in for all the supposedly faceless young girls who "sit at home with no appetite," filling their days with boredom and forced laughter because they dream only of coming to Berlin and achieving fame and wealth "as fast as possible." The telltale surname, Neumann (Newman in English), makes the reference to New Women clear enough and also implies, troublingly, that these women are stepping into territory properly reserved for men. Our hasty and overreach-

45

WERNER ROHDE (German, 1906–1990), *Man with Mask (Mann mit Maske)*, 1928, gelatin silver print, 22.2 × 16, Museum Folkwang, Essen

46

FRANZ ROH (German, 1890–1965), *Greeting Oneself (Selbstbegrüssung)*, 1927–1933, gelatin silver print, 15.4 × 19.8, The J. Paul Getty Museum, Los Angeles

47

YVA (ELSE NEULÄNDER-SIMON) (German, 1900–1942), *"Ramona in the littlest flying machine" ("Ramona in der kleinsten Flugmaschine")*, 1929–1930, gelatin silver print, 20.6 × 27.8, Ullstein Bild-Yva

She smiles at us, well appointed from the pages of every glossy magazine. People are amazed at her abilities: "Ramona in the littlest flying machine."

ing young lady, then, heads for the capital, determined to succeed as a fashion model. She logically chooses as her first stop a photographer's studio, "so as not to waste time"; of course, the studio she picks is Yva's.

The sequence of twelve photographs, arranged in six double spreads, presents the reader with nearly as many variations in scene and costume in which the only constant is the protagonist's face: a fresh yet devilish mask of sparkling teeth and bright circles of lipstick and eyeliner, often topped by the additional sphere of a modified bowler hat, as in the image reproduced here. Golf clubs, cars, horses, even an airplane are Lieschen's new accessories, and "Ramona Silvaré" is her new, unplaceable name. Name and goods both belong to the magazines, however, while the "real" Lieschen Neumann, hapless and untalented, sinks into the disgrace of poverty. In the sequence with the horse, for example, we are told in one picture that our protagonist has made the grade, as she smiles regally in a half-length picture next to a steed shot majestically from below. A second photograph, taken from a more level distance and at full length, reveals Neumann in an awkward stance and a skirt eminently unsuited to riding, accompanied by the caption: "the impression would naturally be different if one saw the lower half of the picture."[10] The photograph of "Ramona in the littlest flying machine" carries a similarly ironic caption, emphasizing the gap between appearance and reality.

"Lieschen Neumann" amounts to a farcical critique of female careerism, one that delights in the complicity of magazines and photographers such as UHU and Yva, yet assigns responsibility for fraudulent posturing to the simplemindedly avaricious New Woman. In the final frames, we see a distraught, doomed "Ramona," her money spent, her purchases repossessed, and her luck run dry. Vanity and inexperience, we are told, are to blame, for "A pretty face is unquestionably a talent . . . but that alone?"

One should doubtless see in this sort of critique, which seems to accompany the New Woman from her very emergence, an expression of chauvinist fright at a society in which women hold real public standing and financial clout. One might also interpret this cautionary tale as a warning against excessive dependence upon images — specifically photographic images — in determining a person's social worth. Both conclusions get at the heart of anxieties over the potential loss of profundity or stable meaning in a world made modern. They also suggest as a corollary that Yva, the photographer (who, like

Lieschen Neumann, works under an exoticizing pseudonym), is hypocritical, increasing her own fame through depictions that belittle others who share her ambition. A charge of hypocrisy would be too tidy, however. Yva, and the vast majority of those working in the new image world of the 1920s and 1930s — including the readers of UHU, many if not most of them women — neither attempted to change that system nor to hide its contradictions and moral inequities. The lighthearted, caricatural tenor of this picture story bespeaks such transparency and places it at odds with condescending denunciations of women common in male-dominated quarters at the time. As agents of production and consumption alike, to follow the analysis of art historian Marsha Meskimmon, "there was present for women both a critical distance from the visual types and an engagement with their pleasures."[11]

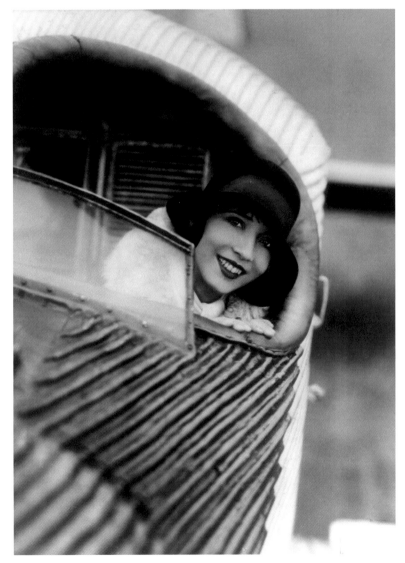

47

The balancing act that resulted between private identity and publicly traded stereotypes is tellingly preserved in a suite of photographs that constitutes the most innovative dance publication from this time, the 1926 Czech book *Alphabet*. Modern dance, which ranged from updated balletic routines to the more popular spheres of gymnastic exercise and rhythmic movement, as well as the epidemic craze for ballroom dancing, was a favorite leisure activity for women. Methods introduced by Jacques Dalcroze, Isadora Duncan, and Rudolf von Laban, the three great teachers of modern dance in Europe, attracted a heavily female enrollment in private classes offered widely in Germany and in the major cities of Czechoslovakia, Austria, and Hungary.[12] Milča Mayerová, a privileged graduate of Laban's master school in Hamburg, created *Alphabet* just as she was opening a dance institute herself in Prague.[13] *Alphabet* incorporates photographs from a dance choreographed by Mayerová to accompany a poem of the same title by Vítězslav Nezval, a key member of Devětsil. Mayerová persuaded her family's publishing firm to produce the book, which was brilliantly designed as a series of photomontages by Devětsil leader Karel Teige, and she hired studio operator Karel Paspa to photograph her in stills from each of the "letters" that compose the dance (see **cat. 23**).

Alphabet served Mayerová like a calling card in her new occupation as dance instructor, especially as the idea to "dance the alphabet" echoed Laban's own conception of dance as a form of written language.[14] Mayerová underscored her bold publicity campaign through repeated performances of this dance and related appearances in the press **(fig. 4.2)**. Yet in the choreography itself, Mayerová deliberately undid the idea that dance could function like a legible alphabet. Far from the ideal of universal communicability formulated by her mentor Laban, Mayerová shows in her different poses that "body language" holds meaning always and only in context. Her costume, especially, conveys competing meanings: it converts its wearer into a machine-made typographic symbol, but it also advertises the athletic New Woman bound for the swimming pool or the dance hall. In the first acceptation, Mayerová appears impersonal, ageless, and sexless, as if out of all human time; in the second, she is the controversial female very much of her moment. "And what of purpose?" responded Mayerová to a survey on clothing and self-image. "Take for instance a bathing suit: it can serve many purposes, so I don't know, perhaps it could be called 'formal wear'?"[15]

4.2 Milča Mayerová just after the release of *Alphabet*, in Staša Jílovská, ed., *Pestrý týden* 1, no. 9 (29 December 1926), photolithograph, 57 × 43, Museum of Decorative Arts in Prague, Library

Mayerová's play with multiple and conflicting identifications emphasizes the masquerade in gender identity, suggesting that to be modern means to adopt a guise, to perform before a collective audience. Mayerová's contribution is to bring forth the latent ambiguity of such a performance. The challenge she poses, with her mix of the erotic and the impersonal, to more regular associations of women and dance becomes clearer when juxtaposed with the work of her compatriot František Drtikol, the most famous photographer of dance poses internationally in their day. Like Mayerová, Drtikol contrasted elements of the abstract and the erotic; unlike Mayerová, he aimed to fuse these elements into an ecstatic unity.[16]

Dance and eroticism, twin boosts to Drtikol's imagination, appear already in the early 1910s, and they dominate his oeuvre from roughly 1924 through the early 1930s. His eclectic blend of expressionist theater decor and art deco design during these years followed larger aesthetic fashions yet became an instantly identifiable look. Drtikol moved between more or less coquettish scenes with a strong narrative dimension and tableaux in which the nude form, almost always female and ever leaner, complements or contrasts with geometrically shaped props and the shadows they cast **(cat. 48)**. His version of

48

FRANTIŠEK DRTIKOL (Czech, 1883–1961), *Movement (V pohybu)*, 1927, pigment print, 27.5 × 22.8, Museum of Decorative Arts in Prague

49

JÓZSEF PÉCSI (Hungarian, 1889–1956), *Fashion (Mrs. Pécsi) (Divat [Pécsi Józsefné])*, 1932, gelatin silver print, 22.5 × 17, June and Bob Leibowits

the New Woman, muscular but not threatening, with short hair visible on her head and between her legs (the latter decision won him both his audience and his opposition at salon exhibitions), is deployed as a balancing element—with sexual tension tipping the balance.

In certain works by Drtikol from around 1928–1929, the female figure appears blurred or attenuated, as if transformed into a miniature, while various series beginning the following year include no live bodies but instead wood cutouts of anorexic waifs. These late studies apparently represented a turn toward mystic spirituality; their creator became progressively more introverted, eventually selling the studio and his commercial license to devote himself to Buddhism in 1935. At the same time, Drtikol's figuration of the female body as an increasingly unreal attraction, with its endpoint in maquettes incapable of actual physical relations, simply furthers the displacement of carnal emotion onto stage decor important to Drtikol's work from the beginning. In Drtikol's photographs, it is the props and the lighting that make love, not the people, for they have become automatons.

Drtikol maintained a large studio operation, and like his Hungarian contemporaries Rudolf Balogh and József Pécsi, or Rudolf Koppitz in Austria, he built an artistic reputation for himself at the amateur salons while staying solidly anchored in the business world. Pécsi, who made nudes a minor artistic specialty in the 1920s as well, popularized the New Woman directly in advertising photographs from the end of that decade.[17] Pécsi took a more straightforward view of the socially and physically liberated woman. His picture of a lady smiling and smoking, wearing a glittering evening gown that appears to have been transferred directly from the shopwindow mannequin behind her, recalls *vanitas* paintings yet sets aside the cautionary message of that artistic genre **(cat. 49)**. The mannequin, stripped of clothing, is left to contemplate its likeness in a mirror, as often happens in a *vanitas*, yet it appears as content with its own appearance as the model herself (none other than Pécsi's wife). As in Drtikol's work, but without the atmospheric daring, a symbolic equivalence obtains between lifeless props and living people, implying a fundamental interchangeability—it is in this era too that live models are first commonly designated "mannequins."

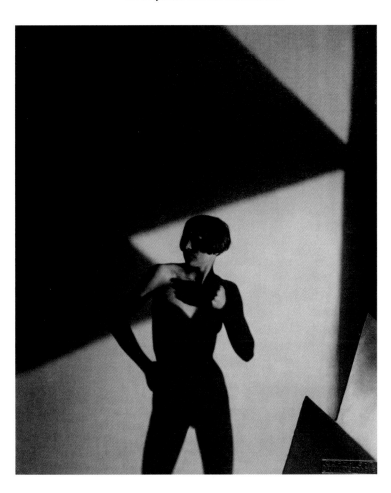

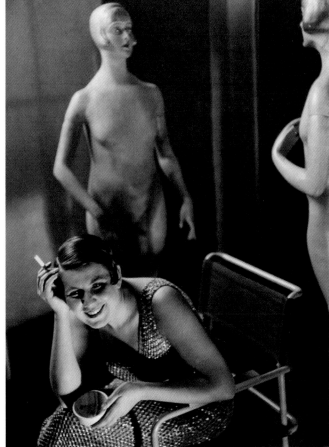

In the field of photography, however, women hardly were simple accessories. To a remarkable degree, in fact, women earned diplomas and licenses in photography beginning in the early 1900s, and during the interwar decades women schooled in central Europe gained international renown.[18] Drtikol and Pécsi were among leading studio operators who gave lessons or took on multiple apprentices, including several women. Such was also the case in the ateliers of Hugo Erfurth, Franz Grainer, Heinrich Kühn, and Rudolf Dührkoop; the last was headed jointly from 1907 by Minya Diéz-Dührkoop, the photographer's daughter. In addition to family businesses, private and state-run applied art schools and art academies offered degree courses in photographic techniques, particularly retouching and reproduction photography, for a majority female student body from the 1880s.[19] In increasingly prominent ways, the world of commercial photography in which Drtikol and Pécsi operated was historically female.

An article of February 1908 by one Helene Littmann in the Viennese journal *Photo-Sport* indicates a growing visibility for women photographers already at the turn of the twentieth century.[20] Genre scenes, pictures of children and pets, and floral studies seem to Littmann the areas of greatest success, hardly inspiring for those wishing creative and social emancipation for women. Yet she voices an observation that will be developed with remarkable insight by women photographers in decades to come: "The achievements of women are also remarkable regarding the composed image."[21] Littmann's comment on the importance of staged photography returns us to the subject of the masquerade, the conversion of social identity into an evident performance, which becomes a mainstay of the image world in the 1920s.

Littmann curiously omits mention of Dora Kallmus, one of the most successful studio operators of the early twentieth century and someone with a keen sense for the theatrical as well. A graduate of the Graphische Lehr- und Versuchsanstalt in her hometown, Vienna, and erstwhile apprentice to Nicola Perscheid in Berlin, Kallmus opened the Studio d'Ora in 1907, one of the first woman-owned photographic ateliers in Europe. She specialized in portraits of social elites, and from the end of World War I in the newly lucrative realm of couture photography for the press. Kallmus' business remained highly profitable during the interwar decades, with a summer operation (1921–1926) in the Czech town of Karlovy Vary, better known as Karlsbad, and from 1925 a new headquarters in Paris. Kallmus' ability to gain access to high society ran

from moribund imperial families (see **cat. 2**) to stars of the new era, such as Josephine Baker.[22] Kallmus also mastered the new network of illustrated journals and their publishers, particularly in Berlin.

Certain women in charge of studios, such as Wanda Wulz in Trieste (**cat. 50**), Lotte Jacobi in Berlin (**cat. 51**), or Diéz-Dührkoop in Hamburg, had inherited operations run by their fathers; others, like Olga Máté in Budapest and Fleischmann in Vienna, took advantage, as Kallmus did, of new possibilities in training and licensing for women. Some of the younger studio operators, for example Yva, capitalized in their work on the controversial limelight enjoyed by the New Woman, fundamentally merging their personal and professional identities. In her self-portrait, *Cat + I*, Wulz renders the merger especially provocative, asserting with hyperbolic literality the threatening allure projected on media starlets of her time. Wulz confronts clichés of femininity in this work with compact dramatic flair, creating a composite image that causes her to appear as diminutive feline but also as rapacious tigress. Neither association likely captures the reality of Wulz' daily life and business—but it hardly matters. In this age of visual extravagance, images answer not to external factuality but to the demands of rhetorical persuasiveness, at which Wulz' self-promotional head shot excels.

If fashion, portraiture, and domestic views formed the principal branches of photography open to women, as Littmann commented in 1908, by the later 1920s newer areas such as advertising and photo-reportage counted women in their ranks too. Lotte Jacobi, for instance, made portraits not only for private clients but also for the press, and she filed (among others) a terrific series of pictorial travel reports from central Asia in the 1930s. Her published portraits, meanwhile, gave shape to the dramatic, equivocal relation between private identity and public image characteristic of her age. The stunning double portrait of Klaus and Erika Mann, for example, epitomizes projections of sexual indeterminacy in Weimar Germany. Children of Nobel Prize-winning author Thomas Mann, Klaus and Erika were not twins but undertook many projects together and became as a result inseparable in the public imagination: from Klaus' first play (1925), in which Erika, a professional actress, performed alongside her brother and their future spouses, to well-publicized adventure travels and later antifascist activities during the Spanish Civil War and World War II. This picture, in fact, appeared in the weekly *Tempo* in the summer of 1930 on the occasion of an African road trip, during which Erika,

50
WANDA WULZ (Italian, 1903–
1984), *Cat + I (Gatto + Io)*, 1932,
gelatin silver print, 29.4 × 23.2,
Lent by The Metropolitan
Museum of Art, Ford Motor
Company Collection, Gift
of Ford Motor Company and
John C. Waddell, 1987

51
LOTTE JACOBI (American,
b. West Prussia, 1896–1990),
Klaus and Erika Mann,
c. 1928–1932, gelatin silver
print, 16 × 19.2, Dietmar
Siegert Collection

50
––
51

the older sibling, most likely did the driving; an enthusiastic car racer, she won a 10,000-kilometer rally the following year.[23]

Neither her greater age nor her racing abilities come across in this photograph, in which Erika, dressed to match her younger brother, looks upon him with fond intimacy while he cocks his head at the camera from a decadent remove. That haughtily sensuous gaze would likely have been understood as homosexual, for Klaus Mann had authored one of the first openly homosexual novels in German literature, *The Pious Dance* (*Der fromme Tanz*, 1925), and addressed homosexuality regularly in his writings. The "unnaturalness" of the siblings' alter-ego pose and shared clothing thus form part of personae that, once again, express complicated, intimate social relations through stagings of the self.

Students at art schools, particularly the Bauhaus, excelled in stagings of this sort. Gertrud Arndt, herself a Bauhaus graduate, made nearly four dozen costumed self-portraits in 1930, during a period of professional inactivity while her husband was teaching at the school. Made up through found and assembled bits of clothing into a socialite, a widow, a little girl, an Asian woman, and others, Arndt worked through the image types of her time in a playfully subversive way. "'The one with the flower in your mouth,'" she later remembered one (male) friend's comments, "'you look like a whore. Say, what kind of photos are you making

there?'...I wasn't thinking of such things of course. I have no idea what a whore looks like. But I mean: you can be anything" **(fig. 4.3)**.[24]

First among many Bauhaus affiliates to explore the intimacy of portrait photography was Lucia Moholy, a trained photographer and primary interlocutor for her husband, László Moholy-Nagy, throughout the 1920s. Lucia Moholy (née Schulz) brought to their artistic partnership not only expertise in camera work and printing—she spent one year as a studio apprentice and another in photographic coursework, 1923–1925—but also an education in art history at Charles University, in her hometown, Prague. Rolf Sachsse has suggested that Moholy's art history education, guided by ideas from Vienna, shaped her contributions to the enormous discussion of "production" versus "reproduction" that she and her husband pursued intensely in 1922 and that sparked Moholy-Nagy's lifelong engagement with photography.[25] The task, as they understood it, was to find a creative (productive) expression suitable for the modern age, which meant one determined in form and content by the particularities of mechanical (reproductive) procedures. Sachsse argues that Lucia Moholy understood this dynamic as analogous to that between cerebral and physical work in the making of all art.[26]

Most of the more than fifty photographic portraits she made of Bauhaus colleagues and other friends, from roughly 1925 through 1930, address that dynamic as well. Moholy alternated in these works between her subjects' heads and their hands, creating a seemingly straightforward division between mind and body. In the latter pictures, though, the hands appear always at rest, delicate, offered contemplatively to the camera. Moholy seems to have aimed at a philosophical meditation on artistic labor that binds body to mind—"thinking hands" rather than pious hands (like those of Karl Kraus in the portrait by Trude Fleischmann), or "creative hands" (*Schaffende Hände*), to quote the title to a famous photograph of a potter at the wheel by Albert Renger-Patzsch. Similarly, in her strongest head shots, faces appear to occupy a refuge isolated from the larger world **(cats. 52, 53)**. Franz Roh, the enthusiastic theorist of vision and visuality, presents himself with eyes shut tight and with downy skin that seems similarly caressed by the photographer's lens.[27] Georg Muche, painter and Bauhaus teacher, peers so intently at the camera that his head seems detached from the body beneath it, leaving only a jacket and tie to float fuzzily below. His unwavering stare and proximity to the

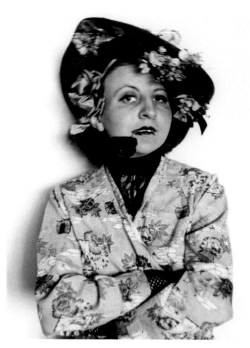

4.3 Gertrud Arndt, *Self-Portrait (Selbstporträt)*, 1930, gelatin silver print, 22.3 × 14.3, Alexandra Bormann-Arndt, Darmstadt

52

LUCIA MOHOLY (British,
b. Bohemia, 1894–1989),
Franz Roh, 1926, gelatin silver
print, 37.3 × 27.8, Lent by The
Metropolitan Museum of Art,
Warner Communications Inc.
Purchase Fund, 1981

53

LUCIA MOHOLY (British,
b. Bohemia, 1894–1989),
Florence Henri, 1927, gelatin
silver print, 37.2 × 27.7,
Lent by The Metropolitan
Museum of Art, Ford Motor
Company Collection, Gift
of Ford Motor Company and
John C. Waddell, 1987

surface plane carry an effect of unnerving, faintly
erotic intimacy, despite his bodiless appearance and
the babylike softness of his features.

The sublime portrait of Florence Henri, by con-
trast, shows a woman with a self-assured, relaxed
gaze. From her mask of makeup and pageboy haircut
to her lidded eyes and keychain-like earring, every-
thing seems to hang lightly yet deliberately in its
place. Nevertheless, as with the portraits of Muche
and Roh, here too we register a restrained indetermi-
nacy: what guiding emotion, what sexual orientation,
what sense of self? This is not the blatant androgyny
of Klaus and Erika Mann, nor of the wife of Peter
Abelen as photographed by August Sander **(cat. 54)**,
yet it remains open-ended in its studied neutrality.
The sitter is unequivocally modern, but to be modern
means to present oneself as a screen of equivocal
possibilities.

As final instances from this domain of portrai-
ture, we may consider two photographs by Hungarian
émigré Éva Besnyő in Berlin, one of her compatriot
György Kepes, the other of herself **(cat. 55, fig. 4.4)**.
Besnyő, one of the most talented of Pécsi's students
in Budapest, came to Germany in 1930 to find work
in the newly available realm of advertising and report-
age. After just one year of positions as an assistant,
including photographing street scenes for the press
agency Neofot, Besnyő was able to set up her own
business, a fact that indicates the tremendous status
of photography and the openness of this profession
for women.[28]

Besnyő spent the first six months of her Berlin
residence in almost constant company with Kepes,
who was then and later an indispensable assistant to
Moholy-Nagy. The recumbent Kepes appears here
decidedly feminine, with gentle features that seem
almost to levitate above a newspaper intended mani-
festly for decoration rather than edification. Besnyő's
mentor, Pécsi, used newspaper sheets for this pur-
pose as well—but with still lifes, not portraits.
Indeed, this portrait looks rather like a still life with
a male figure, a neat reversal of the more common
assimilation of women to mannequins in this era.

In striking contrast, Besnyő figures herself in
a self-portrait from the same time as a busy artist-
laborer, dressed in a workshirt as she manipulates her
camera with hands gloved for the chemical baths, her
hair gloriously unkempt. Photographic self-portraits
"in action" are legion in these years, by men and
women alike. All the same, Besnyő's portrayal of pho-
tography as an effort of concentration—as work—
is singular, as is her dramatic inclusion of the studio

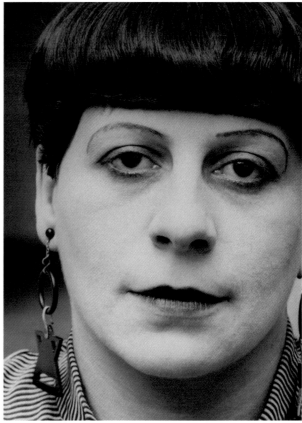

**52
—
53**

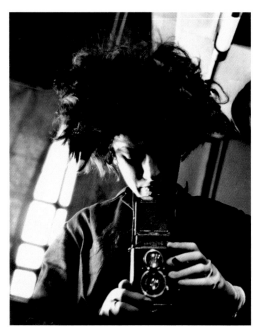

4.4 Éva Besnyő, *Self-Portrait, Berlin (Önarckép, Berlin)*, 1931, printed 1950s, gelatin silver print, 22.5 × 28, Hungarian Museum of Photography

54

55

space, which, when seen from this low angle, looks less like a traditional darkroom or atelier than like an industrial warehouse.

The example of Besnyő leads, as do so many of the works discussed in this chapter, to a consideration not just of gender but of ethnicity. Besnyő, Yva, Jacobi, Kallmus, and many other photographers who rose to prominence in the 1910s and 1920s — especially, though by no means exclusively, women — were Jewish. All came from financially secure, culturally assimilated families, mildly religious or not observant. Many of those who survived the Holocaust later claimed, as Besnyő did, to have reflected on their difference only during the mounting political crisis: "The second year I was in Berlin [Neofot] told me they…could no longer publish my pictures under my name.…until then in Berlin I'd never given a thought to the fact I was Jewish.…In the spring of 1932 it became clear to me I couldn't stay.…Everywhere in the city you could see Nazis with clubs hanging from their belts. I began to feel terribly insecure. People were kicked and beaten up. There were reports in the newspaper every day about acts of violence against Jews. Then one day I thought: 'I've got to get out.'"[29]

Like the category "woman," that of the "Jew" formed a subject of debate, with the tremendous difference that feminine attractiveness as a factor in discussions of the New Woman was not matched by philo-Semitism in exchanges over Jewishness. The photography world kept silent on this issue. In contrast to artists who worked to express Jewish heritage in modernist forms — Marc Chagall and El Lissitzky, members of the Jung Idysz group and the Moscow State Jewish Theater — or who, like the École de Paris, had their Jewishness thrust upon them, as it were, photographers and photographic organizations seem not to have addressed the subject, nor did it receive explicit attention in period commentary on photography. And yet, the presence of Jewish makers is remarkably high, particularly in Germany and above all in Besnyő's native country, Hungary.

At least four-fifths of Hungarian photographers during the interwar decades came from Jewish families, at a time when Jews made up less than 10 percent of the population. This vastly disproportionate representation extends far beyond photography, for Jews in Hungary were strongly identified in the project of modernization — and also in that of national identity formation. During the half-century prior to World War I, those of Jewish background enthusiastically furthered the cause of Magyarization, whereby the minority Hungarians, in 1867 just 45 percent of the

population, mandated the use of Hungarian language and Christian dominance among polyglot, multiconfessional populations. Jewish families, who made faith an increasingly private matter or, in some cases, converted to Christianity, also spearheaded economic development and urbanization, playing a great role especially in the growth of Budapest.[30]

Jewish enthusiasts evidently found modernization fully compatible with patriotic feeling, after World War I as well as in the decades before it. However, official Hungarian sentiment remained centered on the peasant village, turning dangerously nostalgic after Hungary lost two-thirds of its outlying territories in the treaties that concluded the war. Renewed anxieties over national identity during the 1920s and 1930s generated both chauvinism and anti-Semitism; diminution of the former prejudice was achieved precisely at the expense of an increase in the latter. For example, an early postwar proposal to stem a wartime increase in women students at the universities mutated into a cap not on female, but on Jewish enrollment.[31] "We think it would be insane and suicidal on the part of the nation not to want to recruit its intelligentsia from among its own, native race," declared Cecile Tormay, chair of the country's most influential women's association, in defending the anti-Semitic legislation in 1925.[32] Tormay also cast the socialist wing of the women's movement, the one associated most closely with the struggle for women's rights internationally, as "foreign."

One may readily imagine that Jewish photographers, caught between a modern identity formed through allegiance to the Hungarian nation-state and a modern Hungarian nation-state that rebuffed their allegiance, would have a keen self-consciousness regarding their place in society; and that Jewish women photographers would reflect more keenly still on what is, again, a masquerade. For lack of testimony or clear indications in the pictures themselves, such an assertion must remain speculative. It serves here as an enticement to further research and as a reminder that gender cannot be dissociated historically from ethnicity and other categories of social belonging.

Beyond costume and masquerade, beyond self-irony and self-fashioning, come the shocking bodily deformations that mark an extreme of "newness" for men and women in this modern era. Wanda Wulz' self-portrait as a cat prepares us for this extreme to some extent, as do the photographs of mannequins and masks, particularly eerier variants created by Umbo or Werner Rohde (see **cats. 42, 45**). Some of those

working with photography, however, took physical distortion and deformation consistently as their creative method. Among these, the least familiar are likely Olga and Adorján Wlassics, creators of the Viennese glamour studio Manassé. The Wlassicses, who founded Manassé sometime before 1924, supplied portraits of stage and screen stars, as well as humorous erotic "studies," to lifestyle magazines and talent agencies in Vienna and internationally. During the 1930s, the couple, both born in Hungary, established a branch office in Bucharest, Romania, then relocated to Berlin in 1936 before settling at last in Vienna once again. Their fabulously excessive compositions, in which props and painted additions count far more than the record of a living subject, were sought after by society types seeking dramatic chic and by magazine editors in search of fairy-tale set pieces.[33]

One Manassé specialty consisted in transforming live models, mostly women but occasionally men, into miniature dolls set in one-line narrative fantasies **(cat. 56)**. As figurines, the nude women appear—at least to a viewer today—less alluring or sensual than fetchingly, sublimely ridiculous. It could not be said that Manassé photographs raise constructive doubts about the roles thrust upon women in a patriarchal

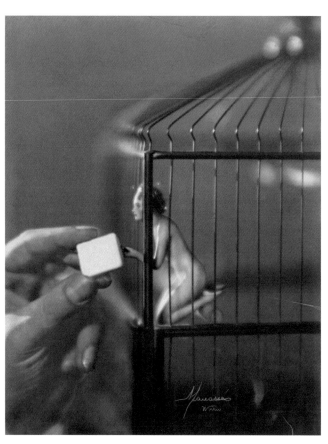

society. But the tremendous exaggeration of Hollywood norms new at that time—unblemished skin, slender figure, machinic aura—makes superbly evident the irreality of those norms, at a time when Hollywood ideals were otherwise having a very real impact on personal appearance for both sexes.[34] Manassé setups, such as this view of a caged "bird" feeding eagerly from her "sugar daddy," also take points of anxiety over women's emancipation to a laughably cynical extreme.

If an outfit such as Atelier Manassé pushed the boundaries of myth and fantasy from within the mainstream media, the artist Hannah Höch fractured mainstream fantasies in photomontages that no mass media outlet could find acceptable. Among the most intelligent bodies of commentary on gender relations in modern times, Höch's art addresses with special force the intersection of self-fashioning and stereotyping constitutive of the New Woman. Höch developed this critical photomontage practice during her involvement with Berlin Dada, helping pioneer avant-garde uses of photomontage. She concentrated from the start on signs of women's work, such as embroidery patterns, and on the emerging New Woman in her various guises: dancer, athlete, politician, fashion plate. A part-time position at the Ullstein publishing house gave Höch ready access to printed images, which she recycled into works of art that she saw as a continuation of the cutting and pasting of photographs done by women since her grandmother's generation, for example in making family scrapbooks or memorial images of sons sent off to war. For many years after her debut in photomontage at the 1920 Dada Fair, Höch kept these works private, preferring instead to exhibit paintings and watercolors.[35]

In 1929, however, Höch once again presented photomontages, both in a one-person show in the Netherlands, and more significantly in the great traveling exhibition *Film und Foto*. Her next important one-person show, held in Brno, Czechoslovakia in 1934, contained photomontages exclusively, among them *The Coquette I* **(cat. 57)**. The show's organizer, Czech architect František Kalivoda, carried on an extended correspondence with Höch that yielded two new essays by her—one of them her only printed statement on photomontage—and the acquisition of two original pieces.[36] Kalivoda also suggested a second exhibition to Höch in 1934 and an extensive monograph, both projects that unfortunately remained unrealized.[37] Nevertheless, the 1934 show, together with a one-person exhibition by Moholy-Nagy in Brno the following year (which did lead to a monograph),[38]

56

ATELIER MANASSÉ (Olga Spolarics [Austrian, b. Hungary, 1895–1969] and Adorján Wlassics [Austrian, b. Hungary, 1893–1947]), *My Little Bird (Mein Vögerl)*, 1926, gelatin silver print, 21.5 × 16.8, Dietmar Siegert Collection

57

HANNAH HÖCH (German, 1889–1978), *The Coquette I (Die Kokette I)*, 1923–1925, photomontage (printed matter), 18.5 × 20.5, Institut für Auslandsbeziehungen e.V, Stuttgart

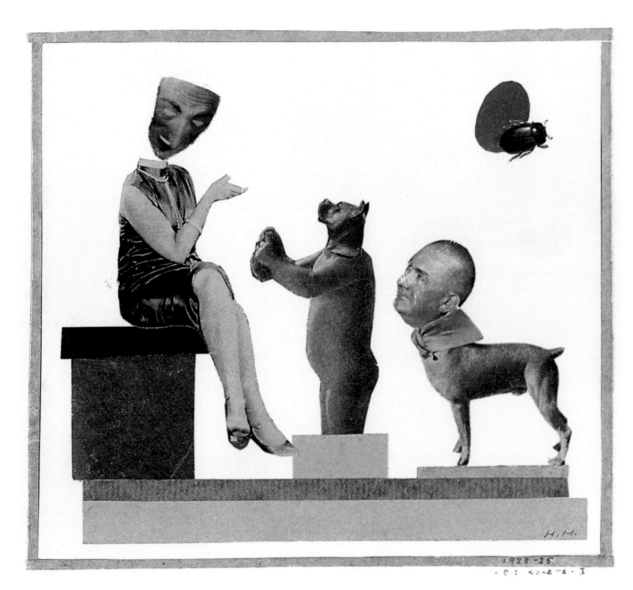

57

constitute a high point in international exchanges of photography within the central European region.

Kalivoda, whom Höch early on corrected in his speech — "For your information: I am Frau [not Fräulein] Hannah Höch" — seems to have preferred to see her daring in terms of class revolution than in terms of gender.[39] The title to his opening-night lecture at her exhibition, "Militant and Playful Photomontage," suggests that Kalivoda built his discussion on the understanding, particularly widespread in Czech circles, of Dada as salutary laughter and of photomontage as a game with revolutionary potential. Höch herself emphasized an interplay of discipline and delight in the creation of photomontages: "Whenever we want to force this 'photomatter' to yield new forms, we must be prepared for a journey of discovery... most of all, we must be open to the beauties of fortuity, [which], wandering and extravagant, obligingly enrich our fantasy."[40]

The fantasy in The Coquette I, while certainly playful, is, like most of Höch's photomontages, also highly planned and sets gender relations blatantly in the foreground. The inspirational role of fortuity notwithstanding, Höch's finished works look anything but spontaneous. They seem on the contrary programmatic in their travesty of social and sexual conventions. In The Coquette I, an allegory of New Womanhood sits enthroned before bestial suitors, who stand frozen in supplication before her like statues of mythical, hybrid creatures. The commonplace that men are animals at heart appears here laughable rather than threatening; indeed, the males look not just puny but infantilized or emasculated as well. The woman does not fare much better, however, tipping her face-mask like a hat as she holds court before this Circean society. More than any other artist of her time, Höch showed how the new media world could be dismantled and restructured precisely through its characteristic images — most prominently, as here, images of the New Woman.

Dismantling and restructuring constitute the modus operandi of Hans Bellmer as well, without doubt the most disturbing artist in interwar Germany and perhaps, indeed, in the whole of modern art. Bellmer's work, which is profoundly self-absorbed, cannot be connected straightforwardly to larger social or artistic trends and seems particularly far removed from the insights articulated by Höch. Yet the two artists share a willingness to take the caricature associated with the New Woman phenomenon to extreme ends, in ways, moreover, that expressly implicate men as well.

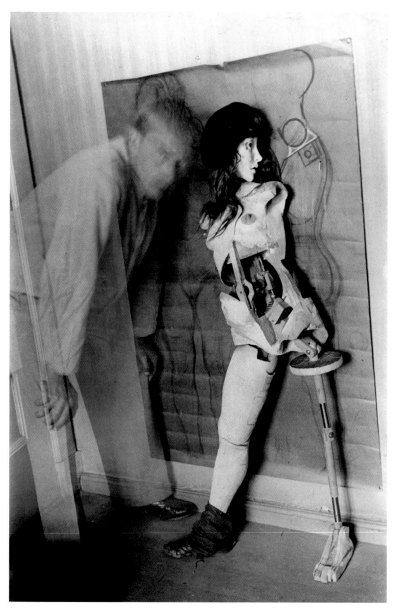

58

Bellmer, about whom more will be said in the final chapter, quit his job as a graphic designer and turned to "useless" artistic work in 1933, directly following Adolf Hitler's takeover of the German state. From then until his resettlement to France in the spring of 1938, Bellmer worked intensively at photographing and drawing successive incarnations of a jointed female doll, his own invention, which suggested in its height and costume (hair bows, pinafores, and patent-leather pumps) a prepubescent girl.[41] Bellmer's photograph of himself standing next to the first version of his creation (cat. 58) appeared in a series of "construction documents" in The Doll, the first of several books by Bellmer, published in Karlsruhe in 1934. That year, he

58

HANS BELLMER (French, b. Silesia, 1902–1975), *The Doll (Self-Portrait with the Doll) (Die Puppe [Selbstporträt mit der Puppe])*, 1934, gelatin silver print, 29.9 × 19.7, Collection of Carla Emil and Rich Silverstein

sent these photographs for presentation to the surrealists in Paris, where they found instant acceptance, so that his artistic career from the start merged with streams of thought flowing outside his native Germany.

Among the many German sources for Bellmer's artistic obsession, however, must be counted the New Woman vogue and its attendant controversies regarding social and sexual identity. An obsession with self-image is interpreted here in the register of the grotesque. In Bellmer's construction, for instance, the female body becomes a parlor for dirty movies: the open stomach cavity pictured here was intended to house a rotating set of panoramic "colored pictures distinguished by bad taste," a sort of peep-show version of the Tru-Vue or View-Master toys invented at nearly the same time.[42] Added to this smutty conflation of body and screen is a destabilization through sex of the image of "man" and "woman," mixed together through the anatomy of hermaphroditism.[43] This and other physical abnormalities, such as extra or missing limbs, as well as poses suggesting androgyny, form the core of Bellmer's work with the doll. Such trespasses against standard categories explode contemporary debates over the "manly" or asexual woman, by collapsing bodily sex distinctions while privileging sex above all other bodily functions.

Bellmer called his creation an "artificial girl," and he recalled later that photographing this automaton made sense because "the photographs blended the real and the imaginary, but they had to be provocative to be effective."[44] The doll's artificial existence, neither real nor exactly fictive, would become clear through photographs and would therefore make Bellmer's creature intensely convincing: "an object that is simply identical to itself," he noted, "lacks any reality."[45] Identity must be represented to be real. That attitude dominates the New Woman era, and understanding it makes palpable not only the giddiness but also the instability that characterized this era's experience of modernity.

chapter 5

Modern Living

59

Modern Living

59

LÁSZLÓ MOHOLY-NAGY (American, b. Hungary, 1895– 1946), *Radio Tower Berlin (Funk- turm Berlin)*, 1928, gelatin silver print, 39.5 × 29.9, National Gallery of Art, Washington, Patrons' Permanent Fund

Photography and its younger sister, film, came to hold unprecedented influence on habits of daily life in central Europe during the 1920s and 1930s. Still and moving pictures inundated reader-viewers in the tens of millions with model images of leisure and work, sports, travel, fashion, home, and the built environment. The illustrated press, a burgeoning industry since the late 1800s, reached an explosive level of activity after World War I, fueled partly by the habituation to photography in print during the war itself.[1] Photographs had shaped public consciousness around the world for decades. New after the war, and initially specific to central Europe, was the sophisticated critical discussion of photography and its role in the mass media—a phrase coined during these years. With tremendous self-awareness, commentators and practitioners alike took stock of what could for the first time properly be called an image world.

The normative character of this image world— its usefulness in disseminating standard topics and motifs of "the modern"—corresponds to more than a demand for a new look or new consumer goods. Photography became a pivotal means to establish the very terms of modernity, to familiarize the broadest possible public with a "new vision" for contemporary society. To deploy and propagate that vision meant, for representatives of politics as well as culture across the region, to help endow the general population with a mindset as modern as the world around it. This reformist call, broadcast stridently throughout the avant-garde, was also articulated by the media, industry, and even government. Although the premises and goals of avant-gardists differed fundamentally from those of industrialists or state officials, and from media representatives as well, a remarkable sense of shared aspiration adhered for a time around the term "modern": a longing to grasp the seismic changes that had occurred as a result of World War I and to find one's place in the new world order.

In recognition of that utopian convergence, the present chapter focuses on artistically ambitious innovators, many of them self-identified as avant-garde, while placing their activities insistently within the broader context of the cultural mainstream. It is a remarkable feature of central European modernism that the avant-garde, a historically marginal social formation, played a real public role here. The engagement with a mass audience palpably desired by vanguard artists in using photomontage, or in teaching and exhibiting experimental photography, is fulfilled— if on other or adulterated terms—through the sympathetic efforts of art editors, publishers, critics, and exhibition organizers, some of whom themselves emerge from the ranks of the avant-garde.

Influence flows both ways, of course: trends in popular taste, linked to and in many ways shaped by official discourse, establish the parameters for avant-garde thinking. Innovations such as the hand-held camera, the photo essay, or even the "styles" of New Vision and New Objectivity, are created for and within the marketplace, and while initially they are labeled avant-garde—meaning shocking, combative, even revolutionary—their transformative potential is intentionally defined by market guidelines. Such innovations might more appropriately be called forms of "alternative" or "independent" culture, as the movies or the music industry are today. Indeed, photobooks, a genre that came suddenly to prominence in the late 1920s, have recently been called the printed equivalent of auteur cinema.[2]

Views of the new, meaning both pictures of expressly modern subjects and expressly modern kinds of pictures, received a quasi-official welcome in many parts of central Europe, for they often helped legitimate a modernization campaign driven by business and state interests. Photographs of the recently industrialized port of Bratislava by amateur enthusiast Miloš Dohnány, for example, or Arthur Köster's

60 | 61

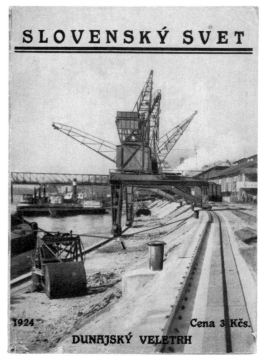

record of innovative construction projects in the German capital and other cities **(cat. 60)** appeared in celebratory publications such as the periodical *Slovenský svet* (Slovak World, 1924) **(cat. 61)** or *New Building in Berlin* (1931).[3] Echoing these partnerships with industry, amateur photographers began to produce paeans to the metropolis, which trickled into salon exhibitions during the later 1920s and swelled to a flood following the *Film und Foto* show and its reprises in 1929–1930. Photographers spurred and were spurred in turn by a vogue in which views of industry, steel or concrete constructions, dizzying fairground entertainments, neon-illuminated nightlife, and other urban sights — even prettified trash — became shorthand for the attractions of modern living **(cats. 62–69)**.

Leisure activities, particularly sports, dance, and travel, reached a feverish level of popularity that conveyed assumptions about what was positive in this reconfigured world: freedom of movement, physical fitness, individual expression, cosmopolitanism **(fig. 5.1)**. An urban, middle-class viewpoint, long the standard of value in France or England, now became the norm in central Europe as well. At the same time, much of central European society retained a mistrust of urban social rhythms, machine technology, and a cosmopolitan outlook — characteristics summarized for good and ill as evidence of "Americanization." Photography and cinema also served therefore to articulate an ongoing, deep-seated identification with the peasantry and countryside.

That identification, which could be viewed schematically as the opposition of village to city, seems simply antimodern. Yet in central Europe, where peasant traditions and the land itself had long been presented as the repository of national values, the state- and media-sponsored embrace of modernity

deliberately accommodated — in many instances apotheosized — country life. Folk festivals, landscapes, regional costumes, and artisanal production remained popular just as they had in the decades before World War I. In this manner, images of the rural world suggest not only an ethnographic interest in vanishing elements of national civilization, but also an ongoing need to retain the countryside as that part of the authentic past which has endured into the present. By depicting rural folk as part of the spectacle of modern life, purveyors of photographic imagery assisted greatly in making the arrival of modernity broadly palatable in the region **(cats. 70–72**, see also chapter 8).

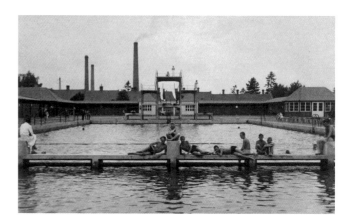

5.1 Unknown, View of municipal swimming pool, Neutitschein, Czechoslovakia (today Nový Jičín, Czech Republic), 1930s, gelatin silver print, 12.6 × 7.6, Muzeum Novojičínské

60

ARTHUR KÖSTER (German,
1890–1965), *Georgsgarten
Housing Project, Celle — Architect
Otto Haesler* (Siedlung Georgsgar-
ten, Celle — Architekt: Otto Haesler),
1928, gelatin silver print,
15.4 × 20.5, National Gallery of
Art, Washington, Gift of Hen-
drik A. Berinson and Adam J.
Boxer, Ubu Gallery, New York

61

MILOŠ DOHNÁNY (Slovak,
b. Austria, 1904–1944), cover
for *Slovenský svet* (Slovak World)
4, no. 34 (Bratislava, 1924),
Emo Bohúň, ed. (Slovak, dates
unknown), photolithograph,
28 × 20.7, Peter Bagi,
Bratislava

62

MAX BURCHARTZ (German,
1887–1961), *Worker before
Machines* (Arbeiter vor Maschi-
nen), c. 1928–1930, gelatin
silver print, 27.3 × 39.8,
Museum Folkwang, Essen

63

HAJO (HANS-JOACHIM) ROSE
(German, 1910–1989), *Construc-
tion Site* (Baustelle), 1930–1933,
gelatin silver print, 31 × 21.9,
The J. Paul Getty Museum,
Los Angeles

64

IMRE KINSZKI (Hungarian,
1901–1945), *Untitled (Bridge
and Fog)* (Cím nélkül [Híd és köd]),
c. 1930, gelatin silver print,
6.1 × 8.4, National Gallery
of Art, Washington, Patrons'
Permanent Fund

62
63 | 64

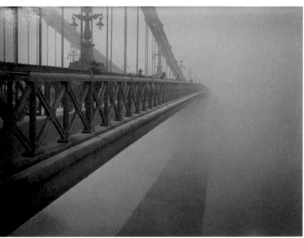

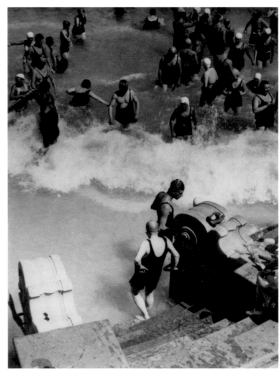

65 | 66

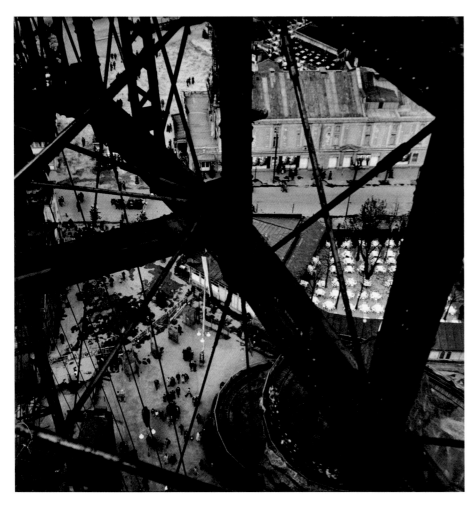

65

EDITH TUDOR-HART (British, b. Austria, 1908–1973), *The Ferris Wheel at the Prater (Prater Riesenrad)*, 1928, gelatin silver print, 24.8 × 24.5, Collection of Monika and Hans Schreiber, Vienna

66

ERNŐ VADAS (Hungarian, 1899–1962), *Hotel Gellért*, 1930s, gelatin silver print, 23 × 17.6, Private Collection, Paris

67

JAN LAUSCHMANN (Czech, 1901–1991), *Outdoor Café, Barrandov (Terasy na Barrandově)*, 1932, printed later, gelatin silver print, 32.1 × 28.9, On loan from the Rubin Family Collection

68

JOSEF EHM (Czech, 1909–1989), *Untitled (Bez názvu)*, c. 1935, gelatin silver print, 11.6 × 8.6, Collection of Darina and Vladimír Birgus, Prague

69

RUDOLF KRAMER (German, 1900–unknown), *Garbage (Müll)*, before 1929, gelatin silver print, 22.4 × 27.4, Staatliche Museen zu Berlin, Kunstbibliothek

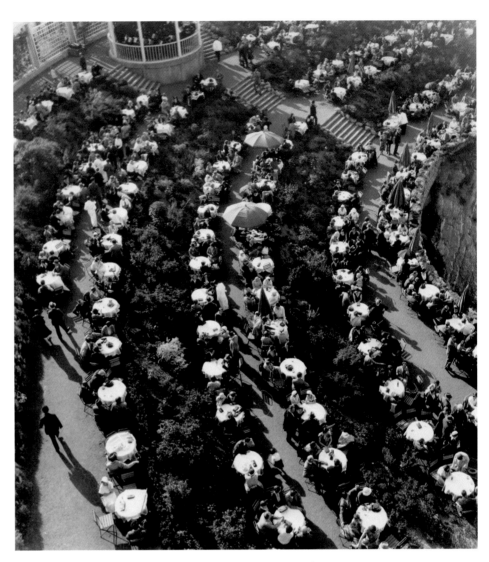

67
69 | 68

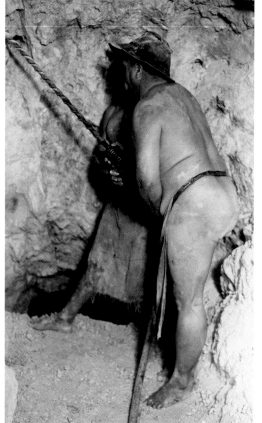

70

MILOŠ DOHNÁNY (Slovak, b. Austria, 1904–1944), *Building the Červená skala-Margecany Railway Line (Výstavba železničnej trate Červená Skala-Margecany)*, 1934, gelatin silver print, 38.7 × 28.9, Slovak National Gallery, Bratislava

71

SERGEJ PROTOPOPOV (Slovak, b. Russia, 1895–1976), *Untitled (Bez názvu)*, from the series *Gold Mining in Banská Štiavnica (Dolovanie zlata v Banskej Štiavnici)*, 1927–1929, gelatin silver print, 13.2 × 8.2, City Museum in Brno

72

SERGEJ PROTOPOPOV (Slovak, b. Russia, 1895–1976), *Untitled (Mechanical Drilling) (Bez názvu [Strojové vŕtanie])*, from the series *Gold Mining in Banská Štiavnica (Dolovanie zlata v Banskej Štiavnici)*, 1927–1929, gelatin silver print, 13.2 × 8.2, City Museum in Brno

The illustrated press formed the principal conduit for image diffusion, no matter what the subject, becoming a vast, extramural school for the new generation of photographers. In addition to publishing work by amateurs and studio photographers, the steadily proliferating network of Sunday newspaper supplements and picture magazines engendered its own class of camera operator: the photojournalist. Cutting across specialties such as portraiture, sports, or street scenes, the photojournalist supplied not only the omnivorous needs of the press, but also the new, globalizing claims for photography as an encyclopedic and "inherently modern" medium. Talent in this field came not only from art schools such as the Bauhaus, but also from local photo clubs and, in a self-aggrandizing myth of origins, from "nowhere": Erich Salomon, Lothar Rübelt, Martin Munkacsi, and Károly Escher all made much of their independence from formal training. Journalism featured prominently in central European discourse on photography, showcased in panoramic expositions such as *Pressa* or *Fifo*, and occasionally in monographic presentations. Thirty thousand visitors attended a 1936 survey of Karel Hájek's work in Prague, which the author accompanied with a radio address on "Photography and Newspapers," while Salomon's sensational photobook, *Famous People in Unguarded Moments*, became an international bestseller.[4] This tremendous pool of photoreporting talent, tinged with avant-garde cachet, spilled over into the West. The beginnings of *Vu* or *Life* are unthinkable without the participation of émigrés from central Europe, and Paris in particular depended heavily on these arrivals for its photojournalism trade.[5]

Press photography had blossomed in tandem with the daily and weekly press during World War I, despite the strict censorship imposed on all means of public and private communication.[6] Investment in media for the war itself—telephones, radio, and, above all, camera equipment—generated as a sideline a vigorous public interest in photographically illustrated news stories and a corresponding enthusiasm among soldiers for picture-taking at the front. In Hungary, a captivating weekly paper, *Érdekes Újság* (Interesting News), founded in 1913 on the model of the Viennese paper *Das Interessante Blatt*, managed despite the closely controlled atmosphere to host a series of wartime competitions in which the editors published soldiers' private photographs, most of these inoffensive but some including scenes of grisly carnage.[7] Other Budapest newspapers followed suit, creating a uniquely receptive structure there for the

development of freelance photojournalism after the war. Even photographers with decidedly fine-art aspirations, such as André (at the time still Andor) Kertész or Rudolf Balogh, turned their attention to the war; Balogh, indeed, had managed since the early 1900s to combine respected achievements as a pictorialist amateur with a career in the illustrated press **(fig. 5.2)**. For Kertész or the Czech photographer Josef Sudek, who lost an arm in military service, the postwar world made it possible to outdo even that balancing act, by pursuing modern art and commerce not in complementary fashion but as a single goal.

Histories of photojournalism have rightly focused on Germany, which offered a market for press images unrivaled in central or western Europe before 1930, and on the theory and praxis of reportage pioneered in early Soviet Russia. An exemplary level of production in these two countries was matched by a remarkable awareness of press photography as a constitutive genre of modern times. The field of discourse was particularly broad in Germany, where a strong and regionally diversified market yielded perhaps eight hundred daily newspapers and hundreds more magazines with regular photographic illustrations from the late 1920s.[8] The greatest Soviet presence in central Europe came through Germany's newspaper culture as well, exemplified in the *Pressa* exhibition (see chapter 2).

At nearly the same time as *Pressa*, beginning in March 1928, a series of exchanges appeared in *Zeitungs-Verlag*, mouthpiece of the Verein Deutscher Zeitungsverleger (Association of German Newspaper Publishers), on "The Cultural Meaning of the Newspaper Picture" and "A New Career Branch: The Picture

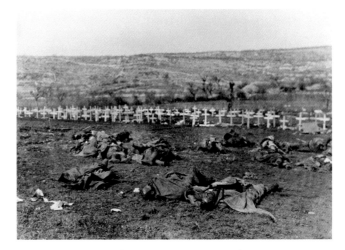

5.2 Rudolf Balogh, *The End of the Battle (A csata végén)*, 1914–1918, gelatin silver print, 16 × 22.8, Hungarian Museum of Photography

Editor."[9] In these and related essays tradespeople stated repeatedly the need for *Kulturbewußtsein* or "cultural consciousness" in their business and praised the uplifting potential of good pictures on journalistic stories. Pedantic rhetoric flowed throughout the press in Germany and across the region, such that the "classroom" of illustrated journalism included not just eager photoreporters but the readership of entire nations.

The preeminence of Germany and Russia has obscured the breadth of enthusiasm in central Europe for an illustrated press. Large-circulation picture magazines appeared everywhere by the mid-1920s, with specialized publishing outfits to match. A number of these periodicals placed the art and ideas of avant-gardists directly on their pages, although they served basically to propagate bourgeois conformism. The Czech sheet *Pestrý týden* (Colorful Week), for example, a luxury offering from the printing house Neubert and Sons (its debut issue, in November 1926, measured a mammoth 57 × 43 cm), formed a bridge in its early years between Devětsil interests and a broad cultural public. Neubert's competitor, the publishing colossus Melantrich—a multicity corporation producing books, fashion, music, and film, which in 1934 used more than one-quarter of all paper consumed in Czechoslovakia—issued a half-dozen newspapers and magazines, from the socialist party daily *České slovo* (Czech Word) with its Sunday photo supplement, to the weekly *Pražský Illustrovaný Zpravodaj* (Prague Illustrated Reporter or PIZ, begun 1920), and from 1928, the monthly women's magazine *Eva*.[10] Solidly middle-brow, these publications, particularly *České slovo* and *Eva*, nevertheless included intellectual voices, while attaining impressive circulation levels; the PIZ, for example, to which *Pestrý týden* offered the nearest alternative, reached print runs of around 150,000 copies.[11]

In Kraków, Poland, the IKC conglomerate expanded in the later 1920s and 1930s from its eponymous prewar tabloid, the *Ilustrowany Kurier Codzienny* (Illustrated Daily Courier), begun 1910, to sensationalist magazines such as *As* (Ace), *Na szerokim świecie* (Out in the World), and *Tajny Detektyw* (Secret Detective) **(cat. 75**; see also **cat. 113)**. Janusz M. Brzeski, Kazimierz Podsadecki, Mieczysław Choynowski, and other artists schooled in Polish avant-garde circles found employment with IKC, just as many Bauhaus graduates supplied the Ullstein media empire in Berlin **(cat. 73)**. Meanwhile in Budapest, the newspaper *Pesti Napló* (Diary of Pest) inaugurated a Sunday picture

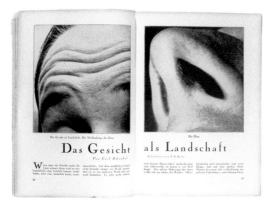

5.3 Paul Edmund Hahn, photographs for Carl Schnebel, "The Face as Landscape" (Das Gesicht als Landschaft), in UHU, no. 5 (5 February 1929), Friedrich Kroner, ed., 25 × 17.3, photolithograph, Robert Lebeck, Berlin

supplement in 1925 **(cat. 74)** that set the standard for photojournalism in Hungary, providing Balogh, Escher, Munkacsi, Ernő Vadas, and many others with regular employment as purveyors of a modernism suitable for mass consumption **(cats. 60, 81)**.

Certain of these artists also served, officially or informally, as picture editors, performing a crucial function of selection and presentation. Podsadecki and Brzeski, for example, designed layouts of text and image that, like contemporary work in Soviet magazines, broke open the traditional columnar frame **(cat. 75)**. Other editors, while not themselves artists, initiated or promoted far-reaching creative innovations in newspaper practice. Foremost among these are Stefan (István) Lorant and Kurt Korff, editors at *Münchner Illustrierte Zeitung* and Ullstein's *Berliner Illustrirte Zeitung* (BIZ), respectively. The Hungarian-born Lorant, who also worked briefly at BIZ and *Pesti Napló* in Budapest, is said to have brought to prominence the serial narrative form later known as the photo essay; both men, meanwhile, are credited with establishing photographs as nearly autonomous news elements, flanked only by pithy, "illustrational" captions.[12] Korff's employer, Ullstein, became the ne plus ultra of illustrated press institutions, offering select photographers multiyear contracts that demanded unparalleled loyalty and paying premium sums to freelancers for individual images. Concomitantly, their leading magazines, such as BIZ or UHU, edited by Friedrich Kroner, featured reflections on photography in written essays and through the pictures themselves. Stories such as "The Face as Landscape," for example, in which extreme close-ups transform ordinary visages into stubbled or undulating abstractions, set the tone for this photophilic age **(fig. 5.3)**.[13]

73

ERICH COMERINER (German, 1907–1978), Berlin, Friedrich-straße, from the series Berlin, Metropolitan Impressions (Berlin, Großstadimpressionen), c. 1929–1931, gelatin silver print, 24.3 × 18, Bauhaus-Archiv, Berlin

74

ERNŐ MIHÁLYFI, ed. (Hungarian, 1898–1972), Sunday supplement to Pesti Napló (Pest Diary) (22 February 1925), photolithograph, 28 × 20.5, National Gallery of Art Library, Gift of Attila Pőcze

75

JANUSZ M. BRZESKI (Polish, 1907–1957), design for "People on the Moon" (Ludzie na księżycu), As (Ace) 1, no. 15 (9 June 1935), Jan Stankiewicz, ed. (Polish, 1890–1952), photolithograph, 30 × 23, Collection of Marcin Giżycki, Warsaw

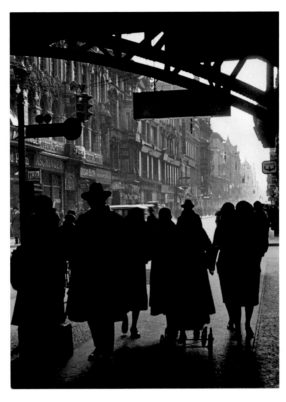

73
——
75 74

The term "photo essay" actually covers a variety of pictorial narratives, from purely self-reflexive pieces, such as a spread of sundry objects in the Prague magazine *Letem světem* (Around the World), titled, "All the Things Men Carry in Their Pockets," to moralizing fables created by Yva and others in UHU, but also reportage stories of the sort later made famous in the United States by W. Eugene Smith, in which subjects are recorded over a period of time.[14] The last-named photo essay type, favored by the political press, found its most influential example in "A Day in the Life of a Moscow Working-Class Family," a story by photojournalists Maks Al'pert and Arkadi Shaikhet for the Soviet magazine *Proletarskoe foto* in 1931, which chronicled the joys and hardship of a family named Filipov. The *Arbeiter Illustrierte Zeitung* (AIZ) reissued the piece in German translation in September of that year, following it in December with an original project tailored to German conditions, called "Die deutschen Filipows." The next month, *Der Arbeiter-Fotograf*, sister publication to AIZ, printed a story on the *making* of "Die deutschen Filipows" that stressed the value of collective work in preparing, generating, and editing a politically effective article. The original photographic series apparently toured for exhibition, meanwhile, to Berlin, Vienna, and Prague, a fact that underscores the diffusion of photographic work in this era as a media event.[15]

The late 1920s also saw the emergence of the photobook, a similarly media-savvy innovation aimed at the bibliophile market. "Photobook," like "photo essay," designates a variety of publications in which images are deliberately sequenced to form a quasi-narrative arc, accompanied by little or no text (not even captions) on the main pages. Words were by no means eliminated, but rather displaced into prefatory essays or checklists of titles at the back. Remarks framing the images generally came from literary or art-historical figures of some renown and, especially for books made by central Europeans living abroad, from native talents: Pierre MacOrlan, Florent Fels, and Raymond Mortimer wrote the respective forewords to *Paris Vu par André Kertész* (1934), Germaine Krull's *Métal*, and Bill Brandt's *The English at Home* (1936), not the artists themselves, ensuring the domestic acceptance of otherwise foreign views. Certain photobooks, such as the Hungarian group publication *From Our Lives* (see **cat. 128**), may have served as the record of an exhibition, while others, including August Sander's *The Face of Our Time* and Albert Renger-Patzsch's *The World Is Beautiful*, functioned among other things to precipitate further publishing or exhibition projects.

In the field of book publishing as in the daily press, photographic production circulated ceaselessly between object and image, between individual creation and mass communication in the burgeoning image world.

As in Germany, intellectuals elsewhere in the region reflected on the cultural significance of this new photographic economy. An early, exemplary instance is given by *The Humblest Art* (1920), a book of essays on sign painting, children's toys, primitive art, and other expressions deemed to be genuinely "of the people," written by artist Josef Čapek mostly as newspaper feuilletons (including the piece "Photographs of Our Parents," discussed in chapter 3). Photography found favor with Čapek as an everyman's creative form for the industrial age, an age to be admired not for its own sake but for the experience it offers of human suffering and achievement, "the multifarious drama of modern life." That drama, Čapek asserts, is best captured in journalistic photography, which "has its own perfection."[16] He describes at impressive length two illustrations from an American newspaper of soldiers heading into battle, calling each one "an epic poem and a splendidly conceived picture."[17] In contrast to his praise for "Western" outfits, Čapek deems the German *Woche* (Week) and *Leipziger Illustrirte* "weak," finds *Das Illustrierte Blatt* in Vienna "miserable," and considers the papers of his own country —

76

ZDENĚK ROSSMANN (Czech, 1905–1984), *The Civilized Woman (Civilisouaná Žena),* (Brno, 1929–1930), cover by the author, photolithograph of photomontage, 24.4 × 17.3, June and Bob Leibowits

77

MIECZYSŁAW CHOYNOWSKI (Polish, 1909–2001), *America (Ameryka),* 1932, photomontage (printed matter), 55 × 29, National Museum in Warsaw

Světozor (World View) or *Český svět* (Czech World)—worst of all. Čapek faults the lack of organization, a willingness to fill the page with a mosaic of smaller images rather than "taking a risk" with a single larger one, and a banality of composition in the pictures themselves. Summarizing these faults as products of a regional insufficiency, Čapek concludes: "All told, central European illustrated news services have not gone much beyond the level of average amateur photography. They've simply industrialized it."[18]

With a show of dissatisfaction that hints in its vehemence at an inferiority complex, Čapek thus sermonizes domestic readers on the achievements of modern culture in the West and on the need for critical evaluation of such culture closer to home—even as he exhibits precisely this critical awareness to a degree as yet unmatched in England, France, or even the great beacon of America herself. The only way forward in this rapidly industrializing world is to have wider representation of that world, accompanied by greater reflection on its meaning. Čapek asks the institutions of the press to accomplish this on behalf of their readers, who evidently need guidance. "In our country, the public still needs to be educated, and not catered to in every respect," he comments with professorial certainty, for despite the tendency toward "the worst mediocrity," he believes that "good things can be introduced here and do catch on."[19]

This pedantic emphasis, traditional in Germanic thought, was reinforced for many intellectuals (though emphatically not for Čapek) by the twin examples of American industry and the Soviet Revolution, with their opposing missions to rationalize society in its most basic habits and relations. The manufacturing ideas of Henry Ford and the campaign by Frederick Taylor and his disciples for scientific management of human labor provoked an obsessive level of interest from the early 1920s.[20] The inaugural issue of *Pestrý týden,* for example, launched a serialized column on "The Modern Home," in which (implicitly female) readers were given advice on how to improve their domestic environment by following "scientific work principles, generally valid and used in America, which make all work activities simpler and easier."[21] The first installment suggested alternating chores to vary one's muscle movements, thereby increasing physical flexibility and improving the rate of performance—a nearly verbatim adaptation of Taylor's recommendation to rotate tasks among employees on the factory floor.[22] Cities in the Czech lands, particularly Brno, amalgamated German and Soviet debates over "Americanization" with exceptional flair, as in

77

Zdeněk Rossmann's photomontage book *The Civilized Woman,* which shows how false habits may be removed through a deft stroke of the scissors—not coincidentally Rossmann's own artistic tool of choice (**cat. 76**).

To many citizens of the region, bombarded with stories about the United States from newspapers as well as letters sent home by emigrant countrymen, America seemed both the promised land and the epicenter of culture shock. Illustrated weeklies in Poland played expertly on the dreams and fears of the larger populace regarding industrial modernity, particularly

in the years of economic catastrophe around 1930. *America* by Choynowski, for example **(cat. 77)**, appeared as one of a suite of three photomontages—a sort of photo essay, unaccompanied by any text—in the weekly *Wiadomości Literackie* (Literary News) in January 1932, presenting contradictory values in contemporary America with riveting sensationalism. The promise of liberty is shown here to be unattainably remote, primarily for the enslaved black man, who stretches his shackled hands skyward, but implicitly for all city dwellers, buried in a suffocating crush of skyscrapers gone amok.[23] Podsadecki proffered similarly apocalyptic views in photomontages to accompany articles such as "In the Jungle on Lake Michigan" or "People in the City of the Future." He also designed

cover compositions not connected to any article, of which the most impressive surviving example is *City the Mill of Life* from 1929 **(cat. 78)**.[24] Elements of extreme optimism, such as athletes leaping to the height of airplanes, commingle here with scenes of anarchic horror in a condensed cinematic melodrama. The young woman at the center of the work allegorizes the desired reader response: paralytic fascination with the spectacle of a world in which creation and destruction form mutually sustaining, all-consuming cancers.

As these examples show—and as one would expect from the mainstream press—radical innovations in form did not bespeak radical content. By the same token, even areas of activity that held next to no potential for critical commentary could advance a reformist visual message. Sports, for example, perennially popular since the advent of illustrated newspapers in the 1880s, formed an ideal testing ground for a modern "look." Blur, close-range views, unusual angles, and dynamic croppings progressively become the norm on the pages of magazines such as *Das Illustrierte Sportsblatt* (Vienna) or the gloriously titled *Der Kicker* (Munich) around 1922.[25] Sports also served as one of the principal vehicles whereby the explosive nationalist sentiments that underlay World War I could be channeled into innocuous catharsis. As the Viennese Rübelt recalled decades afterward, he and Munkacsi, who worked then in Budapest, met after the war "at the grand soccer celebration," namely the yearly match between Austria and Hungary. For Rübelt, a highly talented but unreflective image-maker who in later years served contentedly under fascist rule, sports restored a lost imperial harmony: "The fallen monarchy seemed here to rise again."[26] Such sentimental passéism did not at all conflict with his ambition, realized more famously by Munkacsi, to reposition the photographer as key to a bold, dynamic form of print journalism **(cats. 79, 80)**.

Rübelt doubtless applauded the July 1923 cover of *Fußball* (Munich), where the shot of a sideways-leaping goalie, his body stretched into a nearly levitating pose, comes buttressed by a caption that calls attention to the image as much as its subject **(fig. 5.4)**. *Stopped on the Goal Line!* screams the headline, followed by the proud announcement: "A picture that won't happen a second time!" Despite the new emphasis on seeing rather than reading, words served a welcome pedagogical function, providing decipherment even to apparently simple images: "Just as the panther springs upon its prey," continues the caption,

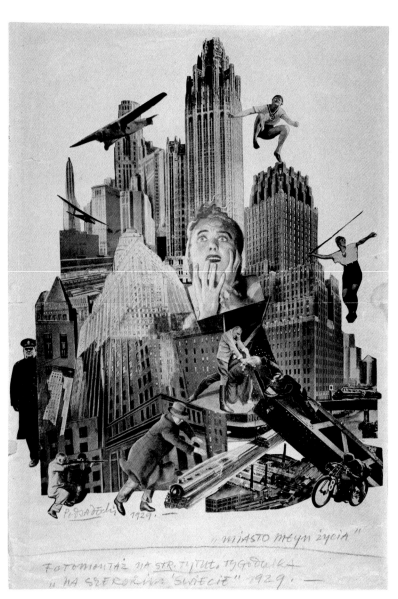

79
—
80

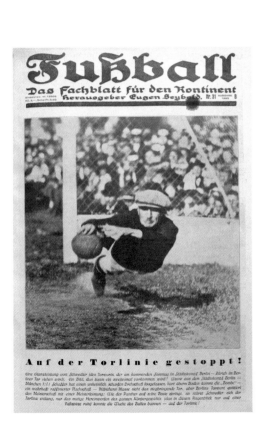

5.4 Eugen Seybold, ed., "Stopped on the Goal Line!" (Auf der Torlinie gestoppt!), in Fußball 13, no. 31 (July 1923), photolithograph, 29.7 × 21.5, Rübelt-Archiv, Österreichische Nationalbibliothek, Vienna

81

"Schwedler leaps along the goal line; only by energetically thrusting his entire body weight (which at this instant rests upon the toes of a single foot) was he able to halt the impact of the ball—at the goal line!" As Rübelt raged in a letter to one journal editor in 1925, without such "explanatory text" one had merely "an impossible *mess*! Good pictures, badly placed, hang in the air without any larger text attached to them."[27] The unstoppable flow of pictures came accompanied with an equally boundless outpouring of captions designed to frame and legitimate their potentially disorienting appearance.

Architecture and urbanism formed another prime area of investment in photography, which served to showcase rapid changes in the built environment and furthered debates over their impact. For decades, building programs had held tremendous material and symbolic importance across the central European region as expressions of national aspiration and progressivist sentiment.[28] Official support intensified and shifted tenor during the 1920s to produce a remarkable array of state-sponsored modernist undertakings, from Red Vienna to the New Frankfurt, Josef Gočár's postcubist redesign of Hradec Králové or the classicist remodeling of Ljubljana by Jože Plečnik.[29] Even the puritanically abstract, antiornamental tendency loosely called functionalism gained adherents in officialdom, such that convention centers, banks and insurance companies, hospitals, housing proj-

ects, spas, and even some churches and crematoria were built along functionalist principles.[30] Photography supplanted drawing in documenting these many ventures for the architects and their clients. It also became the principal means to disseminate knowledge of the results, which were trumpeted in newspapers, illustrated books, and trade journals.[31]

The "dizzying rise" of the European metropolis entailed more than architecture alone; it meant bustle, commerce, entertainment, crowds. These subjects, which had in the nineteenth century been treated in literature and painting, now found their most direct reflection in photographs. Thus Sasha Stone, a Russian émigré who operated an advertising studio in Berlin, became in 1927–1928 the staff photographer for director Erwin Piscator. In that capacity, Stone not only documented but also publicized Piscator's theater, in individual pictures **(cat. 81)** and most notably in illustrations to Piscator's manifesto book *The Political Theater* of 1929.[32] Stone's colleague Umbo likewise advertised the allure of entertainment through sensual, Hollywood-inspired portraits of young actresses, views of movie houses, or circus performers **(cat. 82)**.

One of the most regionally influential images of the period, the 1926 photomontage *The Raging Reporter* **(cat. 83)**, came from Umbo as well. Filmmaker

82

81

82

83

Walter Ruttmann enjoined several photographers, including Stone, to make a series of perhaps twenty autonomous photomontages as publicity images for his kaleidoscopic, feature-length work, *Berlin: Symphony of a Metropolis*. Umbo, who had not yet begun his photographic career, likely received the commission by way of his friend and mentor Paul Citroen.[33] Art historian Herbert Molderings posits that Umbo took his formal inspiration from Aleksandr Rodchenko's montage illustrations for *About This* by Vladimir Mayakovsky (1923), an acknowledged reference for Citroen's *Metropolis* photomontages made in that year.

Umbo's choice of theme, however, had a more local flavor. Egon Erwin Kisch, the man whose face appears in Umbo's montage, used *The Raging Reporter* as the title to a collection of his newspaper articles in 1925. Kisch came from Prague and had been writing stories (in German) since 1905 for papers in his hometown as well as his adopted residence, Berlin. Kisch's captivating details and tightly described scenes resembled the new snapshot photojournalism, making him a perspicacious choice for apotheosis through photography. Straddling the city, Kisch as multiappliance cyborg seems to deploy all the machinery of electric transmission (only the train and the telegraph are missing) to gather and deliver his news flashes. In Umbo's conception, Ruttmann's modern city is a communications hub, dominated by information flow. The fantasy is enticing but also worrisome, as this hyperbolic construction suggests, for Kisch seems as much slave as master to his machines. "Our ideals have changed today," commented Umbo ambivalently in his diary directly after making this work. "Our viewpoints are more materialistic. Things . . . objectivity [*Sachen . . . Sachlichkeit*] form the ideal of our age. We no longer care about problems of the soul."[34]

Kisch dedicated the print reproduced here to his Czech lover, the writer Jarmila Haasová, for Christmas, thereby retracing the route of his own influence from Berlin back to Prague. He also used the piece on a second, Czech-language edition of the book that had inspired Umbo, which appeared in Prague in 1929 as part of a multivolume paperback collection, designed exclusively with photomontage covers and translated in large part by Haasová.[35] The international echoes of Umbo's work, however, greatly exceed those established by its subject. It was hailed in Paris and Moscow as the epitome of "modern man" and directly incorporated into a poster for Ruttmann's film by the Soviet artists Vladimir and Georgii Stenberg. The montage proved fundamental as well in the commercialization of Polish photomontage,

83

until then squarely in the domain of revolutionary agit-prop. Podsadecki and Brzeski likely saw Ruttmann's film in 1928, when it first came to Poland, and they openly imitated Umbo's work in their own subsequent montages for the press.[36] A further print (Galerie Kicken, Berlin) bears a Latvian censor's stamp, indicating its use as a publicity image for Ruttmann's film in that country also.

The international reception of Umbo's *Raging Reporter* suggests the dimensions of a new artistic dialogue mediated by the press. As the wealth of photography in print grew in the 1920s, makers of photomontage moved from employing anonymous sources to "sampling" work by their peers. Podsadecki, for example, incorporated into *Women and Children* (**cat. 84**) an overhead crowd scene by Munkacsi printed in the BIZ in July 1929. Brzeski recycled his 1934 image of an apocalyptic horse and rider (see **cat. 158**) from a nearly contemporary issue of *Das Deutsche Lichtbild*,

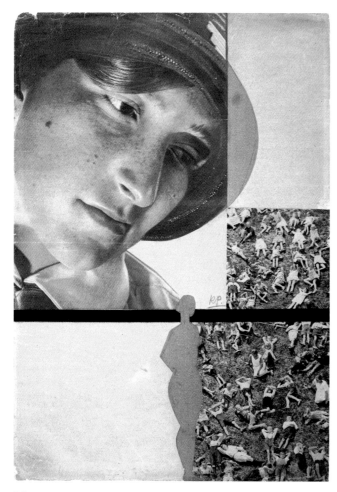

84

fellow émigré Lorant.[38] All of these images follow the raking shots of Soviet subjects favored by Rodchenko; they echo most closely, however, views of the Eiffel Tower, which was photographed in adventurous croppings by a long list of central European visitors during the 1920s (Krull, Jaroslav Rössler, Else Thalemann, and once again Moholy-Nagy come to mind). In the new image economy, propelled by the illustrated press, pictures circulated broadly and unceasingly, generating homages and adaptations that further standardized the value of modernity and made it into common currency.

This inflationary economy—so labeled at the time—also affected the widespread practice of amateur photography, which, with the advent of cheaper materials and a rising standard of living, claimed increasing numbers of faddish enthusiasts from the mid-1920s. Many newspapers and magazines in the region published advice columns for amateurs, and several also solicited submissions from them.[39] Despite this imbrication in the press, leadership of the amateur network generally resisted modern photojournalism and its stated desire to break with older habits of seeing. Pictorialism itself, after all, had developed with the ambition to reform photographic practice in the 1890s, and its defenders did not enjoy seeing their own solutions superseded by other approaches. Individual amateurs across the region nevertheless began to propagate new subjects, compositions, and printing techniques with the pedagogical zeal of their predecessors. Imre Kinszki (Hungary), Dohnány (Slovakia), Antoni Wieczorek (Poland), and Jan Lauschmann (the Czech lands) all used their photographs and frequent essays to exhort fellow amateurs on behalf of what they called the "modern style."

Kinszki **(cat. 64)** seems to have taken up photography as a hobby in the later 1920s, quite possibly following an international salon exhibition in Budapest in 1927 that announced a programmatic renaissance for Hungarian amateur photography.[40] Writing in Hungary's leading amateur photo periodical, *Fotóművészeti Hírek* (Art Photography News), during the 1930s, Kinszki shared views on subjects such as modern exhibition design or the seductions of nighttime photography, mixing technical advice with cautiously reformist aesthetic pronouncements.[41] His contemporary Dohnány, a railway engineer in Bratislava, took on a far more public role, establishing an advice column, "What Does My Picture Need?" for the cultural magazine *Vesna* already in 1931 and initiat-

while their compatriot, Aleksander Krzywobłocki, pasted into one of his cryptic montages of the early 1930s a depersonalizing study of stockinged mannequin legs by Umbo. Scholar Jindřich Toman has found loving, wholesale theft of covers from *Vu*—but also from the Polish tabloid *Tajny Detektyw*—on a wide variety of photomontage designs for dime novels in Czechoslovakia, particularly those created by surrealists Jindřich Štyrský and Toyen.[37] In straight photography, such direct citations find their close approximation in a seemingly plagiaristic repetition of motifs. To follow one of hundreds of such chains of imitative imagery: Austrian journalist Edith Suschitzky's (later Tudor-Hart) dizzying shot from the Ferris wheel in the Prater, Vienna's amusement park, pays homage to her Bauhaus training and perhaps specifically to Moholy-Nagy's vertical plunge from atop the Berlin Radio Tower, likely made earlier that year **(cats. 59, 65)**. Moholy's composition in turn repeats one of a pair of pictures of the Berlin Tower included in "The World from a Bird's- and Worm's-Eye Perspective," a photo essay by

84

KAZIMIERZ PODSADECKI
(Polish, 1904–1970), *Women
and Children (Kobiety i dzieci)*,
1933, photomontage (printed
matter and ink), 40.5 × 28,
Muzeum Sztuki w Łodzi

85

ALBERT RENGER-PATZSCH
(German, 1897–1966), *Still
Life with Tools (Gerätestilleben)*,
before 1929, gelatin silver print,
27.9 × 38.3, Staatliche Museen
zu Berlin, Kunstbibliothek

86

JOSEF SUDEK (Czech, 1896–
1976), *Advertising Photograph
(Reklamní fotografie)*, 1932–1936,
gelatin silver print, 38.7 × 26.8,
Museum of Decorative Arts
in Prague

ing evening courses in photography three years later. Dohnány popularized everything technological, from heavy industry to radio, cars (he died in an automobile accident), and even speed-reading.[42] With endearing paternalism, he proposed to guide presumably inexperienced readers through the marvels of the rapidly changing world around them, never failing to stress the tremendous opportunities that the end of war and newfound statehood had brought his fellow citizens. In the 1930 article "Everyone Can Be a Good Amateur Photographer," Dohnány stressed above all increases in individual liberty: "The newest direction [in photography] gives amateurs total freedom. It means one can capture one's chosen subject the way that seems most effective in artistic or practical terms." Although guidebooks "from before the last war" held sound advice, in the current era one might test unusual camera angles or other deviations with equanimity.[43]

Renger-Patzsch and Sudek, exemplary in their synthesis of commerce and art, took the established amateur movement as their guide and their foil. While keenly attentive to the avant-garde investment in photography, Renger and Sudek did not attach themselves to radical groups (though they befriended progressive artists in various disciplines), and neither man much used photomontages or photograms, the two techniques prized by avant-gardists as keys to a photographic renaissance. Renger, the son of a bookseller, inherited his father's passion for amateur photography; Sudek, first an apprentice bookbinder, studied for a professional license in photography but also joined early on the leading Czech club for amateur photographers. Both men thus entered photography through an artisanal circuit, one significantly tied to books as well, and they logically regarded successful photography as the product of skill and manual labor. Recycling found images or cutting up one's own prints, the bases for photomontage, or making photographs without a camera, bordered on dishonesty. Nevertheless, both men understood in their formative years that they were witnessing a conceptual reevaluation by leading artists of industrial technology, once the antithesis of creative culture yet now prized — particularly in those European nations newly formed or redrawn after the war — as a means of cultural affirmation. Renger and Sudek accordingly chose not simply to take industrial modernity for their subject, but beyond this, to define their artisanal identity in industrial terms **(cats. 85, 86)**.

Renger-Patzsch studied lithography and photographic printing, then gained a position as house photographer with the Folkwang Auriga publishing house in Darmstadt. In 1925, Renger opened a business supplying commissioned photographs for publishers and industry; that same year, he organized an exhibition in his own studio and began to cultivate contacts for further shows. He also published a "heretical" manifesto, as he called it, in *Photographie*

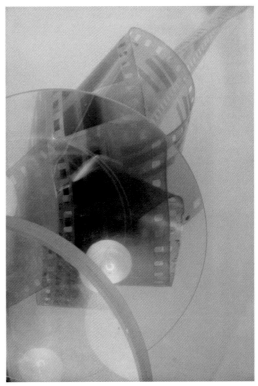

85
86

für Alle, a popular photography journal from Berlin, in which he argued for clean, rigorous camera work picturing "simple" sights in nature and the contemporary city. As examples of such work, he naturally offered his own photographs.[44] Renger thus bypassed the amateur system, serving as his own exhibition organizer, while simultaneously engaging that system polemically in text and image. At the same time, he presented his photographs both as samples, suitable for commercial replication, and as original works of art—although he remained coy about that term, out of nervousness over the potential associations with pictorialist "art photography."

In the succeeding years, Renger had his pictures printed in periodicals such as the *Berliner Tageblatt* (Berlin Daily Paper) and *Das neue Frankfurt*, gaining great visibility for his work and the ethic that subtended it. From the first, Renger stressed the ability of photography, when properly practiced, to grant viewers a feeling of existential presence, no matter whether the objects depicted were historical or futuristic, monumental or insubstantial: "To depict the height of a Gothic cathedral so that we feel dizzy, to depict an automobile so that we see the speed inherent in it, to depict air so that we feel space."[45] That encyclopedic potential, which gave Renger license to photograph any scene, for any purpose, also elevated his particular approach to the status of a general model of "new photography." Headlines to articles by or about him accordingly tend toward the categorical: "Albert Renger-Patzsch and Modern Photography" or simply "Pictorial [*Bildhafte*] Photography."[46]

Renger's normative vision reached its epitome with the December 1928 release of *The World Is Beautiful*. A bona fide media event, this Christmas book came accompanied by two prearranged reviews, one by leading essayist and satirist Kurt Tucholsky, the other by Thomas Mann, writing in the BIZ, the most widely circulated illustrated weekly in the world at that point.[47] Carl Georg Heise, *spiritus agens* of this publication, arranged for a complementary one-person exhibition in Hannover; the following year, Heise's close collaborator, the Viennese art historian Heinrich Schwarz, wrote a lengthy review for *Photographische Korrespondenz*, the leading Austrian journal for amateur photography. Schwarz then mounted an exhibition for Renger-Patzsch, also using selections from his book, at the Société Française de Photographie in Paris, the world's second-oldest photographic association, and he suggested to the photographer that he also contact the very oldest association, the Royal Photographic Society in London.[48]

The greatest echo for this publication, however, came from central Europe, where institutional leaders commented on it extensively. József Pécsi, editor of the preeminent Hungarian amateur photography journal *Magyar Fotografia* and a frequent exhibition juror, received a review copy: "and I take the opportunity," he replied, "to congratulate you on this 'advance battle.' Your works bring real revitalization to the tired, moribund atmosphere of photography. I will of course review this work in my journal as befits its value."[49] For all this talk of revolution, with its mixed metaphors of "advance battle" to "revitalize" a flagging creative field, the establishment of a modernist paradigm in photography occurred not against institutions but within them, to calculatedly institutionalizing effect.

The career path taken by Sudek is remarkably similar. In 1924, after completing his professional training in photography at the Státní grafická škola (State Graphic School, or SGŠ) in Prague, he noisily left the amateur association to which he had belonged since 1921 and founded a separate club together with his close contemporaries Jaromír Funke, Adolf Schneeberger, and others. As attested by its inaugural exhibition in December 1926, the Česká fotografická společnost (Czech Photographic Society, or ČFS) promoted pictorialist modernism: bolder than conventional amateur work in its abstraction and its interest in urban or technological subject matter, but retaining the amateur emphasis on harmony and subtle gradations of tone. The show garnered exceptional praise from J. B. Marek, a mildly promodernist art critic for the daily paper *Národní listy*, who declared himself taken with the "honest photography everywhere" and the "strict selection" of works.[50] In reviewing the group Devětsil earlier that year, Marek had made a point of deriding the practice of photomontage, which struck him as "orderves [*sic*] with every dish but no main course."[51] The "honesty" of ČFS prints, with their evident display of mastery and taste, evidently seemed to Marek worthy of a full meal.

Sudek never ceded the principle of mastery, but having established his place in the amateur world, he shifted his concentration away from it. Soon after the ČFS exhibition, in June 1927, Sudek opened a commercial studio that specialized, as did the one run by Renger-Patzsch, in commissions for publishing. His principal employer became the design and publishing cooperative Družstevní práce (Cooperative Work, or DP). Sudek had befriended Ladislav Sutnar, an energetic advertising and exhibition designer zealously

87

LADISLAV SUTNAR, ed. (American, b. Bohemia, 1897–1976), *Žijeme (We're Alive)* 1, no. 4/5 (July–August 1931), cover by the author, photolithograph of photomontage, 25.3 × 17.9, June and Bob Leibowits

88

LADISLAV SUTNAR (American, b. Bohemia, 1897–1976), *On Living (O bydlení)* (Prague, 1932), cover by the author, photolithograph, 29.5 × 21.6, Jindřich Toman, Ann Arbor

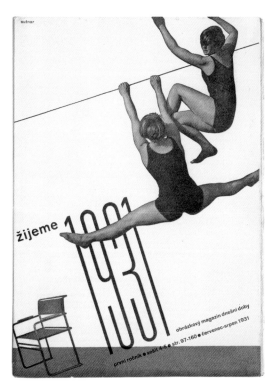

enamored of recent developments in Germany. Sutnar held a rising position of influence in the Svaz Československého Díla (Association of Czechoslovak Crafts), an artisans' organization modeled on the Deutscher Werkbund, whose members he led on an outing in 1927 to the Werkbund's model housing exposition *Die Wohnung* in Stuttgart. The following year, to publicize their growing projects in functionalist architecture and related exhibition work, Sutnar arranged a long-term partnership between the Svaz and DP, where he increasingly took on an editorial role as well.

5.5 František Bertl, View of Ladislav Sutnar installation at the *Výstava moderního obchodu* (Modern Commerce Exhibition), Brno, 1929, gelatin silver print, 15.9 × 21.6, June and Bob Leibowits

As Sutnar rose to prominence, assuming responsibility for exhibition design and publicity at these interconnected conglomerates, Sudek became an indispensable associate. Starting in 1928, Sudek produced the vast majority of photographs for the DP magazines *Panorama* and *Žijeme* (We're Alive), edited by Sutnar, which directed readers to the spectrum of upbeat, thoroughly modern offerings available from DP and the Svaz **(cat. 87)**. Sutnar also designed exhibition rooms and produced a series of books to this effect, from the Svaz stand at the *Výstava moderního obchodu* (Modern Commerce Exposition) in Brno in 1929 **(fig. 5.5)** to the 1932 book *On Living* **(cat. 88)**. Sudek's DP photography, a blend of the industrial fetishism cultivated by Renger with the radical diagonals favored by Moholy-Nagy, proved indispensable to these undertakings, as Sutnar fully understood. In 1933, when Sutnar, now director of the SGŠ as well — the school where Sudek had studied ten years earlier — sought to introduce a course in advertising photography, he argued to the Ministry of Education that a shortage of trained students in this field was forcing companies to commission work from neighboring countries, for "Photography is a very important aspect of advertising" — an acknowledgment of Sudek's rare and crucial status.[52] The course would soon be taught by Sudek's former accomplice in rebellious amateurism, Funke.

89 | 90

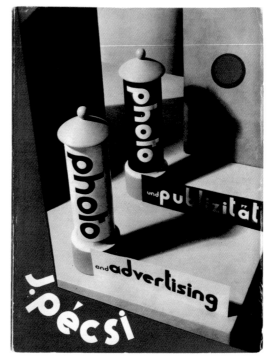

5.6 József Pécsi, *Photo and Advertising / Photo und Publizität* (Berlin, 1930), cover by the author, photolithograph, 22.1 × 29.7, June and Bob Leibowits

89

RINGL+PIT (Grete Stern [Argentinian, b. Germany, 1904–1999] and Ellen Auerbach [American, b. Germany, 1906–2004]), *Hat and Gloves (Hut und Handschuhe)*, 1930, gelatin silver print, 37.7 × 24.7, The J. Paul Getty Museum, Los Angeles

90

RÉVÉSZ-BIRÓ (Imre Révész [Hungarian, 1895–1975], and Irma Biró [Hungarian, dates unknown]), *Photo Advertising (Photo reklam)* (Budapest, 1932?), cover by the authors, photolithograph, 34.7 × 25, June and Bob Leibowits

91

LÁSZLÓ KÁLDOR (Hungarian, 1905–1963), *Boat (Hajó)*, c. 1930, gelatin silver print, 30.1 × 21.6, National Gallery of Art, Washington, Patrons' Permanent Fund

Like sports, architecture, and entertainment, advertising was a principal domain for photography across the central European region. Once again, Germany stands out **(cat. 89)**, but the German emphasis on advertising photography as a form of modern art was not unique. Pécsi, who accepted many publicity commissions in his studio, published a primer of ostentatiously modern design in 1930 titled *Photo and Advertising*, with an explanatory preface and illustrations of different model advertisements **(fig. 5.6)**. A curiously similar book appeared probably two years later by the Hungarian journalist team of Imre Révész and Irma Biró **(cat. 90)**, and there is some indication that the graphic designer László Káldor wished to produce an album of his work as a marketing scheme on the line between art and advertising as well — Káldor's photograph *Boat* **(cat. 91)** figures in maquettes for this project.[53]

Sudek assumed a singular position in this burgeoning field, for he used his growing fame as a commercial photographer to promote his photographs as art — not in the separate sphere of amateur salons, as had been done by ambitious studio operators in the past, but directly in the world of advertising and publishing. While negotiating to join the DP staff, in mid-1928, Sudek arranged for the cooperative to produce an album of his photographs celebrating the St. Vitus cathedral in Prague **(fig. 5.7)**.[54] The album, published in an edition of 120 copies, continued the tradition of bibliophile print portfolios, but its timing and presentation absolutely did not. Appearing on the occasion of the tenth anniversary of Czechoslovakia's founding in October 1928, this collection of views of one of the country's centerpiece buildings found the widest possible echo in the press and on the pages of DP magazines. Measuring 40 × 50 centimeters, the impressively sized publication was given a full-page advertisement on the back page of the DP journal *Panorama*, which had nearly the same dimensions. A lengthy review appeared in *Lidové noviny* (The People's News), the nation's largest daily newspaper, written by graphic designer and Devětsil affiliate Otakar Mrkvička. Further reviews emerged regularly for the next three months, including a suite of full-page reproductions in the illustrated weekly *Světozor*.[55] As reported by *Panorama* that December, half of Sudek's portfolio was also featured at the *Výstava soudobé kultury* (Exhibition of Contemporary Culture), a mammoth manifestation on behalf of "modern living" organized in Brno; this additional exposure was likely orchestrated by Sutnar.

Thanks to Sutnar as well, and in recognition of his prominence, Sudek was offered a one-person exhibition at the DP showrooms in October 1932. Sudek showed here his commissioned portraits of authors and artists who had also published with DP, as well as a selection of the many photographs of St. Vitus he had made during and after the DP portfolio. Every text about that portfolio stressed its author's labor and tenacity, classic amateur values. The preface, with its description of good photography as "waiting patiently for the exact minute … when a shadow gains a certain angle and, like the hands on a clock, shows that the moment when beauty makes its full appearance has arrived," distinctly parallels one-time amateur leader Alfred Stieglitz's legendary memory of spending hours in a snowstorm to capture his 1894 photograph *Winter, Fifth Avenue*.[56] Yet Sudek did not turn now to the amateur circuit for validation of these principles. Like Renger-Patzsch, he seized upon the newfound possibility to realize an artistic career in

91

the commercial sphere, and to play on that sphere for his artistic ideas. Sudek's *Advertising Photograph* (**cat. 86**), for example, is not identifiable with a particular advertisement, but serves instead to trumpet a new photographic genre, one that performs a double duty as modern commerce and modern art.

The modernism of Renger-Patzsch and Sudek, formed in dialogue with the institutions of amateur photography, also makes evident the pressure of nationalist sentiment on the discourse of modernity in this region. It is not by chance that Renger gives the "height of a Gothic cathedral" as his first example of a photographable sensation, nor that his books oscillate in subject between industry and nature, with a regular admixture of German churches and small towns. Sudek similarly chose St. Vitus and the tenth anniversary of Czechoslovak nationhood for his grand debut, and subsequently rested his fame on a balance of cosmopolitan advertisements and paeans to Old Prague.[57] The patriotism of both men ran deep, but it would also have been exceedingly difficult for them to succeed without honoring their nation. When Renger-Patzsch politely declined an offer to join the amateur association Gesellschaft Deutscher Licht-

5.8 Jan Bułhak, *Kaziuki*, 1930s, from Jan Bułhak, *Bromoil Printing (Technika bromowa)* (Vilnius, 1933), photolithograph of bromoil transfer print (*wtórnik*), 25 × 17, Maciej Szymanowicz, Poznań

bildner in February 1928, claiming lack of time and a need for independence, he received a second letter insisting on the importance of *Vaterlandsarbeit* (work for the homeland): "Mr. [Hugo] Erfurth did tell me you resisted attachments and liked to be free. I understand this well enough; but there is still one duty from which we cannot escape, which is to help restore our German economy and work. If an association such as ours cultivates a competitive ideal, it instructs the masses thereby...."[58] Renger held out against patria and pedagogy for a time, but by May 1930 Erfurth himself was writing to congratulate his colleague on joining the group.

The embrace of "modern living" in central Europe took place in an atmosphere of resurgent nationalism, and photography, despite its promotion as the image medium of postnationalist renewal, was largely deployed in ways that accommodated or furthered ethnocentric desires. Dohnány's photograph of villagers in traditional costume helping to build a new railway line, for example, provides a heroic view of Slovak peasantry constructing a new world in which it will continue to occupy the place of honor (**cat. 70**). In Polish circles, as historian Maciej Szymanowicz has observed, photographers responded to the advent of New Objectivity, with its celebration of technology and industrial labor, by stressing the artisanal in industry and the timeless in the modern. Jan Bułhak, the father of serious amateur photography in Poland, even developed a riposte to Renger-Patzsch that consisted in photographing accumulations of objects found not in the city or with large manufacturers, but at village markets. At a one-person exhibition in 1932, Bułhak referred to these works with the collective title *stara rzeczowość* or Old Objectivity (**fig. 5.8**).[59]

5.7 Josef Sudek, *St. Vitus Cathedral (Ze Svatovítského chrámu)*, Prague, 1928, gelatin silver print, 50.1 × 41.3, Museum of Decorative Arts in Prague

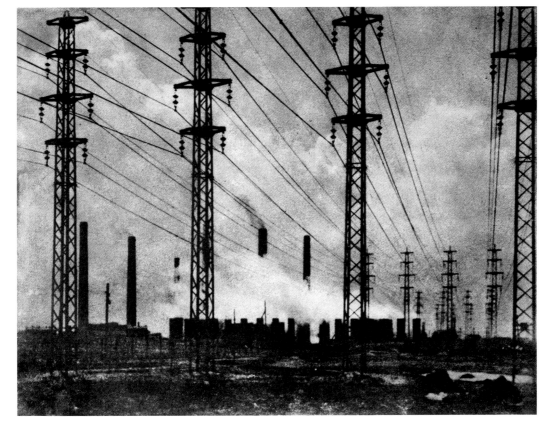

92

WITOLD ROMER (Polish, 1900–1967), *High Voltage Lines in Chorzów (Linia wysokiego napięcia w Chorzowie)*, 1928, bromoil print, 30.5 × 40, National Museum in Wrocław

92

WITOLD ROMER (Polish, 1900–1967), *High Voltage Lines in Chorzów (Linia wysokiego napięcia w Chorzowie)*, 1928, bromoil print, 30.5 × 40, National Museum in Wrocław

93

ANTONI WIECZOREK (Polish, 1898–1940), *Factory (Fabryka)*, 1935, gelatin silver print, 20 × 27.7, National Museum in Wrocław

Other Polish photographers set industrial modernity within a program of emphatically traditionalist discourse. Professor Witold Romer photographed high-voltage lines, for instance, as a forest of steel, a quasi-natural monument that, when viewed from a respectful distance and rendered in a bromoil print, assumes the characteristics of an immutable landscape **(cat. 92)**. His colleague Antoni Wieczorek adopted a similar approach for a documentary commission from a nitrogen manufacturers' association in Silesia, the new industrial heartland of Poland **(cat. 93)**. Taken with a hand-held film camera but printed as if made with glass plates and long exposure times, Wieczorek's series mythicizes industrial production, infusing it with a ritual glow.[60] Wieczorek showed these works in the company of landscapes and ethnographic studies at *Piękno Ziemi Śląskiej* (The Beauty of the Silesian Land), an exposition organized to demonstrate the compatibility of industrialization with agrarian and peasant traditions in the region.[61] That same exhibition served Bułhak as a platform to articulate the Polish version of Homeland Photography.

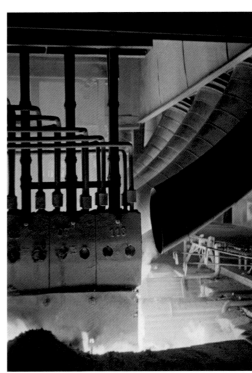

92
—
93

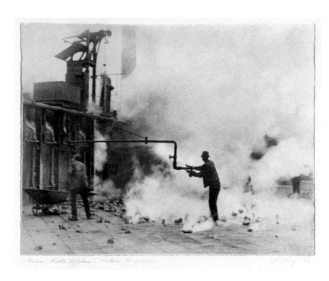

5.9 Konrad Koch, *Extinguishing Coke in Coking Plant, Rheinpreussen (Beim Kokslöschen Kokerei Rheinpreussen)*, 1927, bromoil print, 32 × 42, Museum Folkwang, Essen

The overlay of pictorialism and modernity was by no means limited to Poland. Fine-art print techniques had a long life within and beyond central Europe; even in Germany, the country most "comfortable" with industrial modernization, photographers rendered decidedly modern views using bromoil or gum prints **(fig. 5.9)**. Questions of technique are of secondary importance, however, in grasping the widespread desire at that time to legitimate industrial modernity as a form of national self-expression. An instrument of that desire, the pedagogy of "modern living" tended, despite the revolutionary utopianism of its avant-garde propagators, toward an embrace of the state. The state in turn found it easy to accommodate this response to modernity, with the result that reactionary political structures in the 1930s deployed progressivist, technophile language to great effect. National Socialism above all represented not the rejection of modernism, but rather state control of its most perverse aspects — primarily using film and photography.

For a camera operator such as Paul Wolff, enthusiasm over new visual technologies fused seamlessly with a nostalgic image of the homeland. His first book, published just before World War I, presented mezzotints from photographs he had taken of the historic center of Strasbourg.[62] Wolff relocated to Frankfurt after the war — Alsace had been ceded to the enemy — and joined a film company producing documentaries and advertising shorts. A series of further books on historic German cities brought Wolff success, such that by 1925 he had established his own

commercial studio. That same year, the German company Leica, located near Wolff's new city of residence, first marketed its eponymous small-format camera to the general public, selling one thousand units by the end of the year and fifty thousand by 1930. Wolff seized upon this camera and, doubtless subsidized by its manufacturer — he had befriended Ernst Leitz, owner of the firm, as well as Oskar Barnack, the camera's inventor — zealously promoted it at home and abroad.

Wolff's illustrated travelogues, sports books, and first-person publications, most famously the 1934 bestseller *My Experiences with the Leica*, suggested this newfound equipment as the emblem of an unfettered, individualist lifestyle appropriate for the age.[63] Such impressions, while reformist at a superficial level, dovetailed profoundly with the ambitions of state and industry. Wolff's view of a lone car speeding down a German highway in 1936 encapsulates that false promise of personal freedom **(cat. 94)**. The road in question is the new Reichsautobahn, "Hitler's Highway," for which the Führer himself broke ground to great fanfare in September 1933, directly outside Frankfurt, in fact.[64] The project became a cornerstone of proposed improvements to German infrastructure, which Hitler touted heavily in public as a scheme to boost employment, and privately as a means to facilitate troop deployment — both claims that turned out to be without foundation. Nevertheless, the vision of a system of endless two-way roads, offering the possibility of rapid movement and unimpeded surveillance across the dominion of a newly reestablished empire, emblematizes the Nazi adaptation of technological progress.

All media were pressed into service to publicize this enterprise, including photography. The project overseer, Fritz Todt, was himself an amateur photographer, and his pictures appeared in celebratory volumes as construction progressed.[65] Wolff sent the photograph pictured here to his Viennese picture agency, Schostal, so it was intended for print, although no published version has yet been located. Graceful and spacious, his picture suggests paradoxically that speed is relaxing and travel by highway the equivalent of a solitary walk in the countryside.[66] In this, the culminating vision of modern living, industrial technology is naturalized as a landscape with a nearly infinite horizon, a lie of horrific proportions that is put forth by the image, but more profoundly by the conception of modernity that underlies its making.

94

PAUL WOLFF (German, 1887–1951), *Imperial Highway (Reichsautobahn)*, 1936, gelatin silver print, 23.8 × 17.7, National Gallery of Art, Washington, Gift of Christian Brandstätter

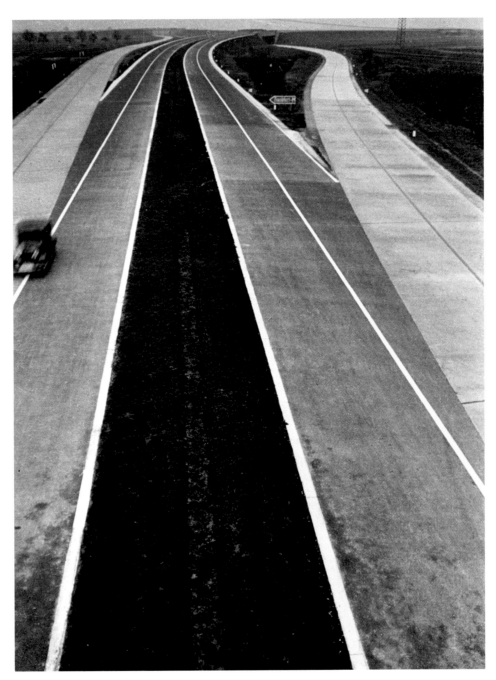

94

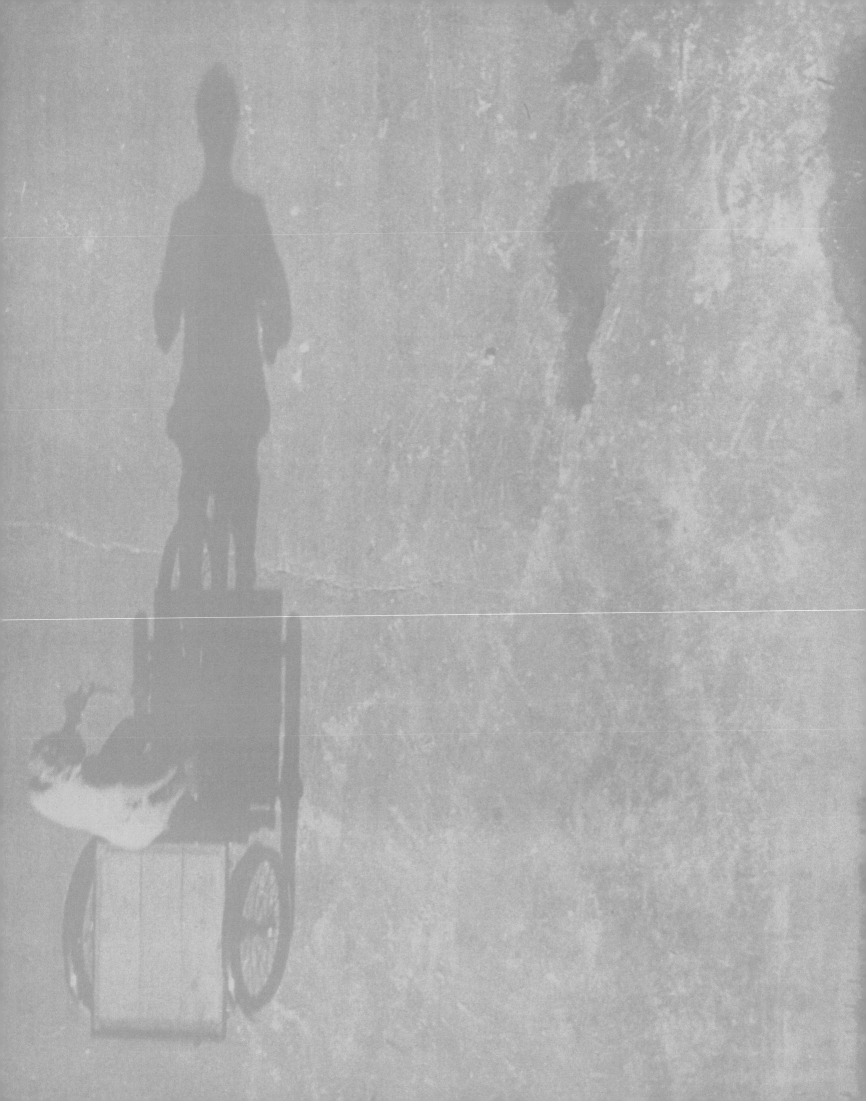

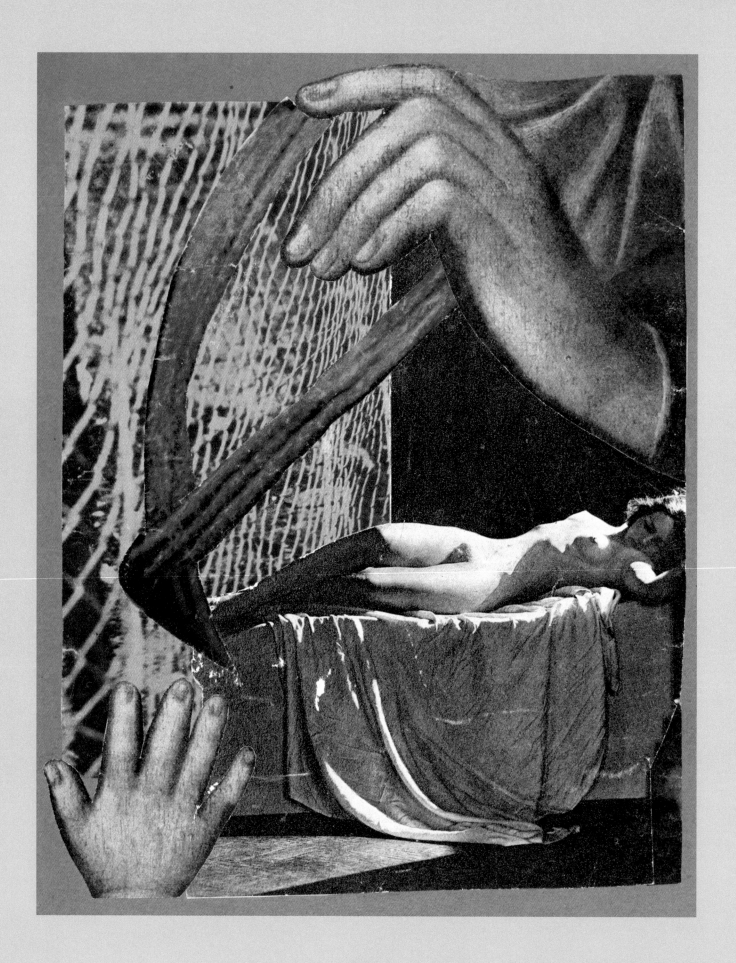

95

95

Surrealism took hold widely, if unevenly, in central Europe from around 1930. Many artists from the region spent time in Paris, where the term surrealism was coined in 1917 and where the surrealist movement was founded as such in 1924. Personal ties to French surrealists spurred the declaration of official sister groups in Czechoslovakia, Serbia, and Romania, and Prague in particular became the second-greatest center of surrealist activity after Paris. In Poland, where surrealism never gained the status of a named movement, surrealist methods and themes nevertheless were explored both by individuals, such as Janusz M. Brzeski, Władysław Bednarzuk, or Stefan Themerson, and communally, by the Lviv group Artes **(cats. 95, 106)**. Meanwhile in Germany, surrealism found a niche as an expression of private fantasies, whether more or less humorous **(cats. 96, 97)**, or truly menacing in the case of Hans Bellmer (see chapter 9).

The personal, or private, nature of surrealist creation sets it radically apart from other responses to modernity in central Europe. Most aspects of the photographic phenomenon discussed in this book are emphatically public, entailing a presupposition of mass communicability to photographic imagery and a pedagogical desire for standards or even conformity. Impelling these uses of photography is the pressure on artists and intellectuals, uniquely strong in central Europe, to participate in collective life by helping to shape public opinion. In the 1920s, even avant-garde opposition to society in this region operated on the premise of art as an expression of civic engagement. Surrealism offered a means to break with this premise, to turn one's back on communicability and on the public sphere. This was precisely the attraction of the movement for artists such as Bellmer or Karel Teige, who, working in the era of Hitler, Stalin, and Mussolini, sought at all costs freedom from complicity with totalitarian society. Alexandr Hackenschmied's film *Aimless Walk* (1930) **(cat. 98)**, the diaristic photo series of Jindřich Štyrský, or inscrutable performances staged in apartments or secluded spots by Václav Zykmund and Aleksander Krzywobłocki all similarly attest to the rejection of photography as a vehicle of mass communication.

At the same time, central European artists did adapt the private realm of surrealist investigation— dreams and instinctual drives, serendipitous occurrences, the experience of one's own body and of death—for public dissemination in various ways. Štyrský, one of the most resolutely nonconformist artists in Europe, nevertheless wrote articles on psychoanalysis and the Marquis de Sade for *Magazin DP*, *Rozpravy Aventina* (Aventinum News), and *Literární kurýr Odeonu*, all commercial publications and intended for a general readership; in his capacity as editor of the last-named periodical (1929–1931), Štyrský also proposed to compile an "extensive, representative *Anthology of Surrealist Poetry*...that would provide a real picture of this movement."[1] To take another example, Josef Bartuška, founding member of the Czech collective Linie (Line) and editor of its eponymous journal, treated the surrealist "inner model" as an aid to classroom art exercises. Bartuška was a high-school teacher, and some of his most inspired visual experiments, for example a series of close-up studies of tire tracks and footprints in the mud **(cat. 99)**, appeared as illustrations in a trade magazine for secondary school educators and their students.[2]

Surrealist themes also reached a vast audience in central Europe through outright popularization, primarily in the form of photomontage designs for illustrated weeklies or paperback thrillers. Several artistic talents in Poland, above all Brzeski and Kazimierz Podsadecki, supplied photomontages to the sensationalist press that traded skillfully on surrealist "style" for humorous ends. Long before Salvador Dalí gave a surreal look to the films of Alfred Hitchcock, Štyrský deployed the surrealist unconscious in imitation of penny arcade suspense films with his covers for the ghoulish book series *Fantômas* in 1929–1930 **(cat. 100)**. This "low" surrealism, created by people conversant with or even fluent in serious surrealist discourse, mirrors in spirit the "high" initiatives of journal essays, lectures, and the like.

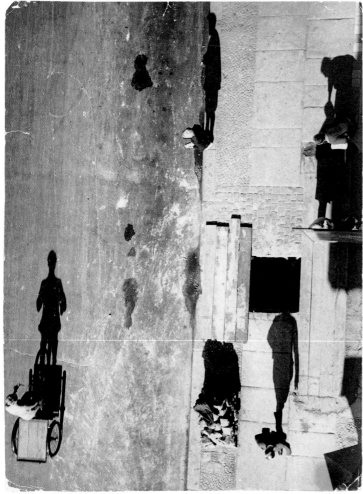

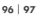

Photography was by no means the only vehicle for surrealist expression in central Europe, but it did find many adherents, far more in fact than in France or Belgium, today the best-known centers for surrealist photography. Particularly remarkable is the diffusion of interest in experimental photography, with surrealism as one source of inspiration, to provincial towns or secondary cities: České Budějovice in southern Bohemia, Olomouc and Brno in Moravia, or Lviv in eastern Poland (now Ukraine). It was through photography as well, rather than painting or drawing, that surrealist themes and effects—if not necessarily the substance of surrealist ideas—seeped into the mass media. The "spread" of surrealism in the 1930s, then, designates both a broadened geographical reach for the movement and an increased elasticity regarding its motivating concepts.

96

UMBO (OTTO UMBEHR)
(German, 1902–1980), *Eerie Street (Unheimliche Straße)*, 1928, gelatin silver print, 23.7 × 17.8, Thomas Walther Collection

97

HERBERT BAYER (American, b. Austria, 1900–1985), *Lonely Metropolitan (Einsamer Großstädter)*, 1932, photomontage (printed matter with gouache and airbrush), 41 × 29.8, Courtesy of the Buhl Collection

98

ALEXANDR HACKENSCHMIED (American, b. Austria, 1907– 2004), Still from the film *Aimless Walk (Bezúčelná procházka)*, 1930, gelatin silver print, 12.2 × 17, The Museum of Modern Art, New York

99

JOSEF BARTUŠKA (Czech, 1898–1963), *Untitled (Bez názvu)*, from the series *Tracks in the Landscape (Stopy v krajině)*, 1939, gelatin silver print, 17.7 × 12.5, Private Collection

In the Czech lands, where surrealism took hold with great force, its diffusion also extended temporally, into the years of Nazi occupation and World War II (and for decades afterward). Continuing their work under extremely oppressive conditions, artists committed to a surrealist ethos deepened the movement's expressive range, again in all the arts, but particularly in photography: from pseudo-documentary views of "objective chance," to the record of happenings or ephemeral sculpture, to manipulated photography and photomontage. The vibrancy of surrealism under trying circumstances in this part of the world forms a marked counterpoint to the situation in western Europe, where many practitioners went into internal or transatlantic exile and the leading circles disbanded, to be reconstituted after 1945 as pale imitations of their prewar selves.

The Czech encounter with surrealism likewise came especially early, in 1922, at a time when Guillaume Apollinaire's term had not yet been codified into a movement.[3] Teige introduced the word to a Czech audience in his essay "Foto Kino Film," as part of a discussion of photographs by Man Ray, including one from his recently published album *Delicious Fields (Champs délicieux)*, which Teige had seen in Paris. "Photography can never leave reality, not even here," he commented, "but it can become *surrealistic [nadrealistická]. Surréalisme* [now in French] is the quality possessed by Man Ray's photographs."[4]

Man Ray represented for Teige a supreme practitioner of Apollinairean surrealism, whereby everyday reality is converted into something whimsical and fantastic. Apollinaire's 1917 play, *The Breasts of Tiresias*, subtitled a "surrealist drama," features a creative disruption of meaning in which the ordinary sense of

words, objects, and situations shifts onto the plane of the marvelous. In the first scene, a character picks up a bedpan and calls it a piano; the action takes place throughout in front of a single stage setting, which we are told is in Paris and Zanzibar simultaneously, and at one point is said to be near the state of Connecticut. "When man wanted to imitate walking," quipped the author by way of a definition, "he created the wheel, which doesn't resemble a leg. In this way he unconsciously made surrealism."[5]

The unconscious was nevertheless not a subject of abiding interest for Apollinaire, nor did it initially attract the attention of the Czechs—at least not officially. Štyrský began recording his dreams in late 1925, just after he and his partner, the painter Toyen, arrived in Paris for what proved to be a three-year stay. The two artists followed closely the activities of established surrealism, although they did not become friendly with surrealist leader André Breton until the following decade. In print, however, Devětsil affiliates both in Paris and at home reported on surrealism with tremendous skepticism until the end of the 1920s. Defending their homegrown poetist movement, Czech artists charged surrealist production with a misplaced return to literary or illustrational painting, indicative of a neoromantic worldview that they found

98 | 99

100

naively isolated from political concerns. In the context of 1920s central Europe, the political significance of surrealist "convulsive beauty" remained untranslatable, such that French surrealist appeals to an inner psychic state were perceived as a crutch for convention rather than a call to revolution: "The unconscious is a gag many people stuff in their mouths to keep from thinking further."[6]

This attitude began to shift in 1929–1930, when members of Devětsil, several of them personally friendly with Parisian surrealists, made public overtures to the group. In April 1929, Teige published a selection from the *Songs of Maldoror* by the nineteenth-century French writer Comte de Lautréamont, a hero to Breton, which Teige had chosen together with poet Philippe Soupault. (Soupault, who visited Prague twice in the 1920s, provided many of the introductions for Czechs in Paris circles.) Censors confiscated the book three months later, citing concerns for public morality.[7] Devětsil writer Vítězslav Nezval began publishing poetry and plays with plainly surrealist themes, such as "The Ragpicker" and *Fear*, and in November–December 1930 he edited the little magazine *Zvěrokruh* (Zodiac), in which contemporary surrealist poetry from France appeared for the first time in translation, as well as the full text of Breton's

Second Manifesto of Surrealism.[8] Two years later, the same principal actors organized a vast, ambitious exhibition of recent painting and sculpture composed largely of French and Czech surrealist work, to which they gave, in a lingering sign of independence, the neutral title *Poesie 1932*. On 9 May 1933, Nezval and Devětsil theater director Jindřich Honzl finally met Breton in Paris; the next morning, Nezval wrote to offer Devětsil allegiance to the French cause. This letter of entente appeared days later in Breton's magazine, *Le surréalisme au service de la révolution*, and it formed the prologue to a brochure announcing the charter of an official Surrealist Group in Prague in March 1934.

In photography too, surrealism had made inroads into Czech practices before the institutionalization of the movement in 1934. An enduring inspiration for this photographic work, in the Czech lands as in Germany, came from the surrealist-led apotheosis of Eugène Atget. Atget, a purveyor of architectural views and street scenes in and around the French capital, had become the object of ennobling attention by several surrealists in the final years of his life. Man Ray selected three photographs by Atget for a 1926 issue of the journal *La Révolution surréaliste*, while his colleague, poet Robert Desnos, credited the photographer posthumously with turning Paris into a "dream capital," in which "the crossroads always serve for pathetic rendezvous."[9] That same year (1928), prints by Atget were included in the so-called *Salon de l'Escalier* (Stairway Salon), the first group exhibition of vanguard photography in Paris; in 1930, Man Ray's one-time studio assistant Berenice Abbott engineered the publication of a trilingual homage to Atget, with simultaneous distribution in France, the United States, and Germany.[10]

While veneration of Atget in France remained limited to those who had known him personally, a relatively widespread cult arose in central Europe, particularly in Germany and Czechoslovakia, spurred in great measure by Atget's inclusion in the *Fifo* exhibition in 1929. Eleven works by Atget figured in the contemporary section, many of them surrealist favorites akin to the ones reproduced here **(fig. 6.1)**. These pieces, including some of vitrines and mannequins, lent a historical pedigree to truly contemporary experiments on this theme, notably five views of shopwindow dummies submitted for *Fifo* by Umbo under the thematic heading *Wachspuppen* (Wax Dolls).[11]

Hackenschmied, principal organizer of the two Czech echoes to *Fifo*, emulated Atget's late views in a number of works, perhaps beginning directly after his

100

visit to the Stuttgart show.[12] In November 1929, mean-
while, Teige reproduced a variant of Atget's *Avenue des
Gobelins* in the Devětsil journal *ReD*. Motivated doubt-
less partly by *Fifo* and by journals circulating directly
from Paris, Teige seized upon Atget as the corner-
stone in a Marxist, modernist history of photography.
His 1931 essay "The Tasks of Modern Photography,"
like Walter Benjamin's "Short History of Photography"
from the same year, characterizes Atget as an isolated
beacon of promise for modern times. In Teige's his-
torical narrative, Atget becomes emblematic of the
"early era" [sic], characterized by "honest work devoid
of artistic tricks."[13] Threatened neither by "photo-
graphic kitsch," which Teige detects already in Nadar,
nor by the "real fall of photography" in the decades
preceding World War I—in fact the years of Atget's
greatest activity—the French photographer becomes,
in Teige's history as in the one fashioned by Benjamin,
a forerunner of photography's triumphal age. For
Teige, the culmination of that triumph comes not with
the experimental avant-garde, but in a purely "task-
oriented" photography practiced by ordinary people
in great times (see chapter 7): "Three thousand photo-

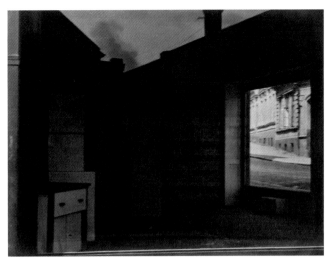

6.2 Jaromír Funke, *Reflections (Reflexy)*, 1930, gelatin silver print,
30 × 40, National Gallery of Art, Washington, Patrons' Permanent Fund

circles, one hundred thousand worker-photographers
in the USSR: from the icy sea to the Turkmenistan
steppes the camera is recording…the theme of life,
not a pose."[14]

Atget's work thus emerged in central Europe,
more explicitly than in France, as the prototype for a
documentary style that could be both class-conscious
and visually compelling, even poetic. More important,
this work quickly became accepted as a milestone
in the ever-advancing, all-embracing history of the
photographic medium. Jaromír Funke, for instance,
took up Atget's subject matter in 1929–1930 with a
clear understanding that he was building upon photo-
graphic history and bringing that history into a new
phase. After paying homage to Atget in a series of
shopwindow *Reflections* **(fig. 6.2)**, Funke fashioned his
own form of surrealist elegy in *Time Persists* (*Čas trvá*,
c. 1932–1935), a symbolically pregnant collection of
views of unpeopled urban spots—a deserted railway
station, a cemetery, forlorn sculpture in front of a
1900-era patriotic building—that emanate a grand,
wistful air of abandonment.

In 1936, Funke introduced the term "emotional
photography" to define his recent work: "simple real-
ity has a lot of mystery, [to which] photography sup-
plies fantasticality, newness and an evocative, poetic
value."[15] The occasion for this article was an issue
of the illustrated weekly *Světozor* devoted to the ques-
tion "Is Photography Art?" Five works from *Time Per-
sists* appeared in the issue, including a laconic view
of a fairground photographer's booth, the Czech
answer to Atget's "Paris of the people," on the cover.
Funke wrote the lead article, titled "On Old Photogra-
phy." Recapitulating the ideas expressed in the 1930
monograph on Atget—which Funke knew, signifi-

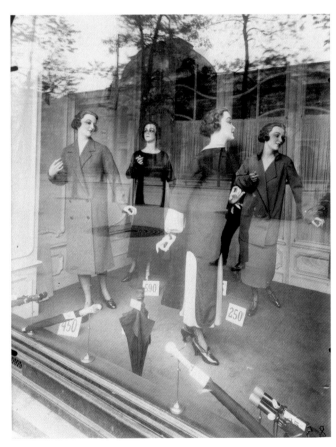

6.1 Eugène Atget, *Store, Avenue des Gobelins (Magasin, Avenue des
Gobelins)*, 1925, gelatin silver printing-out paper, 22.5 × 17.8, National
Gallery of Art, Washington, Patrons' Permanent Fund

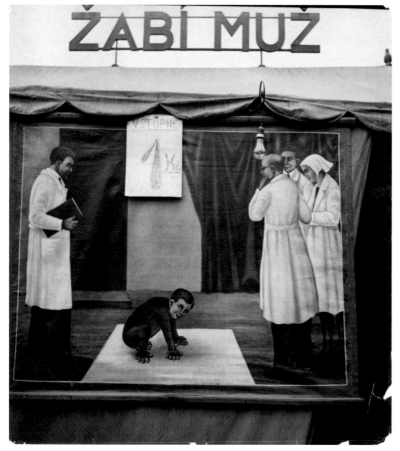

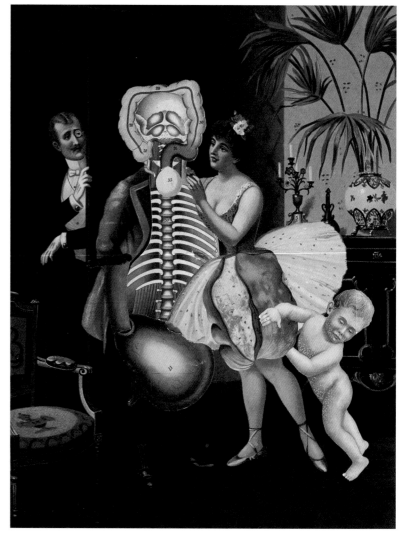

101 | 102

101
JINDŘICH ŠTYRSKÝ (Czech,
1899–1942), *Untitled (Bez
názvu)*, from the series *Frog
Man (Žabí muž)*, 1934–1935,
gelatin silver print, 31 × 30,
Museum of Decorative Arts
in Prague

102
JINDŘICH ŠTYRSKÝ (Czech,
1899–1942), *Untitled (Bez názvu)*,
from the series *The Movable
Cabinet (Stěhovací kabinet)*, 1934,
photomontage (printed matter),
41.5 × 33, Roy and Mary Cullen,
courtesy of Galerie 1900 ★ 2000

cantly, not in its French version, but in a German edition prefaced by Camille Recht—Funke characterized Atget as a street poet with a melancholic feel for the intimate and the overlooked:

Atget discovered . . . the banality [*všednost*, literally "everydayness"] of bourgeois calm, with the magic of a once-warm oven and a drawer with the perfumed remnants of love letters that he used to receive when he was young. One smells in Atget's photographs the musty odor of the wide skirts worn by a girl in the street, standing at the door to her house. Magic, supported by an imperfect technology, fallen shadows, tall lights. . . . Banality with enchantment, the street and fantasy, Proust's search for lost time, this is Atget's photography.[16]

Populist elegy also marks the surrealist "snapshots" of Štyrský, contained in three extensive series from the years 1934–1935: *The Man with Blinders*, *Frog Man*, and *Parisian Afternoon* **(cat. 101)**. A selection of seventy-four photographs from the first two series, printed by amateur photographer Jaroslav Fabinger, were presented along with examples from Štyrský's collage series *The Movable Cabinet* in Prague in 1935, at the first exhibition of the Czech Surrealist Group. It was the most extensive and prestigious showing of photography in a surrealist context anywhere in interwar Europe. Indeed, this exhibition, like *Poesie 1932*, was organized under the auspices of Mánes, an artists' association with municipal funding and the status of a semiofficial arbiter of aesthetic values. Far more than its French counterpart, Czech surrealism occupied a prominent, respected place in public culture.

Surrealist photography, wrote Štyrský in an article for the socialist daily *České slovo* in early 1935, concentrates most properly on "objects that are out of fashion," commemorative, or simply bizarre. As examples, Štyrský cited the contents of his own recent work: barbershop heads, orthopedic legs, and other items with a "latent symbolism."[17] The caricature of fashionable Parisian life pictured by Atget is taken here to a fetishistic extreme, as Štyrský points sweetly toward the dismemberment, violent sexuality, and blindness found more plainly in his photomontages **(cat. 102)** and paintings.[18]

In these photographs of old-fashioned window displays and sideshow attractions, Štyrský also furthered a set of reflections on tourism and its relation to the uncanny begun with his "picture poem" *Souvenir* (see **cat. 20**). In that early composition, the lightheartedness of what appears to be a summer trip along the Mediterranean coastline is rendered ever

6.3 Toyen (Marie Čermínová), *Nocturnal Celebration (Noční slavnost)*, 1929, oil on canvas, 92 × 65, Private Collection, Prague, courtesy City Gallery Prague

so slightly disturbing by the inclusion of indecipherable written marks on the bodies of bathing girls, as well as an irradiated fish that haunts the sea. The two-person movement titled artificialism, which Štyrský and Toyen founded in Paris in 1926, built on this early insight into the psychic discomfort occasioned by tourist travel. Artificialist paintings underscore the uncanniness of touristic encounters with the foreign and unfamiliar, most evidently by giving to pictures of festering, oleaginous abstraction titles that evoke exotic locales or leisure travel. The latent anxiety that Freud specified as *unheimlich*, literally "un-home-like," which structures of tourism normally hold in check, comes to the fore here through a sensation of boundlessness calculated to provoke spatial and psychic disorientation **(fig. 6.3)**.

Štyrský's photographic series of the 1930s address this anxiety in a different, highly subversive way, precisely by sticking close to home. The details he selects, such as a sideshow poster featuring a hairy midget with suckers for fingers **(cat. 101)**, hold forth the promise of a bizarre spectacle, yet there is no way to enter their world to witness it. All we see of this purportedly everyday surrounding are objects that have been cut off from it, isolated from the street and from the circumstances of their production or

103

6.4 Karel Kašpařík, *Dark Repose (Spočinutí v černém)*, c. 1934, gelatin silver print, 27.6 × 37.2, Moravská galerie, Brno

exchange. We are never introduced to living people, are made to look at store interiors through barriers of glass, and are generally shut out from participatory engagement in what are ostensibly familiar scenes from daily life. In this way, Štyrský offers a quizzical study, almost an ethnography, of his native environment, along the lines established by surrealist photographs of Paris yet more persistently strange. For a Czech audience, especially, the contents of these pictures likely appeared recognizable yet frustratingly remote.

In the essay "Surrealist Photography," Štyrský, evidently worried that his art might be confused with mainstream production, took pains to distance himself from "official photo amateurs, whose stereotypical illustrations flood exhibitions the world over." To exhibit a photograph of any kind, in this context of a globalized discourse about the medium, was necessarily to enter into a larger discussion of photography's aims and means, and Štyrský wanted to make clear his position as a surrealist on that question. Nor were conventional amateurs his only foil. "The only thing that fanatically draws me to photography today . . . is the search for a surreality hidden in the objects of real life," Štyrský declared, stipulating that abstraction and manipulation of either negative or positive could only falsify this search.[19] As examples of such false directions, Štyrský named the *fotoskupina pěti* (Photo Group 5 or f5), whose members had recently exhibited in Prague as well. The f5, begun in the Moravian city of Brno in 1933, held an eclectic relation to surrealism, which they accepted as an important but not exclusive model for creative activity. The group, variously renumbered f3 and f4 to account for a changing membership, insisted precisely on staged compositions and manipulated prints as a means to visualize a libidinous inner state.

Karel Kašpařík, a self-taught amateur who, like his colleagues in the f3 / f4 / f5 group, treated photography seriously but never made a career of it, divided his interests between surrealist erotic fantasies and documents of political oppression. In the relatively prudish milieu of interwar Czechoslovakia, his large and frankly seductive composition *Why?* **(cat. 103)**, exhibited in Olomouc, another Moravian town, during the one and only showing of f3 in October 1935, likely created an effect of shock, especially in conjunction with still more daring photographs shown by Kašpařík at that exhibition **(fig. 6.4)**.[20] For a culture accustomed to trading in answers, the idea to frame an image as a question was radical in itself.[21] The

103

KAREL KAŠPAŘÍK (Czech, 1899–1968), *Why? (Proč?)*, before 1935, gelatin silver print, 38.5 × 28.9, Moravská galerie, Brno

104

BOHUMIL NĚMEC (Czech, 1912–1985), *Experiment*, 1936, gelatin silver print with Sabatier effect, 13 × 11.5, Private Collection

105

FRANTIŠEK POVOLNÝ (Czech, 1914–1974), *Photographic (Fotografika)*, 1933–1934, gelatin silver print, 28 × 38, Moravská galerie, Brno

104

studied under a microscope. In contrast to the careful control of variables necessary to laboratory science, however, Povolný deliberately courted the element of chance.

Montage and staged performances formed other areas of surrealist activity during the 1930s, in both Czechoslovakia and Poland. Krzywobłocki, a founding member of the Lviv group Artes, spurred interest among his colleagues through his work in amateur photography. Trained as an architect, with additional instruction in pictorialist "art photography," Krzywobłocki began making photomontages in 1928 or 1929, at the time that Artes was founded. He took portraits of his fellow artists at this time as well, posed with their heads inside empty painting or chair frames as if to conflate the forms of photography, painting, and object art. Krzywobłocki continued these experiments in living sculpture with a small series of tableaux vivants, made apparently during the course of the existence of Artes and the first year of its successor formation, the so-called Grupa lwowska (Lviv Group), that is, from 1929 until around 1936. The *Montages from Nature* feature variously the artist alone **(cat. 106)** or other Artes members arranged in the landscape. Like the pair of photographs entitled *Gaming* and *Oil Lamp* **(cats. 107, 108)** by his compatriot Brzeski, the film still by Stefan Themerson **(cat. 110)**, or the odd view of his own shoes recorded by fellow Lviv photographer Władysław Bednarczuk **(cat. 109)**, the *Montages from Nature* theatricalize the surrealist experience of

boldly coquettish expression of the unnamed subject, cropped down to a single charmer's eye and half of a lipsticked smile, further suggests a self-assurance bordering on aggressiveness that stands out in the Czech context. This pose and framing recall the language of the New Vision developed in Germany in the later 1920s. Indeed, Kašpařík's flirtation with surrealism, like similar forays by many Czech and Polish artists in the 1930s, remains indebted to German precedents as much as to ideas coming from France (and we have seen that the all-important surrealist "idea" of Atget came filtered through Germany too). Surrealism and the New Vision merged in effect in central Europe in the 1930s, where both tendencies seemed to express the latest stage in an ever-progressing photographic history.

　　Kašpařík's fellow Moravians František Povolný, Jaroslav Nohel, Bohumil Němec, and Otakar Lenhart— all active in multiple creative fields, primarily painting and theater or film—concentrated in their experimental photography on eerie scenes or visions of hallucination. Nohel set up objects like elements in a séance or clues to a crime, while Lenhart arranged superimposed negatives and Němec experimented with toning and solarization, to suggest dream images **(cat. 104)**.[22] Povolný, meanwhile, liquefied the emulsion on gelatin film stock to create distorted, abstract compositions **(cat. 105)**. This technique of *brûlage* or "burning," as it would be baptized a few years later by French surrealist Raoul Ubac, yielded a series of unique prints that Povolný exhibited repeatedly between 1933 and 1936. Exploding globules and other suggestions of silverized matter evoke cellular activity

105

106

106

ALEKSANDER KRZYWOBŁOCKI
(Polish, 1901–1979), *Montage
from Nature (Montaż z natury)*,
1928–1936, gelatin silver print,
29 × 23.5, National Museum
in Wrocław

107

JANUSZ MARIA BRZESKI
(Polish, 1907–1957), *Untitled
(Gaming) (Bez tytułu [Gry])*,
1933?, gelatin silver print,
16.2 × 12.2, Muzeum Sztuki w
Łodzi

108

JANUSZ MARIA BRZESKI
(Polish, 1907–1957), *Oil Lamp
(Lampa naftowa)*, c. 1930,
gelatin silver print, 15.7 × 11.7,
Muzeum Sztuki w Łodzi

107 | 108

109

Janisch's *Sisters*, likely made in 1933 and perhaps exhibited that fall as well, gives one of the sharpest instances of this instrumental attitude toward French surrealism. The collage operates a shockingly funny dehumanization of the bourgeois female body through the replacement of living faces with skulls and internal organs **(cat. 111)**. Five Catholic schoolgirls, their bodies ordinarily stifled by white dresses and an armchair existence, have had their physicality forced violently to the surface, their faces turned into picture frames for formless masses of bone and innards. The French first names signal an overture to Paris, a means of communicating allegiance from a distance that recurs frequently across central Europe. In the context of a regional town such as Lviv, the use of foreign names adds a level of attack: here is an argument not just against rationalist bourgeois mores, but also against aesthetic provincialism. As Marek Włodarski, another Artes member, argued in his 1936 article, "We're Fighting for a Living Art," innovation is not a guarantee of improvement over tradition, but at least "those artists, who traveled to Paris, declare their sympathy for art by modernists" — Pablo Picasso, Fernand Léger, André Masson are among the names given — "[and by] affiliating with young people, are closer to modernity."[24]

Other photomontages made by members of Artes such as Margit Sielska (see **cat. 95**) seem mysterious, even arcane in their signification, and display little connection to orthodox surrealist practices — yet it was these works precisely that seem to have consolidated the group's reputed affinity with the surrealist movement. In a lengthy meditation prompted by the fall 1933 exhibition and especially by Janisch's

play. The camera is used as an instrument of ritual documentation, and the space of the game occupies a three-dimensional environment, giving the production the character of what in the 1950s and 1960s would be called a happening.

Artes was primarily a painters' collective, and of the dozen or so exhibitions organized by the group, only two appear to have included montages.[23] Artes also promulgated no collective program, although its members spoke out from the beginning in favor of youth, experiments, and the importance of giving voice to unconventional personal expression. Surrealism thus held no declared position within the group's activities. And yet Jerzy Janisch, who stayed repeatedly in Paris between 1924 and 1939, tested surrealist motifs, particularly in his few photomontages; his colleague Aleksander Riemer painted two *Surrealist Compositions* for a 1930 exhibition, where he hung them alongside others titled *Paris Fair* and *Parisian Shop*. To this group, it seems, truly modern French art meant, among other things, surrealism, which in turn betokened freedom from aesthetic habit and the shackles of civic responsibility.

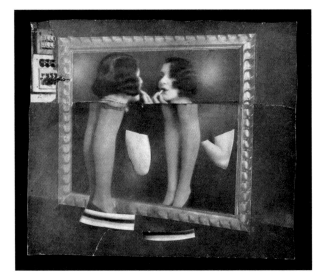

110

109

WŁADYSŁAW BEDNARCZUK
(Polish, 1904–1944), *Untitled*
(Bez tytułu), 1932, gelatin
silver print, 21.6 × 17, National
Museum in Wrocław

110

STEFAN THEMERSON (British,
b. Poland, 1910–1988), *Composition (Study for the Film Europa)*
*(Kompozycja [Studie dla filmu
Europa])*, 1931–1932, gelatin
silver print of photomontage,
10.7 × 12.2, Private Collection

111

JERZY JANISCH (Polish, 1901–
1962), *Sisters (Siostry)*, c. 1933,
photomontage (printed
matter), 24 × 28.2, National
Museum in Warsaw

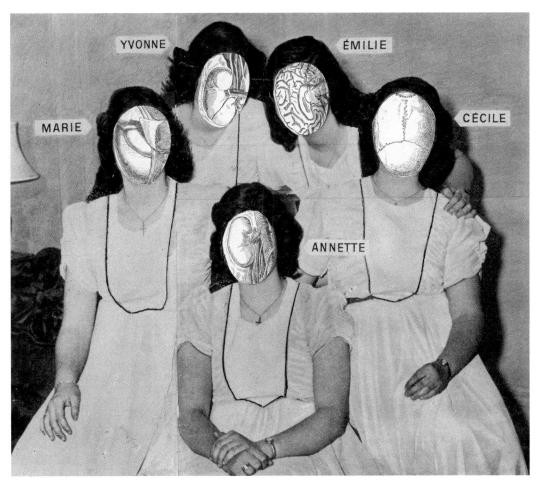

111

montages, Lviv art historian Helena Blum developed
a series of ontological reflections on surrealist creativity that seem particularly suited to operations of
photomontage: "Turning to individual forms in the
external world, the artist gives himself over to them in
all their materiality, strengthening [his art] even by
giving it suggestive, magic traits…the artist goes
beyond the physical characteristics of objects."[25] One
year later, the poet and literary critic Deborah Vogel
was moved by Artes works to propose "A Genealogy
of Photomontage and Its Possibilities," in which surrealism played a catalytic role. In Vogel's "genealogy,"
which takes just two pieces (by Włodarski and Otto
Hahn, both since lost) as its alpha and omega, surrealism gives the initial impulse to make photomontage,
for it provides a rationale to bring together disjunctive associations of real elements: "an external, associative reality, the content and theme of which is compatibility and connection between diverse forms and
rhythms."[26] Vogel contrasts this "magical" abstraction with what she calls "post-surrealist montage," in
which formal suggestiveness is balanced by an attention to figuration and ultimately to social content.

At least one known photomontage by Krzywobłocki clearly echoes a series of associative works
by František Vobecký, a Czech painter who made
important forays into photography in the mid-1930s.
Vobecký's tabletop assemblages of alternately innocuous and threatening sundry objects **(fig. 6.5)** were
evidently made expressly for the camera, as Vobecký
exhibited the photographs but not the sculptural
compositions they showed. *Dancer* **(cat. 112)**, one
such creation from the 1930s, plays on the vogue
for modern dance discussed in chapter 4. Twisted
lengths of wire and celluloid film imitate the undulations of hair and body, respectively; one thinks
particularly of the flowing robes of Isadora Duncan,
whose love of Hellenic culture finds a parodic echo
here in the plinth formed by a white paper cylinder,
perhaps a simple cigarette.

6.5 František Vobecký, *Torso (Torso)*, 1937, gelatin silver print,
28 × 38.6, National Gallery of Art, Washington, Gift of Annette and
Rudolf Kicken, Berlin

112

FRANTIŠEK VOBECKÝ (Czech, 1902–1991), *Untitled (Dancer) (Bez názvu [Tanečnice])*, 1930s, gelatin silver print, 39.1 × 29.6, The J. Paul Getty Museum, Los Angeles

113

JANUSZ M. BRZESKI (Polish, 1907–1957), cover for Marian Dąbrowski, ed. (Polish, 1878–1958), *Tajny Detektyw (The Secret Detective)* 1, no. 35 (13 September 1931), photolithograph of photomontage, 40 × 29, Jindřich Toman, Ann Arbor

The dancer's face, figured by a roughly punctured metal washer, expresses a seemingly exceptional hint of brutality in this otherwise winsome creation—but the whole composition, despite its premise of frivolity, comes to feel menacing. There is a tawdry quality to the roughly glued paper background, with its torn edges and blistered surface, and the sculptural materials speak insistently of cheapness and trash. Whereas Štyrský's photographs of barbershop dummies and orthopedic body parts stay within the realm of purchasable goods, Vobecký's *Dancer*, like other arrangements of found materials by Czech avant-gardists at this time—Lenhart, Nohel, and sculptor Ladislav Zívr in particular—has as much in common with dadaist explorations in recycling utterly unsalable refuse.[27] The rawness of this work, intensified by a grainy, metallic print surface, resists the poise suggested in its title. A creative tension thus subsists between art and garbage, between things to keep and things to throw away. As in many Czech and Polish creations, furthermore, that subversive insight is delivered with a disarming sense of humor.

Humor is broadly evident in many surrealist-inflected works for the popular press throughout the central European region, again primarily in Poland and Czechoslovakia. The Kraków artist Brzeski, for example, seems to have switched regularly between "difficult" experiments such as *Gaming* (see **cat. 107**), which he showed only to friends, and montages for mass consumption that merely flirt with surrealist motifs (**cat. 113**; see also chapter 9). Brzeski had a predecessor in Štyrský, although the two appear not to have known of each other. In 1929–1930, Štyrský eagerly participated in a Czech edition of the pre–World War I French crime thriller series *Fantômas* (see **cat. 100**). It is possible that Štyrský himself suggested this project to publisher Jan Fromek, who for years had collaborated with foreign and domestic avant-gardists. Indeed, even before the poet Desnos pleaded (in the 1928 homage to Atget quoted earlier) for a French reissue of the *Fantômas* series—a project that succeeded there only later—Štyrský and Toyen had explored surrealist motifs in photomontage covers for homegrown literary products such as *Haunted House (Strašidelný dům)* by Jan Bartoš (1926).[28]

Unlike Brzeski's mass-media creations, the *Fantômas* covers can in no way be regarded as superficial adaptations of surrealism, for they were made by a practicing surrealist (if not yet an officially consecrated one) and brought to life a project called for by members of the ultimate surrealist authority in Paris. They exemplify rather an "earnestly humorous" entry

into the circuits of popular culture, not yet a capitulation to it but engaged in a way that the francophone surrealists never were or wanted to be. Štyrský and his partner Toyen pursued that line of reasoning to its basest, boldest extreme, publishing books and journals for (potentially) general distribution during the early 1930s that featured dirty images—one of them in fact adapted from a Brzeski cover for the crime tabloid *Tajny Detektyw* (see **cat. 113**). The two artists cultivated erotomania, particularly in the short-lived journal *Erotická Revue*, which in accordance with censorship laws was distributed in brown paper covers to subscribers only. Apart from Toyen, Štyrský found a willing fellow traveler in Bohuslav Brouk, an adept of Marxism and psychoanalysis who wrote treatises on sexuality, autoeroticism, and—as an afterword to Štyrský's most daring work, *Emilie Comes to Me in a*

113

114

Dream—pornography.[29] Poet Nezval also availed himself of Štyrský's illustrations for his book *Sexual Nocturne*, an account in verse of a whoring escapade.[30] In a remarkable, transgressive act of maturation, as art historian Karel Srp points out, members of the future Czech surrealist group thus "exchanged the sincere love and emotional embrace typical of the sentimentally inclined Devětsil generation in the early 1920s for cold sex."[31]

These sexually explicit works, like Štyrský's gleeful vivisection of domesticated bourgeois bodies in his series *The Movable Cabinet* (see **cat. 102**), are transgressive in the central European context for another, signal reason as well: they shamelessly introduce strictly private concerns into public discourse. Štyrský's photomontages share this trait with hallucinatory self-portraits by several Czech photographers, the sensual composition *Why?* by Kašpařík, and the nudes and portraits photographed by Ada Novák in the early 1930s **(cat. 114)**, most if not all of which were placed on public view in exhibitions. Such openly intimate or personal creations challenged the guiding assumption that culture represented a national heritage, and as such should be educative and understandable to all.

That this insight became clear to the artists themselves is attested by the Czech surrealist group's protest homage to nineteenth-century romantic poet Karel Hynek Mácha in 1936, on the hundredth anniversary of his death. Mácha, who died at age twenty-six, had been venerated for decades as an ill-fated literary genius; his epic love poem *Máj* (May), first published in 1836, is considered even today the greatest example of verse in the language. With this vaunted standing in literature came lionization as a Czech patriot, a worshipful stance that presented the soulful Mácha, who counted Lord Byron among his inspirations, in the mold of a professorial "national revivalist."[32] The surrealists wished precisely to disentangle poetry from patria, and to reclaim Mácha, perversely, as a "true revolutionary" by reason of his self-conscious sensuality and fantasy—the Czech word *máj* itself is a cliché of youthful ardor.

The anthology *Neither Swan nor Moon*, a collective surrealist publication on Mácha, accordingly was filled with illustrations by Štyrský, Toyen, and others, accompanied by pointedly subversive writings. The honor that tour guides, bad artists, and memorabilia hunters pretend to heap upon the long-dead writer "amounts merely to the vulpine antics of vultures feeding on the fame of an outstanding personality, as priests once did with popular saints," wrote Brouk in the book's most incendiary contribution, "The Cult of Mácha." Instead of vaunting Mácha's supposed national zeal and upstanding morals, these "leeches" and the sightseers they keep in tow ought to read his private diary, filled with intimate records of his marital relations, for in them "Mácha left proof that his sex wasn't overgrown with moss."[33] Such calls elicited vehement criticism, aimed particularly at Brouk for suggestions that were deemed not just blasphemous, but traitorous as well. And yet, as Alfred Thomas has observed, Mácha himself demonstrably played patriotism and verse against each other, "freeing poetry from its social and political responsibilities to the nation" in what, within this context, may be construed as "a profoundly subversive and political act."[34]

This surrealist "rescue operation" in the domain of national cultural expression would soon take on a different cast. During the first week of October 1938, even as the Nazis were beginning their annexation of Bohemia and Moravia, Mácha's body was exhumed from its resting place in the German-majority borderlands and moved under army command to Prague. On 6 May 1939, two months after the occupation of Czechoslovakia, more than one-quarter million citizens attended a tearful state burial for

ADA NOVÁK (Czech, 1912–
1990), *Nude (Akt)*, 1932, gelatin
silver print, 21.5 × 15.5, Morav-
ská galerie, Brno

115
VÁCLAV ZYKMUND (Czech,
1914–1984), *Self-Portrait
(Vlastní podobizna)*, 1936,
gelatin silver print, 18 × 13,
Moravská galerie, Brno

6.6 Jiří Sever, *Untitled (Bez názvu)*, from the series *The Investigation
Yielded No Results (Pátrání zůstalo bez výsledku)*, 1941, gelatin silver print,
17.3 × 23.4, Museum of Decorative Arts in Prague

Mácha, "the nation's great minstrel."[35] The surrealist
group had splintered in the meantime precisely over
the question of loyalty to a larger political body—
not the Czechoslovak state, of course, but the Soviet
state. Like its French counterpart, the circle around
Teige was riven by this debate, with Nezval filling
the Stalinist role of Louis Aragon, and Teige siding
with Breton in a stand for nonalignment: "We serve
the common interest of avant-garde art and an
avant-garde proletariat, [that is] the struggle *for
a true freedom of the mind*; we protest every persecu-
tion of independent art, no matter who signs the
censorial decrees."[36]

Surrealism was forced from view in Nazi
Czechoslovakia, but unlike in France, many of its
adherents—those who survived—neither left the
country nor stopped developing their ideas. Jindřich
Heisler, one of the youngest members of the group,
collaborated with Štyrský on a book, pairing Štyrský's
pseudo-documentary photographs of 1934–1935
with verses by Heisler that emanate a deceptively nos-
talgic atmosphere of discomfiture. A sense of irrita-
tion developing into unease obtains already in the
"pricking" title: *On the Needles of These Days*.[37] Inspired
by Štyrský, and once again by the surrealist reading
of Atget, Jiří Sever (Vojtěch Čech) began around
1940 to fashion imitation photo essays that demon-
stratively lack a narrative thread, such as *The Investiga-
tion Yielded No Results* **(fig. 6.6)**. Meanwhile, Heisler,
like Teige, made an impressive body of manipulated
photographs and photomontages (see chapter 9).

Both staged and documentary surrealism con-
tinued to develop at a distance from Prague, princi-
pally in the Moravian capital of Brno. Václav Zykmund
led a group of participants in two "actions" during
1944, for example, in which the collective experience
of ritualized play was organized explicitly for the cam-

era. These *řádění* or "sprees" consisted of objects and
friends posed in mysterious, often fetishistic arrange-
ments: faces covered with shards of glass or tattered
newspaper; hands turned into potted plants; arcane
symbols suggesting astrology or distant travel
inscribed on patches of exposed skin. Deceptively
light-hearted—Zykmund later opined that Czech
surrealism had inherited a native legacy of softness
and lyrical refinement in art—the two events never-
theless emanated a claustrophobic sense of threat.[38]
Zykmund had tested a juvenile surrealism during the
1930s, for instance in self-portraits from 1937, one
with his head bound in fine string **(cat. 115)**, another
showing himself in hearty laughter while holding
a lightbulb between his teeth. Suggestions here of
bondage or eroticism are pranksterish; the string
around Zykmund's face is absurdly thin, while the
lightbulb, a substitute breast, reads as the prop for
an ambiguously gendered flirt. In this jokiness lies
Zykmund's strength. His inventive photographic por-
trayals, which neither avoid existential themes nor
propose a ponderous reflection on them, form a
"gentle" resistance to Art with a capital A, and to the
society that venerates it.

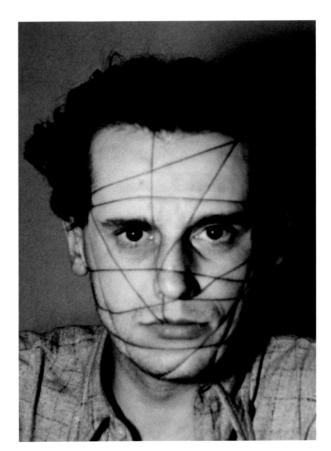

115

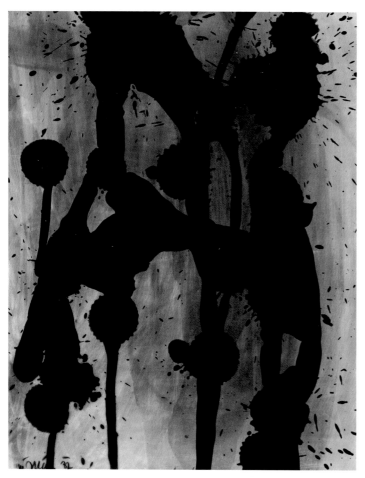

136

116

Similarly gentle, but with a more ruminative, melancholic thrust, are the many pictures taken during the war years by Miroslav Hák, perhaps the most gifted photographer of this lost generation. Hák, who apprenticed in photography as a teenager with the prestigious Langhans portrait firm in Prague, was one of the rare adepts of surrealism in Czechoslovakia who expressed himself exclusively with the camera. During the 1930s, Hák experimented with a variety of darkroom techniques designed to liberate the unconscious, leading in 1937 to a method of gestural abstraction he called *strukáž* **(cat. 116)**. Spattered, poured, and partially washed-off fixing solution (Hák's name for these prints derives from *struktura* or "structure" but echoes as well the verb *stříkat* or "spraying") yields compositions of radically subjective expression, devoid of the connotations of micro-photography or other scientific investigative procedures that accompany much surrealist abstraction in photography, for example the *fotografiky* by Povolný discussed earlier.

Hák turned from automatist works during the war years to hushed scenes of the outlying districts in Prague. His photographs of graffiti-covered walls, tattered street posters, criss-crossed tram lines, or a hulking natural gas container[39] refuse all engagement with the city's baroque charm and its modernist dynamism—refuse, that is, the city's public or official face. Here, once again, we see the legacy of Atget in a turn toward the popular and peripheral aspects of a changing capital city. Hák is only somewhat interested, however, in the "no longer fashionable objects" that so fascinated Štyrský, and his pictures resist nostalgia. The rubble glimpsed through an open street-car door in *End of the Line in Dejvice* **(cat. 117)** is not a sign of vanishing urban ways, it is a picture of what has simply been destroyed—and of what will endure.[40] The end of the line is always there. It is a prosaic place, unmoving, potentially hopeless. Yet through a small door that opens onto the wrong side of the tracks, we see what may be taken as a minimal offer of individual liberty: a threshold just wide enough for one person at a time.

116

MIROSLAV HÁK (Czech, 1911–1977), *Structage (Strukáž)*, 1937, gelatin silver print, 31 × 24.4, Museum of Decorative Arts in Prague

117

MIROSLAV HÁK (Czech, 1911–1977), *End of the Line in Dejvice (Konečná v Dejvicích)*, 1944, gelatin silver print, 29.7 × 39.8, Moravská galerie, Brno

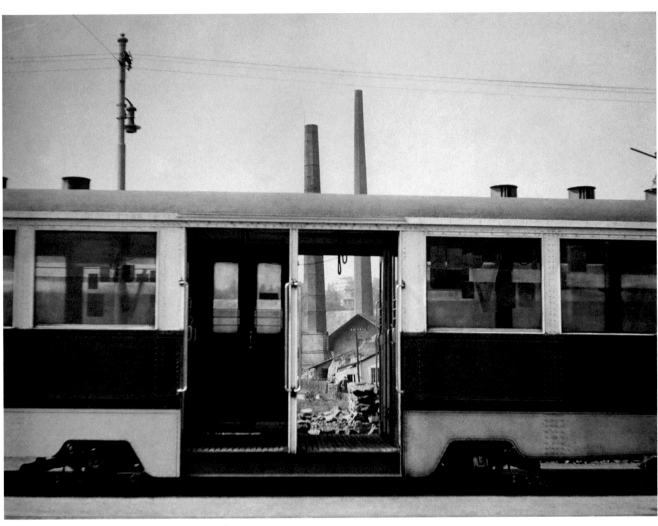

117

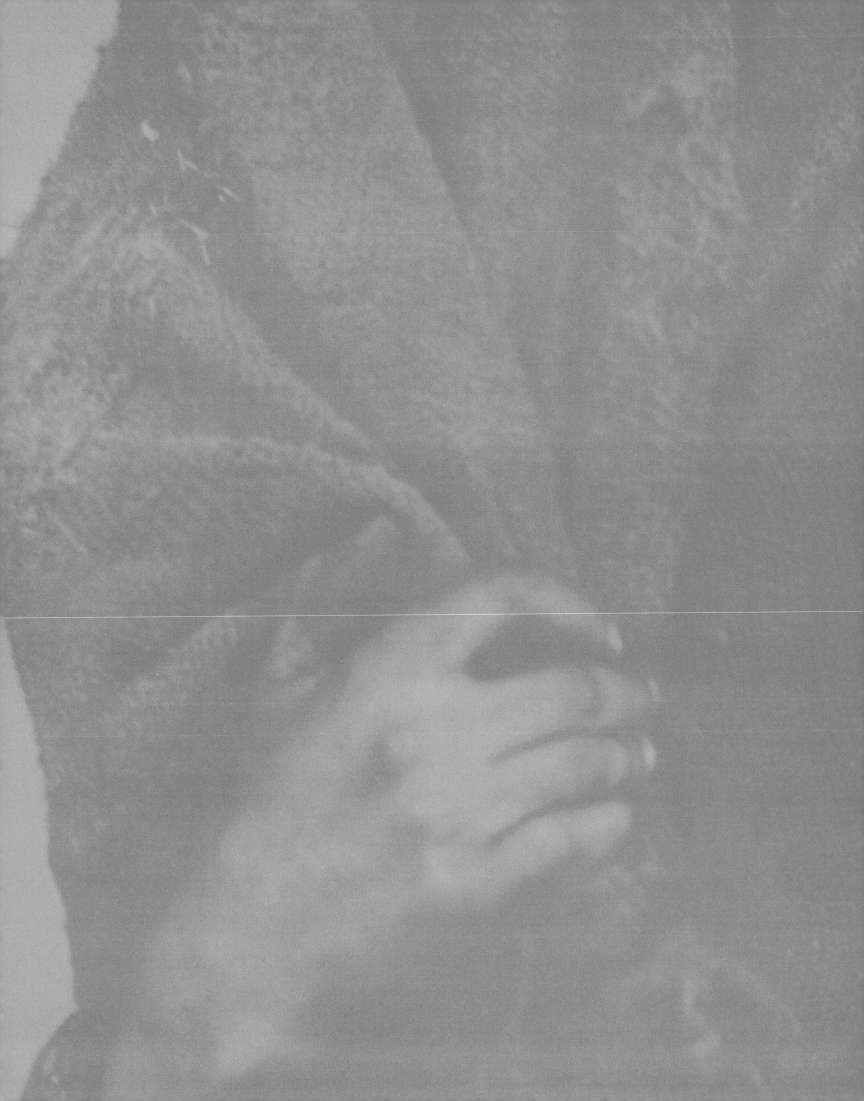

chapter 7

Activist Documents

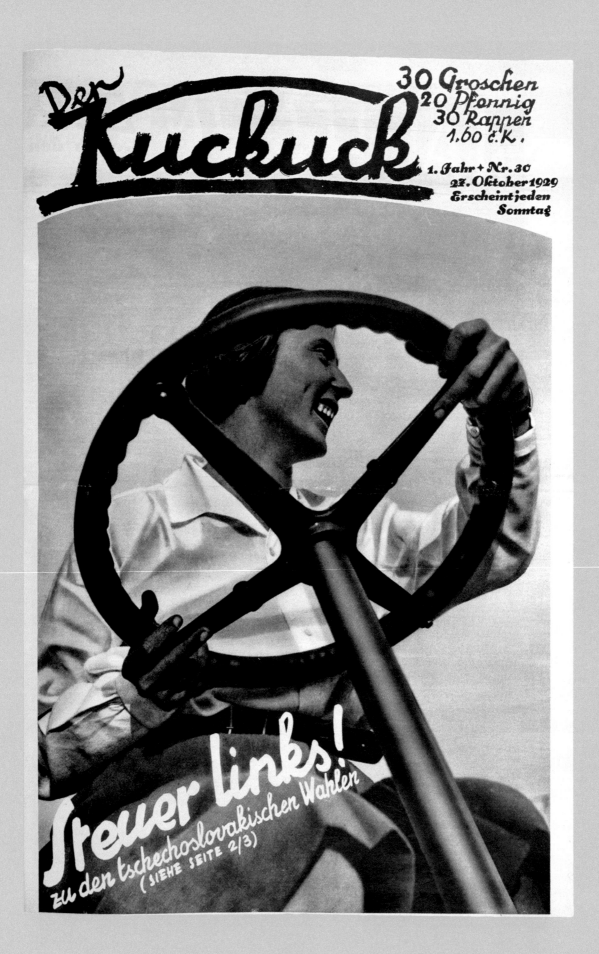

Activist Documents

126

SIEGFRIED WEYR, ed.
(Austrian, 1890–1963), "Steer
Left: On the Elections in Czecho-
slovakia" (Steuer Links: zu
den Tschechoslowakischen
Wahlen), *Der Kuckuck* (*The
Cuckoo*) 1, no. 26 (October 1929),
photolithograph on newsprint,
48.6 × 32.3, Collection of
Josef Seiter, Vienna

A class-conscious photography movement called vari-
ously worker photography (*Arbeiterfotografie* or *munkás-
fotó*), reportage, and social photography (*szociofotó*
or *sociální fotografie / sociálna fotografia*) developed
everywhere in interwar central Europe except Poland.
Celebrating labor and protesting its oppression by
capital, this tendency gained momentum around
1930, attracting thousands to its cause and leading
to some of the most provocative publication and
exhibition projects of the subsequent decade. A spe-
cific, in certain ways surprising concept of the term
"documentary," which came into widespread use in
photographic discourse during the late 1920s, proved
vital to this movement. Presentation of facts and
"real-life situations" was of course paramount. Yet the
commonly held documentary ideal of a neutral or
"unmediated" record had no place here; instead, edi-
torializing guaranteed the propaganda value of what
we are calling "activist documents." The quasi-scientific
impartiality considered "true documentary" by some
contemporary commentators, which remains a model
today for news reporters and other photographers —
one far more often questioned, however, than
upheld — did not match the activists' aims.[1] Nor did
the subtler approach championed in the late 1920s
by Soviet avant-gardists (including Aleksandr Rod-
chenko) under the term "factography," whereby a
deliberately impersonal and exhaustive montage of
raw data offered greatest enlightenment regarding
the fundamental causes of a given historical situation.[2]

The worker photography movement wanted
"documents" stamped by a strong, interpretative
point of view. Photographs were understood, however
naively, to convey truths, but those truths needed to
be amplified, underscored, put to work. Exhortatory
captions, explicitly instructional compositions, and
montages with an emphatic satirical or moral mes-
sage — all of which also proliferated in Soviet Russia —
decisively shaped this understanding of documentary
in left-wing central European circles. Presentations of
Soviet reportage at exhibitions throughout the region

helped spread enthusiasm for uncaptioned "snap-
shots" as well **(fig. 7.1)**. Yet the Russians' triumphal
mode was not replicated by Soviet sympathizers in
central Europe. Pathos, not heroism, characterizes
much worker photography, along with an emphasis
on revealing and criticizing existing power structures
to impel the transformation to a Soviet-style, class-
less society **(cat. 118)**.

Activist documentary advanced in tandem
with professional photojournalism, which, as it
blossomed during the 1920s, gave rise to specialists
in political affairs, such as Erich Salomon **(cat. 119)**,
as well as to omnivorous photoreporters like Károly

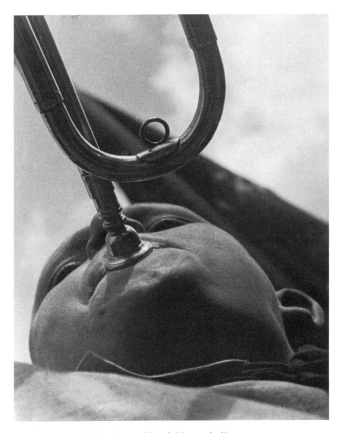

7.1 Aleksandr Rodchenko, *Pioneer with Bugle (Pioner-trubach)*, 1930,
gelatin silver print, 24.3 × 19.8, National Gallery of Art, Washington,
Patrons' Permanent Fund

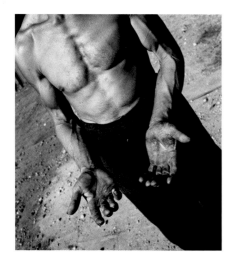

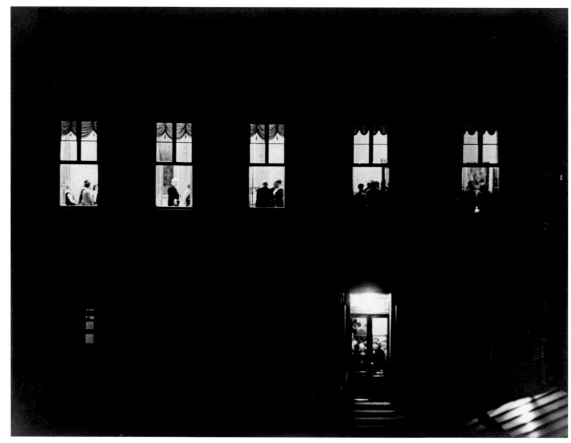

118

119

120

Escher **(cat. 120)**, whose encyclopedic repertoire included comments on social inequity. Its roots, meanwhile, lie partly in a prewar tradition of reformist sociology, exemplified in the United States by Lewis Hine's photographic reports on immigration, mining, and child labor.[3] Unlike Hine, however, social photographers in the 1930s, with notable exceptions, did not instigate specific or local reforms, as Hine did, for example, when he fought to improve working conditions for children. They aimed mainly to develop an eye sensitive to the proletariat, and even a proletarian eye. This revolutionary struggle therefore had as much to do with photography, and even with art, as with political activism. In theorizing a proletarian function for photography, the activist documentary movement exhibited once again the drive to reflect on structures of the modern image world that is utterly characteristic of central Europe.

The most visible vehicle for worker photography was also the earliest, the *Arbeiter Illustrierte Zeitung* or *AIZ*. Begun in Berlin in 1921 within the ranks of a German communist charitable association, the magazine became an independent, highly successful periodical under this name in 1924, reaching a distribution of nearly one-quarter million copies after its shift to a weekly format in December 1926. To circumvent established press agencies, which furnished photographs deemed inimical to the proletarian cause, the *AIZ* launched a call for submissions by its own readers in March of that year, offering fifty prizes of books for "photographs illustrating the worker's political, economic, and social life."[4] The enormous response prompted creation of *Der Arbeiter-Fotograf*, a new magazine devoted entirely to amateur photographs by workers.

Worker photography took hold at a grassroots level in Germany as nowhere else in the world. Though small in comparison to the established amateur network, the Vereinigung der Arbeiterfotografen Deutschlands (Association of Worker Photographers in Germany, or VDAFD) soon numbered around 2,500 members in more than a dozen local clubs.[5] For a small annual fee, VDAFD members obtained access to communally owned equipment and meeting halls, as well as the right to participate in lectures, outings, and annual exhibitions frequently organized—as they would later be in Austria, Hungary, and Czechoslovakia—by proletarian *Naturfreunde* or outdoor recreation associations.

Beyond such militant amateur groups, the idea of worker-friendly documentary held widespread

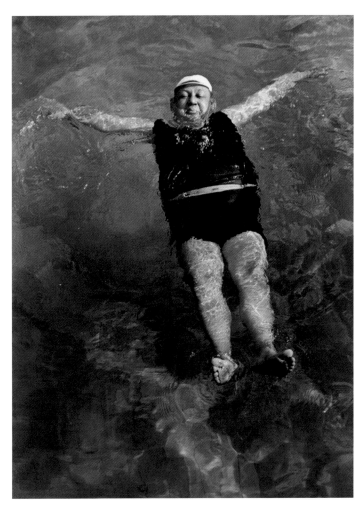

120

appeal in the 1930s, giving a ready political interpretation to a variety of photographic production. Compositions that seem far removed from the lay picture-taking prized by the VDAFD, for example the monumental study of May Day demonstrators by Bauhaus graduate Hajo Rose **(cat. 121)**, or the beautifully printed close-up of raised fists titled *Mighty Hands* by Polish professional Władysław Bednarczuk **(cat. 122)**, nevertheless fit the movement in their day. Bednarczuk, one of the few prominent Polish photographers with a working-class background, featured this painterly allegory of solidarity at an exhibition he organized with the self-conscious title *Pierwsza wystawa fotografii robotniczej w Polsce* (First Exhibition of Worker Photography in Poland) in December 1936. There never was a second such exhibition, nor did the first one travel, after weathering charges of political subversion and aesthetic inadequacy at its lone presentation in Lviv.[6] In formal terms, the works by Bednarczuk and most other participants remained strictly

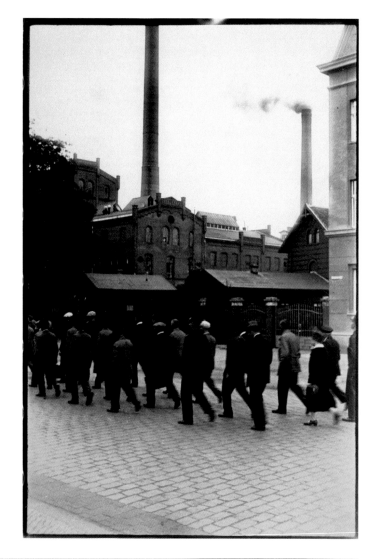

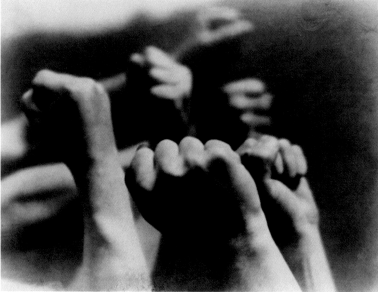

121
—
122

within the conventions of established pictorialist practice. Yet the beacon of worker photography, its light steadily fading in central Europe by the date of Bednarczuk's exhibition, gave him political focus and creative inspiration even absent the communal structures of support that had developed elsewhere in the region.

Photojournalism, a much more expansive and better funded enterprise than the largely amateur worker photography network, nevertheless responded somewhat to the ideas of activist documentary. Beyond a thematic attention to poverty or unemployment, which often signaled complacent sensationalism rather than calls for revolution, press professionals in the 1930s absorbed something of the marriage between lofty political ideals and radical (anti)aesthetic ambitions consecrated within this photographic movement. This may explain Karel Hájek's inclusion, in a gloriously large format, of a hypnotic view of antifascist student demonstrators in his one-person exhibition of newspaper pictures in 1936 **(cat. 123)**. It also helps clarify the language of itinerant journalist Heinrich Hauser, who, in his 1929 book *Black District*, an illustrated chronicle of life in the coal- and steel-producing Ruhr valley, fairly well apologized for the lack of class-conscious agitation in his text and his photographs: "These descriptions are apolitical. The author considers this a mistake, but he has to admit that his views on many of the subjects he has described are not fixed."[7] The photographs, which seem actually to have been taken by a woman named Else Thalemann **(cat. 124)**, portray the Ruhr as an eerie netherworld of blasted landscapes and spectral dwellers divorced from all semblance of nature. They fit exceedingly well Hauser's claim to have produced a narrative that works "like a Laterna magica from the beginnings of technology: pictures cast upon a canvas, often unfocused, badly lit and badly taken." The terms of this defense closely echo the emphasis in worker photography on immediacy and honesty rather than technical proficiency—but in fact such "inadequacies" are deliberately exploited here for aesthetic impact. Other works unequivocally attributed to Hauser likewise appear "unfocused, badly lit and badly taken," with the same arrestingly primitivist results **(cat. 125)**.

The blur in Hájek's composition, the delicate bromoil printing by Bednarczuk, and the attenuated silhouettes characteristic of Hauser and Thalemann all enhance visual interest without in themselves furthering a political critique through images. Their creations attest rather to the popularity of labor and

121

122

123

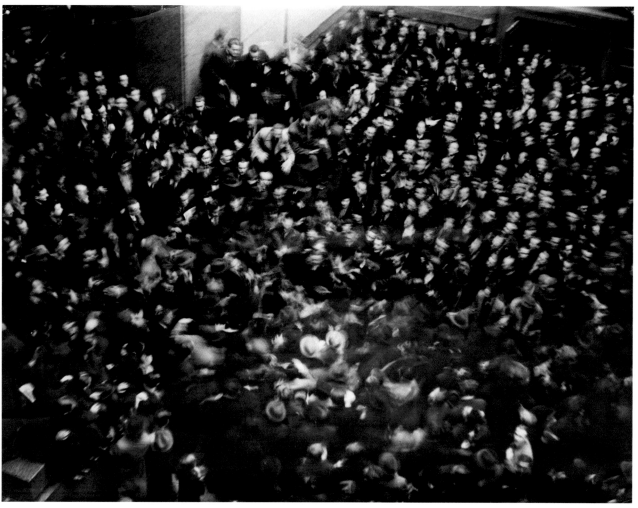

123

attendant political struggles as noteworthy pictorial subjects in the heyday of activist documentary; that is, the decade of unrest framed by the collapse of the New York stock market (1929) and the declaration of World War II. However, advocates for activist documentary themselves vigorously debated the criteria for such a critique from the mid-1920s. Kurt Tucholsky pleaded in 1925 for dialectical juxtapositions and leading text rather than stand-alone images: "Only someone who has tried it once knows the effect to be had from confronting one photograph with another. It is indelible. . . . A short caption and the public is won to your cause."[8] Photo essays, such as those on the "Filipov Family" discussed in chapter 5, appeared regularly in worker photography publications, inspired by cinematic narratives and sometimes literally emulating a cinema newsreel (**fig. 7.2**). Photomontages also found widespread favor as "documentary" imagery (**fig. 7.3**), thanks largely to the appeal and visibility of covers by John Heartfield for the AIZ beginning in 1930.

These various strategies—dialectical contrasts, narrative sequences, photomontage—all emphasize the need to construct truth rather than merely record it. Interestingly, this did not lead to wholesale skepticism concerning the intrinsic truthfulness of photographic representation, such as Hine had implied, for example, by calling his work "photo-interpretation."[9] On the contrary, many partisans of social photography took for granted the objectivity of photographs and even photomontages. One year after his call for "short caption lines," Tucholsky argued forcefully that such textual additions serve to reinforce what is in the best cases an inherent, unequivocal message: "Every propagandist knows the effect of a tendentious image . . . from advertising to the political poster, such a picture hits us, sings, shoots us in our hearts and says—when it has been well chosen—a new truth and always but one truth."[10] The supposed legibility of photographic documents, their active, even aggressive communicativeness,

found wide acceptance throughout the region.
"The meaning of photography rests . . . in its ability
to deliver the most exact copy of objects and events,"
asserted Lajos Kassák in introducing the 1932 Hun-
garian *szociofotó* book *From Our Lives*, which held no
captions at all. Yet to the extent that doubts were
articulated anywhere during these years, it was pre-
cisely within the activist movement. Thus Lubomír
Linhart, in his 1934 book *Social Photography*, argued
against fetishizing technological reliability: "The
photographic apparatus is *in reality* the same means
as a painter's brush, a writer's pen or a typewriter. . . .
It depends on *who* is using it and *to what end*. In a
mechanistic understanding of technology, we could
speak similarly of the 'objectivity' of pens or brushes,
always just as incorrectly."[11]

Advocates of activist documentary identified
their enemy as twofold: a bourgeois cultural system,
and within that system a preoccupation with photog-
raphy as art. It follows that those seeking artistic rec-
ognition for camera images, whether pictorialists or
proselytizers for "new photography," would be sub-
ject to particular scorn. "The 'New Objectivity' runs
from reality toward abstract, formal games," reads
a typical statement in *Der Arbeiter-Fotograf*, "an idyllic
world of objects that in reality is not at all objective
because it makes us believe that a minuscule, unim-
portant part of the world's images equals 'the image
of the world.'"[12] At the same time, because modernity
itself remained in many places a subject of partisan
debate, the aesthetic insights of "new photographers"
Renger-Patzsch and Moholy-Nagy continued to hold
revolutionary appeal in the 1930s. Initiators of social

7.2 Alexander Stern, *Film of a Working Person's Life (Film des Arbeiter-
lebens)*, in Siegfried Weyr, ed., *Der Kuckuck* 3, no. 49 (5 December 1931),
photolithograph of photomontage, 48.6 × 32.3, Collection of Josef
Seiter, Vienna

7.3 Francis Haar, *Untitled (Cím nélkül)*, c. 1931, photomontage
(printed matter and gouache), 24.1 × 24.1, Richard and Ronnie
Grosbard Collection, New York

photography projects in Hungary, Austria, and
Czechoslovakia combined strident calls to produce
"unaestheticized" documentary images with a scho-
lastic admiration for innovative aesthetics from Ger-
many. The imported character of these innovations
helped leaders such as Kassák, Linhart, or the Vien-
nese newspaper editor Siegfried Weyr assert the
value of internationalism against nationalist opposi-
tion to modern living and modern class politics.

This instrumental use of "international avant-
gardism" may be seen most clearly in *Der Kuckuck*,
the socialist illustrated weekly edited by Weyr from
1929 until 1934.[13] At the paper's founding in April 1929,
Weyr established satellite editorial offices in the
Saxon town of Zwickau and in Prague, the latter to
help him reach ethnic Germans in Czechoslovakia,
as the journal's coverage makes clear **(cat. 126)**.
Weyr himself had a provincial background typical for
Austro-Hungary, in which artistic and aristocratic
connections mixed with a taint of social inferiority.
Born in Galicia (in a town now part of Ukraine) to a
minor military officer of Bohemian parentage, Weyr
grew up in Vienna but was returned to the provinces
during World War I, posted to Kraków as a military
educator. He took up art history at the university
there, having studied painting in high school; upon
his return from the front he pursued but never com-
pleted a degree at the Vienna university's Institut für

Kunstgeschichte, taking classes with professors Max Dvořák and Julius Schlosser. This exposure to the successors of Alois Riegl proved decisive for Weyr, as it did for his classmate Heinrich Schwarz, one of the shaping forces in the history of photographs as images.[14] Combining his art-historical training and populist personal convictions with practical experience gained in a Vienna newsroom, Weyr shaped the *Kuckuck* into a running forum on the value of "new photography" and its suitability to promoting the socialist cause.

Der Kuckuck followed the example of AIZ in basic respects, from its mix of politics and entertainment to the alternation of photomontage and reportage, the latter derived partly from reader submissions. Weyr, like the editors at the AIZ, called for readers to make and submit their own photographs, which he then incorporated into feature articles and advice columns on photography. Average working Viennese, however, turned out to show little interest in making oppositional photographs. Weyr and his staff contributors regularly bemoaned the "bourgeois" taste of Austrian reader contributions, which forced them to rely heavily on photographs furnished by career reporters in Vienna such as Alexander Stern (see **fig. 7.2**) or Mario Wiberal (**cat. 127**), and politically sympathetic concerns such as Union Foto, the Soviet-sponsored press agency started in Berlin in 1930. The contrast between professional and lay submissions in *Der Kuckuck* grew startling, notes Josef Seiter, historian of the magazine: "Violent pictures of everyday

fascism versus *neusachlich* or neo-romantic pictures of everyday life and holidays. With the New Objectivity, worker photographers even managed to turn strikes into an idyll."[15]

The answer to this problem in Germany, where it arose as well, followed two directions. The first, militant response took the form of monitory addresses on the revolutionary responsibility that proletarian amateurs alone could fulfill. This approach found its most brilliant formulation in an essay titled "The Worker's Eye" (1930) by Communist Party education official Edwin Hoernle. Likening the brain to a built-in camera, Hoernle argued that a banker's "apparatus" is simply blocked, so that even unavoidable scenes of poverty cannot imprint themselves: "the pictures taken by his natural Camera-Head are never developed, remaining invisible to his consciousness." Only the worker might see "the hungering shape of six million unemployed" in the United States, or the "impertinent, provocative, criminal physiognomy of that Nazi youth." Yet the majority of workers, Hoernle laments, also fail to register such scenes. Their perambulating optical devices "[run around] with explicitly petit-bourgeois eyes," for they have not "trained" their vision; working people need to cultivate and implement a dialectical materialist optic, so that there might be "no camera without a proletarian class eye!"[16]

The German socialist annual *Das neue Lichtbild* (The New Photograph) trod a more conciliatory path, stressing the importance of progressive aesthetics to progressive (though not militant) politics. *Der Kuckuck* took this route as well, loading aesthetic reform with the attributes of political agitation. A review of Renger-Patzsch's *The World Is Beautiful*, for example—a book spurned in *Der Arbeiter-Fotograf*—praised this work as "one of the most meaningful documents [*sic*] of the new aesthetic and the new will to beauty. It has broken radically with the past and wants nothing to do with Winckelmann's aesthetic ideal, which still haunts the minds of the masses." What is "documented" in this account is not politics but a "radical new aesthetic" with a political valence, for it promises to free the "masses" from the oppression—of outmoded art history.[17]

"New photography" thus became a means to reeducate the proletariat, one that was seized on as eagerly by Weyr as by his less politically engaged compatriots, such as fellow art historians Schwarz or Wolfgang Born. All three men applauded *Film und Foto* when it came to Vienna in 1930, and *Der Kuckuck* published photographs from the exhibition while it

127

127

128

was still in Germany.[18] In breaking with established pictorialist convention, Weyr hoped that amateur photographers would also destroy the class conditions that determined such conventions. This is comparable in principle to Rodchenko's call for new camera angles as a means to emancipate subjectivity from class-determined habits of seeing, to establish what Rodchenko specialist Leah Dickerman calls "a transformative art…grounded in new systems of representation."[19] The demonstrable foreignness of "new photography," both in its cultivation of perceptual estrangement and in its geographic origins, added to the attractiveness of this tendency for Weyr who, like so many central European reformists, habitually looked abroad when breaking with the domestic status quo.

Thus it is that in a 1932 column on "good pictures," Weyr holds up for distinction a photograph from Hungary, showing demonstrators in a standoff with mounted police at a May Day parade **(cat. 128)**. "A good picture for our photo competition," the editorial begins, "is in our opinion one which shows an excerpt from life that both embodies an idea and appears beautiful, formally speaking. This implies that the excerpt should not be a thing with no context, but a subject which we may draw upon for our struggle." *Untitled (Violence)* presents in Weyr's estimation a "classical solution" to that proposition. "Look at it carefully. Demonstrators between the legs of the police horses. Children, women, and men. Seen through the dungeon bars of [prime minister Miklós] Horthy = Hungary. A political thought, a historical situation that the photograph expresses completely and in a way comprehensible to everyone. An ideal photo for our competition."[20]

The photograph thus presented in *Der Kuckuck* for collective admiration and interpretive scrutiny carries no authorial source, as Weyr explains to spare its maker political reprisals. In fact, the picture, made by Lajos Lengyel, is the lead image in *From Our Lives*, which appeared already in May 1932 with all its picture credits in place. Subtitled "the first Munka photo book," *From Our Lives* marked the most ambitious undertaking to date of the Munka-kör or Work Circle, the leading entity for worker photography in interwar Hungary. While never truly popular as in Germany or even Austria, activist documentary in Hungary achieved an organized presence of remarkable dimensions, both within the borders of the postwar state and in cities formerly under Hungarian domain, such as Bratislava (Slovakia) and Timişoara (Romania).

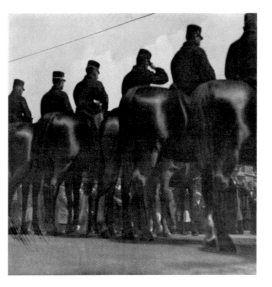

128

From Our Lives—as a book and as the published record of an exhibition[21]—marks a distinctive contribution to the activist documentary movement. In contrast to the German concentration on city workers, this book devotes significant attention to laboring peasants and the rural poor, a reflection of the agrarian economy on which Slovak social photographers focused as well. The book also intersperses agitational photographs, such as the one by Lengyel, with paeans to modern technology and indeed to modern photography, in keeping with the interpretation offered by one reviewer of a Munka show held at the time: "Beyond the search for documents [and] socialist propaganda…these photographs, even if unknowingly, or at times even despite conscious goals, attempt—to use an old, faded, but forever true word—to be beautiful."[22]

In Munka-kör camera images we see once again the instrumentalization of "new photography," whereby aesthetic innovation and political radicalism merge into a single revolutionary struggle. As Kassák himself said (in a review of a book titled *The New Photography*), an understanding of photographic modernism "is [especially] useful for worker photographers, who as a result of their situation are largely uncultured in the methods, sociology and aesthetics of art photography, without which it is virtually impossible to fulfill the role [they] have assumed."[23] Activist documentary, in other words, does not oppose politics to art per se, but rather equates new art with radical politics. Learning "new photography," Kassák contends, is indispensable to formulating an effective new political message. *From Our Lives* may thus be considered as much a primer in style as a call to action.

The photographers included in this book—Lengyel, Francis Haar, Tibor Bass, Sándor Frühof, and others—were in fact career photographers rather than proletarian amateurs, so that the "our" in the title amounts to a figure of projected solidarity. Kassák, meanwhile, stood as a bridge between the large community of Hungarian expatriates at the Bauhaus and in Berlin, and artists or designers at home who sought kinship with international avant-gardism. Kassák himself had gone into exile during the "White Terror" that followed the suppression of the short-lived procommunist government in August 1919. He continued there to publish *MA* (Today), an art periodical that juxtaposed the work of Hungarian and other European avant-garde artists. *MA* published writings and art from many dadaists, for example, particularly in Germany, and sparked a Hungarian strain of Dada as a result. Moholy-Nagy, who accompanied Kassák to Vienna but stayed only briefly, became the journal's representative in Berlin and contributed important material by himself and others to the magazine in 1921 and 1922.[24]

Although Kassák did not subsequently begin to make photographs himself, as Moholy did, he welcomed first film and then photography increasingly into his publishing activities and art criticism. Returning home in 1926, Kassák founded the periodical *Dokumentum*, its title the expression of a preference for "honest" facts rather than aesthetic falsification. "We are not making an art magazine," declared one editorial, "but trying to sketch the state of the world in cross-section from a social point of view."[25] To judge by its contents, the journal more accurately traced the utopian world of "modern living": body culture, rationalist architecture, urban planning, film, advertising, aviation. *Munka* (Work), a monthly journal inaugurated in September 1928, one year after the demise of *Dokumentum*, would focus aggressively on social goals; it carried the subtitle *Report on Art and Society*. "We want to act as artists, teachers, technicians, and critics of the society: we are not professional politicians," Kassák argued in the opening editorial, presenting the magazine as nonpartisan. "Political struggles have a thousand elements," he continued, however, "[and] those who know more … will have greater opportunities within … the clash of ideologies."[26] This is where *szociofotó* had a role to play.

Articles on photography and related subjects ran from the first issues, including many drawn from Kassák's Bauhaus connections: a piece by Herbert Bayer on "Typography and Propaganda" and Moholy-Nagy's article "The Renaissance of Photography," to give two early examples.[27] Reproductions of photographs by Moholy and by like-minded local talents such as László Reiter underscored the new journal's orientation. Then in January 1930, *Munka* staff writer Lajos Gró sounded an appeal for reader submissions that, had it yielded results, would have turned the journal into a cousin of *Der Arbeiter-Fotograf*. Workers must go beyond the recreational pursuits of Sunday photographers, Gró proclaimed, and record the world around them from a socialist point of view, "so that [their] photographs, more than entertainment, become expressions of a human vision: partly a weapon of class struggle, partly a historic document of the workers' movement."[28] The small pool of working people who owned cameras, combined with sustained opposition by studio photographers and established amateurs to what they viewed as "unaesthetic" and dangerously unpatriotic imagery, kept activist documentary in Hungary a restricted affair.[29] In place of a popularly illustrated journal there arose the Munka-kör, a tightly knit professional collective formed just one month after Gró's article, which shared outings, discussions, and plans to publish and exhibit social photography.

In addition to its book project, *From Our Lives*, the Munka-kör organized four exhibitions and a short-lived magazine, *Munka Kultúrstudiója* (Munka Cultural Workshop) in 1931–1932. Group activities declined thereafter, but individual members, particularly Haar, gained in prominence and continued to be featured in the pages of the *Munka* journal.[30] It was also Haar who, following the first exhibition, held in Budapest in February–March 1931, explained the group's postulates and goals in *Munka*. Among the principal aims he listed education, the unfalsified depiction of reality, formal experimentation, and breadth of inquiry: "The worker has to strive toward knowing the world through photography. This does not mean, however, that the activities of a worker photographer are limited to recording the hungry in shantytowns and children affected by polio."[31] The point would be stressed as well by Kassák, who argued in *From Our Lives* that a worker's photograph "mirrors his character also in cases when it tells us nothing about misery or pathetic revolt." Such scenes, Kassák warned, appeared often in the daily newspapers, where they served only to spectacularize the suffering of others: "From photos of misery or street demonstrations as sensation it is still a long way to photography with socialist eyes."[32] The push to represent both dignity and suffering, or what photography historian Ľudovít Hlaváč has called "the full life range of social themes,"

marks activist documentary in Hungary and Slovakia, and gives a further explanation for advocating "new photography" in these countries. A study of a jug on a windowsill, or a view of cattle or city lights, could complement scenes of hard labor and squalor to suggest the spectrum—and the modernity—of a working-class environment.

At the same time, a notable prejudice subtends these ostensibly dispassionate observations on working people. At the opening of *From Our Lives*, Kassák develops a worrisome analogy between "gray" proletarian life and the tones of the photographic print: "Such a life appears as gray only to those who see color exclusively in the multi-colored. What an endless, manifold variety of color there is in the grayscale! What childlike immediacy, what a beautiful play of force lines extend through the angular movements of an apparently awkward worker." The equation of new art and radical politics can make for uncomfortable inferences. Kassák seems to suggest here a parallel between photographer and subject, in which both make a virtue out of given limitations—yet the "worker photographer" in this comparison chooses and manipulates his materials, whereas the actual worker forms a passive, infantile object of aesthetic contemplation. It bears repeating here that the photographers and designers in Munka-kör, even those who, like Kassák, came from working-class families, were all educated professionals. When Kassák likens the photographer's "tender" approach to that of a doctor preparing to operate on a sick person, one understands with full force the condescension implicit in his reasoning.

This gap in consciousness, which bedevils documentary photography even today, affects particularly that subset of documentary that merges with ethnography or sociological study. At the same time, social science research has provided a lasting motivation for documentary work that aims at empowerment and increased social consciousness, and this is particularly the case in central Europe. In 1931, Árpád Szélpál, staff photographer for the Social Democratic Party newspaper *Népszava* (The People's Word) in Budapest, issued an appeal for contributions of family photographs to a Munkásfotomuzeum or Museum of Worker's Photography. Calling photography "the new means of writing history" and citing the now standard comparison of cameras to weapons in class struggle, Szélpál announced that the museum had been brought into being "to have an arsenal . . . where we gather all the visual data that relate to the worker's

condition. . . . " Readers were accordingly invited to submit for preservation and future deployment images touching on "all phases of life and work, the home, sports, and everything even of the remotest relevance."[33]

A number of long-term sociological studies were undertaken in the 1930s, meanwhile, by leftist collectives in Hungary and Slovakia. These various projects radicalized a standing tradition throughout central Europe of unapologetically ideological ethnographic research conducted to bolster national pride and calls for political autonomy.[34] Glorification of village traditions and the landscape itself, part of a complex mythology of ethnic nationhood formed in the nineteenth century, persisted through World War II as an integral component of modernism in the region. Reacting against depictions of Slovak highlanders or life on the Hungarian plain as objects of timeless, idyllic fascination, members of the Sarló (Sickle) and Sociofoto groups, along with independent photographers such as Kata Kálmán, reported on contemporary struggles for existence in rural areas and on the outskirts of major cities.

Members of the student confederation Sarló spent several summers working in the southern Slovak region of Gemer, making documentary reports that included drawings and, from perhaps 1928 or 1929, photographs as well. Sarló affiliates went "wandering" in small groups through the villages, undoubtedly with the nineteenth-century Russian *peredvizhniki* (Wanderers) in mind, gathering information destined for exhibitions and illustrated articles intended to improve social benefits for peasants and particularly for ethnic Hungarians living in what had become Slovak and Romanian countryside.[35] The movement seems to have peaked in 1930–1932, when as many as a half dozen cohorts spread out simultaneously over the summer, presenting the results of their research at exhibitions in Bratislava and in rural Hungarian towns. "Talk to the unemployed, go to the working peasant, listen to the people from the middle class," cried the militant among them, "and compare all of that to those who see as their biggest problem deciding to which sea-side resort bar they should go. . . . "[36]

The first exhibition in Slovakia seems to have been the most ambitious, accompanied by a catalogue and a conference that included addresses in both Hungarian and Slovak—an important demonstration of regionalist inclusiveness. To this inaugural showing, which opened in Bratislava on 28 September 1931, go the honors for introducing the term *szociofotó*

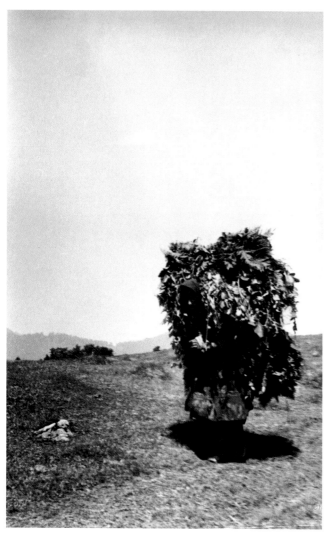

129

into Hungarian discourse. While the mostly ethnic Hungarians of Sarló pursued research in the south, a majority Slovak group undertook documentary series on grape harvesting, hay making, tobacco production, and other seasonal labor in the area around Žilina, to the northwest. Just as Sarló was breaking up, in 1934, members of this second group founded their own exhibiting collective, likewise based in Bratislava, that took as its name the Slovak version of the title to the 1931 Sarló exhibition: Sociofoto.

The leading figures in the Sociofoto collective—Karol Aufricht **(cat. 129)**, Iren Blüh (also Blühová), and Barbora Zsigmondiová—all inserted Slovak agrarian activism into an international context of worker photography focused largely on urban situations. Blüh, who had previously taken part in Sarló activities, by her own account began documenting illness and misery in the Slovak countryside on behalf of Communist Party charity initiatives already in 1925. (Her earliest

pictures were apparently introduced by party delegates in Parliament arguing for legislation to improve rural infrastructure in Slovakia.[37]) After studying photography under Walter Peterhans at the Dessau Bauhaus in 1931–1932, she returned to Bratislava and later worked at the ŠUR (School of Applied Arts) there (the "Bratislava Bauhaus," see chapter 3). In 1933, with party funds, she opened a bookstore in her name that became a gathering place for the Sociofoto membership and a distribution point for activist documentary literature.[38] Zsigmondiová, meanwhile, placed a reportage titled "The Slovak Village" in the AIZ in 1933, which offered metropolitan readers images of hardship particular to rural life. When the shelves are bare in the country, for example, the food is really gone; it is not possible to search for scraps in restaurants, markets, or the garbage **(fig. 7.4)**.

A further, nonaligned ethnographic movement developed at the university in Szeged, a large city in southern Hungary, during the early 1930s. Led by Gyula Ortutay, a young professor of social studies, the Falukutató mozgalom (Village Exploration Movement) pursued research into music, handicraft, and other village traditions.[39] For an exhibition in August 1933, titled *Városból tanyára 15 km* (15 Kilometers from Town to Homestead), Ortutay's group collaborated with photographer Judit Kárász, a former classmate of Blüh at the Dessau Bauhaus.[40] Kárász's pictures of hunger and poverty, particularly among children, emphasized the disparity in living conditions between highly proximate locations in city and countryside. As an indication of the regional circulation of ideas, this exhibition is important, for it took its inspiration from a 1930 feature in *Der Kuckuck*, "Fifteen Kilometers from Vienna," which described a visit of inspection to immigrant textile workers occupying a hideously dilapidated former refugee camp in nearby Mitterndorf.[41]

Building on these many sociologically motivated projects, in 1937 photographer Kálmán released a major book, *Tiborc*, which imprinted the countryside onto the city and onto national consciousness in an unprecedented way. Named for a downtrodden serf in the 1821 novel *Bánk Bán*, considered a foundational literary work of the Hungarian nation, Kálmán's book presented only searching, empathetic portraits of regular workers, captioned with the name and occupation of her subjects and paired with short biographical sketches **(cat. 130)**. Zsigmond Móricz, a highly regarded writer, introduced this spare, moving collection. Reviews of the project were secured, meanwhile, from a wealth of

129

KAROL AUFRICHT (Slovak, 1910–1975), *Fačkov: Carrying a Load (Fačkov: S batohom)*, 1932–1933, gelatin silver print, 22 × 14, Slovak National Gallery, Bratislava

literary and critical talents, with the result that *Tiborc* became the first genuine photobook phenomenon in Hungarian history.[42]

Kálmán had turned to photography in 1931, presumably under the influence of her companion, the critic and historian Iván Hevesy, who had been himself impelled toward photography partly by Moholy-Nagy. Unlike Hevesy, who advocated a temperate modernism, Kálmán trained her camera from the first exclusively on subjects sympathetic to the political left, such as destitute Roma or famished children (John Heartfield incorporated one of the latter photographs into a German Communist Party election poster in 1932).[43] Throughout the 1930s, Kálmán continued unvaryingly in this vein, photographing dock workers, women in construction jobs, and other sensitively chosen subjects **(cats. 131, 132)**. She does not appear to have exhibited or published often before *Tiborc*, but her concentration on portraiture and on select communities suggests the tenacity of a career photographer-ethnologist. Despite its undertone of patronizing sentimentality, *Tiborc* signaled a new level of respect for working-class citizens, represented here as individuals possessed of a historically defined subjectivity.

7.4 Barbora Zsigmondiová, *Empty Shelves (Prázdne police)*, 1932, from Wieland Herzfelde, ed., *Arbeiter Illustrierte Zeitung* 13, no. 27 (5 July 1934), photolithograph, 38.2 × 28, The Museum of Fine Arts, Houston, Gift of Max and Isabell Smith Herzstein

Working from a rather different position, one grounded in an ideal not of one-on-one encounters but of rigorous statistical analysis, Czech architect Jiří Kroha likewise demonstrated his engagement with photographic investigation as social science in his encyclopedic visual report, "Excerpts from a Sociology of Habitat." Kroha and his colleagues in the Levá fronta (Left Front), a communist cultural organization, argued that a scientific, class-conscious analysis of existing social conditions necessarily precedes any effective urban or housing plan. Undoubtedly inspired by didactic Soviet installations such as the *Pressa* pavilion, Kroha presented this analysis at exhibitions in 1933 and 1934 in the form of collectively produced, portable photomontages. For three years, Kroha and his students at the Technická vysoká škola (Institute of Technology) in Brno compiled the statistics and magazine images necessary for a suite of eighty-nine mammoth photomontage boards on the theme of housing and daily life in industrial capitalist society. This extensive series, which treats topics from dress and child care to employment, nutrition, recreation, and sexual activity, was first presented at a *Výstava stavby a bydlení* (Exhibition on Construction and Housing) held in Brno in September 1933, traveling thereafter to the capital, Prague, for a reprise in March 1934. "Modern production methods made possible a higher social standard," Kroha observed in an article to accompany the 1933 exhibit, his language evoking clinical precision while discarding the clinical premise of detachment. "If instead of a higher universal social standard, for example in housing, we have aimed at elevating only the standard for certain social classes, the reason for this conflict is understandably...the structural composition of society."[44]

Like most of the panels in "Excerpts," *Hygiene of Clothing and Kitchen Utensils* **(cat. 133)** presents a cross-section of social classes—laborers, office workers or professionals, and managerial elite—arranged in columns from left to right. A norm for tableware is provided at left that does indeed represent "modern production methods"—a dinner service designed by Ladislav Sutnar and photographed by Josef Sudek for the "good design" guild Družstevní práce (Cooperative Work). Against this exemplary "standard" appear, along the panel's bottom half, instructional composites showing life far below the norm ("několik kusů," or "a few dishes"); near the norm, with a six-piece service, soup on the table, and pots piled in front of the sink; and well above the norm, with a full dinner set, maid service, and a copious spread to match. A similar progression is described for clothes washing

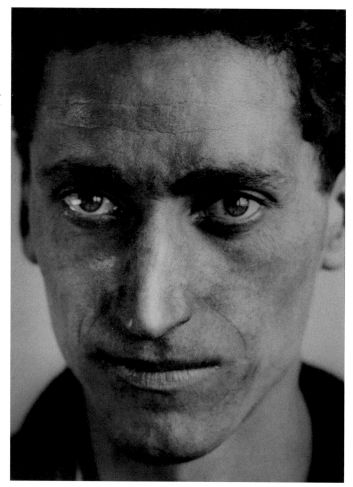

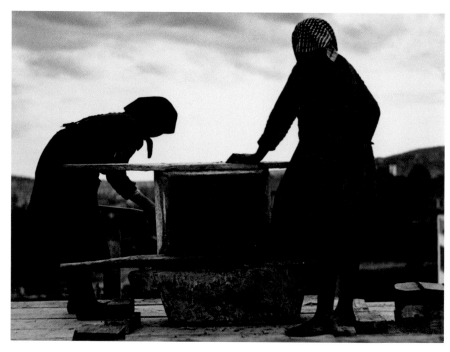

130 | 131
132

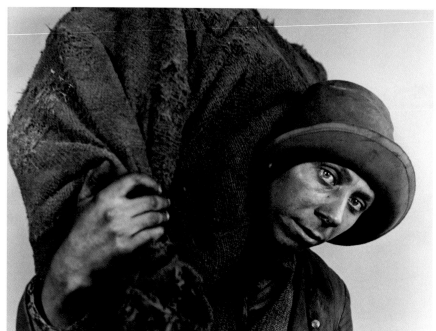

130

KATA KÁLMÁN (Hungarian,
1909–1978), *Ernő Weisz,
23-Year-Old Factory Worker,
Budapest (Weisz Ernő 23 éves
gyári munkás, Budapest)*, 1932,
printed before 1955, gelatin
silver print, 24.2 × 17.6,
National Gallery of Art, Wash-
ington, Patrons' Permanent
Fund

The fire of the golden era of
the workers' movements
burns in his eyes. The heat of
forges, furnaces, and rallies
spills onto us.... Officially he
does physical labor, though
he works not with his strength,
but with his tenacity. For his
job, not more muscle is
needed than for accounting
or X-raying. Still: the ...
conveyor belt[s] wear upon,
wring out the body more
than hammering.... He has
already started to think, but
little does he know that he is
leaving the secure darkness
[of labor] for the vague
obscurity of thought.... It is
not merely his problem, and
not narrowly that of his class.

IVÁN BOLDIZSÁR in Kata
Kálmán, *Tiborc* (Budapest, 1937)

131

KATA KÁLMÁN (Hungarian,
1909–1978), *Women Bricklayers
(Kőműves asszonyok)*, 1930s,
gelatin silver print, 18 × 24.2,
Hungarian Museum of
Photography

132

KATA KÁLMÁN (Hungarian,
1909–1978), *Coal Carrier (Szén-
munkás)*, 1931, gelatin silver
print, 18 × 24, Hungarian
Museum of Photography

133

JIŘÍ KROHA (Czech, 1893–
1974), *Hygiene for Clothes and
Kitchen Utensils (Hygiena prádla
a kuchyňského nářadí)*, from
the series *Excerpts from a Soci-
ology of Habitat (Sociologický
fragment bydlení)*, 1932–1933,
photomontage (printed
matter and ink), 69 × 99, City
Museum in Brno

133

across the top half of the panel. While the source
images have been carefully excised from their original
context to facilitate a concise and pointed compari-
son, the two proletarian sections also offer views
of the claustrophobic, unhygienic quarters in which
these activities must take place. The clean yet cramped
middle-class apartment is suggested through an
accumulation of pots on the floor, as if to say that
consumers who can afford such household items
still do not have nearly the space in which to keep
them. The actual owners of the clothing and dishware
at right, meanwhile, are nowhere to be seen. In a
different panel, Kroha represented the wealthy
as display dummies and compared them explicitly to
a high-rise designed by Walter Gropius, which Levá
fronta architects condemned as mere window dress-
ing for social ills: "a plan and a dead mannequin."[45]

The inaugural showing of "Excerpts from a Sociology
of Habitat" in 1933 took place nearly simultaneously
with the first of two large-scale *Sociální fotografie* exhi-
bitions in Prague. These exhibitions stand as the most
ambitious projects in activist documentary under-
taken anywhere in interwar central Europe, including
Germany.[46] Organized once again by the Levá fronta,
in particular its vibrant film and photography wing
(Film-foto skupina levé fronty), they presented an

international selection of works in an encyclopedic
format, suggesting thereby a scope and coherence to
worker photography that made it the fitting herald
of a worldwide proletarian revolution.

The 1933 exhibition addressed in separate sec-
tions children, work, leisure, poverty **(cat. 134)**, war,
masses, and factories: "the life and world of the class
to whom the future belongs," as declared in the cata-
logue. Following this thematic overview, comprising
work exclusively by Czechs and Slovaks, the exhibi-
tion presented nearly thirty photographs from the
Club des photographes amateurs ouvriers (Amateur
Worker Photographers Club) in Paris, who declared
themselves in a catalogue statement "still far behind
the technical and expressive means of our German
comrades, and of yourselves." The greatest sensation
came at the end: fifty works from various Soviet col-
lectives, including Sojuzfoto and a Ukrainian group,
as well as an eighteen-image sequence from the
Dnieprostroj river dam project, also in Ukraine. The
latter photographs, probably the first Soviet report-
age series to be shown at exhibition in Czechoslova-
kia, were much touted in the press. Just one month
before, Hitler had seized power in Germany, suppress-
ing the greatest outlet for Soviet film and photogra-
phy in the region. During the run of the show as well,
the "offices" of the AIZ, in the person of John Heart-

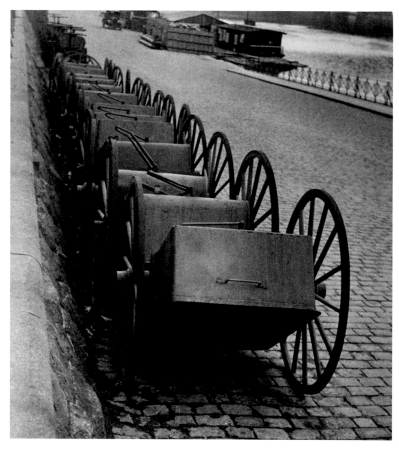

134

practices best suited to worker photography.[48] Linhart states the need to depict uplifting moments as well as suffering, and he includes an illustration by the Bratislava Sociofoto group, although he does not address the place of rural experience in the proletarian situation. Linhart also takes pains to distinguish between superficial expressions of "humanitarian sympathy" and class-conscious imagery, which must make apparent structural inequities and present a holistic analysis of social conditions. "He's sorry for the hungry child," he writes of the typical "bourgeois" photographer, "but ferociously resists removing the system . . . that is guilty for the hunger and misery of this and a million other children."[49] Turgid and somewhat repetitious, Linhart's book nevertheless summarizes with remarkable completeness the insights that make activist documentary one of the outstanding movements in photographic history.

Linhart indicates his opposition at several points to any form of photography not directed toward revolutionary social analysis, yet he admits that the best "bourgeois" work has reached an indisputable level of technical accomplishment, and *Social Photography* opens, significantly, with a short section on the history of photography as a technology and a form of artistic expression. In his two eponymous exhibitions and in the mammoth international exposition he helped organize in 1936, Linhart in fact included many examples of "new photography," modern in form but not explicitly political in content. Certain thematic sections in the 1933 social photography exhibition, such as "Environment" or "Types"—a category undoubtedly influenced by Helmar Lerski's stylized portraits of working people **(cat. 135)**, one of which is reproduced in *Social Photography*—permitted a broad range of subject matter, while the final section, "Studies," essentially gave Linhart a free curatorial hand. Works from this section, such as *Surface Composition* or *Parabola* by Alexandr Hackenschmied, are now lost and it is not possible to judge their imagery, but the titles suggest a flexibility to the term "social photography," whereby, once again, avant-garde experiment carries an educative value for the proletarian cause.

"Modernist art photography will end sooner or later as infamously as its precursor [pictorialism]," asserted Karel Teige, who delivered the opening remarks at the 1933 exhibition. It should cede, Teige continued, to the work of Rodchenko and other Soviet photographers, who are "quite clearly aware of the tasks to be fulfilled by photography: documentary,

field and Wieland Herzfelde, relocated to Prague, already home to the principal foreign desk of *Der Kuckuck*. From this time until the Munich accords in 1938, then, Czechoslovakia became the most visible location for activist documentary in central Europe.

The primary organizer for the two *Sociální fotografie* exhibitions was Linhart, a Marxist cultural critic who would continue to play a major role in the Czech photography establishment in the 1950s and after.[47] Linhart surrounded his two exhibition projects with magazine articles and a book-length study in 1934, titled simply *Social Photography*, that constitutes the first global overview of the worker photography movement ever written. At more than one hundred pages, with several dozen illustrations, extensive footnotes, and a bibliography, the book carries a significant scholarly cast. Linhart explains here, with many references to recent Soviet writing, the importance of dynamism, dialectical contrast, cropping, and titling to image-driven critique; at one point, he mentions the preparation of a companion volume (unfortunately never realized) on *Photoreportage, Photomontage, Photoseries*, widely accepted as the three

134

FRANTIŠEK ČERMÁK (Czech, 1904–1991), *Sadness of a Quai in Prague (Smutek pražského nábřeží)*, 1934, gelatin silver print, 30.5 × 28, Moravská galerie, Brno

135

HELMAR LERSKI (Israel Schmuklerski) (Swiss, b. Alsace, 1871–1956), *Stoker (Heizer)*, before 1929, gelatin silver print, 29.3 × 19.6, Staatliche Museen zu Berlin, Kunstbibliothek

journalistic, scientific, pedagogical, propagandistic, and agitational."[50] The catalogue cover for the first exhibition **(fig. 7.5)**, by Jiří Lehovec, makes plain this revolutionary teleology. Three photographs rise here in layers from a photographer's camera, like fragments of an expanding visual consciousness: a soft-focus landscape, a photogram, and uppermost an allegorical depiction of poverty. Pictorialism yielded to modernism, which must in turn yield to socialism.

Yet this progression, rather than abandoning art for politics, inscribes political expression within what is ultimately a history of art. Documentary engagement is folded into a developmental progression that merges at its apex with true class awareness, such that the advance from "art photography" to "new photography" and finally to "social photography" matches up with stages of emancipation from bour-

7.5 Jiří Lehovec, Maquette for *Exhibition of Social Photography (Výstava sociální fotografie)* (Prague, 1933), gelatin silver prints and ink, 22.8 × 14.5, Private Collection

geois politics and cultural habits—but emphatically not from a history of the photographic image. "It is necessary…to reject bourgeois photography *in no way* 'totally,' but rather *critically, dialectically*," writes Linhart, who timed the 1933 exhibition to rival an international amateur salon in Prague. By measuring "photography as weapon" always in relation to "photography as art," Linhart and Teige joined Kassák, Weyr, and the many central European advocates for activist documentary who, steeped in aesthetic education, helped to expand the global aesthetics of photography particular to this region.

135

chapter 8

Land without a Name

136

Land without a Name

136

LOTTE GOLDSTERN-FUCHS
(German, 1906–1976), *Fishing
Nets (Fischernetze)*, 1929, bro-
moil transfer print, 41.3 × 30.2,
Museum Folkwang, Essen

For all its connotations of urban cosmopolitanism
and industrial progress, modernity in central Europe
included significant overtures to nonindustrial, rural
life. Polemical clashes at the time between partisans
of "city" and "country," which seem easy to grasp
today, obscured a complex phenomenon of inter-
twined development in the region with a history
reaching back well before the interwar era. Country
life and landscape formed the very basis of national
identity in modern central Europe, where nationalism
spurred growth and creativity throughout the nine-
teenth and early twentieth centuries. Literary works
from *Bánk Bán* (1821) to *Pan Tadeusz* (1834) or *Grand-
mother* (*Babička*, 1855) consecrated peasants, nobility,
or villagers as the bedrock of national character.
Discussions of political and economic modernization
proceeded against the background of this over-
whelmingly important agrarian romanticism. In
nationalist rhetoric, indeed, becoming modern meant
in part "recovering" ties to folk wisdom and to the
land itself, ties that had supposedly been severed by
the incontestable reversals of history. In the tone of
lament common to central European cultures, moder-
nity balanced between technological utopia and an
arcadian past.

Photography perfectly complemented this
strain of thought, which Jeffrey Herf, focusing on
Germany, has described as "reactionary modernism."
A decisive intellectual current from around 1900
through the Nazi period, Herf argues, reconciled
industrial capitalism and machine technology with
anticapitalist, romantic ideals of community and
social order. This illiberal viewpoint, while not synony-
mous with Nazism, nevertheless proved highly ame-
nable to Nazi politics, where it also found its most
destructive enactment. "The really characteristic and
dangerous aspect of National Socialism," Herf quotes
from Thomas Mann, "was its mixture of robust
modernity and an affirmative stance toward progress
combined with dreams of the past: a highly techno-
logical romanticism."[1] Other countries in the region

arrived at different expressions of a nationalist-
modernist formula, with varying degrees of the racial-
izing and specifically anti-Semitic admixture that
made the German variant horrific. In all cases, the
camera, a product of industrial scientific research
continually improved through market forces, served
as a peculiarly ideal instrument to construct national
identities apparently unswayed by the corrosive
effects of industry, science, or the marketplace.

The marriage of premodern ways and values
to modern technology found consummate symbolic
expression in the photography of "native" rural life.
Village scenes and country landscapes communicated
the persistence of "national" character in an interna-
tional age, as well as the variety of distinctive types
said to compose it. A tourist impulse underlies this
folkloric photography, which purveys sights intended
to appear at once familiar and spectacularly novel.
Such images express what one Hungarian commen-
tator from the 1930s called, without a trace of irony,
heimische Exotik: the exotic at home.[2] *Heimatphotogra-
phie*, which we will translate here as Homeland Pho-
tography, accordingly had as one of its motivating
factors the growth of the tourist industry. This enor-
mously popular movement, hailed by cultural conser-
vatives and financed by state agencies, developed
into a media phenomenon during the 1930s every-
where in the region except the Czech lands.

Along with such celebratory image production,
a real lament over the land can be seen in certain
photographs from these years, when land-grabbing
came to dominate international politics. The Nazi
platform of ever-increasing *Lebensraum* or "room to
live" laid claim to supposedly primal Germanic ter-
ritories: Alsace in France, the Czech Sudetenland,
Silesia, "Ostmark" Austria. For those opposed to this
violent geopolitical reclamation, camera images
became a way of holding on to the land during a time
of "inner emigration." Landscape photography, which
experienced a tremendous revival during the 1930s,
can thus be understood in dialogue with folklore on

the one hand and activist documentary on the other, as a key theme during the final decade of modernity in central Europe.

The title to this chapter comes from a book by Czech communist writer Ivan Olbracht (Kamil Zeman), which, despite being at odds with most of the works here in political terms, encapsulates the paradoxical modernist dialogue they engage. Olbracht penned his journalistic report from the region east of Slovakia, now in Ukraine, called Ruthenia or Subcarpathian Ruthenia, after the Carpathian mountain chain that defines its topography. For centuries located on the easternmost fringe of the Austro-Hungarian empire, this population of Greek Catholic woodcutters and crop farmers and of Chassidic Jews was annexed to the newly established Czechoslovakia in 1919.[3] During the 1930s Ruthenia took on dramatic proportions in the Czech and Slovak public imagination. Olbracht was the leading popularizer of life in what amounted to the first and only Czech colony, a region that he described in class-conscious yet unabashedly romanticizing terms. Of a series of writings on this subject, his most beloved became *The Robber Nikola Šuhaj* (1933), the fictionalized tale of a modern-day Robin Hood based explicitly on documentary sources.[4]

Land without a Name, which appeared in 1932 with a cover design by Jindřich Štyrský **(fig. 8.1)**, conveys a sobering picture of economic and societal decline in Ruthenia hastened by the advent of Czechoslovak control and, with it, industrial capitalism in the region. Olbracht's discussion of banks, schools, and courts is prosaic and highly critical of institutional authority. His descriptions of locals and the landscape, in contrast, are a populist travelogue, an ode to pastoral rhythms and petty commerce in which ordinary life acquires a timeless, tragic allure. That sempiternal dramatic pull emanates in Olbracht's descriptions from the land itself, a world at once virginal and ageless, constantly feeding on its own death and decay:

Furrowed and rugged: mountains upon mountains and gullies upon gullies....Forests of beech and pine grow on the slopes, but the ones higher up blend into a jungle, dark, smelling of rot and suffocatingly quiet. The dead here do not allow the living to grow. Upturned, moldering trees cover the ground....from the root of an ancient beech that died standing grow pine saplings destined for extinction. If one steps on an apparently healthy branch, it snaps into tinder; what lies here remains untouched by man or beast.[5]

Like the "ancient beech," Ruthenian social relations in Olbracht's writings form an age-old knot of rituals and superstitions perpetually "destined for extinction." The metaphoric light toward which people struggle becomes, importantly, that of a unifying proper name. Ruthenia is a region "still without a name," as Olbracht explains deep into the book, because it is the site of so many competing national interests: Russian, Polish, Ukrainian, Hungarian, Czech, and Slovak: "Or better put, it has too many to have a single one." As the author superbly illustrates, claims to place—and to a place in history—are the prerogative not of those who live on the land but of those who write its name.

The Homeland Photography movement, which may be understood as the pictorial equivalent of just such a nominalist writing, seems to have gained its official designation first in Germany. This movement formed an offshoot of a much larger *Heimatschutzbewegung* or Homeland Preservation Movement that flourished there and in Austrian lands from the 1890s. Paul

8.1 Jindřich Štyrský, cover for Ivan Olbracht, *Land without a Name* (*Země bez jména*) (Prague, 1932), photolithograph, 17.4 × 10.7, Private Collection

137

CAROLA VON GRODDECK
(German, 1911–1989), *Rose
Monday Float (Rosenmontagszug),*
1933, gelatin silver print, 15.5 ×
11.7, Museum Folkwang, Essen

Schultze-Naumburg, president of the Bund Heimat-schutz at its founding in 1904, promoted the pedantic value of documentary photographs in a series of best-selling readers on housing, gardens, town planning, landscape, and other environmental subjects. Schultze-Naumburg illustrated his publications with hundreds of his own camera views, paired mostly as "example" and "counter-example": "a method...of confronting the hateful with the good in such a way that no one might escape [seeing] this verdict."[6]

Homeland Photography thus developed in Germany as a combination of the prosaic and the pro-pagandistic. Adolf Kuhfahl, author of perhaps the first book to be titled *Heimatphotographie,* in 1921, pre-scribed both a documentary emphasis on "character-istic and important isolated scenes" and attention to signs of place; these included costumes, old trees, native fauna, and all varieties of folk art, including Kuhfahl's own specialty, milestone markers.[7] Although Kuhfahl held no truck with modernist photography, he approved of the camera as a means to record signs of German cultural authenticity. Echoes of his preservationist call may be seen in "new photogra-phy" views of antiquated subjects, such as a deli-cately abstract view of fishermen's nets or the floats in a Rose Monday parade **(cats. 136, 137).**

Kuhfahl's book reflects the experience of World War I that radicalized traditionalist positions in the Germanic lands and brought forth their underly-ing racism. Kuhfahl laments more than once in his book the loss of Alsatian and Silesian treasures, a "looting by our enemies" that in his view culminates a decades-long domestic threat to the "untouched homeland character...through the thoughtlessness or avarice of certain social elements...."[8] Schultze-Naumburg, later a supreme advocate of Nazi cultural policy, developed his binary pictorial method during and after the final war years into a means of demon-strating the superiority of "healthy" art and architec-ture free of "Jewish" taint.[9] Racist ethnographers such as Ludwig Ferdinand Clauß similarly compiled picture books of "Aryan" and "non-Aryan" faces in an effort to delimit German archetypes through comparative physiognomic study. Portrait photographers Erna Lendvai-Dircksen and Erich Retzlaff, meanwhile, assembled libraries of "Aryan" facial types, proceed-ing region by region throughout the German country-side. Claiming the camera as a scientific instrument, they elevated compositional signs of objectivity— level viewpoint, even lighting, apparently unretouched prints—into the realm of the monumental, where all poses are stern and heartfelt, and suffering is digni-

137

fied through pathos **(fig. 8.2)**. "I was presented not with the life of *one* woman," Lendvai-Dircksen recalled of the mid-1916 portrait session that decided her career, "but with the type of Woman in the life strug-gle of her class [and] with the essential expression of a Swabian woman."[10]

In their pseudo-typological aspect, such proj-ects derived from a perversion of ethnographic pho-tography, on the one hand, and a reaction to the work of August Sander on the other.[11] Sander's 1929 book, *The Face of Our Time,* caused a tremendous sensation in the German press.[12] Already in 1927, at the initial showing of his portrait studies in Cologne, reviewers felt that Sander had transformed views of individuals, through aggregation, into a panoramic record of the contemporary epoch. For that show, Sander hung his portraits in twos, perhaps in an echo of Schultze-Naumburg, and like Kuhfahl he insisted upon quasi-scientific precision. In stark contrast to those men, however, Sander claimed not to favor beauty or immemorial permanence; indeed, he claimed to have no preferences at all, other than for truthfulness

8.2 Erna Lendvai-Dircksen, *Woman with Knitting Needles (Frau mit Stricknadeln)*, 1916, printed later, gelatin silver print, 24 × 18, Museum Ludwig, Cologne

and objectivity. "We must be able to accept seeing the truth," he warned in a pamphlet to accompany the exhibition; "above all, we should transmit that truth to our fellow humans and to posterity, whether or not it is favorable for us."[13]

"Comparative photography," as author Alfred Döblin termed Sander's approach, thus was divested in theory of preferential prejudice or evaluative judgments regarding those posed before the lens. This tremendous principle of neutrality links Sander's monumental project to true ethnography and just as decisively separates it from the tenets of Homeland Photography, which on the contrary foregrounded a revanchist set of likes and dislikes. Sander's de-idealizing approach nevertheless left room for certain personal convictions. The order of his various "portfolios," for example, implies that the ur-identity of contemporary German society (still) rests with the land **(cat. 138)**. Farming families constituted his *Stammappe* or model portfolio, presented to his early interlocutor, the photography historian Erich Stenger perhaps simultaneously with a now famous letter of July 1925, in which Sander first set forth his ambitious enterprise: "to give a cross-section of our time and our German people [*Volk*] . . . beginning with the farmer and ending with the intellectual aristocracy."[14] Sander explains in this letter his fidelity to "absolute photography" and his aim of portraying "a true psy-

chology"; yet he also indicates his ongoing search for "meaningful types," a phrase that suggests the division of German citizens into "meaningful" and "meaningless" and belies suggestions of a statistical impartiality.

Important elements of Sander's project thus connect tangentially with the agrarian nationalism that galvanized Homeland Photography, particularly in the deliberately documentary guise it took in Germany. What saves his work from the pitfalls of that movement is, ironically, its conservative (re)turn to nineteenth-century conventions of photographic portraiture. Sander wrote Stenger to discuss daguerreotypes and the chemical means of their manufacture, and he professed to the Berlin collector his great love for bygone photographic practices.[15] The stillness and formality, or the lack of all but the sparest setting, in Sander's works recall conventions of the daguerreotype era. Sander also seems consciously to have refreshed the tradition of the itinerant, rural portrait photographer, going door to door in search of clients for whom city studios lay geographically and financially out of reach.[16] Such a trade favored setting aside elaborate studio decor and finding other, more lifelike ways to convey the dignity of a portrait session. By photographing sitters in Sunday clothes and conscious poses rather than capturing putatively natural genre scenes, Sander catered to his subjects' self-image; by removing their names from his captions, he reclaimed their likenesses for his own artistic project. In this way, Sander arrived, like the Homeland Photography movement but with very different results, at a synthesis of the modern and the national so fervently desired in interwar central Europe.

Fotografia ojczysta, a close translation of *Heimatphotographie* into Polish (*ojczyzna* means "fatherland"), appears to have taken its inspiration directly from German sources, beginning with a November 1935 lecture on the subject in Warsaw by one Professor Lüking, president of the Verband Deutscher Fotografenvereine (Union of German Photography Associations).[17] In the Polish context, German *Heimatphotographie* and Soviet reportage were understood as analogous developments, each leading to the ineluctable conclusion that photography must serve society and the state as an instrument of persuasion. Tadeusz Cyprian, editor of the leading amateur journal *Fotograf Polski*, had broached this subject the previous year: "From the propaganda of machines in Russia and Germany to propaganda of the beautiful countryside in Switzerland or Italy, there is no country or

AUGUST SANDER (German, 1876–1964), *Westerwald Farmer Family (Bauernfamilie aus dem Westerwald)*, c. 1913, printed c. 1927, gelatin silver print, 17.2 × 22, Thomas Walther Collection

field in which photography in fact does not serve propaganda most intensively."[18]

There followed a series of extended, often nuanced considerations in Polish amateur journals on art and documentation in the service of national propaganda — essays that vastly exceed in merit most images produced according to these theoretical exchanges. Leading the discussion was Jan Bułhak, father of Polish pictorialism and principal organizer of the amateur movement in Poland. Bułhak, since 1919 head of photography at Stefan Batory University in Vilnius, had a successful studio practice already before World War I, focusing on folkloric and historical commissions. It was Bułhak who coined the term *fotografia ojczysta* in 1937, just as he had invented *fotografika* to categorize Polish fine art photography exactly one decade earlier. Bułhak imagined a nation-wide project, in which amateur clubs around the country would dispatch their members (again on the German model) to capture the emotional resonance of a given region in pictures: "The land in its evidently meaningful aspects; landscape and the buildings upon it; human settlements; and views of types, tribal groups, occupations, costumes, ceremonies, customs, traditions."[19]

Bułhak provided this shopping list of worthy subjects from a circular on *Heimatphotographie* distributed by the German Lüking. Bułhak translated the circular into Polish, adding anotations that provide a basis for comparison between the German and Polish programs for Homeland Photography. Bułhak faults his German colleagues for an excessive dependence on factuality, and he disapproves of non-photographic experts, presumably ethnographers or preservationists. He tellingly adds "and civilisation" alongside the German praise for "culture," ignoring (or perhaps contesting?) the crucial polarization of these terms in German rightist ideology. His largest complaint, however, is with the German movement's emphasis on neutrality and legibility, and the concomitant resistance to any manipulation of print or negative. Bułhak criticizes this approach as "too strict a line … [Polish Homeland Photography] greatly emphasizes artistic conception and is not afraid of reducing the informational value of the print accordingly. It's the task of the intelligent photographer to reconcile these two postulates." Combining what Bułhak called "documentary fidelity" with "some artistic autonomy" would seem an impossible proposition in these years of totalizing propaganda — were

138

139

not the very idea of "artistic autonomy" itself a useful propaganda tool, suggesting the latitude available to an individual fully identifying with his nation.[20]

In his 1939 booklet *Polish Homeland Photography*, Bułhak addresses this point more forcefully by way of a review of historical origins.[21] Homeland Photography, he argues, picks up where *fotografia krajoznawcza*, a broad field of ethnographic, folkloric, and nativist nature photography, left off around World War I. It retains the documentary basis for an argument about "our ethnic and cultural uniqueness" while increasing the persuasiveness of that argument through artistic enhancement. Homeland Photography, in short, means "nationalizing photography without depriving it of artistic merit to benefit a pedagogical program."[22]

The counterpoint, really the enemy, in what does amount to a highly pedagogical program, is *Amerykanizm*. Not limited to the United States, this nemesis may be defined loosely as the blind celebration of money, machines, and metropolitan life, coupled to the dreaded homogenizing sign of "internationalism," all of which are constant targets for Bułhak and his fellow advocates, among them Edward Hartwig, Kazimierz Lelewicz, and Antoni Wieczorek **(cats. 140–142)**. "Ours is a nation of farmers, not factory workers," Bułhak contends, "a rural nation, not an urban one; peasants and nobility, not proletariat and merchants."[23] Modern achievements in Poland ought to reflect this character. Thus, for example, the authentic Polish road is not a paved highway but a *gościniec*, a dusty yet heroic ribbon lined with birches

(cat. 139): "a wide band of earth…leading far away, through wavy twists and turns across the infinity of our age-old Republic from sea to sea."[24] That the image in question was made in 1916, some twenty years before the rise of a Homeland Photography movement, only adds to its value, at once visionary and inscribed within the hallowed past. Indeed, Bułhak proudly reproduces a photograph quite similar to this one, and from nearly the same date, to underscore his point about authentic Polish roads in the 1939 book *Polish Homeland Photography*.

His diatribes against cosmopolitanism and industry notwithstanding, Bułhak and his colleagues were sensitive to the need for depictions of expressly modern subject matter. The 1938 photography exhibition *Piękno Ziemi Śląskiej* (The Beauty of the Silesian Land), which took as its subject and site of presentation the most heavily industrialized region in Poland, marked a high point for the *fotografia ojczysta* movement.[25] This propaganda show—financed by the Silesian government, held in rooms in the Silesian Parliament in Katowice, and inaugurated by the governor of Silesia—treated industrial manufacture as the new "local product" of the region. Industry here could presumably become a tourist attraction, a spectacle with pedagogical benefits. Factories and high-voltage lines were domesticated in this exhibition as harmonious emanations of the Silesian natural environment, a symbiosis of machine and "beautiful land" exactly analogous to the pictorialist marriage of industrial mechanical equipment with artisanal print techniques. Bułhak contributed an essay on "The Essence of Homeland Photography" to the accompanying catalogue, and he presented at the exhibition photographs such as *A Forest of Smokestacks (Las kominów)*, in an evident bid to naturalize the built environment.

A similarly naturalizing effect is produced by Russian-born Sergej Protopopov's empyrean view, *Chimneys in Banská Štiavnica* **(cat. 143)**, taken in his adopted hometown in west-central Slovakia. This lofty image, which gives the sensation of a magical city suspended in the clouds, accords well with the aesthetic movement in painting known as *Slovenská Moderna*. This Slovak equivalent to American regionalism in the 1920s and 1930s concentrated on rural genre scenes and compositions deliberately close to folk art, but with a weightiness to the figures variously suggestive of high drama or epic stasis. Led in various directions by writers such as Milo Urban or Petr Jilemnický and painters Martin Benka, Miloš Bazovský, Ľudovít Fulla,

139

JAN BUŁHAK (Polish, 1876–1950), *Highway to Minsk (Gościniec do Mińska)*, 1916, gelatin silver print, 10.2 × 16.2, National Gallery of Art, Washington, Anonymous Gift

140

EDWARD HARTWIG (Polish, b. Russia, 1906–2003), *Planting Potatoes (Sadzenie kartofli)*, before 1930?, gelatin silver print, 25.5 × 33.4, Private Collection, Warsaw

141

KAZIMIERZ LELEWICZ (Polish, 1896–1986), *Polesia Folklore (Folklor Polesia)*, before 1938, photomontage, 37.7 × 28.5, Muzeum Sztuki w Łodzi

142

ANTONI WIECZOREK (Polish, 1898–1940), *Kościelec Peak (Kościelec)*, before 1934, gelatin silver print, 21.5 × 27.7, National Museum in Wrocław

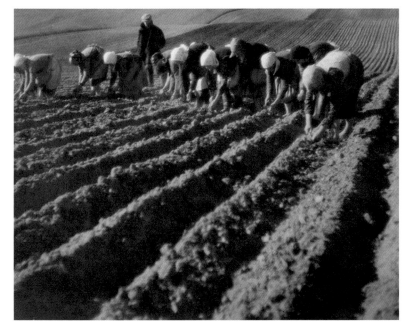

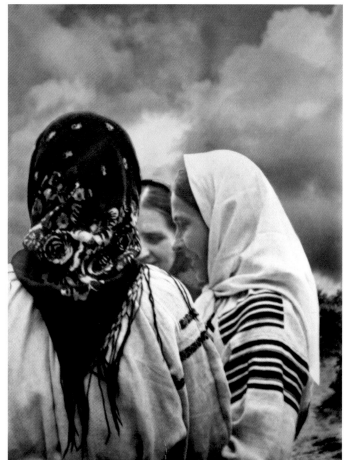

140 | 141
142

and others **(fig. 8.3)**, Slovenská Moderna dominated discussions of fine art in the country particularly during the 1930s.[26] At the heart of these discussions lay once again the fraught marriage of nationalist sentiment to modernization so important in central Europe. In Slovakia, the embrace of (imported) forms of cultural innovation was allied ostentatiously with a celebration of timeless (domestic) values located in the land and in those who live on it. The debates of Slovenská Moderna affected photography in the region as well. On the one hand, the monthly magazine *Krásy Slovenska* (The Charms of Slovakia), begun 1924, transposed this alliance of modern means and rural subjects to the supposedly "inherently modern medium" of photographic illustration. On the other, the left-wing documentarists discussed in the preceding chapter, who stood philosophically opposed to *Krásy Slovenska*, nevertheless arguably had Slovenská Moderna also on their minds when they set out to make deliberately antiepic, modern-day peasant genre scenes.[27]

The man who brought greatest international recognition to a photographic version of Slovenská Moderna was, like Protopopov, not Slovak, although he spent much of his life traveling the Slovak countryside. Karel Plicka was born in Vienna to Czech parents,

and through the completion of his studies lived and worked primarily in the Czech lands, Vienna, or Berlin. From early childhood, Plicka expressed great musical aptitude, which he cultivated despite paternal opposition. He also showed a strong folkloric sense shot through with national sentiment, a leaning of which his father certainly did approve. At age thirty, Plicka landed his dream assignment: to collect folk melodies for the recently restarted Matica Slovenská, a nationalist benevolent association. Between 1924 and 1939, when the Nazi dismemberment of Czechoslovakia sped Plicka back to Prague, he transcribed tens of thousands of melodies and lyrics, even becoming a semiofficial spokesman for Slovak culture abroad. An avid photographer from childhood, Plicka took thousands of pictures on these field trips and transposed his ethnographic interests into filmmaking as well. Shortly before the war years, Plicka (who died only in 1980) stopped his musicological research to produce celebratory documentary films and picture books on Czech and Slovak landmarks.

Plicka was a popularizer, with a classic natural-history view of folk customs and the environment from which they "spring." His 1933 film *Singing Earth* (*Zem spieva*) indicates in its title Plicka's assumption that folk song arises spontaneously from native soil.

143

143

8.3 Martin Benka, *On the Liptov Highlands (Na liptovských holiach)*,
1922, oil on canvas, 139 × 116, Slovak National Gallery, Bratislava

Like the American Edward Curtis, Plicka worked
strenuously to arrange this impression of unmediated
naturalness, placing villagers as he required for a
shot and asking them to don exceptional costumes
to create the effect of an unposed ritual moment
(fig. 8.4). At the same time, he seems to have shown
real affection for what in anthropological terminol-
ogy were his informants, and remained friendly with
at least a few of them for decades. Early works, such
as *Peasant from Madačka* **(cat. 144)**, stay closer to reality
than later images, in which Plicka miniaturized his
human subjects under a baroque, billowing sky. The
simple shoes, rough-cut pants, and squinting smile
of this *gazda* (a land-owning farmer or husbandman)
convey mute casualness, as if photographer and sub-
ject had reached a noncommittal accord. Somewhere
between a genre study and a portrait, this picture
suggests in its straightforwardness the modernity
of both its subject and its means of execution.

In interwar Hungary, hurting economically and psy-
chologically from the loss of Slovakia and other for-
mer subject regions, nationalist photography zeal-
ously suppressed evidence of modernization within
the picture frame — even as it capitalized on the new
mass media and modern tourist initiatives to publi-
cize its interests. *Magyar stílus*, the Hungarian Style,
developed as elsewhere from patriotically motivated
ethnographic projects. With regular funding from

boards of commerce and tourism, and a network of
amateur clubs and professional trade associations to
support its spread, the Hungarian Style reached well
beyond the country's newly reduced borders. Indeed,
of all the Homeland Photography movements in the
region, Hungarian Style achieved the greatest collec-
tive recognition internationally in its day. "'Hungari-
ans represent a unique style in photography,' writes
the Swiss journal *Camera*, and its editor, A. Herz, a
well-wisher of ours, has named it 'Hungarian style,'"
reported amateur Dezső Dózsa in late 1933.[28] From
then until the end of World War II, this putative
uniqueness was a staple in Hungarian cultural export
maintained through books, exhibitions, and submis-
sions to periodicals abroad.[29]

The "style" in Hungarian Style seems to derive
largely from the subject, which properly speaking is
a matter not of style but of selection. Village inhabi-
tants in costume, secular and religious folk festivals,
artisanal labor, and the animals and expanse of
the *puszta* or Great Hungarian Plain provide the core
material. The characteristic depiction of these
themes, which might be called a style, favored a low
horizon line, liberal use of backlighting, crisply delin-
eated contours, and glossy prints, as these were bet-
ter suited to reproduction. For all the talk of Hungar-
ian uniqueness bundled in these compositional and
technical matters, aesthetic and ideological aims
here remain consonant with those of other Homeland
Photography movements. "The major factors of
Hungarian atmosphere," claimed *Magyar stílus* leader
Rudolf Balogh, "are unique sunshine … primitive
environment and unspoiled people … harmony in
light effects, calm tracing, excellence and variety of
subject matter, and unsurpassable sureness of com-
position."[30] Pictorialist values — mastery, balance,
harmonious beauty — are revamped here at a hyper-
bolic level and claimed as right not just for art, but
also for the nation.

More compelling than style or aesthetics is
the institutional formation of Hungarian Style and its
deployment in various spheres of public life. Balogh,
whose age and stature compare roughly to those of
Bułhak, had a career of more than thirty years in the
illustrated press, most prominently as lead photogra-
pher for the Sunday supplement to the *Pesti napló*
newspaper in 1925–1937. Balogh also operated a stu-
dio from 1912, and during World War I he served as a
military photographer. To offset this prolific commer-
cial and documentary activity, viewed by cultural
guardians as debased, Balogh worked hard to gain

8.4 Unknown, Karel Plicka photographing in Slatinské Lázně, 1956, modern gelatin silver print from original negative, 6 × 6, Slovenské národné múzeum, Martin

144
—
145

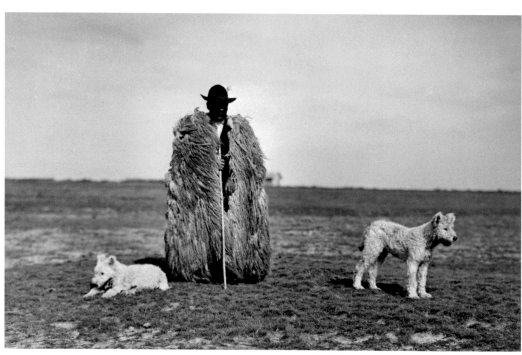

144

KAREL PLICKA (Czech, b. Austria, 1894–1984), *Peasant from Madačka (Gazda z Madačky)*, 1926, gelatin silver print, 28.5 × 18.3, Slovak National Gallery, Bratislava

145

RUDOLF BALOGH (Hungarian, 1879–1944), *Shepherd with His Dogs (Juhász kutyáival)*, c. 1930, gelatin silver print, 18.4 × 29, Hungarian Museum of Photography

146

ANDRÉ KERTÉSZ (American, b. Hungary, 1894–1985), *Blind Musician, Abony (Vak zenész, Abony)*, 1921, gelatin silver print, 5.1 × 3.8, National Gallery of Art, Washington, Gift of the André and Elizabeth Kertész Foundation

artistic status in amateur circles. He submitted prints to club salons regularly from 1903, with correspondingly regular reviews in *Az Amatőr*, and he edited or founded three separate amateur journals in 1911, 1914, and 1930.[31]

Dominance in all the principal institutions of photographic production—Sunday papers, art salons, specialized press, studios—gave Balogh the broad platform from which to rally Hungarian photographers and a wider public to the unifying cause of a national "style." His increasingly frequent views of folkloric rituals and sunny scenes filled the pages of the popular *Pesti Napló* and the "art photography" journals alike, as well as prestigious exhibition rooms in Hungary and internationally. Images such as *Shepherd with His Dogs* **(cat. 145)** rendered native clothing and setting utterly exotic, as if out of all time; though the wind whips over the endless plain, its canine and human inhabitants remain steadfast as pillars. To the urban Hungarian audiences who delighted in such pictures, the subjects were an escapist attraction, no less than for readers who saw them abroad.

The phrase "the exotic at home" comes from the introduction to Balogh's 1935 book *Hungarian Pictures*, which was published for foreign export with a subvention from the ministry of commerce.[32] That such pictures, when produced for domestic or even purely private consumption, retained their exoticizing flair is abundantly clear; André Kertész, who later recalled Balogh's work with great praise, photographed gypsy musicians and villagers with a similar sensibility, premised on the distance between his life circumstances and theirs **(cat. 146)**. The illustrated newspapers in which such photographs circulated served to reinforce that gap, presenting to their consumers the spectacle of their fellow countrymen as objects of leisurely contemplation. At the same time, the rhetoric surrounding such image production was manifestly one of national unity, asserting a spurious bond of solidarity between reader / photographer and photographic subject.

A singular twist on ethnographic photography developed as part of this rhetorical campaign, more forcefully in Hungary than elsewhere. In each country, areas designated as scenic (the town of Kazimierz on the Vistula in Poland, for instance, or the Hortobágy region of the Hungarian *puszta*) attracted crowds eager to capture a vanishing way of life in photographs. But in Hungary as nowhere else did such spots become a sort of theme park. The village of Boldog, which nicely means "happy" in Hungarian,

146

regularly hosted Balogh, Ervin Kankowsky, Ernő Vadas, and other photographers taken with the transmutation of ethnography into national myth. Located just fifty miles from the capital, Boldog featured in photographs (many published by Balogh in *Pesti Napló*) and films as its idyllic antipode.

Select villagers from Boldog were among the first to become part of a traveling performance cooperative called Gyöngyösbokréta (Pearly Bouquet), which by the mid-1930s had culled participants from "every village where original peasant art was to be found," as proclaimed in a picture book from 1937, published once again for the international leisure industry.[33] According to this book, the first Pearly Bouquet performance, held in Budapest in 1931, presented peasant groups from ten villages. As "the cult of Hungarian peasant art," to cite the book's editor, "[came] to be a conscious effort," involving ever-widening levels of organization and publicity, certain *Magyar stílus* photographers themselves were put off by the institutionalized fakery. Commenting on a recent exhibition, Gyula Ramhab, a leader of the movement, noted sourly in 1935 that "lasses and maids dressed in their best clothes were photographed doing jobs they would never do in such attire."[34] Indeed, in his study of Boldog and its transformation through the media, historian Zoltán Fejős observes that members of the Pearly Bouquet tended to be photographed more frequently than their fellow villagers, presumably for their willingness to pose as prettified versions of themselves.[35]

Photographers largely or partly involved in the left-wing social photography movement, such as Kata Kálmán or Francis Haar, also went to Boldog on assignment, producing images there that, as Fejős comments, had a more complacent air than their agitational work. Haar's photograph *The Land-*

147

lord **(cat. 147)**, made as part of a government-sponsored tourist initiative covering life on the Hungarian plain, reads ambiguously in this regard.[36] Certainly, the photograph has a picturesque charm. Yet the enormous opposition in scale between the stout landowner looming over walking cane and property alike, and the blurred, miniature farmhands behind him, suggests a dialectic message at odds with the touristic fiction of harmonious *puszta* life. This sort of irony glimmers more brightly still in the photograph *Lowlands* by Bauhaus graduate Gyula Pap, taken near his hometown of Orosháza in the southern part of the Great Plain **(cat. 148)**. We have here the horses, the dusty road, the wide expanse celebrated as signs of the authentic *puszta,* but in place of an archetypal tableau we feel ourselves lurching along sluggishly toward emptiness. The scene is captivating, in a highly modernist way, and moving, but it is decidedly unheroic.

The Austrian variant of Homeland Photography, in its grandest moments the most sumptuous of all those studied here, gained prominence in the early 1930s as a program of shared values between ambitious amateur and professional photography. *Heimatphotographie* was lauded as an economic stimulus that rose above mere materialism thanks to its fundamental patriotic merit. Good landscapes showing "our beautiful Austria," claimed Silverius Frey, president of a commercial photographers' association, inspire "joy and collective benefit"; this abstract sentiment in turn aids the travel industry and economic life generally.

Frey made his remarks in the catalogue to a thirteen-room show held in June 1933 that crystallized the spectacular goals for Homeland Photography in that country.[37] Writing in the catalogue as well, Franz Hainzlmayr, a state representative charged with advertising initiatives, assigned himself the task of clarifying photography's place in homeland art and preservation (*Heimatkunst und Heimatschutz*). Photography constitutes a modern folk art, Hainzlmayr asserted, as it is widely practiced, largely anonymous, and authentically contemporary. "Folk art unaffectedly expresses the artistic sensibility of its time.... Homeland preservation thus has no reason to protest contemporary art movements and technology—on the contrary," Hainzlmayr continued, making a remarkable point: "material authenticity, unifying spatial composition and the feel for personality are characteristics shared by folk and contemporary art."[38] This reasoning, in which industrial and traditional creative forms find a harmonious reconciliation, exemplifies the "reactionary modernism" analyzed by Herf.

Postcards, the most common expression of a photographic *Volkskunst*, are too often condemned out of hand, Hainzlmayr maintains. Circulating from hand to hand, for example, postcards provide a comparative aesthetic sense, domesticating awareness of what is beautiful and noteworthy: "Artistic buildings or picturesque sites are first rendered popular [*volkstümlich*] in their homeland through postcards."[39] This contention neatly elides the intervention of tourist bureaus, postcard publishers, and other corporate interests in designating sights and scenes of pictorial merit. Amateur photographers—who by and large disdained postcards—could occasionally be more open about strategies for generating the picturesque. Writing in the Viennese journal *Der Lichtbildner*, one Michael Mont set forth ten rules for producing good homeland pictures (*Heimatbilder*), including a concentration on sunshine; folk costumes, (traditional) architecture, sports, landscape, and above all people as preferred subjects; the avoidance of contradictory visual information, for instance a new schoolhouse next to an old church; and the presentation of places only in their most "typical" aspect or season.[40]

147

148

Hainzlmayr's remarks, like Mont's advice, constitute the Austrian nation as a transparent, unified collective subject, a projection desperately needed (and widely accepted as valid) to counter the disorientation caused by Austria's truncation after World War I. After nearly four hundred years as a supra-national rainbow of peoples, languages, and religions, post-1918 Austria became a rump state of minor geopolitical influence, with only its citizens' variegated surnames to suggest the multiethnic extent of its former empire. The search for a coherent identity became, as in neighboring Hungary, a pressing need—although it should be noted that territorial "winners" and "losers" alike experienced an identity crisis following the war. Hainzlmayr's formulation: "The inhabitants grow out of the homeland," is absolutely expressive of the romantic attitude prevalent in central Europe, equally evident in the left-wing book *Land without a Name*. There is a balancing act involved here, however, for neither a *Heimat*-loving civil servant such as Hainzlmayr nor a communist travel writer such as Olbracht identifies personally with the "types caught straight from life" provided, in Hainzlmayr's words, by Homeland Photography. Both men write for a middle-class, urban audience that is made to feel simultaneously a preternatural bond with the "folk" and paternalism toward that imagined entity. The quality and the terms of this conflict between oneness and superiority, identification and otherness, change depending on one's political views, but the affective bind itself remains unresolved.

Heimatphotographie enjoyed a long life in Austria. A steady run of oversize picture books and exhibitions identified with this movement appeared from

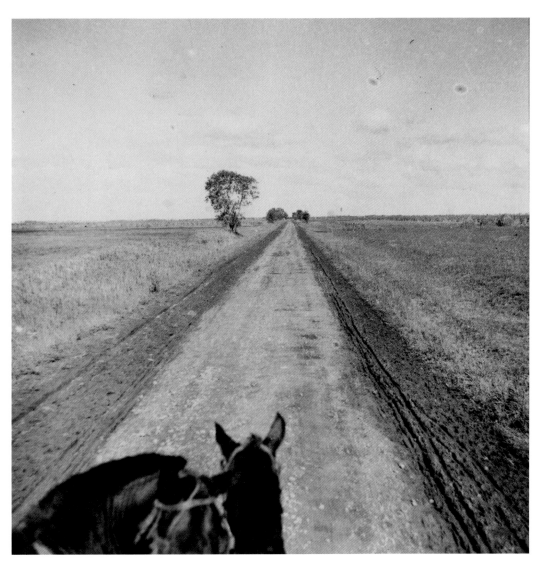

148

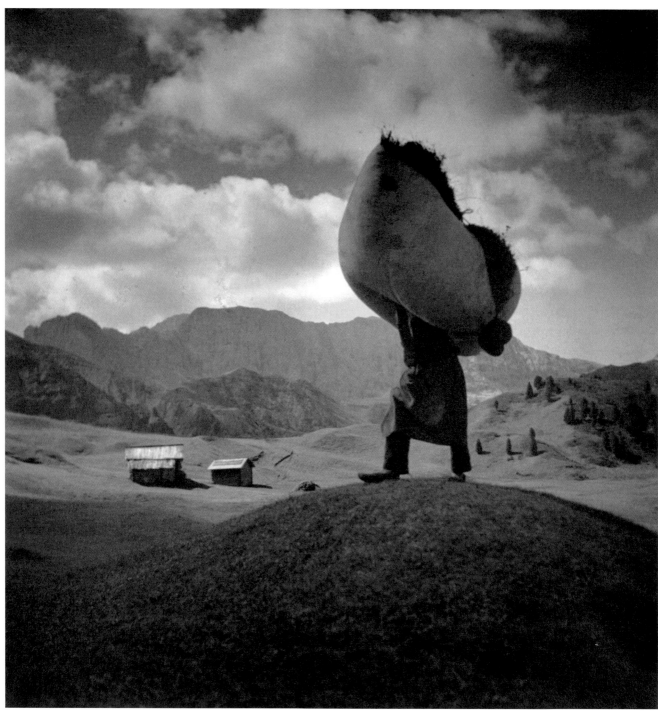

149

149

RUDOLF KOPPITZ (Austrian, 1884–1936), *Heavy Burden (Schwere Bürde)*, c. 1930, gelatin silver print, 31.5 × 30.4, Albertina, Vienna

150

ALFRED EDWARD FRAUENFELD, ed. (Austrian, 1898–1977), "Ski Heil," *Der Notschrei (Cry for Help)* 2, no. 14 (15 December 1932), photograph by Lothar Rübelt (Austrian, 1901–1990), photolithograph, 34 × 24.5, Rübelt-Archiv, Österreichische Nationalbibliothek, Vienna

the early 1930s through the 1950s—from well before the Anschluss with Nazi Germany, that is, until many years after World War II. Already in January 1934, *Der Lichtbildner* carried an advice column on the subject intended to codify and elevate its practice; the first installment argued for the importance of serial rather than single images, to heighten narrative authenticity.[41] Photography historian Otto Hochreiter has emphasized the escapism of these pictures, which avoid showing actual labor or the disastrous economic conditions in agricultural work. Rudolf Koppitz, Peter Paul Atzwanger, Wilhelm Angerer, and their followers instead visited the Tirol and other rural areas of their reduced country with a "romantic-pedagogic attitude whereby rural life served as an antidote to metropolitan living, marked by alienated labor and political radicalization."[42]

Again, however, this antiurban, antimodern emphasis needs to be understood in its paradoxical reconciliation with modern technology and urban careers. Both Koppitz and Atzwanger taught at the Graphische Lehr- und Versuchsanstalt (GLV) in Vienna, where they had also trained. Their "romantic-pedagogic" orientation accords entirely with the school's increased emphasis on creative design and "higher" aesthetic values at the expense of science and technical knowledge (that is, copy photography). That shift had begun before World War I, with the arrival of Karel Novák as instructor of photography. Novák taught Atzwanger and Koppitz, and the latter in particular became one of his star pupils.[43]

Koppitz came from an ethnic German family in Czech Silesia, and he completed his initial apprenticeship in photography in the Moravian city of Brno.[44] Talented and inordinately ambitious, he prospered in the jewelry trade and in commercial photography before entering the GLV in 1912. He studied there alongside Anton Trčka, who in those years collaborated with Egon Schiele on an instantly celebrated series of photographic portraits of the painter; likely through Trčka, he also met Gustav Klimt. Such new acquaintances no doubt furthered Koppitz' aspiration toward artistic recognition as a photographer. His work accordingly took on elements of secessionist painting, the model for high-minded amateurs in Austro-German lands since the 1890s. Within a few years, however, Koppitz introduced a twist on this aesthetic blend. On the one hand, he updated secessionist conventions in sensual still lifes and languorous "move-

ment studies" using the language of modern dance. As a counterpoint to this decadent eroticism, Koppitz presented scenes of heroic idyll, featuring either healthy, youthful athletes (including himself) in the act of returning to the land, or rugged farmers rising eternally above it **(cat. 149)**.

In 1924–1925, Koppitz, now head of photographic instruction at the GLV, began systematically applying himself to advancement within the institutional hierarchy of the amateur movement. He soon became a regular prizewinner at international photography salons and often served on the salon juries.[45] From around 1930, Koppitz increased his output of Homeland Photography, matching this shift with uncanny timing to developments in popular taste. Along with Lothar Rübelt **(cat. 150)**, Koppitz provided pictures for reactionary publications; covers for *Der Lichtbildner* include an Aryan mountain climber astride an Alpine peak and girls in church uniform traversing a meadow.[46] Very much unlike Rübelt, and different from Balogh or Bułhak too, Koppitz concentrated on making gorgeous exhibition prints. The size and splendor of these prints matches Koppitz' classically centered compositions, in which the human form becomes a statuesque, monumental abstraction.

150

8.5 Peter Paul Atzwanger, *Harvest on the Tuxerberg Meadows* (*Das Hineintragen auf den Tuxerbergwiesen*), 1930–1935, gelatin silver print, 12 × 18, Tiroler Landesmuseum Ferdinandeum, Historische Sammlungen, Innsbruck

In his one printed statement, published in 1928 as his star was beginning to rise, Koppitz advocated precisely "calm, uniform pictorial effect" as the key to a successful photograph. His watchword, "pictorial temperance" (*Bildmäßigkeit*), dictated traditionalism, which, to judge by the work itself, seems to correspond with crypto-fascist leanings. These works, once again, gave to Austrian "traditions" a highly modern form, new in its monumentality and explicit recognition of the power of photography to shape communal identity. At five hundred works and less a retrospective than a manifesto, Koppitz' 1936 exhibition, *Land und Leute* (The Land and the People), was unprecedented in Austria for its size and impact. After his untimely death later that year, one of Koppitz' many pupils, Czech photographer Jan Lukas, concluded an obituary for *Der Lichtbildner* with the proud assertion: "whoever studied with him will try to continue on the path he showed us."[47]

There were contemporaries of Koppitz, such as Simon Moser or Atzwanger, who framed more naturalistic scenes of daily life in the Alpine valleys.[48] Both men had great feeling for their subject, a sense of personality that comes across especially in Atzwanger's portraits. Their pictures, however, portray labor as a nearly effortless ritual set in an arcadian landscape **(fig. 8.5)**.[49] Atzwanger, for example, taught alongside Koppitz in Vienna from 1928, yet he never took a photograph of the capital city, preferring the people and pastures of his Tirolean birthplace. "An *enlivened scenery* . . . demands the greatest skill,"

he wrote in *Der Bergsteiger* (The Mountain Climber) in 1929, revealing his conception of the Alpine world as monumental theater decor.[50]

Angerer, meanwhile, outdid Koppitz even in his evocation of a timeless, symbolic landscape. Scion of a multigenerational family of studio photographers, he, too, gravitated toward the Tirolean Alps from around 1933. His breathless views of snow-covered slopes, on which trees and houses figure as miniature models, appeared in 1942 in the evangelical picture book *A Song Sweeps Down from the Mountains* **(cat. 151)**. Each plate is given a correspondingly grandiose title — *Last Sunshine, Giant Avalanche, Onward, Alone* — and paired with the author's versified ruminations on redemptive violence and celestial will. Here are the lines crafted for *Onward, Alone*:

Onward, alone — morning in one's eyes.
Beauty rises golden-winged
From the hour
Deep in the world's being
Yearning souls — blessed dream.

Day's return
Light in one's face
Call and point
Onward, alone.[51]

Such were the dominant figures of "land," in words and images, across central Europe during the 1930s: sacral, pathetic, abstract, transcendental. Picturing place in other terms seems to have been next to impossible. Perhaps only Roman Vishniac, in his years of clandestine travels to photograph Jewish communities, produced a countervailing record of life in the region. In the second half of the 1930s, Vishniac, raised in Moscow, left his adopted hometown of Berlin to visit shtetls, ghettos, and Jewish neighborhoods across all the countries in that area. He spent time in Ruthenia, the place that so attracted Olbracht. His first book, meanwhile (from 1947), focused on Poland, where three million of the six million Jews who perished in the Holocaust had been killed. Vishniac undertook his many trips, he later recalled, out of a conviction that he must bear witness to a people faced with extinction. While traveling, he presented himself as a salesman to calm suspicions and took photographs secretly, for fear of trespassing against the ban on graven images or provoking police reprisals. Nevertheless, many of the surviving pictures show people responding to his hidden camera with a wariness or hostility that is equally sly.[52]

151
WILHELM ANGERER (Austrian, 1904–1982), *Song of the Blessed* (*Gesang der Seligen*), 1933–1942, gelatin silver print, 28.7 × 31.6, Albertina, Vienna

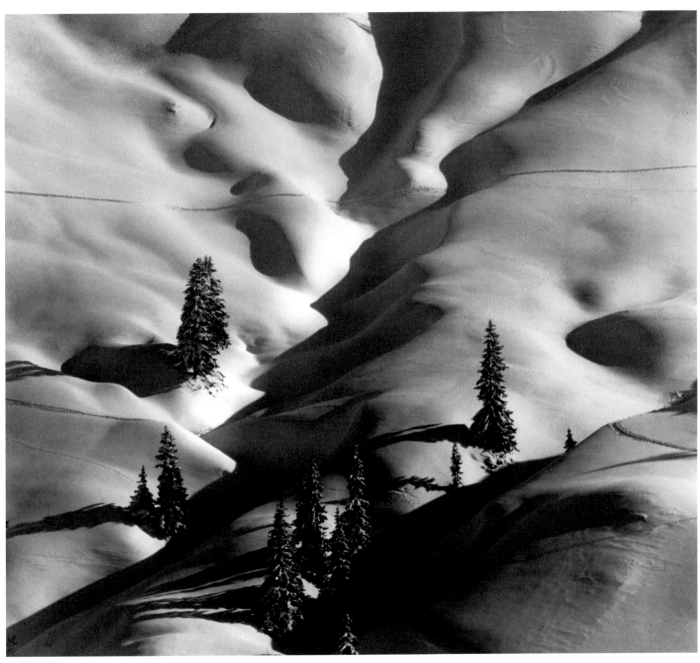

151

Vishniac was undoubtedly moved to undertake his remarkable documentary out of idealism and ethnic patriotism, sentiments not dissimilar to those motivating Homeland Photography movements in the various countries he visited. His subjects, however, had no homeland in Europe—indeed, this was a historically crucial factor in their identity, as it was for the equally persecuted Roma and Sinti (gypsy) populations. Vishniac did not photograph assimilated Jews such as himself, although he did record both secular and religious aspects of daily life. As such, his work might be seen to perpetuate the false equation of authenticity with a pre- or antimodern existence fostered by Homeland Photography. Yet Vishniac's often hurried shots and whispered commentary con-

vey above all a sense of the precarious here and now. Vishniac aimed not at ethnographic completeness but at testimonial partiality, and he wanted that testimony to address the specifically modern experience of east-central European Jewry after 1933: day-to-day social relations in a time of mounting hardship. The shadowy figure ambling away from Vishniac's camera in *Entrance to the Ghetto, Kazimierz* **(cat. 152)** of course symbolizes the impending disappearance of millions, and the gloomy drizzle of snow in a penumbral alley accordingly reads as premonitory (the caged dove drives home this point). But that alleyway, and the ghetto beyond, represent a home environment as well, one that is real, functional—and already depressing—at the time of the photograph.

That same spirit of elegiac realism may be found in certain landscape photographs of the time, including *Little Tree* by Albert Renger-Patzsch **(cat. 153)** or the confrontations with decaying undergrowth in Jaromír Funke's darkly toned series *Primeval Forests*, of 1937–1938 **(fig. 8.6)**. (Funke made this series, tellingly, in Olbracht's Ruthenia, and he likewise presents the forest as an environment "destined for extinction.") Sander, who concentrated increasingly on landscape photography from 1930, took an impressive number of lonely hilltop views that seem openly reminiscent of German romantic painting from one century earlier.[53]

Eugen Wiškovský's 1939 *Flattened Wheat* exemplifies this mournful symbolic turn, particularly resonant by that date with a world headed once more into war **(cat. 154)**. Keeping a pretense of distance from the newly unsettled land, a fiction of mastery over borders and names, no longer makes sense. By the date of this picture, place names throughout the region have again been forcibly changed. Known also by its later title, *Disaster*, Wiškovský's careening composition illustrates the parting observation given by his close colleague Funke in an article, "The Photographed Landscape," written afterward. In contrast to Homeland Photography, which assumed a stable and omniscient viewership, Funke suggests the mutability of both subject and audience: "Thus it is possible, through photogenic discovery, for the magic locked within reality by spells to amaze the surprised viewer as well [as the photographer], to score him forever with its evocative metaphor."[54]

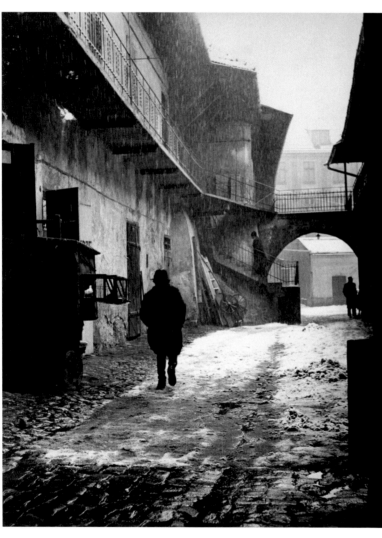

152

152

ROMAN VISHNIAC (American, b. Russia, 1897–1990), *Entrance to the Ghetto, Kazimierz,* 1937, titled later, gelatin silver print, 25.2 × 19.5, Collection of the Prentice and Paul Sack Photographic Trust

153

ALBERT RENGER-PATZSCH (German, 1897–1966), *Little Tree (Das Bäumchen),* 1929, printed c. 1945 or earlier, gelatin silver print, 38.3 × 28, Betsy Karel

154

EUGEN WIŠKOVSKÝ (Czech, 1888–1964), *Flattened Wheat (Catastrophe) (Lehlé obilí [Katastrofa]),* 1939, gelatin silver print, 18.2 × 24, Museum of Decorative Arts in Prague

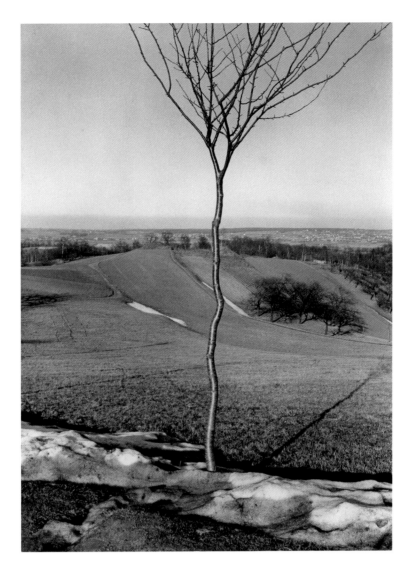

153
—
154

8.6 Jaromír Funke, *Untitled (Bez názvu),* from the series *Primeval Forests (Pralesy),* 1937–1938, gelatin silver print, 50.6 × 40.5, National Gallery of Art, Washington, Patrons' Permanent Fund

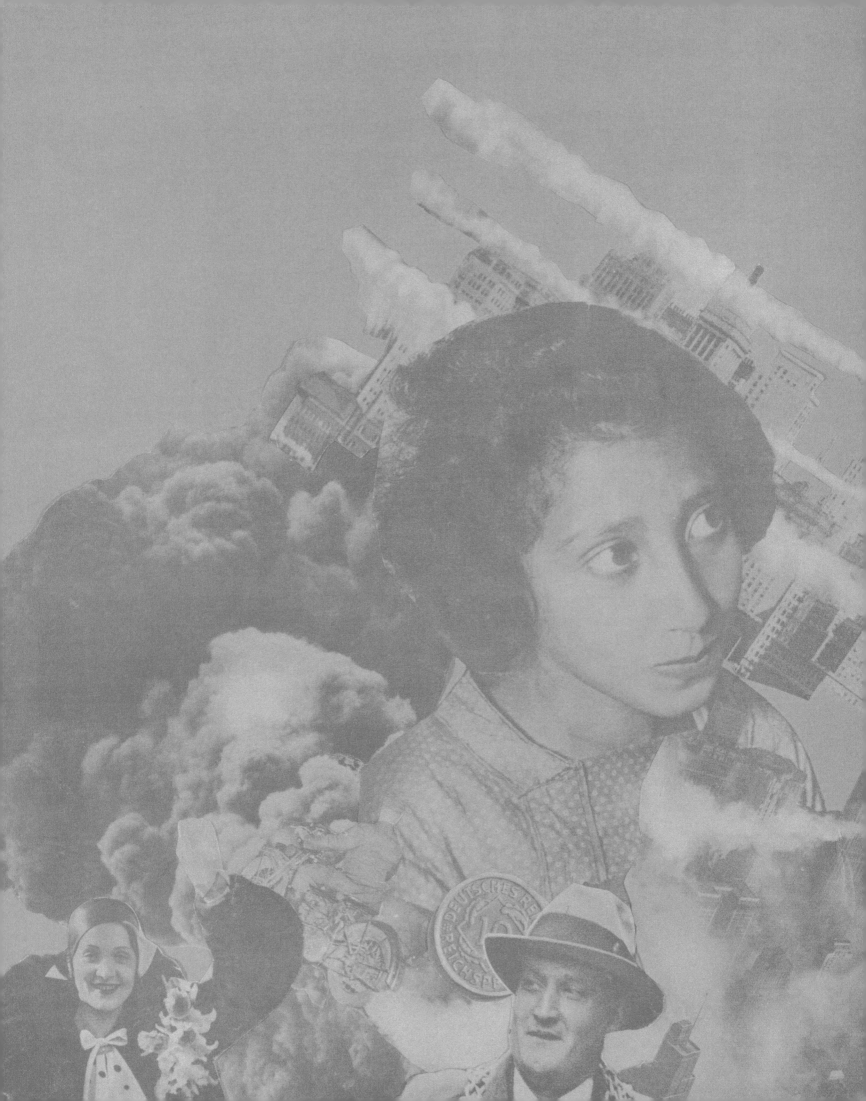

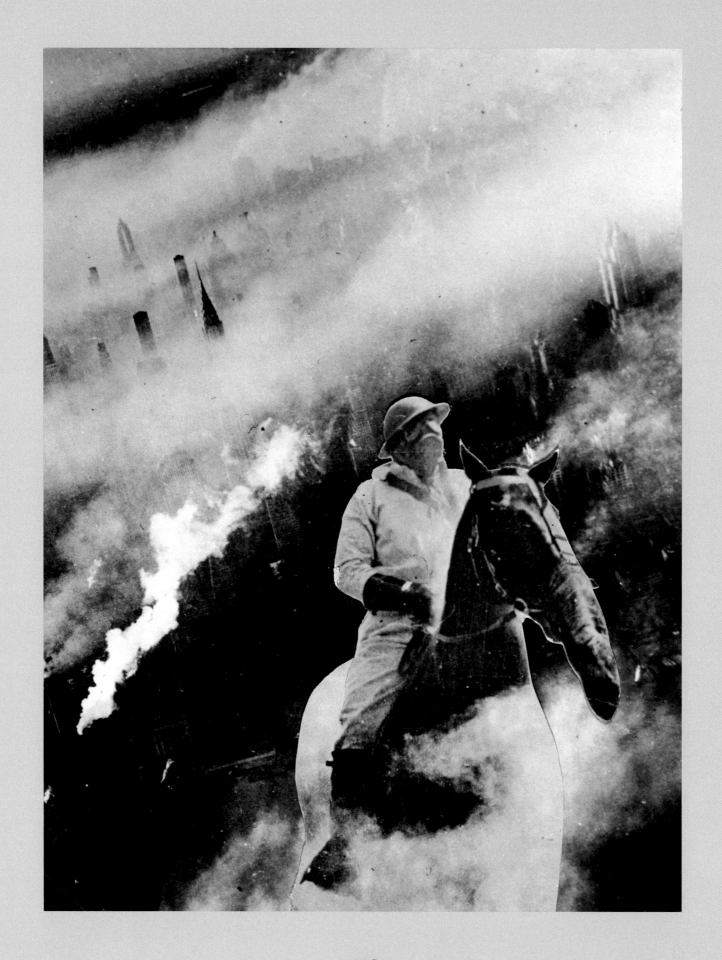

158

158

Among the various techniques and processes associated with modernist photography in central Europe, none was as widespread as photomontage. Photomontage infiltrated all facets of photographic practice in this region. It became a leading element in the vogue for "new photography" that peaked around 1930, and for years afterward exemplified the era's omnivorous photomania. Although the 1931 show *Photomontage* in Berlin, which crystallized the topicality of this subject, remained unique in its day, intellectual and popular interest persisted far into the decade, such that photomontage featured in everything from small surrealist experiments to grand exhibition designs, cheap literature, and even some public works projects as well as a good deal of political press, mostly on the left but to a lesser degree also on the right **(figs. 9.1, 9.2)**. In its many manifestations, photomontage embodied the conception of modernity elaborated throughout this book: pedagogical, publicly oriented, revolutionary yet mindful of history, and particularly (for questions of photographic meaning) the history of art.

It is with these guiding characteristics of central European modernity in mind that we turn once again to the relationship between photomontage and war, which shifts significantly over the period in question. For most of the artists who took up photomontage initially in 1919–1924, war was a traumatic firsthand experience, the larger impact of which centered on their homelands in years of seismic transition from empire to nation-state. The conflicts depicted in photomontages of the 1930s, by contrast, traverse the globe. International belligerence, whether American lynchings, the (re)militarization of Germany, or the Japanese invasion of Manchuria, has become a staple of current events, and photomontages from this later time feed on the spectacularization of violence in the illustrated newspapers. Much Polish photomontage is created for the mainstream press by avant-gardists such as Janusz M. Brzeski, whose works teeter between transformational critique and trivial commentary on the great events of their day.

Despite this shift in context, photomontage continues to engage the discourse of *foto* and modernity developed during the previous decade. Avant-garde work of the 1930s especially tests in new ways the relation of private to public expression, of singular creation to mass communication, in this region where art bears an overwhelmingly public, communicative role. Several dozen strictly private compositions by Bauhaus graduate Marianne Brandt and one-time Munka associate Lajos Vajda trade on modes of public address, in their grand scale and their resemblance to newspaper reportage. Surrealists Jindřich Štyrský and Hans Bellmer, meanwhile, ostentatiously cross the line dividing public from private to political effect, entering the taboo realms of sadism and pornography in the watershed year of 1933. Through books and exhibitions, both men insistently publicize acts or poses ordinarily hidden shamefully from view.

Agitational montage might seem to refuse art altogether as an irrelevancy in making images for a political cause. Aesthetics versus utility presents a convenient topic of debate, but the work by John Heartfield, like the theories of documentary advanced by Lajos Kassák, Karel Teige, and others, utterly dissolves this opposition. Art and politics are allies here, not enemies. Heartfield's photomontages, which correlate political effectiveness to aesthetic impact, make particularly clear the value in seeing photography as art on the part of those who wield the camera as a weapon.

Antinomies between private and public, art and politics thus are transgressed or overcome in avant-garde photomontage after 1930, at least until the advent of World War II. Progressive art is subsequently forced underground. Jindřich Heisler, Władysław Strzemiński, and Teige each turn to photomontage in secret during the war years, when the formerly ever-swelling streams of media imagery have dried up and unprecedented atrocities are perpetrated free of troublesome coverage by the press. The persistence of creative vision in these unimaginably

9.1 Unknown, View of photography fresco, lobby of Budaörs airport, Budapest, 1937, gelatin silver print, 17 × 23.4, Magyar Építészeti Múzeum, KÖH, Budapest

difficult times warrants special attention, both for what it tells us about modernity in central Europe and about its demise.

Teige's wartime work summarizes the enormous, paradoxical ambitions of the formative era that preceded it. His compositions cull from a once image-saturated world in which photojournalism and documentary flowered alongside the output from film studios, design schools, art movements, and the amateur photography network — all circulating ceaselessly in the pages of illustrated books and journals. Mixed into the prodigious visual array are innumerable examples of earlier art and architecture, particularly from the baroque. In his deployment of such wide-ranging references, Teige epitomizes the understanding of photography as an encyclopedic, continuously developing medium, its essence defined above all by its exemplary history as modern art. The force of that understanding, which in its day expressed both aesthetic awareness and a profound commitment to historical change, did not survive its distortion and suppression under the Nazis. Inheritors of central European modernism, for example authors of postwar histories of photography, failed to acknowledge their debt to the "new vision" as a mode of historical awareness, perpetuating its self-serving formalism while evacuating it of any social dimension. Central Europe, meanwhile, ceased to exist as such.

Heartfield, the most famous photomontage practitioner of these years, is renowned especially for his nearly decade-long association with the *Arbeiter Illustrierte Zeitung* (AIZ). Already in 1929, when Heartfield was beginning to design for the AIZ, he had a reputation in Germany and internationally for photo-

montage book and poster designs in the service of communist agitation. His work for Malik publishers, which, as critic Walter Benjamin shrewdly observed "[turned] the book cover into a political instrument," created a great effect in the region.[1] A 1923 layout for Franz Jung's story *The Conquest of the Machines* (*Die Eroberung der Maschinen*), for example, which features a disembodied factory worker's fist thrusting a pistol nearly straight out of the page, was recycled in three separate Czech and Polish projects during 1927 and 1928, and reappeared in a photomontage by Teige from the later 1930s.[2]

Heartfield's unique standing reached new heights at the Stuttgart showing of *Film und Foto*, where he nearly filled a room with more than one hundred original cover designs, printed materials, and other photomontage compositions from the Dada period onward.[3] During the year following this presentation, in effect a full retrospective embedded within the larger exhibition, Heartfield became a regular contributor to the AIZ, producing nearly 250 compositions between 1930 and the journal's precipitous collapse in 1938. He also continued to exhibit,

9.2 Unknown, Hitler addressing a crowd, in Hans Diebow and Kurt Goeltzer, *Hitler: Eine Biographie in 134 Bildern* (Berlin, 1932), photo-lithograph of photomontage, 26.6 × 19, Jindřich Toman, Ann Arbor

155

JOHN HEARTFIELD (German, 1891–1968), *Twenty Years Later! (Nach Zwanzig Jahren!)*, in Wieland Herzfelde, ed. (German, 1896–1988), *Arbeiter Illustrierte Zeitung* 13, no. 36 (6 September 1934), photolithograph of photomontage, 38 × 26.5, The Museum of Fine Arts, Houston, Gift of Max and Isabell Smith Herzstein

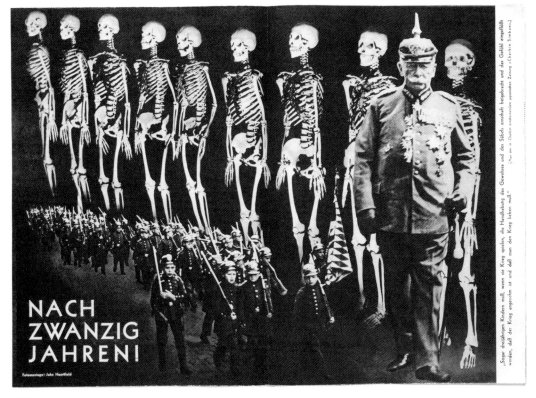

155

showing the original maquettes to his AIZ montages and book designs in Moscow, Paris, and several times in Prague, the latter city becoming the base for AIZ operations after Heartfield, his brother Wieland Herzfelde, and others relocated there following the Nazi coup in March 1933.

It can seem difficult to reconcile the strident political content of Heartfield's photomontages with the subtleties of their aesthetic form. In his own day, certainly, Heartfield endured attacks both from those who found his compositions self-indulgent in their erudition and those who deemed them merely one-liners.[4] At the same time, as shown in chapter 7, a wide welcome was extended to this sort of work in the field of "activist documentary," whose advocates explained the value of photographic imagery—whether in photomontage or "straight" pictures—precisely as a superlative alignment of artistic and political operations: casting down traditional art-making while taking political agitation to new heights of artistry. "Photomontage is 'painting' for the era of machines and rotogravure; it's class 'painting,' gigantic industrial building, mass production," Teige declared in a lengthy article "On Photomontage," published just months before Heartfield relocated to Prague. Teige ranked Heartfield's carnivalesque sat-

ire, it is true, one step below the "revolutionary praxis of the proletariat" depicted in Soviet montage. Yet he appreciated the sophisticated interplay of text and image in these works as a means to challenge art from within its own domain, a protest that was itself political and grounded, furthermore, in revolutionary politics. Conceptual and aesthetic excellence thus became indissociable from sloganeering: "[Photomontage] created a new 'painting,' which is not painting in a traditional sense either with regard to its social and ideological mission, nor in its materials and techniques, and which will actively affect and change the world and humanity's ideological mindset [*lidská psychideologie*]."[5]

Heartfield's AIZ work **(cat. 155)** found emulators during the 1930s across central Europe and beyond, from Mieczysław Berman in Poland, to Sándor Ék (Alexander Keil) and Kati Horna in Hungary, the Austrian Siegfried Weyr and his journal *Der Kuckuck*, or the Catalán artist Josep Renau. Remarkably, Heartfield did not inspire followers in Czechoslovakia during his five and a half years there, nor did AIZ pay much attention to events in the Slavic world outside of Russia.[6] Nevertheless, Heartfield found a place in the Czech photography and publishing environment.[7] He participated in at least three Czech-run exhibi-

tions, including the *Mezinárodní výstava fotografie* (International Exhibition of Photography) organized in 1936 by Lubomír Linhart, which turned out to be the last of the mammoth "new photography" exhibitions in interwar Europe. Heartfield also created some photomontages for left-wing Czech magazines in which Linhart and others were involved, such as *Svět práce* (The World of Work). In the first footnote to "On Photomontage," Teige notes the absence of prior historical studies on the subject; Linhart, like German designer Jan Tschichold before him, intended to publish such a study in the mid-1930s, doubtless inspired in part by his acquaintance with Heartfield.[8]

Heartfield benefited from exceptional public sympathy by Czechs in the matter of an April 1934 exhibition on international caricature, from which seven of his works were forcibly removed after repeated demands for censorship by the German and Austrian embassies. The incident was widely reported in the local Czech and German press, prompting a sudden upsurge in attendance.[9] Heartfield, meanwhile, fashioned a caustic rejoinder in the AIZ, in which the formerly solid grid of his exhibition objects, now pockmarked with gaps, reveals the façade of a prison with a bloodied corpse lying

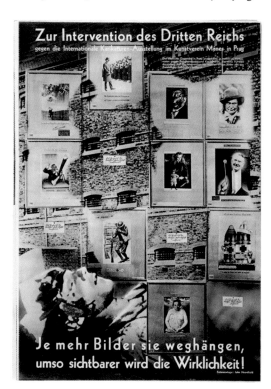

9.3 John Heartfield, *On the Intervention of the Third Reich…* (*Zur Intervention des Dritten Reichs…*), in Wieland Herzfelde, ed., *Arbeiter Illustrierte Zeitung* 13, no. 18 (3 May 1934), photolithograph of photomontage, 38.2 × 28, The Museum of Fine Arts, Houston, Gift of Max and Isabell Smith Herzstein

before its walls **(fig. 9.3)**: "The more pictures they remove, the clearer the reality becomes!"

It is worth noting the manner in which Heartfield presented his work at exhibition, visible in this montage.[10] Heartfield did not oppose showing his compositions in their primary state, rather than as published, with their all-important textual component kept separate from the image. This mode of display casts the compositions as titled works of art, a suggestion heightened by their placement in frames. The association in no way undercuts their agitational effect. Indeed, it suggests rather that Heartfield's montages derived political force, in their own time, by operating in constant dialogue with conventions of art, a marriage of art and politics in keeping with the larger activist movement in photography. Both the 1934 caricature show and Linhart's international photo survey two years later were hosted by the Mánes art society, where Heartfield accepted honorary membership in 1937.

Another formative influence on central European photomontage was Bauhaus professor László Moholy-Nagy. Although Moholy used the term "photomontage" only hesitantly in the two editions of his book *Painting Photography Film*, he elevated it soon thereafter to designate a separate class of photographic object, equal to the photogram in its innovative effect. Two essays of 1927–1928, both published in the largely conservative Austrian amateur journal *Photographische Korrespondenz*, set forth qualities of an ideal photomontage composition: unity, legibility, "organic super-reality."[11] Moholy's appreciation of blank space and his emphasis on narrative clarity found widespread admiration, particularly among his Bauhaus students. A number of them, like the designer and metalworker Brandt, made montages as a serious pastime, never exhibiting these works but applying themselves assiduously to their research and creation **(cat. 156)**.

The untitled photomontage shown here seems to have been among the last of nearly fifty known works in this technique by Brandt, who apparently began to save photographic clippings from the *Berliner Illustrirte Zeitung* (BIZ) and UHU even before she had made many photomontage compositions. Brandt kept this budding archive at her side, taking the clippings with her to Paris on a nine-month sabbatical in 1926, for example, where her activity in photomontage really took off.[12] This maintenance of a portable store of images, culled from the press for private creative ends, suggests photomontage as a sort of diaristic interface for artists with the news of their day.

156

MARIANNE BRANDT (German, 1893–1983), *Untitled (Ohne Titel)*, c. 1930, photomontage (printed matter), 65 × 50.1, National Gallery of Art, Washington, Gift of the Pepita Milmore Memorial Fund, the R. K. Mellon Family Foundation, and Thomas Walther

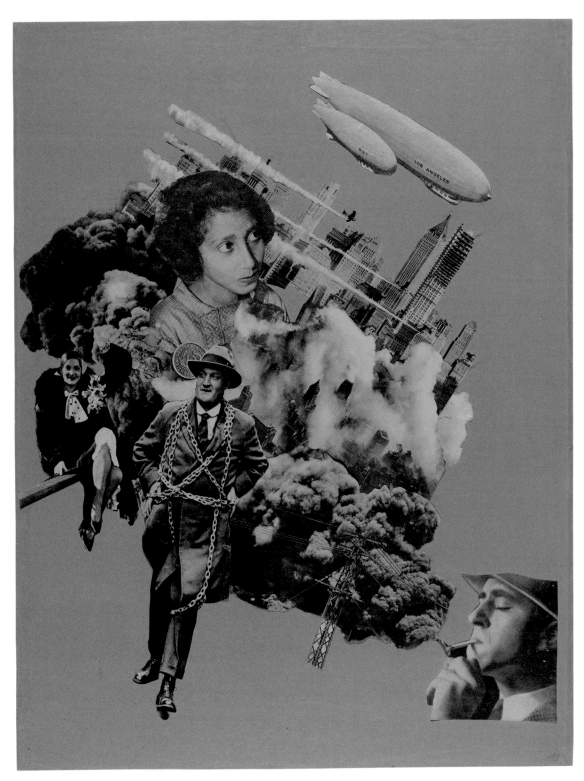

9.4 Lajos Vajda, *Collage with Bird (Madaras kollázs)*, 1937, collage (printed matter and ink), 40 × 50, Directorate of Museums in Pest County— Ferenczy Museum, Szentendre

The technique also seems to have helped artists combat feelings of isolation while abroad. In addition to Brandt, Devětsil affiliates Jaroslav Rössler and František Halas, the Polish artist Brzeski, and the Hungarian painter Vajda all pursued photomontage during Paris sojourns, without seeking to exhibit the results there or at home.

While several of Brandt's photomontages, particularly the early ones, depict private dramas using publicly circulating imagery, many others comment critically on public welfare in the 1920s. Works with editorializing titles such as *This Is How We Live (So Leben Wir)*, *Our Unnerving City (Unsere irritierende Großstadt)*, or *It's a Matter of Taste (Es ist Geschmackssache)*, all from 1926, offer the didactic analysis of class and gender relations by now familiar in central European modern photography. The young, perhaps Jewish, girl at the center of *Untitled* rises with enhanced stature above the mayhem, emanating a sense of dignity that gives (false) hope she might survive this apocalyptic scene. Her expression of perturbed innocence, suggesting a wisdom beyond her years, contrasts markedly with the smugness of the man at lower right, who seems happy to puff away with closed eyes while his oblivious actions spark mass metropolitan destruction.[13]

Brandt's photomontages amount to melodramatic narratives transferred from cinema to the printed page. Beginning with the gesture of the unwitting arsonist, *Untitled* unfolds as a story of escape and entrapment, in which moves toward departure by the Houdini-like man in chains and a cheerily waving Marlene Dietrich are set against a tense duet between the young heroine and her cigarette-smoking nemesis. Current events of 1930 propel this storyline: the aftermath of Black Monday on the New York stock market (28 October 1929), symbolized by the ten-*pfennig* coin at the heart of the composition; Dietrich's sudden emigration to the United States, one day after the grand premiere of her signature film *The Blue Angel* (1 April 1930). Overshadowing even these momentous happenings, like the Zeppelins and fighter planes crossing the dangerously tilted skyline, is the clandestine German rearmament campaign, pursued in violation of the Versailles peace accords since the early 1920s, but particularly after 1926, with broad public support.[14] Brandt's *Untitled* invests this turbulent history with Dickensian pathos, keeping the viewer at a safe remove while tugging at his heartstrings: it was the best of times, it was the worst of times.[15] The implicit distancing of a stable, if compassionate, audience from scenes of manifest instability vitiates the transformational force of Brandt's photomontages. In their visual cogency and attention to detail, these works nevertheless present a remarkable power of attraction—one based, significantly, on an artistically sophisticated treatment of headline news.

From around 1930 as well, the Hungarian Vajda created a series of approximately twenty or more photomontages, many on the themes of violence, death, revolution, and military conflict. Very little is known about the circumstances in which these works were produced, other than that they were made during an extended sojourn in Paris, when the artist supported himself through menial jobs such as window washing and, ironically, painting toy soldiers.[16] Vajda, who was only twenty-two years old when he left for France, did not exhibit the photomontages as far as is known, nor did he write about them. After his return to Hungary, Vajda abandoned photomontage, although he continued sporadically to make collages **(fig. 9.4)** and even to incorporate photographic elements occasionally amid the thin, nervous lines of his remarkable village scenes. Like other Hungarian artists of his generation, such as Endre Bálint or Lili Ország, Vajda seems to have confined photomontage to a separate realm of creative practice, in his case perhaps to match the entirely distinct experience he had of living in bohemian poverty in Paris.

Like Brandt, however, Vajda made numerous and complicated works in photomontage, and at an

LAJOS VAJDA (Hungarian, 1908–1941), *Untitled (Tolstoy and Gandhi) (Cím nélkül [Tolsztoj és Gandhi])*, 1930–1933, photomontage (printed matter and ink on painted plywood), 61.3 × 50.5, Hungarian National Gallery

impressive size (many works by both artists measure roughly 65 × 50 cm). Vajda's insistence upon brutal conflict in these works is impossible to miss. Skulls, destitute children, a hangman, and ferocious animals inhabit these works, along with many soldiers; titles (perhaps attributed posthumously) include *War (Háború)* and *Flogged (A megkorbácsolt hátú)*. *Tolstoy and Gandhi* **(cat. 157)** is named for two world-renowned pacifists, the former represented at nearly architectonic scale by his head alone, the latter shown in miniature at the lower edge of the picture. An only slightly larger image of Lenin in profile, located below center, triangulates between the Russian writer and the Indian activist.

Linking the titular protagonists more directly is a Hungarian girl in peasant costume, originally a brilliant red, who appears ready to release a dove. These and other emissaries of peace inhabit the lower half of the composition, against a monochromatic background that doubles as a horizon line. Falling from the sky, meanwhile, are two dead or dying soldiers, one (at right) heaped like a burden on the shoulders of a comrade in arms, the other reeling from a shot to the gut that Vajda has either enhanced or created through the manual addition of a vermilion stain. A trumpeter lad rises between the wounded, sounding his instrument like a clarion call. The adolescent figure recalls Soviet pioneers photographed by Aleksandr Rodchenko, but it carries a diametrically opposed valence, suggesting here the disheartening transformation of youths eager for uplift into sheer dead weight.

Tolstoy and Gandhi deploys key modernist devices—fragmentation, abrupt shifts in scale, elemental abstraction—to enhance and complement a frankly political content. Vajda is known to have associated with Kassák's leftist Munka-kör in the late 1920s, just prior to his departure for Paris. Kassák, like Teige, approached activist documentary as a revolution in the history of art, considering the value of propaganda in aesthetic terms:

The essence of the montage maker's material is threefold: color, form, and the rational.... A good montage can obviously be made only by a person who... is capable of mastering, shaping, and harmonizing this material to express the values of the creative process.... In the course of its development, the montage has not forsaken its tendentious aspirations, its stress on tendencies of rationality illustrated by motifs of rationality. A painter may aspire to abstraction or the absolutely artistic, but a montage maker must, due to the very nature of his material, also undertake rational solutions in his work.... [17]

In this argument, highly symptomatic of its time and place, photomontage is proposed as a consummate form of modern creativity, a new aesthetic form grounded in "tendentious aspirations" expressed through self-reflexive consideration of "the values of the creative process." Photomontage takes social analysis as a material property; it marries individualist aesthetics and subjectivity with didacticism and an attendant emphasis on collective public reception (Kassák's interest lay in advertising, the subject of a book in May 1930 in which this essay first appeared). Lacking Kassák's ideal public arena, *Tolstoy and Gandhi* nevertheless fits his program, and in fact demonstrates the space opened up within fine art proper by Kassák's theses. For a time at least, it became possible to make of politics the stuff of art, skirting the pitfall of an inartistic representation of political content on the one hand and the increasingly dominant aestheticization of politics on the other.

In Poland, meanwhile, avant-garde attention to photomontage in the 1930s took a thoroughly populist turn. Brzeski, a leading designer of photomontages for the illustrated press, made a series

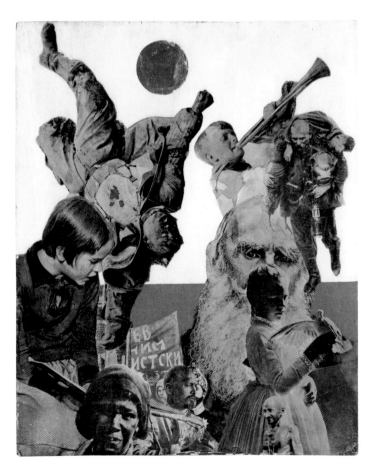

157

of erotic compositions while working for *Vu* in Paris, which he, like Brandt and Vajda, kept wholly private **(fig. 9.5)**. Brzeski developed the twinned themes of sex and mechanization in this series into a further suite of fantasy scenes that he did publish in 1934 as illustrations for his own science-fiction story, "Birth of the Robot," in the mass-circulation Sunday magazine *Kurier Literacko-Naukowy* (*Literary-Educational Courier*).[18] The text presents a vision of civilization driven to the brink of annihilation by its own machines— a compressed version of Czech author Karel Čapek's immensely successful play R.U.R. (1922), which introduced the term "robot." Where Čapek reflected, rationally, on the worrisome premises of rationalized industry, Brzeski swings between worshipfulness toward technology and alarmist visions of technological catastrophe. "Birth of the Robot" is trivial entertainment, making exaggerated and contradictory sentiments about modernization rather than exposing the fault lines of modernity.[19] For all that, Brzeski's absurdist mix of technology fetishism and apocalypse strikes a meaningful chord in the context of the long

buildup to World War II. In its hyperbolic iteration of popular themes, one might even see it as a sendup of the naive hand-wringing that marked contemporary attitudes toward war.

"Birth of a Robot" gained new life in 1936, when certain works in the series, among them *Twentieth-Century Idyll no. 7* **(cat. 158)**, appeared alongside a text replete with just such hapless paranoia. Where Brzeski surrounded his science firmly with fiction, writer Zbigniew Grotowski feigned political acuity as a front for rank escapism: "The war in Abyssinia was faraway and exotic, now we have another one, in Spain... much closer to our borders.... Any day [war] will break out of the Spanish cauldron and endanger all Europe."[20] Following these opening platitudes, Grotowski moves quickly from op-ed to sci-fi, voicing a hope that the "war of the worlds" foreseen by H. G. Wells will be followed by "the dawn of everlasting peace," guaranteed through colonies established in outer space.[21] In *The War with the Newts*, his parodic science fiction novel of the same year, Czech writer Čapek travestied this mix of inaction and sensationalism fueled by addiction to the daily news:

It was hot and the height of the silly season, when nothing, but positively nothing, happens, when there are no politics, when there is not even a European crisis. Yet even then the newspaper readership, sprawled out in agonies of boredom on sandy beaches or in the dappled shade of trees... expects, with hopes dashed anew every day, that at least in their paper they'll find something new and refreshing, some murder perhaps or a war or an earthquake, in short Something. And if they don't find it, they throw down their papers and angrily declare that there isn't a thing, not a damned thing, in the paper, that it's not worth reading at all and that they'll stop taking it.[22]

Travesty of another, primal order occurs in work by Štyrský and Bellmer that treats the pornographic image. Štyrský, who had taken up photomontage in the context of the Devětsil poetist movement, broadened his activities in this technique under the auspices of international surrealism. Like his partner Toyen, who had painted orgies and scenes of bondage already in 1922–1923, Štyrský was drawn to nonconformist sexuality, particularly sadism; he wrote the first Czech biography of the Marquis de Sade in 1930 and illustrated a September 1933 article on "Sade's Country" with a selection of photographs from his own extensive documentation of the infamous château at La Coste.[23] Earlier that year, in May,

9.5 Janusz M. Brzeski, *Lesbos II*, 1930, photomontage (printed matter and ink), 32.4 × 25.1, Ubu Gallery, New York, and Barry Friedman Ltd., New York

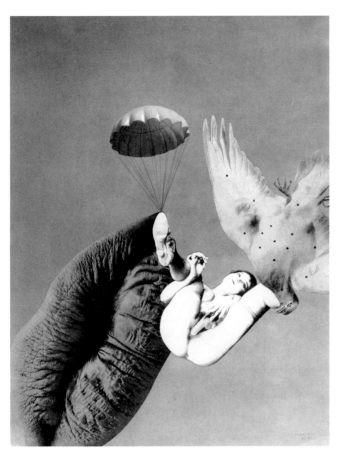

9.6 Jindřich Štyrský, *Untitled (Emilie Comes to Me in a Dream)* (*Bez názvu [Emilie přichází ke mně ve snu]*), 1933, photomontage (printed matter), 24 × 19.5, Thomas Walther Collection

Štyrský published privately, in an edition of sixty-nine copies, the scandalous book *Emilie Comes to Me in a Dream*. An introductory essay by Štyrský narrates a pedophilic obsession experienced and overcome, in tough yet emotive sentences that anticipate the prose of Henry Miller: "Emilie is fading from my days, my evenings and my dreams. . . . I no longer blush as I recall the mysterious marks of teeth I glimpsed one night below her little belly. The last traces of dissimulation impeding the emotion I was ready to feel have disappeared. . . . Even her face has been exorcised at last, the face I modeled in snow as a child, the face of a woman whose compliant sex had consumed her utterly."[24]

Accompanying this short story of death from sex is a series of ten photomontages, many of which juxtapose acts of copulation and masturbation with signs of morbidity and decay (**fig. 9.6**). In one scene, a man and woman fornicate on a bed set adrift before a wall of enormous staring eyeballs, all trained on their coupling; in another, an orgiastic threesome seems to pile out of an upturned coffin that has

spilled into an empty cellar. A skeleton possessed of a tumescent erection (for which Štyrský recycled an image by Brzeski from the cover of *Tajny Detektyw*, see chapter 6) and a frozen female corpse inhabit two other compositions, while the final piece shows two women kissing and masturbating each other in an apartment gutted by fire, as a soldier in full gear wearing a gas mask crawls past. Inventive, playful, and troubling, these desublimatory photomontages propose sex as an utterly physical act that emerges from and quickly returns to the state of material decomposition. "Emilie's beauty was not meant to fade," concludes Štyrský, after describing a double scene of incest that supposedly initiated him into the mysteries of lovemaking, "but to rot."

An afterword by Bohuslav Brouk argues that the target here is not carnal pleasure, but rather the repressed sadistic tendencies in society at large. (One has to smile at this recourse to professorial legitimation for what might have seemed merely a tawdry enterprise.) Tellingly, the issue for Brouk hinges on a public / private debate. "Pornophilia tends to immorality only in the eyes of puritans," he charges, who like such literature and pictures "to be hidden carefully in closed drawers for the use of occasional arousal. . . . This is the only branch of pornophilia that does not need an audience." Secretiveness amounts to a "kitschy treatment of pornography," an impotent simulation of real sex acts. Štyrský, by contrast, shares his lascivious imagery to the extent possible under state censorship. He also makes a point of its lewdness, dissociating sex from procreation or closeted prurience. "Not bound to letting the semen perish in the yellowish stain on the sheet," writes Brouk, "[the artist] may choose to split a Gothic dome with it. . . . He may replace the lovers' bed with a universe and under the woman's backside he may choose to place a globe." By shifting the scene of sex from the bedroom to a public, even a cosmic stage, Štyrský transforms mere kitsch into something profoundly emancipatory: "The artist, unrestricted by the rational coordination of representations, liberates sexuality through genuine proportionality and syntax from its biological function—the breeding of new generations."[25]

Bellmer's various doll series, discussed in chapter 4, do violence to a girlish body that seems almost living, and thus seem more real and disturbing than the magazine images manipulated by Štyrský, Brzeski, or other devotees of erotica—despite the fact that those images, unlike Bellmer's, show actual human beings. His lifelike dolls are deployed to stage

libidinal acts and impulses that seem abhorrent, unassimilable by any conventional measure. In its motivations and effects, nevertheless, Bellmer's art does hold common ground with other work from central Europe, particularly in photomontage, and particularly as it relates to Nazism and war.

Certain facts of Bellmer's biography bear repeating in this context. There is his family's passage from Prussian to Polish to German residence, which begins in the Silesian town of Kattowitz. Following three years of insurrections after the declaration of Polish independence in 1918, Kattowitz is ceded in 1922 by Germany, becoming (under the name Katowice) the capital of Upper Silesia, an autonomous region of great economic and political importance in the new Polish Republic. Bellmer, the son of a pro-Reich, militaristic father, falls afoul of Polish authorities—and no doubt that of his father as well—for his labor activism, escaping across the border once in 1922 to avoid imprisonment for what is called, prophetically, "undermining moral supports of the State." He settles in Berlin the following year. The parents relocate to Karlsruhe, in southern Germany, but they also acquire a property in the town of Gleiwitz, literally on the German-Polish border, where several family members remain; a place with a perennially substantial Polish population that will in fact pass into Polish hands after 1945, recovering in the process its older, local name of Gliwice. Only in 1931, as border tensions begin to escalate, does the family reunite in Berlin. Eight years later, Nazi agents plant a bomb in Gleiwitz / Gliwice that Hitler claims came from Polish nationalists and that he uses as the pretext for the invasion of Poland, which launches World War II.

Then there is Bellmer's early career as a graphic designer, the consummate new art job in 1920s central Europe, a trade that Bellmer enters, equally characteristically, after pursuing studies in fine art. His parallel practice in photography and drawing on the theme of the doll reflects this double training, as does his ease with studio procedures: posing of the model, lighting, props, and extensive manual interventions (coloring, retouching, overpainting) on the final prints. Finally, there is his rejection of family and country, a rejection that is as ostentatious as it is contradictory. As he begins to work with the doll, Bellmer declares that he has quit design work so as to avoid benefiting in any way the newly established fascist regime. The force of that decision cannot be overstated, for central European culture—and by no means simply official culture—is then structured precisely by an ethic of social utility. At the

same time, Bellmer does not turn on his family, excoriating (on the Oedipal model) only his father; quite the contrary, the making of the first doll, as historians have noted, is very much a family affair.[26]

Photographs of the doll first appeared, together with an introductory essay, in an anonymously published book in 1934, a project analogous to Štyrský's *Emilie* but with correspondingly higher stakes in its aim now to "undermine moral supports" of the Nazi state.[27] The French surrealist journal *Minotaure* printed a centerfold of doll photographs in December 1934, leading to further collaborations in France, where Bellmer eventually moved in 1938. His major sculptural project of 1937, for example, *Machine Gun(neress) in a State of Grace* (**cat. 159**), is titled in French and dedicated to Bellmer's close friend Jean Brun. Despite his deep affinities with the French avant-garde, however, Bellmer, like Max Ernst before him, came out of a Germanic environment and found a creative identity in work that addressed the worst of that environment. Hal Foster has proposed that the early art of both men wounds the battle-hardened, impervious male body imagined by Nazi ideology, making manifest, and manifestly unpalatable, the devastating psychic and physical violence wrought in the name of that ideology.[28]

Such an art cannot stand strong and whole, for it achieves its effect only by staging its own breakdown. Thus, *Machine Gun(neress)* sets before us a creature as threatening as a mutant praying mantis, but also as abject as a caricatural aging whore, with sagging breasts and a nimbus of pink gouache that evokes caked makeup. The machine gun, a leading cause of the carnage and stalemate in World War I, is anthropomorphized here not just as feminine—the French word *mitrailleuse* is gendered female—but as feverish, delusional. Yet like the dolls, it is a love object as well. Indeed, this photograph, one of a series exhibited against all probability in southern France during the war, elegizes at monumental scale the sculpture itself (herself), which Bellmer was forced to leave behind at emigration.

Bellmer was lucky to find a home for himself and his art in France; many of the people named in this book spent the years of Nazi rule in internal exile, if they survived at all. Surrealist poet Heisler, born during the first days of World War I, was barely twenty-four years old when the Germans dismantled Czechoslovakia. As a registered member of the Prague Jewish community, Heisler was ordered to present himself to the authorities in 1941 (the Star of David, compulsory

159

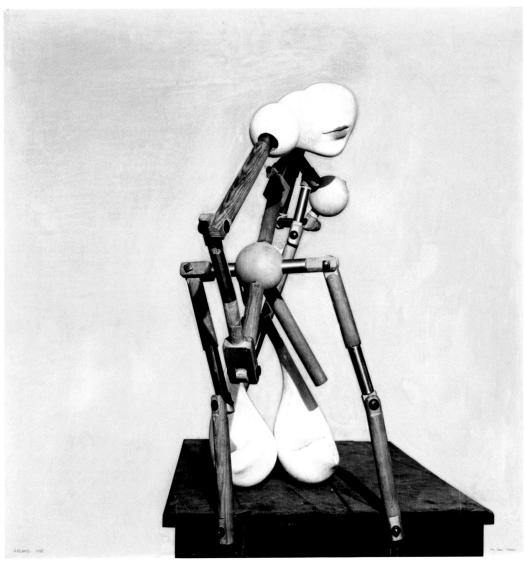

159

in Poland since 1939, was declared mandatory through-
out the Reich that September; Theresienstadt [Terezín]
concentration camp opened in October). Heisler went
into hiding instead. For more than three years he
shuttled between the nearby apartments of his sister,[29]
Teige, and the painter Toyen, Štyrský's longtime com-
panion (Štyrský died of illness in 1942). Nearly caught
twice following the assassination of Reinhard Heydrich,
administrator of the Czech Protectorate and principal
architect of the so-called Final Solution, Heisler there-
after left his enclosures almost exclusively at night.
At the same time, in a sign of inspired resistance, he
apparently attached on his nocturnal sorties a watch-
spring to his nose, to "aryanize" its profile.

Heisler's war years were remarkably prolific.
Already in 1939, coincident with the occupation, he
and Toyen published the collection *Only Kestrels Piss
Calmly on the Ten Commandments*, defiantly printed in
Czech and German.[30] Later that year, the pair collabo-
rated on *Specters of the Desert*, in which Toyen's ink
scenes of cracked and hollowed flesh float above tight-
lipped vignettes by Heisler:

**Necklaces rest in shopwindows in velvet boxes
a slavey rushes into the street
The courtyards are all filled with gunpowder
and a billiard cue scared of the green felt
prefers to spit blue chalk from its tip
on the newspapers of central Europe**[31]

Further manuscripts and private printings followed in 1940–1942: "Far beyond the Front"; *On the Needles of These Days*, with photographs by Štyrský, mentioned in chapter 6; a commemorative album for Toyen's fortieth birthday.[32] Especially impressive is *From the Casemates of Sleep*, 1940, a collection not so much of verse as of photographic arrangements to which the subtitle gives the newfound category of *realisované básně* or "realized poems" **(figs. 9.7, 9.8)**. Heisler and Toyen collaborated on these mock window displays, which are pervaded by a camp aesthetic and include many winsome or simply silly items: false teeth, miniature Christmas trees, bonbons, the "spooky" lettering for the cover. Such low-brow humor recurs regularly in Devětsil and in Czech surrealism. It is not an antidote, nor an escape, but something like a license to engage tragic or momentous events on what are literally dis-

arming terms. Yet a sense of claustrophobic nihilism persists. Sleep is a casemate, an armored battleship cell, fortified against an outside enemy yet a prison nonetheless. As the title to the last poem indicates, the goal is "That I Not Wake Up."

And so it is as well with the roughly thirty autonomous photomontages, manipulated photographs, and objects that Heisler made between 1942 and 1945, the years of his confinement. *Super-male* **(cat. 160)**, which Heisler prepared for an unrealized edition of Alfred Jarry's book by that title (*Le Surmâle*, 1902), shows a tiny cyclist struggling uphill inside an endless loop, which could be a moonscape or, more fatefully, the workings of a watch (the watch motif, which relates to Heisler's nighttime outings, recurs in several works from these years). The passage from surrealism to existentialism, with its sense for time as the

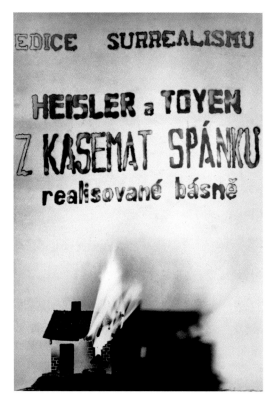

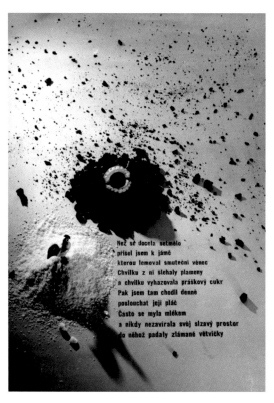

9.7 Jindřich Heisler and Toyen, *From the Casemates of Sleep: Realized Poems (Z kasemat spánku: realisované básně)* (Prague, 1940), cover by the authors, photolithograph of gelatin silver print from assemblage, 16.3 × 14.2, Galerie Maldoror, Prague

9.8 Jindřich Heisler and Toyen, "That I Not Wake Up" (Abych se neprobudil), in *From the Casemates of Sleep (Z kasemat spánku: realisované básně)* (Prague, 1940), photolithograph of gelatin silver print from assemblage, 16.3 × 14.2, Galerie Maldoror, Prague

Before the sky grew utterly dark
I came to the pit
ringed by a funerary wreath
One moment flames whipped upward from it
The next it spewed confectioner's sugar
I began to go there daily
to listen to its lament

It washed itself often in milk
and never closed its tearful opening
into which broken twigs fell

160

161

measure of endless entrapment, becomes clear in such a composition, as it does in Heisler's series *As Bad as Each Other* **(cat. 161)**. Made by spreading melted glue (the binder of choice in photomontage) over the photographic surface, the latter works, nearly a dozen in all, mine their physical material for metaphoric associations. Heisler cripples and miniaturizes the able-bodied, flays their flesh, and leaves them at once stuck to their fate and unglued. To the violent analysis of contemporary situations common to all artists in this chapter, Heisler adds poignant lyricism and an enduring sense of gallows humor.

Poignancy, but no humor, governs a series produced under similar circumstances in Łódź, Poland, by abstract painter Strzemiński. Strzemiński is one of the most formidable artists of interwar central Europe, and his series *To My Friends the Jews* counts as a singularly moving contemporary response to the annihilation that sealed this region's fate **(cats. 162, 163)**. The nine sheets that constitute the series contain one ink drawing and one photograph each. Three of the photographs show healthy, adult Jewish men in silhouette, one barely past adolescence, one a more seasoned worker, and the last an older religious man wearing the hateful yellow star. The remaining photographs memorialize the capture, deportation, and murder of Jewish citizens. Four of these documentary images are presented whole; the others, including the three male silhouettes and the two works shown here, are shaped with scissors. Drawing and photograph face off against each other, or overlap uneasily, against a blank ground. The works, titled but unnumbered, were given by the artist to the Yad Vashem Holocaust Memorial in Israel shortly before his death, in 1952; a tenth composition, showing another Jewish man in silhouette, went to the National Museum in Kraków.

Although Strzemiński never worked with photographs before or after *To My Friends the Jews*, the series culminates more than a decade of reflection on issues of representation and, during wartime, on commemoration as well. In 1934, Strzemiński and his wife, the sculptor Katarzyna Kobro, stopped identifying their work with the revolutionary approach to abstraction they called unism. Formulated beginning in 1924, unism posited an end to all forms of dynamism or division in painting, which the artists charged with individualism now discredited in the new world order of collective, industrial production. This meant, in practice, abandoning not just figuration, but also

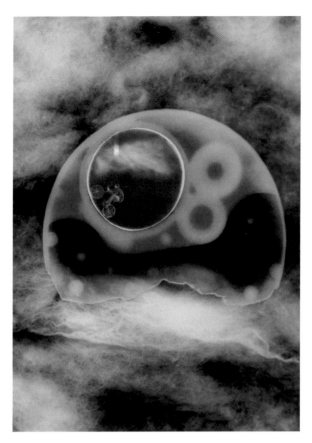

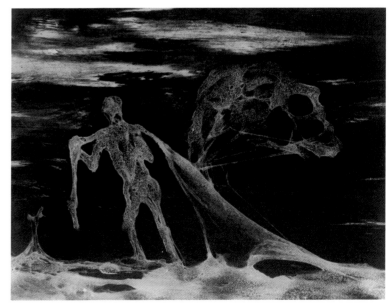

160
—
161

the "drama" of differentiated shapes, compositions with a center and a periphery, or tensions between figure and ground. All such elements would distract viewers from the primary fact of the flat, framed canvas or, in the case of sculpture, the three-dimensional shape in real space.

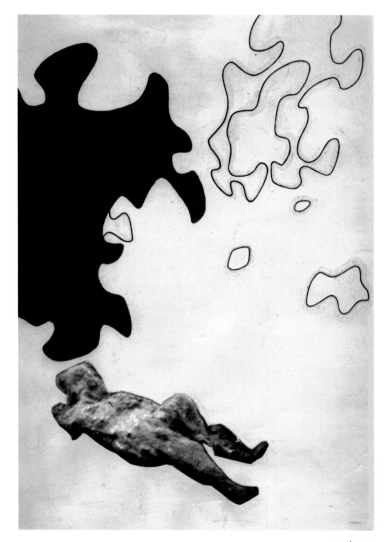 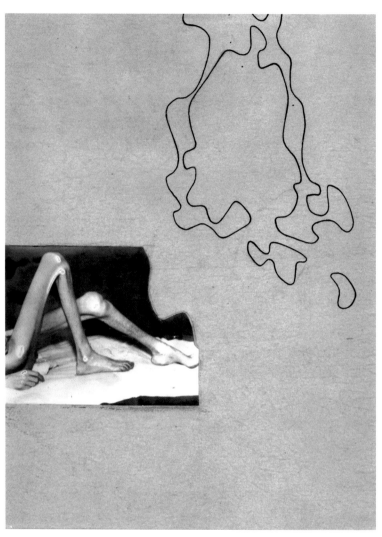

162 | 163

162

163

Unist abstraction was not intended to yield work directly serviceable within a socialist revolution. Instead, the artists viewed their art in strict analogy with the socialist ideal of a liberated, self-aware humanity. "A form of existence produces a form of consciousness. An appearance of a new form creates a new content. *Therefore form is value,*" Strzemiński contended in 1924.[33] Ten years later, Kobro restated the case: "A work of art cannot be more or less 'functional.' It can be simply a field of plastic experiment, offering more or less useful solutions of forms for a utilitarian realization of functionalism."[34] The two unists, who attracted many disciples in the 1930s, thus abstained from debates over art's subservience to or autonomy from politics, treating art and politics instead as complementary means toward existential improvement. They also remained, in their orientation toward the future, profoundly conscious of history: Strzemiński taught art and art history for much of his career, and he and Kobro helped found the Muzeum Sztuki in Łódź in 1931, one of the earliest public collections of international contemporary art. Far from discarding all that had come before him, or evaluating past centuries according to a self-serving teleology, Strzemiński in particular became what Yve-Alain Bois calls "a historian of the long duration."[35] In his 1934 book *Modern Art in Poland,* Strzemiński proclaimed that the truly modern artist must "recapitulate the entire trajectory of the evolution of art, so that he will be able to elaborate in full consciousness the form appropriate to our own time."[36]

Strzemiński, and Kobro after him, changed course in the early 1930s, turning from a variety of architectonic propositions in painting and sculpture **(fig. 9.9)** to adopt in Strzemiński's case the noodling line ultimately found in *To My Friends the Jews.* Strzemiński thereafter forsook the radicality of his all-over, modular or serially constructed unist compositions for classically centered tableaux, switching between abstract and figurative compositions. His biomorphic period thus marks a "retreat" from unism, suggesting a loss of faith in the utopian possibilities of that particular abstract program.

At the same time, this change in direction furthers, in the logic propounded by Strzemiński himself, a necessary project of ceaseless historical reevaluation, aiming always to find "the form appropriate to our own time."[37] In this regard, it seems highly significant that Strzemiński's new drawing style, thin contours set against a neutral surface, offered the possibility of expressing alternately abstract and representational scenes with no change in idiom. The problematic of oscillating between representation and abstraction is germane to experimental photography, particularly photomontage, a procedure that can increase legibility but also easily frustrate it, by detaching shapes from their larger context. Problems of representation and legibility take on a monstrous dimension, moreover, with regard to the Holocaust, not only at an ethical level—should one try to picture genocide, or can it be adequately visualized—but in the brute, wrenching effort to apprehend victims' grossly distorted bodies as human.

Trapped in Łódź—renamed Litzmannstadt—Strzemiński, Kobro, and their young daughter Nika endured the war in a cramped apartment with barely room for a bed and a table. Kobro, who burned her surviving sculptures in 1945, stopped making art altogether; Strzemiński used the lone table for his drawings and for commissioned portraits. In 1941, their works were requisitioned for a show of *Entartete und jüdische Kunst* (Degenerate and Jewish Art). Neither artist was Jewish. Because of this, rather than being herded into the ghetto, they surmised its murderous operations from the outside. The first of the Reich ghettos, Litzmannstadt Ghetto was established by forcibly relocating the local population, the second greatest Jewish community in Europe after Warsaw—and walled in during March–April 1940. More than 160,000 Jews were imprisoned there at the outset, to be joined by 5,000 Roma and 20,000 more Jews from Austria, Czechoslovakia, Germany, and Luxem-

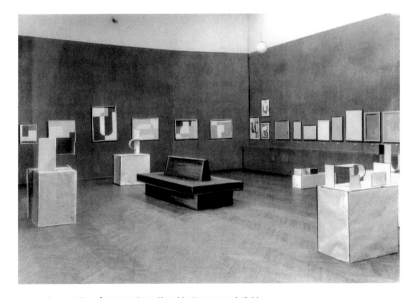

9.9 Unknown, View of *Wystawa Grupy Plastyków Nowoczesnych* (Exhibition of the Modern Artists' Group), Warsaw, 1933, including paintings by Władysław Strzemiński and sculptures by Katarzyna Kobro, gelatin silver print, 23 × 16, Archiwum Dokumentacji Mechanicznej, Warsaw

bourg—a perverse compression of the central European regionalism discussed throughout this book. Around 120,000 of those interned died or were deported during 1940–1942. Between 7 and 29 August 1944, in anticipation of liberation, the ghetto was decimated and its remaining 70,000 inhabitants removed to the concentration camp near Auschwitz (Oświęcim), about a five-hour journey south. Łódź, or what survived of it, recovered its name and its freedom with the arrival of Russian troops on 20 January 1945.[38]

It is in these circumstances that Strzemiński created the groups of drawings he recycled in To My Friends the Jews, engaging what he called "the tangling of the biological line of the surrealists, desperately wriggling while searching for a way out...."[39] Beginning in 1939 with Western Belarus (Białorus Zachodnia), and continuing with Deportations (Deportacje), 1940; Faces (Twarze), 1942; and Cheap as Mud (Tanie jak błoto), 1944, Strzemiński accumulated grim drawings in which, despite their descriptive titles, the bloblike outlines themselves hover on the edge of recognizability. Shapes emerge from bleak, undying abstraction into deathly figuration, then cross back into abstraction, as if pursuing the endlessly looping route of the Stygian ferryman. Shattered in his search to construct a field of absolute oneness, in painting as in society, Strzemiński resorted to tracing hollow contours. Utopia is, after all, a nonspace.

These drawings served as the substrate for To My Friends the Jews, which Strzemiński assembled directly after the city's liberation. The Sticky Stain of Crime, for instance, repeats with some alterations a motif from Cheap as Mud; other sheets retrace or rework compositions from Faces and Deportations. The introduction of photographs, particularly the shaped ones shown here, carries a brutalizing effect, making the drawn silhouettes seem themselves like violent cut-outs, a form of torture through pressure that distends bones and flesh nauseatingly into jigsaw puzzle pieces. Never did the action of pen and scissors seem so similar, or so cruel. Sickeningly alike, too, is the blending of figuration and abstraction achieved in drawing, but also through charred or starved human bodies. This is a world in which a man's legs can in fact be stretched into wires (cat. 163). The series is evidently commemorative, but more specifically it seems mnemonic, its abstracted human forms, or piles of bones and skulls, acting as ciphers to prompt recollection of what it once meant to be a person. Photomontage, an act of shaping and reframing the photographic, heightens the force of that undertaking, yet in its very fragmentation it makes tragically clear the impossibility of reconstructing humanity from memories.

The final body of work to be considered in this narrative of central European modernity likewise operates in a diaristic dialogue with the outside world, one in which utopian hopes for the future collide with commemorations of a defunct civilizational past; a dialogue that develops, moreover, into something like an art-historical treatise on photography. The photomontages produced in prolific quantity by Teige from around 1935 until his death in 1951 form an idiosyncratic monument to modernity in central Europe. Literally a Sunday pastime, the montages were kept out of sight and shown or given only to intimate relations or close friends among the surrealists in Prague and Brno. Teige never sought to publish or exhibit these works, even in the few years when that would have been politically feasible. And yet they articulate a scholastic attention to public space, mediated through Teige's published theories and through his belief in artistic and political revolution as the twin motors for true world change.

There are approximately four hundred works in all, most signed, dated, and inventoried by the artist. Almost all are made strictly from photographic reproductions, although a few betray the xylographic inspiration of Max Ernst. Teige titled his creations Collages rather than photomontages, presumably because he associated the latter term at that point exclusively with agitational propaganda; his own works would be political but not topical and would pay homage (as the choice of title suggests) to cubism, a heroic but by then historical period in modern art. The ubiquitous presence of fragmentary female nudes in the Collages has led writers to evaluate them in line with Freudian theory and the dictates of French surrealism. As Vojtěch Lahoda suggests, however, such an alignment is part of a larger parallel between the photomontages and Teige's theories on art and society (including theories of surrealism). The eroticism of his works, in other words, like their title, carries a distinctly pedagogical cast.

Teige situates many of his nudes in public spaces, reshaping limbless or headless torsos into counter-monuments.[40] His choice of site is frequently provocative—the National Theater (see cat. 5), quaint cobblestone streets, a cemetery, Prague Castle—but carries an important measure of idealism as well, implying that it would be to the general

164

KAREL TEIGE (Czech, 1900–1951), Collage no. 129 (Koláž č. 129), 1940, photomontage (printed matter), 44 × 29.5, Museum of Czech Literature in Prague

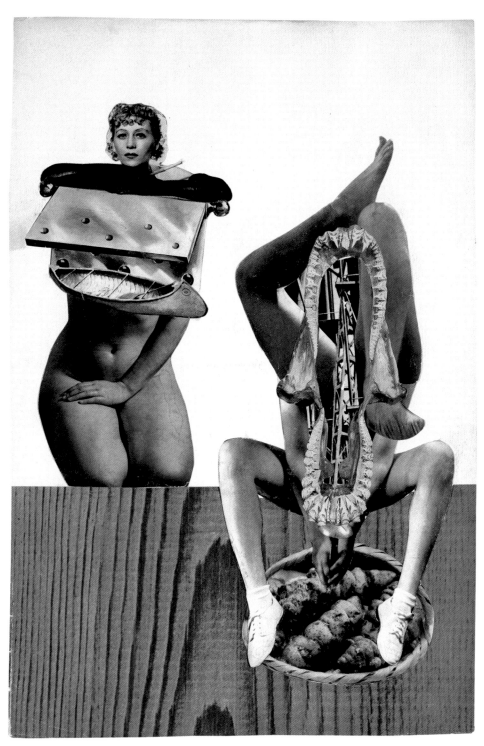

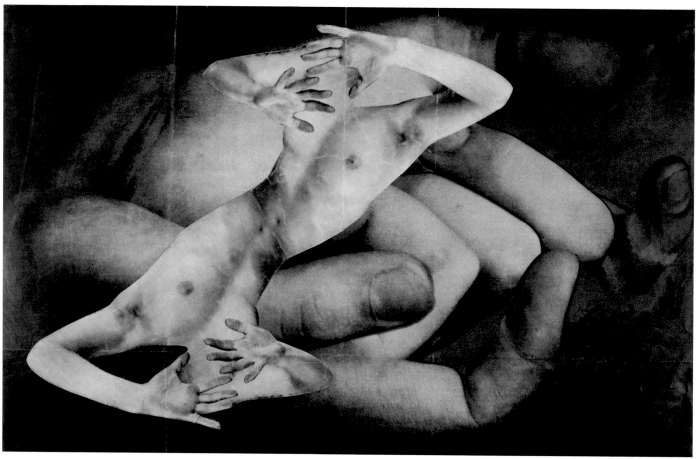

165

165

KAREL TEIGE (Czech, 1900–
1951), *Untitled (Bez názvu)*, 1943,
photomontage (printed
matter), 35 × 55, Dietmar
Siegert Collection

good if traditional or memorial public spaces could be cast down or filled up with displays of eroticized flesh. Lahoda notes the mix of sweet, romantic projection and aggressive social critique in Teige's erotic fixation, a pairing that aligns his work with the concept of "convulsive beauty" espoused by Teige's close friend André Breton. Other interests besides an extroverted libido are at stake, however, in this engagement with the public sphere.

There is, for one, a profound reaction against the war, in which the fascist sublimation of violence is replayed in the register of dysfunction and dismemberment (again, quite problematically, with passive female protagonists as the visible victims of male aggression). A cluster of *Collages* takes war and totalitarianism as its theme, picturing bomb casings, fighter planes, or a Moscow subway station named for Feliks E. Dzerzhinsky, founding head of the Soviet secret police.[41] Cataloguing these thematic references does not do justice to the scope of Teige's critique, which comes through just as forcefully in images such as the multilegged nude, its guts opened into yawning metal jaws, which sits mixing its own defecated larvae on a plate **(cat. 164)**. Although Teige's "hobby" spans more than fifteen years, the great majority of these works date from the Nazi occupation. We might consider again in this light the preponderance of public sites such as the National Theater. By projecting the female body in parts onto so many recognizable Czech spaces, Teige effectively pushes out the occupiers and replaces them with a liberating, if just as invasive, erotomania.

Teige's meditations on the return of war are augmented by a highly involved dialogue with the history of art and, in particular, recent photography. Reproductions of notable art and architecture, as well as popular culture, abound in these works. The untitled piece from 1943, for example **(cat. 165)**, features two copies of a 1939 nude photographed by Jaromír Funke. The remarkable source image, one of three Funke made by arranging a model under a rippled pane of glass, adds an erotic element to Bauhaus studies in light and texture that Funke adapted for his own courses at the Státní grafická škola (SGŠ) in Prague. Teige, who had lectured at the Bauhaus in 1928–1929, knew this curriculum well in its German and Czech mutations; other photomontages riff on the book Funke produced with his SGŠ pupils in 1935, *Photography Sees the Surface*. Teige also knew of Funke's resistance to photomontage, which he considered a sabotage of photographic technique. By copying Funke's work twice within the same composition and placing it against the echo of its own

(doubled) subject, Teige reprises these associations to equally instructional effect.

This is not to say that the dialogic commentary embedded within these montages gives them their ultimate meaning—it would be hard, indeed, to determine what that meaning is exactly. Teige, one guesses, turned to photomontage precisely to free himself from the constraints of expository writing, driven always by the desire to explicate. For all that, the wealth of art-historical references in the works remains striking. Scholar Karel Srp lists two pages of visual quotations, ranging from baroque architecture to Marcel Duchamp's *Rotative Demi-Sphere*, from Jacques-Louis David's *Oath of the Horatii* to silent film star Musidora. Photographic references proliferate: Moholy-Nagy, Florence Henri, Blossfeldt, Rodchenko, Funke, Sudek, and more than a dozen others. Alongside these renowned modernists are now-forgotten authors from the amateur circuit, which Teige knew well—he designed the covers for an eight-year run of the amateur yearbook *Československá fotografie*, 1931–1938—and of course countless photographs from Sunday magazines. The technique of photomontage is shown here at its most analytic: precise lines, recognizable referents, a discursive harmony that borders on the pedantic. It is a professorial technique, and Teige is an avant-garde professor. Small wonder that, two years after the war's end (and just months before the advent of the Stalinist regime that would hound him to death), Teige wrote what stands as the first art-historical survey of the medium in his country, "Paths in Czechoslovak Photography."[42]

That photography had a history as art, that it was an image medium invested with aesthetic potential no matter what the field or technology, was no longer a subject for debate. Teige could rest his writing in 1947 on his own long-standing advocacy of that argument, which he had initiated in 1922, and on an outpouring of art-historically minded texts that followed it in the later 1920s and 1930s. Above all, Teige could take as a given that photography was *the* art form for modern times, and that its hundred-year history both recapitulated and legitimated a general public embrace of modernity. What he could not recover in good faith were the utopian and critical dimensions of that "new vision," and it would be decades before other, similarly expansive theories of photography emerged to fill the resulting void. Having conquered the world, photography in 1947 **(cat. 166)** was reduced to recording its disintegration into fragments and rubble.

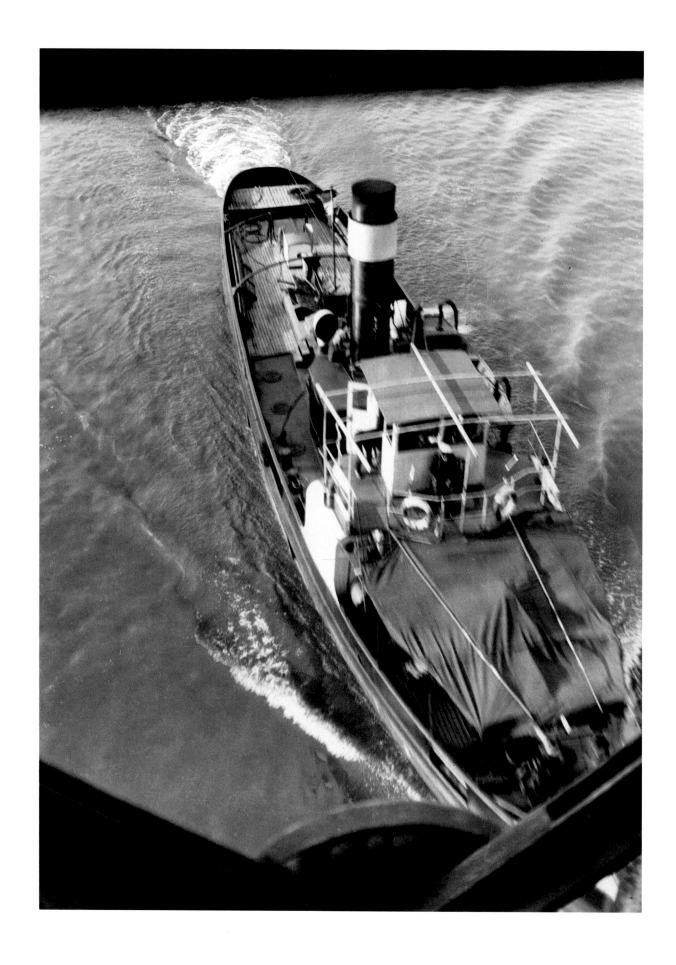

CHAPTER 1

Starting Points

1 Jiří Jeníček, "Druhý mezinárodní fotografický salon" (Second International Salon of Photography), *Pestrý týden* (Colorful Week) 8, no. 18 (30 April 1933): 11.

2 These countries constitute roughly the successor states to the Prussian and Austro-Hungarian empires, the political entities that provide the fundamental framework for this book. Places distanced from this geographical orbit after World War I, such as Königsberg or Trieste, unfortunately receive at most a passing mention. Others, by contrast, such as Vilnius, which counted before 1918 and after 1945 as "eastern" but belonged to one of the countries under discussion during the interwar decades, are included in these pages.

3 Matei Călinescu, *Five Faces of Modernity: Modernism, Avant-garde, Decadence, Kitsch, Postmodernism* (Durham, N.C., 1987), 42.

4 Iván T. Berend, *Decades of Crisis: Central and Eastern Europe before World War II* (Berkeley, 1998), 3, 24.

5 See also James Shedel, "Fin de Siècle or Jahrhundertwende: The Question of an Austrian *Sonderweg*," in *Rethinking Vienna 1900*, ed. Steven Beller (New York, 2001), 80–104. Shedel demonstrates that the Austrian *Rechtsstaat* sponsored and coopted modernism in many instances, thereby binding elements of both the bourgeoisie and the avant-garde to the state rather than marginalizing them within a societal bohemia.

6 On the adaptive reuse of foreign artistic styles in central European modernism, see Naomi Hume, "Contested Cubisms: Transformations of the Czech Avant-garde, 1910–1914" (PhD diss., University of Chicago, 2004), 7–13.

7 See Paul Lendvai, *The Hungarians: A Thousand Years of Victory in Defeat* (Princeton, N.J., 2003), esp. chaps. 30–32. Jacek Kochanowicz describes industrial development in the nineteenth-century Kingdom of Poland metaphorically as "islands of modernization in a sea of traditional peasants"; see Kochanowicz, "The Polish Economy and the Evolution of Dependency," in *The Origins of Backwardness in Eastern Europe: Economics and Politics from the Middle Ages until the Early Twentieth Century*, ed. Daniel Chirot (Berkeley, 1989), 122.

8 Viennese amateurs Heinrich Kühn, Hugo Henneberg, and Friedrich Spitzer, for example, all had darkrooms at home. See Astrid Lechner, "Der Camera-Club in Wien und die Kunstfotografie um 1900" (PhD diss., Universität Wien, 2005), 80–83.

9 Amateur membership during the 1920s and 1930s remains incompletely documented. A 1908 article (Lechner 2005, 41) lists twenty-seven amateur clubs with 2,377 members in Austria and Hungary; enrollment in German and Czech clubs was undoubtedly several times higher at that date. Polish amateurism never attained these proportions; just 208 members entered the three leading photography clubs for the period 1927–1939 (Warsaw, Vilnius, and the nationwide Fotoklub Polski). As elsewhere across the world, however, lesser amateur clubs were active in all midsize Polish cities.

10 *Photographische Rundschau* (Photographic Survey) was followed in the Czech lands by *Fotografický obzor*, a title with the identical meaning, which began publication in 1893. Budapest amateurs launched *A fény* (Light) in 1904.

11 *Kunstphotographie* in Germany and Austria, *umělecká fotografie* in the Czech lands, *fotoművészet* in Hungary (including Slovakia, where serious amateur photography prior to World War I was largely the province of Hungarian speakers). Jan Bułhak coined the term *fotografika* in 1927, in codifying principles of Polish pictorialism (see chap. 3).

12 Lechner 2005, 158–159.

13 Alfred Lichtwark, *Übungen in der Betrachtung von Kunstwerken* (Berlin, 1904); *Wege und Ziele des Dilettantismus* (Munich, 1894). Lichtwark's most frequently cited work in histories of photography is *Die Bedeutung der Amateurphotographie* (Halle an der Saale, 1894).

14 Thus the Voigtländer firm, for example, sponsored awards and underwrote operating costs at the Vienna Lehr- und Versuchsanstalt. On other partnerships of this sort, see Ulrich Keller, "The Myth of Art Photography: A Sociological Analysis," *History of Photography* 8, no. 4 (October–December 1984): 268–269.

15 Heise to Tucholsky, 3 May 1928, copy sent by Heise to Renger-Patzsch; Renger-Patzsch papers, Getty Research Institute.

16 The editors of *Agfa-Photoblätter*, house journal of the Agfa film company, wrote Renger on 10 October 1929 to solicit an essay on "modern photography." They included the latest issue of their magazine, drawing Renger's attention to an essay, "Gedanken zur neuen Sachlichkeit" (Thoughts on New Objectivity), "which should interest you especially"; Renger-Patzsch papers, Getty Research Institute.

17 See Olivier Lugon's brilliant essay, "Photo-Inflation: La Profusion des Images dans la Photographie Allemande, 1925–1945," *Les Cahiers du Musée national d'art moderne* 49 (Fall 1994): 91–113.

18 The term New Vision was popularized in English as the translated title of Moholy-Nagy's book *Von Material zu Architektur* (1929), issued by W. W. Norton in 1938. Its status as classic nomenclature for all of modernist photography became apparent with the 1989 exhibition *The New Vision: Photography between the World Wars*, at the Metropolitan Museum of Art in New York.

19 László Moholy-Nagy, *Malerei Fotografie Film* (1925, rev. ed. 1927), trans. Janet Seligman (Cambridge, Mass., 1969).

20 Of the nearly eighty articles Moholy-Nagy published between 1922, the date of his incipient involvement with photography, and his emigration from Germany in 1936, only fourteen appeared in publications outside of Germany, Austria, Hungary, or Czechoslovakia. Seven of these pieces were published in German in the Amsterdam revue *i 10*, not far removed from the Bauhaus orbit. Essays such as "Light—A Medium of Plastic Expression" (*Broom*, New York, 1923), however, or "La Photographie, ce qu'elle était, ce qu'elle devra être" (Photography, What It Was and What It Should Be, *Cahiers d'Art*, Paris, 1929), undeniably extended Moholy-Nagy's influence well beyond the central European region. *Painting Photography Film* appeared in Russian as well in 1929.

21 Iván Hevesy, *A modern fotoművészet* (Budapest, 1934), 11; Hevesy, "A Foto reneszánsza," *Magyar Fotografia* 6 (1931): 6–7.

22 Hevesy 1934, 17.

23 Franz Roh, *Holländische Malerei: 200 Nachbildungen mit geschichtlicher Einführung und Erläuterungen* (Dutch Painting: 200 Illustrations with a Historical Introduction and Explanations) (Jena, 1921).

24 Franz Roh, *Nach-Expressionismus; Magischer Realismus, Probleme der neuesten Europäischen Malerei* (Leipzig, 1925), 42–52.

25 This study collection passed into the hands of dealers Ann and Jürgen Wilde in the 1970s; unfortunately, it was not possible to verify the contents of Roh's holdings.

26 Roh delivered this lecture, perhaps for the first time, at the Kunsthalle Mannheim on 29–30 November 1928; see letter Gustav Hartlaub to Roh, 19 June 1928; Franz Roh papers, Getty Research Institute.

27 Franz Roh, "Mechanismus und Ausdruck: Der Eigenwert der Fotografie" (1930), in English in David Mellor, ed., *Germany, the New Photography, 1927–33: Documents and Essays* (London, 1978), 29–34.

28 Oswell Blakeston, "Recapitulation: A Review of Franz Roh's *Fototek* Series" (1931), in Mellor 1978, 43.

29 See letters from Roh to fellow art historian Wilhelm Flitner and his wife Lisabeth, undated (1928?) and 30 December 1932; Franz Roh papers, Getty Research Institute.

30 Similarly, nearly all the first aesthetic histories of photography, a new approach focused less on technique than on the value of the image, are authored by natives of central Europe. See Martin Gasser, "Histories of Photography 1839–1939," *History of Photography* 16, no. 1 (Spring 1992): 53–55.

31 Stanisław Witkiewicz (Sr.), *Sztuka i krytyka u nas, 1884–1898* (Art and Criticism in Poland) (Lviv, 1899).

32 Stanisław Ignacy Witkiewicz, *Nowe formy w malarstwie i wynikające stąd nieporozumienia* (Warsaw, 1919), in English in Daniel Charles Gerould, ed., *The Witkiewicz Reader* (Evanston, Ill., 1992), 110. Witkiewicz finished this treatise, begun in 1914, just after serving as an officer in the Tsarist army (Witkiewicz was an Austrian citizen but born in Warsaw, part of the Russian empire, and he chose to fight against the Germans). He spent two years in Russia, where he witnessed the revolutions of 1917; see Gerould 1992, 76–78.

33 Stanisław Ignacy Witkiewicz, *Regulamin Firmy Portretowej "S. I. Witkiewicz"* (1928), in English as "Rules of the S. I. Witkiewicz Portrait-Painting Firm," in Gerould 1992, 239–242.

34 These later works appear in Stefan Okołowicz, ed., *Face au néant: les portraits de Stanisław Ignacy Witkiewicz* (Nantes, 2004).

The Cut-and-Paste World: Recovering from War

1 Cubist collages, while immensely influential within avant-garde circles, did not have a major public showing until May 1923 at the notorious auction of art dealer Henry Kahnweiler's possessions, more than a decade after their creation. See Isabelle Monod-Fontaine and E. A. Carmean, *Braque, the papiers collés* (Washington, 1982), 155. Thanks to Anne Umland for clarifying this chronology. Discussing the early reception, furthered exclusively through written descriptions or studio visits, Christine Poggi notes that the isolated publication of "collages" (actually three-dimensional constructions) by Pablo Picasso in *Les Soirées de Paris* in November 1913 caused all but six of the magazine's forty subscribers to cancel their subscriptions; Poggi, *In Defiance of Painting: Cubism, Futurism, and the Invention of Collage* (New Haven, 1992), 125.

2 Brigid Doherty cites in particular photo albums (*Klebebücher*) and manually altered picture postcards sent to and from the trenches; discussions of American assembly-line manufacturing; and the proliferation of illustrated magazines. See her essay, "Berlin," in *Dada: Zurich, Berlin, Hannover, Cologne, New York, Paris*, ed. Leah Dickerman (Washington, 2005), 90–99.

3 Raoul Hausmann, ed., *Der Dada*, no. 1 (June 1919).

4 Wieland Herzfelde, "Zur Einführung" (1920), in English as "Introduction to the First International Dada Fair," trans. Brigid Doherty, *October* 105 (Summer 2003): 102.

5 Wieland Herzfelde, *John Heartfield: Leben und Werk* (1962), cited in Washington 2005, 94.

6 John Heartfield, radio address (1966), cited in Washington 2005, 94.

7 This statement also figures as the first of three epigraphs in Herzfelde's catalogue text. It is liberally adapted, as Doherty has shown, from an 1855 essay by Antoine Wiertz, a Belgian painter who counted among many nervous spectators to photography's rise in the mid-nineteenth century. See Herzfelde 2003, 97.

8 Jay Leyda, *Kino, a History of the Russian and Soviet Film* (Princeton, N.J., 1983, 1st ed. 1960).

9 Benjamin H. D. Buchloh, "From Faktura to Factography," *October* 30 (Fall 1984): 82–119.

10 Jeremy Aynsley, "Pressa Cologne, 1928: Exhibitions and Publication Design in the Weimar Period," *Design Issues* 10, no. 3 (Fall 1994): 53–76.

11 El Lissitzky, "Der Künstler in der Produktion" (1928), cited in Buchloh 1984: 102.

12 Lev V. Kuleshov, "Americanitis" (1922), in English in *Kuleshov on Film: Writings*, ed. Ronald Levaco (Berkeley, 1974), 130.

13 Aleksandr Rodchenko (the probable author), "Konstruktivisty" (1923), cited in Christina Lodder, "Promoting Constructivism: Kino-fot and Rodchenko's Move into Photography," *History of Photography* 24, no. 4 (2000): 296.

14 Vladimir Mayakovsky, *Pro eto: ei i mne* (Ann Arbor, Mich., 1973, 1st ed. 1923). I am indebted to Jindřich Toman for information on the colophon to this book.

15 George Grosz, *Mit Pinsel und Schere: 7 Materialisationen* (Berlin, 1922).

16 Z (possibly A. Zorich), "O 'Kino-Pravde'" (1923), in English as "On Cine-Truth," in *Lines of Resistance: Dziga Vertov and the Twenties*, ed. Yuri Tsivian (Sacile, Italy, 2004), 47.

17 Thanks to Peter Zimmermann for confirming, through conservation and archival research, the sometimes disputed date of creation for this montage.

18 Anonymous, "Foto-montazh" (1924), in English in *Photography in the Modern Era: European Documents and Critical Writings, 1913–1940*, ed. Christopher Phillips (New York, 1989), 211–212, attributed there with probability to Gustav Klucis. The fourth issue of *LEF* in which this article appeared was prepared in August–September 1923 but published only in January 1924. Thanks to Leah Dickerman for this information. Dickerman convincingly assigns authorship of this text to Brik in her essay, "The Fact and the Photograph," *October*, no. 18 (Fall 2006): 135 n.3.

19 *Malerei Photographie Film* (Munich, 1925), reissued with the second word spelled *Fotografie* in 1927, and in Russian as *Zhivopis' ili Fotografia* (Painting or Photography) in 1929. The text to this book was written largely in the summer and fall of 1924.

20 László Moholy-Nagy, *Painting, Photography, Film*, trans. Janet Seligman (Cambridge, Mass., 1969), 36.

21 Moholy-Nagy 1969, 29.

22 Moholy-Nagy 1969, 29.

23 The territory formed as the Kingdom of Serbs, Croats, and Slovenes in December 1918 was renamed the Kingdom of Yugoslavia in January 1929.

24 For comparative accounts of these three collectives in their regional context, see Timothy O. Benson et al., *Central European Avant-gardes: Exchange and Transformation, 1910–1930* (Los Angeles, 2002); Krisztina Passuth, *Treffpunkte der Avantgarden Ostmitteleuropa 1907–1930* (Budapest and Dresden, 2003).

25 Ivan Goll's poem *Paris Brennt* (Paris Is Burning), illustrated with postcard photographs, was published by Zenit leader Ljubomir Micić in 1921 and soon found a warm echo in Prague; see Matthew S. Witkovsky, "Surrealism in the Plural: Guillaume Apollinaire, Ivan Goll and Devětsil in the 1920s," *Papers of Surrealism*, no. 2 (Summer 2004), http://www.surrealismcentre.ac.uk/publications/. See also Jindřich Toman, "Now You See It, Now You Don't: Dada in Czechoslovakia, with Notes on High and Low," in Gerald Janeček and Toshiharu Omuka, eds., *The Eastern Dada Orbit: Russia, Georgia, Ukraine, Central Europe and Japan* (New York and London, 1998), 11–40.

26 See Marcin Giżycki, *Awangarda wobec kina: film w kręgu polskiej awangardy artystycznej dwudziestolecia międzywojennego* (Warsaw, 1996), 27–40, 77–100.

27 Andrzej Turowski, *Budowniczowie Świata: z dziejów radykalnego modernizmu w sztuce polskiej* (Kraków, 2000), 69–70. The precedent-setting exhibitions were, first, *Międzynarodowa Wystawa Sztuki Młodej* (International Exhibition of Young Art), December 1923, organized in Łódź by the group Jung Idysz (Jewish Youth, in Yiddish), and second, *Wystawa Sztuki Nowej* (Exhibition of New Art), May–June 1923, in Vilnius. The catalogue to the second show, with a superb suprematist design, has been reprinted in facsimile with Italian translation in Silvia Parlagreco, *Costruttivismo in Polonia / Konstruktywizm Polski* (Turin, 2005), 15–26.

28 The tractor on the cover of *Blok*, no. 2, was directly inspired by *Veshch / Gegenstand / Objet*, the trilingual journal produced by El Lissitzky and Ilya Erenburg in Berlin in 1922. El Lissitzky had stayed in Warsaw on his way to Germany in the fall of 1921. Berlewi in particular became enamored of his ideas and kept in touch with Lissitzky during his own period in Berlin in 1922–1923; see Turowski 2000, 37–40.

29 Stanisław Czekalski, *Awangarda i mit racjonalizacji: fotomontaż polski okresu dwudziestolecia międzywojennego* (Poznań, 2000), 92. The lines from *Dymy nad miastem* (Warsaw, 1927) are found here as well.

30 See Jadwiga Bocheńska, *Polska myśl filmowa do roku 1939* (Wrocław, 1974), and her accompanying anthology of primary materials, *Polska myśl filmowa: antologia tekstów z lat 1898–1939* (Wrocław, 1975); Marek Haltof, "Film Theory in Poland before World War II," *Canadian Slavonic Papers* 40, no. 1/2 (March–June 1998): 67–79.

31 Giżycki 1996, 87–88; Turin 2005, 152.

32 The isolated historical commentaries on photomontage in Poland are bizarrely lopsided, for instance Strzemiński's incredible claim that photomontage was a "Polish invention," specifically by Szczuka ("Fotomontaż wynalazkiem polskim," *Europa*, no. 1, 1929), or the reflections published by poet and critic Deborah Vogel in 1934, "Genealogie fotomontażu," which take just two works by members of the Lviv group Artes as the alpha and omega of this technique (see chap. 6).

33 Karel Teige, "Foto Kino Film" (1922), in Karel Teige, *Svět stavby a básně* (A World of Construction and Poetry), ed. Jiří Brabec et al., 3 vols. (Prague, 1966), 1: 71–72.

34 *Život*, an annual begun one year previously by the staid art association Umělecká beseda, was "loaned" to Devětsil for the 1922 issue. It is dated that year, as are certain of its contents, but external evidence suggests it was finished and published only in the spring of 1923.

35 Karel Teige, "Malířství a poesie" (Painting and Poetry), in *Avantgarda známá a neznámá*, ed. Štěpán Vlašín et al., 3 vols. (Prague, 1971), 2: 495.

36 Karel Teige, "Manifest poetismu" (1928), in Teige 1966, 324.

37 Jindřich Štyrský, "Obraz" (1923), in English in *Between Worlds: A Sourcebook of Central European Avant-gardes, 1910–1930*, ed. Timothy O. Benson and Éva Forgács (Los Angeles, 2002), 366.

38 See Poggi 1992, 83, 129–137.

39 Zdenek Primus, *Tschechische Avantgarde 1922–1940: Reflexe europäischer Kunst und Photographie in der Buchgestaltung* (Hamburg, 1990).

40 J. B. Marek, "Umění a psina" (Art and Gags), *Národní listy* (23 May 1926): 5.

41 Exceptionally, Moholy-Nagy referred repeatedly to April Fools' images, as well as trick newspaper photography, in *Painting Photography Film* and in essays that immediately followed its second edition, such as "Die Photographie in der Reklame" (Photography in Advertising, September 1927) and "Photographie ist Lichtgestaltung" (Photography Is Creation with Light, January 1928).

42 The number of Citroen photomontages on the theme of the metropolis and / or metropolitan life (dancing, boxing) is difficult to tell because of possible variant titles. See Flip Bool et al., eds., *Paul Citroen (1896–1983)* (Amsterdam, 1996), 52–58, esp. the detailed accounting provided there by Herbert Molderings, 24–25, nn. 5–14.

Molderings makes a convincing case for dating all the *Metropolis* works to 1919–1920, rather than 1923, as has been commonly supposed; however, a scrapbook entry by Citroen indicates that the one pictured here, unlike the rest, was created for the Bauhaus exhibition, Weimar 1923. Thanks for this information to Herbert Molderings.

43 Herbert van Rheeden et al., eds. *Paul Citroen: kunstenaar, docent, verzamelaar / Künstler, Lehrer, Sammler.* (Zwolle, 1994), 44.

44 Karel Teige, "Obrazy" (Pictures), in *Avantgarda známá a neznámá*, ed. Štěpán Vlašín et al., 3 vols. (Prague, 1971), 1: 540. This article, originally published in April 1924, likely constitutes the first mention of the term "photomontage" in Czech.

45 The works, reproduced on pages 95–97 of that first edition of Moholy's book, carried the titles *die Stadt I*, *die Stadt II*, and *Boxkampf in New York*; the first is the one now known in English as *Metropolis*. For the 1927 edition, Moholy retained only this one work, likely in recognition of its iconic status.

46 *Berliner Illustrirte Zeitung* (14 June 1925), illus. in Bool 1996, 54.

47 Franz Roh, *Nach-expressionismus; Magischer Realismus: Probleme der neuesten europäischen Malerei* (Leipzig, 1925), 46.

CHAPTER 3

Laboratories and Classrooms

1 See Matthew Drutt, "El Lissitzky in Germany, 1922–1925," in Margarita Tupitsyn, *El Lissitzky: Beyond the Abstract Cabinet: Photography, Design, Collaboration* (New Haven, 1999), 17–18; illus. 73, 86–89.

2 Rolf Sachsse, *Lucia Moholy* (Düsseldorf, 1985), 14–18, 31–32; Jeannine Fiedler, ed., *Photography at the Bauhaus* (Cambridge, Mass., 1990), 9.

3 Herbert Molderings, "Moshé Raviv-Vorobeichic (Moï Ver)," in Cambridge 1990, 75; Rainer Wick, *Teaching at the Bauhaus* (Ostfildern-Ruit, 2000).

4 Cambridge 1990 includes biographies on seventy-nine of the school's affiliates involved with photography (the list is not comprehensive). Fifty-seven of these came from Germany, including Silesia and the Rhineland, while two to four each came from Hungary, Poland, Czechoslovakia, Austria, and Yugoslavia. For a listing of non-German, central European students and teachers of architecture, see *Centropa* 3, no. 1 (January 2003): eight each (these names do not coincide with those in Fiedler's book) came from Hungary, Czechoslovakia, and Poland, and three from Yugoslavia. Certain of these individuals, such as Karel Teige, Zdeněk Rossmann, Ladislav Foltýn, and Avgust Černigoj, had an interest in photomontage and photography as well.

5 Moï Ver, *Ein Getto im Osten: Wilna* (1931), shows the artist's hometown in a series of montage photographs. See also the work by Gyula Pap reproduced in chapter 7. Less bold, but noteworthy nonetheless, are photographs made by Edith Tudor-Hart from Vienna (see cat. 65) and her friend, the architect Foltýn, from Bratislava; see Iva Mojžišová, *Ladislav Foltyn's Photographic Études* (Bratislava, 2002).

6 András Ferkai, "Schools Associated with the Bauhaus," *Centropa* 3, no. 1 (January 2003), 25–26. Ferkai also notes the existence from 1932 to 1938 of Atelier Művészeti tervező és Műhelyiskola (Atelier Artistic Design School and Workshops), run by painter Dezső Orbán, which offered a specialty in photography after the first year. Thanks to Péter Baki for information on Bortnyik's school.

7 Hannes Beckmann, "Entwurf eines Fotolehrplanes für die Rotterschule" (Proposal for a Lesson Plan in Photography at the Rotterschule); Hannes Beckmann papers, Getty Research Institute. These papers also contain two typescripts, "Das Arbeiten mit der Kleinkamera Leica" (Working with the Small-format Leica) and "Photographie," all three undated. Beckmann worked as a press and stage photographer in Prague before emigrating to the United States, where, like so many other Bauhaus graduates, he became an art professor.

8 Walter Peterhans, "zum gegenwärtigen stand der fotografie" (1930), in Inka Graeve, *Walter Peterhans, Fotografien 1927–38* (Essen, 1993), 88–90. A shorter, related text had appeared already in a Bauhaus advertising prospectus in early 1929.

9 Jozef Rybák, "Bratislavský Bauhaus" (1931), cited in Susanne Anna et al., *Das Bauhaus im Osten: Slowakische und Tschechische Avantgarde 1928–1939* (Ostfildern-Ruit, 1997), 13 n. 5.

10 Rainer Wick, "Prüfstand Bauhaus-Pädagogik: Die Kunstgewerbeschule in Bratislava," in Ostfildern-Ruit 1997, 14–31.

11 Wick in Ostfildern-Ruit 1997, 15–16.

12 Klára Soós, *Berda Ernő 1914–1961: Festőművész Emlék-kiállítása* (Budapest, 1971), 1.

13 Antonín Dufek, "Der Pädagoge Funke und das Bauhaus," in Ostfildern-Ruit 1997, 128.

14 See Matthew S. Witkovsky, "Jaromír Funke's *Abstract Photo Series 1927–1929*: History in the Making," *History of Photography* 29, no. 3 (Fall 2005): 228–239.

15 Dufek in Ostfildern-Ruit, 124–126; citations in English (178–179) and Czech (60–61) from the original letters in Dufek, *Jaromír Funke (Pioneering Avant-garde Photography)* (Brno, 1997), 60–61.

16 Dufek in Ostfildern-Ruit 1997, 128.

17 Ladislav Sutnar and Jaromír Funke, *Fotografie vidí pourch / La photographie reflète l'aspect des choses* (Prague, 1935), reprinted in English with an afterword by Matthew S. Witkovsky and Jindřich Toman (Ann Arbor, Mich., 2004).

18 Exhibitions on "new photography" merged with a larger wave of didactic shows across the region on hygiene, design, technology, and so forth, in which photographic images served as exhibit materials (see, for example, the work by Sutnar in chap. 5). Designs for these exhibits displayed far greater innovation in the presentation of photography than the photographic exhibitions themselves. See (for the German context) Olivier Lugon, "'La photographie mise en espace': Les expositions didactiques allemandes (1925–2945)," *Etudes photographiques* 5 (November 1998): 97–118.

19 This exhibition was the work of Hans Finsler, librarian and lecturer in art history at Burg Giebichenstein. Finsler, yet another art historian in the world of "new photography," spent nearly fifteen years in graduate studies, partly under Heinrich Wölfflin. He trained in photography in 1926–1927 and inaugurated a workshop in photography and advertising at the Burg from summer 1927, in step (and in collaboration) with developments at the Bauhaus. Five years later, Finsler was called to Zurich to establish the first accredited course in photography in Switzerland. See Klaus E. Göltz et al., eds., *Hans Finsler: Neue Wege der Photographie* (Halle and Leipzig, 1991).

20 Lubomír Linhart, "Úvodem" (Introduction), *Mezinárodní výstava fotografie* (Prague, 1936), 6.

21 Information on the contents and exact tour of Fifo remains unevenly researched. The Munich showing took the title *Das Lichtbild* and traveled to Essen, Dessau, and Wrocław. For new information on the Berlin presentation, including three priceless installation views, see Christine Kühn, *Neues Sehen in Berlin: Fotografie der Zwanziger Jahre* (Berlin, 2005), 18–20, 27. Classic studies of what has been called the most important photographic exhibition of all time include Ute Eskildsen and Jan-Christopher Horak, eds., *Film und Foto der zwanziger Jahre: Eine Betrachtung der Internationalen Werkbundausstellung "Film und Foto" 1929* (Stuttgart, 1979); Inka Graeve, "Internationale Ausstellung des Deutschen Werkbunds Film und Foto," in *Stationen der Moderne* (Berlin 1988), 236–273; and the 1979 reprint in Stuttgart of the original exhibition catalogue, ed. Karl Steinorth.

22 László Moholy-Nagy to Franz Roh, 10 November 1929; Franz Roh papers, Getty Research Institute.

23 Albert Renger-Patzsch to Carl Georg Heise, 8 June 1929; Albert Renger-Patzsch papers, Getty Research Institute.

24 Marcin Giżycki, *Awangarda wobec kina: film w kręgu polskiej awangardy artystycznej dwudziestolecia międzywojennego* (Warsaw, 1996), 84–87.

25 Karol Hiller, *Heliografika jako nowy rodzaj techniki graficznej (Heliografika as a New Genre in the Graphic Arts)* (1934), in Zenobia Karnicka and Janina Ładnowska, *Karol Hiller 1891–1939: Nowe widzenie, malarstwo, heliografika, rysunek, grafika* (Łódź, 2002), 67–68.

26 Alexandr Hackenschmied, "Fotografie ve Stuttgartě," *Fotografický obzor* 38 (1929): 115.

27 See Antonín Dufek, *Aventinské trio: Ladislav E. Berka, Alexander Hackenschmied, Jiří Lehovec* (Brno, 1989); Vladimír Birgus, *Czech Photographic Avant-garde, 1918–1948* (Cambridge, Mass., 2002), 110–112.

28 Karel Srp traces the probable influence of cubism and futurism on the early Rössler in "Zones of Visuality: Rössler's Drawings, Photomontages, and Radio," in Vladimír Birgus and Jan Mlčoch, eds., *Jaroslav Rössler* (Cambridge, Mass., 2004), 29–35.

29 See Matthew S. Witkovsky, "Experiment in Progress," in Mlčoch and Birgus 2004, 40–45.

30 Astrid Lechner, "Der Camera-Club in Wien und die Kunstfotografie um 1900" (PhD diss., Universität Wien, 2005), 58, 174–175.

31 See Vanessa Rocco, "Before Film und Foto: Pictorialism to the New Vision in German Photography Exhibitions from 1909–1929" (PhD diss., City University of New York, 2004), 1–34. Reaching further back, one should note that the Universal Expositions and other commercial shows of the 1800s presented myriad applications for photographs, far more even than Iphad or later the "new photography" exhibitions—without, however, granting exhibitors the privilege of aesthetic autonomy. See Ulrich Pohlmann, "'Harmonie zwischen Kunst und Industrie': Zur Geschichte der ersten Photoausstellungen (1839–1868)," in Bodo von Dewitz and Reinhard Matz, eds., *Silber und Salz: Zur Frühzeit der Photographie im deutschen Sprachraum 1839–1860* (Cologne and Heidelberg, 1989), 496–513. Pohlmann notes (509 n. 53) that only in Philadelphia, at the 1876 Centennial Exhibition, did certain photographers gain a separate pavilion, a right routinely accorded painters. European organizations, meanwhile, repeatedly denied requests to show photography in proximity to the fine arts.

32 Monika Faber asserts (personal communication) that the early photographs on display at Fifo were reproductions, not originals, from the Stenger collection. If this is true, it serves to underscore Moholy-Nagy's appreciation of photographs above all as images, not objects. It remains unclear, however, what was shown from this collection in Stuttgart, let alone the many other Fifo venues.

33 Bodo von Dewitz, "sich von einer Arbeit durch eine andere erholen.... Erich Stenger und *seine* Geschichte der Fotografie" (to rest from one task by doing another.... Erich Stenger and His History of Photography), *Fotogeschichte* 17, no. 64 (1997): 17–18.

34 Dewitz 1997: 14.

35 August Sander, "Wesen und Werden der Photographie: Aus der Werkstatt des Alchemisten bis zur exakten Photographie" (The Essence and Development of Photography: From the Alchemist's Workshop to Exact Photography), radio address, Westdeutscher Rundfunk (1931); manuscript SK Stiftung Kultur—August Sander Archiv, Cologne. The archive also contains two daguerreotypes by Sander. There is ample evidence from his earlier career that Sander did not always feel enmity toward pictorialism; see Thomas Wiegand, "August Sander und das Photographengewerbe" (August Sander and Commercial Photography), in *Menschen des 20. Jahrhunderts: Studienband*, ed. Susanne Lange et al. (Munich, 2001): 52–66.

36 Virginia Heckert, "Ich werde dafür tun, was irgend in meinen Kräften steht (I will do what is in my power): Carl Georg Heise und Albert Renger-Patzsch," in *Die Neue Sicht der Dinge: Carl Georg Heises Lübecker Fotosammlung aus der 20er Jahren*, ed. Ortrud Westheider (Hamburg, 1995), 19–27.

37 Josef Čapek, "Fotografie našich otců" (1918), in Josef Čapek, *Nejskromnější umění*, ed. Dagmar Magincová et al. (Prague, 1997, first ed. 1920), 41.

38 Walter Benjamin, "Kleine Geschichte der Fotografie" (1931), in English as "A Short History of Photography," in Alan Trachtenberg, ed., *Classic Essays on Photography* (New Haven, 1980), 204, 200.

39 Tatiana Danecka, Adam Sobota, and Danuta Dziedzić, *Fotografia we Lwowie do roku 1939* (Wrocław, 1991).

40 Historical information comes largely from Maciej Szymanowicz, "Miejsce Piktorializmu w historii polskiej fotografii dwudziestolecia międzywojennego" (PhD diss., Adam Mickiewicza Uniwersytet im. Poznań, 2004), 15–17.

41 Henryk Mikolasch, ed., *Album fotografów polskich* (Lviv, 1905).

42 Adam Sobota, *Szlachetność Techniki* (Warsaw, 2001), 116–119.

43 Sobota 2001, 120. The *fotoryt* is described with equal brevity in Jerzy Piwowarski, *Słownik technik i tendencji stylistycznych stosowanych w polskiej fotografii artystycznej przed 1939r* (Częstochowa, 2001), 24.

44 Sobota 2001 notes (120) the reference to Charlie Chaplin.

45 Summary biographical information on Neuman appears in Szymanowicz 2004, 124–125.

46 Marian Dederko, "W Obronie Fotonizmu," *Polski Przegląd Fotograficzny* 6, no. 4 (1930): 73–75.

47 Szymanowicz 2004, 136–137.

CHAPTER 4

New Women—New Men

1 Ute Frevert notes that unmarried women in service jobs (office work, retailing) often exceeded the standard eight-hour day and still had to help with domestic chores upon returning to their parents' home—very few could afford to live on their own. Frevert, *Women in German History: From Bourgeois Emancipation to Sexual Liberation*, trans. Stuart MacKinnon-Evans (Oxford and New York, 1989), 183. A textile union survey of female workers from 1930 (*Mein Arbeitstag, Mein Wochenende: 150 Berichte von Textilarbeiterinnen*, Berlin) indicates that for women in factories as well, "the work at home would be enough"; excerpted in Anton Kaes, Martin Jay, and Edward Dimendberg, eds., *The Weimar Republic Sourcebook* (Berkeley, 1994), 208–210.

2 Ute Eskildsen, "Die Kamera als Instrument der Selbstbestimmung," in Eskildsen, ed., *Fotografieren hieß teilnehmen: Fotografinnen der Weimarer Republik* (Düsseldorf, 1994).

3 Karen Offen, *European Feminisms, 1700–1950: A Political History* (Stanford, 2000). Offen calls the interwar period "Feminism under Fire."

4 Many contributors make these points in discussing women's roles, country by country, in Kevin Passmore, ed., *Women, Gender and Fascism in Europe, 1919–45* (New Brunswick, N.J., 2003). See also Sharon L. Wolchik and Alfred G. Meyer, *Women, State, and Party in Eastern Europe* (Durham, N.C., 1985).

5 See David F. Good, Margarete Grandner, and Mary Jo Maynes, *Austrian Women in the Nineteenth and Twentieth Centuries* (Providence, R.I., 1996); Claudia Papp, *"Die Kraft der weiblichen Seele": Feminismus in Ungarn, 1918–1941* (Münster, 2004); Anna Żarnowska and Andrzej Szwarc, eds., *Kobieta i świat polityki w niepodległej Polsce, 1918–1939* (Women and the Political World in Independent Poland, 1918–1939) (Warsaw, 1996).

6 Particularly helpful reading on Germany includes Katharina von Ankum, ed., *Women in the Metropolis: Gender and Modernity in Weimar Culture* (Berkeley, 1997); Marsha Meskimmon and Shearer West, eds., *Visions of the "Neue Frau": Women and the Visual Arts in Weimar Germany* (Aldershot, England, and Brookfield, Vt., 1995); Claudia Schmölders and Sander L. Gilman, eds., *Gesichter der Weimarer Republik: Eine physiognomische Kulturgeschichte* (Cologne, 2000); Patrice Petro, *Joyless Streets: Women and Melodramatic Representation in Weimar Germany* (Princeton, N.J., 1989).

7 Among publications that at least touch upon representations of self in the 1920s and 1930s outside of Germany—as opposed to purely political or economic questions—are Lisa Fischer and Emil Brix, eds., *Die Frauen der Wiener Moderne* (Munich and Vienna, 1997); A. Żarnowska and A. Szwarc, eds., *Kobieta i kultura: Kobiety wśród twórców kultury intelektualnej i artystycznej w dobie rozbiorów i w niepodległym państwie polskim* (Women and Culture: Women among the Creators of Intellectual and Artistic Culture from the Partitions to Independence) (Warsaw, 1996); Wilma Iggers, *Women of Prague: Ethnic Diversity and Social Change from the Eighteenth Century to the Present* (Providence, R.I., 1995).

8 Masquerade, a central point of feminist analysis (particularly of cinema) in the 1970s and 1980s, is addressed already in theory of the 1920s, most famously by Joan Riviere, "Womanliness as a Masquerade" (1929), in Victor Burgin, James Donald, and Cora Kaplan, eds., *Formations of Fantasy* (New York and London, 1986), 35–44.

9 Yva, "Lieschen Neumann will Karriere machen, oder das Scheindasein vor der Kamera," UHU, no. 6 (1930): 68–73.

10 Marion Beckers and Elisabeth Moortgat, "Ihr Garten Eden ist das Magazin: Zu den Bildgeschichten von Yva im UHU 1930–1933" (Her Paradise Is the Magazine: On Yva's Picture Stories), in Düsseldorf 1994, 242.

11 Marsha Meskimmon, *We Weren't Modern Enough: Women Artists and the Limits of German Modernism* (Los Angeles, 1999), 68.

12 Karl Toepfer, *Empire of Ecstasy: Nudity and Movement in German Body Culture, 1910–1935* (Berkeley, 1997); Gunhild Oberzaucher-Schüller, ed., *Ausdruckstanz: Eine mitteleuropäische Bewegung der ersten Hälfte des 20. Jahrhunderts* (Wilhelmshaven, 1992). For a rare account of the movement from a non-Germanic perspective, see Jarmila Kröschlová, *Výrazový tanec* (Expressive Dance) (Prague, 1964).

13 Matthew S. Witkovsky, "Staging Language: Milča Mayerová and the Czech Book *Alphabet*," *The Art Bulletin* 86, no. 1 (March 2004): 115, 124–125.

14 Witkovsky 2004: 122–123.

15 Milča Mayerová, "Anketa" (Survey), *Eva* 3, no. 7 (February 1931): 19.

16 Karl Toepfer, who stresses the eroticism of Ausdruckstanz, cites Drtikol's photographs as his initial inspiration; Toepfer 1997, 379–381.

17 József Pécsi published *12 Aktaufnahmen* (12 Photographs of Nudes) in Berlin in 1922, catering to a market for erotica that also furnished buyers for Drtikol's luxury portfolio, *Les Nus de Drtikol*, published in Paris in 1929. Note that neither work appeared in the artist's home country, where book censorship was stricter.

18 The number of women photographers in Germany, Austria, and Hungary in particular greatly surpasses that for the countries of western Europe. Using Naomi Rosenblum, *A History of Women Photographers* (New York, 2000) as a guide, augmented by the information for this book, it seems that roughly one dozen women practiced photography professionally in western Europe during the 1910s–1930s, while more than two and a half times that number were active in central Europe. Furthermore, many prominent women working in the West came from central Europe and had often begun a career there as well. Numbers for the nineteenth century, by contrast, suggest a diametrically opposite distribution.

19 Rolf Sachsse, "Eloge de la reproduction: La photographie dans les écoles d'arts appliqués allemandes," *Études Photographiques* 8 (November 2000): 52.

20 Helene Littmann, "Die Frau als Photographin," *Photo-Sport* 4, no. 2 (February 1908): 21–22. Littmann names women successful internationally in both amateur and professional circles. She asserts, however, that one hundred times more men take up photography as amateurs than women (one in three hundred versus one in three), because women generally cannot afford the materials and equipment.

21 Littmann 1908: 22.

22 Ute Eskildsen, "Die Kamera als Instrument der Selbstbestimmung," in Düsseldorf 1994, 14.

23 Marion Beckers and Elisabeth Moortgat, *Atelier Lotte Jacobi, Berlin, New York* (Berlin, 1997), 63; biographical information on Klaus and Erika Mann available at http://www.dhm.de/lemo/html/biografien/MannErika and /MannKlaus (both accessed August 2006).

24 Cited as personal communication with the author from 1993 in Sabina Leßmann, "Die Maske der Weiblichkeit nimmt kuriose Formen an: Rollenspiele und Verkleidungen in den Fotografien Gertrud Arndts und Marta Astfalck-Vietz" (The Mask of Femininity Takes Strange Forms: Role-Playing and Disguise in the Photographs of Gertrud Arndt and Marta Astfalck-Vietz), in Düsseldorf 1994, 275.

25 The pathbreaking text, "Production-Reproduction," first published in *De Stijl* in May 1922, has long been credited to both partners, although Moholy-Nagy signed it alone; see Rolf Sachsse, *Lucia Moholy* (Düsseldorf, 1985), 10–11, and Andreas Haus, *Moholy-Nagy: Photographs and Photograms*, trans. Frederic Samson (New York, 1980), 12.

26 Sachsse 1985, 7, 11–13; on the portraits, 21–23, 32–39. In connection with Lucia Moholy's portraits of hands, Sachsse mentions writings by Josef Strzygowski, a Vienna School professor with connections to the Bauhaus and, from early on, to the Nazi regime. More research is needed to determine with which ideas of the Vienna School Moholy was conversant.

27 A small print of this portrait (The Metropolitan Museum of Art, New York), has been rounded at one corner in what seems a deliberate echo of Roh's own rounded prints; as mentioned in chapter 2, Roh likely took up photography actively around this time.

28 Flip Bool et al., ed., *Eva Besnyö [sic]*, text by Willem Diepraam (Amsterdam, 1999), 65–84.

29 Bool et al. 1999, 84.

30 Vera Ranki, *The Politics of Inclusion and Exclusion: Jews and Nationalism in Hungary* (New York, 1999), 27–82.

31 Mária M. Kovács, "Hungary," in Passmore 2003, 86–88.

32 Cecile Tormay, chair of Magyar Asszonyok Nemzeti Szövetsége (National Association of Hungarian Women), 1925, cited in Mária M. Kovács, "Hungary," in Passmore 2003, 87.

33 Monika Faber, *Divas and Lovers: The Erotic Art of Studio Manassé*, trans. Margot Bettauer Dembo (New York, 1998).

34 Katharina von Ankum, "Karriere—Konsum—Kosmetik: Zur Ästhetik des weiblichen Gesichts" (Career—Consumption—Cosmetics: On the Aesthetic of the Female Face), in Schmölders and Gilman 2000, 175–190. One example Ankum discusses is Max Factor, a Hollywood makeup artist who started a cosmetics line with movie stars as promoters and scientific specialists to guarantee an appearance modeled on the silver screen.

35 For an overview of Höch's work in painting and drawing, see *Hannah Höch 1889–1978: Ihr Werk, Ihr Leben, Ihre Freunde* (Berlin, 1989).

36 The surviving letters between Höch and Kalivoda (see following note) indicate Kalivoda purchased one work (*Von Oben*, St. Louis Art Museum) and received another as a gift (*Der Melancholiker*, Institut für Auslandsbeziehungen, Stuttgart). Höch's essay "Několik poznámek o fotomontáži" appeared in Kalivoda's journal *Středisko* 4, no. 1 (1934); the untitled German-language manuscript survives in the Kalivoda archives, Muzeum města Brna, Brno. In English as "A Few Words on Photomontage," in Maud Lavin, *Cut with the Kitchen Knife: The Weimar Photomontages of Hannah Höch* (New Haven, 1993), 219–220.

37 Correspondence from Kalivoda to Höch is archived in the Berlinische Galerie and referenced although not published in *Hannah Höch: Eine Lebenscollage*, 3 vols. (Berlin, 1995), 2: 539–540. Correspondence from Höch to Kalivoda is with the Muzeum města Brna in Brno.

38 *Telehor*, a unique double-issue journal produced by Kalivoda in February 1936. Moholy-Nagy may — in contrast to Höch — have already visited Brno in 1931, at the time of his lectures in nearby Bratislava.

39 Letter, Höch to Kalivoda, 16 October 1933; Kalivoda archives, Muzeum města Brna in Brno.

40 Hannah Höch, "A Few Words on Photomontage," in Lavin 1993, 220.

41 Sue Taylor describes the first doll thoroughly in *Hans Bellmer: The Anatomy of Anxiety* (Cambridge, Mass., 2000), 23–28.

42 Hans Bellmer, *The Doll*, trans. Malcolm Green (London, 2005), 42 ("The Panorama"). Tru-Vue, founded in 1931, and View-Master, introduced at the New York World's Fair in 1939, featured stereoscope filmstrips of panoramic scenes.

43 Malcolm Green stresses this point in his new translation of *The Doll*, commenting on Bellmer's interest in "the inherent reversibility of the sexes and their complex interlocking nature"; Bellmer 2005, 20–22.

44 Bellmer, interview with Peter Webb, cited by Green in Bellmer 2005, 17; the quote about creating an "artificial girl," also cited by Green (16), is taken from an interview with Bellmer first cited in the 1980s but seems to refer to the preparatory stages of his work in the 1930s.

45 Bellmer 2005, 20, source unspecified.

Modern Living

1 The history of photography in journalism is vast and long predates the interwar period. One milestone is a shantytown scene printed in the New York *Daily Graphic* (1880) using a raster method invented in 1857. Developments thereafter include half-tone reproduction, apparently first used by the Leipzig *Illustrirte Zeitung* in 1883, and the rise of tabloids such as the *Daily Mirror* in London (1903) or *L'Illustré* in Paris (1907). See *Kiosk*, ed. Bodo von Dewitz (Cologne and Göttingen, 2001), and for the interwar decades specifically, *Fotografía Pública / Photography in Print, 1919–1939*, introduction by Horacio Fernández (Madrid, 1999). Bernd Weise, *Fotografie in deutschen Zeitschriften, 1883–1923* (Stuttgart, 1991); Ute Eskildsen et al., *Fotografie in deutschen Zeitschriften, 1924–1933* (Stuttgart, 1982); and Tim N. Gidal, *Modern Photojournalism: Origin and Evolution, 1910–1933* (New York, 1973), all concentrate on Germany. Accounts for the other countries in central Europe are not numerous. Juliusz Garztecki wrote an eleven-part article on press photography in Poland for the Polish periodical *Fotografia*, beginning with issue no. 7 in 1968. For Austria, see Leo Kandl, "Pressefotografie und Fotojournalismus in Österreich bis 1960," in *Geschichte der Fotografie in Österreich*, ed. Otto Hochreiter and Timm Starl (Bad Ischl, 1983), 311–324. No comparable overview currently exists for the Czech and Slovak Republics and Hungary, although Péter Baki, in his *A Vasárnapi Ujság és a fotográfia (1856–1921)* (Kecskemét, Hungary, 2005), addresses the uses of photography in that one important periodical.

2 Martin Parr and Gerry Badger, *The Photobook: A History* (London, 2004), 6–7.

3 *Slovenský svet*, begun in Prešov in 1921 under the direction of Emo Bohúň, moved in July 1922 to Bratislava, where it lasted through 1925; see Ľudovít Hlaváč, *Dejiny slovenskej fotografie* (Martin, 1989), 125 n. 49. Heinz Johannes, *Neues Bauen in Berlin; ein Führer mit 168 Bildern* (Berlin, 1931).

4 Karel Hájek, "Fotografie a noviny," *Fotografický obzor*, no. 3 (March 1936): 49–50; first read on Radio Prague, 4 February 1936. Erich Salomon, *Berühmte Zeitgenossen in unbewachten Augenblicken* (Stuttgart, 1931). On the latter book, see Janos Frecot, ed., *Erich Salomon: "Mit Frack und Linse durch Politik und Gesellschaft"; Photographien 1928–1938* (Munich, 2004), 17–18.

5 Sarah Kennel, "Fantasies of the Street: Émigré Photographers in Interwar Paris," *History of Photography* 29, no. 3 (Fall 2005): 287–300.

6 The same day war was declared in Austro-Hungary (28 July 1914), a *Kriegspressequartier* or War Press Office was established in Vienna to regulate the photography of war scenes; it remained in operation until the fall of the monarchy in 1918. Roughly eighty thousand prints were generated through this process; Kandl 1983, 313.

7 Sarah Greenough, "A Hungarian Diary, 1894–1925," in *André Kertész* (Washington, 2005), 8–9; Károly Kincses and Magdolna Kolta, *Minden magyar fotóriporterek atyja: Balogh Rudolf* (Kecskemét, Hungary, 1998), with a list of all his published photographs between 1903 and 1917, 175–183.

8 Hanno Hardt, "The Site of Reality: Constructing Photojournalism in Weimar Germany, 1928–33," *Communication Review* 1, no. 3 (1996): 7, citing a 1928 survey of newspapers only.

9 "Die kulturelle Bedeutung des Zeitungsbildes" and "Ein neuer journalistischer Berufszweig: Der Bildredakteur," both 1928, cited in Hardt 1996: 7.

10 Vojtěch Fejlek, *Melantrich 1898–1998: nepodlehne ani ohni ani meči* (Melantrich: Will Not Submit to Fire or Sword) (Prague, 1998), 15–16.

11 Petr Vilgus, "Pestrý týden, 2. listopadu 1926–28. dubna 1945" (*Pestrý týden*, November 2, 1926–April 28, 1945 (Master's thesis, Slezská Univerzita Opava, Czech Republic, 2001), 17–18.

12 Claims of primacy in press innovation, often purely anecdotal, are difficult to verify. Writing in 1927, Korff connected the image-driven layout at the BIZ with cinema and implied that he (who had been editor there since 1905) had recognized the potential of that connection on his own; Kurt Korff [Kurt Karfunkel], "Die illustrierte Zeitschrift," in Wilfried Wiegand, ed., *Die Wahrheit der Photographie: Klassische Bekenntnisse zu einer neuen Kunst* (The Truth of Photography: Classic Confessions on a New Art) (Frankfurt, 1981), 207–208. Lorant, by contrast, named *Érdekes Újság* as his model, and in fact, as Greenough notes, that newspaper did publish a photo essay of sorts on life in Budapest in March 1913; see Washington 2005, 8.

13 Carl Schnebel, "Das Gesicht als Landschaft," UHU, no. 5 (February 1929): 42–43, photographs by Paul Edmund Hahn.

14 Anonymous, "Co všechno muži v kapsách nosí," *Letem světem* 2, no. 34 (14 June 1928), 10.

15 Madrid 1999, 212–213.

16 Josef Čapek, *Nejskromnější umění*, ed. Dagmar Magincová et al. (Prague, 1997, 1st ed. 1920), 50.

17 Čapek 1997, 53.

18 Čapek 1997, 55.

19 Čapek 1997, 54.

20 Mary Nolan, *Visions of Modernity: American Business and the Modernization of Germany* (New York, 1994).

21 Anonymous, "Moderní domácnost," *Pestrý týden* 1, no. 1 (2 November 1926): 10.

22 For primary documents on Taylorism and Fordism in the German context — which led the way in central Europe — see Anton Kaes, Martin Jay, and Edward Dimendberg, eds., *The Weimar Republic Sourcebook* (Berkeley, 1994), 393–411.

23 Stanisław Czekalski discusses and reproduces all three photomontages, two of which have not survived, in *Awangarda i mit racjonalizacji: fotomontaż polski okresu dwudziestolecia międzywojennego* (Poznań, 2000), 218–220.

24 Kazimierz Podsadecki, "W dżungli nad jeziorem Michigan," *Na szerokim świecie*, no. 17 (1931) (the first of three articles under the rubric "Podziemna Ameryka" [Underground America], further installments of which appeared in nos. 25 and 28 that year); Podsadecki, "Człowiek w miejsce przyszłości," *Na szerokim świecie*, no. 13 (1931); Podsadecki, "Miasto młyn życia," *Na szerokim świecie*, no. 27 (1929).

25 Sports photography, which thrived on sensationalist vivacity, presented many features typical of interwar modernism already in the first two decades of the twentieth century. Cover images of a motorcycle conflagration in the *Deutsche Illustrierte Zeitung* in 1909, or of a close finish to a track race in the *Hamburger Woche* in 1912, exemplify the dynamic composition on the pages of daily newspapers prior to World War I (see Weise 1991, 79–80). Nevertheless, a decided preference for blur and for a framing so close as to banish the surrounding context seems to date to the first postwar years.

26 Lothar Rübelt, "Martin Munkaczi" [sic], n.d. [c. 1960?]; Rübelt Archiv, Österreichische Nationalbibliothek.

27 Lothar Rübelt, letter to Emmerich Bekessy, editor of *Die Stunde*, 22 October 1925; Rübelt Archiv, Österreichische Nationalbibliothek.

28 See Ákos Moravánszky, *Competing Visions: Aesthetic Invention and Social Imagination in Central European Architecture, 1867–1918* (Cambridge, Mass., 1998); Eve Blau and Monika Platzer, eds., *Shaping the Great City: Modern Architecture in Central Europe, 1890–1937* (Munich and New York, 1999).

29 Blau and Platzer 1999; Damjan Prelovšek, *Jože Plečnik, 1872–1957: Architectura Perennis*, trans. Patricia Crampton et al. (New Haven, 1997).

30 See, for example, Wojciech G. Leśnikowski, ed., *East European Modernism: Architecture in Czechoslovakia, Hungary, and Poland between the Wars 1919–1939* (New York, 1996).

31 Jaroslav Anděl documents this convergence of interests in *The New Vision for the New Architecture: Czechoslovakia, 1918–1938* (Prague, 2005).

32 Erwin Piscator and Felix Gasbarra, *Das politische Theater* (Berlin, 1929).

33 Herbert Molderings, *Umbo: Otto Umbehr, 1902–1980* (Düsseldorf, 1995), 89–90. Molderings notes that this composition differs in its frenetic exuberance from Umbo's usual Baudelairean detachment; see Molderings, "Umbo's Aesthetic," *History of Photography* 29, no. 3 (Fall 2005): 240–255.

34 Umbo, diary entry, December 1926, cited in Molderings 1995, 93.

35 The series appeared with the Prague publisher Pokrok. It included writings from Russia (*Caři, Popi, Bolševici* [Czars, Popes, Bolsheviks], vol. 1) and a collection of "all true" crime stories modeled on a French crime reporter (*Pražský Pitaval*, vol. 7). Many thanks to Bob and June Leibowits for showing me these books.

36 Marcin Giżycki, *Awangarda wobec kina: film w kręgu polskiej awangardy artystycznej dwudziestolecia międzywojennego* (Warsaw, 1996), 77–100.

37 Jindřich Toman, *Territories of the Modern Eye: Photography and Photomontage in Print, Czechoslovakia, 1918–1938* (Prague, 2007).

38 Stefan Lorant, "Die Welt aus der Spatzen- und Mäuseperspektive," *Revue des Monats* (July 1927), in Diethart Kerbs and Walter Uka, *Fotografie und Bildpublizistik in der Weimarer Republik* (Bönen, Germany, 2004), 270–273.

39 *Pestrý týden*, which featured an advice column by Augustín Škarda, chief editor of the Czech amateur mainstay *Fotografický obzor*, took competition initiatives to an extreme of precision. In 1927, the paper broadcast a call for submissions on twelve subjects, ranging from "photographs of roadside crosses" or "unposed shots of celebrities" to "portrait studies of laughter," "a subject in shadow," and "photomontage on a freely chosen theme"; cited in Vilgus 2001, 19.

40 Sándor Fejérváry, "History of Hungarian Art Photography," in *II. Nemzetközi művészi fényképkiállítás / 2nd International Exhibition of Photographs* (Budapest, 1927). The 1927 exhibition, held in the prestigious Műcsarnok exhibition hall, presented amateur photography at a level it had not enjoyed in Hungary since before the war. With notable regret at the loss of his country's empire and the many centers of photographic activity it used to include,

Fejérváry nevertheless celebrates the increased consciousness among amateurs of photography's "inherent" possibilities, uniquely suited to the times. He concludes that what is lacking, more than talented photographers, are talented theorists to explain the distinctiveness of this mechanical art. Kinszki, Iván Vydareny, Iván Hevesy, Erwin Kankovsky, and several others soon took up this challenge in earnest.

41 Imre Kinszki, "Éjszakai felvételek" (Photographing at Night), *Fotoművészeti Hírek* 13, nos. 11–12 (November–December 1932), 300, 305–308; "A kiállítási kép esztétikája" (The Aesthetics of the Exhibited Picture), *Fotoművészeti Hírek* 15, no. 9 (September 1934), 183–184.

42 Miloš Dohnány, "Bratislavský prístav" (The Bratislava Port), *Vesna* 4 (April 1927): 65–66; "Život na veľkej rozhlasovej stanici" (Life at a Big Radio Station), *Slovenský Ľud* (10 and 17 February 1927): 64, 76; "Ako rýchlo možno čítať?" (How Fast Can One Read?), *Slovenský Ľud* (22 July 1931).

43 D-Amatér [Miloš Dohnány], "Každý môže byť dobrým fotoamatérom," *Vesna* 2 and 3 (March and April 1930), 53–58, 111–115.

44 Albert Renger-Patzsch, "Ketzergedanken über künstlerische Photographie," *Photographie für Alle* (1925), in English as "Heretical Thoughts on Artistic Photography" in *History of Photography* 21, no. 3 (Fall 1997): 179–181.

45 Renger-Patzsch 1997: 180.

46 W. Goldschmidt, "Albert Renger-Patzsch und die moderne Photographie"; Ernst Kállai, "Bildhafte Fotografie" (both 1928), in Wolfgang Kemp, ed., *Theorie der Fotografie*, 2 (Munich, 1979); the latter essay appears also in Christopher Phillips, ed., *Photography in the Modern Era* (New York, 1989), 116–120. Kállai's term *bildhaft*, or pictorial, does not indicate a connection with pictorialism, which as has been noted was called "art photography" in central Europe (*Kunstphotographie* in German).

47 Thomas Mann, "Die Welt ist schön," *BIZ* 37, no. 52 (23 December 1928); Peter Panter [Kurt Tucholsky], "Das schönste Geschenk" (1928), in Tucholsky, *Gesamtausgabe Texte und Briefe*, ed. Ute Maack (Reinbek, 2001), 10: 622–623.

48 Heinrich Schwarz, letter to Renger-Patzsch, 27 December 1929; Renger-Patzsch Papers, Getty Research Institute (GRI). Schwarz indicates here his preference for an exhibition almost exclusively based on *Die Welt ist schön*, "as the book is barely known in France." On the much cooler responses to Renger in England, see Ulrich Rüter, "The Reception of Albert Renger-Patzsch's *Die Welt ist schön*," *History of Photography* 21, no. 3 (Fall 1997): 192–196. Another letter in the GRI, from Claude de Santeul, who installed the show in Paris and in a reduced version in Amiens (summer 1930), indicates that Schwarz also wrote an accompanying encomium. While Heise stood behind the initial contacts between Renger and Schwarz, this correspondence makes clear that he did not directly organize the Paris exhibition, as Donald Kuspit has suggested; see "A Critical-Biographical Profile," in *Albert Renger-Patzsch: Joy before the Object* (New York and Philadelphia, 1993), 5.

49 József Pécsi, letter to Renger-Patzsch, 12 December 1928; Renger-Patzsch Archives, Getty Research Institute. See also letters from Pécsi dated 16 March 1927 and 12 April 1928. In the first letter, Pécsi offers to translate Renger's writing for a Hungarian audience; in the second, he proposes that his German colleague publish a picture series in *Magyar Fotografia* and that he exhibit in Budapest as well.

50 J. B. Marek, "Umělecká fotografie" (Art Photography), *Národní listy* (25 December 1926), suppl.: 17.

51 J. B. Marek, "Umění a psina," *Národní listy* (23 May 1926): 10 (see chap. 2).

52 Ladislav Sutnar, letter to the National Education Ministry (1933), cited in Iva Janáková, ed., *Ladislav Sutnar: Prague—New York; Design in Action* (Prague, 2003), 143.

53 The maquettes, unpublished in Káldor's lifetime, have been preserved and collected in a posthumous catalogue; see Katalin Bakos, *Káldor László: Budapesti Napló 1931; Káldor László kollázs-sorozata / Budapest Diary 1931; László Káldor's Collages* (Budapest, 2002).

54 In *Josef Sudek* (Munich, 1999), Anna Fárová cites (46) a cryptic letter of 29 April 1928 in which Sudek states his price for individual images of the cathedral, to which she adds information indicating that Sudek took and printed the necessary photographs between May and July 1928, the month in which he formally joined DP.

55 *Světozor* (1929), in facsimile in Fárová 1999, 46–47.

56 Jaroslav Durych, introduction to *Svatý Vít* (Prague, 1928), cited in Fárová 1999, 44, via the review by Otakar Mrkvička, "Svatý Vít," *Lidové noviny* (18 October 1928). Sudek did in fact plan his photographs carefully, using particularly long exposures, as documented by his working notes. Stieglitz first mentioned his three-hour wait in "The Hand Camera—Its Present Importance," *American Annual of Photography and Photographic Times Almanac* (1897): 25.

57 Sudek's first foray into publishing actually was a series of enchanting Old Prague sights, called *Praha: Deset náladových fotografií* (Prague: Ten Atmospheric Photographs) (Prague, 1922–1924).

58 Franz Grainer, president, Gesellschaft Deutscher Lichtbildner, letter to Renger-Patzsch, 17 April 1928; Renger-Patzsch papers, Getty Research Institute. The initial offer of membership is dated 20 January 1928, and the first response by Renger on 8 February of that year. In 1929, he allowed himself to be drawn into a members' exhibition, as attested by further letters from April and July; the congratulatory missive from Erfurth was written 14 May 1930.

59 Maciej Szymanowicz, "Miejsce piktorializmu w historii polskiej fotografii dwudziestolecia międzywojennego" (Ph.D. diss., Uniw. A. Mickiewicza, Poznań, 2004), 107–117.

60 Szymanowicz 2004, 161. See also M. Szymanowicz, "Śląska idylla: O przemyśle, folklorze i fotografii lat 30. / Silesian Idyll: On Industry, Folklore and Photography of the 1930s," *Fotografia*, no. 14 (2004): 129–132 (English).

61 Wieczorek described his intentions in "Zdjęcia wielkiego przemysłu" (Photographs of Heavy Industry), *Nowości Fotograficzne* 2 (1938): 27–32.

62 Paul Wolff and Adolf Krencker, *Das alte Strassburg* (Berlin, 1923, 1st ed. 1914).

63 Paul Wolff, *Meine Erfahrungen mit der Leica* (Frankfurt, 1934).

64 Plans for a speedway predate the Nazi period. Discussions began among private citizens in Germany before World War I and were pursued seriously by industrial leaders in the 1920s; in 1932, the first, short stretch of "Nur-Autostraßen" (Car-Only Roads) was opened between Cologne and Bonn. See "Das Unternehmen Reichsautobahn" (The Imperial Highway Project), adapted from an essay by Gernodt Pehnelt, http://www.dessau-geschichte.de/unternehmen_reichsautobahn_essay.htm (accessed December 2005).

65 *Die schöne Straße im Bau und unter Verkehr* (The Beautiful Highway in Construction and with Traffic, 1936) includes pictures by Todt. See also Erhard Schütz, "'Jene blaßgrauen Bänder' oder 'Anmut, Härte und Zielstrebigkeit': Die Reichsautobahn in Literatur und anderen Medien des 'Dritten Reiches'" ("Those Light Gray Stripes" or "Grace, Strength, and Single-mindedness": The Imperial Highway in Literature and Other Media in the "Third Reich"), *http://iasl.uni-muenchen.de/* (accessed December 2005).

66 Erhard Schütz notes ('Jene blaßgrauen Bänder,' section "Malerei und Fotografie") that while paintings of the project concentrate on construction, deploying many diagonals and foreshortened perspectives, most of the corresponding photographs emphasize harmony between the roadway and the surrounding land. This false suggestion was doubtless made the special province of photography not only because photography held the greatest supposed truth value, but also because, if not used "correctly," it threatened to underscore rather than refute the invasion of nature by technology.

CHAPTER 6

The Spread of Surrealism

1 News of the planned (but never realized) *Antologie z poesie surrealistů* appeared in the *Literární kurýr Odeonu*, no. 7 (April 1930), as a venture to be edited by Štyrský and Vítězslav Nezval, in collaboration with André Breton. French and Czech surrealist poetry emerged in book and journal publications with gathering frequency from this time. See also "Život Markýze de Sade" (1931) and "Kraj Markýze de Sadea" (1933), in book form in Jindřich Štyrský, *Život Markýze de Sade* (The Life of the Marquis de Sade), ed. Lenka Bydžovská (Prague, 1995); and "Psychoanalysa u nás" (Psychoanalysis in Our Country) (1936), in Štyrský, *Každý z nás stopuje svoji ropuchu: Texty 1923–40*, ed. Karel Srp (Prague, 1996), 125–126.

2 Jaroslav Anděl, *The Avant-garde across Media: Josef Bartuška and the Linie Group 1931–1939* (Prague, 2004), 16–17.

3 See Matthew S. Witkovsky, "Surrealism in the Plural: Guillaume Apollinaire, Ivan Goll and Devětsil in the 1920s," *Papers of Surrealism*, no. 2 (Summer 2004), http://www.surrealismcentre.ac.uk/publications/.

4 Karel Teige, "Foto Kino Film" (1922), in Teige, *Svět stavby a básně*, ed. Jiří Brabec et al., 3 vols. (Prague, 1966), 1: 74.

5 Guillaume Apollinaire, "Les mamelles de Tirésias" (1917), in *L'enchanteur pourrissant, suivi de Les mamelles de Tirésias et de Couleur du temps* (Paris, 1957), 94.

6 Jindřich Štyrský, "Básník" (1928), in English as "The Poet," in Timothy O. Benson and Éva Forgács, eds., *Between Worlds: A Sourcebook of Central European Avant-gardes* (Los Angeles and Cambridge, Mass., 2002), 590–593. For a detailed chronology of Czech-French surrealist relations, see Lenka Bydžovská, Karel Srp, et al., *Český surrealismus 1929–1953: skupina surrealistů v ČSR; události, vztahy, inspirace* (Prague, 1996).

7 See ReD 3, no. 1 (July 1929): 2–5.

8 Vítězslav Nezval, "Hadrář," ReD 2, no. 7 (March 1929): 205–207; Nezval, *Strach* (Prague, 1930). Bydžovská and Srp note a *contrario* (Prague 1996, 19) that Nezval also planned a new poetist manifesto in 1930 for the third, unrealized issue of *Zvěrokruh*, in which he had formulated a series of critical objections to surrealism.

9 Robert Desnos, "Spectacles de la rue : Eugène Atget" (1928), in English in Christopher Phillips, ed., *Photography in the Modern Era: European Documents and Critical Writings, 1913–1940* (New York, 1989), 16–17.

10 In its French and English iterations, *Atget photographe de Paris* (Paris and New York, 1930) appeared with a preface by Pierre MacOrlan. Significantly for this account, Camille Recht, who published a German version of the book in Leipzig, replaced this with his own preface. Jaromír Funke (see below) and Walter Benjamin both based their accounts of the French photographer on this text rather than on the French version.

11 It is not clear whether Atget, as recycled through the surrealist movement, gave the primary impulse for German work on mannequins and dolls prior to *Film und Foto* (Werner Rohde and Moholy-Nagy made similar, isolated photographs, in 1928 and 1925, respectively), or whether this work grew principally out of dadaist fascination with the subject in 1920–1922. Nevertheless, the precedent of Atget was fundamental to the spread of this theme throughout central Europe and among central Europeans living in France from 1929 onward: Hackenschmied, Funke, Štyrský, Rohde, Krull, and Bayer count among the foremost examples.

12 The exhibition *Aventinská mansarda: Otakar Štorch Marien a výtvarné umění* (Prague, 1990), which reconstructed the two "new photography" shows of 1930 and 1931, mentions (122, cat. 713) a photograph by Hackenschmied titled *Před vetešnictvím* (In Front of the Pawn Shop), 1929, which, if the date is correct, would likely be the earliest example of his interest in subject matter identified with Atget and French surrealism. This work may or may not have been shown at one of the two Prague exhibitions.

13 Karel Teige, "Úkoly moderní fotografie" (1931), in English in Phillips 1989, 316–317.

14 Phillips 1989, 320.

15 Jaromír Funke, "Od pictorialismu k emoční fotografii" (From Pictorialism to Emotional Photography), *Fotografický obzor* 44, no. 7 ([July] 1936): 148–149.

16 Jaromír Funke, "O staré fotografii," *Světozor* 36, no. 29 (16 July 1936): n.p.

17 Jindřich Štyrský, "Surrealistická fotografie" (1935), in Štyrský 1996, 111–112.

18 For more on Štyrský's use of blindness, exemplified in a late self-portrait with gouged and bloodied eyes, see Lenka Bydžovská, "'Vidíte něco?' zeptal se Poussin... Informe, Bataille a čeští surrealisté" (Can you see anything? asked Poussin... Informe, Bataille and Czech surrealists), *Umění* 45, no. 5 (1997): 477–488.

19 Jindřich Štyrský, "Surrealistická fotografie" (1935), in Štyrský 1996, 111.

20 Information on the exhibition contents comes from Jolana Havelková et al., *Karel Kašpařík 1899–1968* (Brno, 2000), 14.

21 One notes as well Hugo Táborský's remarkable 1935 piece *Odpovědi* (Answers). Táborský's composition, a negative print filled with layered text fragments and repeated figural groups, flagrantly belies the promise of its title—itself taken from one of the fragments of text and thereby treated as a motif rather than a meaningful word. See Jaroslav Anděl et al., *Czech Modernism, 1900–1945* (Houston, 1989), 139.

22 Antonín Dufek, "O jedné fotografii Otakara Lenharta" (On a Photograph by Otakar Lenhart), *Umění* 40, no. 1 (1992): 67–73.

23 Krzywobłocki contributed photomontages to the group's fifth and seventh exhibitions, both in 1931. In 1933–1934 and 1936, when several Artes members took up photomontage for a time, works in this medium appeared in at least one exhibition (October 1933), a book (Alina Lan, *Kometa Halleya*, with illustrations by Krzywobłocki and Jerzy Janisch—the original photomontages were also displayed in a bookstore in the small town of Stanisławów, near Warsaw), and an article by Deborah Vogel discussed below. Adam Sobota, *Aleksander Krzywobłocki fotomontaże* (Wrocław, 1975), 2–3.

24 Henryk Streng [Marek Włodarski], "Walczymy o żywą sztukę," *Sygnały*, no. 17 (1936): 8.

25 Helena Blum, "Wystawa plastyków w teatrze Rozmaitości (Artists' Exhibit in the Variety Theater), *Słowo polskie* (14 October 1933): 5–6. Blum applauds photomontage as key to the "modern character of the exhibition" and praises Janisch's works particularly.

26 Deborah Vogel, "Genealogija fotomontażu i jego możliwości: II uzupełnienie," *Sygnały*, no. 13 (November 1934): 9.

27 As photographic examples one could cite the photograms made by Christian Schad using dustbin finds, or Man Ray's 1920 work *Transatlantic*, which includes a shot of cigarette butts and litter.

28 The initial *Fantômas* series, written by Marcel Allain and Pierre Souvestre, resulted in thirty-two volumes. Selected works from this vastly popular run were translated unceasingly throughout the twentieth century; see John Ashberry's introduction to Marcel Allain and Pierre Souvestre, *Fantômas*, 1st ed. 1911 (New York, 1986), 2–4. French director Louis Feuillade made five Fantômas films in 1913–1914, increasing the popularity of the character still further. Despite this, it seems that a complete French reedition of the original volumes began only in 1932.

29 See Vladimír Borecký, "Bohuslav Brouk a psychoanalýza v českém surrealismu," in Prague 1996, 66–75. Brouk's publications include *Psychoanalýsa* (1932, cover by Štyrský); *Psychoanalytická sexuologie* (1933); *Autosexualismus a psychoerotismus* (1935); *O smrti, lásce a žárlivosti* (On Death, Love, and Jealousy, 1936).

30 Vítězslav Nezval, *Sexuální nocturno: příběh demaskované iluse* (A Story of Illusion Unmasked) (Prague, 2001, 1st ed. 1931), afterword by Karel Srp.

31 Karel Srp, "Erotická revue a Edice 69," in Prague 1996, 57.

32 Ironically, directly following the publication of *Máj*, its author was remembered as insufficiently patriotic, judgment that would begin to shift only in the 1850s; see *Literární pouť Karla Hynka Máchy* (Karel Hynek Mácha's Literary Journey), ed. Pavel Vašák, (Prague, 1981). Thanks to Jonathan Bolton for this and other information concerning Mácha.

33 Bohuslav Brouk, "Máchův kult," in Konstantin Biebl and Vítězslav Nezval, eds., *Ani labuť ani Lůna: sborník k stému výročí smrti Karla Hynka Máchy* (Anthology on the 100th Anniversary of Karel Hynek Mácha's Death) (Prague, 1995, 1st ed. 1936), 79, 81.

34 Alfred Thomas, *The Labyrinth of the Word: Truth and Representation in Czech Literature* (Munich, 1995), 75.

35 *Lidové noviny* (1939), quoted in Derek Sayer, *The Coasts of Bohemia: A Czech History* (Princeton, 1998), 25.

36 Karel Teige, *Surrealismus proti proudu* (Surrealism against the Current), (Prague, 1993 1st ed. 1938), 21.

37 Jindřich Heisler with Jindřich Štyrský, *Na jehlách těchto dní*, 1st ed. 1945 (privately in 1941), in English (Berlin, 1984). See Ian Walker, "Between Photograph and Poem: A Study of Štyrský and Heisler's 'On the Needles of These Days,'" *Papers of Surrealism*, no. 3 (Spring 2005), http://www.surrealismcentre.ac.uk/publications/.

38 See Zykmund's contribution to *Karel Teige: Surrealistické Koláže 1935–1951* (Essen, 1966).

39 This last subject became a surrealist favorite during and after the war years. See Lenka Bydžovská and Karel Srp, *Libeňský plynojem* (The Gas Container in Libeň) (Prague, 2004).

40 In his article "Objective Poetry: Post-War Czech Surrealist Photography and the Everyday," *History of Photography* 29, no. 2 (Summer 2005), Krystof Fijalkowski boldly connects this picture of tram tracks to the rail lines leading to Terezín and Auschwitz (168).

CHAPTER 7

Activist Documents

1 See Olivier Lugon, *Le Style documentaire d'August Sander à Walker Evans, 1920–1945* (Paris, 2001), 62–67. Lugon dates the term "documentary" in international photographic discourse roughly to 1928. While Sander and Evans found their voice in relation to calls for objectivity articulated by German commentators such as Walther Petry, Lugon notes a contemporaneous attraction (within the Farm Security Administration, for instance) to a manipulative photography also termed documentary.

2 See Leah Dickerman, "The Fact and the Photograph," *October*, no. 118 (Fall 2006): 132–152.

3 On Hine's work of 1908–1909 and after, see Maren Stange, *Symbols of Ideal Life: Social Documentary Photography in America, 1890–1950* (New York, 1989), 47–87. No comparable message may be found in central European photography this early. Documentary photography at this time recalls instead the lantern-slide lectures and book by Jacob Riis on the tenements of lower Manhattan, *How the Other Half Lives* (1890); Stange astutely describes Riis and his middle-class audience as motivated by an exploitative, sensationalist if sincerely felt compassion for that "other half." The Viennese equivalent to Riis was journalist Emil Kläger, who held lectures beginning 1908 at the Urania, one of a chain of popular lecture halls in central Europe (first founded in Berlin), to accompany the publication of his book *Durch die Wiener Quartiere des Elends und Verbrechens: Ein Wanderbuch aus dem Jenseits* (Vienna, 1908), with photographs by Hermann Drawe. In Budapest, Kornél Tábori followed the Austrian precedent with a two-year engagement at his city's Uránia theater in 1911–1913. The newly installed Horthy regime commissioned Tábori in 1920 to refresh his findings for publication, an offer that led to the picture album *Egy halálraítélt ország borzalmaiból: Razzia a nyomortanyákon*. This ostensibly meliorative project served in reality to demonize the short-lived Republic of Councils brutally suppressed by Horthy rather than to initiate government plans for social betterment.

4 "Preis-Ausschreiben der AIZ" (1926), in Olivier Lugon and François Mathieu, eds., *La photographie en Allemagne: anthologie de textes (1919–1939)* (Nimes, 1997), 286–287.

5 Leah Ollman, *Camera as Weapon: Worker Photography between the Wars* (San Diego, 1991), 41. Whereas just 25 regional groups formed the original VdAFD membership (*Arbeiterfotografie* [cited 27 December 2005]; available from http://de.wikipedia.org/wiki/Arbeiterfotografie), by 1932, Germany apparently held 125 such groups with more than 3,000 members (*Entstehung der Arbeiterfotografie* [accessed 27 December 2005]; available from http://members.aol.com/Arbeitfoto/).

6 Adam Sobota, *Szlachetność techniki* (Warsaw, 2001), 121–122.

7 Heinrich Hauser, *Schwarzes Revier* (Berlin, 1930), 9.

8 Ignaz Wrobel [Kurt Tucholsky], "Die Tendenzphotographie" (1925), in French as "La photographie orientée" in Lugon and Mathieu 1997, 284–286.

9 Alan Trachtenberg, *Reading American Photographs: Images as History, Mathew Brady to Walker Evans* (New York, 1989), 219.

10 Peter Panter [Kurt Tucholsky], "Ein Bild sagt mehr als 1000 Worte" (1926), in Tucholsky, *Gesamtausgabe: Texte und Briefe; Texte 1926*, ed. Antje Bonitz, 17 vols. (Reinbek bei Hamburg, 2004), 8: 455.

11 Lubomír Linhart, *Sociální fotografie* (Prague, 1934), 71.

12 Heinz Luedecke, "Schulter an Schulter" (1930), in French as "Côte à côte" in Lugon and Mathieu 1997, 292.

13 Joyce Tsai, "*Der Kuckuck* and the Problem of Workers' Photography in Austria," *History of Photography* 29, no. 3 (Fall 2005): 275–286.

14 See Anne McCauley, "Writing Photography's History before Newhall," *History of Photography* 21, no. 2 (Summer 1997): 87–101; Bodo von Dewitz and Karin Schuller-Procopovici, eds., *David Octavius Hill & Robert Adamson* (Cologne and Göttingen, 2000), 45–52.

15 Stefan Riesenfellner and Josef Seiter, *Der Kuckuck: Die moderne Bild-Illustrierte des Roten Wien* (Vienna, 1995), 108.

16 Edwin Hoernle, "Das Auge des Arbeiters" (1930), in English as "The Worker's Eye," in David Mellor, ed., *Germany, the New Photography, 1927–33: Documents and Essays* (London, 1978), 47–49 (trans. modified).

17 Anonymous [Siegfried Weyr?] in *Der Kuckuck* (1929), cited in Riesenfellner and Seiter 1995, 107.

18 Riesenfellner and Seiter 1995, 106. *Film und Foto* was reviewed in *Der Kuckuck* in February 1930, at the time of the Vienna presentation.

19 Leah Dickerman, "The Propagandizing of Things," in *Aleksandr Rodchenko*, ed. Magdalena Dabrowski et al. (New York, 1998), 64. Rodchenko's oblique angles, Dickerman notes, codified "attempts to reorient the viewer's perspective as much as the camera's point of view."

20 [Siegfried Weyr], "Das Gute Lichtbild: Einige Programmatische Bemerkungen zu einigen Bildern" (Some Programmatic Comments on Some Pictures) (1932), in Riesenfellner and Seiter 1995, 108.

21 A traveling exhibition by the Munka group in 1931–1932 ended in conflict in April 1932, when it was due to open in the small town of Szolnok, roughly 100 km southeast of Budapest. The police, having granted permission, changed their minds upon seeing the exhibition installed, and apparently detained the organizers overnight with interrogations and beating, according to a later remembrance by coorganizer Lajos Tabák. The book *From Our Lives* appeared one month later, its contents close or identical to those of the planned exhibition in Szolnok. However, Kassák does not make reference to any exhibition in his preface. See Michael Simon, "A History of Photography in Hungary," unpublished ms., 1991, chap. 5 (misdated to 1931).

22 Farkas Zoltán, "Munkásfotográfiák" (Worker's Photography) (1932), in András Bán, ed., *Fotográfozásról* (Budapest, 1982), 235.

23 Lajos Kassák, "Roth László: Az új Fotográfia" (1933), in Bán 1982, 222.

24 Krisztina Passuth, *Moholy-Nagy* (London, 1985), 21, 24.

25 "Hat Hónapja" (Editorial), *Dokumentum*, no. 5 (May 1927): 1.

26 Lajos Kassák (Introduction), *Munka: Művészeti és társadalmi beszámoló*, no. 1 (September 1928): 1, 3.

27 Herbert Bayer, "Tipográfiai és propaganda eszközök," *Munka*, no. 1 (September 1928): 19–20, with full-page illustration of a photogram by Moholy-Nagy on page 19; László Moholy-Nagy, "A fényképezés megujulasa," *Munka*, no. 2 (October 1928): 42.

28 Lajos Gró, "A Munkásfényképész" (1930), in Bán 1982, 223.

29 Bán 1982, 153, 157–158.

30 See the issues of *Munka* for June 1930 and for June and December 1936; the January 1938 issue featured Haár's work in a four-page centerfold spread.

31 Ferenc Haár, "A Munka fotokiállitásához," *Munka*, no. 17 (March or April 1931): 470.

32 Lajos Kassák, ed., *A mi életünkből: a munka első fotókönyve / Aus unserem Leben: Fotobuch der Munka*, trans. Georg László (1932), n.p.

33 Árpád Szélpál, "Megalakítottuk a Munkásfoto-muzeumot" (1931), in Béla Albertini, ed., *Szemelvények a szociofotó forrásaiból*, 2 vols. (Budapest, 1984–1985 and 1989), 1: entry 19. Albertini has indicated (personal communication) that the many pictures collected for this museum project were eventually dispersed.

34 The cornerstone of such discussions in recent scholarship is Eric Hobsbawm and Terence Ranger's provocative anthology *The Invention of Tradition* (Cambridge, England, 1983), which concentrates, however, on the nation-states of western Europe. Myriad revisionist studies since then have focused on central-eastern Europe, in echo, one should say, of vigorous debates over "invented traditions" ongoing in those lands since the 1800s as well.

35 Béla Albertini, *A Sarló szociofotós vonulata* (Bratislava, 1993), 7–19.

36 Szalatnai Rezső, "Júniusi levél" (June Letter) (1931), cited in Albertini 1993, 28–29. Albertini observes that this strong leftist articulation was not present at the founding of the movement in 1925 and stresses that Sarló contained varying orientations within its membership; from around 1930, nevertheless, agitational politics came to the fore.

37 Iva Mojžišová, ed., *Irena Blühová* (Martin, Slovakia, 1991), 16, 17.

38 Mojžišová 1991. Photographs reproduced on page 12 show the storefront with simply the word "bookstore" in Slovak, German, and Hungarian, as well as a label titled *Knihy* (Books) I. Blüh. It appears that the Sociofoto group did not try to found its own illustrated magazine and published only rarely in existing journals in Czechoslovakia or abroad. Ľudovít Hlaváč, personal communication, October 2005.

39 Gyula Ortutay, "A Szegedi Fiatalok Művészeti Kollégiuma" (Szeged Youth Art Circle) (1933), in Albertini 1989, 2: entry 51.

40 Béla Albertini, *A magyar szociofotó története a kezdetektől a második világháború végéig* (Budapest, 1997), 101. Kárász had been asked to leave Germany for electioneering in 1931 and would in turn flee from Hungary in 1935, presumably for political reasons, resettling in Denmark until after World War II. Károly Kincses, *Fotógrafos Made in Hungary: los que se fueron; los que se quedaron* (Seville, 2002), 340.

41 "15 Kilometer von Wien," *Der Kuckuck* 2, no. 10 (9 March 1930): 5. Thanks to Josef Seiter for locating this article.

42 A presumably complete set of reviews, eight in all, is collected in Albertini 1984–1985, 1: 1–33. Ortutay and Szélpál were among the reviewers.

43 Peter Pachnicke and Klaus Honnef, *John Heartfield* (New York, 1992), 147.

44 Jiří Kroha, "Sociologický fragment bydlení" (Excerpts from a Sociology of Habitat) (1933), in Josef Pechar and Petr Urlich, *Programy české architektury* (Czech Architecture Manifestoes) (Prague, 1981), 222.

45 See *Jiří Kroha: Kubist, Expressionist, Funktionalist, Realist* (Vienna, 1998), 75.

46 *Výstava sociální fotografie: Československo— Francie— SSSR*, April–May 1933; II. *mezinárodní výstava sociální fotografie*, April 1934; both with catalogues. See Vladimír Birgus, *Czech Photographic Avant-garde, 1918–1948* (Cambridge, Mass., 2002), 175–179.

47 Linhart founded in 1956, at the state-run cultural publishing house SNKLHU, a series of square, small-format monographs on Czech and foreign photographers both past and present. The series eventually reached nearly fifty volumes, and it inspired imitators elsewhere in the Soviet bloc, for example in Hungary, where Kata Kálmán helped launch a domestic version in 1966. Brought by dissident photography historian Anna Fárová to the attention of Robert Delpire in Paris, the SNKLHU series inspired the Photo Poche monographs, a hugely influential popular editorial line. Among the successors to these initiatives—which include Phaidon's 55 and the In Focus books at the J. Paul Getty Museum—is a new run of small, square monographs from the Prague publishing house Torst, inaugurated in 2000 under the rubric Fototorst.

48 Linhart 1934, 70–71; the new book is announced for publication in the fall of 1934. Reportage, photomontage, and serial imagery accordingly receive just a brief description in the present book.

49 Linhart 1934, 54.

50 Karel Teige, "Úkoly moderní fotografie" (1931), in Teige, *Zápasy o smysl moderní tvorby*, ed. Jiří Brabec et al., 3 vols. (1969), 2: 58–60; excerpts in English as "The Tasks of Modern Photography," in Christopher Phillips, ed., *Photography in the Modern Era: European Documents and Critical Writings, 1913–1940* (New York, 1989), 312–322.

CHAPTER 8

Land without a Name

1 Thomas Mann, "Deutschland und die Deutschen," first delivered May 1945 as a lecture in the Library of Congress, cited in English in Jeffrey Herf, *Reactionary Modernism: Technology, Culture, and Politics in Weimar and the Third Reich* (Cambridge, England, 1984), 2.

2 Ladislaus [László] von Szabó, introduction to Rudolf Balogh, *Ungarnfibel: Eine Bilderreihe aus dem Leben und Schaffen des ungarischen Volkes*, also published as *Hungarian Pictures: A Pictorial Series from the Life and Work of the Hungarian People* (Budapest, 1938), n.p.

3 For a modern history of this contested region, see Paul Robert Magocsi, *Of the Making of Nationalities There Is No End*, 2 vols. (New York, 1999).

4 Ivan Olbracht, *Nikola Šuhaj, loupežník* (Prague, 1933).

5 Ivan Olbracht, *Země bez jména* (Land without a Name), (Prague, 1932), 5.

6 Paul Schultze-Naumburg, unpublished memoirs (1942–1947), paraphrased in Norbert Borrmann, *Paul Schultze-Naumburg, 1869–1949: Maler, Publizist, Architekt; vom Kulturreformer der Jahrhundertwende zum Kulturpolitiker im Dritten Reich* (Essen, 1989), 26.

7 Gustav Adolf Kuhfahl, *Heimatphotographie: Die Photographie im Dienste von Heimatschutz und Heimatforschung* (Halle an der Saale, 1921), 14.

8 Kuhfahl 1921, 1.

9 See Paul Schultze-Naumburg, *Flaches oder geneigtes Dach?* (Flat or Pitched Roof?) (1927) and *Kunst und Rasse* (1928). For an example of this binary comparative method applied to racist ethnography, see Ludwig F. Clauß, *Die nordische Rasse* (The Nordic Race) (Berlin, 1941); this work and the others discussed below are critically reviewed in Ulrich Hägele, "Die Visualisierung des 'Volkskörpers': Fotografie und Volkskunde in der NS-Zeit" (Visualizing the Body of the Volk: Photography and Ethnography in the Nazi Era), *Fotogeschichte* 21, no. 82 (2001): 5–20.

10 Erna Lendvai-Dircksen, *Ein deutsches Menschenbild: Antlitz des Volkes* (Frankfurt am Main, 1961), v. This late quotation is entirely consistent with the series of books Lendvai-Dircksen produced from 1932 through 1944 on *Das deutsche Volksgesicht* (in later volumes extended to "friendly" foreign cultures as *Das germanische Volksgesicht*), which purported to identify unifying *völkisch* traits throughout the Reich.

11 Erich Retzlaff's books *Das Antlitz des Alters* (1930), and *Die von der Scholle* (1931), seem specifically to have been published as nationalist competition for Sander's *Antlitz der Zeit*. See Susanne Lange and Gabriele Conrath-Scholl, "August Sander: Menschen des 20. Jahrhunderts; Ein Konzept in seiner Entwicklung" (A Concept in Its Development) in *Menschen des 20. Jahrhunderts: Studienband*, ed. Susanne Lange et al. (Munich, 2001), 18.

12 August Sander and Alfred Döblin, *Antlitz der Zeit: Sechzig Aufnahmen deutscher Menschen des 20. Jahrhunderts* (Munich, 1929).

13 August Sander, "Erläuterung zu meiner Ausstellung im Kölnischen Kunstverein," November 1927. Erich Stenger Archiv, Agfa Photo-Historama, Museum Ludwig, Cologne.

14 August Sander, letter to Erich Stenger, 21 July 1925, Stenger Archiv. Lange and Conrath-Scholl consider it "probable" that this letter traveled with the *Stammappe* (Munich 2001, 13, with a lengthy excerpt). Nevertheless, Sander writes only of having sent Stenger "one picture or so," and promises here to send "a series of pictures from the various portfolios for you to look at," should Stenger so desire. The portfolio itself carries the handwritten mention "published Nov. 1927."

15 Sander to Stenger, 21 July 1925, Stenger Archiv. Sander indicates his desire to exhibit his own prints alongside a range of nineteenth- and twentieth-century material, to demonstrate "how far modern processes have gotten from the true origin and essence of photography." Sander credited Daguerre's work as exemplary in the first of six radio addresses he delivered in 1930 (Munich 2001, 41 n. 77); he also placed photographs by Daguerre and Nièpce in one window of his studio. See Thomas Wiegand, "August Sander und das Photographengewerbe" (Munich, 2001), 57 and 64–65 n. 38.

16 Thomas Wiegand in Munich 2001, 61–62. For a record of one such itinerant photographer, see Claudio Hils, *Von Königskindern und anderen: Friedrich Pöhler, ein Photograph in Wilhelmsdorf 1909–1910* (Salzburg, 1997).

17 See Tadeusz Bobrowski, "O czynnik społeczny ruchu fotograficznym," *Fotograf Polski* (December 1935). Many thanks to Maciej Szymanowicz for information on the *fotografia ojczysta* movement, which he describes in "Miejsce Piktorializmu w historii polskiej fotografii dwudziestolecia międzywojennego" (PhD diss., Poznań, 2004).

18 Tadeusz Cyprian, "Splendid Isolation" [sic], *Fotograf Polski* (1934), cited in Szymanowicz 2004, 144.

19 Jan Bułhak, "Linje Wytyczne Fotografji Ojczystej," *Przegląd Fotograficzny* (February 1938): 23.

20 Bułhak 1938: 23–24.

21 Jan Bułhak, *Polska Fotografia Ojczysta* (Poznań, 1939). From 1931, Bułhak wrote tirelessly on this subject and on issues of national identity in photography.

22 Bułhak 1939, 4.

23 Jan Bułhak, "Amerykanizm a Fotografja Ojczysta," *Przegląd Fotograficzny* (July 1938): 124–128, cited in Szymanowicz 2004, 159.

24 Bułhak 1939, 25.

25 Maciej Szymanowicz, "Śląska idylla: O przemyśle, folklorze i fotografii lat 30. / Silesian Idyll: On Industry, Folklore, and Photography of the 1930s," *Fotografia* 14 (2004): 96–103, English 129–132.

26 Ján Abelovský and Katarína Bajcurová, *Art in Changing Times: Painting & Sculpture in Slovakia 1890–1949* (Bratislava, 2000), 167–259.

27 Ľudovít Hlaváč, *Sociálna fotografia na Slovensku* (Bratislava, 1974), 53–54, 62–65; Aurel Hrabušický and Václav Macek, *Slovenská fotografia / Slovak Photography 1925–2000* (Bratislava, 2001), 16–25.

28 Dezső Dózsa, "Magyar stílus" (1933), cited in English in Mihály Gera, ed., *A fénykép varázsa / The Magic of Photography, 1839–1989* (Budapest, 1989), 160.

29 England, for one, was demonstrably receptive to Hungarian tourist imagery. The London annual *Modern Photography* included work by six to ten Hungarian photographers yearly from 1931; see also Jozef Gross, "Master of Escapism," on Ernő Vadas and his contributions to the British magazine *Lilliput*, in *British Journal of Photography* 137, no. 6765 (19 April 1990): 9–11.

30 Rudolf Balogh, "Interjú Balogh Rudolffal: Hogyan született a 'magyar stílus'?" (1934), cited in English as "Interview with Rudolf Balogh: How Was 'Hungarian Style' Born?" in Budapest 1989, 160.

31 Károly Kincses and Magdolna Kolta, *Minden magyar fotóriporterek atyja: Balogh Rudolf* (Kecskemét, 1998), with a complete listing of Balogh's published photographs.

32 *Ungarnfibel* appeared first in German, then was released in English, French, and Italian versions.

33 Béla Paulini, ed., *The Pearly Bouquet* (Budapest, 1937), 3.

34 Gyula Ramhab, "Az etnográfiai felvételekről" (1935), cited in English as "On Ethnographic Pictures" in Budapest 1989, 160.

35 Zoltán Fejős, *Boldog Képek* (Budapest, 2005), 125.

36 Other pictures made on this assignment are entirely unambiguous in their portrayal of peaceable longhorn cows, carp fishermen, and herdsmen cooking goulash. See Tom Haar, ed., *Francis Haar: A Lifetime of Images* (Honolulu, 2001), 7 and 20–25. Soon after moving to Japan in 1939, Haar produced a similarly nostalgia-laden picture book for the Hungarian tourist board.

37 Fachverbände der Fotografen-Genossenschaften Österreichs, *Foto-Ausstellung: Österreichs Bundesländer im Lichtbilde* (Vienna, 1933).

38 Franz Hainzlmayr, "Lichtbild und Heimatkunst," in Vienna 1933, 20.

39 Hainzlmayr in Vienna 1933, 22.

40 Michael Mont, "Das werbende Heimatbild," *Der Lichtbilder* (June 1934): 174–176.

41 See "Heimatphotographie" and Felix Göhlert, "Zum Wesen der Heimatphotographie," *Der Lichtbilder* (January 1934): 13. The rubric remained current through the journal's ten-year production.

42 Otto Hochreiter, "Ländliches Leben: Zur Darstellung des Bauern und der alpinen Landschaft" (Rural Life: On the Representation of Peasants and the Alpine Landscape), in *Geschichte der Fotografie in Österreich*, ed. Otto Hochreiter et al. (Bad Ischl, 1983), 414.

43 See Astrid Lechner, "Fine Arts Photography at the Grapische Lehr- und Versuchsanstalt in Vienna," in *The Eye and the Camera: The Albertina Collection of Photographs*, ed. Monika Faber et al. (Paris, 2003), 172–182. Novák, who was Czech by birth, was named head of the newly founded Státní grafická škola in Prague in 1919.

44 Jo-Ann Conklin, Monika Faber, and Peter Weiermair, *Rudolf Koppitz, 1884–1936* (Vienna, 1995).

45 Vienna 1995, 64, 76 n. 64, and 106. Koppitz took part in nearly sixty amateur exhibitions at home and around the world between 1925 and 1933. His participation brought financial reward as well as esteem; Faber notes that Koppitz sold at least fifteen prints of his best-known work, *Bewegungsstudie (Movement Study)* in the United States during these years.

46 *Der Lichtbildner*, April and June issues, 1934.

47 Jan Lukas, "Prof. Rudolf Koppitz," *Der Lichtbildner* (August 1936): 243. Lukas established himself as a photojournalist in the Czech lands and the United States after World War II. His first book, *Země a lidé / The Land and the People* (Czech and English editions, 1946) completed his parting promise to Koppitz quite literally, down to its plagiarized title. The dust-jacket photograph shows a farmer leading oxen across a darkening field under an enormous, demonstrative sky. Lukas did not acknowledge his mentor here, however, no doubt for political reasons.

48 Another exceptional contemporary is Fritz Macho, who took honest, insightful portraits of mountain dwellers and the landscape around his native Salzburg in the 1930s. Little is known of Macho, and there may well be others with similarly unpretentious work from the time. See Peter Rosei, O. P. Zier, and Peter Weiermair, *Menschen am Land: Photographiert von Fritz Macho in den dreissiger Jahren* (Country People Photographed by Fritz Macho in the 1930s) (Salzburg, 1981).

49 Hochreiter 1983, 416. See also Otto Hochreiter and Peter Weiermair, eds., *Peter Paul Atzwanger, 1888–1974: Photographien* (Innsbruck, 1981).

50 Peter Paul Atzwanger, "Die Lichtbildnerei als Kunst" (1929), in Hochreiter and Weiermair 1981, 166.

51 Wilhelm Angerer, *Ein Lied rauscht von den Bergen* (Vorarlberg-Tirol, 1942).

52 It is impossible to gain a sense of the scope and motivation for this project except through recollections by Vishniac himself, who escaped to the United States via a French concentration camp in 1940–1941. Only a small percentage of negatives survived this journey. See Roman Vishniac, *Roman Vishniac* (New York, 1974).

53 See Olivier Lugon, *August Sander: Landschaften* (Munich, 1999), 23–51.

54 Jaromír Funke, "Fotografovaná krajina" (1940), in Czech only in Antonín Dufek, *Jaromír Funke (1896–1945): Průkopník fotografické avantgardy / Pioneering Avant-garde Photography* (Brno, 1996), 46.

CHAPTER 9

The Cut-and-Paste World:
War Returns

1 Walter Benjamin, "The Author as Producer" (1934), in *Selected Writings: 1927–1934*, ed. Marcus Paul Bullock et al., 4 vols. (Cambridge, Mass., 1996), 2: 775.

2 See Stanisław Czekalski, *Awangarda i mit racjonalizacji: fotomontaż polski okresu dwudziestolecia międzywojennego* (Poznań, 2000), 95–97; Jaroslav Anděl, *El Arte de la vanguardia en Checoslaquia, 1918–1938 / The Art of the Avant-garde in Czechoslovakia, 1918–1938* (Valencia, 1993), 37. Karel Srp, whose book *Karel Teige* (Torst, 2001), reproduces the work from 1939, contends (13) that Teige and Heartfield may have been inspired independently by the same source image.

3 See the reconstruction by Elizabeth Patzwall in Peter Pachnicke and Klaus Honnef, eds., *John Heartfield* (New York, 1992), 323–328.

4 Brandon Taylor reviews this debate as it affects more recent scholarship in his essay, "Montage and Its Comedies," *Oxford Art Journal* 16, no. 2 (1993): 91–96.

5 Karel Teige, "O fotomontáži" (1932), in Teige, *Zápasy o smysl moderní tvorby*, ed. Jiří Brabec et al., 3 vols. (Prague, 1969), 2: 72, 69–70.

6 One exception is "Das Dorf in der Slowakei," *AIZ* 13, no. 27 (5 July 1934): 430–431.

7 Vladimír Birgus, *Czech Photographic Avant-garde, 1918–1948* (Cambridge, Mass., 2002), 18–20.

8 Jan Tschichold proposed a study of photomontage (never realized) for Franz Roh's book series *Fotothek*. On Linhart, see chap. 7. Heartfield himself was the subject of a 1936 monograph by Sergei Tretyakov in Moscow.

9 Sabine Kriebel analyzes the 1934 show and surrounding media spectacle in "Revolutionary Beauty: John Heartfield, Political Photomontage, and the Crisis of the European Left, 1929–1938" (PhD diss., University of California, Berkeley, 2003), 181–198.

10 See also the installation view printed in *AIZ* 13, no. 16 (19 April 1934): 242.

11 László Moholy-Nagy, "Die Photographie in der Reklame," *Photographische Korrespondenz* 63, no. 9 (September 1927): 257–260; "Fotografie ist Lichtgestaltung," *Photographische Korrespondenz* 64, no. 5 (May 1928): 133–138. The latter text first appeared earlier in 1928 in *Bauhaus*, the school's house journal.

12 I am indebted here to Elizabeth Otto, author of *Tempo, Tempo! Bauhaus-Photomontagen von / The Bauhaus Photomontages of Marianne Brandt* (Berlin, 2005).

13 The source for this image is, intriguingly, a photograph by Paul Wolff titled *Der erste Zug aus der Zigarette* (First Puff on a Cigarette). See chap. 5 for more on Wolff's profascist corporatism. Thanks to Elizabeth Cronin for discovering this image in Wolff, *Meine Erfahrungen mit der Leica* (Frankfurt am Main, 1934), pl. 17 (image dated 1929–1931).

14 Berlin 2005, 127, 129.

15 Thanks to Robin Kelsey for noting the "safe remove" that Brandt affords viewers in these scenes of distress.

16 Stefánia Mándy, *Vajda Lajos* (Budapest, 1983), 170. At least twelve photomontages by Vajda remain extant. Mándy reproduces an undated photograph showing sixteen photomontages against a studio wall. Three of the surviving compositions appear different from those in this photograph. A fourth composition not depicted in the documentary photograph is reproduced as fig. 43 in Mándy's book, for a total of perhaps twenty photomontages. Vajda is said to have left others in Paris, perhaps in lieu of rent (if a landlord did indeed accept such works as payment, this would indicate remarkable market validation for the technique).

17 Lajos Kassák, "A fotomontázs" (1930), in English in *Lajos Kassák: The Advertisement and Modern Typography*, ed. Ferenc Csaplár (Budapest, 1999), 20.

18 Janusz M. Brzeski, "Narodziny robota," *Kurier Literacko-Naukowy*, Sunday suppl. to *Ilustrowany Kurier Codzienny* (1 January 1934).

19 Stanisław Czekalski, "Kazimierz Podsadecki and Janusz Maria Brzeski: Photomontage between the Avant-garde and Mass Culture," *History of Photography* 29, no. 3 (Fall 2005): 269–274.

20 Zbigniew Grotowski, "Za kulisami przyszłej wojny" (Behind the Scenes in the Coming War) (1936), cited in Czekalski 2005, 273.

21 See Czekalski 2000, 306.

22 Karel Čapek, *War with the Newts*, trans. Ewald Osers (North Haven, Conn., 1990), 21; in Czech as *Válka s mloky* (1936).

23 Jindřich Štyrský, "Kraj Markýze de Sadea" (1933), in Štyrský, *Život Markýze de Sade* (The Life of the Marquis de Sade), ed. Lenka Bydžovská (Prague, 1995).

24 Jindřich Štyrský, *Emilie Comes to Me in a Dream* (New York, 1997), 3, in Czech as *Emilie přichází ke mně ve snu* (1933) (trans. modified).

25 Bohuslav Brouk, afterword, in Štyrský 1997, 32–33.

26 See in particular Sue Taylor, *Hans Bellmer: The Anatomy of Anxiety* (Cambridge, Mass., 2000), 33–34. The doll supposedly was inspired by a box of childhood toys sent by Bellmer's mother from Gliwice; the arrival of his seductive cousin Ursula Naguschewski from Kassel; and a performance of Jacques Offenbach's opera *Contes d'Hoffmann* (Tales of Hoffmann, 1881), based in part on E. T. A. Hoffmann's novella *Der Sandmann* (1815 / 1816), which features a psychologically distraught student and his tragic love for a female automaton. Construction of the doll, meanwhile, greatly involved Bellmer's brother Fritz, who had also relocated from Gliwice.

27 Hans Bellmer, *The Doll*, trans. Malcolm Green (London, 2005), in German as *Die Puppe* (1934) and in French as *La Poupée* (1936).

28 See Hal Foster, "A Bashed Ego: Max Ernst in Cologne," in *The Dada Seminars*, ed. Leah Dickerman et al. (Washington, 2005), 127–149, and Foster, "Armor Fou," *October* 56 (Spring 1919): 65–97.

29 Anna Heislerová, Jindřich's sister, was registered as a Christian from birth, although she was baptized only in 1938; she was also married to a Christian. These circumstances afforded her some protection from arrest or searches, although Heisler's decision to stay with her occasionally was extremely risky—there was one camp near Prague especially for such *Mischlinge* or mixed-faith citizens. Thanks to Jindřich Toman for this information.

30 Jindřich Heisler and Toyen, *Jen poštolky chčí klidně na desatero / Nur die Turmfalken brunzen ruhig auf die 10 Gebote* (1939), in Jindřich Heisler et al., *Z kasemat spánku* (Prague, 1999), 21–41.

31 Heisler 1999, 18.

32 All collected in Heisler 1999, 73–159.

33 Władysław Strzemiński, "B=2," *Blok* (1924), in English in Timothy O. Benson and Éva Forgács, eds., *Between Worlds: A Sourcebook of Central European Avant-gardes, 1910–1930* (Los Angeles, 2002), 498.

34 Katarzyna Kobro, "Funkcjonalyzm" (1936), cited in English in Yve Alain Bois, *Painting as Model* (Cambridge, Mass., 1993), 134.

35 Bois 1993, 128–129.

36 Władysław Strzemiński, *Sztuka nowoczesna w Polsce*, cited in English as *Modern Art in Poland* in Bois 1993, 130.

37 Esther Levinger explains that Strzemiński emphasized a biologically conditioned, rather than disembodied, eye in these later works—a turn to corporeality that would make his artistic response to war and holocaust particularly acute. See Levinger, "Return to Figuration: Władisław [sic] Strzemiński and the Move from Idealism," *Art History* 24, no. 1 (February 2001): 103–131.

38 Dates and statistics taken from http://www.shtetlinks. jewishgen.org/Lodz/statistics.htm (accessed March 2006), and from Lucian Dobroszycki, ed., *The Chronicle of the Łódź Ghetto 1941–1944*, trans. Richard Lowrie, Joachim Neugroschel, et al. (New Haven, 1984), xxx–lxv.

39 Władysław Strzemiński, "Aspekty rzeczywistości" (1936), cited in English as "Aspects of Reality" in Bois 1993, 132.

40 Vojtěch Lahoda calls these "female 'monuments'"; see Lahoda, "Karel Teige's Collages, 1935–1951: The Erotic Object, the Social Object, and Surrealist Landscape Art," in Eric Dluhosch et al., *Karel Teige, 1900–1951: l'Enfant Terrible of the Czech Modernist Avant-garde* (Cambridge, Mass., 1999), 301–305.

41 Vojtěch Lahoda, "Karel Teige's Collages," in Dluhosch 1999, 306.

42 Karel Teige, "Cesty československé fotografie" (1947), in Teige, *Osvobozování života a poezie*, ed. Jiří Brabec et al., 3 vols. (Prague, 1994), 3: 235–256.

A Note on Place Names

To reflect the enormous political changes that took place during the lifetimes of nearly all the individuals discussed here, between c. 1890 – 1910 and the second half of the twentieth century, listings for places and countries of birth and death shift from one era to the next (see also maps, xxx–xxxi). Localities of birth and death are given in the official language or languages of the time, not in contemporary English usage. For the years prior to 1918, Prague therefore appears as Prag / Praha (German / Czech), and for the years following as Praha (Czech). Localities so small they are not included on most maps are accompanied by nearby towns of greater prominence. For events prior to 1918, the official administrative name (in English) follows the locality for the corresponding imperial region: Kingdom of Galicia and Lodomeria, Archduchy of Upper Austria, and so forth. (In the case of the Kingdom of Prussia, which had more than one dozen dependencies, individual provinces are listed as well.) These administrative regions, including the kingdoms, are all subordinate entities within the larger German, Austro-Hungarian, and Russian empires. For events after 1918, the official administrative name (in English) follows the locality for the corresponding nation-state, again as known at the time: for example, Republic of Poland before 1939, General Government of Poland for 1939–1945, People's Republic of Poland for 1948–1989, and Poland after 1989.

SOURCES

"German Empire." http://en.wikipedia.org/wiki/German_empire (accessed November 2006).

Lelkes, György, ed. *Magyar helységnév-azonosító szótár* (Hungarian Geographical Lexicon). Baja, Hungary, 1998.

Magocsi, Paul Robert. *Historical Atlas of East Central Europe.* Toronto, 1993.

Pfohl, Ernst. *Ortslexikon Sudetenland* (Sudetenland Geographical Lexicon). Nuremberg, 1987.

Thanks to Peter Bugge and Eagle Glassheim for additional consultation on the Czech lands.

Wilhelm Angerer

(Schwaz, Tirol 1904 – 1982, Schwaz, Austria)

Angerer learned photography first in the family business, as both his father and his grandfather were photographers in Tirol. After gaining practical experience in several small studios, he completed his education at the Höhere Fachschule für Phototechnik (Institute for Higher Education in Technical Photography) in Munich. In 1933 Angerer opened a photo shop with a postcard publishing business in Kitzbühel, Tirol. He traveled to Scandinavia during World War II as a combat photographer but was imprisoned in Norway and returned to Tirol only at the end of the war. In the late 1960s he retired and signed the business over to his daughter.

Along with Rudolf Koppitz, Angerer is regarded as one of the most significant representatives of *Heimatphotographie* (Homeland Photography), a movement in which thematic concentration on traditional culture and the landscape was deployed to construct a new image of Austria and a new national identity, after the loss of empire and the attendant substantial reduction in size at the conclusion of World War I. Angerer focused mainly on landscape and provided lyrical titles for his pictures. In his most important group of works, the snow landscapes, he concentrated on surface structure, reducing the Alpine slopes to nearly abstract planes through tight cropping and retouching. In this way, Angerer combined a conservative mindset and traditional worldview with modern formal methods. In other works, he turned to the equally popular theme of folklore, showing views of people in rural costume doing farm work to "document" daily life in the countryside. In the 1950s, his landscape views were used particularly for postcard production, to meet the demands of the tourism industry. The continuing popularity of Angerer's landscape photographs after World War II is explained by the renewed wish to convey an idyllic and harmonious image of Austria and to forget the horrors of the war. AL

LITERATURE

Heubacher, Franziska. *Wilhelm Angerer 1904 – 1982: Das photographische Werk.* Innsbruck, 2002.

Weiermair, Peter, ed. *Wilhelm Angerer 1904 – 1982: Retrospektive des photographischen Werks.* Exh. cat., Museum Rabalderhaus. Schwaz, 1999.

Karol Aufricht

(Pozsony / Prešporok, Kingdom of Hungary [today Bratislava, Slovakia] 1910 – 1975 Bratislava, Czechoslovak Socialist Republic)

In 1930 Aufricht, by training a tailor but repeatedly unemployed for economic and health reasons (he suffered from tuberculosis), joined a local hiking club in Bratislava, the Verband der Naturfreunde (Society of Nature Lovers), and started to photograph with fellow members. Like many clubs with this name in central Europe, the Naturfreunde, affiliated with the Social Democratic Party, fostered an interest in photography, recreation, and socialist politics. Outdoor activities for the working poor or unemployed were offered together with darkroom training and the opportunity to participate in members' exhibitions of photography. Traveling in this circle, Aufricht in 1932 met Iren Blüh, leader of an activist photographers' group documenting social conditions among the rural poor in various Slovak villages. At her suggestion, the Naturfreunde established a working committee for class-conscious photography called Sociofoto (1934), headed, among others, by Aufricht. This group's activity culminated one year later, when the overwhelming majority of exhibits at the annual Naturfreunde members' show addressed social ills. Aufricht also took part in two large-scale *Výstavy sociální fotografie* (Exhibitions of Social Photography) in Prague, in 1933 and 1934. His photographs hone in on lonely people: tramps, tinkers, the unemployed, the elderly, scavengers for firewood (cat. 129), and others from the fringes of society. He organized his work in series, with emphatic titles such

as *Unemployed* (*Nezamestnaní*) or *Still We Made a Living* (*Aj tak jsme sa živili*), to which he added new photographs over the years. He also created various photo stories, among them *On the Hay above Fačkov* (*Na senách nad Fačkovom*) and *Wine Growers in Karlova Ves* (*Vinohradníci v Karlovej Vsi*).

With the onset of fascism, Aufricht joined the resistance, for which he was convicted in 1942 and spent almost a year in jail. A relapse of tuberculosis left him in a critical state at his release. After the liberation, he worked on the newspaper *Pravda* until 1950 and from 1951 on *Hlas Ľudu* (The Voice of the Masses), a local Communist Party newspaper, once more returning to photography as a journalist and organizer. He published many reviews, articles, and portraits of photographers and served on advisory bodies for amateur photography. He also received numerous official awards. JP

LITERATURE

Fárová, Anna. "Karol Aufricht." *Československá fotografie*, no. 3 (1972): 116.

Theo Ballmer

(Lausanne, Switzerland 1902 – 1965 Basel [?], Switzerland)

Before arriving at the Bauhaus in 1928, August Théophile Ballmer, a Swiss typographer, worked for the Hofmann-LaRoche company. At the Bauhaus, he probably studied photography with Walter Peterhans, whose curriculum emphasized the investigation of the physical and chemical properties of photography; his students were asked to calculate the focal lengths of lenses, construct tables of exposure times, and mix developer solutions for themselves. An object fabricated by Ballmer (*Untitled*, J. Paul Getty Museum) is described as "22 photographs on 8 boards, illustrating experiments with lighting, focus, exposure etc." It also includes samples of fabric and wood veneer, that is to say, textured materials, another area of research emphasized by Peterhans (see cat. 28). After returning to Switzerland, Ballmer took part in shows of new typography during the early 1930s and furthered his career in poster design, working particularly successfully with linocut and letterpress layouts of boldly simplified, original typefaces. He designed a family of fonts known as Ballmer, which was further refined by his son, Theo, and more recently digitized by his grandson, Thierry. From 1931 until his death, meanwhile, Ballmer's primary occupation was as professor of design at the Basel Allgemeine Gewerbeschule (School of Applied Arts), where he conscientiously furthered Bauhaus principles, including the study of "basic optical concepts" that involved serial exercises in photography. MW

Rudolf Balogh

(Budapest, Kingdom of Hungary 1879 – 1944 Budapest, Republic of Hungary)

In 1900 Balogh earned a photography degree at the Graphische Lehr- und Versuchsanstalt in Vienna, a prestigious institution with exceptional equipment and resources. Returning to Budapest, Balogh became actively involved in Hungarian photography circles. He worked as a photojournalist but also began to make fine art prints, winning numerous amateur salon competitions throughout Europe. Balogh was a long-time member of MAOSZ, the Hungarian amateur photography association, and in 1914 founded the Magyar Fotoművészek Klubja (Art Photography Club) and the short-lived journal *Fotoművészet* (Art Photography). Throughout World War I he photographed extensively for the newspaper *Vasárnapi Újság* (Sunday News); temporarily abandoning his aestheticizing sensibility, he also depicted life at the front and documented war casualties with bold clarity. From 1925 until January 1937, Balogh published regularly in the popular illustrated newspaper *Pesti Napló* (Diary of Pest), and in 1930 he became the editor of the largest amateur photography journal in Hungary, *Fotoművészeti Hírek*. He was widely known in these years for depictions of contented women and children in traditional Hungarian dress, representatives of the "Hungarian style," an internationally recognized movement that reacted to postwar instabilities by emphasizing a regionalist, folkloric continuity. Despite criticism of his bucolic idealizations and his practice of dressing peasants in costly garb, Balogh remained popular and became increasingly entrenched in the national establishment; government agencies such as the Hungarian State Railways commissioned his photographs. In 1935–1936, Balogh published *Hungarian Pictures* (*Ungarnfibel*), a lavish album of full-page photographs showing life on the *puszta* or grasslands in the east of the country. The portrayal of nomadic folk as shepherds—worshiping, defending, and spreading Christian Hungarian-ness— fits with a growing sentiment of extreme nationalism. Declining a position to work for National Geographic in the United States, Balogh remained in Hungary in spite of the oncoming war. His studio was bombed in 1944 and he died of health complications shortly thereafter. EC

LITERATURE

Kincses, Károly, and Magdolna Kolta. *Minden magyar fotóriporterek atyja: Balogh Rudolf* (Rudolf Balogh: Father of All Hungarian Photojournalism). Exh. cat., Magyar Fotográfiai Múzeum. Kecskemét, 1998.

Vajda, Ernő. *Balogh Rudolf munkássága* (The Work of Rudolf Balogh). Budapest, 1969.

Josef Bartuška

(Rozovy, Moldauthein / Týn nad Vltavou, Kingdom of Bohemia 1898 – 1963 Rudolfov, České Budějovice, Czechoslovak Socialist Republic)

Bartuška was a photographer, poet, writer, theater director, filmmaker, painter, and graphic artist. From 1931 until 1939, he also led both the progressive arts group Linie (Line) and its subgroup Fotolinie, which he created together with Ada Novák. The first Fotolinie show made plain their orientation toward "new photography" in all its possible manifestations, taking as the exhibition subtitle *Photo, Photogram, Typophoto, Photomontage* (1932). In one of his outstanding series, *Shadow Plays* (*Stínohry*), Bartuška explored the formal properties and symbolic resonance of shadows divorced from the objects that cast them. These photographs, made during the early to mid-1930s, grew out of the author's literary interests (he assembled a collection of poems under the same title in 1930), and poetry, photography, and work in other media frequently came together in Bartuška's creations throughout and after the 1930s. A grade-school teacher by profession, he was a man of many and varied talents.

As editor in chief of Linie's eponymous journal, Bartuška published theoretical reflections there for many years. Some of his writings on photography, as on other arts, read as criticism but also as poetry. In the article "Unreal Landscapes" (Neskutečné krajiny, 1932), for instance, he discusses the dreamy evocativeness of a patch of criss-crossed earth: "In a sense it was a landscape, this stretch of road with the imprints of boots, shoes, and heels, with the lattice-work of rubber car and bicycle tires and the imprint of a child's cart.... We strayed through these unreal landscapes and delighted in new discoveries." Two photographic series address this theme, the second of which is entitled *Traces*. The imprint, like the shadow, held poetic potential for Bartuška in its indexical distortions; it was "a record of life and its movement . . . a testimony to events, shapes, creatures and things," as he wrote in "Traces in the Landscape" (Stopy v krajině), an article for the teachers' journal *Kreslíme* (We Draw) in 1940. JP

LITERATURE

Civiš, Svatopluk. *Josef Bartuška*. České Budějovice, 1969.

Valoch, Jiří. *Josef Bartuška*. Exh. cat., Dům umění města Brna. Brno, 1988.

Herbert Bayer

(Haag am Hausruck, Archduchy of Upper Austria 1900 – 1985 Santa Barbara, United States)

As a youth, Bayer apprenticed in applied arts studios in Linz and Darmstadt, where he learned typography, graphic design, and architectural drawing. In Darmstadt in 1920, he found Walter Gropius' *Bauhaus Manifesto*; he immediately sought out the author and was accepted into the preliminary course with Johannes Itten. As a student at the Bauhaus from 1921 to 1925, Bayer executed murals and exterior signage while perfecting his typographic skills with designs for postcards and invitations. When the Bauhaus moved to Dessau, Gropius asked Bayer to head the newly established workshop of printing and advertising. Bayer became responsible for virtually all printed material for the school. His new typeface, *klein schreiben*, consisting solely of sans-serif lower-case letters, appeared on the school stationery along with a text promoting its universal application. He continued to employ this typeface throughout his life, even insisting that citations of his spoken remarks or written work be set in what is known as "universal" type. Bayer initially used photography primarily as a complement to typography. When he began taking his own pictures around 1928, with a Leica, he moved quickly from unmanipulated images to dramatic montages, compelling both as advertising design and as surrealist fantasy. Eleven photomontages, part of a series he referred to as *Man and Dream (Mensch und Traum)*, were published in a small edition in 1932. Bayer achieved a lasting uncanniness in these images, partly by rephotographing the assembled montages to create an effect of seamless verisimilitude.

After leaving the Bauhaus in 1928, he was the art director for German *Vogue* in Berlin. Before emigrating permanently to the United States in 1938, Bayer was instrumental in gathering materials for a landmark Bauhaus exhibition at the Museum of Modern Art, for which he also designed the exhibition space and catalogue. Throughout the 1940s and 1950s he worked as a graphic designer for department stores, drug companies, magazines, and industrial corporations. AH

LITERATURE

Cohen, Arthur Allen. *Herbert Bayer: The Complete Work*. Cambridge, Mass., 1984.

Droste, Magdalena, et al. *Herbert Bayer: Das künstlerische Werk, 1918 – 1938*. Exh. cat., Bauhaus-Archiv. Berlin, 1982.

Newhall, Beaumont. *Herbert Bayer: Photographic Works*. Introduction by Leland Rice. Exh. cat., ARCO Center for Visual Art. Los Angeles, 1977.

Władysław Bednarczuk

(Lemberg / Lwów, Kingdom of Galicia and Lodomeria [today Lviv, Ukraine] 1904 – 1944 Lemberg / Lwów, General Government of Poland)

Bednarczuk was born into a working-class family. In 1927 he enrolled in a course on aesthetics and printing taught at Politechnika Lwowska by pictorialist photographer Henryk Mikolasch, in which he learned about "art photography" techniques such as gum print, transfer print, and bromoil. Beginning in the late 1920s he became active in the Lwowskie Towarzystwo Fotograficzne (Lviv Photographic Society). He was employed in several photography studios before opening his own atelier in 1937. He experimented with established formal methods in "new photography" and also developed an innovative print technique of his own, called *fotoryt*, characterized by a thick network of cracks that gave photographs the look of engravings.

In December 1936, Bednarczuk organized the *Pierwsza Wystawa Fotografii Robotniczej w Polsce* (First Exhibition of Worker Photography in Poland), a singular event in the history of Polish photography. The exhibition title referred to a leftist movement in Europe and the Soviet Union, and Bednarczuk received assistance from the Polish Socialist Party. "An organized, conscious proletarian movement," wrote Bednarczuk in the accompanying catalogue, "must try to create a culture of the spirit to replace the culture of capitalism, which is departing from the cultural scene.... We realize that worker photography will find its value and expression only if it encompasses the whole spiritual content of the worker's experiences and does not cut itself off from his life and his struggle." Despite its author's intentions, the exhibition failed to instigate the creation of a domestic movement; indeed, opposition from the pictorialist photography establishment ultimately led to the cancellation of a planned tour for the show and caused Bednarczuk to withdraw from that milieu altogether. MS

Hans Bellmer

(Kattowitz, Silesia, Kingdom of Prussia [today Katowice, Poland] 1902 – 1975 Paris, France)

As a youth, Bellmer was frequently in trouble with the authorities and was once even arrested for "undermining the moral supports of the State." In 1923 his father personally escorted him to Berlin to enroll him in the Polytechnisches Institut. But Bellmer, who had no desire to study engineering, soon joined the artists associated with Dada. He worked as an apprentice typographer at the Malik Verlag run by John Heartfield and his brother, and he illustrated books by dadaist writers Mynona (Walter Friedlander) and Walter Serner.

In 1931 Bellmer's father suffered a stroke, and the extended family moved to Berlin. The following year Bellmer went to see Max Reinhardt's production of *Tales of Hoffmann*, which most likely inspired him to construct his first doll, made with his brother Fritz in 1933. Bellmer took about two dozen photographs of the doll during its construction, ten of which were published with a fictional essay as *The Doll (Die Puppe)* in 1934 (cat. 58). The same year, through his aunt, Bellmer made contact with the poet André Breton, which resulted in the publication of eighteen doll photographs in the surrealist journal *Minotaure*. Gratified by the enthusiastic reception of his work in France, Bellmer traveled to Paris in the winter of 1935, where he met important members of the surrealist group, including Breton and Paul Éluard. Upon his return, he began work on a second doll—constructed with ball joints and thus more flexible—which he photographed provocatively disarticulated and dressed in little girl's clothing. *Minotaure* also published his hand-colored photos of this second doll, and over the next several years Bellmer's work was included in major surrealist exhibitions. In 1937, the year before he left Germany permanently for Paris, Bellmer constructed a third doll, known through a photograph as *Machine Gunneress in a State of Grace* (cat. 159).

Bellmer was interned as an enemy alien before and during World War II and was threatened by the Vichy authorities until he could produce proof that his parents were Protestant and "Aryan." In the 1940s he illustrated several erotic works that had played key roles in the development of surrealism, including Georges Bataille's *The Story of the Eye (Histoire de l'oeil)*, the Marquis de Sade's *Justine*, and Pauline Réage's *The Story of O (Histoire d'O)*. AH

LITERATURE

Angliviel de La Beaumelle, Agnès. *Hans Bellmer, anatomie du désir.* Exh. cat., Centre Pompidou. Paris, 2006.

Lichtenstein, Therese. *Behind Closed Doors: The Art of Hans Bellmer.* Exh. cat., International Center of Photography. Berkeley and New York, 2001.

Taylor, Sue. *Hans Bellmer: The Anatomy of Anxiety.* Cambridge, Mass., 2000.

Ernő Berda

(Budapest, Kingdom of Hungary 1914–1961 Budapest, People's Republic of Hungary)

Berda grew up in what is now the Slovak capital of Bratislava. At age fourteen, he began night courses in painting and graphics at the newly founded Škola uměleckých řemesel (School of Applied Arts, or ŠUR), subsequently known as the "Bratislava Bauhaus." Inspired by reading László Moholy-Nagy, Berda began experimenting with photography, particularly with photograms. In March 1931, Moholy-Nagy came to the ŠUR to deliver a series of lectures, among them one on photography. Berda's experiments apparently attracted the master's attention, yet Berda did not continue working in photography. He returned to Hungary that year to study painting at the privately run Szőnyi szabadiskola (Szőnyi School), continuing in 1933 at the Magyar Képzőművészeti Főiskola (Hungarian Academy of Fine Arts). Berda, who also joined a socialist arts group, supported himself thereafter as a technical draftsman but continued with political work as well. As influences, he cited German expressionism and the art of Diego Rivera and Frans Masereel. In 1939 he made a series of twelve linocuts, titled in Spanish *No Pasarán (Apocalípsis Humana)*, to memorialize the Spanish civil war, and after 1945 he reaffirmed his commitment to the Communist Party. Following a steady postwar exhibition career, Berda died of poor health in 1961, at age forty-seven. EC

LITERATURE

Soós, Klára. *Berda Ernő 1914–1961: Festőművész Emlékkiállítása (Ernő Berda: Retrospective Exhibition).* Exh. cat., Magyar Nemzeti Galéria. Budapest, 1971.

Ladislav Emil Berka

(Prag/Praha, Kingdom of Bohemia 1907–1993 Praha, Czech Republic)

Berka's photographic oeuvre is the product of an intensive period of activity (1929–1933) sparked by a visit to the *Film und Foto (Fifo)* exhibition in Stuttgart in the company of Alexandr Hackenschmied, his friend and former schoolmate. That visit led to two substantial exhibitions of "new photography" held at the Aventinská mansarda (Aventinum Attic) in Prague, an arts space founded by Otakar Štorch-Marien, owner of the somewhat progressive publishing house Aventinum. The Aventinum shows, held in 1930 and 1931, brought together under the rubric of the avant-garde a cross-section of all Czech contemporary photography for the first time. Berka exhibited here and at a successor exhibition to *Fifo*, held in Munich, jointly with Hackenschmied and Jiří Lehovec, which earned them the nickname Aventinské Trio. At the Munich exhibition, called *Das Lichtbild* (The Photograph), Berka showed works from his series *Prague Overprinted (Praha v surimpresi)* (cat. 37), in which his hometown is transformed through double exposure into a cinematic montage. The diagonal views crossing each other form a metaphorical condensation of the urban dynamic, in which the eye registers in quick succession a variety of impressions: scaffolding, lights, advertising billboards. Cinema in fact attracted the friends as much or more than still photography; all three were active in film criticism at this time, and Hackenschmied and Lehovec devoted their careers to it. Berka, unlike his colleagues, went on to specialize in graphic design. From 1933 he worked as an editor at the illustrated periodical *Ahoj na neděli* (Sunday Hello), and from after World War II until 1967 at *Květy* (Flowers), likewise a weekly cultural magazine. In the 1930s he was a member of the Filmklub and also, briefly, of Levá fronta (Left Front), the leading communist cultural association. At that time Berka published numerous theoretical essays in various journals for a largely middle-class audience, including the fashion monthlies *Gentleman* and *Eva*.

Although Berka's photographic career was short, he was included in key Czech exhibitions throughout the 1930s, among them the first *Výstava sociální fotografie* (Exhibition of Social Photography) in 1933 and the *Mezinárodní výstava fotografie* (International Exhibition of Photography) in 1936. JP

LITERATURE

Dufek, Antonín. *Aventinské trio: Ladislav E. Berka, Alexander Hackenschmied, Jiří Lehovec.* Exh. cat., Moravská Galerie. Brno, 1989.

———. "Fotografie L. E. Berky." *Bulletin Moravské Galerie* 29 (1980): 39–41.

Éva Besnyő

(Budapest, Kingdom of Hungary 1910–2003 Laren, The Netherlands)

Besnyő began studying photography in 1928 at József Pécsi's private school of photography. Pécsi primarily taught his students technical skills, but because of Besnyő's noticeable talent she soon was introduced to and learned from her teacher's foremost colleagues, including Rudolf Balogh and Károly Escher. While still a student, Besnyő was already using her Rolleiflex to photograph blue-collar workers and the homeless on the outskirts of Budapest. Upon arriving in Berlin in 1930, she worked briefly in the advertising studio of Renée Ahrle and then for Dr. Peter Weller, who published her photographs in the *Berliner Illustrirte Zeitung* under his name. By 1931, however, Besnyő had her own portrait studio and was publishing through the left-wing German photo agency Neofot. Besnyő quickly befriended other photographers, including György Kepes, whom she had first met through Pécsi. Besnyő later credited Kepes, a Bauhaus graduate, with strengthening her commitment to left-wing politics and teaching her how to view form when photographing. An awareness of the Russian avant-garde, which partly came from Kepes, brought new meaning to the high angles, strong diagonal compositions, and proletarian subjects that were already a part of Besnyő's photographic work. Like many in the press, Besnyő did not consider herself an artist but instead an observer who recorded people in their daily lives.

In 1932 Besnyő left Berlin for Amsterdam with Dutch cameraman John Fernhout. There she joined the Dutch press and continued photographing until 1942, when she was forced into hiding. After the war she resumed her work, and during the 1960s and 1970s she became involved in the Dutch feminist movement Dolle Mina, avidly documenting their cause. EC

LITERATURE

Diepraam, Willem, and Flip Bool, eds. *Eva Besnyö.* Amsterdam, 1999.

Kerbs, Diethart. *Eva Besnyö, György Kepes: mit anderen Augen; Berlin, 1928–1930.* Berlin, 1987.

Marianne Brandt

(Chemnitz, Kingdom of Saxony 1893–1983 Kirchberg, Zwickau, German Democratic Republic)

The Bauhaus designer Marianne Liebe received a formal art education from the Hochschule für bildende Kunst (School

of Visual Arts) in Weimar. Shortly after her graduation in 1918, she married a fellow student, the Norwegian painter Erik Brandt, and spent the next several years traveling with him in Norway and France. After visiting the first Bauhaus exhibition in 1923, she made the radical decision to burn all her previous work and enroll immediately at the school. In 1924, on the recommendation of László Moholy-Nagy, she entered the metal workshop, where, as the only female student, she was assigned minor projects. Yet the small household objects she produced in her first year there have become icons of Bauhaus design. In 1925, when the Bauhaus moved to Dessau, Moholy-Nagy installed her lighting fixtures in the new buildings and later boasted, "ninety percent of all Bauhaus designs are by her." From 1927 to 1929, as a paid member of the metal workshop (and from 1928 its director), she was instrumental in facilitating cooperation between Bauhaus designers and industry, which resulted in the actual manufacture of Bauhaus designs.

During her years at the Bauhaus, Brandt also experimented with photography, producing multiple experimental self-portraits and photographs of objects in the metal workshop. In a series of photomontages highly influenced by her teacher Moholy-Nagy, she explored her identity as a woman and an artist in the context of a modern culture newly saturated with media representations. After leaving the school in 1929, Brandt worked until 1933, first with Walter Gropius in Berlin as an interior designer and then as the head of design for a metalware manufacturer. Unable to find work afterward, she lived in relative isolation at her parents' house in Chemnitz. Only in the early 1950s was she able to renew her activities, initially at the Hochschule für Angewandte Kunst (School of Applied Art) in Berlin and later as a freelance designer for various state-owned concerns. AH

LITERATURE

Kruppa, Karsten. "Marianne Brandt: Annäherung an ein Leben" (Approaching a Life). In *Die Metallwerkstatt am Bauhaus*, edited by Klaus Weber, 48–55. Exh. cat., Bauhaus-Archiv. Berlin, 1992.

Otto, Elizabeth. *Tempo, Tempo! Bauhaus-Photomontagen von / The Bauhaus Photomontages of Marianne Brandt*. Exh. cat., Bauhaus-Archiv. Berlin, 2005.

Wynhoff, Elisabeth, ed. *Marianne Brandt: Fotografien am Bauhaus*. Exh. cat., Institut für Kunst und Design im Kolkmannhaus. Ostfildern, 2003.

Janusz Maria Brzeski

(Warszawa, Province of Warsaw 1907–1957 Kraków, People's Republic of Poland)

Brzeski was one of the principal creators of photomontage and avant-garde cinema in the 1930s in Poland. He graduated from the Szkoła Sztuk Zdobniczych (School of Decorative Arts) in Poznań and during that time also studied on a fellowship in Italy and Paris. In 1929 he helped design exhibition pavilions for the *Powszechna Wystawa Krajowa* (Universal National Exposition) in Poznań. He then left for France, where in 1929–1930 he worked as a graphic designer and film production assistant. He created a cycle of photomontages entitled *Sex*, a sort of register of erotic fantasies (fig. 9.5), showing cutouts of male and female bodies strewn among fragments of advertisements for cosmetics and luxuries and drifting against a white background as if in outer space, yet succumbing to sexual gravitational forces. On his return to Poland, Brzeski settled in Kraków, where he met Kazimierz Podsadecki. In 1931, Brzeski and Podsadecki organized the *Pierwsza Wystawa Fotografii Modernistycznej* (First Exhibition of Modernist Photography), in which they displayed the works of such prominent photographers as László Moholy-Nagy, Man Ray, and Hans Richter; they also created the Studio Polskiej Awangardy Filmowej (SPAF). In this studio, Brzeski made two experimental films inspired by Walter Ruttmann's cinematic feature *Berlin: Symphony of a Big City*, *Cross-Cuts* (*Przekroje*, 1931) and *Concrete* (*Beton*, with Podsadecki, 1933). At the same time, Brzeski was employed in the publishing house Ilustrowany Kurier Codzienny (Daily Illustrated Courier, or IKC) to illustrate its mass-market weeklies. Using the experience he had gained with the French magazine *Vu*, Brzeski treated layout as a stylish equivalent of dynamic film montage. Brzeski used this method most frequently in the scandal-mongering crime sheet, *Tajny Detektyw* (Secret Detective, 1931–1934), where he paired photographs of actual crime scenes liberally with shots of actors and other staged photographs, giving his "reportage" compositions the poetics of cinematic thrillers. In 1935 Brzeski became the graphic arts director of another IKC weekly, *As* (Ace), aimed at the modern woman. Brzeski created his best-known photomontage series, *Birth of the Robot* (cat. 158), in 1933. It addressed abrupt civilizational changes brought on by man's fascination with a potentially traitorous world of increasingly perfect and powerful machines. After World War II, Brzeski became a graphic designer at the weekly *Przekrój* (Cross-Cut). SC

LITERATURE

Czekalski, Stanisław. "Kazimierz Podsadecki and Janusz Maria Brzeski: Photomontage between the Avant-Garde and Mass Culture." *History of Photography* 29, no. 3 (Fall 2005): 256–274.

Zagrodzki, Janusz, ed. *Janusz Maria Brzeski, Kazimierz Podsadecki: z pogranicza plastyki i filmu* (Beyond Art and Film). Exh. cat., Muzeum Sztuki. Łódź, 1980.

Jan Bułhak

(Ostaszyn, Nowogródek, Province of Minsk [today Astašyn, Belarus] 1876–1950 Giżycko, People's Republic of Poland)

Bułhak came from the gentry. He took up photography around 1905, emerging as a theoretician and advocate of pictorial photography already before World War I, thanks to connections with the Photo Club de Paris. In 1912 he apprenticed in Hugo Erfurth's studio in Dresden, but it was his friendship with Ferdynand Ruszczyc, a Polish painter interested in native landscapes and historical architecture, that definitively influenced Bułhak's work. He made numerous photographs modeled on Ruszczyc's paintings. In 1927 he coined the term *fotografika*, artistic photography that copied models in painting, which became popular in Poland. His own influence grew when Ruszczyc helped name him head of a newly created Zakład Fotografii Artystycznej (Department of Artistic Photography) at the Uniwersytet Wileński, which had just reopened in Vilnius following the Polish declaration of statehood after World War I. Bułhak subsequently steered the course of Polish photography, founding and chairing the elite associations Fotoklub Wileński (1927) and Fotoklub Polski (1929), and, following World War II, the Związek Polskich Artystów Fotografików (Association of Polish Art Photographers, 1947). Bułhak authored a dozen books on photographic aesthetics and techniques, including *Fotografika* (1931), *Estetyka światła* (The Aesthetics of Light, 1936), and *Polska Fotografia Ojczysta* (Polish Homeland Photography, 1939). These writings have survived, fortunately, unlike the work itself, which was nearly all destroyed during World War II.

Bułhak was especially interested in landscape, but he was also a documentarist, an activity launched in 1912 when he was appointed director of the city photographic archive in Vilnius and charged with creating a photographic inventory of the city's monuments. In Bułhak's romantic understanding, urban tissue ought to be incorporated into nature's circulatory system. He highlighted the absorption of city

into nature by placing buildings within broad panoramas of enveloping vegetation, dominated by atmosphere and the play of light and shade on their walls.

In 1937 Bułhak launched the nationalist program known as *Fotografia ojczysta* (Homeland Photography). Inspired by German *Heimatphotographie,* this propaganda movement sought to document Polish landscapes, folklore, and historic sites, as well as industrial development. Enthusiasts across the country created an idealized image of Poland, highlighting the rural motifs of gentry and folklore, and giving a traditionalist slant to nascent urbanism. To Bułhak, photographs of landscapes and historical architecture needed to be made available to a wide public to deepen national consciousness. MS

LITERATURE

Lech Grabowski. *Jan Bułhak.* Warsaw, 1961.

Jolanta Kucharska, ed. *Jan Bułhak. Kraj lat dziecinnych* (The Land of Jan Bułhak's Youth). Gdynia, 2003.

Lechowicz, Lech, ed. *Jan Bułhak: fotografia polska.* Warsaw, 2000.

Szymanowicz, Maciej. "Pomiędzy Wilnem a Czombrowem: Mickiewiczowski ślad w twórczości Jana Bułhaka" (Between Vilnius and Czombrów: Tracing Adam Mickiewicz in Jan Bułhak's Work), in *Punkt widzenia: Fotografia Miasta* (Viewpoint: Photographing Cities), edited by Iwona Święch et al., 59–64. Kraków, 2004.

Max Burchartz

(Elberfeld [today Wuppertal], Rhine Province, Kingdom of Prussia 1887–1961 Essen, Federal Republic of Germany)

Burchartz was trained in furniture textile design at his father's factory, then studied painting at the Kunstakademie in Düsseldorf. After military service in World War I, he settled in Weimar until 1924 and began working as a graphic designer. He had close contact with the early Bauhaus and designed the school's publications. After attending Theo van Doesburg's de Stijl course in 1922, Burchartz jettisoned his expressionist leanings to produce constructivist pictures, and then to concentrate exclusively on applied rather than fine art. With his firm werbebau (Design Construction), founded in the industrial town of Bochum in 1924, Burchartz became known for a form of design that Moholy-Nagy dubbed *typophoto* and praised as "the visually most exact rendering of communication." Burchartz used his own photographs of factories, machines, and

machine parts to create dynamic photomontages that he juxtaposed with clean, bold typography. In addition to advertising for industry, he designed furniture, interiors, and domestic products, including a patented door handle for the firm Gehag. Participation in several exhibitions in the late 1920s brought Burchartz increased public recognition. In 1928 he designed a room for the Arbeiterverlag at the Cologne show *Pressa;* in 1929 he exhibited ten photos at *Film und Foto* and delivered the opening address at an exhibition of new typography; and in 1931, *Lotte's Eye (Lottes Auge),* a photograph of his daughter, was blown up to a poster more than six feet high for the entrance of the exhibition *Das Lichtbild* in Munich.

Since 1926 Burchartz had also been teaching at the Folkwangschule in Essen, which by the end of the 1920s was recognized as one of the foremost art schools in Germany. Unfortunately, financial cutbacks in 1932 cost him his position. The following year he joined several Nazi organizations and provided photographs for a propaganda brochure on the navy of the Third Reich. After serving in World War II, he returned to his position at the Folkwangschule and began painting and drawing again. AH

LITERATURE

Froning, Hubertus. *Max Burchartz, 1887–1961: Zeichnungen, Gouachen, Aquarelle, Druckgraphik.* Exh. cat., Museum Folkwang. Essen, 1986.

Stürzebecher, Jörg, ed. *Max Burchartz, 1887–1961: Typografische Arbeiten, 1924–1931, im reprint.* Baden, 1993.

František Čermák

(Ondřejov, Kingdom of Bohemia 1904–1991 Praha, Czechoslovak Republic)

Čermák ran a shop for photographic supplies in Prague while also attending the Střední grafická škola (Institute of Graphic Arts). As a photographer and member of Levá fronta (Left Front), he took part in its activities and supported the association financially. He was an active supporter of the Scout movement for progressivist youth and photographed at their jamborees worldwide. He worked in cinematography from 1935 and likely filmed the *Wereld-Jamboree Nederland* (World Scout Jamboree) in Holland in 1937, but his films have not survived. He exhibited from 1931, particularly within the Klub českých turistů (Czech Outdoors Club), a Czech-language equivalent of the Naturfreunde associations. He also published photographs,

exhibition reviews, and occasionally theoretical articles about photography in a variety of magazines, activities that culminated in 1939–1940 with the position of editor at the trade journal *Foto.* His photographs, arranged at their best into visual essays on burning social topics, focused on the hopelessness of the unemployed and the life circumstances of an urban underclass. Certain of these pictures were shown at the two exhibitions of social photography organized by Lubomír Linhart in 1933 and 1934. During World War II, Čermák joined the resistance, and after liberation in 1945 he became a party functionary, heading the photographers' cooperative Fotografia and serving as photographer at the Vysoká škola politická (Political Science University) in Prague. JP

Mieczysław Choynowski

(Poland 1909–2001 Mexico)

Choynowski is known for his work in two areas: photomontage, which he explored in the early 1930s, and scientific research, following World War II. Photomontage formed only a short episode in Choynowski's life, and today we know the majority of this work from reproductions in the press, where it was regularly published. Choynowski began to study mathematics, architecture, and philosophy in 1928. In 1931, under the influence of avant-garde art, especially László Moholy-Nagy's photomontages, he debuted his photomontages in the literary-cultural weekly *Wiadomości Literackie* (Literary News), where they appeared for several months. From 1931 to 1933, many works were also published in the popular monthly *Naokoło Świata* (Around the World). Choynowski treated photomontage not as illustration but as a modern form of graphic art possessed of a distinct poetics and metaphorical reach. Inspired, beyond Moholy-Nagy, by the overtly political imagery of John Heartfield and Mieczysław Berman, he frequently made pictorial commentary on social and political subjects, for example in the trio of photomontages called *America* (cat. 77), which branded the American legal system as degenerate, socially and racially oppressive, and in violation of civil rights. Other, decisively lyrical photomontages emanated both philosophical reflection and tender humor. Absurdity as a motivating principle for montage, with photographs juxtaposed to generate semantic tension, was a constant feature of Choynowski's work.

Erich Comeriner

(Wien, Archduchy of Lower Austria
1907 – 1978 Tel Aviv, Israel)

Comeriner was born in Vienna and grew
up in Berlin. He attended the Bauhaus from
April 1927 through October 1928. As a stu-
dent, he participated in Oskar Schlemmer's
theater and studied art and advertising
with László Moholy-Nagy, Herbert Bayer,
and typographer Joost Schmidt. During his
time at the Bauhaus, Comeriner created
a variety of works on paper, ranging from
photomontages and photograms to statio-
nery and posters; he later worked with
Moholy-Nagy on advertising and on stage
sets for Erwin Piscator's political theater
and the experimental Kroll Opera House.
Moholy-Nagy, in addition, chose Comeri-
ner's photograph *Head (Kopf)* for inclusion
in the opening room of the *Film und Foto*
exhibition in 1929. One year previously,
Comeriner had opened a photography stu-
dio in Berlin, naming it Comofot. Comeri-
ner entered this increasingly lucrative field
without the aid of a press agency, selling
his photographs directly to illustrated
newspapers. His studio work fits with gen-
eral currents in German "new photogra-
phy." The modern metropolis as subject—
technology, traffic, street workers,
nightlife—correlates with a declarative
approach to camera work that empha-
sizes extreme high and low angles, strong
shadows, and frequent combinations of
text and image. Reacting to anti-Semitic
pressure on the one hand and the promise
of Zionism on the other, Comeriner left
Berlin in 1934 for Palestine. There he
worked on a collective farm and continued
to photograph. From 1940 he found
employment as a freelance photographer
and advertising artist in Tel Aviv, where he
stayed until his death in 1978. EC

Miloš Dohnány

(Linz, Archduchy of Upper Austria 1904 –
1944 Bratislava, Republic of Slovakia)

Dohnány was an outstanding figure in
Slovak amateur photography. He spent his
life involved with the camera, from grade
school until his untimely death from a car
accident while at the ministry of transpor-
tation and public works, where he had
founded a department of film and photo-
graphic documentation. After several years
of solitary endeavors, Dohnány joined
the amateur movement in the 1930s. He
became a member of the Združenie foto-
grafov amatérov (Amateur Photographers'
Association) at the Bratislava branch of
the YMCA, later known as the Fotoskupina

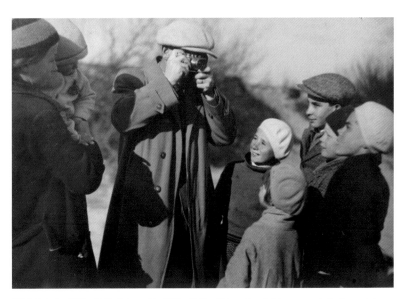

Miloš Dohnány, *Viliám Malík photographing (Viliám Malík pri fotografovaní)*, late 1930s, gelatin silver print,
28 × 39.8, Peter Bagi, Bratislava

In the second half of the 1930s, Choy-
nowski abandoned photomontage for pho-
tography with a camera, and during World
War II he operated a portrait studio. After
the war he stopped working with photogra-
phy altogether to devote himself to psychi-
atry. He edited a monthly journal, *Życie
Nauki* (The Life of Science), and led a semi-
nar on the study of science at the university
in Kraków; from 1958 until 1970, he headed
the Pracownia Psychologiczna (Psycho-
metric Workshop), a facility for quantita-
tive testing in psychiatry at the Polska
Akademia Nauk (Polish Academy of Sci-
ence) in Warsaw. SC

LITERATURE

Mieczysław Choynowski, untitled memoirs in
Fotomontaże 1924 – 1934. Exh. cat., Galeria KMPiK,
edited by J. Bogucki. Warsaw, 1970.

Paul Citroen

(Berlin, Brandenburg, Kingdom of Prussia
1896 – 1983, Wassenaar, The Netherlands)

The son of a Dutch furrier who had settled
in Berlin, Paul Citroen left high school early
to attend the Brandenburger Kunstakademie.
There he met Georg Muche, who became a
lifelong friend. He introduced Citroen to
members of the Sturm group gathered
around Herwarth Walden. Upon encoun-
tering expressionist art at the Sturm gallery,
Citroen became discouraged and gave up
painting to work in Walden's bookstore.

Citroen lived primarily in Holland dur-
ing World War I. After the war, he traveled
frequently to Berlin, making the acquain-
tance of Dada artists and serving as one of
Dada's representatives in the Netherlands.
According to his diary notes, it was at this

time, in 1919 – 1920, that he created a series
of photographic collages focusing on the
theme of the modern city. In 1922, at the
suggestion of Muche, Citroen enrolled in
the preliminary course at the Bauhaus
taught by Johannes Itten. There, he made
the most famous and ambitious of his col-
lages, the large-scale work *Metropolis*, for
the first Bauhaus exhibition in 1923 (cat. 24).
Described by the critics as a "revelation,"
Metropolis was reproduced in newspapers
and in László Moholy-Nagy's seminal book
Painting Photography Film, above the cap-
tion: "Here the experience of the sea of
stone is raised to gigantic proportions."

In 1926 Citroen and a friend from the
Bauhaus, Otto Umbehr (Umbo), began
experimenting with a camera—a pastime
that Umbo would soon transform into a
highly successful career. Although Citroen
also made photographs throughout his
life and earned a living primarily through
portrait photography in the early 1930s,
he never considered photography fine art,
maintaining what he described as a "roman-
tic" attachment to painting. Between 1933
and 1937 he directed the Nieuwe Kunst-
school in Amsterdam, which he founded
with a curriculum modeled on the Bauhaus.
After his school closed, he lectured on
visual design and in his later years devoted
himself to painting. AH

LITERATURE

Bool, Flip, et al., eds. *Paul Citroen (1896 – 1983)*.
Amsterdam, 1996.

Citroen, Paul Roelof. *Paul Citroen*. Introduction by
Michael Pauseback. Bielefeld and Düsseldorf, 1978.

Rheeden, Herbert van, Monique Feenstra, and
Bettina Rijkschroeff. *Paul Citroen: kunstenaar,
docent, verzamelaar / Künstler, Lehrer, Sammler*. Exh.
cat., Hannema-de Stuers Fundatie. Zwolle, 1994.

Klubu slovenských turistov a lyžiarov (Photo Section of the Slovak Recreation and Ski Club). At the same time, he attended photography courses at the Škola umeleckých remesiel (School of Applied Arts) taught by Jaromír Funke, in which—as surviving photographs attest—Dohnány mastered "classic" Bauhaus studies in spatial composition, surface textures, and structure. Like his instructor, Dohnány took great interest in photographic theory and technology. He helped organize courses for amateurs, prepared exhibitions, and sat on their juries. He also wrote articles and reviews for Czech and Slovak trade journals as well as daily newspapers, among them *Lidové noviny* (The People's News), *Fotografický obzor* (Photographic Horizons), *Nový svet* (New World), *Panorama*, and *Krásy Slovenska* (The Charms of Slovakia). In certain publications, he even established advice columns for photographic amateurs.

Although his work in general ranged broadly across genres (except for portraiture), Dohnány concentrated in his commissions and in his private work on architecture and on the spaces of modern life: the Bratislava port, bank lobbies, bus terminals, and the construction of a new railway line. His documentation of the latter project (cat. 70) contains in many instances suggestions of a social critique. Above all, however, Dohnány strove in his art and writings to spread word of an avant-garde program in photography. JP

LITERATURE

Hlaváč, Ľudovít. "Miloš Dohnány a fotografia 30. a 40. rokov" (Miloš Dohnány and Photography of the 1930s and 1940s). *Výtvarníctvo, fotografia, film*, no. 2 (1965): 38–39.

Hrabušický, Aurel. *Miloš Dohnány*. Exh. cat., Slovenská národná galéria. Bratislava, 2004.

František Drtikol

(Pribram / Příbram, Kingdom of Bohemia 1883–1961 Praha, Czechoslovak Socialist Republic)

Drtikol made his name as a photographer of nudes and as a portraitist. His flair for working with models and rendering their psychology and his sense for innovation within the parameters of contemporary style placed him at the forefront of commercial and salon photography in his day. His popularity was enhanced by his association with the applied arts cooperative Artěl, which marketed his photos. Drtikol's early career, however, was undistinguished, and the studio he established

Károly Escher, *Preparing the* Illustrated Supplement: *Ernő Mihályfi Assembling Picture Materials with János Tábor and Imre Szőke (Készül a műmelléklet. Mihályfi Ernő, Tábor Jánossal és Szőke Imrével összeállítja a képanyagot)*, 1930, gelatin silver print, 23.2 × 17.3, National Gallery of Art, Washington, Patrons' Permanent Fund

in 1907 in his native Příbram did not flourish. The situation only improved when he set up business in Prague (1911) and, in 1913, entered into partnership with Augustin Škarda, a leader in the amateur movement and Drtikol's main backer until 1921; together, the two attracted many celebrities to their studio. Drtikol's artistic orientation was largely influenced by his period of study in Munich, from 1901 until 1903. The Lehr- und Versuchsanstalt für Photographie, which had been founded only one year previously, cultivated connections to the Jugendstil movement, and Drtikol's professor, Hans Spörl, encouraged his student's interest in Jugendstil subject matter—including erotic allegorical studies—as well as the pictorialist "fine art" print processes favored by Drtikol throughout his career.

Drtikol radically changed his style in the mid-1920s. His earlier, brooding look gave way to more sharply defined spaces structured by the dynamics of dance movement, in combination with theatrical, geometrically shaped props. Drtikol became increasingly rigorous, making sketches and films to study body positions before setting up his camera. Nevertheless, he did not entirely refuse the impromptu inspiration resulting from a new lighting arrangement or a model's involuntary gesture. These years marked the apogee of Drtikol's career, with a terrific reputation at salons worldwide for his theatrical nude studies and

a strong market at home for his portraits of theater and other famous personalities. The advance of the Great Depression cut short that career, but by then Drtikol had begun to turn to Eastern philosophy. Live models, increasingly attenuated in appearance, gave way around 1930 to paper cut-outs, while the organization of light and shade in his compositions now frequently carried a spiritual or mystic symbolism. In 1935 Drtikol abandoned photography, selling his studio and devoting himself entirely to painting and to Eastern teachings. JP

LITERATURE

Birgus, Vladimír. *The Photographer František Drtikol*. 2nd rev. and expanded ed. Prague, 2000.

Doležal, Stanislav, Anna Fárová, and Petr Nedoma. *František Drtikol: fotograf, malíř, mystik*. Exh. cat., Galerie Rudolfinum. Prague, 1998.

Mlčoch, Jan. *František Drtikol: Fotografie z let 1918–1935 / Photographs from the Years 1918–1935*. Exh. cat., Uměleckoprůmyslové muzeum. Prague, 2004.

Josef Ehm

(Habartow / Habartov, Falkenau / Sokolov, Kingdom of Bohemia 1909–1989 Praha, Czechoslovak Socialist Republic)

Ehm's ultimately exemplary career was determined by circumstance. As a young man he had painterly ambitions, but financial straits forced him into a more remunerative profession. He therefore trained in photography with Karel Podlipný in Poděbrady

(1928). He left for Prague to start an independent career in 1933, just as the economic crisis set in motion four years earlier by America's stock market crash was coming to a head in Czechoslovakia. Sharp competition for studio work led him to give up professional photography in favor of teaching. He joined the photographic department of the Státní grafická škola (State Graphic Arts School, or SGŠ) at a crucial moment when the moderate Karel Novák was retiring, to be replaced by the insistently progressive Jaromír Funke. Funke, who preferred theory, complemented the seasoned and practical Ehm. Ehm remained on the staff at SGŠ until 1946. From 1939 until 1941, he edited *Fotografický obzor* (Photographic Horizons), the leading Czech journal for amateur photography, possibly in association with Funke. Under his editorship color was introduced for the magazine covers, but more importantly, a number of innovative photographs and crucial theoretical studies were published by Funke, Eugen Wiškovský, and others.

Ehm appreciated not only the value of unusual camera angles, but also technical perfection at one's craft; he also displayed at times an imaginative sense of reality, as in his solarized nudes or the superimposition of neon signs as an allegory of modern city life (cat. 68). Many outstanding photographs resulted from commissions and were made both in the studio and on the street, in the city and in the countryside. Ehm was particularly in demand as a photographer of historical monuments and published several picture books on Prague in his career. He also enjoyed photographing people in their homes and created a remarkable gallery of celebrity portraits. He remained involved throughout his life with amateur photography, and at the end of his career was recognized chiefly as a figure of pedagogical authority and discernment. JP

LITERATURE

Josef Ehm (1909–1989): A Retrospective Exhibition. Introduction by Zdenek Kirschner. Exh. cat., Jacques Baruch Gallery. Chicago, 1990.

Macků, Jiří. "Na besedě s Josefem Ehmem" (In Conversation with Josef Ehm). *Revue fotografie*, no. 3 (1979): 22–24.

Mašín, Jiří. *Josef Ehm: fotografie.* Prague, 1961.

Tausk, Petr. "Sedmdesát let Josefa Ehma" (Josef Ehm at Seventy). *Revue fotografie*, no. 3 (1979): 65–73.

Max Ernst

(Brühl, Köln, Rhine Province, Kingdom of Prussia 1891 – 1976 Paris, France)

A central figure in Dada and surrealism, Ernst was a radical innovator whose invention of new artistic techniques and development of those already in use, such as collage and photomontage, had far-reaching consequences for twentieth-century art. From 1909 to the outbreak of World War I, Ernst studied at the Universität Bonn, taking courses in art history, psychology, philosophy, and literature. Before and during his wartime service, he wrote art criticism and exhibited his paintings with various expressionist groups. In Cologne after the war, Ernst became the leader of a fledgling Dada group. Inspired by Giorgio de Chirico, Kurt Schwitters, and Francis Picabia, whose work he saw reproduced in Dada journals, Ernst began to make collages and overpaintings using engravings and prints excised from nineteenth-century novels, mail-order catalogues, and teaching manuals. In 1920, in collaboration with fellow dadaist Hans Arp, he created a series of photomontages that he rephotographed to disseminate as postcards or enlarged reproductions. These experiments laid the ground for Ernst's later forays into combinations of painting, drawing, collage, and frottage (rubbings).

Ernst's first exhibition in Paris in 1921 brought him into the collective of artists and writers associated with Dada, and later surrealism, in France. Among his most important collaborators was the poet Paul Éluard; when Ernst resettled in Paris illegally in 1922, it was to join Éluard and his wife Gala. Ernst exhibited his paintings frequently there from 1924, often in the context of surrealist exhibitions. He developed the medium of the collage novel and in 1937 published an autobiographical and theoretical text on surrealism entitled "Beyond Painting" (Au delà de la peinture). In Paris in 1939, Ernst was imprisoned as an enemy alien. After two escape attempts, he emigrated to the United States in 1941 with the help of the wealthy American art dealer and collector Peggy Guggenheim. He returned to Paris in 1953, and in the last twenty-three years of his life oversaw numerous retrospective shows, the publication of his collected writings as well as monographs in German and English, and the first two volumes of a catalogue raisonné. AH

LITERATURE

Camfield, William A. *Max Ernst: Dada and the Dawn of Surrealism.* Exh. cat., The Menil Collection. Munich, 1993.

Foster, Hal. "A Bashed Ego: Max Ernst in Cologne." In *The Dada Seminars*, edited by Leah Dickerman with Matthew S. Witkovsky, 127–149. Washington, 2005.

Spies, Werner, and John William Gabriel. *Max Ernst Collages: The Invention of the Surrealist Universe.* Trans. John William Gabriel. New York, 1991.

Károly Escher

(Szekszárd, Kingdom of Hungary 1890 – 1966 Budapest, People's Republic of Hungary)

Escher was a self-taught photographer who became one of the most active Hungarian photojournalists. He received a position as a sports reporter at Frölich-Fodor film report and then made newsreels of the short-lived Hungarian Soviet Republic. Afterward he worked as a cinematographer for Star studio on numerous Hungarian films. Amid a rapid decline in Hungarian film production, around 1928, Escher received an invitation by Rudolf Balogh to work for the illustrated press papers *Est Lapok* (Evening Pages) and *Pesti Napló* (Pest Diary). His photographs soon appeared regularly in the latter paper, often on the cover or as two-page spreads, ranging in subject from city streets and village life to sports and political events. Escher did not take portraits, but as a photojournalist he photographed celebrities, including Thomas Mann and Béla Bartók, portraying them naturally and often in a witty manner. Although not politically engaged, he often used framing, viewpoint, and choice of subject to hint at social injustice.

Escher has been described as a humanist, and indeed his photographs of both the destitute and the middle class suggest a genuine compassion for life. He photographed with a thought-provoking directness that encourages closer examination of the reality depicted. Escher, in addition, supposedly never used a magnesium flash, an unconventional choice for his time that helped minimize distraction and contributed to the candid appearance of his photographs. He considered himself first and foremost a photojournalist and not an artist, but he participated occasionally in salon shows and won first prize in the 1934 Milan Applied Arts Exhibition. EC

LITERATURE

Mihályfi, Ernő. *Escher Károly munkássága* (The Work of Károly Escher). Budapest, 1966.

Tőry, Klára. "Károly Escher (1890–1966)." In *A fénykép varázsa / The Magic of Photography, 1839–1989*, edited by Mihály Gera, 90–96. Exh. cat., Budapest Festival. Budapest, 1989.

Trude Fleischmann

(1895, Wien, Archduchy of Lower Austria–
1990 Brewster, United States)

Fleischmann was one of the most sought-after portrait photographers in interwar Vienna. Her studio, opened in 1920, particularly attracted high-society clients. Nearly all the celebrities of the Viennese world of art and culture commissioned portraits from her. From her training at the Graphische Lehr- und Versuchsanstalt and apprenticeships with Hermann Schieberth and Dora Kallmus (Madame d'Ora), she retained a psychologizing approach to portraiture influenced by pictorialism c. 1900. Modulated light and a concentration on heads and hands are especially significant in her work, exemplified in her portrait of Austrian satirist and journalist Karl Kraus (cat. 43). Fleischmann used the impression of immediacy created through tight cropping to focus on personality and thus to underscore the irreducible individuality of her subjects. At the same time, an elegant matter-of-fact appeal distinguishes her portraits from those of her contemporaries. She supplied the booming markets of illustrated magazines of the 1920s and 1930s with portraits, theater and dance photographs, and nudes.

As a Jew, Fleischmann was forced to emigrate after the Nazis took power in 1938. She traveled to America by way of Paris and London, arriving one year later. There she was supported by her former apprentice Helen Post, who had already established herself as a photojournalist. Together with Frank Elmer (Franz Epstein), Fleischmann opened a studio in New York in 1940 specializing in fashion and portrait photography. Along with commissions for magazines, a circle of clients from New York's upper middle class developed. Fleischmann's work from this time adhered to conventional style. Her career as an active photographer ended in 1969. AL

LITERATURE

Sachsse, Rolf. "Trude Fleischmann: Von Österreich aus." Camera Austria 54 (1996): 41–54.

Trude Fleischmann: Fotografien 1918–1938. Exh. cat., Galerie Faber. Vienna, 1988.

Jaromír Funke

(Skutsch / Skuteč, Kingdom of Bohemia 1896–1945 Prag / Praha, Protectorate of Bohemia and Moravia)

From his beginnings in photography, around 1920, Funke charted a course between the institutions of amateur photography and avant-garde art. He admired Pablo Picasso but had reservations about Man Ray and László Moholy-Nagy, whose innovations in photography, while impressive, seemed to discredit technical mastery and with it the basis (from an amateur standpoint) of true photographic art. Funke therefore followed the activities of Devětsil (1920–1931) closely but guardedly and collaborated with the group only from 1929. Expelled from Fotoklub Praha, a leading amateur organization, for his harsh criticism of prevalent amateur production, Funke joined with Josef Sudek and others to found the "avant-garde amateur" association Česká fotografická společnost (Czech Photographic Society, 1924). At this time, Funke undertook an investigation of still life made out of the common objects of photographic work: mat board, glass negatives, and other items. These Compositions led in 1927–1929 to a series on cast shadows known as Abstract Photo (cats. 31, 32), which marks a culminating moment in photographic modernism.

In 1931 Funke joined the Škola uměleckých remesiel (School of Applied Arts) in Bratislava, then came in 1935 to the Státní grafická škola (State Graphic School) in Prague. At both schools he taught a modified Bauhaus curriculum consisting of studies in form and texture, followed by advertising and design. During the 1930s, Funke branched out into reportage, architectural studies, and a documentary surrealism inspired by Eugène Atget. He also developed thoughts on the art history of photography, for example in a pair of essays from 1936 titled "On Old Photography" and "Contemporary Directions in Photography" (Současné směry ve fotografii). He then turned increasingly to landscape, finding in it a limitless field to explore what he now deemed photography's basic trait: the revelation of latent, emotional surprise in a factual world. His choice of subject marked his patriotic resistance in a land overrun once more after two decades of independence. During World War II, Funke published portfolios on classic Czech churches and cathedrals, the first of them in his childhood town of Kolín. He was at work on a second book about Kolín when he died of a duodenal ulcer. MW

LITERATURE

Dufek, Antonín. Jaromír Funke, 1896–1945: Průkopník fotografické avantgardy / Pioneering Avant-Garde Photography. Exh. cat., Moravská Galerie. Brno, 1997.

Linhart, Lubomír. Jaromír Funke. Prague, 1960.

Souček, Ludvík. Jaromír Funke, fotografie. Prague, 1970.

Witkovsky, Matthew S. "Jaromír Funke's Abstract Photo Series of 1927–29: History in the Making." History of Photography 29, no. 3 (Fall 2005): 228–239.

Lotte Goldstern-Fuchs

(Chemnitz, Kingdom of Saxony 1906–1976 Essen, Federal Republic of Germany)

Lotte Fuchs attended the Höhere Fachschule für Phototechnik (Institute for Higher Education in Technical Photography) in Munich from 1926 to 1928. In 1929 she married and then started to work in Berlin for Erna Lendvai-Dircksen, a well-known portrait photographer with an emotive style intended to convey a putative German-ness in her subjects. Working with the soft-focus bromoil print process popular in amateur art photography, Goldstern-Fuchs nevertheless broke with conventional amateur composition, finding vanguard abstraction in everyday aspects of rural as well as modern life: fishing nets (cat. 136), bridges, or medieval stairs. In 1930 she exhibited her work on the occasion of the thirtieth anniversary of the Munich photography school. The same year Goldstern-Fuchs opened a photography studio in Berlin-Zehlendorf, which she closed three years later due to the Nazi boycott of Jewish businesses. Goldstern-Fuchs moved to Munich and then emigrated to Vienna in 1936. When her husband was arrested in 1938, she left the continent for London and eventually settled in Leeds. Because Goldstern-Fuchs was deemed a hostile foreigner, her photographic equipment was confiscated and she was forbidden to work. She resumed photography during the 1950s but stopped in 1963 due to poor health. In 1968 Goldstern-Fuchs and her husband returned to Germany and settled in Essen. EC

Carola von Groddeck

(Essen, Rhine Province, Kingdom of Prussia 1911–1989 Essen, Federal Republic of Germany)

Von Groddeck attended the Folkwangschule in Essen from 1929 to 1931, where Max Burchartz taught new and experimental photography in the advertising department. She produced a number of montages while in school that combine multiple exposures on a single print. These experimental photographs suggest a surrealist touch in emphasizing the illusory, and often manipulated, appearance of reality in photographs. After finishing her studies Groddeck worked first as an assistant and then as an independent photographer in the studio of Kurt Hege, the brother of well-known architectural photographer Walter

Hege. One of her photographs from this period, entitled *Rose Monday Float* (cat. 137), portrays masked doll characters in a parade. Her photograph gives the traditional holiday custom an uncanny sense as it plays with the dolls' contrived appearance and life-size proportions.

In the years preceding the war Groddeck worked as a photo technician in Mary Römer's photography studio in Wuppertal-Elberfeld; a year later she was employed by Witzel studio in Essen; and from 1935 to 1938 she photographed for the advertising studio Bildgut in Essen. These various positions did not allow her to develop fully the creativity that she had demonstrated while studying. After the war she worked as a freelance photographer in advertising, industry, and architecture until 1952, when she gave up employment for family reasons. She began to live on welfare in 1968 and took her own life in 1989. EC

Francis Haar (Haár Ferenc)

(Csernátfalu, Brassó / Braşov, Kingdom of Hungary [today Braşov, Romania] 1908–1997 Honolulu, United States)

Haar learned the basics of photography from his father, an ardent amateur, and he studied interior and architectural design at the Magyar Iparművészeti Iskola (Hungarian School of Applied Arts) in Budapest. After being dismissed from an architectural firm that was undergoing economic difficulties, Haar fortuitously found work as an architectural photographer. He soon joined the left-wing Munka-kör (Work Circle) led by Lajos Kassák and took part in its unusual blend of folk song, poetry, and dance, with discussions of international avant-garde art. Six of Haar's photographs appeared in *From Our Lives* (cat. 128), a Munka photobook that heralded the working-class photographer as an objective chronicler of modern times. Despite this and future collaborations with Kassák's group, Haar was not a radical socialist; indeed, he showed great fondness for old-fashioned folkloric subjects in Hungary and throughout his peripatetic career.

In 1934 Haar apprenticed for the well-known portrait photographer Olga Máté, taking over her studio the following year (studio licenses in pre–World War II Hungary remained difficult to obtain). The government subsequently commissioned him to photograph Hungarian culture for the tourist industry, and in 1937 his work was exhibited in the Hungarian pavilion of the Exposition Universelle in Paris. Impressed by the artistic culture and community in the French capital, Haar emigrated, only to

Central European Photopress, Opening of the *Výstava nové fotografie* (Exhibition of New Photography), Prague, 1930; the assembled include Jaroslav Přibík and Josef Mencl (second and sixth from left), editors at the publishing conglomerate Melantrich, and photographers Pavel Altschul, Jaromír Funke, Alexandr Hackenschmied, and Josef Sudek (third, fourth, seventh, and eighth from left), modern gelatin silver print, location of original unknown, Private Collection

leave shortly thereafter for Japan to escape the war. He stayed for many years, working occasionally from his European connections while devoting himself extensively to photographing Japanese landscape and culture. After the war, Haar filmed and photographed in the service of the United States occupiers. He then worked for several years in Chicago but eventually settled in Hawaii, where he began to teach at the University of Hawaii and continued his filmmaking and photography. EC

LITERATURE

Haar, Francis, and Tom Haar, ed. *Francis Haar: A Lifetime of Images*. Honolulu, 2001.

Kincses, Károly, Magdolna Kolta, and Tom Haar. *Haár Ferenc magyarországi képei: út a Munka-körtől a zen-buddhizmusig* (Ferenc Haár's Hungarian Pictures: From the Munka Circle to Zen Buddhism). Exh. cat., Magyar Fotográfiai Múzeum, Kecskemét. Budapest, 2004.

Alexandr Hackenschmied (Alexander Hammid)

(Linz, Archduchy of Upper Austria 1907–2004 New York City, United States)

Hackenschmied's approach to photography was crucially influenced by his visit to *Film und Foto* in Stuttgart (see biography for Ladislav Emil Berka). Although employed at the beginning of the 1930s (through family connections) as a photographer for *Pestrý týden* (Colorful Week), Hackenschmied regarded still photography as a stepping-

stone to film. He approached the two media with parallel ideas, testing mirror images, odd angles, and blurring or fading. Following in the pioneering footsteps of Karel Teige, Hackenschmied helped establish Czech film criticism, editing a film column for *Pestrý týden* in 1929–1931. He wrote on current events and promoted Russian and German avant-garde films as a contrast to "soulless" run-of-the-mill Hollywood productions. He also organized the first local showings of avant-garde films, to accompany the "new photography" exhibitions he helped mount in 1930 and 1931. Hackenschmied made a number of short films at this time as well; his *Aimless Walk* (*Bezúčelná procházka*, 1930), which traces a meandering pedestrian's course from the center of town to the urban periphery, is considered the first Czech avant-garde film (see cat. 98). In the mid-1930s he made commercials in the film studios of the Bat'a shoe company in Zlín. He also collaborated there with American producer Herbert Kline on the film *Crisis*, dealing with the increasingly heated standoff in the Czech borderlands between native Czechs and Germans, the latter backed by Adolf Hitler, who won the "right" to invade these regions as a result of the Munich accords in the fall of 1938. As part of that film project, Hackenschmied traveled to Paris in 1939 and then emigrated to New York. In America he worked for decades as a director and cameraman, changing his surname to Hammid. His *Meshes of the Afternoon* (1943), made in collaboration with his wife Maya Deren, is often regarded as the first experimental American film. JP

LITERATURE

Anděl, Jaroslav. *Alexandr Hackenschmied.* Trans. Derek Paton. Prague, 2000.

Brož, Jaroslav. *Alexander Hackenschmied.* Prague, 1973.

Valasek, Thomas E. "Alexander Hammid: A Survey of His Film-Making Career." *Film Culture,* nos. 67–69 (1979): 250–322.

See also literature for Ladislav Emil Berka.

Karel Hájek

(Lasenitz / Lásenice, Neuhaus / Jindřichův Hradec, Kingdom of Bohemia 1900–1978 Praha, Czechoslovak Socialist Republic)

After training as a locksmith and metal-worker, Hájek took up the camera in 1926, joining the Český klub fotografů amatérů (Czech Amateur Photographers Club) two years later in Prague, where he had moved after World War I. Hájek left his initial trade definitively in 1932 for a position with Melantrich, the principal illustrated press concern in Czechoslovakia. He filled Melantrich magazines with pictures in the 1930s and counted among the country's few career photojournalists at the time. While most better-known Czech and Slovak photographers who published in the press also maintained their reputation in the presumably more refined amateur world or operated studios for portraits, advertising, and other commissions, Hájek worked exclusively for the print media. He did not turn his back on art entirely, however, for in early 1936 he held a one-person show at the Městská knihovna (City Library) of Prague, still an important venue for fine art today. The exhibition, evidently attended by tens of thousands, served Hájek as a forum to discuss the constraints and the mission of photojournalism, first in a radio address and then for the more select audience of *Fotografický obzor* (Photographic Horizons), the leading amateur journal. Speed, precision, truthfulness, and objectivity are the photojournalist's watchwords, he claimed, while his ultimate goal is universal harmony and understanding: "Photography is a faithful propagator of peace. Pictures speak in the great Esperanto of the soul." That statement was made, of course, in an atmosphere of rapidly increasing tensions, revealed in his own picture of a clash over fascism—one of the show's most striking images, chosen as well for reproduction in the catalogue (cat. 123).

Hájek continued in journalism after World War II, advancing to leadership in the state-run Svaz československých novi-nářů (Union of Czechoslovak Reporters) and organizing a second solo exhibition in 1959–1961 that traveled widely in the Soviet bloc. MW

LITERATURE

Rýpar, Vladimír. *Karel Hájek.* Prague, 1969.

Miroslav Hák

(Neupaka / Nová Paka, Kingdom of Bohemia 1911–1978 Praha, Czechoslovak Socialist Republic)

Hák trained as a photographer in his father's studio, coming suddenly to public attention when his photographs were exhibited at the *Mezinárodní výstava fotografie* (International Exhibition of Photography, 1936). He took part in the first photographic exhibitions at the leftist theater D 37 (the group changed its name each year, with the calendar) and became its resident photographer the following year. D 37 enlivened the local theater scene by combining drama with film projection, music, and dance in multimedia spectacles. Hák made his name there above all for stage photographs taken only with available light. He also experimented in this period with a quasi-alchemical abstract technique he termed enigmatically *strukáž* or structage, from "structure"; this primitivist method, perhaps inspired by French and earlier Czech experiments in *décalque,* involved pouring photographic chemicals on light-sensitive paper and then fixing the results directly. Some of Hák's postwar work also features abstractions that are intended to stimulate libidinal associations. In the early 1950s, he created the series *Magical Nature (Divotvorná příroda),* in which erotic allusions are suggested in the shape of tree roots and stumps, and in the 1960s he similarly identified female torsos in rock formations.

During World War II, Hák cofounded Skupina 42 (Group 42), which lasted from 1942 until 1948. His brilliant photographs of life at the outskirts of the city, made in defiance of Nazi prohibitions against taking a camera into the street, furthered the group's interest in the poetry of urban settings (cat. 117). In the later 1940s, Hák developed urban themes in a series devoted to shopping arcades. Across these varied projects—abstract, pseudo-documentary, and also two series of minimal, expressively lighted nude studies—one detects as a common thread a persistent surrealist sensibility tinged with existentialist leanings. Hák gave up photography in 1969 due to health problems. At that year's meeting of *Interkamera,* a leading trade show, an unforgettable retrospective exhibition of his work was held in Prague. Pride of place was given to a large-scale photograph of the artist nude in the shower, a daring move for this period of political and cultural retrenchment. JP

LITERATURE

Dufek, Antonín. "Miroslav Hák." In *Vademecum: Moderní umění v Čechách a na Moravě 1890–1938* (Modern Art in Bohemia and Moravia 1890–1938), edited by Hana Rousová. Prague, 2002, 124–129.

Kolář, Jiří. *Miroslav Hák: fotografie z let 1940–1958.* Prague, 1959.

Edward Hartwig

(Moskva, Province of Moscow 1909–2003 Warszawa, Poland)

Hartwig's father ran a photography studio first in Moscow and later, after the family returned to Poland following the 1917 Revolution, in Lublin. Even though Hartwig worked in his father's studio, he initially wanted to be a painter; he was especially moved by impressionist art. He took his first noncommercial photographs of Lublin's Old Town in the mid-1920s. Hartwig had his first solo show in 1929 in Lublin. Three years later he opened a photography studio where, like his father, he specialized in portraits. In 1935 he took a two-year course at the Graphische Lehr- und Versuchsanstalt in Vienna and studied photography with Rudolf Koppitz. Hartwig's photographs were largely destroyed during World War II. He published more than twenty books and albums, among them *Fotografika* (1958), a seminal work in Polish photography, and from 1945 he was considered an authority in his field.

Most of Hartwig's pre–World War II work consisted of staged urban scenes in a romantic mood, with hooded monks or painters working at their easels as staffage. He also produced many atmospheric landscapes featuring low morning light, mist, and hazy outlines. He sought out associations with painting and engraving. His photographs initially reflected impressionist influences and, after World War II, also abstract tendencies. Hartwig sought particularly to present the landscape as an abstract, ascetic structure reduced to a few spaces. His c. 1930 photograph *Planting Potatoes* (cat. 140) announces this later type of composition, which presents the landscape in a structured, geometric order. The unique use of low side lighting throws the contours of the undulating landscape into maximum relief. Hartwig exposed here, as often, the tectonic structure of the land and placed humans in strict subordination to the earth's geometry. MS

LITERATURE

Bohdziewicz, Anna Beata, and Edward Hartwig. "Psy czy koty? Fotografia czy fotografika? Kolor czy? Edward Hartwig odpowiada na pytania Anny Beaty Bohdziewicz" (Dogs or Cats? Photography or *fotografika*? Color or? Hartwig Answers Questions by Bohdziewicz), *Format* 24, no. 25 (April – May 1997): 14 – 31.

Plater-Zyberk, Małgorzata. *Edward Hartwig (1909 – 2003): Fotografie*. Exh. cat., Muzeum Narodowe w Warszawie. Warsaw, 2004.

Heinrich Hauser

(Diessen, Kingdom of Bavaria 1901 – 1955 Federal Republic of Germany)

Else Thalemann-Moosdorf

(Berlin-Treptow, Brandenburg, Kingdom of Prussia 1901 – 1984 Stift Lauterbach, Austria)

Little is known about the extent of the collaboration between Hauser and Thalemann. Both photographed for the book *Black District (Schwarzes Revier)*, authored by Hauser, but none of the photographs is credited to Thalemann. During the mid-1920s Thalemann apprenticed for a photography studio in Berlin. Shortly thereafter she began working with Hauser, an author and sailor, on his first book project, a novel called *Bitter Waters (Brackwasser)*, which won him acclaim in the United States. In 1928 Hauser received an assignment to assemble a photographically illustrated report on the industries in the Ruhr river valley. Having already worked there as a miner, Hauser was familiar with the worker's view of this industry. *Black District* portrays the increasingly dominant culture of industrial production in Weimar Germany and was intended to provide an "apolitical" documentation of industry's effects (cat. 125), despite Hauser's statement that the social structure of the factories is far from transparent and cannot be objectively portrayed. Architectural masses and elements in the surrounding environment, such as the close-up of a car wheel, a distant view of workers' barracks, or the face of an old coalminer provide single glimpses of a complex industry. A prolific author, Hauser continued sailing, writing, translating, and photographing until his death in 1955.

After her project with Hauser, Thalemann worked from her photographic studio in Berlin. While not financially dependent on photography, she did make advertising photographs and submitted landscapes and genre scenes for a photo agency called Mauritius. In 1934 she collaborated with scientist Ernst Fuhrman to produce *The Wonder of Plants (Das Wunder der Pflanzen)*,

a publication in which she is credited. These detailed photographs mirror the work of Karl Blossfeldt, an art teacher widely recognized for his close and precise photographs of plants. Thalemann's interest in professional photography waned in the 1950s. EC

LITERATURE

Beckers, Marion, and Elisabeth Moortgat. *Else Thalemann: Industrie- und Pflanzenphotographien der 20er und 30er Jahre*. Exh. cat., Das Verborgene Museum. Berlin, 1993.

John Heartfield
(Helmut Herzfeld)

(Berlin, Brandenburg, Kingdom of Prussia 1891 – 1968 East Berlin, German Democratic Republic)

Herzfeld was eight years old when he and his three siblings were left behind by their parents because their father, a socialist writer, had to flee a prison sentence. Raised by a guardian with limited means, Herzfeld left school to apprentice in publishing and commercial design before studying art in Munich and Berlin. In 1916, as a protest against the rampant nationalism and anti-English sentiment encouraged in wartime Germany, he anglicized his name, becoming John Heartfield.

Heartfield, his brother Wieland Herzfelde, and his friend, the artist George Grosz, were critical opponents of the war; in 1917 they issued the pacifist journal *Neue Jugend* and founded a press, the Malik Verlag, to publish like-minded art and writing. As the Dada movement in Berlin gathered momentum, Heartfield and Grosz emerged as leaders of the group. Between 1917 and 1921, the Malik Verlag brought out key publications of Berlin Dada, including small satirical journals, portfolios of Grosz's caricatures, and the catalogue to the *Erste Internationale Dada-Messe* in 1920. Heartfield executed nearly all the Malik designs, which were among the first to incorporate photography and photomontage.

By 1921, Heartfield began to use his art for expressly political ends; a member of the German Communist Party (KPD) since 1918, he now began to work for them on the journals *Der Knüppel* (The Cudgel) and *Die Rote Fahne* (The Red Flag). He also designed sets for Erwin Piscator's Proletarisches Theater, once again incorporating photography and film. In 1929 Heartfield's book jacket designs were given a separate room at the *Film und Foto* exhibition in Stuttgart; on the wall next to his already famous design for a KPD election poster, which

showed a violently expressive, outstretched hand, he printed the slogan: BENUETZE FOTO ALS WAFFE (Use Photography as a Weapon). The application of this slogan is exemplified in Heartfield's montages for the *Arbeiter Illustrierte Zeitung* (AIZ). From 1930 to 1938, Heartfield contributed photomontages addressing the hidden links between big business and fascist politics that he believed could only result in another war. Maquettes for these pieces were shown to great acclaim in Moscow, Prague, and Paris, and in London in 1939 they featured in an exhibition entitled *One Man's War against Hitler*.

When the Nazis came to power, Heartfield and Herzfelde narrowly escaped to Prague, the city to which operations for AIZ and the Malik Verlag also shifted. After two decades in exile, including time in London (despite the exhibition) interned as an enemy alien in 1940, Heartfield eventually returned to what had become the Soviet-led German Democratic Republic in 1950. AH

LITERATURE

Lavin, Maud. "Heartfield in Context." In Lavin, *Clean New World: Culture, Politics, and Graphic Design*, 12 – 25. Cambridge, Mass., 2001.

März, Roland. *Heartfield montiert, 1930 – 1938*. Leipzig, 1993.

Pachnicke, Peter, and Klaus Honnef, eds. *John Heartfield*. Exh. cat., Akademie der Künste zu Berlin. New York, 1992.

Jindřich Heisler

(Kratz / Chrast, Chrudim, Kingdom of Bohemia 1914 – 1953 Paris, France)

Far younger than most of the artists included here, Heisler began his creative career only around 1935, following chemistry studies in Prague and in the Slovak mining town Banská Štiavnica (see biography for Sergej Protopopov). He joined the Skupina surrealistů v ČSR (Surrealist Group in Czechoslovakia) in 1938. Within months of his entrance, surrealism was driven underground by the Nazi occupation and Heisler himself, the child of a mixed-faith marriage but registered with the Jewish community in Prague, spent much of the next several years (1941 – 1945) in hiding. (In Pinkas Synagogue, where his name is on the wall, he is listed simply as having disappeared.) His debut collection, *Only Kestrels Piss Calmly on the Ten Commandments* (*Jen poštolky chčí klidně na desatero / Nur die Turmfalken brunzen ruhig auf die 10 Gebote*, 1939), set the tone of humorous defiance characteristic of his poetry and of his forays into visual art. While sequestered, Heisler composed books and series of photographs

and assemblage objects, excerpts from which appeared in print or in reproduction after the war. His 1941 collaboration with Jindřich Štyrský, for example, *On the Needles of These Days*, was published by the firm of František Borový in 1945, while individual poems graced exhibition catalogues for Toyen and (posthumously) Štyrský, his two closest friends among the older artistic generation. Heisler and Toyen left for Paris in 1947, sensing the return of totalitarianism at home, and they immediately joined the French surrealist movement (Heisler had published an anthology of verse by Paul Éluard one year earlier). In 1948–1949, Heisler headed the editorial team of *Néon*, a key surrealist journal of the first postwar years. Alone and with André Breton, Benjamin Péret, and of course Toyen, Heisler created more object art—including a marvelous alphabet of wooden letters (1952), faced with glued-on montages reminiscent of Max Ernst—as well as posters, filmscripts, and poems. He died suddenly of heart failure in 1953. MW

LITERATURE

Claverie, Jana, and Germain Viatte. *Štyrský, Toyen, Heisler.* Exh. cat., Centre Georges Pompidou. Paris, 1982.

Šmejkal, František, with Karel Srp and Jindřich Toman, eds. *Jindřich Heisler: Z kasemat spánku (From the Casemates of Sleep).* Prague, 1999.

Toman, Jindřich. "Wort, Bild und Objekt: Zum Werk des tschechischen Surrealisten Jindřich Heisler" (Word, Image, and Object: On the Work of the Czech surrealist Jindřich Heisler). *Bruckmanns Pantheon* 43 (1985): 165–170.

Karol Hiller

(Lodsch / Łódź, Kingdom of Galicia and Lodomeria 1891–1939 Łódź, General Government of Poland)

Hiller studied chemistry, architecture, and painting in Darmstadt, Warsaw, and Kiev, returning to Łódź in 1921. At the time, Łódź was a major center of industry and avant-garde art in Poland. Hiller became involved primarily in abstract painting, graphic design, and illustration. A prolific theoretician, he wrote primarily for the Łódź journal *Forma* (1933–1938), acting as its editor from the inaugural issue until January 1936. *Forma* concentrated, its name notwithstanding, equally on formal innovations and on the social dimension of art. Hiller was involved directly in leftist politics as well. He was a member of the Liga Obrony Praw Człowieka i Obywatela (League for the Defense of Human and Civil Rights) and had contacts with the Polish Communist Party. In December 1939, he was executed by the Nazis.

In 1928 Hiller created a new technique, *heliografika*, in response to the photograms with which László Moholy-Nagy, Man Ray, and others had been experimenting since the early 1920s. Hiller believed that these artists were handicapped by giving too much room to chance. He aimed to make broader use of light-sensitive paper and, in contrast to his predecessors, did not wish to reflect the outlines of existing objects. He initially used glass panes as plates, and later colorless celluloid, on which he placed white tempera to create negative images; he then copied the negatives onto photographic paper. This technique had more in common with graphics than with photography, which Hiller never practiced; he did, however, show his work at the *Pierwsza Wystawa Fotografii Modernistycznej* (First Exhibition of Modernist Photography) in Kraków in 1931, alongside Man Ray and Moholy-Nagy. Hiller explained the motivation behind *heliografika* in 1934: "As he watches the mysteries of matter, which have been observed and recorded in different areas of science and in microphotography, the modern artist finds it difficult to resist the desire to include these phenomena in the sphere of conscious artistic creation." In the 1930s, as he became interested in surrealism, Hiller came to favor "art with a psychological content" over what he viewed as purely formal art, including his own earlier abstractions. Although one of the best-known avant-garde artists, Hiller did not wield a major influence on the development of Polish photography in the interwar period. MS

LITERATURE

Jurecki, Krzysztof. "Heliografika Karola Hillera." *Fotografia* 12 (2003): 81–85.

Karnicka, Zenobia, and Janina Ładnowska. *Karol Hiller, 1891–1939: nowe widzenie; malarstwo, heliografika, rysunek, grafika.* Exh. cat., Muzeum Sztuki. Łódź, 2002.

Vladimír Hnízdo

(Schreckenstein / Střekov, Aussig / Ústí nad Labem, Kingdom of Bohemia 1906–1983 Praha, Czechoslovak Socialist Republic)

Hnízdo trained as a lithographer and worked in Prague for the Štenc printing firm while studying applied arts at night school. In 1927 he transferred to the firm of Schulz, which printed a number of important journals, including the magazine *Fotografie*; after the Nazis took power in Germany in 1933, it also published the *Arbeiter Illustrierte Zeitung* in exile (1933–1938). By 1940 Hnízdo had risen from company draftsman and printer to the post of

operations manager. Through his work at Schulz, he became friendly with leading left-wing figures in the arts, including writers Kurt Konrad and Franz Weisskopf, and the editorial staff of the AIZ, particularly John Heartfield. Hnízdo also made paintings, and in Poděbrady, central Bohemia, where he lived from 1911 until the 1920s, he associated with the painter Oldřich Kerhart. There too he started to take photographs and befriended the future photographer Josef Ehm in 1923. During the 1930s he concentrated in photography on the depiction of social ills, in compositions that betray his keen interest in progressive art and the "new photography." He is remembered now only for this work, although he appears to have made series of photographs dealing with art-historical themes as well. From 1951 until his retirement in 1972, he worked as a freelance photographer. JP

Hannah Höch

(Gotha, Duchy of Saxe-Coburg-Gotha 1889–1978 Berlin-Heiligensee, Federal Republic of Germany)

Höch, the only female member of the Berlin Dada group, was a pioneer in the technique of photomontage. As a young woman, she attended schools of applied art in Berlin, studying graphic arts and glass design. Between 1916 and 1926, she worked in the handicrafts department of the Ullstein publishing house, designing patterns for women's fashions, embroidery, crochet, and lace. In addition to a steady income, Höch's position at Ullstein provided her with scraps of patterns that she incorporated into her photomontages. Through her association with Raoul Hausmann, her lover for eight years, Höch entered the Dada circle. While Hausmann, John Heartfield, and George Grosz were at its center, Höch contributed in equal measure to the definition of Dada's aesthetics and its political ideas. Using images culled from newspapers and popular illustrated magazines, Höch offered a quiet but mordant critique of gender stereotypes and of contemporary media representations of women. In *Heads of State* (cat. 9), she pasted photographs of the recently elected president, Friedrich Ebert, and his defense minister Gustav Noske, already ridiculous in their bathing trunks, onto a decorative "feminine" background, caricaturing their political impotence. At the 1920 *Dada-Messe*, she exhibited several dolls, photomontages, and sculptures. Although she did not show photomontages publicly again until 1929—in a one-person show and at *Film und Foto*—this work was widely recognized and reproduced in avant-garde publications, such as

El Lissitzky and Hans Arp's *The Isms of Art* (1923), *Painting Photography Film*, and *Photo-Eye* by Franz Roh (1930).

In a 1934 statement to accompany an exhibition exclusively of photomontages in Brno, Czechoslovakia, Höch outlined the historical development of this technique, identifying her own use of "free-form photomontage" as "an art form that has grown out of the soil of photography." Although Höch practiced this technique throughout her career, after 1933 she was prohibited from exhibiting in Germany and withdrew from public life. Living on the outskirts of Berlin, she continued to cut and paste, but her work, once highly critical of society and the government, now turned to nature as its primary visual resource. AH

LITERATURE

Aliaga, Juan Vicente, ed. *Hannah Höch.* Exh. cat., Museo Nacional Centro de Arte Reina Sofía. Madrid, 2004.

Boswell, Peter W., Maria Martha Makela, Carolyn Lanchner, and Kristin Makholm. *The Photomontages of Hannah Höch.* Exh. cat., Walker Art Center. Minneapolis, 1996.

Lavin, Maud. *Cut with the Kitchen Knife: The Weimar Photomontages of Hannah Höch.* New Haven, 1993.

Moortgat, Elisabeth, Cornelia Thater-Schulz, and Armin Schulz. *Hannah Höch 1889–1978: Ihr Werk, Ihr Leben, Ihre Freunde.* Exh. cat., Berlinische Galerie. Berlin, 1989.

Lotte Jacobi

(Thorn, West Prussia, Kingdom of Prussia [today Toruń, Poland] 1896–1990 Concord, United States)

Jacobi began taking pictures at age eight, and at age twelve constructed her own pinhole camera. She came from a family of photographers; her great-grandfather is said to have met Daguerre on a trip to Paris and to have purchased the equipment and rights to use his process, returning to his hometown to found a photography studio that would be passed down through four generations. After studying art history and literature, Jacobi married and in 1920 moved with her husband to Berlin. The following year, her parents also settled in Berlin, where her father opened a new business, the Atelier Jacobi. When Jacobi separated from her husband, she returned to live with her parents and began working as her father's assistant. In 1925 she left Berlin to complete a two-year course in photographic techniques at the Staatliche Höhere Fachschule für Phototechnik in Munich (State Training School in Photographic Technology), and later she began

working independently out of her father's studio. She drew her portrait subjects from the worlds of Berlin theater, dance, and film; among them were Lotte Lenya, Peter Lorre, Leni Riefenstahl, and Kurt Weill. Around 1930 she developed a sympathy for the communist cause, supplying John Heartfield with photographs for his anti-capitalist collages and providing campaign photographs for Ernst Thälmann, the Communist Party candidate for the German presidency. In 1932 she embarked on a trip to the Soviet Union, traveling alone to Moscow and through the central Asian republics of Tajikistan and Uzbekistan, producing some six thousand photographs along the way.

As working conditions for Jews deteriorated, Atelier Jacobi was forced to distribute its photographs under various assumed names. In 1935, after her father's death, Jacobi emigrated to New York, where she once more opened a portrait studio. Her subjects in the United States included Alfred Stieglitz, Marc Chagall, and Albert Einstein, with whom Jacobi fashioned a portrait series at Princeton University that was rejected by *Life* as too unconventional. AH

LITERATURE

Beckers, Marion, and Elisabeth Moortgat. *Atelier Lotte Jacobi, Berlin, New York.* Exh. cat., Das Verborgene Museum. Berlin, 1997.

Jerzy Janisch

(Gródek Jagielloński, Kingdom of Galicia and Lodomeria 1901–1962 Warszawa, People's Republic of Poland)

Janisch was a painter, draftsman, and collage artist who participated in the interwar Lviv avant-garde. From 1921 through 1924, he studied drawing and painting with Kazimierz Sichulski at the Państwowa Szkoła Przemysłowa (State School of Industry) in Lviv. After graduating, he traveled three times to Paris (1924–1925, 1928–1929, and 1930–1931) for further study at the École Nationale des Beaux-Arts, and became interested in surrealism. In 1929 he and two other devotees of surrealism, Aleksander Krzywobłocki and Mieczysław Wysocki, founded the Zrzeszenie Artystów Plastyków "Artes" ("Artes" Artists' Association) in Lviv, with the aim of coordinating research on modern forms in different art genres. In formulating the ideological precepts of "Artes," Janisch described painting as the most direct communication of an artist's internal emotions and visions. While Janisch's art theory included general references to the credos of French surrealism, only distant echoes of the work of

André Masson and Max Ernst are present in his paintings and drawings. His idea to express an uninhibited imagination can be seen especially in his landscapes, both in their transformation of visual objects and the confrontation of heterogeneous motifs, and in their liberal use of thick and intense color. Janisch's collages likewise adhere to the poetics of orthodox surrealism. They represent unusual contrasts of photographic and other reproductions of anatomical cross-sections of the human body, open "innards" of machines and humanoid figures of ambiguous status, and mysterious constellations of stars (*Nude and Car* [*Akt i samochód*], 1933; *Figure with Parasol* [*Figura z parasolem*], 1934). Heavenly bodies, astronomical phenomena, and cosmic forces that penetrate the human world dominate the photomontages Janisch made to illustrate Alina Lan's book *Halley's Comet* (*Kometa Halleya*, Lviv, 1934), crisply executed with additional elements of drawing. In the second half of the 1930s, Janisch's paintings combined a post-impressionist color sense with absurdist themes and references to classical iconography. Janisch also worked in Lviv restoring antique polychrome sculpture. Following World War II, he moved to Warsaw, where he made decorative paintings and continued to create surrealist collages and photomontages. SC

László Káldor

(Budapest, Kingdom of Hungary 1905–1963 Budapest, People's Republic of Hungary)

Little is known about Káldor's early life. He studied furniture design at the Magyar Iparművészeti Iskola (Hungarian School of Applied Arts) in Budapest during the 1920s. After several years in Paris, Káldor returned to Budapest, where the furniture company Gróf and Faragó employed him until 1935. Káldor worked primarily as an advertising artist and graphic designer but he was also a self-taught amateur photographer evidently influenced by the New Vision aesthetic, for example in his attraction to unusual angles and diagonal shadow. His photograph *Boat* (cat. 91) was one of a number of camera images Káldor recombined in photomontages for an unpublished project called *Pest Diary*, on the greater, modern half of Budapest. This project, undertaken in 1931, illustrates the extent to which many graphic artists and designers were experimenting with "new photography" and its applications. After

the war, Káldor continued his work in advertising, creating political posters and prospectuses for foreign trade magazines that rarely included photographs. EC

LITERATURE

Bakos, Katalin. *Káldor László: Budapesti Napló 1931; Káldor László kollázs-sorozata / Budapest Diary 1931; László Káldor's Collages*. Budapest, 2002.

———. *Szivárvány Áruház és Nagyvilág: Káldor László (1905–1963) és Gábor Pál (1913–1992): két magyar reklámgrafikus* (Rainbow Department Store and the World at Large: László Káldor and Pál Gábor: Two Hungarian Graphic Designers). Exh. cat., Magyar Nemzeti Galéria. Budapest, 2001.

Dora (Philippine) Kallmus

(1881, Wien, Archduchy of Lower Austria – 1963 Frohnleiten, Austria)

Kallmus was one of the first Austrian photographers to apply the pictorial portrait style of the turn of the century to commercial studio photography. Her elegant portraiture was produced for the cultural and artistic milieux, and above all for Vienna high society and aristocracy, including the kaiser's family. Through careful lighting and individually differentiated poses, Kallmus displayed a nuanced feel for the relation between her customers and the picture frame. She produced portraits and dance photographs for the illustrated market and specialized after World War I in fashion photography, beginning with the Wiener Werkstätte. Kallmus' studio was first among the many in Vienna led by women photographers (such as Trude Fleischmann or Trude Geiringer and Dora Horovitz) between the two World Wars.

Kallmus trained at the Graphische Lehr- und Versuchsanstalt and in an apprenticeship with Nicola Perscheid in Berlin, an internationally renowned portrait photographer at the beginning of the twentieth century. In 1907 Kallmus opened the Studio Madame d'Ora. Arthur Benda, Perscheid's assistant at the time, followed her to Vienna and took over the technical aspects as studio manager. To retain her wealthy clientele in the summer, Kallmus set up an affiliate studio in the Czech resort town of Karlovy Vary (Karlsbad). Another branch was opened in Paris in 1925 that Kallmus herself oversaw, a move that led her two years later to sell her Vienna studio to Benda. In Paris she targeted a comparable clientele, which, however, disappeared with the outbreak of war. Upon the German occupation she was forced, as a Jew, to flee Paris and to go underground, but she was able to reclaim her business after World War II. Pictures of an Austrian refu-

gee camp made shortly after the war, and images from Paris slaughterhouses in the 1950s, opened up entirely new ground, indicating a radical break with her previous work. Nothing of her former society life, and little of its accompanying aesthetics, is left in the immediacy of her documentary work, nor in the cruelty of her slaughterhouse pictures, which are influenced by surrealism. AL

LITERATURE

Faber, Monika. *Madame d'Ora: Wien — Paris; Portraits aus Kunst und Gesellschaft 1907–1957* (Madame d'Ora: Vienna — Paris; Portraits from Art and Society 1907–1957). Vienna, 1983.

———. *Madame d'Ora, Wien — Paris: Vienna & Paris, 1907–1957: The Photography of Dora Kallmus*. Exh. cat., Vassar College Art Gallery. Poughkeepsie, N.Y., 1987.

Kempe, Fritz. *Nicola Perscheid, Arthur Benda, Madame d'Ora*. Hamburg, 1980.

Kata Kálmán

(Korpona / Krupina, Kingdom of Hungary [today Krupina, Slovakia] 1909–1978 Budapest, People's Republic of Hungary)

Influenced by her husband, art historian and photographer Iván Hevesy, Kálmán took up photography in the early 1930s, quickly embracing the activist and politically engaged documentary movement known in Hungary as *szociofotó* (social photography). Kálmán depicted blue-collar work in carefully composed shots, frequently leaving out the face of the worker, who is more often than not seen from behind or depicted in shadow (cat. 131). These aestheticizing photographs seem, oddly enough, to deemphasize labor. Yet Kálmán also produced many portraits of the homeless and hungry, closely framed views that solicit compassion for workers chiefly through their intense, detailed facial expressions (cats. 130, 132). These photographs were collected in Kálmán's first, sensational photobook *Tiborc*, published in 1937. Named after the oppressed character in József Katona's 1821 novel *The Viceroy* (*Bánk bán*), the album tells personal stories of hardship through photographic portraits and accompanying biographical vignettes. The book's many and well-respected reviewers praised Kálmán's publication for its ingenuity and honesty. Kálmán did not restrict herself to social photography, but like many of her contemporaries also photographed Hungarian landscapes, city streets, and (following her own career prior to photography) modern dance. She also participated in several European exhibitions. In 1955 Kálmán revisited her one acclaimed project to pro-

duce *The New Face of Tiborc*. Juxtaposing recent and older portraits of many of the same sitters, the album ambitiously aimed to show the newfound satisfaction workers experienced under a socialist state. During the 1950s and 1960s, Kálmán worked as a photographic illustrator and editor. In her last major project, she launched a popular series of small, square monographs on Hungarian photographers, their format based on an analogous series published from the late 1950s in Czechoslovakia. EC

LITERATURE

Furkó, Zoltán. *Kálmán Kata munkássága* (The Work of Kata Kálmán). Budapest, 1981.

Hevesy, Anna, Katalin Hevesy, and Károly Kincses. *Hevesy Iván és Kálmán Kata könyve* (Books on Iván Hevesy and Kata Kálmán). Exh. cat., Magyar Fotográfiai Múzeum, Kecskemét. Budapest, 1999.

Karel Kašpařík

(Loschau / Lošov, Olmütz / Olomouc, Margraviate of Moravia 1899–1968 Olomouc, Czechoslovak Socialist Republic)

A self-taught photographer from a working-class background, Kašpařík joined the local Klub českých fotografů amatérů (Czech Amateur Photographers Club) in Olomouc in the early 1930s. He soon met Jaroslav Nohel, a member of the Brno-based fotoskupina pěti (Photo Group Five or f5), who probably introduced him to photomontage, photograms, and other experimental techniques. Together with Otakar Lenhart, they organized an exhibition in 1935 called, in a similar vein, *f3*, with the subtitle *photo-experiments, photomontage, photograms, photos, advertising photos*. A half-decade later, Kašpařík again exhibited with an all-embracing experimental photo collective, this time a tetrad named f4 (Prague, 1939). Kašpařík branched out, meanwhile, into the other great domain of avant-garde photographic production in the 1930s, namely social documentary. He produced an extensive series of photographs in his hometown of Lošov, which attests not only to the extent of penury in his day but also to his artistic abilities. He also created a number of audacious erotic photographs. Soon after taking up the camera, in 1934, Kašpařík published his photographs in the leftist magazine *Index*; a friendship with director Oldřich Stibor then brought him work in the Olomouc theater, where his photographs were used in some productions, possibly in the form of slide projections (Jaromír Funke and Miroslav Hák participated in theater in this way as well). At the very beginning of World War II he was arrested for resistance activities and

imprisoned until the end of the war. We know nothing about his postwar photography; while he made collages during the 1940s and 1950s, it seems he later engaged less in creating art than in collecting it. JP

LITERATURE

Babler, O. F. "O umění fotografickém a o jednom fotografovi" (On Photographic Art and on One Photographer). *Index* 8, no. 7 (1936): 73–74.

Dufek, Antonín. *Karel Kašpařík 1899–1968.* Exh. cat., Moravská galerie. Brno, 2000.

Lajos Kassák

(Érsekújvár / Nové Zámky, Kingdom of Hungary [today Nové Zámky, Slovakia] 1887–1967 Budapest, People's Republic of Hungary)

One of the most influential Hungarian cultural figures of the modernist era, Kassák was an art critic, poet, artist, writer, and, above all, an avid socialist. He published his first magazine *A Tett* (The Deed), an antiwar journal, from 1915 through its banning in 1916. Already with *A Tett*, Kassák put in practice his belief in art as a field of revolutionary forms: design, typography, communication for the masses. In the fall of 1916 he founded *MA* (Today), a crucial magazine for disseminating knowledge of international progressive art to a Hungarian audience. In its multilingual pages, *MA* brought together varieties of Dada, constructivist, expressionist, and futurist practice from across Europe, with special issues

József Pécsi, *Lajos Kassák*, late 1920s, gelatin silver print, 21 × 27, Hungarian Museum of Photography

on topics both broad (new music) and deep (the epochal 1922 exhibition of Russian art in Berlin). Begun in Budapest, the journal remained an essential vehicle for creative exchange during the years of Kassák's Vienna exile, from 1920 to 1926. After his return to Hungary, he ran the journal *Dokumentum* (1926–1927) and then the unusually long-lived *Munka* (Work), which lasted from 1928 until 1939. As leader of the Munka-kör or Work Circle, Kassák edited and introduced the collective publication *From Our Lives*, 1932 (cat. 128). Through dialectical pairings, his judicious layout stresses the injustices meted to the working class, as well as the obligation for people to study and reflect on photographic evidence of that injustice. Constantly defending his work in the years leading up to and during World War II proved difficult for Kassák, who reduced his activity in the postwar years. In the late 1950s, however, he returned to making constructivist art and resumed his correspondence with many European avant-garde artists. EC

LITERATURE

Csaplár, Ferenc, ed. *Lajos Kassák: The Advertisement and Modern Typography.* Budapest, 1999.

Levinger, Esther. "Lajos Kassák: MA and the New Artist, 1916–1925." *The Structurist* 25 / 26 (1986): 78–84.

Štraus, Tomáš. *Kassák: Ein ungarischer Beitrag zum Konstruktivismus / A Hungarian Contribution to Constructivism.* Cologne, 1975.

André Kertész (Kertész Andor)

(Budapest, Kingdom of Hungary 1894–1985 New York City, United States)

Kertész is among the most accomplished and best-loved photographers of the twentieth century. He began publishing and exhibiting at home and abroad in the late 1910s. Before leaving Hungary in 1925, Kertész mostly photographed familiar aspects of his Hungarian life, including his family, his home city of Budapest, and typical sights in the nearby countryside. Many of these small, early snapshots focused on individuals, portraying the simplicity of humanity with inquisitive charm. Kertész also occasionally photographed larger events, but only from a distance. Indeed, the political upheavals and generally unstable environment of postwar Europe led Kertész and other Hungarian photographers to concentrate on the personal, traditional Hungary they knew best.

In 1925 Kertész left for Paris, where he established his photographic reputation within a couple of years. Influenced

by French avant-garde artists, Hungarian émigrés, and the city's modern cultural environment, he significantly developed his artistic command of photography. With increased praise came commissions for French, Hungarian, English, and German periodicals. Magazines such as *Vu* and *UHU* published individual pictures but also used serial photographs as the basis for an increasingly popular genre, the photo story. In 1936 Kertész settled in New York, where he continued his photographic career but struggled for some time to reestablish the prominence he had enjoyed in Paris. During the 1960s he finally gained lasting success, enjoying career retrospectives and exhibitions of new work in major United States and French institutions. EC

LITERATURE

Greenough, Sarah, et al. *André Kertész.* Exh. cat., National Gallery of Art. Washington, 2005.

Kertész, André. *Hungarian Memories: André Kertész.* Introduction by Hilton Kramer. Boston, 1982.

Phillips, Sandra S., David Travis, and Weston J. Naef. *André Kertész: Of Paris and New York.* Exh. cat., The Art Institute of Chicago. Chicago, 1985.

Imre Kinszki

(Budapest, Kingdom of Hungary 1901–1945 Sachsenhausen concentration camp)

More than an inspired photographer of daily life, Kinszki was also an intellectual and a critic. He studied at the university in Budapest, publishing articles on natural philosophy and politics, but anti-Semitic legislation kept him from earning a degree. He took up photography as a hobby in the 1920s and was assiduous both as a photographer and as an advocate for modernism; surviving correspondence indicates exchanges with the prominent contemporaries Albert Renger-Patzsch and Paul Wolff, for example. Kinszki wrote for numerous Hungarian publications, among them the amateur journal *Fotoművészeti Hírek*, as well as foreign magazines such as *National Geographic* and *Popular Photography*, submitting articles on popular technical and aesthetic subjects. He was a member of Magyar Amatőrfényképezők Országos Szövetsége (National Association of Hungarian Amateur Photographers, or MAOSZ) and a founding member of Modern Magyar Fényképezők Egyesületét (Association of Modern Hungarian Photographers), which favored the New Objectivity associated with Renger-Patzsch. Kinszki participated almost yearly in photographic exhibitions at home and abroad during the 1930s. His photographic oeuvre concentrates on typically modern scenes of daily life and the

urban environment, often in details: a section of the Elizabeth Bridge (cat. 64), for instance, at its completion in 1903 the world's longest chain-suspension bridge. His perceptive interest in minutiae led Kinszki to design his own lens for microphotography and a special 6 × 6 cm camera, which he marketed as well. The last published works by Kinszki before his deportation appeared in 1944 in the magazine *Képes Vasárnap* (Sunday Pictures). EC

LITERATURE

Kiscsatári, Marianna. *Kinszki Imre.* Budapest, 2001.

Rudolf Koppitz

(Schreiberseifen / Skrbovice, Czech Silesia 1884–1936 Wien, Austria)

After apprenticeships at several studios, Koppitz concluded his photographic education—interrupted by a highly promising career in imitation jewelry—at the Graphische Lehr- und Versuchsanstalt (GLV) in Vienna, obtaining an assistantship at this prestigious institution as early as 1913. During World War I he was deployed as a reconnaissance pilot and photographer, then returned to the GLV, where he later became (in 1930) head professor of photography. Through his teaching he influenced generations of graduates, while running a private studio and taking part in dozens of international salon exhibitions. He also placed pictures in almost every German-language photo magazine in the 1930s. Koppitz is regarded as the most influential Austrian photographer of the interwar period.

Koppitz' early work exhibits a pictorialist soft focus and a preference for frontal planarity characteristic of the Vienna Secession; secessionist flatness and ornament, indeed, characterized his view of the human body throughout his life. Koppitz explored these stylistic premises during the 1920s in many symbolically laden compositions, most famously his series titled *Movement Study* (*Bewegungsstudie*). With labor-intensive print techniques, he translated the formal language of a painter such as Gustav Klimt into photography. During the 1930s he turned toward sharply focused prints, yet his themes remained conservative, in the realm of *Heimatphotographie*. Romanticization and monumentalization of the landscape, and idealization of rural life, marked his later photographic output. This body of work found its consummate presentation in the solo exhibition *Land und*

Leute (The Land and the People), held at the prestigious Österreichisches Museum für Kunst und Industrie (Austrian Museum for Art and Industry) in 1936. This exhibition represents not only the high point of Koppitz' successful career, but it is also one of the most important photographic manifestations in Austria of the interwar period. AL

LITERATURE

Conklin, Jo-Ann, Monika Faber, and Peter Weiermair. *Rudolf Koppitz, 1884–1936.* Exh. cat., Historisches Museum der Stadt Wien. Vienna, 1995.

Gottschammel, Josef, and Rudolf Hans Hammer, eds. *Rudolf Koppitz.* Vienna, 1937.

Arthur Köster

(Pausa, Kingdom of Saxony 1890–1965 Berlin, Federal Republic of Germany)

Köster was introduced to photography as an apprentice during World War I. After the war, he completed his training in the photography office of the Ernst Wasmuth publishing house, which specialized in architectural books. He became the office director and during his tenure at Wasmuth established enough connections to open his own office, the Fotowerkstatt für Architektur (Photo Studio for Architecture), in 1926. Between 1926 and 1933, Köster had the lion's share of architectural photography commissions in Berlin, where a postwar building boom coincided with a rapid rise in the use and appreciation of photography. Instead of drawings, architects now demanded photographs to illustrate publications of their work. Beginning in the fall of 1926, Köster became the staff photographer for Gehag developers, whose "house" architect between 1925 and 1932 was the renowned Bruno Taut. He also worked regularly for the committed modernists Luckhardt and Alfons Anker, Hans Scharoun, and Paul Rudolf Henning. As the exclusive photographer for Erich Mendelsohn, one of the most prolific architects of this period, he shot all of Mendelsohn's buildings in Germany and supplied most of the photographs for his publications. He became the most important architectural photographer in Berlin: in a 1931 guide to new architecture, *New Building in Berlin*, nearly half of the 107 photographs are by Köster. His approach, characterized by close-ups, diagonal views, and a shallow depth of field, was as modern as the buildings he photographed. Particularly innovative were his nighttime views, which, by emphasizing internal illumination, also showcased the modern use of glass.

Köster and his brother, who had joined the studio in 1929, continued to receive many commissions during the building boom that occurred under National Socialism. They provided pictures of Nazi prestige objects, such as the Autobahn bridges and the Tempelhof airport, as well as photographs of more modest projects for propaganda materials. AH

LITERATURE

Förster, Simone. "Theorie-Entwurf-Fotografie: Erich Mendelsohns Einsteinturm in den Fotografien von Arthur Köster" (Theory-Proposal-Photograph: Erich Mendelsohn's Einstein Tower in Photographs by Arthur Köster). *Thesis* 49, no. 4 (2003): 166–173.

Stöneberg, Michael. "Das Bild vom Neuen Bauen in Berlin: Arbeiten des Berliner Architekturfotografen Arthur Köster (1926–33) / The Image of Neues Bauen in Berlin: Architectural Photography by the Berliner Arthur Köster (1926–33)." *Daidalos*, no. 66 (December 1997): 92–99.

Rudolf Kramer

(Plauen, Kingdom of Saxony 1900– unknown)

When Kramer exhibited his photos at an exhibition called *Die neue Fotografie* in 1931, he was described as a painter who had switched to taking photographs because "through photography, things can be represented more convincingly and truthfully." Though Kramer was most likely a commercial photographer—he placed a notice for his photo-advertising studio in 1930— little is known of his work or life. His photographs appeared occasionally in photography magazines and yearbooks, and as late as 1949 he was listed as a member of the Verein Deutscher Lichtbildner (Association of German Photographers). AH

Jiří Kroha

(Prag / Praha, Kingdom of Bohemia 1893– 1974 Brno, Czechoslovak Socialist Republic)

Kroha studied architecture from 1911 to 1916 under leading Czech practitioners Josef Fanta, Jan Koula, and others. He took his initial inspiration from cubism, already transformed by his contemporaries into a style for architecture and applied art as well as painting. Kroha's greatest contribution to this vibrant domestic movement was his cubist design for the Montmartre bar (1918), which enlivened the festive café and cabaret scene in the Bohemian capital. Kroha spent several years thereafter in

theater design, then landed a series of municipal commissions in Mladá Boleslav and elsewhere in northern Bohemia. In the midst of this ascendant phase of his career, in 1925, Kroha was named professor at the Technická vysoká škola (Institute of Technology) in Brno, a position he held until 1953. From this scholastic perch he launched *Horizont* in 1927, a journal for innovative architectural and cultural trends; traveled in 1930 to the Soviet Union and helped found Levá fronta (Left Front), a movement for socialist activity in the arts; and led the creation of the eighty-nine mammoth photomontage panels collectively titled *Excerpts from a Sociology of Habitat* (cat. 133). Kroha supervised this tremendous group effort, undertaken by his students in Brno between 1930 and 1932, with the idea to isolate and contrast quality-of-life factors—hygiene, diet, commuting patterns, sexual and reproductive measures, life expectancy, and many others—across the social spectrum. Only by assembling and juxtaposing statistical evidence, Kroha argued, would architects and other social planners gain information truly useful to the citizenry they wished to serve.

Kroha spent 1939–1940 in prison and in concentration camps (Dachau and Buchenwald). After the war he turned principally to exhibition design and to painting, a lifelong avocation. MW

LITERATURE

Císařovský, Josef. *Jiří Kroha a meziválečná avantgarda* (Jiří Kroha and the Interwar Avant-Garde). Prague, 1967.

Jiří Kroha. Introduction by Jaroslav B. Svrček. Geneva, 1930.

Jiří Kroha: Kubist, Expressionist, Funktionalist, Realist. Exh. cat., Architektur Zentrum Wien. Vienna, 1998.

Aleksander Krzywobłocki

(Lemberg / Lwów, Kingdom of Galicia and Lodomeria 1901–1979 Kraków, People's Republic of Poland)

Krzywobłocki was one of Poland's most brilliant photographers and photomontage artists of the interwar period, perhaps even the most original and creative. Many photomonteurs assembled photographic cutouts into structures determined by the visual contrast between individual pieces, and between these pieces and a neutral background. Krzywobłocki instead treated photomontage as a modification of traditional camera practice, arranging his own original photographs in layers or staging scenes before the camera. He studied architecture at Politechnika Lwowska from 1922 to 1928 and also attended a photography course taught by Henryk Mikolasch, a Polish exponent of pictorialism. In the early 1930s, Krzywobłocki worked in the municipal conservator's office creating photographic documentation of architectural monuments. Architectural themes formed a frequent component of his photomontages. In 1929 he helped found in Lviv the Zrzeszenie Artystów Plastyków "Artes" ("Artes" Association of Artists), an avantgarde group influenced by surrealism that promoted artistic experiments guided by the free flow of the imagination. Beginning in 1928, these ideas were present in Krzywobłocki's photographs, visually surprising arrangements of people and objects he called *Montages from Nature* or *Photographic Compositions* (cat. 106). In some works, the human figure came to seem increasingly unreal by an optical game of reflections on glass panes. There were photomontages filled with forms emerging from other forms, and blurred objects possessed of unexpected, abstract values. One characteristic motif, along with unconventionally positioned architectural elements, is a mysterious open hand that appears among them and seems to reach toward an unidentified object. Several of Krzywobłocki's photomontages illustrated published stories, whether in tabloids such as *Na szerokim świecie* (Out in the World) or in experimental books (Alina Lan's *Halley's Comet*, 1934). Following World War II, which Krzywobłocki spent saving works of art in Lviv, he moved to Wrocław, where he worked as a conservator of monuments and a photographer. In 1948–1949 he made a series of photomontages of classical architecture and sculpture, and later others using photographs of lace and glass vessels. Krzywobłocki moved to Kraków in 1971. SC

LITERATURE

Sobota, Adam. *Aleksander Krzywobłocki: fotomontaże.* Exh. cat., Muzeum Narodowe we Wrocławiu. Wrocław, 1975.

Jan Lauschmann

(Raudnitz / Roudnice, Kingdom of Bohemia 1901–1991 Brno, Czechoslovak Republic)

A chemist by profession, Lauschmann considered photography a serious hobby. For many years he worked at the Neobrom photographic paper plant in Brno and subsequently lectured on photography and its chemistry at various universities. He started taking photographs in high school, then pursued photography seriously while at the university. In 1921 the Czech-American Drahomír Josef Růžička, a student of Clarence White, exhibited so-called straight or clean (*čistá*) photography in Prague, showing prints on bromide paper. This exhibit sparked debate among amateurs about proper approaches to photography; Lauschmann joined Jaromír Funke, Josef Sudek, and Adolf Schneeberger in defending Růžička's approach and advocating what they deemed a "purely photographic" process, independent of painting or the other graphic arts. (In fact, like most modern amateurs, Lauschmann used soft-focus lenses and many compositional devices indebted to a pre–World War I ideal of painterliness until the very end of the 1920s.) Lauschmann served on the board of the most influential magazine for amateurs, *Fotografický obzor* (Photographic Horizons), from 1923 to 1934. In that capacity, he authored numerous articles and played an important, if cautious, role in publicizing international trends.

Beginning in the 1930s, Lauschmann's compositions became more sharply focused and schematic, inclined increasingly toward an abstract interplay of lines and shapes. Certain pieces markedly echo constructivism, for instance *Outdoor Café, Barrandov* from 1932 (cat. 67). Bird's-eye views of the café, a series of curved terraces located on a steeply sloping hillside below one of the major film studios of interwar Europe, were a favorite among Czech photographers. Casting the hillside as a succession of geometric planes and emphasizing the rhythmic repetition of shining white tables, Lauschmann nevertheless did not crop the picture to the point of abstraction; his composition therefore retains ties to older landscape photography despite its aerial position and eminently modern subject.

After a period of intense activity in the later 1920s and 1930s, the demands of his profession caused Lauschmann to give up photography for a number of decades. Retrospective exhibitions in the 1970s led him to renew his interest, and he also published several reminiscences of his interwar career. JP

LITERATURE

Lauschmann, Jan. "60 let fotografie" (Sixty Years of Photography). *Revue fotografie* 16, no. 2 (1972): 14–17.

Mrázková, Daniela. *Jan Lauschmann.* Prague, 1986.

Tausk, Petr. "Jan Lauschmann and Czechoslovak Photography." *History of Photography* 5, no. 2 (April 1981): 157–168.

Kazimierz Lelewicz

(Lubartów, Province of Lublin 1896–
1986 Gdańsk, People's Republic of Poland)

Following studies at the Wawelberg-
Rotwand Szkoła Techniczna in Warsaw,
Lelewicz worked as a civil engineer. He
later moved to Vilnius to take up employ-
ment in railway construction. In 1923, more
than one decade after his initial interest,
he began to study with the excellent com-
mercial portraitist Jan Kurusza-Worobiew,
who showed models often in half-darkness
and usually took his photographs using
a single source of light. Lelewicz retained
an interest in portraits ever after. He also
sought the advice of painter Ferdynand
Ruszczyc and of Jan Bułhak about land-
scapes. In the second half of the 1920s, he
began to work closely with Bułhak, who
left a powerful imprint on his work; Lele-
wicz frequently adopted subjects for which
Bułhak was known, such as architectural
documentation. He joined Fotoklub Wileń-
ski and Fotoklub Polski, both founded by
Bułhak, and participated in shows of Buł-
hak's Homeland Photography program.

Lelewicz typified the generation of
photographers who debuted in the late
1920s. His work combined classical pictori-
alist approaches with an interest in mod-
ern subjects. He frequently employed the
vocabulary of "new photography" and pho-
tographed industrial themes from unusual
angles with close cropping. At the same
time, he held a strong interest in folklore
and the land, looking for the roots of con-
temporary society in the picturesque and
in idealized representations of pastoral life.
Simple folk, "untainted" by civilizational
changes, were seen as the cradle of the
contemporary nation and helped construct
the myth of the modern Polish state.

After World War II Lelewicz lived in
Gdańsk, where he documented the city's
wartime destruction and postwar recon-
struction. He remained artistically active
and belonged to the Związek Polskich Artys-
tów Fotografików (Association of Polish Art
Photographers, or ZPAF). From 1949 until
1970, he headed the photography program
at Politechnika Gdańska. MS

LITERATURE

Lelewicz, Kazimierz. Ankieta (Questionnaire),
conducted by the ZPAF in Warsaw, typescript.
Gdańsk, 1974.

Helmar Lerski
(Israel Schmuklerski)

(Straßburg / Strasbourg, Imperial Territory
of Alsace-Lorraine 1871–1956 Zürich,
Switzerland)

Born to German-speaking Polish parents
who had emigrated to France but became
Prussian subjects with the cession of Alsa-
tia to Germany, Lerski left Europe as a
young man to join his older sister in Chi-
cago. There, he changed his given name
and worked as an actor for several German
theaters in the Chicago and Milwaukee
area. In 1910, he and his wife, a professional
photographer, opened a photo studio. His
photographs of actors in character roles
soon attracted attention for their dramatic,
theatrical lighting, which critics credited
to Lerski's experience on the stage. His
style of photograph came to be known as
a "Lerski picture."

In 1915, Lerski returned to Europe, set-
tling in Berlin, where an exhibition of his
photographs brought him notice from the
film industry. The result was a twelve-year
career as cameraman, cinematographer,
and technical director. Only in 1928 did he
return to taking still pictures, but by 1929
his photographs were appearing in illus-
trated magazines and journals. Through-
out his career, Lerski's nearly exclusive
subject was the human face. In an ambi-
tious project of 1929, exhibited and pub-
lished as a book under the title Everyday
Faces, Lerski photographed eighty unem-
ployed workers identified only by their occu-
pations: housemaid, seamstress, heating
technician (cat. 135). Advertised as por-
traits of the "often seen but never noticed,"
Lerski's pictures were praised for their
noble representation of the poor.

In mid-1931, Lerski left Berlin for Pales-
tine, where he remained until 1948. His
work there included a photo documentary
series on the Jewish and Arab peoples,
several Zionist films, and a major photo-
graphic project entitled Metamorphosis
through Light. A suite of 175 photographs
of one man's face, Metamorphosis was Ler-
ski's ultimate expression of his belief that
"within each person there is everything; it
is only a matter of where the light falls." AH

LITERATURE

Ebner, Florian. Metamorphosen des Gesichts: Die
"Verwandlung durch Licht" von Helmar Lerski (Meta-
morphoses of the Face: Helmark Lerski's "Trans-
formation through Light"). Exh. cat., Museum
Folkwang, Essen. Göttingen, 2002.

Eskildsen, Ute, and Jan-Christopher Horak.
Helmar Lerski, Lichtbilder: Fotografien und Filme,
1910–1947. Trans. J.-C. Horák. Exh. cat., Museum
Folkwang. Essen, 1982.

El Lissitzky

(Pochinok, Province of Smolensk 1890–
1941 Moskva, Russian Soviet Federative
Socialist Republic)

An architect, painter, typographer, exhibi-
tion designer, and children's book author,
El Lissitzky was trained as an architectural
engineer, receiving degrees from both the
Technische Hochschule in Darmstadt, Ger-
many, and the Rizhskyi Politekhnicheskyi
Institut (Riga Polytechnical Institute) in
Moscow (where the Latvian institution had
relocated during World War I). Between
1919 and 1921, he taught graphic arts and
architecture in Vitebsk. The suprematist
painter Kazimir Malevich, then formulating
his most visionary theories, exerted a
tremendous influence on Lissitzky, who
invented the term Proun (Project for the
Affirmation of the New) for his own
abstract canvases. After returning briefly
to Moscow in 1921 to teach at VKhUTEMAS
(Higher State Artistic-Technical Work-
shops), Lissitzky left the Soviet Union for
Germany, where he would live for the next
five years. In addition to his connection
with Berlin's circle of Russian émigré art-
ists and writers, Lissitzky forged contacts
with German artists such as Kurt Schwit-
ters and Hans Arp. He published one of his
first photograms, made in 1923 in collabo-
ration with Vilmos Huszár, in Schwitters'
magazine Merz (cat. 26), and with Arp he
produced Kunstismen / The Isms of Art, a
visual summary of recent art movements.
While recuperating from a bout of tuber-
culosis in Switzerland in 1924, Lissitzky
experimented with the double-printing of
negatives to produce a series of portraits
of himself, Arp, and Schwitters. He also
used photography, in the form of photo-
montage and photograms, for book jack-
ets, advertising, and wall murals.

Lissitzky frequently employed photog-
raphy in his exhibition designs as well. His
1928 plan for the Soviet pavilion at Pressa
in Cologne featured an enormous photo
frieze that introduced the abrupt rhythm of
photomontage into public space at a previ-
ously unattempted scale. This experimen-
tal use of photomontage was furthered in
Lissitzky's design for the exhibition's cata-
logue, which combined photomontage
with typomontage in what he described as
a "typographic kino-show" (cat. 11). The
Soviet pavilion was highly praised by Euro-
pean critics, and Lissitzky was appointed
to design the Soviet contributions to sev-
eral successive international exhibitions.
Beginning in 1932, he also contributed

photographic and typographic montages to publications such as the monthly propaganda magazine, *SSSR na stroike* (USSR in Construction). Much of this work he accomplished while seeking treatment in the south of Russia for tuberculosis, to which he eventually succumbed in 1941. AH

LITERATURE

Dickerman, Leah. "El Lissitzky's Camera Corpus." In *Situating El Lissitzky: Vitebsk, Berlin, Moscow*, edited by Nancy Lynn Perloff et al., 153–176. Los Angeles, 2003.

Puts, Henk, et al. *El Lissitzky, 1890–1941: Architect, Painter, Photographer, Typographer*. Exh. cat., Municipal Van Abbemuseum. Eindhoven, 1990.

Tupitsyn, Margarita, ed. *El Lissitzky: Beyond the Abstract Cabinet: Photography, Design, Collaboration*. Exh. cat., Sprengel Museum, Hannover. New Haven, 1999.

Rudolf Lutz

(Heilbronn, Kingdom of Württemberg 1895–1966 Heilbronn, Federal Republic of Germany)

Lutz was a furniture designer and architect who attended the Bauhaus between 1919 and 1921. He took the preliminary course with Johannes Itten, studied architecture with Walter Gropius, and also worked in the carpentry and pottery workshops. A 1921 photograph shows Lutz dressed in costume for one of the famous Bauhaus parties. Wearing a short tunic decorated with feathers, cardboard moons, and pieces of newsprint, his muscular legs accentuated by white stockings, he poses dramatically for the camera. A cut-up copy of the photograph became the basis for a collage he made the same year. Called *Utopia*, the collage shows a fragmented Lutz in costume, surrounded by bits of childish lyrics, jaded love sighs ("O thou, o thou, o thou etc."), hearts, and smudges of purple and pink watercolor (cat. 6). In 1922 Lutz took a job in an architect's office in Stuttgart. He then worked briefly at Gerstel's furniture factory in Prague before opening his own architecture office back home in 1925. He designed the furniture for a terrace residence exhibited by J. J. P. Oud at the Stuttgart Werkbund housing exhibition, *Die Wohnung* (1927). After serving in World War II, Lutz again set up an independent architectural practice, designing residential and industrial buildings. AH

Olga Spolarics

(Tolna, Kingdom of Hungary 1895–1969, Wien, Austria)

Adorján Wlassics

(Veszprém, Kingdom of Hungary 1893–1947, Baden bei Wien, Austria)

The married couple Spolarics and Wlassics, both Hungarian by birth, founded Atelier Manassé in Vienna by 1924. Olga took charge of staging and photography, while Adorján was responsible for montage and retouching. Specializing in portraits, nudes, and photographic illustration, within a few years they led the Austrian magazine market. For the title pages of the monthly *Wiener Magazin*, whose illustrated section was largely provided by Atelier Manassé, Wlassics created an individual style with paintings based on photographs. The couple's Hollywood-oriented star portraits transformed actresses and unknown models into glamour girls. Extravagant, frequently suggestive photomontages soon became the studio's trademark. Unconventional, absurd fantasy worlds were created through a playful embrace of clichés and ironic alienation. Extraordinarily kitschy, mostly erotic photomontages had been distributed throughout Europe by the late 1880s, and these images undoubtedly inspired Manassé. Their montages sometimes came close to surrealism, but the resemblance in no way reflects shared concepts.

In the mid-1930s, Spolarics and Wlassics opened a second studio in Bucharest. A studio in Berlin followed shortly, under the name "WOG" (for Wlassics-Olge-Geschke, the latter surname indicating the studio owner whose premises the couple took over). Simultaneously with the move to Berlin, the Vienna studio and its name were sold to a former assistant, yielding the hyphenated enterprise Manassé-Ricoll. Directly before the end of World War II, the two partners returned to Vienna, where Olga ran the studio Foto Wlassics after Adorján's death. AL

LITERATURE

Faber, Monika. *Divas and Lovers: The Erotic Art of Studio Manassé*. With a story by D. H. Lawrence. Trans. Margot Bettauer Dembo. New York, 1998.

Jindřich Marco

(Praha, Czechoslovak Republic 1921–2000 Praha, Czech Republic)

Marco's career in photojournalism began when he published, in the tabloid *Ahoj*, photographs he had secretly taken of his high-school teachers. His first professional job was with the agency Umění-služba umělcům (Art-Services for Artists), where he wrote advertising copy and photographed stage and screen productions. He also worked for the magazine *Praha v Týdnu* (Weekday Prague). Toward the end of World War II (1944) he was arrested and taken to a labor camp at Opole in Poland, from which he managed to escape. He reached Slovakia in early 1945 and joined the staff of the Czechoslovak government, then based temporarily in Košice, where he took pictures for the ministry of information. In April 1945, he left to photograph life in Budapest during the bombardments that marked the final weeks of war there. The project evolved into an extensive series mapping the war's effects on a number of cities in Yugoslavia, Austria, Germany, Poland, and England. These photographs appeared in many Czechoslovak magazines; through collaboration with international agencies such as Black Star, Agence France-Presse, and others, they were also included in *Picture Post, Paris-Match*, and other leading foreign magazines. Following his work on the aftermath of war, Marco collaborated with Artia publishers, a company dedicated to publicizing Czechoslovakia abroad.

In 1950, during the height of Stalinist purges and power struggles in communist Czechoslovakia, Marco was convicted on trumped-up charges. He spent seven years in prison but was ultimately exonerated. He subsequently devoted himself chiefly to publications on art and history, as well as to portraits of artists. However, he occasionally returned to documentary photography, for instance when he photographed the occupation of Prague in August 1968. JP

LITERATURE

Birgus, Vladimír. "S Jindřichem Marcem o fotografickém svědectví z prvních poválečných měsíců" (An Interview with Jindřich Marco on His Photographic Testimony of the First Post-war Months). *Československá fotografie*, no. 5 (1985): 197–199.

———. "Když skončila válka: fotografie Jindřicha Marca" (When the War Ended: The Photographs of Jindřich Marco). *Revue fotografie*, no. 2 (1990): 20–23.

Evžen Markalous

(Prag / Praha, Kingdom of Bohemia 1906–
1959 Praha, Czechoslovak Socialist
Republic)

Almost nothing has been uncovered thus
far about the artistic career of Markalous,
a physician who joined the branch of Devětsil
active in Brno, the capital city of Moravia.
For a few years around 1930, Markalous
apparently published photomontages in
Czech avant-garde periodicals, deriving
his compositional approach and thematic
interests from the "picture poem" genre
first promulgated by Karel Teige and other
Devětsil members in 1923–1924. Marka-
lous had his moment in the international
spotlight when Teige selected his works for
inclusion in *Film und Foto;* two of the pieces
later entered the photography collections
at the Museum Folkwang, Essen, which
mounted a fiftieth-anniversary re-creation
of that historic exhibition in 1979. MW

Lucia Moholy

(Prag-Karolinenthal / Praha-Karlín,
Kingdom of Bohemia 1894–1989 Zollikon,
Switzerland)

Lucia Schulz studied art history and philos-
ophy at the Karl-Ferdinand Universität
(the German division of the university in
Prague) before leaving for Germany in 1914
to take a job in publishing. By 1918 she had
settled in Berlin, where she worked as an
editor and publisher's assistant. She met
the Hungarian painter László Moholy-
Nagy in the fall of 1920, and they were
married in 1921. She and Moholy experi-
mented together with the photogram
and with photomontage, and in 1922 they
published a jointly written theoretical text,
"Production-Reproduction" (Produktion-
Reproduktion) on uses of photography and
the implications of the photogram. When
Moholy-Nagy was invited to head the metal
workshop at the Bauhaus in 1923, Lucia
accompanied him. Her photography skills
were soon put to use in brochures and
advertising material for the Bauhaus. In
1925, she attended a year-long course
on photographic printing techniques in
Leipzig, and after the school moved to Des-
sau she became its primary documentary
photographer. In addition to photograph-
ing Walter Gropius' new buildings, she
documented the functional objects pro-
duced in the metal, wood, ceramic, and
textile workshops; these photos were later
used to promote partnerships between
Bauhaus designers and industrial manufac-
turers. She also took a series of portraits
of Bauhaus students and teachers. Although

she claimed to have photographed people
as impassively as houses, the intellectual and
creative presence of Bauhaus figures cap-
tured by her camera is still palpable today.

When Walter Gropius left the Bauhaus
in 1928, Lucia and László left also, and they
soon parted ways. In 1933 Lucia Moholy
emigrated to London, where she taught the
history and practice of photography at art
schools. Beginning in 1939 she was trained
in microfilming and documented signifi-
cant portions of the library of Cambridge
University, before being employed by
UNESCO, traveling to document libraries
in the Near and Middle East. AH

LITERATURE

Sachsse, Rolf. *Lucia Moholy.* Düsseldorf, 1985.

———, and Sabine Hartmann. *Lucia Moholy:
Bauhaus Fotografin.* Exh. cat., Bauhaus-Archiv.
Berlin, 1995.

László Moholy-Nagy
(Nagy László)

(Bácsborsód, Kingdom of Hungary 1895–
1946, Chicago, United States)

The Hungarian artist László Moholy-Nagy,
an ardent believer in the radical potential
of photography, was probably the single
most influential promoter of the New
Vision in 1920s Germany. As a youth, he
began drawing and making watercolors
during convalescence from a severe injury
sustained in World War I; after the war
he was briefly associated with the avant-
garde Hungarian literary and art group
MA, both in Budapest and in Viennese exile.
He soon moved to Berlin, where he exhib-
ited with Der Sturm and took part in the
1922 Konstruktivistischer-Dadaistischer
Kongreß in Weimar. He met Lucia Schulz
in 1920; they were married the next year
and together began experimenting with
cameraless photography, or photograms.

From 1923 to 1928, Moholy-Nagy taught
at the Bauhaus, first as head of the metal
workshop and then as the teacher of the
all-important *Vorkurs* or preliminary course.
Although no formal photography class
existed during his tenure, he was among
those at the Bauhaus who most encour-
aged extracurricular photographic experi-
mentation. (After three years of work with
photograms and photomontages, he
began to use a camera himself while on
vacation in 1925.) Moholy-Nagy's book
Painting Photography Film, published in 1925
as the eighth in the Bauhaus book series
he edited with Walter Gropius, showcased
the formal and theoretical principles of

"new photography," with pictures and an
accompanying text on the supreme value of
photography as the medium most suited to
contemporary life. The book's role in insti-
gating the vogue for photography among
progressive artists during the latter half of
the 1920s cannot be overestimated.

After Gropius left the Bauhaus in 1928,
Moholy-Nagy moved to Berlin and opened
a private graphic design studio. Over the
next several years and during the process
of emigration via London to the United
States, he relied on commercial work with
manufacturers, theater companies, and
publications to provide an income. In Chi-
cago in the 1940s, Moholy helped to found
the New Bauhaus, later called the Institute
of Design. His Bauhaus book, *Von Malerei zu
Architektur,* published in a revised edition in
1938 under the title *The New Vision,* became
a standard art school text in America, help-
ing to shape art education for the next gen-
eration and offering a ready phrase with
which to categorize retrospectively the
advances of photography in his day. AH

LITERATURE

Botar, Oliver A. I. *Technical Detours: The Early
Moholy-Nagy Reconsidered.* Exh. cat., Art Gallery
of the Graduate Center, CUNY. New York, 2006.

Haus, Andreas. *Moholy-Nagy: Photographs and
Photograms.* Trans. Frederic Samson. New York,
1980.

Hight, Eleanor M. *Picturing Modernism: Moholy-
Nagy and Photography in Weimar Germany.* Cam-
bridge, Mass., 1995.

Molderings, Herbert. "Laszlo Moholy-Nagy und
die Neuerfindung des Fotogramms" (Moholy-
Nagy and the Rediscovery of the Photogram). In
*Kunst und Fotografie: Floris Neusüss und die Kasseler
Schule für Experimentelle Fotografie 1972–2002,*
edited by Renate Heyne, 117–131. Marburg, 2003.

Passuth, Krisztina. *Moholy-Nagy.* London, 1985.

Martin Munkacsi
(Memelstein Márton)

(Kolozsvár / Cluj, Kingdom of Hungary
[today Cluj, Romania] 1896–1963 New York
City, United States)

Munkacsi—the modern master of the
snapshot—was born into a working-class
Jewish family. His father was a house-
painter and a locally famous magician. By
age sixteen, Munkacsi had left home for
Budapest, where he found a job as a jour-
nalist and sports reporter. In 1917 he
opened a portrait studio; his real start in
photography came in 1923, however, when
pictures he shot from a moving tram cap-
tured the key moments of an altercation
that ended in murder. At the trial, his pho-
tos were crucial evidence, and he became
an overnight sensation.

Photographs of suspenseful and potentially violent events taken in midaction would become Munkacsi's trademark. As a sports photographer for the leading Budapest newspapers *Az Est* (The Evening), *Pesti Napló* (Pest Diary), and *Ma Este* (This Evening), he captured soccer players in midair, diving to the ground, or just moments before a collision. Covering an auto race, he strapped himself to the side of one of the racecars and was seriously injured when he fell off during the competition. Munkacsi would also sometimes attach a fake lens to his camera so that it appeared to be photographing something other than his true subject. When he left for Berlin in 1928, his success was building: he had just participated in a group exhibition in Vienna and was one of only a few photographers in Budapest always credited by name for their images. He signed a three-year contract with Ullstein publishers shortly after his arrival in Berlin. For the next several years, he traveled on assignment throughout Europe, the Middle East, and Africa. In 1931 the British journal *Modern Photography* listed him among the top one hundred photographers in the world.

After 1933, many editors at Ullstein were replaced with Nazi party members and working conditions became nearly impossible. Munkacsi's photographs of a fruit market were apparently rejected, for example, because according to his new editor, "Bananas are not an Aryan fruit." In 1934, Munkacsi settled permanently in the United States and signed a contract with *Harper's Bazaar* that made him one of the world's highest-paid photographers. In "Think while You Shoot," a 1935 article offering advice to amateur photographers, Munkacsi reiterated what his career had demonstrated: "All great photographs today are snapshots." AH

LITERATURE

Gundlach, F.C., ed. *Martin Munkacsi.* Exh. cat., Deichtorhallen Hamburg. Göttingen, 2005.

White, Nancy, and John Esten. *Style in Motion: Munkacsi Photographs, 20s, 30s, 40s.* New York, 1979.

Bohumil Němec

(Steinitz/Ždánice, Margraviate of Moravia 1912–1985 Praha, Czechoslovak Socialist Republic)

Němec studied advertising and window dressing at the Škola uměleckých řemesel (School of Arts and Crafts) in Brno (1929–1934) under Emanuel Hrbek. While still at school he founded with fellow students the group f5 (1933–1936), which concentrated on experiments with both negative and positive prints in photography. He exhibited with f5 and later, in 1939, with their reorganization as a foursome under the name f4. Němec displayed great inventiveness in combining and modifying photographic techniques. He tested optical deformations, tilting the negative and the positive during printing. He combined negatives with positives to create relieflike structures and also printed simultaneously from negatives and slide positives of the same object, turning the two images 180 degrees from each other. He approached the chemistry of printing with equal creativity. Like his colleagues, Němec admired the work of El Lissitzky, László Moholy-Nagy, and, above all, Man Ray, the perennial favorite of the Czech avant-garde. His work *Experiment* (cat. 104) pays tribute to Man Ray's portraits while pushing in new directions. A negative print, solarized during printing, has yielded a face rimmed with a shining line, transformed into a mysterious, rigid mask. Němec pursues here a favorite surrealist confusion between the living and the inanimate; a hybridization rendered more disorienting still by the use of brown toning agents in the developing bath (coloring, or discoloring, black-and-white photographs was Němec's specialty). This work may have been part of the album *Experiments*, which f5 exhibited as a collective work at the second *Výstava sociální fotografie* (Exhibition of Social Photography) in Prague in 1934.

In the course of his professional life, Němec alternated between painter, designer, graphic artist, and scenographer. He also designed excellent advertisements, including posters for the 1946 elections (see František Povolný). He ceased making photography in the 1950s. JP

Ada (Adolf) Novák

(Budweis/České Budějovice, Kingdom of Bohemia 1912–1990 České Budějovice, Czechoslovak Republic)

During his studies at the Akademie výtvarných umění (Academy of Fine Arts) in Prague, the painter Novák helped found the České Budějovice collective Linie (1931–1939), whose members were mostly literary figures and painters. Together with Linie leader Josef Bartuška (see biography), he formed the photographic subgroup Fotolinie, strongly oriented toward "new photography." A keen collector of jazz records, his musical selections often accompanied openings of Linie and Fotolinie exhibitions. Novák photographed a wide variety of subjects, from everyday studio items to nudes, portraits, and architecture. He employed uncommon camera angles and a short depth of field. Quite often, sharply focused details stand out as if dialectically from a larger, blurred background. The properties of light held fundamental importance in his oeuvre, most likely the influence of post-impressionist painter Willi Nowak, his professor at the Prague Academy (1930–1936). Novák's untitled composition (cat. 114) transforms the model's skin into an abstract play of modulations in light and shade. The nude's off-center position in this picture recalls explorations in the physiology of vision by impressionists and post-impressionists, who painted deformations and seemingly unnatural juxtapositions of color that presumably followed the natural functioning of human sight. (Similar considerations, ironically, motivated the early pictorialists, photographers against whose legacy Novák rebelled in his own photographic work.) When Fotolinie disbanded, Novák, like most of the group's members, abandoned photography. He returned to it in the 1960s, but never again achieved the standard of that earlier period. After the war he concentrated chiefly on landscape painting, and in the 1950s his work began to conform to the dictates of Stalinist socialist realism. JP

LITERATURE

Formánek, Václav. *Ada Novák.* České Budějovice, 1972.

Gyula Pap

(Orosháza, Kingdom of Hungary 1899–1983 Budapest, People's Republic of Hungary)

Best known as a sculptor and painter, Pap began his artistic training at the Graphische Lehr- und Versuchsanstalt in Vienna from 1914 to 1917, where he also learned the basics of photography. Serving thereafter on the Italian front, Pap took documentary images that can be viewed as significant precursors to his later, socially conscious work. Following the war, he studied briefly at the Magyar Iparművészeti Iskola (Hungarian School of Applied Arts) in Budapest, then relocated to Germany after the fall of the short-lived Hungarian socialist republic in 1919. There he enrolled in the Weimar Bauhaus specifically to study under Johannes Itten, who became a mentor for life. Offered the opportunity to lead the school's metal workshop, Pap declined in order to return to Hungary and care for his ailing mother; from 1924 to 1927, he also worked as a lithographer in various cities

throughout the nearby region of Transylvania, formerly Hungarian but now in Romanian hands. During this time, Pap began seriously to pursue photography. He is not known to have exhibited his works, but some appeared in the Hungarian press. In late 1928 he returned to the Itten School in Berlin, founded two years previously, and taught a variety of courses in the graphic arts alongside fellow Bauhaus graduate Umbo, whom Lucia Moholy succeeded as the school's photography teacher. The rise of the National Socialists led Pap to move in 1934 to Budapest, where he quickly established contact with Lajos Kassák and other outspoken socialist artists. He founded a painting school in the town of Nagymaros for children of workers and peasants. Two years later, in 1949, the Képzőművészeti Főiskola (Academy of Fine Arts) in Budapest hired him as a professor of painting. Here too, Pap took photographs, completing a number of series. EC

LITERATURE

Bajkay, Éva. "Gyula Pap: The Last Hungarian Bauhaus Artist." *The New Hungarian Quarterly* 25, no. 94 (Summer 1984): 185–187.

Haulisch, Lenke. *Pap Gyula.* Exh. cat., Petőfi Művelődési Központ. Orosháza, 1985.

Mihály, Ida F. *Pap Gyula.* Exh. cat., Magyar Nemzeti Galéria. Budapest, 1979.

József Pécsi
(Goldberger Sámuel)

(Budapest, Kingdom of Hungary 1889–1956 Budapest, People's Republic of Hungary)

The highly influential Pécsi was among the leading popularizers of modernity in Hungarian photography. Before World War I, he first studied business in Budapest and then photography at the Lehr- und Versuchsanstalt in Munich. In addition to running a private school in his lavishly decorated Budapest studio, Pécsi founded the photography department at the Székesfővárosi Iparrajziskola (Budapest School of Industrial Drawing) in 1913. By this time he had received numerous medals and been made an honorable member of the London Salon of Photography. Pécsi also served as editor for *Magyar Fotografia*, the journal of the Hungarian Photographer's Guild. Enormously productive and successful, he wrote *The Photographer's Art* in 1916 (2nd ed., 1926), championing in good pictorialist fashion a gentle use of light and harmonious aesthetic expression. Pécsi's 1930 primer *Photo and Advertising*, by contrast, adopted many conventions of the ascen-

dant "new photography." This bilingual, illustrated how-to album presented dynamic diagonals, bold colors, and the (still harmonious) mixture of photography and typography. The typography in Pécsi's advertising work is due to photographer György Kepes and to Pécsi's wife Rózsa Balázs, who studied fashion in Paris and worked briefly for Chanel. Pécsi's many commissions included photographs of architectural monuments as well as portraits of artists such as Béla Bartók and Russian dancer Anna Pavlova. Pécsi traveled throughout Italy in 1927–1928 and six years later toured Spain, Algiers, Greece, and Turkey, taking photographs of regional cultures. His travels, his career as a teacher and exhibitor, and his cultivation of international contacts helped disseminate modernist ideas in Hungary, yet despite Pécsi's wide range of subject matter the pictorialist sensibility that marked his early work never fully yielded to a "modern look." After Pécsi's studio burned during the war, he went into hiding in Oradea, Romania, to escape further anti-Semitic violence. When he returned to Budapest in the summer of 1946, he was met with repressive political demands that eventually reduced his professional activities to taking passport photos. He died after an extended illness. EC

LITERATURE

Beke, László. "The Centenary of József Pécsi's Birth." In *A fénykép varázsa / The Magic of Photography, 1839–1989*, edited by Mihály Gera, 239–276. Exh. cat., Budapest Festival. Budapest, 1989.

Féjja, Sándor. *Pécsi József munkássága* (The Work of József Pécsi). Budapest, 1976.

Walter Peterhans

(Frankfurt, Grand Duchy of Hesse 1897–1960 Stetten, Federal Republic of Germany)

Peterhans came to photography in 1925, after several years spent studying mechanical engineering, mathematics, and philosophy. Upon completion of a course in photographic reproduction and printing techniques at the Staatliche Akademie für Graphische Künste und Buchgewerbe (State Academy of Printing and Book Arts) in Leipzig, he moved to Berlin and opened a studio for commercial and portrait photography. He also gave private photography lessons. Among his most important pupils were the future advertising team of Grete Stern and Ellen Auerbach (see ringl+pit). Between 1929 and 1933, while teaching the first formal photography course offered at the Bauhaus, Peterhans produced a series of experimental still lifes,

eight of which were shown at *Film und Foto* in 1929. Exquisitely composed of a mixture of natural and manmade objects, these works are a study in contrasting textures and levels of translucency, arranged to exemplify what Peterhans considered to be photography's inherent strength: the precise and detailed capture of tonal gradations. In his only written statement on photography, published in full in the Czech journal *ReD* in 1930, Peterhans referred to the prevalence of forced tonal contrasts in "new photography" as photographing "with a hammer." Only by attaining ever subtler gradations of midrange tones would one produce a photograph true to the unique characteristics of the medium. Although his method was scientific and detached, his photographs are often strange and elusive, with an otherworldly beauty (cat. 29).

After the Bauhaus closed in 1933, Peterhans continued to teach at private photography schools in Berlin. In 1938 he emigrated to Chicago, joining Mies van der Rohe at the Illinois Institute of Technology as instructor of visual training and analysis. AH

LITERATURE

Auerbach, Ellen. "Walter Peterhans." In *Fotografie 1922–1982: Erfundene Wirklichkeit* (Photography 1922–1982: Invented Reality). Exh. cat., International Photo- and Cine Exhibition. Cologne, 1982.

Graeve, Inka. *Walter Peterhans, Fotografien 1927–38.* Exh. cat., Museum Folkwang. Essen, 1993.

Karel Plicka

(Wien, Archduchy of Lower Austria 1894–1987 Praha, Czechoslovak Socialist Republic)

Plicka's career choices—in photography, film, folkloric research, musicology, and arts education—were determined above all by his innate musical abilities (he was a semiprofessional violinist) and his proclivity toward art. In 1923 he started to collect folk songs and photograph folk culture for the Matica slovenská (Slovak Foundation), a patriotic organization governing projects in culture and social science, founded in 1863 on a model established first in Serbia (1826) and then in the Czech lands (1831). Abolished in 1875 by the Hungarian rulers for fomenting Slovak cries for independence, the Matica was reestablished in 1919, in an atmosphere of jubilation at the attainment of statehood. Nationalist pride deeply affected Plicka, who spent his childhood in Austria and Bohemia but came to Bratislava, the Slovak capital, to study musicology and ethnography (1924–1928). Plicka inclined toward the heroicization of

country life, a programmatic message he put forward through aesthetically original and poetically stylized still images and also films: *In Search of the Slovak People* (*Za slovenským l'udom*, 1929), *Through the Hills, Through the Valleys* (*Po horách, po dolách*, 1930), and most famously *The Singing Earth* (*Zem spieva*, 1933), the latter made with Alexandr Hackenschmied. Plicka combined these odes to rural tradition with attempts at cataloguing folk dances, costumes, stories, and other customs. He also produced a series of picture books from the late 1930s on the Czech lands and Slovakia, including one on Prague (1940), in which the city's premodern architecture is shown in timeless and monumental perspective. His interest in architecture manifested itself in two further documentary films, *Eternal Song* (*Věčná píseň*) and *Baroque Prague* (*Barokní Praha*), made during the Nazi occupation to strengthen national self-awareness. After the war Plicka became a founding member of FAMU, the legendary film school in Prague (1946), where he served as dean and professor. He was awarded the title of National Artist in 1968 for his achievements in the fields of art, folklore, and teaching. JP

LITERATURE

Jeníček, Jiří. "Zem spieva." *Fotografický obzor* 61, no. 1 (1933): 156.

Slivka, Martin. *Karol Plicka: básnik obrazu* (Karol Plicka: Poet of the Image). Martin, Slovakia, 1999; 1st ed., 1982.

Kazimierz Podsadecki

(Zabierzów, Kraków, Kingdom of Galicia and Lodomeria 1904–1970 Kraków, People's Republic of Poland)

Podsadecki was a leader in Polish photomontage of the interwar years. After finishing his studies in decorative arts at the Szkoła Przemysłowa (Industrial School) in Kraków in 1923, he entered the literary and artistic avant-garde circle around the periodical *Zwrotnica* (Switch) and began experimenting with photography and photomontage. In 1926 he joined the avant-garde group Praesens and exhibited abstract paintings. At the same time he began designing magazine layouts, both for art periodicals such as *Zwrotnica* (1926–1927) and *Linia* (1931–1932), and for a mass readership. In his work he persistently combined an interest in avant-garde art, especially constructivism, with experimental and popular cinema and the developing illustrated press market. In 1928, Podsadecki began to work for the IKC press concern, which published news and

entertainment weeklies. He illustrated two of these, *Na szerokim świecie* (Out in the World) and *Światowid* (Eye on the World), with elaborate photomontages aimed at imbuing reportage and other stories with a cinematic atmosphere. A set of sparer, more lyrical compositions, entitled *And This Is My Design for an Illustrated Weekly* (*A to projekt mój tygodnika ilustrowanego*), followed in 1933. Podsadecki's fascination with film and photographic techniques bore fruit in 1931 in an international exhibition of "new photography," as well as the founding of SPAF, a club for experimental cinema, both organized in Kraków together with Janusz Maria Brzeski (see biography). Podsadecki considered the montage of photographs the foundation of cinematographic technique and showed satirical photomontages at SPAF screenings as his own kind of cinematic effect. He published articles about film and continued to paint, his style evolving from geometric abstraction to coloristic figuration. Following World War II, he worked as designer for the magazines *Przekrój* (Cross-Cut) and *Dziennik Polski* (Polish Daily). SC

LITERATURE

See biography for Janusz M. Brzeski.

František Povolný

(Brünn / Brno, Margraviate of Moravia 1914–1974 Brno, Czechoslovak Socialist Republic)

When Povolný worked as a journalist at the Brno communist newspaper *Rovnost* (Equality), in the post–World War II era, not even his closest colleagues suspected he was a photographer. He and the group f5 came to renewed attention only with the exhibition *Avantgardní fotografie 30. let na Moravě* (Avant-Garde Photography of the 1930s in Moravia, Brno, 1981). The full significance of that group, in which Povolný played a key role, is still gradually coming to light (see also biographies for Karel Kašpařík and Bohumil Němec). Povolný, the group's theorist, opposed the ideal of photographic reproducibility, asserting instead the uniqueness of the individual print. In response to critics who regarded manipulation of negative and positive as "tinkering," he declared that a work's aesthetic impact carries greater importance than the technique used to produce it. Unique at that time were Povolný's so-called *Photographics* (1933–1934, cat. 105), created by heating the emulsion on glass negatives, then printing the resultant distortion through an enlarger. These amorphous structures suggest a hallucinatory state of mind, one that encourages free

associations and leaves fixing the picture's meaning to chance and to the viewer. In the mid-1930s Povolný's studio was a meeting place for devotees of surrealism in Moravia; through the poet Vítězslav Nezval, Povolný also formed contacts with the Prague center of the Czech surrealist movement (founded officially in 1934). He also photographed on social topics and exhibited at the second *Výstava sociální fotografie* (Exhibition of Social Photography) in Prague (1934). After World War II he and Němec founded the P5P group; it produced canvassing materials for the Communist Party in the elections of 1946, which it ultimately won. Although photography enhanced these propaganda materials, Povolný's creative activity in the darkroom remained confined to the 1930s. He abandoned photography for journalism but continued to work in the arts, helping, for instance, to found the popular satirical theater Večerní Brno (Brno in the Evening). JP

LITERATURE

Pátek, Jiří. "Dodatky k surrealistické inscenované fotografii Františka Povolného" (Appendix to František Povolný's surrealist photography), *Bulletin Moravské Galerie v Brně*, no. 61 (2005): 259–270.

Sergej Protopopov

(Valuyki, Province of Voronezh, Russia 1895–1976 Banská Štiavnica, Czechoslovak Socialist Republic)

Protopopov learned photography in high school in Voronezh before studying figurative painting in Kharkiv (now Ukraine). He was mobilized in 1918 and evacuated to Turkey a year later, leaving for Czechoslovakia in 1920 to find work. Initially a laborer, he obtained a stipend to study forestry in the South Bohemian town of Písek, which led to employment from 1926 at the forestry school in Banská Štiavnica, a mining town in central Slovakia once critical to the Hungarian silver and gold trade. After a further stay (1929) in the Czech part of Czechoslovakia, studying painting at the Akademie výtvarných umění (Academy of Fine Arts) in Prague, he took up residence permanently in Banská Štiavnica, purchasing a photographic atelier there in 1932 and establishing himself as a painter, photographer, and filmmaker. When private enterprise was abolished by the communists in 1948, he made photographs and tourist films for local state agencies, then found a position with an educational institution in town.

Not until 1970, soon after his retirement, did he have a solo exhibition, in Bratislava, where the greatest surprise was a photographic series entitled *Log Drivers on the River Uh (Pltníci na rieke Uh*, 1927), displayed for the first time in public. Another reportage series looked at his adopted hometown's legendary, though rapidly declining, mining industry (cats. 71–72); these pictures had appeared in newspapers throughout Czechoslovakia in the early 1930s and counted among the first examples of photojournalism in Slovakia. A certain stiffness in Protopopov's figures contrasts remarkably with his portrayals of people in other outdoor series, which treat everything from religious pilgrimages to the rigors of country life with uncompromising directness. While the stylized appearance may reflect Protopopov's training as a painter, technical limitations surely made it difficult to capture movement in artificial light and thus encouraged static, guided poses. In his retirement, Protopopov returned to this subject in a sense, undertaking to photograph the collections of the local mining museum. JP

LITERATURE

Hlaváč, L'udovít. "Za Sergejom Protopopovom." *Výtvarný život*, no. 9 (1976).

Albert Renger-Patzsch

(Würzburg, Kingdom of Bavaria 1897– 1966 Wamel bei Soest, Federal Republic of Germany)

The son of a bookseller with a passion for photography, Renger-Patzsch was educated early in lithography and photography techniques. In 1922, he was appointed to direct the photography department at the Folkwang-Archiv, Essen, where an assignment to supply photographs for a series of books on plants launched his professional career. In 1925 he relocated to Bad Harzburg, in the center of Germany, where he opened a business supplying photographs to industry, architects, and publishers. He received his first widespread publicity in 1928, with the publication of *The World Is Beautiful*, a book of one hundred photographs of natural and man-made objects. As if to emphasize the neutrality of his vision, Renger-Patzsch had wanted to call his book *Things (Die Dinge)*, a bold suggestion overruled by his publisher. Immensely popular in Germany and throughout central Europe, the book was favorably reviewed by luminaries, including the satirist Kurt Tucholsky, who described Renger-Patzsch's photographs as expressing a

"pure visual joy in the concrete thing." Also promoted by amateur photography clubs internationally, *The World Is Beautiful* made the term "new objectivity" a household word and created a niche for the photo-book as a marketable form of artistic expression. Renger-Patzsch's work was featured soon afterward in a one-person show at the venerable Société Française de Photographie, Paris, and at leading exhibitions of "new photography" in subsequent years.

In 1928 Renger-Patzsch returned to Essen, where he produced a body of commissioned work documenting the heavy industry and bleak landscapes of the surrounding Ruhr district, the center of Germany's coal and steel production. In 1933 he was invited by Max Burchartz to teach photography at the aesthetically progressive Folkwangschule. After only two semesters there the Nazi government began to exert pressure on the arts and he gave up his position. Renger subsequently turned to landscape photography and a life of semiretirement. AH

LITERATURE

Heckert, Virginia, ed. *Albert Renger-Patzsch*. Special issue of *History of Photography* 21, no. 3 (1997).

Kuspit, Donald B. *Albert Renger-Patzsch: Joy before the Object*. Exh. cat., The J. Paul Getty Museum, Los Angeles. New York, 1993.

RÉVÉSZ-BIRÓ

Imre Révész

(Budapest, Kingdom of Hungary 1895– 1975 New York City, United States)

Irma Biró

(unknown)

Extremely little is known about the Hungarian team of Révész-Biró. In fact, confusion persists over Ms. Biró's first name (Irma or Judit). It is fairly certain, however, that in 1934 the pair exhibited at the *Országos Magyar Iparművészeti Társulat Kiállítása* (National Hungarian Applied Arts Association Exhibition) in Budapest and that they authored the illustrated instructional manual *Photo and Advertising* (cat. 90). Appearing around 1932, two years after József Pécsi's book of the same title, Révész-Biró's *Photo and Advertising* has a notably similar layout. The introductory essay, printed in Hungarian, German, and English, hails the objective lens of photography as the basis for the "new science" of advertising, which Révész-Biró believes "should tell the truth

by all means." On the whole, the pictorial guide suggests the broad popularity by then in Hungary of advertising design techniques signifying an internationalized modernity. Photomontages and photograms, strong diagonals, and other hallmarks of constructivist typography from the 1920s recur here in a thoroughly integrated context. EC

RINGL+PIT

Grete Stern (ringl)

(Elberfeld [today Wuppertal], Rhine Province, Kingdom of Prussia 1904– 1999 Buenos Aires, Argentina)

Ellen Auerbach (pit)

(Karlsruhe, Grand Duchy of Baden 1906– 2004 New York City, United States)

Stern studied art in Stuttgart and, from 1927, photography in the private studio of Bauhaus professor Walter Peterhans. Auerbach, who had studied sculpture in art school, decided to focus on photography because it presented a better chance to earn an independent living. In 1929, after seeing Peterhans' photographs, she moved to Berlin expressly to study with him. At that time, Stern was his only other private pupil, so the two often collaborated. From their teacher, they learned a high standard of technical precision in the studio and darkroom—they refused subsequently to allow retouching or cropping of their images in publication—as well as a skill for capturing subtle surface textures and material qualities. In 1930, using her inheritance, Stern bought Peterhans' equipment, and together she and Auerbach opened a commercial studio under their childhood nicknames.

Although ringl+pit provided commissioned photographs primarily for small magazines or individual clients and had only modest financial success, their work gained renown through a feature article in 1931 for the German trade magazine *Gebrauchsgraphik*, where it was praised for its attention to nuance and its technical fidelity. In some images, the team combined precision with an unexpected spoof of publicity clichés: a 1931 advertisement for Petrole Hahn shampoo shows a smiling mannequin with glossy artificial hair, but a real human hand holding the shampoo bottle. Additional recognition of ringl+pit's work came in 1933, when they received first prize at an international photography exhibition and competition in Brussels.

By the end of 1933, Stern and Auerbach, both Jewish, had made plans to leave Nazi Germany. With a financial gift from Stern, Auerbach and her future husband left for Tel Aviv, eventually joining Stern in London two years later. In 1937, when the British government did not renew their visas, Stern emigrated to Buenos Aires, where she worked as a portrait, still-life, and landscape photographer, and Auerbach moved to New York, finding work as a teacher of photography and freelance photojournalist. AH

LITERATURE

Eskildsen, Ute, and Susanne Baumann. *Grete Stern, ringl+pit, Ellen Auerbach.* Exh. cat., Museum Folkwang. Essen, 1993.

————. *Ellen Auerbach: Berlin, Tel Aviv, London, New York.* New York, 1998.

Lavin, Maud. "Ringl + Pit: The Representation of Women in German Advertising, 1929–33." In Lavin, *Clean New World: Culture, Politics and Graphic Design,* 50–67. Cambridge, Mass., 2001.

Schalcher, Traugott. "Fotostudien Camera Studies ringl+pit (Ellen Rosenberg Grete Stern)." *Gebrauchsgraphik International Advertising Art* 8, no. 2 (1931): 33–39.

Sykora, Katharina. "Doppelspiele: Über die fotografische Zusammenarbeit von Ringl + Pit alias Grete Stern und Ellen Auerbach" (Doubling Games: On the Photographic Collaboration of ringl+pit alias Grete Stern and Ellen Auerbach). In *Liebe macht Kunst: Künstlerpaare im 20. Jahrhundert,* edited by Renate Berger, 87–108. Cologne, 2000.

Franz Roh

(Apolda, Grand Duchy of Saxe-Weimar 1890–1965 München, Federal Republic of Germany)

As a university student, Roh explored philosophy, literary criticism, history, and art history. From 1916 to 1919, he served as assistant to Heinrich Wölfflin, one of the fathers of the modern discipline of art history. After completing a dissertation on Dutch painting under Wölfflin, he worked as a freelance art critic and writer for various art magazines. During the mid-1920s, Roh became increasingly interested in contemporary art. He established a correspondence with Max Ernst, and after reading László Moholy-Nagy's book, *Painting Photography Film,* he began to make photographs himself, experimenting with the techniques of photomontage, layered negatives, and negative printing. *Under Water (Unter dem Wasser),* a series of his negative prints, was shown at *Film und Foto* in 1929. In conjunction with this exhibition, Roh and Jan Tschichold published *Photo-Eye,*

a book of experimental photographs that is now a classic manifestation in the history of "new photography." In his introduction, Roh emphasized the importance of untrained amateurs, arguing that the medium of photography is accessible even to those with no formal art education or drawing skills—even "Raphaels without hands" are capable of artistic expression. In 1930, as part of *Fototek,* an encyclopedic photography series he planned to edit, Roh published monographs on his contemporaries Moholy-Nagy and Aenne Biermann. Both books included essays by Roh that further refined his photographic theories.

After the Nazi seizure of power, Roh spent many months in an internment camp; on his release, he was forced into internal exile. After the war, he reemerged into public life as an editor, art critic, and professor of modern art history at the Universität München. In the early 1960s he exhibited collage works for the first time and, inspired by Max Ernst, began organizing them into a novel to be called *The Metamorphoses of Mr. Miracolossus (Metamorphosen des Herrn Miracoloss).* AH

LITERATURE

Bischoff, Ulrich, ed. *Franz Roh: Kritiker, Historiker, Künstler.* Exh. cat., Staatsgalerie Moderner Kunst, Bayerische Staatsgemäldesammlungen. Cologne, 1990.

Fernández, Horacio. *Franz Roh: teórico y fotógrafo.* Trans. Karel Clapshaw. Exh. cat., IVAM Centre Julio González. Valencia, 1997.

Werner Rohde

(Freistadt Bremen 1906–1990 Worpswede, Federal Republic of Germany)

Rohde grew up surrounded by art and craft. His father, a craftsman who specialized in painting on glass, also enjoyed taking family photographs and used the camera to make studies for his glass paintings. After it was agreed that Rohde, too, would become an artist, his father sent him to the Kunstgewerbeschule (School of Applied Arts) in Halle from 1925 to 1927, where Rohde studied painting. He also began to take photographs, assembling an album of nearly seven hundred snapshots, and may have attended photography lessons with Hans Finsler, a former student of Heinrich Wölfflin and the school's librarian and art history teacher. Along with Walter Peterhans at the Bauhaus and Max Burchartz at the Folkwangschule in Essen, Finsler was one of the foremost teachers of photography at Germany's art and design schools in the 1920s.

In 1927, Rohde ended his studies to return to Bremen for training in his father's workshop. Between 1927 and 1932, he learned his father's trade, but this was also his period of greatest experimentation with the camera. He and his future wife Renata Bracksieck, a fashion designer he met in 1928 who shared his love of film, cabaret, and masquerades, would dress up and take photographs. In many of his portraits and self-portraits, faces appear half-hidden behind screens, panes of glass, or webs of shadows, creating an eerie effect (cat. 45). Rohde first exhibited his photographs in 1929, when he responded to an announcement in an art magazine asking for submissions to *Film und Foto* in Stuttgart. Seven of his photos were shown. In the early 1930s, Rohde did some work as a professional photographer, documenting a museum's collection of historic clothing and shooting a series of artist portraits for a gallery in Berlin. During World War II, he was captured by the British and held prisoner from 1942 to 1945. Upon his return, he continued to work with his father; together they completed the restoration of stained glass windows in the Bremen Cathedral, which had been destroyed by Allied bombing. AH

LITERATURE

Barchan, Pawel. "Der Fotograf Werner Rohde." *Eva* 10, no. 5 (Prague, 1937 / 1938): 10, 11.

Brüggemann, Ferdinand, and Ingo Taubhorn. *Werner Rohde: Fotografien, 1925 – 37.* Exh. cat., Museum Folkwang, Essen. Berlin, 1992.

Witold Romer

(Lemberg / Lwów, Kingdom of Galicia and Lodomeria 1900–1967 Wrocław, People's Republic of Poland)

Romer began to exhibit his photographs in 1926, and in 1932 became the director of the photography program at the Lviv Polytechnic. He also worked in the graphic design firm Książnicy-Atlas in Lviv, which in 1937 began to print photographic postcards using a technique he had developed. This technique was used primarily for documentary photographs of Polish landscapes and architecture by, among others, Jan Bułhak and Antoni Wieczorek. The firm created a collection of 2,080 postcards, which became the cornerstone of the program of Homeland Photography. After World War II, Romer headed the photography department at the Polytechnic in Wrocław.

Romer's work ranged from purely pictorial themes, such as landscapes, to photographs modeled on the German New Objectivity. He was also interested in industry and

industrial products, often reducing these subjects to blocks melting into a landscape, their powerful contours standing out against the background (cat. 92). Such simplified, monumental images of architecture were popular in Poland in the second half of the 1930s. In 1932 he announced the development of a new photographic technique, *izohelia,* which reduced the tonality in a photograph. The son of prominent cartographer Eugeniusz Romer, Witold took his invention from hypsometrical maps, which represent the earth's topography through contoured single-color fields separated by lines. Romer later recalled: "I had the idea to present photographic images in a similar way, by demarcating fields of identical tonal gradation and filling out the areas bounded by these lines with uniformly colored half-tones of gradually increasing lightness, beginning with the deepest black and finishing with pure white." Romer's process, while modernist in a way, reflects less an affinity for "new photography" than a scientist's attraction to technology and to an analysis of the workings of photography. MS

LITERATURE

Nowak, Piotr, Jerzy Piwowarski, Adam Zaleski, and Aleksander Żakowicz. *Profesor Witold Romer (1900–1967): działalność naukowa i artystyczna* (His Scientific and Artistic Work). Wrocław, 1998.

Sobota, Adam. *Witold Romer, 1900–1967.* Exh. cat., Muzeum Narodowe we Wrocławiu. Wrocław, 1983.

Hajo (Hans-Joachim) Rose

(Mannheim, Grand Duchy of Baden, 1910–1989 Leipzig, German Democratic Republic)

Rose attended the Kunstgewerbeschule (School of Applied Arts) in Königsberg, a German-controlled port city on the Baltic Sea (now Kaliningrad, Russia), in 1929–1930. From 1930 until 1933, he was a student at the Bauhaus, where he took the foundation course with Josef Albers and worked with painter Vasily Kandinsky and with Walter Peterhans in photography. He earned a diploma from the Bauhaus in advertising and was an assistant to Moholy-Nagy in Berlin in 1933–1934. From 1934 until 1939, he lectured in advertising graphics, typography, and photography at the Nieuwe Kunstschool in Amsterdam, which was founded and directed by Paul Citroen, also a former Bauhaus student. Rose served in World War II and was taken prisoner. Between 1949 and 1958 he lectured at various colleges in the German Democratic Republic and did freelance work for industry. AH

Jaroslav Rössler

(Smilau / Smilov, Deutschbrod / Německý Brod [today Havlíčkův Brod], Kingdom of Bohemia 1902–1990 Praha, Czechoslovak Republic)

Rössler moved to Prague at age fifteen to apprentice in the studio of František Drtikol. His eight years with Drtikol released a remarkable, almost miraculous flowering of modernist talent. Rössler began to make highly original still lifes using studio props already in 1919–1920, and in the years afterward created radical experiments in abstract photography and photomontage. (He also drew pastels in an inspired, if less than innovative, cubist manner.) He consistently rendered objects dematerialized, diminishing their solidity through flattening or blurring, and he composed several studies with no subject but light alone. Rössler joined Devětsil in 1923, although he exhibited with the group only in 1926; at that time, he also collaborated with the Osvobozené divadlo (Liberated Theater), Devětsil's theater section, led by director Jindřich Honzl. In the meantime, however, Rössler had spent a season in Paris, where he returned to live from 1927 until 1935, working for advertising and glamour photographer Lucien Lorelle. In this second phase of his interwar career, Rössler concentrated on product photography (aspirin, detergent, toothpaste) in a fashionably modern style, while privately pursuing experimental ideas in film, radio (he was a lifelong amateur radio enthusiast), and photomontage.

A fateful police encounter led to Rössler's expulsion from France and prompted a lasting mental crisis. Although Rössler operated a small studio in Prague from 1936, he did not return to serious artistic experiments until twenty years later. Semi-abstract studies of street scenes, still lifes, and architecture, made with prismatic lenses or through so-called sandwich montage (multiple negatives enlarged simultaneously to make one print), characterize his work of the 1960s and 1970s, which includes psychedelic color images as well. Rössler lived, happily, to see his own historical recognition, beginning with acquisitions by the leading Czech museums for photography around 1970 and a string of subsequent exhibitions in his final two decades. MW

LITERATURE

Birgus, Vladimír. *Jaroslav Rössler.* Prague, 2001.

Birgus, Vladimír, and Jan Mlčoch, eds. *Jaroslav Rössler: Czech Avant-garde Photographer.* Exh. cat., Uměleckoprůmyslové muzeum v Praze. Cambridge, Mass., 2004.

Lothar Rübelt

(Wien, Archduchy of Lower Austria 1901–1990 Velden, Austria)

An athlete himself, Rübelt became involved in sports photography in 1919, giving up engineering studies for increasingly successful work as a photojournalist. With his brother Ekkehard, he founded the agency Phot-Rübelt around 1922 in Vienna and directed the film *Over the Clouds on a Motorcycle (Über die Wolken mit dem Motorrad,* 1926–1927) in the Dolomites. Rübelt supplied photos first primarily for Austrian and German magazines, then increasingly for Swiss, British, and other news agencies. In addition to his mainstay in sports journalism, he published in books, took advertising commissions, and prepared travel reports. At the same time he documented current social and political events. Rübelt achieved recognition especially for his pictures from the 1936 Summer Olympics in Berlin, produced on assignment for the *Berliner Illustrirte Zeitung.* With the help of hand-held cameras, including modifications of his own design, Rübelt was able to take snapshots of surprising spontaneity. Influenced by "new photography," he employed unusual angles and worked intensively with the possibilities afforded by bird's- and worm's-eye views. During World War II he was active in propaganda for the Nazi regime and was sent to Poland as a war correspondent. After the war he continued his career, resuming his specialty in sports photography. His importance as a pictorial witness to Austria between the wars led to his inclusion in numerous historical picture books. AL

LITERATURE

Brandstätter, Christian, ed. *Österreich zwischen den Kriegen: Zeitdokumente eines Photopioniers der 20er und 30er Jahre* (Austria between the Wars: Documents of a Photo Pioneer of the 1920s and 1930s). Vienna, 1979.

———. *Sport, die wichtigste Nebensache der Welt: Dokumente eines Pioniers der Sportphotographie, 1919–1939* (Sports, the World's Most Important Triviality: Documents of a Sports Photography Pioneer, 1919–1939). Introduction by Bernd Lohse. Vienna, 1980.

Willi Ruge

(Berlin, Brandenburg, Kingdom of Prussia 1892–1961 Offenburg, Federal Republic of Germany)

Unsuccessful in his first career choice of building airplanes, Ruge turned to photography, which, as he read in the *Illustrative Photographer,* could be as dangerous as flying

a plane; for Ruge, photojournalism was just that. He began his adventurous career as a prototypical tabloid photographer in Berlin around 1910. His enthusiasm for aerial photography led to a stint as a photoreporter for the air force during World War I. Ruge created a daredevil series of photographs while parachuting from a plane more than a decade later; the extremely popular photo story that resulted first appeared in 1931 in the *Berliner Illustrirte Zeitung* and later in several European papers. Ruge's sense of adventure also led him to photograph popular sporting events and heated political actions, such as the short-lived 1919 communist rebellion in Berlin.

Ruge's single best-known photograph today is that of fellow photographer Arno Boettcher (cat. 34). The deliberate, almost confrontational position of Boettcher's camera and the photographer who controls it suggest the invasive presence of photography in the modern era. This visual "sign of the times" appeared on the cover of *Die Form* and in various magazines, including the *Arbeiter Illustrierte Zeitung;* most famously, it served as the poster for the 1929 *Film und Foto* exhibition in Stuttgart—even though career photojournalists were overlooked in the show itself. Ruge's darkroom expertise and flair for sensationalism kept him a noticeable presence in the dominant media culture. He also operated a press photo agency, Foto-Aktuell. Ruge returned to the air force during World War II; ironically, his entire Berlin archive was destroyed in the bombings of November 1943. After the war he worked for magazines in Berlin and Munich. EC

LITERATURE

Kerbs, Diethart. "Es kommt der neue Fotograf auf Spatzen- und auf Mäusefüssen" (Here Comes the New Photographer Shouting and Tiptoeing). In Diethart Kerbs and Walter Uka, eds. *Fotografie und Bildpublizistik in der Weimarer Republik,* 221–223. Bönen, 2004.

Erich Salomon

(Berlin, Brandenburg, Kingdom of Prussia 1886–1944 Auschwitz concentration camp)

Salomon, the pioneer of photojournalism whose work inspired the phrase "candid camera," came to photography only by accident. The son of wealthy assimilated German-Jewish Berliners, he had studied zoology and engineering, ultimately taking a degree in law. When the family's fortunes were decimated by post–World War I inflation, he started a taxi service offering free legal and financial advice en route. This innovative venture brought him to the

Erich Salomon, *Self-Portrait,* c. 1930, gelatin silver print, 18 × 24, Berlinische Galerie, Landesmuseum für Moderne Kunst, Fotografie und Architektur

attention of the advertising office at Ullstein Verlag, where he was offered a job in 1925 overseeing billboards along the railroad lines in Berlin. He began taking pictures to document vandalism to the billboards and initially sold a number of picturesque views to local newspapers. In 1928 he landed his first "scoop" — exclusive photos of a murder trial — by hiding his ultra-fast Ermanox camera inside a bowler hat fitted with a hole for the camera's lens. Over the next several years, with the help of a letter of introduction from the German chancellor later signed by other prominent politicians and dignitaries, Salomon attended high-profile political and economic conferences throughout Europe. He became known for his prescient ability to capture people in intimate and unposed situations, earning himself the nickname "king of the indiscreet." His book, *Famous Contemporaries in Unguarded Moments,* was published in 1931. That same year, in celebration of his forty-fifth birthday, Salomon held a slide presentation titled "With Coat and Camera through Politics and Society," to which he invited more than four hundred prominent guests, many of whom had appeared in his photographs. He became something of a celebrity himself, leading a prominent diplomat to quip that "one can hold conferences these days without ministers, but not without Dr. Salomon."

In 1933, Salomon and his wife moved to the Netherlands. Prevented from publishing in Germany, Salomon struggled to find a venue for his work, while at the same time organizing the removal of his glass negatives and archives from Berlin to the Hague. In 1944, he, his wife, and one of his sons were deported from a Dutch camp to Theresienstadt (Terezín) and then to Auschwitz. AH

LITERATURE

Bool, Flip, Veronica Hekking, and Oscar van der Wijk, eds. *Erich Salomon: foto's 1933–1940 / photos 1933–1940; Peter Hunter: foto's 1935–1940 / photos 1935–1940.* Exh. cat., Haags Historisch Museum. Amsterdam, 1996.

Frecot, Janos, ed. *Erich Salomon: "Mit Frack und Linse durch Politik und Gesellschaft"; Photographien 1928–1938* (With Coat and Camera through Politics and Society). Exh. cat., Berlinische Galerie. Munich, 2004.

August Sander

(Herdorf, Palatinate, Kingdom of Bavaria 1876–1964 Köln, Federal Republic of Germany)

Prior to his projects of the 1920s, which made him into a central figure in German photography, Sander had a successful career as a portrait photographer in Linz, Austria, from 1902 to 1910. During this time, he entered his work frequently in competitions and was awarded many prizes. As his business in Austria dissolved, he returned to his native region in 1909, started a studio there, and began taking photos as an itinerant portraitist in the surrounding countryside of Westerwald to increase his clientele.

During the early 1920s, Sander befriended the Gruppe Progressiver Künstler, or Cologne Progressives. Encouraged by Franz Seiwert, one of the group's leaders, he developed ideas for a comprehensive photographic survey and sociological classification of his countrymen to be called *People of Our Time* (Menschen der Zeit). He planned to organize it according to profession, under a system of "guilds." A portion of the project was published in 1929 as *The Face of Our Time,* to considerable acclaim. Critic and theorist Walter Benjamin commented upon its social usefulness in penetrating the hidden layers of the German class system. In the 1930s Sander added two sections, entitled "Nazis" and "Jews." Members of the first category banned the book in 1936 and had the plates destroyed. Already prior to that disheartening experience, Sander had begun a retreat from view—taking fewer portraits to concentrate on landscapes and botanical studies, and moving his home and studio in 1934 to the outskirts of Cologne, bringing ten thousand negatives with him and squirreling away the rest (thirty thousand) in the basement of his downtown apartment. Although these negatives survived the almost total destruction of the city during World War II, they were lost to fire a year later. Sander spent his last years reordering and cataloguing his remaining negatives. AH

LITERATURE

Keller, Ulrich, and Gunther Sander. *Menschen des 20. Jahrhunderts: Portraitphotographien von 1892–1952*. Munich, 1980.

Lange, Susanne, and Gabriele Conrath-Scholl, eds. *Menschen des 20. Jahrhunderts: Studienband*. Exh. cat., SK Stiftung Kultur. Munich, 2001.

Lugon, Olivier. *August Sander: Landschaften*. Exh. cat., MediaPark Köln. Munich, 1999.

Sander, August, and Gunther Sander. *Men without Masks: Faces of Germany, 1910–1938*. Trans. Maureen Oberli-Turner. Greenwich, 1973.

Margit Sielska

(Reich-Sielska, Kolomea / Kołomyja, Kingdom of Galicia and Lodomeria [today Kolomyia, Ukraine] 1900–1980 Lʹviv, Ukrainian Soviet Socialist Republic)

Sielska was a painter and collage maker, involved in the artistic avant-garde in Lviv between the wars. She studied at the Akademia Sztuk Pięknych (Academy of Fine Arts) in Kraków in 1920–1922 with Władysław Jarocki, then pursued her education abroad in Vienna (1926–1927) and in Paris (1928–1930), where she enrolled at the Académie Moderne run by Fernand Léger and Amédée Ozenfant. In 1929 she joined the Zrzeszenie Artystów Plastyków "Artes" (Artes Association of Artists), working to further the search for modern forms in different media. Artes had no clearly defined artistic doctrine but leaned toward surrealism and promoted a liberated imagination. Important to Sielska and others in the group were the synthetic simplification and clear forms of Léger's painting, which bordered on *art naïf*. In her own compositions, Sielska did not shy away from allusions to folk patterns, country fair pictures, mawkish postcards, and hand-painted signs. She came closest to the poetics of surrealism in her colored collages and photomontages, of which only a handful survive. These compositions stress the contrast between form and texture by using cutouts from reproductions of paintings or photographs and pieces of colored paper. *Untitled*, 1934 (cat. 95), is a good example: the nude lying in bed contrasts in both shade and texture with a highly foreshortened photograph of metal fencing, which blurs the object and provides a virtually abstract play of lines and lighting. The illusory effect of space opening up within the picture contrasts with the two different hands, one a woman's and the other a child's, coming out of opposing corners from an old amateur painting. Placed between the hands at an angle is a piece of tape, which underscores the contrast in texture between the wire

fence in the background and the soft fabric of the sheet on the bed below.

Little is known of Sielska's life after the outbreak of World War II. She remained in Poland's eastern territories, which were occupied by the Soviet Union, and during the period when socialist realism was compulsory she was a member of Soviet artists' organizations. She continued to make art, primarily portraits and landscapes, and to exhibit her work. SC

Sasha Stone
(Aleksandr Serge Steinsapir)

(St. Petersburg, Province of St. Petersburg 1895–1940 Perpignan, The French State)

In 1929 Stone was at the peak of his career. UHU, a trendy Berlin magazine, listed him as one of the eight most significant photographers of his day, and sixty-eight of his photos were included in the landmark *Film und Foto* exhibition, more than those of any photographer save the show's shadow organizer, László Moholy-Nagy. Despite his immense popularity at that time, until the late 1980s little more was known about Stone, his background, or his career. After studying electrical engineering in Warsaw, Aleksandr Steinsapir emigrated to the United States, where he worked as a draftsman for an airplane construction firm and began using the surname Stone. He enlisted in the U.S. Army during World War I and after the war studied art in Paris on a military scholarship. He then probably made his way to Berlin around 1922 to study sculpture with Aleksandr Archipenko, a Ukrainian-born painter and sculptor. Through Archipenko, Stone became acquainted with the avant-garde artists around Hans Richter's magazine G. In 1924, he opened Atelier Stone, a studio for industrial and commercial advertising photography. In addition to supplying magazines with illustrations ranging from household work to chiromancy, he specialized in modern industry and entertainment. As the staff photographer for Erwin Piscator's avant-garde theater group, he took portraits of the actors for the programs, constructed photomontages of Piscator and his innovative stage designs, and provided all the photographs for Piscator's 1929 book, *The Political Theater*. For another good friend, Walter Benjamin, he designed the photomontage cover of *One-Way Street* (*Einbahnstraße*), Benjamin's prose poem on modernity. Benjamin would later quote Stone's statement—"photography as art is a dangerous thing"—in his 1931 essay "A Short History of Photography."

By 1932 Stone had moved to Belgium, where he reestablished his business based primarily on contracts with industry. In 1940, as German troops marched on the city, Stone and his family left Brussels with the plan to emigrate once more to the United States. On their way through France, Stone fell ill and died of tuberculosis. AH

LITERATURE

Kerbs, Diethart, and Peter Maaswinkel. "Sasha Stone: Randbemerkungen zum Lebensweg und Lebensende eines staatenlosen Fotografen" (Marginal Remarks on the Life and Death of a Stateless Photographer), *Fotogeschichte* 10, no. 37 (1990): 37–53.

Köhn, Eckhardt, ed. *Sasha Stone: Fotografien 1925–1939*. Berlin, 1990.

Władysław Strzemiński

(Mińsk, Province of Minsk [today Minsk, Belarus] 1893–1952 Łódź, People's Republic of Poland)

Strzemiński was one of the outstanding artists of the constructivist avant-garde. He worked in Soviet artistic institutions in Moscow and Smolensk from 1918 to 1921, where he collaborated with, among others, Vladimir Tatlin and Kazimir Malevich. Influenced by discussions with these artists and their ideas on the rational organization of work, he moved to Poland in 1922, where he formulated his own artistic system, unism. Its principles became an important element of the programs of subsequent avant-garde groups, in whose creation Strzemiński took part: Blok (1924–1926), Praesens (1926–1929), and a.r. (1929–1939). Unism subordinated to the principles of economic rationalization various genres of artistic output, and later all activity aimed at shaping the real world. Unists aimed to organize all of society functionally and effectively, to minimize effort and maximize comfort. Strzemiński, however, did not personally abandon art for practical labor, but rather maintained that abstract art provided a parallel or model for concrete activity. He formulated his theoretical views most fully in the booklets *Unism in Painting* (*Unizm w malarstwie*, 1928) and *Spatial Composition: Measuring the Rhythm of Space-Time* (*Kompozycja przestrzeni: Obliczenia rytmu czasoprzestrzennego*, coauthored with sculptor Katarzyna Kobro, 1931).

Around 1930, inspired by the ideas of German typographer Jan Tschichold, Strzemiński became more interested in printing and in the uses of photography and photomontage as techniques to improve textual "economy of legibility." Writing on photomontage in 1929, Strzemiński curiously accorded the invention

of this technique to his compatriot Mieczysław Szczuka (see biography). In 1932 Strzemiński and the a.r. group organized an international exhibition called *Drukarstwo nowoczesne* (Modern Printing) in Łódź, which included many works, among them photomontages, by artists of Tschichold's Neue Werbegestalter (New Advertisers) group. Yet Strzemiński used actual photographs in his work only in 1945, in his photomontage series *To My Friends the Jews* (cats. 162, 163). After World War II, Strzemiński taught at the Wyższa Szkoła Sztuk Plastycznych (Higher School of Art) in Łódź, where he developed the concept that art is a product of the optical apparatus that functions according to a historically changing, socially conditioned image of reality. Strzemiński wrote about these ideas in *A Theory of Seeing (Teoria widzenia)*, published posthumously in 1958. SC

LITERATURE

Bois, Yve Alain. "Strzemiński and Kobro: In Search of Motivation." In Bois, *Painting as Model*, 123–156. Cambridge, Mass., 1993.

Janik, Jadwiga, Zenobia Karnicka, and Janina Ładnowska. *Władysław Strzemiński, 1893–1952, w setną rocznicę urodzin* (The Hundredth Anniversary of his Birth). Exh. cat., Muzeum Sztuki. Łódź, 1993.

Jedliński, Jaromir, et al. *Władysław Strzemiński 1893–1952*. Exh. cat., Kunstmuseum Bonn. Cologne, 1994.

Levinger, Esther. "Return to Figuration: Władysław Strzemiński and the Move from Idealism." *Art History* 24, no. 1 (February 2001): 103–131.

Jindřich Štyrský

(Böhmische Tschermna / Čermná v Čechách [today Dolní Čermná], Wildenschwert / Ústí nad Orlicí, Kingdom of Bohemia 1899– 1942 Prag / Praha, Protectorate of Bohemia and Moravia)

Štyrský attended the Akademie výtvarných umění (Academy of Fine Arts) in Prague from 1920 to 1924. By the end of his art school tenure, he had joined Devětsil, exhibited with them, and published his first manifesto; he would remain a central figure in the Czech avant-garde from then until his death from illness in 1942. Štyrský's creative identity is in many ways inseparable from that of the painter Toyen (Marie Čermínová), whom he met while vacationing in Yugoslavia in 1922. The two artists developed parallel interests in eroticism, dreams, and death, and exhibited almost always together; they also collaborated on certain book designs. In 1925, Štyrský and Toyen moved to Paris, where the next year

they launched the two-person movement artificialism (*artificielisme / artificielismus*), creating quasi-abstract paintings inspired in part by the photograms of Man Ray, as well as aerial and scientific photography. Hardly a disciplined employee, Štyrský nevertheless served as stage designer at Devětsil's Osvobozené divadlo (Liberated Theater) in 1928–1929 and as editor for the house journal of Jan Fromek's publishing outfit Odeon in 1929–1931. In the latter capacity he wrote on the Marquis de Sade, one indication of his increasing acceptance of orthodox surrealism; Odeon also published Štyrský's biography of Arthur Rimbaud (1930), a poet long championed by surrealist leader André Breton.

Štyrský made many photomontages, some as independent art objects, but most as covers for popular literature. He delighted in trivial visual culture, from tourist postcards to horror stories and pornography. His 1933 book *Emilie Comes to Me in a Dream*, illustrated with his own photomontages, culminates several publishing forays into erotica during the early 1930s. In 1934 and 1935, meanwhile, Štyrský created three photographic series that capture with deliberate banality circus posters, displays of petty commerce, and disused consumer curiosities. Štyrský selected from these photographs in preparing the wartime book *On the Needles of These Days* with poet Jindřich Heisler (1941). The photographs had their first showing, however, in 1935, when they were featured extensively at the inaugural exhibition of the Czech surrealist group, along with an equally extensive series of photomontages by Štyrský entitled *The Movable Cabinet* (cats. 101, 102). This was the most prominent public showing anywhere of photography alongside fine art before World War II. MW

LITERATURE

Fárová, Anna. "Un Tchèque: Jindřich Štyrský," in Mission du Patrimoine Photographique, *Colloque Atget*, 74–81. Paris, 1986.

Nezval, Vítězslav, and Karel Teige. *Štyrský a Toyen*. Prague, 1938.

Srp, Karel. *Jindřich Štyrský*. Prague, 2001.

———. "The Philosophy of the Recess." *Umění* 44, no. 1 (1996): 41–52.

Josef Sudek

(Kolin / Kolín, Kingdom of Bohemia 1896– 1976 Praha, Czechoslovak Socialist Republic)

Sudek is legendary in Czech photography and the subject of many wondrous anecdotes. Above all, he must be remembered as a professional artist who systematically

promoted photography as a medium capable of profound personal expression. A seemingly uncomplicated figure, he nevertheless clearly managed his career adroitly, aware of the shifting opportunities in his day and how best to use them. Trained as a bookbinder, Sudek lost his right arm at the front in 1917. On his return, he lived for a time at Invalidovna, a convalescent home for wounded soldiers, and while there joined the amateur photography movement. From 1922 to 1924 he studied photography at the newly founded Státní grafická škola (State Graphic Arts School) under Professor Karel Novák. In the split over "straight" and "art" photography (see biography for Jan Lauschmann), he joined the former camp, along with his friends Jaromír Funke and Adolf Schneeberger, with whom he founded (1924) the Česká fotografická společnost (Czech Photographic Society), a rebel amateur group. From 1927 he ran a studio in Prague, specializing in reproductions of art, architecture, and applied art. The crucial moment that heralded Sudek's subsequent career was the publication of his portfolio *St. Vitus Cathedral (Svatý Vít*, 1928), a "report" in large and glorious prints on the final reconstruction of that treasured national monument. In this ambitious publishing project, realized for the design guild Družstevní práce (Cooperative Work, or DP), photography appeared in the Czech context at last equal to other forms of modern art. Sudek worked for DP for nearly a decade, producing book covers, magazine illustrations, calendars, and postcards. He also had his first solo exhibition in the DP bookstore and salesroom in 1933.

In the 1930s Sudek purposely returned to older photographic methods in his noncommercial photography, insisting on heavy, large-format cameras and on contact prints rather than enlargements. He subsequently concentrated on still lifes in his increasingly cluttered studio and on gardens, parks, and forests in his outdoor views. At the same time, he published several picture books on Prague. One of these, *Prague Panoramic (Praha panoramatická*, 1959), represented the culmination of years of work with an unwieldy panoramic camera that took Sudek also to the "sad landscape" of northern Bohemia, devastated by communist industrial planning. The spare design of *Prague Panoramic* makes it a prototype of many more recent photobooks. In the postwar decades, Sudek deepened his expertise in classical music, hosting weekly soirées, and in contemporary art. He knew many artists and supported some financially by collecting their work. Thanks to his pupil, Sonja Bullaty, Sudek gained an audience in

North America and had a number of over-seas exhibitions in his final years, including one at the George Eastman House in Rochester, a first for Czech photography. JP

LITERATURE

Anděl, Jaroslav. *Josef Sudek o sobě* (Sudek on Sudek). Prague, 2001.

Bullaty, Sonja. *Sudek*. New York, 1978.

Dufek, Antonín, et al. *Josef Sudek: Smutná krajina* (Sad Landscape). Exh. cat., Galerie výtvarného umění, Litoměřice. Prague, 1999.

Fárová, Anna. *Josef Sudek*. Trans. Michael Knight. Munich, 1999.

Řezáč, Jan, and Jan Mlčoch. *Růže pro Josefa Sudka: 1896–1976 / A Rose for Josef Sudek: 1896–1976*. Exh. cat., Uměleckoprůmyslové muzeum v Praze. Prague, 1996.

Edith (Suschitzky) Tudor-Hart

(Wien, Archduchy of Lower Austria 1908–1973 Brighton, United Kingdom)

After training as an elementary school teacher, Edith Suschitzky began her photographic career in 1925. At the end of the 1920s she studied photography briefly with Walter Peterhans at the Bauhaus in Dessau. The influence of "new photography" is evident in pictures she took after returning to Vienna. A deep interest in social conditions led her to photographic documentation of Vienna's poorer classes and to photography as a political tool. The social-democratic newspaper *Der Kuckuck* published her work, and she also found employment in a professional studio. After her marriage to the English physician Alexander Tudor-Hart she moved to London. Here she did further photographic documentation in the London slums, followed by pictures from the mining areas in Wales where her husband's practice had relocated. In 1934 she joined the Artists International Association and later other organizations associated with the socialist workers' movement. Tudor-Hart founded a photography studio with a friend in London in the mid-1930s where she made portraits and pictures for advertisements. However, the studio had to close at the start of World War II. Tudor-Hart sought freelance assignments, working for magazines such as *New Chronicle, Design for Today, Lilliput*, and *Picture Post*. She also undertook varied projects with her brother, Wolfgang Suschitzky, who had followed her to London and would later make a name for himself as a documentary filmmaker. At the end of the 1950s, she gave up photography and opened an antiques store in Brighton. AL

LITERATURE

Forbes, Duncan. "Politics, Photography and Exile in the Life of Edith Tudor-Hart (1908–1973)." In *Arts in Exile in Britain 1933–1945: Politics and Cultural Identity*, edited by Shulamith Behr et al., 45–87. Amsterdam, 2005.

Tudor-Hart, Edith, and Wolf Suschitzky. *The Eye of Conscience*. London, 1987.

Ladislav Sutnar

(Pilsen / Plzeň, Kingdom of Bohemia 1897–1976 New York City, United States)

Avant-garde designer Sutnar received his training at the Uměleckoprůmyslová škola (School of Applied Arts) in Prague from 1915 to 1923, a period of study interrupted by his military service at the Balkan and Russian fronts during and after World War I. Successful first as a craftsman making theater puppets and wooden toys, Sutnar soon began teaching and corresponding with German designer Jan Tschichold, whose groundbreaking ideas he eventually helped disseminate in Czechoslovakia. Around 1926 Sutnar began to concentrate on typography and book design, which led in 1929 to his appointment as art director of the progressive publishing and manufacturing guild Družstevní práce (Cooperative Work, or DP). Sutnar also associated with Czech avant-garde leader Karel Teige, himself active in book design, although Sutnar did not share Teige's stringently utilitarian view of applied arts. Sutnar's journal and book covers emphasize clean lines, simplicity, and rapid legibility. He pushed the rationality and economy of modern design in many ways at DP, most importantly through monthly journals such as *Panorama* and *Žijeme* (We're Alive); "its function is to promote the modern way of living with all its beauty," read a promotional flyer for the latter periodical (cat. 87). In 1932 the Státní grafická škola (State Graphic School) hired Sutnar as its administrator. The following year Sutnar created a class in advertising photography, later hiring Jaromír Funke to teach this course. Sutnar traveled to New York in April 1939 to oversee design for the Czech pavilion at the World's Fair. He stayed on in the United States and established himself by working for Czech institutions. After the war, however, Sutnar achieved a far wider reputation designing corporate identities and promotional catalogues; clients included Knoll, Radio Corporation of America, and American Telephone and Telegraph, for whom Sutnar redesigned the standard phone book. EC

LITERATURE

Janáková, Iva, ed. *Ladislav Sutnar: Prague – New York; Design in Action*. Exh. cat., Uměleckoprůmyslové muzeum v Praze. Prague, 2003.

Rous, Jan. "Ladislav Sutnar, doba a osobnost" (Ladislav Sutnar, The Era and the Person). *Typografia* 81, no. 908 (January 1978): 18–22.

Mieczysław Szczuka

(Warszawa, Province of Warsaw 1898–1927 Zamarła Turnia, Tatra Mountains, Republic of Poland)

Teresa Żarnower

(Poland 1895–1950 New York City, United States)

The versatile artist Szczuka studied painting from 1915 to 1920 at the Warsaw Szkoła Sztuk Pięknych (School of Fine Arts). Although initially inspired by expressionism, cubism, and futurism, by 1921 his work related clearly to suprematism and constructivism, betraying the influence especially of El Lissitzky and Vladimir Tatlin. At that time Szczuka also designed constructivist monuments for activists in the revolutionary movement. Szczuka launched the avant-garde group Blok (1924–1926) in Warsaw, which joined the international current of constructivism, and he became the editor in chief of its eponymous magazine. Like fellow Blok member Władysław Strzemiński, Szczuka hoped to further an "aesthetics of economy," but he split with Strzemiński over the issue of utilitarian purpose; Szczuka wanted above all to engage and popularize modern industrial methods to organize daily activities and raise living standards. For this reason, he neglected painting to focus on new, mechanized media of visual communication aimed at influencing the masses. He experimented with posters, film, and magazine layouts, and attached exceptional importance to the technique of photomontage, which he named *poezoplastyka*. In 1926, Szczuka entered the realm of political agitation, making posters for the communist cause. His programmatic article "Sztuka i rzeczywistość" (Art and Reality, 1927) made clear his transition to proletarian activism. Szczuka acted as editor for *Dźwignia* (Shift), the journal in which this article appeared, which became a leading platform for political art modeled on the Soviet *Novyi LEF*; he also worked as a book designer. An outstanding alpinist, Szczuka died that same year in a climbing accident.

Szczuka's closest collaborator was Teresa Żarnower, who also made propaganda posters and photomontages for

communist publications. She designed the cover for a book version of Anatol Stern's poem "Europa," which Szczuka illustrated (cat. 16). During World War II, which she spent in the United States, she illustrated *The Defense of Warsaw* (fig. 2.5), a publication of the Polish resistance movement, with photomontages in the same style. SC

LITERATURE

Czekalski, Stanisław. "Międzynarodówka salonów automobilowych i hagiografia rewolucji. Mieczysław Szczuka na rozdrożach Nowej Sztuki" (The *Internationale* of Automobile Shows and a Hagiography of the Revolution: Mieczysław Szczuka at the Crossroads of New Art). *Artium Quaestiones* IX (1998): 75–109.

Karel Teige

(Prag / Praha, Kingdom of Bohemia 1900 – 1951 Praha, Czechoslovak Socialist Republic)

Essayist, editor, organizer, and artist, Teige counts among the most energetic and perspicacious figures in European modern art. He wrote extensively on architecture,

Karel Teige, *Study at the Bauhaus!!!* (*Studujte na Bauhause!!!*), in *ReD* 3, no. 5 (1930), photolithograph of photomontage, 17 × 22, Private Collection

painting, graphic design, film, and photography, articulating in each case a disciplinary history that opened onto a broader, always urgent subject: how to remake the world and the place of art within it. In the years of Devětsil, the pan-creative arts collective he helped found in 1920, Teige cast new art as visual poetry and coined for it the term "poetism," set in dialectical relation to utilitarian innovations; both were necessary to improve daily working life in modern society. Teige steered the production of several compilations, particularly *Revolutionary Anthology Devětsil* (*Revoluční sborník Devětsil*) and *Life: Anthology of the New Beauty*, in 1922 – 1923. He installed or inaugurated exhibitions and reviewed projects by the group's many architects — even though, as editor of the monthly journal *Stavba* (Building), Teige argued a functionalist approach often at odds with other members' architectural ideas. He also edited the group's culminating periodical, *ReD* (Revue Devětsil), which appeared in thirty issues between 1927 and 1931. After Devětsil's demise, Teige and many close associates founded the Skupina surrealistů v ČSR (Surrealist Group in Czechoslovakia); surrealism became the dominant idiom in Czech art for decades thereafter.

A series of international speakers came to Prague at Teige's invitation, including Le Corbusier, Adolf Loos, and André Breton. Teige, meanwhile, visited Paris in 1922 and Moscow in 1925, and he lectured at the Dessau Bauhaus in 1929 – 1930. He also curated Czech participation in *Film und Foto*. Although his selections failed utterly to capture the range of Czech production, Teige came to hold great knowledge in photography. His interest, manifested already in the 1922 essay "Foto Kino Film," blossomed in the 1930s with a series of essays on documentary photography, *typofoto*, and photomontage, including the decisive text "The Tasks of Modern Photography" (1931). Teige also designed covers for the amateur almanac *Československá fotografie* (1931 – 1938), and he inaugurated the 1933 *Výstava sociální fotografie* (Exhibition of Social Photography), among other shows. During the war years, while making photomontages privately, Teige introduced *Modern Czech Photography* (1943), a portfolio by the leading artist-photographers of his day: Jaromír Funke, Miroslav Hák, Josef Sudek, and others. Teige followed this project with a brochure, *Modern Photography in Czechoslovakia* (*Das moderne Lichtbild in der Tschechoslowakei*, 1946, also published as "Paths in Czechoslovak Photography"), written to accompany a traveling exhibition seen in Austria and Switzerland. This essay,

which summarizes Czech and international developments since 1839, constitutes the first fully formed art history of photography in Czech. MW

LITERATURE

Codeluppi, Manuela Castagnara. *Karel Teige: Luoghi e pensieri del moderno, 1900 – 1951*. Exh. cat., Castello di Miramare, Trieste. Milan, 1996.

Dluhosch, Eric, and Rostislav Švácha, eds. *Karel Teige / 1900 – 1951: L'enfant Terrible of the Czech Modernist Avant-garde*. Cambridge, Mass., 1999.

Karel Teige: Surrealistické koláže 1935 – 1951. Exh. cat., Museum Folkwang. Essen, 1966.

Srp, Karel, and Michal Bregant, eds. *Karel Teige, 1900 – 1951*. Exh. cat., Galerie hlavního města Prahy. Prague, 1994.

Zusi, Peter. "The Style of the Present: Karel Teige on Constructivism and Poetism." *Representations* 88, no. 1 (Fall 2004): 102 – 124.

Stefan Themerson

(Płock, Province of Płock 1910 – 1988 London, United Kingdom)

Themerson was a colorful figure in Polish twentieth-century culture. He was exceptionally versatile, an avant-garde photographer and filmmaker, the author of photomontages, a poet and essayist, and a publisher. Themerson interrupted his physics and architecture studies in 1928 to make experimental films with his wife, Franciszka. In these films, he used photomontage and photograms, wove in animated sequences, superimposed and juxtaposed images, and sought to synchronize visual, musical, and intellectual experiences liberated by the rhythms of cinematic vision. Before the outbreak of World War II, he made five films in Poland: *Pharmacy* (*Apteka*, 1930), *Europa* (based on the book illustrated by Mieczysław Szczuka with Teresa Żarnower), *Musical Moment* (*Drobiazg melodyjny*, 1933), *Short Circuit* (*Zwarcie*, 1935), and *The Adventure of an Honest Citizen* (*Przygoda człowieka poczciwego*, 1937). In 1935 he founded the Spółdzielnia Autorów Filmowych (SAF), which supported and promoted experimental and independent film, and published two issues of its journal *f.a.* (Artistic Film); there, in an article, "O potrzebie tworzenia widzeń" (The Urge to Create Visions, 1937), he defined his concept of the art of film. Themerson left for Paris in 1938, staying there until the war. He joined the Polish Army in France and in 1942 crossed over to England. While still in military service and under the auspices of the Polish government-in-exile, he made two films there, *Calling Mr. Smith* (1943) and *The Eye and the*

Ear (1944). Surviving from his film *Europa*, which has been lost, is a set of photomontages reminiscent of Dada and surrealist film. Also preserved from that period are a handful of newspaper photomontages, which accompanied political commentary in communist journals as well as more playful writings in the popular monthly *Naokoło Świata* (Around the World). After World War II, Themerson remained in England and devoted himself to writing. SC

LITERATURE

Czartoryska, Urszula. *Stefan i Franciszka Themerson: poszukiwania wizualne / Visual Researches.* Exh. cat., Muzeum Sztuki w Łodzi. Łódź, 1982.

Kubasiewicz, Jan, and Monica J. Strauss, eds. *The Themersons and the Gaberbocchus Press: An Experiment in Publishing, 1948 – 1979.* Exh. cat., La Boetie, Inc. New York, 1993.

Umbo (Otto Umbehr)

(Düsseldorf, Rhine Province, Kingdom of Prussia 1902 – 1980 Hannover, Federal Republic of Germany)

Umbehr left home early for an itinerant life, during which he studied ceramics, acting, and printmaking. In 1921 he was accepted at the Bauhaus and completed the preliminary course directed by Johannes Itten. Although briefly enrolled in the metal workshop, he was soon expelled for "idleness." After moving to Berlin in 1923, he worked as a housepainter and movie-poster artist before entering the film industry as an assistant cameraman. In 1926, while working for director Walter Ruttmann, he made the photomontage *The Raging Reporter* (cat. 83) to advertise *Berlin: Symphony of a Big City,* Ruttmann's now classic montage film on a day in the life of 1920s Berlin. At around this time, Umbehr and his Bauhaus friend Paul Citroen experimented with a camera for the first time, taking pictures of each other and their friends. Umbehr's portraits brought him renown nearly overnight; by mid-1927 he was publishing in leading magazines with Ullstein Verlag and had opened his own studio by the end of that year under the professional name Umbo. His photographs thereafter appeared in every major exhibition and in many important publications of "new photography," and they were admired by like-minded artists in Czechoslovakia, Poland, and elsewhere. In 1928, Umbo and Simon Guttmann formed the picture agency Dephot (Deutsche Photo-Agentur) to cater to the high demand of newspapers and magazines. Umbo soon mastered a new form of photojournalism known as reportage, the construction of a story based solely on photographs. Umbo's piece on shopwindow mannequins, published in 1929 with the title "A Dangerous Street" (*Eine gefährliche Straße*), presents a surreal view of everyday life that also appeared in his street scenes, in which overhead shots of ordinary sidewalks become vignettes in the realm of the unfamiliar (see cat. 96).

After the demise of Dephot in 1933, closed down by the Nazis for distributing antifascist leaflets, Umbo continued to shoot innocuous reportage stories about nature, animals, the cabaret, and the circus. After serving in World War II, he lived in Hannover, where he became staff photographer for the Kestner Gesellschaft art foundation. He lost nearly his entire archive to bombing during the war. AH

LITERATURE

Holeczek, Bernhard, Christiane Hinze, and Heinrich Riebesehl. *UMBO, Photographien 1925 – 1933.* Exh. cat., Spectrum Photogalerie. Hannover, 1979.

Molderings, Herbert. *Umbo: Otto Umbehr, 1902 – 1980.* Düsseldorf, 1996.

———. "Umbo's Aesthetic." *History of Photography* 29, no. 3 (Fall 2005): 240 – 255.

Ernő Vadas

(Nagykanizsa, Kingdom of Hungary 1899 – 1962 Budapest, People's Republic of Hungary)

Vadas' abundant successes in the 1930s marked his career. Winning awards in numerous European competitions and having his photographs appear in illustrated journals throughout the continent and in the United States increased his stature almost overnight, lifting him into the swelling tide of mass media during those years. Vadas began to photograph seriously around 1927. Initially self-taught, he found a mentor in Rudolf Balogh, then earned a professional license in 1937. Vadas early on joined the nationwide amateur association MAOSZ, but with time he, like others, disassociated himself from this limiting, traditional group. In 1936 he joined Francis Haar, Imre Kinszki, and others to found the Modern Magyar Fényképezők Egyesülete (Association of Modern Hungarian Photographers), which was banned later that year. Much of Vadas' work epitomizes *Magyar stílus* or the Hungarian Style, which combines modern photographic approaches with picturesque, idyllic subject matter. His light-hearted subjects range from farm animals and romanticized peasants to prettified urban sights. Vadas continued to work diligently in Hungary as war approached. He was sent into forced labor, then deported to a concentration camp in Gunskirchen, Austria. After recovering, Vadas returned to photography with difficulty, limited by increasing restrictions from the socialist state. As the Hungarian Style was condemned, Vadas began to document the worker, a subject he had never chosen before, although he was certainly aware of "social photography" during his own golden years in the 1930s. EC

LITERATURE

Gross, Jozef. "Master of Escapism: Jozef Gross Remembers the Rural Lyricism of Hungarian Photographer Ernő Vadas." *British Journal of Photography* 137, no. 6765 (1990): 9 – 11.

Végvári, Lajos. *Vadas Ernő munkássága* (The Work of Ernő Vadas). Budapest, 1967.

Lajos Vajda

(Zalaegerszeg, Kingdom of Hungary 1908 – 1941 Budapest, Republic of Hungary)

A keen awareness of the avant-garde and a general independence from its collective manifestations mark Vajda's artistic career. Vajda trained at the Képzőművészeti Főiskola (Academy of Fine Arts) in Budapest, at which time he also associated with Lajos Kassák's Munka group and exhibited paintings influenced by constructivism in 1929. Expelled for his participation in what was deemed a scandalous exhibition, Vajda traveled to Paris, where he stayed for nearly four years. Inspired by surrealism, cubism, and film, he began using photography and collage to explore political subject matter. When he left Paris in 1934, he returned to historic Szentendre, a Serb and Hungarian artist colony near Budapest where he had spent most of his youth. Here Vajda resumed his painting and began to work more with collage, which became an increasingly important way for him to allude to folk art traditions. His search to reconcile fundamental ideas of peasant culture and the avant-garde resulted in partly abstract pieces that contain fragments of familiar elements, such as an onion-domed church or a quiet hearth. By the late 1930s Vajda began to paint what has been described as "inner landscapes," abstractions formed by thick, closely adjoined bunches of parallel lines. These works were his last before an early death from tuberculosis. Vajda's posthumous reputation grew to legendary proportions, and he retains a cult following today. EC

LITERATURE

Bálint, Endre. "Vajda Lajos fotómontázsairól." *Fotóművészet* 75, no. 3 (1975): 23–26.

Mándy, Stefánia. *Vajda Lajos.* Budapest, 1983.

Roman Vishniac

(Pavlovsk, Province of St. Petersburg 1897–1990 New York City, United States)

Part assiduous scientist, part committed social documentarist, Roman Vishniac led an extraordinarily adventurous life, in which the one constant seems to have been his attachment to photography. Vishniac apparently first expressed his various interests at age seven, when he photographed the leg of a cockroach under a microscope. He obtained a doctorate in zoology in Moscow in 1920, simultaneously earning a state-sponsored medical degree to satisfy a shortage of doctors at the front. In response to the political turmoil, Vishniac escaped to Latvia the same year. There he obtained a passport, which proved fortuitous in preventing difficulties in his later travels. Vishniac continued onward to Berlin to join his family; while supporting them through odd jobs, he also found time to research endocrinology and optics and to pursue a third doctorate in Asian art. Recognizing the scale of the anti-Semitic threat, Vishniac decided to preserve the life and culture of his ancestors photographically. His arduous travels began in 1936 and led him through Latvia, Lithuania, Hungary, Austria, Poland, and Czechoslovakia over the course of the next four years. He concealed his Leica and Rolleiflex cameras from both his subjects and non-Jewish authorities, often disguising himself as a salesman or a Nazi to take photographs without raising suspicion. Just before the start of the war in 1939, Vishniac fled to France, only to spend three months in a Vichy concentration camp. In December of 1940 he emigrated to the United States. Vishniac opened a portrait studio, initially to circumvent problems with his inadequate knowledge of English, then closed it in 1950 due to his newfound success as a scientist and scientific photographer. He taught at Yeshiva University in New York, made educational films, worked in microscopy, and lectured on art, photography, science, and Judaica. EC

LITERATURE

Magilow, Daniel H. "People of the (Photographically Illustrated) Book: On Roman Vishniac's *Polish Jews: A Pictorial Record.*" In *Transmedialität: Zur Ästhetik paraliterarischer Verfahren,* edited by Urs Meyer et al., 1–23. Göttingen, 2006.

Vishniac, Roman. *Roman Vishniac.* New York, 1974.

———. *A Vanished World.* Foreword by Elie Wiesel. New York, 1983

František Vobecký

(Trhowy Štěpanow / Trhový Štěpánov, Beneschau / Benešov, Kingdom of Bohemia 1902–1991 Praha, Czechoslovak Republic)

Apprenticed as a tailor in Prague, Vobecký spent 1926 and 1927 in Paris employed at various fashion houses. He devoted himself in his spare time to painting, learning about modern art while attending the Académie Colarossi and the Académie de la Grande Chaumière. On his return to Prague he exhibited at the Svaz Výtvarných Umělců Mánes (Mánes Artists' Association), becoming a full member in 1931. He began taking photographs at the end of the 1920s, mostly of landscapes, sculptural details, and apparently random accumulations of objects. He started to photograph surrealist assemblages of objects at home and in his tailor's workshop in the mid-1930s, later choosing arrangements of magazine clippings and other reproductions. In these works Vobecký approached the poetry of Max Ernst's collages as well as those of Czech leader Karel Teige. His oeuvre includes works in which three-dimensional objects are confronted with two-dimensional cutouts, whether reproductions or original photographs (fig. 6.5).

Vobecký brought that period to a close with his participation in a Mánes photographic exhibition in 1938. He did not leave photography entirely, however, for he made fashion photographs in a journalistic style while employed at the Podolská fashion house in Prague (1938). He continued to paint during and after the war, then faded from view until an article appeared on his early work in 1974. Thanks to interest from abroad, he began at that time to enlarge his old negatives and to create new ones in the spirit of the originals. JP

LITERATURE

Dufek, Antonín. "František Vobecký." In Hana Rousová, ed. *Vademecum: Moderní umění v Čechách a na Moravě 1890–1938 (Modern Art in Bohemia and Moravia),* 383–385. Prague, 2002.

Šmejkal, František. *František Vobecký: raná tvorba (Early Work) 1926–1938.* Exh. cat., Galerie hlavního města Prahy. Prague, 1985.

Siegfried Weyr

(Groß-Mosty / Mosty Wielkie, Kingdom of Galicia and Lodomeria 1890–1963 Wien, Austria)

Weyr was born in the Austrian provinces, in present-day Ukraine, but raised in Vienna. He was returned to the provinces for military service during World War I. At that time, he began to take courses in art history, attending university in the Galician city of Kraków. After the war, he pursued studies in art history in Vienna but also acquired an art education (including photography) at the Graphische Lehr- und Versuchsanstalt in Vienna, and then at the Akademie der Bildenden Künste (Academy of Visual Arts). Hired as a freelance writer by the social-democratic *Vorwärts* (Forward) press, he helped develop the illustrated magazine *Der Kuckuck* (The Cuckoo), which began appearing in 1929. Along with his function as editor in chief, Weyr determined the look of the magazine with his many photomontages. *Der Kuckuck* was one of the first Austrian magazines to follow standards of modern photojournalism in its reporting and its appearance, modeled on the *Berliner Illustrirte Zeitung* and the *Arbeiter Illustrierte Zeitung* in Germany. On the side, Weyr wrote novels and stories, mostly set in Vienna. After the four-day Civil War in February 1934, which was won by the profascist government, socialist magazines were forbidden and *Der Kuckuck* was shut down. Weyr continued in the magazine field, both in Austria and abroad; forced to emigrate at the *Anschluss* or annexation of Austria by Nazi Germany (his wife was Jewish), Weyr found work in America as a graphic designer and technical draftsman. Shortly after World War II, he returned to Vienna with his family and once again took up editorial positions at several Vienna newspapers. AL

LITERATURE

Riesenfellner, Stefan, and Josef Seiter. *Der Kuckuck: Die moderne Bild-Illustrierte des Roten Wien (Der Kuckuck: The Modern Illustrated Magazine of Red Vienna).* Vienna, 1995.

Tsai, Joyce. "*Der Kuckuck* and the Problem of Workers' Photography in Austria." *History of Photography* 29, no. 3 (Fall 2005): 275–286.

Mario (August Maria) Wiberal

(Freistadt Triest, Austrian Littoral 1898–1961 Wien, Austria)

Wiberal was active as a photojournalist from the end of the 1920s, supplying the Austrian magazine market with sports and

regional photographs. Along with Lothar Rübelt, Leo Ernst, Albert Hilscher, and Wilhelm Willinger, Wiberal was a locally well-known figure in the field of photographic current events. His sports photography is comparable in its dynamism to Rübelt's work. He also evidently studied poverty and the proletarian condition, as demonstrated by a small number of images now in the Albertina, Vienna. Research on Wiberal is scant, however, and it is unclear whether his work reached outside Austria.

Wiberal's photograph *Victor Adler Sculpture Destroyed after a Nazi Raid on Worker's Housing in Simmering* (cat. 127) documents the political unrest of the 1930s. Adler, founder of the Austrian Socialist Party, brought together the political coalition that would compete for control of the interwar government and would dominate policy making in "Red Vienna" in particular. Adler's damaged bust, knocked to the ground, attests symbolically to the demise of his vision and remaining resistance to National Socialism. From 1938, after the German annexation, Wiberal joined the Landesverband Alpen-Donau (Alps-Danube Regional Association), a subsidiary of the Nationaler Verband der Deutschen Presse (National Association of the German Press). AL

Antoni Wieczorek

(Zakopane, Kingdom of Galicia and Lodomeria 1898–1940 Kraków, General Government of Poland)

With a PhD in the humanities from Uniwersytet Jagielloński in Kraków and membership in the exclusive Fotoklub Polski, Wieczorek became one of the most influential figures in Polish photography during the 1930s. He published his first articles and photographs in 1928 and by World War II had written more than two hundred texts about photography. He contributed to several important amateur magazines: *Fotograf Polski, Nowości Fotograficzne* (Photography News), *Przegląd Fotograficzny* (Photography Review), and *Leica w Polsce.* Despite his close affiliation with pictorialism, Wieczorek popularized newer areas of photography such as photoreportage and hand-held cameras. Indeed, he often addressed the relationship between modernism and pictorialist traditions, and among the latter camp was identified with modern trends, especially as he called repeatedly for less elaborate print techniques in favor of "purity." Toward the end of the 1930s he was active in the program of Homeland Photography promoted by Jan Bułhak.

Wieczorek's mountain views, a specialty in his oeuvre, were often published in the popular illustrated press but also exhibited in pictorialist circles; the volatile atmosphere and aerial perspective of his scenes from the Tatra mountains were particularly highly regarded (cat. 142). He firmly considered photography as "work detached from life," claiming, "no matter how good its intentions, it is incapable of giving artistic expression to its era and to the work being done in it." Nevertheless, in the late 1930s Wieczorek produced a large set of photographs for the Fabryka Związków Azotowych (Nitrogen Products Factory) in Mościce and Chorzów. These photographs, taken with a 35mm Leica, are among the most telling photoreportage series in interwar Poland (cat. 93). Wieczorek shows the factory floor as a mysterious place steeped in an internal light, filled with spatial ambiguity created by highly foreshortened camera angles. The visual claustrophobia of these closely cropped photographs is often neutralized by a skillfully constructed impression of depth based on high-contrast juxtapositions of bright light and shadow. Wieczorek intended the photographs as an apologia for the industrially developing state. MS

LITERATURE

Czartoryska, Urszula. "Antoni Wieczorek: fotograf i publicysta." *Fotografia,* no. 8 (1961): 267–271.

Eugen Wiškovský

(Königinhof / Dvůr Králové, Kingdom of Bohemia 1888–1964 Praha, Czechoslovak Socialist Republic)

Wiškovský holds a key place in the history of Czech photography for his theoretical writings, illustrated with his photographs, which influenced amateur thinking in the late 1930s and 1940s. Taking the psychology of form as his starting point, Wiškovský focused on compositional principles he derived from cognitive perception. "Form and Subject" (Tvar a motiv, 1940), probably his best-known article, describes photographs as images and their effect on the viewer in terms of Gestalt psychology (Christian von Ehrenfels), whereby the whole is given priority over its parts. Generally speaking, Wiškovský was concerned with mechanisms of perception in relation to photography as an act of creation and communication. He studied French, German, and psychology and worked all his life as a high-school teacher. He also belonged to the Česká psychologická společnost (Czech Psychological Society), where he translated several works by Sigmund Freud, and he competed in tennis. In the 1920s he was encouraged by his former student Jaromír Funke to take a more serious interest in photography. While he published in amateur journals, he did not otherwise participate in that world but rather associated with representatives of the avant-garde. He took part in the *Výstavy nové fotografie* (New Photography Exhibitions) of 1930 and 1931, as well as the *Mezinárodní výstava fotografie* (International Exhibition of Photography) organized by Lubomír Linhart in 1936. The influence of Albert Renger-Patzsch seems strong in his early work, which features a rhythmical repetition of accumulated industrial materials such as steel pipe, electric insulators, spools of cable, and turbine wheels in closely cropped views. From these compositions Wiškovský moved principally to landscape photography, and after World War II to photographs of Prague architecture as well as a series on the city's Old Jewish Cemetery.

Historian and curator Anna Fárová helped revive interest in Wiškovský with a monograph completed shortly after his death; solo exhibitions followed abroad and at home in the 1980s and 1990s. JP

LITERATURE

Anděl, Jaroslav. "Teoretické přístupy a interpretace: Eugen Wiškovský" (Theoretical Approaches and Interpretations). *Československá fotografie,* nos. 1, 2 (1974): 6–7, 56.

Birgus, Vladimír. *Eugen Wiškovský.* Prague, 2005.

Fárová, Anna. *Eugen Wiškovský.* Prague, 1964.

Stanisław Ignacy Witkiewicz (Witkacy)

(Warszawa, Province of Warsaw 1885–1939 Jeziory, Republic of Poland)

Witkiewicz, who also called himself Witkacy, was a versatile and enormously influential artist: painter, writer, art theorist, philosopher, playwright, and photographer. Born in Warsaw, part of Russian Poland, he moved with his family in 1890 to Zakopane, a mountain resort town in Galicia, the region then belonging to Austria. Witkiewicz's father was a painter, art critic, and amateur photographer, and he, together with the symbolist movement of the 1890s, shaped the young boy's creative development. From 1905 until 1910, Witkiewicz studied painting with Józef Mehoffer at the Akademia Sztuk Pięknych (Academy

of Fine Arts) in the Galician capital, Kraków, and took lessons there also with Władysław Ślewiński, a student and friend of Paul Gauguin. As part of his studies Witkiewicz traveled (1908–1911) to Paris, where he closely followed the achievements of the avant-garde. In Poland, he exhibited with the progressive art group Formiści (formists, 1918–1922), acting also as their theorist; members of the group, however, had diametrically opposed points of view. Formists based their art on earlier international experiments, particularly in cubism, futurism, and expressionism. In 1919 Witkiewicz published his treatise *New Forms in Painting and the Misunderstandings Arising Therefrom* (*Nowe formy w malarstwie i wynikające stąd nieporozumienia*), introducing the notion of "pure form" (*czysta forma*), which he described as the quintessence of a work of art. The ideas of Sigmund Freud, which he had studied since 1912, as well as of the physiognomist Ernest Kretschmer, held significant influence on his creative work.

Witkiewicz made his first photographs, family pictures and landscapes, in 1898–1899. He retained landscape and portraiture as primary genres throughout his life, especially making numerous self-portraits. His most compelling work dates to 1912–1914 and features psychological serial studies of friends and relatives in which the face, emerging from a hazy background, is often reduced to a mouth and luminous, wide-open eyes (cat. 3). To Witkiewicz, a person's real face never matched a faithful rendering of his or her superficial traits. Following World War I, Witkiewicz staged dramatic scenes in which he and his friends acted in unusual tableaux that were photographed by others. In 1925, meanwhile, he founded a mock portrait studio (in painting, not photography), offering abstract renderings for very little while charging a relative fortune for realistic likenesses. Witkiewicz's innovations, particularly in portraiture, are considered today a signal achievement in European modern art. Nevertheless, the artist kept his many photographs strictly private, offering them to friends but never once showing them publicly. MS

LITERATURE

Czartoryska, Urszula. "Portret fotograficzny — duchowość i cielesność" (The Photographic Portrait: Spirituality and Corporeality), in Anna Marczak-Krupa, ed. *Portret: Funkcja-Forma-Symbol*, 31–47. Warsaw, 1990.

Immisch, T. O., Klaus E. Göltz, and Ulrich Pohlmann, eds. *Witkacy, metaphysische Portraits / Metaphysical Portraits: Photographien von / Photographs by Stanisław Ignacy Witkiewicz*. Exh. cat., Münchner Stadtmuseum. Leipzig, 1997.

Micińska, Anna. *Witkacy: Stanisław Ignacy Witkiewicz; Life and Work*. Trans. Bogna Piotrowska. Warsaw, 1990.

Okołowicz, Stefan, ed. *Face au néant: les portraits de Stanislaw Ignacy Witkiewicz*. Exh. cat., Musée des Beaux-Arts de Nantes. Nantes, 2004.

Piotrowski, Piotr. *Stanisław Ignacy Witkiewicz*. Warsaw, 1989.

Paul Wolff

(Mühlhausen, Imperial Territory of Alsace-Lorraine 1887–1951 Frankfurt, Federal Republic of Germany)

Wolff began experimenting with a camera as a young man but was discouraged by his father from pursuing photography professionally. In 1914, however, the year he received his doctorate in medicine, Wolff also published his first book, *Old Strasbourg* (*Alt-Straßburg*), a collection of mezzotints after his own original photographs. Upon returning from military service, Wolff took a position with a film studio that produced documentary, industrial, and advertising movies. He worked there as a laboratory technician and cameraman until the company went bankrupt in 1924. He continued simultaneously to develop his photography skills, publishing four more books between 1919 and 1924, each dedicated nostalgically to the historic quarters of a different German city. By 1925, his success with these books had allowed him to establish an independent business as an industrial and commercial photographer. In addition to supplying advertising images for various companies, including the auto manufacturer Opel, he offered genre shots of people and situations suitable for a range of publications. He also continued to publish his own books, among them a volume of botanical photographs in 1931 called *Forms of Life: Botanical Photographic Studies* (*Formen des Lebens: botanische Lichtbildstudien*).

In 1934, after years of friendship and no doubt financial support from the firm of Ernst Leitz, Wolff published *My Experiences with the Leica*, a guide for amateurs on how to use the popular small-format camera introduced by Leitz and inventor Oskar Barnack in 1925. Referring to the Leica as "a little revolution," Wolff advised his readers in both technical and compositional matters. This bestseller was followed by the equally popular volume *My Experiences with Color Photography* (*Meine Erfahrungen mit der Farbphotographie*). Wolff continued to do well in the Third Reich. Although he was not a registered member of the Nazi party, he furnished many propaganda photographs for various Nazi publications. AH

LITERATURE

Böhmer, Sylvia. *Paul Wolff: Fotografien der 20er und 30er Jahre*. Exh. cat., Suermondt-Ludwig-Museum. Aachen, 2003.

Brüning, Jan. "Dr. Paul Wolff, Ein Fotograf im Kraftfeld seiner Zeit" (A Photographer in the Forces of His Time). *Fotogeschichte* 16, no. 61 (1996): 31–46.

Wanda Wulz

(Freistadt Triest, Austrian Littoral 1903–1984 Trieste, Italy)

Wulz trained in the family studio Fotografico Wulz, which her grandfather founded in 1860. The studio gained considerable prominence under her father, Carlo Wulz, and when he died in 1928, Wanda — with the help of her sister Marion — took it over. Around this time she began playing with light, contrast, and exposure in her photography, pushing further a modernist inclination apparent in portraiture by her father. Wulz soon showed her work in several Italian exhibitions, including the 1932 *Mostra Nazionale Fotografica Futurista* (National Exhibition of Futurist Photography). In his inaugural speech, Italian futurist leader F. T. Marinetti called attention to the innovative *Cat + I* (cat. 50), one of six photographs exhibited by Wulz. This striking image, which depicts the face of the family cat seamlessly superimposed onto Wulz' own features, caused an immediate press sensation. Another of her photographs was shown on the cover of the 1932 exhibition catalogue *Futurismo e Fotografia*. Although it remains uncertain whether Wulz actively participated in the futurist circle, these works were certainly progressive within the city of Trieste. Wulz experimented only briefly with futurism, however, before continuing (until 1980) with the professional portrait photography for which the family studio was known. EC

LITERATURE

Guagnini, Elvio, and Italo Zannier. *La Trieste dei Wulz: volti di una storia, fotografie 1860–1980* (The Wulz Family's Trieste: Sides to a Story). Exh. cat., Palazzo Constanzi. Florence, 1989.

Yva (Else Neuländer-Simon)

(Berlin, Brandenburg, Kingdom of Prussia 1900–1942 Majdanek / Sobibór concentration camp)

The Berlin photographer Neuländer-Simon, who early on adopted the simple moniker Yva, entered her profession through a practical route that allowed her quick success.

After studying photography either at the Lette-Verein, a Berlin school for women, or in a private photography or film studio, Yva worked briefly with the photographer Heinz Hajek-Halke. Their cooperation ended with a legal dispute, in which Yva, though unknown and female, prevailed. She established her own studio in 1925, which flourished as a source for illustrated magazines and newspapers during her short career. Yva completed almost half the twenty picture stories that appeared in UHU, a cultural magazine for educated readers. Yva's photography included portraits, nudes, advertising, and fashion often composed using a montage of multiple exposures. Her style attracted the attention of contemporary critics such as Willi Warstat and Hans Böhm, who praised her skill as a "modern" artist.

In 1927, shortly after launching her business, Yva had a solo exhibition of one hundred works, with a catalogue, at Galerie Neumann-Nierendorf. Her photographs were also shown in Film und Foto and one of its successor exhibitions, Das Lichtbild in Munich. Helmut Newton worked as an apprentice in her grand fourteen-room studio from 1936 to 1938, a time during which Yva's "aryan" friend Charlotte Weidler officially managed the studio. Friends encouraged Yva and her husband to leave the country, but only in 1940–1941 did they attempt, and fail, to leave for New York. Yva was forced thereafter to work as an X-ray technician in a Jewish hospital, before being deported together with her husband. EC

LITERATURE

Beckers, Marion, and Elisabeth Moortgat. *Yva: Photographien 1925–1938 / Yva: photographs 1925–1938.* Exh. cat., Das verborgene Museum. Berlin and Tübingen, 2001.

Václav Zykmund

(Prag / Praha, Kingdom of Bohemia 1914– 1984 Brno, Czechoslovak Socialist Republic)

Zykmund was an artist, art theorist, and critic. He started taking photographs while at high school. In the early 1930s he became familiar with avant-garde art and started experimenting with photograms and photography of urban settings as well as natural structures (*Growth Rings* [*Letorosty*], 1935–1945). During this early period, he also photographed double exposures in which female torsos mingle with trees and aquatic surfaces, and studio nudes using inhabitual camera angles, cropping or solarization, as well as juxtapositions of the female body and "primitive" masks. Zykmund painted then as well, initially influenced by Salvador Dalí. His most significant works, however, are his extensive documentation of surrealist stagings held in the apartment of his close friend Miloš Koreček in 1937 and again in 1944, involv-

ing future members of the postsurrealist Skupina Ra (Ra Group, 1947). The participants in these sprees (*řádění*) painted their faces with runic designs, interacted with sundry inanimate objects, and seemed generally to be enacting a ritual happening. Zykmund's self-portrait showing his face bound with delicate thread (cat. 115) comes from the first (as yet unnamed) spree, performed with Bohdan Lacina. These staged situations, the photographs of which became material for compilation in artist's books (for instance *The Menacing Compass* [*Výhružný kompas*], 1944, with photographs by Zykmund and poetry by Ludvik Kundera), clearly evoke the symbolism of shamanistic ceremonies in non-Western cultures.

After the communist putsch in 1948, Zykmund turned briefly to making children's animated films at the Brno film studios (1948–1952). He published studies on modern art, including a series of essays in the periodical *Československá fotografie* on semiotics of the photographic image (1970). He also wrote poetry and prose fiction. In the 1970s he returned to the creation of private, quasi-magical visual art: chiefly collage and drawing, but occasionally photography, and also several short films imbued with absurd humor and irony. JP

LITERATURE

Mžyková, Marie. *Václav Zykmund.* Exh. cat., Galerie výtvarného umění. Olomouc, 1992.

This select bibliography is organized by country with additional regional sections that include early histories of art and photography, materials on cross-cultural exchange, and general or theoretical secondary texts. Each section lists illustrated periodicals and anthologies, followed by primary and secondary books and articles. All entries are organized alphabetically.

A selection of monographs and articles on the photographers represented in this book is found with the corresponding biographies. Texts by the photographers themselves, or by individuals not profiled, are given in the main bibliography.

Publications are grouped according to the country in which the author or subject was most active. Readings on Czech and Slovak topics appear together because many sources on the period address subjects in both countries. Material concerning Hungarian developments within present-day Slovakia and Romania is listed under Hungary, and the section on Poland includes sources that pertain to contemporary Lithuania and Ukraine.

Regional

ANTHOLOGIES

Bann, Stephen, ed. *The Tradition of Constructivism: The Documents of 20th-Century Art*. New York, 1974.

Benson, Timothy O., and Éva Forgács, eds. *Between Worlds: A Sourcebook of Central European Avant-gardes, 1910–1930*. Los Angeles, 2002.

Kemp, Wolfgang, ed. *Theorie der Fotografie*. 3 vols. Munich, 1979.

Kuleshov, Lev V. *Kuleshov on Film: Writings*. Edited by Ronald Levaco. Berkeley, 1974.

Moholy-Nagy, László. *Peinture photographie film, et autres écrits sur la photographie* (Painting Photography Film and Other Writings on Photography). Trans. Catherine Wermester, J. Kempf, and G. Dallez. Nîmes, 1993.

Phillips, Christopher, ed. *Photography in the Modern Era: European Documents and Critical Writings, 1913–1940*. New York, 1989.

Schwarz, Heinrich. *Techniken des Sehens: Vor und nach der Fotografie, Ausgewählte Schriften 1929–1966* (Technologies of Vision: Before and after Photography, Selected Writings 1929–1966).

Edited by Monika Faber with Anselm Wagner. Vienna, 2006.

Trachtenberg, Alan, ed. *Classic Essays on Photography*. New Haven, 1980.

PRIMARY BOOKS AND ARTICLES

Balázs, Béla. *Der Sichtbare Mensch oder die Kultur des Films* (The Visible Man or The Culture of Film). Vienna and Leipzig, 1924. Reprint, Frankfurt, 2001.

Benjamin, Walter. "Das Kunstwerk im Zeitalter seiner mechanischen Reproduzierbarkeit" (1935). In English as "The Work of Art in the Age of Mechanical Reproduction." In *Illuminations*. Edited by Hannah Arendt. Trans. Harry Zohn, 217–252 (New York, 1988, 1st ed. 1968).

———. "Der Autor als Produzent" (1934). In English as "The Author as Producer." In *Walter Benjamin: Selected Writings, 1927–1934*. Edited by Michael Jennings et al. Trans. Rodney Livingstone et al. 4 vols. Cambridge, Mass., 1996, 2: 768–782.

———. "Kleine Geschichte der Photographie" (1931). In English as "Little History of Photography." In *Walter Benjamin: Selected Writings, 1927–1934*. Edited by Michael Jennings et al. Trans. Rodney Livingstone et al. 4 vols. Cambridge, Mass., 1999, 2: 507–530.

Bossert, Helmuth Theodor, and Heinrich Guttmann. *Aus der Frühzeit der Photographie, 1840–70; ein Bildbuch nach 200 Originalen* (From the Beginnings of Photography, 1840–1870; an Illustrated Book after 200 Original Works). Frankfurt, 1930.

Bułhak, Jan. *Estetyka Światła / Esthétique de la Lumière*. Vilnius, 1936.

Čapek, Josef. *Nejskromnější umění* (The Humblest Art). Prague, 1920. Reprint, 1997. Edited by Dagmar Magincová et al.

Dost, Wilhelm. *Vorläufer der Photographie: Beitrag zur allgemeinen Geschichte der Photographie* (Precursors of Photography: Essay on the General History of Photography). Berlin, 1931.

Eder, Josef Maria. *History of Photography*. Trans. Edward Epstean. New York, 1978 (originally published as *Geschichte der Photographie*, Halle an der Saale, 1932; 1st ed. 1891–1892).

Freund, Gisèle. *La photographie en France au dix-neuvième siècle: essai de sociologie et d'esthétique* (Photography in 19th-century France: An Essay on Sociology and Aesthetics). Paris, 1936.

Funke, Jaromír. "O staré fotografii" (On Old Photography). "Je Fotografie Umění?" (Is Photography Art?). Special issue, *Světozor* 36, no. 29 (16 July 1936): n.p.

Gräff, Werner. *Es kommt der neue Fotograf!* (Here Comes the New Photographer). Berlin, 1929. Reprint, New York, 1979.

Hevesy, Iván. *A modern fotóművészet* (Modern Art Photography). Budapest, 1934.

Irzykowski, Karol. *x muza: zagadnienia estetyczne kina* (The Tenth Muse: Aesthetic Questions in Cinema). Warsaw, 1924. Reprint, 1977.

Kassák, Lajos, and László Moholy-Nagy. *Buch neuer Künstler* (Book on New Artists). Vienna, 1922. Reprint, Baden, Switzerland, 1991.

Linhart, Lubomír. *Sociální fotografie* (Social Photography). Prague, 1934.

Lissitzky, El, and Hans Arp. *Die Kunstismen. Les ismes de l'art. The Isms of Art*. Erlenbach-Zürich, 1925. Reprint, New York, 1968.

Moholy, Lucia. *A Hundred Years of Photography, 1839–1939*. Harmondsworth, England, 1939.

Moholy-Nagy, László. *The New Vision: Fundamentals of Design, Painting, Sculpture, Architecture*. Trans. Daphne M. Hoffmann. New York, 1946, 1st ed. 1938 (originally published as *Von Material zu Architektur*, Munich, 1929).

———. *Malerei Fotografie Film*. Munich, 1925, 1927. Reprint (facsimile) as *Painting, Photography, Film*. Trans. Janet Seligman. London and Cambridge, Mass., 1969.

Newhall, Beaumont. *Photography 1839–1937*. Exh. cat., The Museum of Modern Art. New York, 1938.

Pécsi, József. *A fényképező művészete* (The Photographer's Art). Budapest, 1916.

Recht, Camille. *Die alte Photographie*. Introduction by Iwan Goll. Paris and Leipzig, 1931.

Roh, Franz, and Jan Tschichold. *Foto-Auge: 76 Fotos der Zeit / Oeil et photo: 76 photographies de notre temps / Photo-eye: 76 photoes [sic] of the Period*. Stuttgart, 1929. Reprint, New York, 1973.

Schwarz, Heinrich. *David Octavius Hill: Der Meister der Photographie.* Leipzig, 1931.

Skopec, Rudolf. *Sto let fotografie 1839–1939* (One Hundred Years of Photography). Prague, 1939.

Štech, Václav Vilém. *Estetika Fotografie* (The Aesthetics of Photography). Prague, 1922.

Stenger, Erich. *The History of Photography; Its Relation to Civilization and Practice.* Trans. Edward Epstean. Easton, Pa., 1939. Reprint, New York, 1979 (originally published as *Die Photographie in Kultur und Technik; ihre Geschichte während hundert Jahren,* Leipzig, 1938).

Teige, Karel. "Constructivism and the Liquidation of 'Art.'" In *Modern Architecture in Czechoslovakia and Other Writings,* 331–340. Los Angeles, 2000 (originally published as "Konstruktivismus a likvidace 'umění'" [1925], reprinted in *Karel Teige: Svět stavby a básně* [A World of Construction and Poetry], edited by Jiří Brabec et al. 3 vols. Prague, 1966), 1: 129–143.

———. *Film.* Prague, 1925.

———. *The Minimum Dwelling.* Cambridge, Mass., 2002. Trans. and introduction by Eric Dluhosch (originally published as *Nejmenší byt / L'habitation minimum / Die Kleinstwohnung.* Prague, 1932).

———. "Über die Fotomontage." *Fotogeschichte* 9, no. 32 (1989): 61–70 (originally published as "O fotomontáži" [1932], reprinted in *Karel Teige: Zápasy o smysl moderní tvorby* [Struggles over the Meaning of Modern Creation], edited by Jiří Brabec et al. 3 vols. Prague, 1969, 2: 62–79).

SECONDARY BOOKS AND ARTICLES

Barcha, Gisela, and Claudia Jeschke. "Bewegungsrausch und Formenstreben: Der Ausdruckstanz in der Photographie 1900–1937" (The Extasy of Movement and the Search for Form: Expressive Dance in Photography, 1900–1937). In *Ausdruckstanz: Eine mitteleuropäische Bewegung der ersten Hälfte des 20. Jahrhunderts* (Expressive Dance: A Central European Movement of the First Half of the 20th Century), edited by Gunhild Oberzaucher-Schüller, 317–346. Wilhelmshaven, 1992.

Benson, Timothy O. *Central European Avant-gardes: Exchange and Transformation, 1910–1930.* Exh. cat., Los Angeles County Museum of Art. Los Angeles, 2002.

Berend, Iván T. *Decades of Crisis: Central and Eastern Europe before World War II.* Berkeley, 1998.

Berman, Marshall. *All That Is Solid Melts into Air: The Experience of Modernity.* New York, 1982.

Blau, Eve, and Monika Platzer, eds. *Shaping the Great City: Modern Architecture in Central Europe, 1890–1937.* Exh. cat., Canadian Centre for Architecture, Montreal. Munich and New York, 1999.

———, and Nancy J. Troy, eds. *Architecture and Cubism.* Cambridge, Mass., 1997.

Brückle, Wolfgang. "On Documentary Style: 'Anti-Graphic Photography' between the Wars." *History of Photography* 30, no. 1 (Spring 2006): 68–79.

Buchloh, Benjamin H. D. "From Faktura to Factography." *October* 30 (Fall 1984): 82–119.

Bürger, Peter. *Theory of the Avant-garde.* Minneapolis, 1984.

Cadava, Eduardo. *Words of Light: Theses on the Photography of History.* Princeton, 1997.

Călinescu, Matei. *Five Faces of Modernity: Modernism, Avant-garde, Decadence, Kitsch, Postmodernism.* Durham, N.C., 1999, 1st ed. 1987.

Chevrier, Jean-François, et al. "Vienne Prague Budapest," trans. C. L. Clark. *Photographies,* no. 7 (May 1985): 90–109, 138–142.

Clegg, Elizabeth. *Art, Design, and Architecture in Central Europe, 1890–1920.* New Haven, 2006.

Dewitz, Bodo, and Karin Schuller-Procopovici, eds. *David O. Hill & Robert Adamson. Von den Anfängen der künstlerischen Photographie im 19. Jahrhundert* (On the Beginnings of Art Photography in the 19th Century). Göttingen, 2000.

Dickerman, Leah, et al. *Dada: Zurich, Berlin, Hannover, Cologne, New York, Paris.* Exh. cat., National Gallery of Art. Washington, 2005.

———, with Matthew S. Witkovsky. *The Dada Seminars.* Washington, 2005.

Faber, Monika, ed. *Tanz-Foto: Annäherungen und Experimente, 1880–1940* (Dance-Photo: Convergences and Experiments, 1880–1940). Exh. cat., Museum des 20. Jahrhunderts. Vienna, 1990.

———, and Antonín Dufek. *Das Innere der Sicht: Surrealistische Fotografie der 30er und 40er Jahre* (Inner Sight: Surrealist Photography of the 1930s and 1940s). Exh. cat., Museum des 20. Jahrhunderts. Vienna, 1989.

———, and Janos Frecot, eds. *Portraits of an Age: Photography in Germany and Austria, 1900–1938.* Exh. cat., Neue Galerie. Ostfildern-Ruit, 2005.

Foster, Hal. "Armor Fou." *October* 56 (Spring 1991): 65–97.

Fotografía Pública / Photography in Print, 1919–1939. Introduction by Horacio Fernández. Exh. cat., Museo Nacional Centro de Arte Reina Sofía. Madrid, 1999.

Frisby, David. *Fragments of Modernity: Theories of Modernity in the Work of Simmel, Kracauer, and Benjamin.* Cambridge, Mass., 1986.

Gaehtgens, Thomas W. "Künstlerischer Austausch / Artistic Exchange." In *Akten des XXVIII. Internationalen Kongresses für Kunstgeschichte,* 3 vols. (Proceedings of the 28th International Congress on Art History). Berlin, 1993.

Garton Ash, Timothy. *The Uses of Adversity: Essays on the Fate of Central Europe.* New York, 1989.

Gasser, Martin. "Histories of Photography 1839–1939." *History of Photography* 16, no. 1 (Spring 1992): 50–60.

Gellner, Ernest. *Nations and Nationalism.* Malden, Mass., 2005, 1st ed. 1983.

Hambourg, Maria Morris, and Christopher Phillips. *The New Vision: Photography between the World Wars; Ford Motor Company Collection at the Metropolitan Museum of Art, New York.* Exh. cat., The Metropolitan Museum of Art. New York, 1989.

Heilmann, Ann, and Margaret Beetham, eds. *New Woman Hybridities: Femininity, Feminism and International Consumer Culture, 1880–1930.* New York, 2004.

Heynen, Hilde. *Architecture and Modernity: A Critique.* Cambridge, Mass., 1999.

Holz, Keith. *Modern German Art for Thirties Paris, Prague, and London: Resistance and Acquiescence in a Democratic Public Sphere.* Ann Arbor, Mich., 2004.

Huyssen, Andreas. *After the Great Divide: Modernism, Mass Culture, Postmodernism.* Bloomington, 1986.

———. "Critical Theory and Modernity: Introduction." *New German Critique,* no. 26 (Spring–Summer 1982): 3–11.

Janecek, Gerald, and Toshiharu Omuka, eds. *The Eastern Dada Orbit: Russia, Georgia, Ukraine, Central Europe and Japan.* New York and London, 1998.

Johnson, Lonnie. *Central Europe: Enemies, Neighbors, Friends.* New York, 2002, 1st ed. 1996.

Keller, Ulrich. "The Myth of Art Photography: A Sociological Analysis." *History of Photography* 8, no. 4 (October–December 1984): 267–279.

———. "The Myth of Art Photography: An Iconographical Analysis." *History of Photography* 9, no. 1 (January–March 1985): 1–38.

———, Herbert Molderings, and Winfried Ranke. *Beiträge zur Geschichte und Ästhetik der Fotografie* (Essays on the History and Aesthetics of Photography). Lahn-Giessen, 1977.

Král, Petr. *Fotografie v surrealismu* (Photography in Surrealism). Prague, 1994.

Krauss, Rosalind E. *The Originality of the Avant-garde and Other Modernist Myths.* Cambridge, Mass., and London, 1985.

———. "The Photographic Conditions of Surrealism." *October* 19 (Winter 1981): 3–34.

———, Jane Livingston, and Dawn Ades. *L'amour fou: Photography and Surrealism.* Exh. cat., Corcoran Gallery of Art. Washington, 1985.

Labuda, Adam S., Robert Born, and Alena Janatková, eds. *Die Kunsthistoriographien in Ostmitteleuropa und der nationale Diskurs* (Art Historiographies in East-Central Europe and National Discourse). Berlin, 2004.

Lahs-Gonzales, Olivia. "Photography in Modern Europe." *Bulletin St. Louis Art Museum* 21, no. 4 (Spring 1996).

Lesnikowski, Wojciech G., ed. *East European Modernism: Architecture in Czechoslovakia, Hungary, and Poland between the Wars 1919–1939.* New York, 1996.

Lista, Giovanni. *Futurism and Photography.* Exh. cat., Estorick Collection of Modern Italian Art. London, 2001.

Lodder, Christina. "Promoting Constructivism: Kino-Fot and Rodchenko's Move into Photography." *History of Photography* 24, no. 4 (2000): 292–299.

Lugon, Olivier. *Le Style documentaire d'August Sander à Walker Evans, 1920–1945.* Paris, 2001.

Mansbach, Steven A. *Modern Art in Eastern Europe: From the Baltic to the Balkans, ca. 1890–1939.* New York, 1999.

———, ed. "From Leningrad to Ljubljana: The Suppressed Avant-gardes of East-Central and Eastern Europe during the Early Twentieth Century." Special issue, *Art Journal* 49 (Spring 1990).

Marquardt, Virginia Carol Hagelstein, ed. *Art and Journals on the Political Front, 1910–1940.* Gainesville, Fla., 1997.

McCauley, Elizabeth Anne. "Writing Photography's History before Newhall." *History of Photography* 21, no. 2 (1997): 87–101.

Melinz, Gerhard, and Susan Zimmermann, eds. *Wien, Prag, Budapest: Blütezeit der Habsburgmetropolen; Urbanisierung, Kommunalpolitik, gesellschaftliche Konflikte (1867–1918)* (The Golden Age of the Hapsburg Metropolis: Urbanization, Town Planning, Social Conflicts). Vienna, 1996.

Mészáros, Júlia N. *Közép-Európai avantgárd rajz-és grafika 1907–1938 / Central European Avant-garde Drawing and Graphic Art, 1907–1938.* Exh. cat., Városi Művészeti Múzeum. Győr, 2001.

Moravánszky, Ákos. *Competing Visions: Aesthetic Invention and Social Imagination in Central European Architecture, 1867–1918.* Cambridge, Mass., 1998.

Müller-Tamm, Pia, and Katharina Sykora, eds. *Puppen, Körper, Automaten: Phantasmen der Moderne* (Dolls, Bodies, Automatons: Phantasms of the Modern). Exh. cat., Kunstsammlung Nordrhein-Westfalen. Düsseldorf, 1999.

Nickel, Douglas R. "History of Photography: The State of Research." *The Art Bulletin* 83, no. 3 (September 2001): 548–558.

Ollman, Leah. *Camera as Weapon: Worker Photography between the Wars.* Exh. cat., Museum of Photographic Arts. San Diego, 1991.

Paris-Berlin, 1900–1933: rapports et contrastes France-Allemagne, 1900–1933 (Connections and Differences between France and Germany). Exh. cat., Centre Georges Pompidou. Paris, 1978.

Parr, Martin, and Gerry Badger. *The Photobook: A History.* London, 2004.

Passmore, Kevin, ed. *Women, Gender and Fascism in Europe, 1919–45.* New Brunswick, 2003.

Passuth, Krisztina. *Treffpunkte der Avantgarden Ostmitteleuropa 1907–1930* (East-Central Europe: Meeting Points of the Avant-garde, 1907–1930). Budapest and Dresden, 2003.

Price, Renée, et al. *New Worlds: German and Austrian Art, 1890–1940.* New York, 2001.

Schafter, Debra. *The Order of Ornament, the Structure of Style: Theoretical Foundations of Modern Art and Architecture.* New York, 2003.

Schilling, Jürgen. *Wille zur Form: Ungegenständliche Kunst 1910–1938 in Österreich, Polen, Tschechoslowakei und Ungarn* (The Will to Form: Non-Objective Art 1910–1938 in Austria, Poland, Czechoslovakia, and Hungary). Exh. cat., Messepalast. Vienna, 1993.

Sekula, Allan. *Photography against the Grain: Essays and Photo Works, 1973–1983.* Exh. cat., Ohio State University Gallery of Fine Art. Halifax, Nova Scotia, 1984.

Sobieszek, Robert A. "Composite Imagery and the Origins of Photomontage, Part I: The Naturalistic Strain." *Artforum* 17, no. 1 (September 1978): 58–65.

———. "Composite Imagery and the Origins of Photomontage, Part II: The Formalist Strain." *Artforum* 17, no. 2 (October 1978): 40–45.

Stange, Maren. *Symbols of Ideal Life: Social Documentary Photography in America, 1890–1950.* New York, 1989.

Stanisławski, Ryszard, and Christoph Brockhaus. *Europa, Europa: Das Jahrhundert der Avantgarde in Mittel- und Osteuropa.* Exh. cat., Kunst- und Ausstellungshalle der Bundesrepublik Deutschland. 4 vols. Bonn, 1994.

Stiegler, Bernd. "Benjamin und die Photographie: Zum historischen Index der Bilder." In *Schrift, Bilder, Denken: Walter Benjamin und die Künste* (Writing, Images, Thought: Walter Benjamin and the Arts), edited by Detlev Schöttker, 127–142. Exh. cat., Haus am Waldsee, Berlin. Frankfurt, 2004.

Trachtenberg, Alan. *Reading American Photographs: Images as History, Mathew Brady to Walker Evans.* New York, 1989.

Turowski, Andrzej. *Existe-t-il un art de l'Europe de l'Est? Utopie & idéologie* (Is There an Eastern European Art? Utopia and Ideology). Paris, 1986.

Walker, Ian May. *City Gorged with Dreams: Surrealism and Documentary Photography in Interwar Paris.* Manchester, 2002.

Wilk, Christopher. *Modernism: Designing a New World.* Exh. cat., Victoria and Albert Museum. London, 2006.

Wingfield, Nancy M. *Creating the Other: Ethnic Conflict and Nationalism in Habsburg Central Europe.* New York, 2003.

Witkovsky, Matthew S., ed. "Modern Photography in Central Europe." Special issue, *History of Photography* 29, no. 3 (Fall 2005).

Austria

PERIODICALS

Die Galerie, 1933–1943, 1957–1967

Das interessante Blatt (The Interesting Paper), 1882–c. 1922

Der Lichtbildner (The Photographer), 1933–1943

Der Kuckuck (The Cuckoo), 1929–1934

Wiener-Magazin, 1926–?

ANTHOLOGIES

Starl, Timm. "A Bibliography of Photography in Austria." http://alt.albertina.at/e/fotobibl/einstieg.html (accessed June 2006).

———. *Lexikon zur Fotografie in Österreich 1839 bis 1945.* Vienna, 2005.

Sykora, Katharina, et al., eds. *Die neue Frau: Herausforderung für die Bildmedien der Zwanziger Jahre* (The New Woman: Challenge for the Visual Media of the 1920s). Marburg, 1993.

PRIMARY BOOKS AND ARTICLES

Angerer, Wilhelm. *Ein Lied rauscht von den Bergen* (A Song Sweeps Down from the Mountains). Vorarlberg, Tirol, 1942.

———, and Ernst Sturmmair. *Die Einheit Tirols: Ein vergleichendes Bildwerk über die geographische und historische Einheit Nord- und Südtirols* (Tirol's Unity: A Comparative Picture Book on the Historical and Geographical Unity of North and South Tirol). Innsbruck, 1946.

Atzwanger, Peter Paul. "Die Lichtbildnerei als Kunst" (Photography as Art). *Der Bergsteiger* (The Mountain Climber) (May 1929): 354–356.

Born, Wolfgang. "Die Schönheit des Unscheinbaren: Betrachtungen zu Photographien Richard Trägers" (The Beauty of the Inconspicuous: Reflections on Richard Träger's Photographs). *Photofreund* 9, no. 6 (20 March 1929): 101–103.

Fachverbände der Fotografen-Genossenschaften Österreichs. *Foto-Ausstellung: Österreichs Bundesländer im Lichtbilde* (Photo-Exhibit: Austria's States in Photographs). Exh. cat., Österreichisches Museum für Kunst und Industrie. Vienna, 1933.

Göhlert, Felix. "Zum Wesen der Heimatphotographie" (On the Essence of Homeland Photography). *Der Lichtbildner* (January 1934): 13.

Karnitschnigg, Maximilian R. von. "Zur III. Ausstellung des Verbandes in Wien 1930" (On the Association's Third Exhibition in Vienna 1930). *Nachrichten des Verbandes österreichischer Amateurphotographen-vereine* (News of the Austrian Association of Amateur Photographers) 3, no. 5 (May 1930): 1–6.

Kläger, Emil. *Durch die Wiener Quartiere des Elends und Verbrechens: Ein Wanderbuch aus dem Jenseits* (Through the Viennese Slums of Poverty and Crime: A Travelogue from the Netherworld). Vienna, 1908.

Kretschmer, Ferdinand. "Heimatphotographie." *Nachrichten des Verbandes österreichischer Amateurphotographen-vereine* 6, no. 9 (September 1933): 1–3.

M., A. "Film und Foto: Wanderausstellung des Deutschen Werkbundes." *Nachrichten des Verbandes österreichischer Amateurphotographen-vereine* 3, no. 4 (April 1930): 6–7.

Moser, Simon. *Lebendiges Tirol: Ein Bildwerk der Landschaft* (Lively Tirol: A Landscape Picture Book). Innsbruck, 1955, 1st ed. 1946.

Rosenberg, L. "Werbende Heimatbilder" (Homeland Advertising Images). *Der Lichtbildner* (June 1935): 167–171.

Sighart-Graz, Erich. "Die 'Neue Sachlichkeit.'" *Nachrichten des Verbandes österreichischer Amateurphotographen-vereine* 3, no. 2 (February 1930): 1–5.

Springenschmid, Karl, and Peter Paul Atzwanger. *Bauern in den Bergen* (Peasants in the Mountains). Munich, 1936.

Trenker, Luis, and Walter Schmidkunz. *Berge und Heimat: Das Buch von den Bergen und ihren Menschen* (Mountains and Homeland: The Book on the Mountains and Their People). Berlin, 1940, 1st ed. 1933.

SECONDARY BOOKS AND ARTICLES

Beller, Steven, ed. *Rethinking Vienna 1900.* New York, 2001.

Blau, Eve. *The Architecture of Red Vienna, 1919–1934.* Cambridge, Mass., 1999.

Brandstätter, Christian. *Simon Moser: Tirol; Menschen & Landschaften, 1925–50* (Simon Moser: Tirol; People and Landscapes, 1925–1950). Introduction by Wolfgang Pfaundler. Vienna, 1978.

Faber, Monika. *Anton Josef Trčka 1893–1940.* Exh. cat., Rupertinum. Vienna, 1999.

———, and Klaus Albrecht Schröder, eds. *The Eye and the Camera: The Albertina Collection of Photographs.* Trans. Edith Vanghelof et al. Exh. cat., Albertina, Vienna. Paris, 2003.

———, and Timm Starl. *Zeit ohne Zukunft: Photographie in Wien 1918–1938* (Time without Future: Photography in Vienna 1918–1938). Vienna, 1999.

Hochreiter, Otto, and Timm Starl, eds. *Geschichte der Fotografie in Österreich* (History of Photography in Austria). 2 vols. Bad Ischl, 1983.

———, and Peter Weiermair, eds. *Peter Paul Atzwanger, 1888–1974: Photographien.* Innsbruck, 1981.

Kaindl, Kurt. *Harald P. Lechenperg: Pionier des Fotojournalismus, 1929–1937.* Salzburg, 1990.

———, Maria Emberger, and Clemens M. Hutter. *Stefan Kruckenhauser: In weiten Linien; das fotografische Lebenswerk* (Stefan Kruckenhauser: With a Broad Brush; The Complete Photographic Work). Salzburg, 2003.

Lechner, Astrid. "Der Camera-Club in Wien und die Kunstfotografie um 1900" (The Camera Club in Vienna and Art Photography around 1900). PhD diss., Universität Wien, 2005.

Le Rider, Jacques. *Modernity and Crises of Identity.* Trans. Rosemary Morris. New York, 1993.

Mayer, Emil, and Edward Rosser. *Viennese Types / Wiener Typen: Photographs c. 1910 by Dr. Emil Mayer.* Introduction by Rudolf Arnheim. Lexington, Mass., 1999.

Paupié, Kurt. *Handbuch der österreichischen Pressegeschichte, 1848–1959* (A Guide to the History of the Austrian Press). 2 vols. Vienna, 1960.

Rabinbach, Anson. *The Crisis of Austrian Socialism: From Red Vienna to Civil War, 1927–1934.* Chicago, 1983.

Riedl, Joachim, ed. *Wien, Stadt der Juden: Die Welt der Tante Jolesch* (Vienna, City of Jews: The World of Aunt Jolesch). Exh. cat., Jüdisches Museum der Stadt Wien. Vienna, 2004.

Schiffer-Ekhart, Armgard, and Ernst M. Fürböck. *Grazer Kunstphotographen: Maximilian Karnitschnigg (1872–1940), Hugo Haluschka (1880–1951)* (Art Photographers from Graz: Maximilian Karnitschnigg [1872–1940], Hugo Haluschka [1880–1951]). Graz, 1981.

Schögl, Uwe, ed. *Im Blickpunkt: Die Fotosammlung der Österreichischen Nationalbibliothek* (In Focus: The Photography Collection of the Austrian National Library). Exh. cat., Österreichische Nationalbibliothek. Innsbruck, 2002.

Schorske, Carl E. *Fin-de-siècle Vienna: Politics and Culture.* New York, 1979.

Seeber, Ursula. *Asyl wider Willen: Exil in Österreich 1933 bis 1938* (Forced Refuge: Exile in Austria 1933 to 1938). Vienna, 2003.

Seiter, Josef. *"Blutigrot und silbrig hell —": Bild, Symbolik und Agitation der frühen sozialdemokratischen Arbeiterbewegung in Österreich* ("Blood Red and Silvery Bright": Image, Symbolism, and Propaganda of the Early Social Democratic Worker's Movement in Austria). Vienna, 1991.

Czech Republic and Slovakia

PERIODICALS

České slovo (Czech Word), Sunday photography supplement

Disk, two issues, 1923 and 1925

Eva, 1928–1940

Fotografický obzor (Photographic Horizon), 1893–1942?

Koruna (Crown), 1929–1930

Letem světem (Around the World)

Linie (Line), 1931–1939

Magazin DP (Cooperative Work Magazine), 1933–1937

Panorama, 1928–1949?

Pásmo (Zone), 1925–1926

Pestrý týden (Colorful Week), 1926–1945

Prager Presse, Sunday photography supplement, 1921–1938

Pražský Illustrovaný Zpravodaj (Prague Illustrated Reporter), 1920–1935

ReD, 1927–1930

Telehor, one issue, 1936

Slovenský svet (The Slovak World), 1921–1925

Žijeme (We're Alive), 1931–1933

ANTHOLOGIES

Balajka, Petr. Encyklopedie českých a slovenských fotografů (Encyclopedia of Czech and Slovak Photographers). Prague, 1993.

Chvatík, Květoslav, and Zdenek Pešat, eds. Poetismus. Prague, 1967.

Vlašín, Štěpán, et al., eds. Avantgarda známá a neznámá (The Known and Unknown Avant-garde). 3 vols. Prague, 1970–1972.

PRIMARY BOOKS AND ARTICLES

Bartuška, Josef. "Nová fotografie." Linie 2, no. 3 (1932): 20–21.

Čermák, František. "Ideová stránka fotografie" (The Conceptual Side of Photography). Foto, no. 12 (March 1930): 13.

———. "Surrealismus a fotografie." Magazin DP (March 1935).

Drtikol, František. Eyes Wide Open. Prague, 2002.

———. Žena ve světle (Woman in Light). Introduction by J. B. Marek. Prague, 1938.

Funke, Jaromír. "Od pictorialismu k emoční fotografii" (From Pictorialism to Emotional Photography). Fotografický obzor 44, no. 7 ([July] 1936): 148–149.

Hák, Miroslav. Očima. Svět kolem nás (With Our Eyes: The World around Us). Introduction by Lubomír Linhart. Prague, 1947.

Heisler, Jindřich, and Jindřich Štyrský. Na jehlách těchto dní (On the Needles of These Days). Prague, 1945 (private printing, 1941). Reprint (facsimile) in English, Berlin, 1984.

Jesenská, Milena. "Umění fotografovati" (The Art of Photographing). Pestrý týden 2, no. 10 (9 March 1927): 10.

Krejcar, Jaromír, ed. La Vie/Život, no. 2. Prague, 1922 [1923].

Kroha, Jiří. Sociologický fragment bydlení (Excerpt from a Sociology of Habitat). Brno, 1973.

Kudlák, Ľudovít. "Národopisný film Matice slovenskej" (The Ethnographic Films of Matica Slovenská). Slovenské pohľady 45, no. 3 (March 1929): 174–179.

Linhart, Lubomír. Mezinárodní výstava fotografie (International Photography Exhibition). Exh. cat., Film-foto skupina Levé fronty. Prague, 1936.

———. "Od studia tvarové krásy k syntetické fotografii" (From the Study of Formal Beauty to Synthetic Photography). Magazin DP (1935): 119–123.

Lukas, Jan. Země a lidé: kniha fotografií (The Land and the People: A Book of Photographs). Prague, 1946.

Nezval, Vítězslav, with Milča Mayerová. Abeceda. Prague, 1926. Reprint (facsimile) in English as Alphabet. Ann Arbor, Mich., 2001.

Novák, Ada. "Stať o umění" (Essay on Art). Sdružení 3, no. 5 (1932): 9.

Plicka, Karel. Praha ve fotografii (Prague in Photographs). Prague, 1940.

———. Slovensko vo fotografii Karola Plicku (Slovakia in the Photographs of Karel Plicka). Introduction by Laco Novomeský. Turciansky sv. Martin, Slovakia, 1949.

Povolný, František. "Mladá brněnská fotografie" (New Photography in Brno). Světozor, no. 19 (1934).

———. "Společenská funkce fotografie" (Photography's Social Function). Blok 2, no. 6 (1948): 206–208.

Štyrský, Jindřich. Emilie Comes to Me in a Dream. New York, 1997 (originally published as Emilie přichází ke mně ve snu, Prague, 1933).

Sudek, Josef. Josef Sudek, fotografie. Introduction by Lubomír Linhart. Prague, 1956.

———. Svatý Vít. Introduction by Jaroslav Durych. Prague, 1928.

Sutnar, Ladislav. Visual Design in Action: Principles, Purposes. New York, 1961.

———, and Jaromír Funke. Fotografie vidí povrch/La photographie reflète l'aspect des choses. Prague, 1935. Reprint (facsimile) in English as Photography Sees the Surface/La photographie reflète l'aspect des choses. Ann Arbor, Mich., 2004.

Teige, Karel. "Cesty československé fotografie" (Paths in Czechoslovak Photography). Blok 2, no. 6 (1948).

———. "Ladislav Sutnar a nová typografie." (Ladislav Sutnar and The New Typography). Panorama 12 (1934): 11–16.

———, Josef Sudek, and Josef Ehm. Moderní česká fotografie: album deseti původních snímků (Modern Czech Photography: An Album of Ten Original Pictures). Prague, 1943.

———, and Vítězslav Nezval. Štyrský a Toyen. Prague, 1938.

Wiškovský, Eugen. "O obrazové fotografii" (On Pictorial Photography). Foto 12 (December 1929): 183–187.

———. "Tvar a Motiv" (Form and Subject). Fotografický obzor 48, no. 10 ([October] 1940): 109.

———. "Zobrazení, projevy a sdělení" (Representation, Expressions, and Communication). Fotografický obzor 49, no. 1 ([January] 1940): 2–4.

SECONDARY BOOKS AND ARTICLES

Abelovský, Ján, and Katarína Bajcurová. Art in Changing Times: Painting & Sculpture in Slovakia 1890–1949. Bratislava, 2000.

Adlerová, Alena. České užité umění, 1918–1938 (Czech Applied Art). Prague, 1983.

Anděl, Jaroslav. The Avant-garde across Media: Josef Bartuška and the Linie Group 1931–1939. Prague, 2004.

———. "Construction and Poetism in Czech Photography." Photographies, no. 6 (May 1985): 121–123.

———. "The Czech Avant-garde and the Book, 1900–1945." Afterimage 12 (January 1985), supplement: i–xvi.

———. Czech Modernism, 1900–1945. Exh. cat., The Museum of Fine Arts. Houston, 1989.

———. El Arte de la vanguardia en Checoslovaquia, 1918–1938/The Art of the Avant-garde in Czechoslovakia, 1918–1938. Exh. cat., IVAM Centre Julio González. Valencia, 1993.

———. The New Vision for the New Architecture: Czechoslovakia, 1918–1938. Prague, 2005.

Baran, Ludvík. Praha objektivem mistrů (Prague through the Lens of Masters). Prague, 1981.

Becker, Edwin, Roman Prahl, and Petr Wittlich, eds. Prague 1900: Poetry and Ecstasy. Exh. cat., Van Gogh Museum. Amsterdam, 1999.

Birgus, Vladimír. Czech Photographic Avant-garde, 1918–1948. Cambridge, Mass., 2002.

———, and Jan Mlčoch. Akt v české fotografii/The Nude in Czech Photography. Exh. cat., Muzeum umění, Olomouc. Prague, 2000.

Bydžovská, Lenka. Aventinská mansarda: Otakar Štorch Marien a výtvarné umění (The Aventinum Attic: Otakar Štorch Marien and the Fine Arts). Exh. cat., Galerie hlavního města Prahy. Prague, 1990.

———, and Karel Srp. Český surrealismus 1929–1953: skupina surrealistů v ČSR; události, vztahy, inspirace (Czech Surrealism 1929–1953: The Surrealist Group in Czechoslovakia—Events, Relationships, Inspirations). Exh. cat., Galerie hlavního města Prahy. Prague, 1996.

———. Libeňský plynojem. Prague, 2004.

Demetz, Peter. Prague in Black and Gold: Scenes from the Life of a European City. New York, 1997.

Dufek, Antonín. *Avantgardní fotografie 30. let na Moravě.* Exh. cat., Moravská galerie. Brno, 1981.

———. "Fotografie třicátých let" (Photography of the 1930s). In *Dějiny českého výtvarného umění 1890–1938* (The History of Czech Art). Edited by Vojtěch Lahoda et al., 322–353. Prague, 1998.

———, and Zdeněk Kirschner. *Photographes tchèques, 1920–1950.* Exh. cat., Musée national d'art moderne. Paris, 1983.

Eskildsen, Ute. *Tschechische Fotografie 1918–1948.* Exh. cat., Museum Folkwang. Essen, 1984.

Faber, Monika, and Josef Kroutvor. *Photographie der Moderne in Prag, 1900–1925.* Exh. cat., Neue Galerie der Stadt Linz. Schaffhausen, Switzerland, 1991.

Fárová, Anna. *Osobnosti české fotografie I* (Personalities in Czech Photography I). Exh. cat., Uměleckoprůmyslové muzeum v Praze. Prague, 1974.

Fijalkowski, Krzysztof. "Objective Poetry: Post-War Czech Surrealist Photography and the Everyday." *History of Photography* 29, no. 2 (Summer 2005): 163–173.

Hlaváč, L'udovít. *Dejiny slovenskej fotografie* (The History of Slovak Photography). Martin, Slovakia, 1987.

———. *Sociálna fotografia na Slovensku: obsah, dejiny, súvislosti, prínosy* (Social Photography in Slovakia: Content, History, Connections, Contributions). Bratislava, 1974.

Hlušička, Jiří, Sue Davies, and Antonín Dufek. *Jaromír Funke, Jaroslav Rössler / 27 Contemporary Czechoslovakian Photographers.* Exh. cat., Photographers' Gallery. London, 1985.

Hrabušický, Aurel. *Viliam Malík.* Bratislava, 2001.

———, and Václav Macek. *Slovenská fotografia, 1925–2000: moderna, postmoderna, postfotografia / Slovak Photography, 1925–2000: Modernism, Postmodernism, Post-Photography.* Bratislava, 2002.

Krimmel, Bernd, et al. *Tschechische Kunst der 20er und 30er Jahre: Avantgarde und Tradition.* Exh. cat., Mathildenhöhe. Darmstadt, 1988.

Mojžišová, Iva. "Avant-garde Repercussions and the School of Applied Arts in Bratislava, 1928–1939." *Journal of Design History* 5, no. 4 (1992): 273–279.

———. *Fotografické etudy Ladislava Foltýna / Ladislav Foltýn's Photographic Études.* Trans. Peter Tkáč. Bratislava, 2002.

———. "Škola umeleckých remesiel v Bratislave a Bauhaus" (The School of Applied Arts in Bratislava and at the Bauhaus). In *Ars: pramene moderného slovenského výtvarného umenia* (Sources in Modern Slovak Fine Art). Edited by Juraj Záry, 43–54. Bratislava, 1990.

Mrázková, Daniela, and Vladimír Remeš. *Cesty československé fotografie* (Paths in Czechoslovak Photography). Prague, 1989.

Primus, Zdenek. *Tschechische Avantgarde 1922–1940: Reflexe europäischer Kunst und Fotografie in der Buchgestaltung* (Czech Avantgarde 1922–1940: European Art and Photography as Reflected in Book Design). Exh. cat., Kunstverein Hamburg. Hamburg, 1990.

Schafter, Debra. "The Perceptual Transformation of Matter in Czech Photography and Cubist Architecture." *Centropa* 5, no. 1 (January 2005): 26–39.

Scheffel, David, and Josef Kandert. "Politics and Culture in Czech Ethnography." *Anthropological Quarterly* 67, no. 1 (January 1994): 9–23.

Skvarna, Dušan, Václav Macek, and Iva Mojžišová. *Irena Blühová.* Martin, Slovakia, 1991.

Šmejkal, František, and Rostislav Švácha. *Devětsil: Czech Avant-garde Art, Architecture and Design of the 1920s and 30s.* Exh. cat., Museum of Modern Art Oxford. Oxford and London, 1990.

Spector, Scott. *Prague Territories: National Conflict and Cultural Innovation in Franz Kafka's Fin de Siècle.* Berkeley, 2000.

Srp, Karel. *Toyen.* Trans. Karolína Vocadlová. Exh. cat., Galerie hlavního města Prahy. Prague, 2000.

Starcky, Emmanuel, et al. *Prague: 1900–1938: capitale secrète des avant-gardes.* Exh. cat., Musée des Beaux-arts. Dijon, 1997.

Svobodová, Markéta. "Když se led proboří. Lázně, plovárny a bazény v české architektuře 19. a 20. století" (When the Ice Breaks: Spas and Swimming Pools in 19th- and 20th-Century Czech Architecture). *Umění* 48, no. 5 (2000): 351–368.

Tausk, Petr. "The Roots of Modern Photography in Czechoslovakia." *History of Photography* 3, no. 3 (July 1979): 253–271.

Toman, Jindřich. *The Magic of a Common Language: Jakobson, Mathesius, Trubetzkoy, and the Prague Linguistic Circle.* Cambridge, Mass., 1995.

———. *Kniha v českém kubismu / Czech Cubism and the Book.* Prague, 2004.

———. *The Age of the Eye: Czech Photography and Photomontage in Print, 1920s–1940s.* Prague, 2007.

Uchalová, Eva, et al. *Czech Fashion 1918–1939: Elegance of the Czechoslovak First Republic.* Trans. Štěpán Suchochleb. Prague, 1996.

Urban, Otto. *Die tschechische Gesellschaft 1848 bis 1918.* Trans. Henning Schlegel. 2 vols. Vienna, 1994 (originally published as *Česká společnost 1848–1918,* Prague, 1982).

———. *Kapitalismus a česká společnost: k otázkám formování české společnosti v 19. století* (Capitalism and Czech Society: Forming Czech Society in the 19th Century). Prague, 2003, 1st ed. 1978.

Witkovsky, Matthew S. "Envisaging the Gendered Center: Prague's Municipal Building and the Construction of a Czech Nation, c. 1880–1914." *Umění* 47, no. 3 (2001): 203–220.

———. "Truly Blank: The Monument to National Liberation and Interwar Modernism in Prague." *Umění* 49, no. 1 (2001): 42–60.

Wittlich, Petr. *Prague Fin de Siècle.* Paris, 1992.

Zykmund, Václav, and Vratislav Effenberger. *Surrealismus und Fotografie.* Exh. cat., Dům umění města Brna. Brno, 1966.

Germany

PERIODICALS

Arbeiter-Fotograf (Worker-Photographer), 1926–1933

Arbeiter Illustrierte Zeitung (Workers' Illustrated Newspaper), 1925–1938

Berliner Illustrirte Zeitung (Berlin Illustrated Newspaper), 1890–1944

Der Dada, three issues, 1919–1920

Die Dame (The Lady), 1911–1943

Das deutsche Lichtbild: Jahresschau (German Photography Annual), 1927–1938

Gebrauchsgraphik (Advertising Art), 1924–1971

Grüne Post (Green Mail), 1927–1944

Das illustrierte Blatt (The Illustrated Paper), 1913–1944?

Das neue Frankfurt (The New Frankfurt), 1926–1931

Münchner Illustrierte Zeitung (Munich Illustrated Newspaper), 1908–1918; 1923–1944

Photographische Rundschau (Photographic Review), 1887–1941?

Querschnitt (Cross-section), 1924–1936

UHU (Owl), 1924–1934

ANTHOLOGIES

Ankum, Katharina von, ed. *Women in the Metropolis: Gender and Modernity in Weimar Culture.* Berkeley, 1997.

Bulgakowa, Oksana, ed. *Eisenstein und Deutschland: Texte, Dokumente, Briefe.* Berlin, 1998.

Büthe, Joachim, et al. *Der Arbeiter-Fotograf: Dokumente und Beiträge zur Arbeiterfotografie, 1926–1932* (The Worker-Photographer: Documents and Essays on Worker Photography). Cologne, 1978, 1st ed. 1977.

Kaes, Anton, Martin Jay, and Edward Dimendberg, eds. *The Weimar Republic Sourcebook.* Berkeley, 1994.

Kracauer, Siegfried. *The Mass Ornament: Weimar Essays.* Introduction by Thomas Y. Levin. Cambridge, Mass., 1995.

Lange, Susanne, Gabriele Conrath-Scholl, and Gerd Sander, eds. *Menschen des 20. Jahrhunderts: Ein Kulturwerk in Lichtbildern eingeteilt in sieben Gruppen / People of the 20th Century: A Cultural Work in Photographs Divided into Seven Groups / Hommes du xxe siècle: une œuvre culturelle divisée en sept groupes.* 7 vols. New York, 2002.

Lorant, Stefan. *The Life of Stefan Lorant.* 3 vols. Lenox, Mass., 1994.

Lugon, Olivier, and François Mathieu, eds. *La photographie en Allemagne: anthologie de textes (1919–1939).* Nimes, 1997.

Mellor, David, ed. *Germany, the New Photography, 1927–33: Documents and Essays.* London, 1978.

PRIMARY BOOKS AND ARTICLES

Atget, Eugène. *Lichtbilder.* Introduction by Camille Recht. Paris and Leipzig, 1930. Reprint, Munich, 1975.

Biermann, Aenne. *Aenne Biermann: 60 Fotos.* Introduction by Franz Roh. Berlin, 1930.

Blossfeldt, Karl. *Art Forms in Nature.* New York, 1985, 1st ed. 1929 (originally published as *Urformen der Kunst: Photographische Pflanzenbilder,* Berlin, 1929).

Bömer, K. "Ein neuer journalistischer Berufszweig: Der Bildredakteur" (A New Journalistic Profession: The Picture Editor). *Zeitungs-Verlag: Fachblatt für das gesamte Zeitungswesen* (Newspaper Publishing: A Trade Journal for the Newspaper World) 30 (28 July 1928): 1617.

Breuer, Robert. "Grüne Architektur" (Green Architecture). *UHU* 2, no. 9 (June 1926): 28–38.

Claaßen, Eugen. "Deutsche Photographische Ausstellung 1926, Frankfurt a.M." *Die Form* (1925): 275–276.

"Die kulturelle Bedeutung des Zeitungbildes" (The Cultural Importance of Newspaper Pictures). *Zeitungs-Verlag: Fachblatt für das gesamte Zeitungswesen* 29 (31 March 1928): 637–640.

Domela-Nieuwenhuis, Cesar. *Fotomontage.* Exh. cat., Staatliche Kunstbibliothek. Berlin, 1931.

"Eine neue Künstler-Gilde: Der Fotograf erobert Neuland" (A New Artists' Guild: The Photographer Conquers New Territory). *UHU* 6, no. 1 (October 1929): 34–41.

Errell, Richard. *Errell: Photographik auf Ausstellungen* (Art Photography at Exhibition). Berlin-Charlottenburg, 1931.

Feininger, Andreas. *Menschen vor der Kamera: Ein Lehrbuch moderner Bildnisfotografie* (People before the Camera: A Handbook of Modern Portrait Photography). Halle an der Saale, 1934.

Grosz, George. *Mit Pinsel und Schere* (With Paintbrush and Scissors). Berlin, 1922.

Hartlaub, G. F. "Neue Sachlichkeit." *UHU* 4, no. 10 (July 1928): 18–20.

Hauser, Heinrich. *Schwarzes Revier* (Black District). Berlin, 1930.

Herzfelde, Wieland. "Introduction to the First International Dada Fair" (1920). Trans. Brigid Doherty. *October* 105 (Summer 2003): 102.

Hirschfeld. "Die Moderne Photographie / Modern Photography." *Gebrauchsgraphik International Advertising Art* 7, no. 7 (July 1930): 44–51.

Hoppé, E. O. *Deutsche Arbeit: Bilder vom Wiederaufstieg Deutschlands* (German Work: Images from Germany's Return to Greatness). Introduction by Bruno Hans Bürgel. Berlin, 1930.

Internationale Ausstellung des Deutschen Werkbundes Film und Foto: Stuttgart, 1929. Exh. cat., Deutscher Werkbund. Stuttgart, 1929. Reprint, edited by Karl Steinorth, 1979.

Johannes, Heinz. *Neues Bauen in Berlin; ein Führer mit 168 Bildern* (New Building in Berlin: A Guide in 168 Images). Berlin, 1931.

Kuhfahl, Gustav Adolf. *Heimatphotographie: Die Photographie im Dienste von Heimatschutz und Heimatforschung* (Homeland Photography: Photography in the Service of Homeland Preservation and Study). Halle an der Saale, 1921.

"Laßt Fotos sprechen!" (Let Photographs Speak). *UHU* 7, no. 3 (December 1930): 29–37.

Lendvai-Dircksen, Erna. *Das deutsche Volksgesicht* (The Face of the German People). 9 vols. Berlin, 1932, and Bayreuth, 1940–1944.

———. *Ein deutsches Menschenbild: Antlitz des Volkes* (A German Picture of Humanity: The Face of the People). Frankfurt, 1961.

Lerski, Helmar. *Köpfe des Alltags: Unbekannte Menschen* (Everyday Faces: Unknown People). Introduction by Curt Glaser. Berlin, 1931.

Moholy, Lucia. *Marginalien zu Moholy-Nagy: Dokumentarische Ungereimtheiten / Moholy-Nagy, Marginal Notes: Documentary Absurdities.* Krefeld, 1972.

Moholy-Nagy, László. "A fényképezés megujulasa" (The Renaissance of Photography). *Munka* 1, no. 2 (October 1928): 42–43.

Munkacsi, Martin, and Albert Renger-Patzsch. "Halt mal still! Martin Munkascy [sic] und Renger-Patzsch über Amateurphotographie" (Hold Still! Martin Munkacsi and Renger-Patzsch on Amateur Photography). *UHU* 5, no. 10 (July 1929): 18–26.

Piscator, Erwin, and Felix Gasbarra. *Das politische Theater.* Berlin, 1929. Reprint (facsimile) in English as *The Political Theatre.* London, 1980.

Rasch, Heinz, and Bodo Rasch. *Gefesselter Blick: 25 kurze Monographien und Beiträge über neue Werbegestaltung* (Spellbound: 25 Short Monographs and Essays on New Advertising Design). Stuttgart, 1930. Reprint, Baden, Switzerland, 1996.

Renger-Patzsch, Albert. *Die Welt ist schön; Einhundert photographische Aufnahmen von Albert Renger-Patzsch* (The World Is Beautiful: One Hundred Photographs by Albert Renger-Patzsch). Edited by Carl Georg Heise. Munich, 1928. Reprint, Dortmund, 1992.

———. *Eisen und Stahl: 97 Fotos* (Iron and Steel: 97 Photos). Introduction by Albert Vögler. Berlin, 1931.

———. *Lübeck: Achtzig Photographische Aufnahmen* (Lübeck: Eighty Photographs). Introduction by Carl Georg Heise. Berlin, 1928.

Retzlaff, Erich. *Das Antlitz des Alters, Photographische Bildnisse* (The Face of Age: Photographic Portraits). Introduction by Jakob Kneip. Düsseldorf, 1930.

———. *Die von der Scholle: Sechsundfünfzig photographische Bildnisse bodenständiger Menschen* (Those of the Soil: Fifty-six Photographic Images of Indigenous People). Introduction by Hans Fr. Blunck. Göttingen, 1931.

Roh, Franz. *Nach-Expressionismus; Magischer Realismus: Probleme der neuesten Europäischen Malerei* (Post-Expressionism, Magical Realism: Problems in the Newest European Painting). Leipzig, 1925.

Roters, Eberhard, et al. *Hannah Höch: Eine Lebenscollage.* 3 vols. Berlin and Ostfildern-Ruit, 1995.

Ruge, Willi. "Ich fotografiere mich beim Absturz mit dem Fallschirm" (I Am Photographing Myself Parachuting). *Berliner Illustrirte Zeitung* no. 21 (24 May 1931).

Salomon, Erich. *Berühmte Zeitgenossen in unbe-wachten Augenblicken* (Famous Contemporaries in Unguarded Moments). Stuttgart, 1931. Reprint, Munich, 1978.

Sander, August. *Antlitz der Zeit: Sechzig Aufnahmen deutscher Menschen des 20. Jahrhunderts* (The Face of Our Time: Sixty Photographs of German 20th-Century People). Introduction by Alfred Döblin. Munich, 1929. Reprint, Munich, 2003.

Schnebel, Carl. "Das Gesicht als Landschaft" (The Face as Landscape). *UHU*, no. 5 (February 1929): 42–45.

Schultze-Naumburg, Paul. "Aufgaben des Heimatschutzes" (Tasks of Homeland Preser-vation). *Kunstwart* 21, no. 10 (February 1908): 221–227.

Spörl, Hans. *Porträt-Kunst in der Photographie: Ein Lehrbuch über neuzeitliche Porträtdarstellung auf photographischem Wege für Fachleute und Liebhaber* (Portrait Art in Photography: A Textbook on Mod-ern Photographic Portraiture for Professionals and Amateurs). Leipzig, 1909.

Stone, Sasha. *Berlin in Bildern* (Berlin in Images). Edited by Adolf Bruno Behne. Vienna and Leipzig, 1929. Reprint, Berlin 1998.

Tschichold, Jan. *Die neue Typographie; ein Handbuch für zeitgemäss Schaffende*. Berlin, 1928. Reprint (facsimile) in English as *The New Typography: A Hand-book for Modern Designers*. Introduction by Robin Kinross. Trans. Ruari McLean. Berkeley, 1998.

Warstat, Willy. "Neuere Stilwandlungen in der bildmäßigen Photographie: Vom photogra-phischen Impressionismus zur 'Photographik'" (Newer Changes in Style in Pictorial Photogra-phy: From Photographic Impressionism to Photographic Art). *Photographische Korrespondenz* 63, no. 6 (1 June 1927): 177–182.

Weiskopf, F. C. "Benütze Foto als Waffe! Zur Ausstellung der Arbeiten von John Heartfield auf der Grossen Berliner Kunstausstellung" (Use Photography as a Weapon! On the Works of John Heartfield at the Great Berlin Art Exhibition). *Arbeiter Illustrierte Zeitung* 8, no. 37 (1929): 17.

Westheim, Paul, ed. *Das Kunstblatt* 13 (May 1929).

Wolff, Paul. *Meine Erfahrungen mit der Leica* (My Experiences with the Leica). Frankfurt, 1934.

SECONDARY BOOKS AND ARTICLES

Aynsley, Jeremy. "Pressa Cologne, 1928: Exhibi-tions and Publication Design in the Weimar Period." *Design Issues* 10, no. 3 (Fall 1994): 52–76.

Baumann, Kirsten, and Rolf Sachsse, eds. *Modern Greetings: Photographed Architecture on Picture Postcards 1919–1939 / Moderne Grüsse: fotografierte Architektur auf Ansichtskarten 1919–1939*. Exh. cat., Schlemmer Master House, Bauhaus Dessau Foundation. Stuttgart, 2004.

"Benjamin." Special issue, *Fotogeschichte* 9, no. 32 (1989), ed. Hubertus von Amelunxen.

Benson, Timothy O., and David Frisby. *Expression-ist Utopias: Paradise, Metropolis, Architectural Fan-tasy*. Exh. cat., Los Angeles County Museum of Art. Los Angeles and Seattle, 1993.

Borrmann, Norbert. *Paul Schultze-Naumburg, 1869–1949: Maler, Publizist, Architekt; vom Kultur-reformer der Jahrhundertwende zum Kulturpolitiker im Dritten Reich* (Painter, Publicist, Architect: From Turn-of-the-Century Cultural Reformer to Cultural Policy Maker in the Third Reich). Essen, 1989.

Brockhaus, Christoph, and Reinhold Misselbeck. *Hannes Maria Flach: Photographien der zwanziger Jahre*. Exh. cat., Museum Ludwig. Cologne, 1983.

Brückle, Wolfgang. "Politisierung des Ange-sichts: Zur Semantik des fotografischen Porträts in der Weimarer Republik" (Politicizing the Face: On the Semantics of the Photographic Portrait in the Weimar Republic). *Fotogeschichte*, no. 65 (1997): 3–24.

Buller, Rachel Anne Epp. "Fractured Identities: Photomontage Production by Women in the Weimar Republic." PhD diss., University of Kansas, 2004.

Coke, Van Deren. *Avant-garde Photography in Germany, 1919–1939*. Exh. cat., San Francisco Museum of Modern Art. New York, 1982.

Dewitz, Bodo von, ed. *Kiosk: Eine Geschichte der Fotoreportage, 1839–1973 / A History of Photo-journalism*. Exh. cat., Museum Ludwig / Agfa Foto-Historama. Göttingen, 2001.

———, and Karin Schuller-Procopovici, eds. *Hugo Erfurth, 1874–1948: Photograph zwischen Tradition und Moderne*. Exh. cat., Museum Ludwig. Cologne, 1992.

Dolgner, Angela, Katja Schneider, and Rita Gründig. *Burg Giebichenstein: Die hallesche Kunst-schule von den Anfängen bis zur Gegenwart* (Burg Giebichenstein: The Art School in Halle from Its Beginnings until the Present). Exh. cat., Staatliche Galerie Moritzburg. Halle, 1993.

Droste, Magdalena. *Aus der Ittenschule Berlin 1926–1934: Beiträge zur Geschichte der Ittenschule in Berlin; Künstler aus der Ittenschule und ihre Werke* (From the Itten School, Berlin, 1926–1934: Essays on the History of the School, Its Artists, and Their Work). Exh. cat., Galerie im Trudelhaus. Baden, 1984.

Du Pont, Diana C. *Florence Henri: Artist-Photographer of the Avant-garde*. Exh. cat., San Francisco Museum of Modern Art. San Francisco, 1990.

Eley, Geoff. *Society, Culture, and the State in Germany, 1870–1930*. Ann Arbor, Mich., 1996.

Emmerich, Wolfgang, and Carl Wege, eds. *Der Technikdiskurs in der Hitler-Stalin-Ära* (Technologi-cal Discourse in the Era of Hitler and Stalin). Stuttgart, 1995.

Eskildsen, Ute. *Aenne Biermann: Photographs, 1925–33*. Trans. Iain Boyd Whyte. London, 1988.

———. *Annelise Kretschmer, Fotografin*. Exh. cat., Museum Folkwang. Essen, 1982.

———, ed. *Fotografieren hieß teilnehmen: Foto-grafinnen der Weimarer Republik* (Photographing Meant Participating: Women Photographers of the Weimar Republic). Exh. cat., Museum Folk-wang. Düsseldorf, 1994.

———, and Jan-Christopher Horak, eds. *Film und Foto der zwanziger Jahre: Eine Betrachtung der Inter-nationalen Werkbundausstellung "Film und Foto" 1929* (Film and Foto of the 1920s: An Examination of the International Werkbund Exhibition Film und Foto, 1929). Exh. cat., Württembergischer Kunstverein. Stuttgart, 1979.

———, Hermann Pollig, and Viola Suhle-Moosmann. *Fotografie in deutschen Zeitschriften, 1924–1933* (Photography in German Magazines, 1924–1933). Exh. cat., Institut für Auslandsbezie-hungen. Stuttgart, 1982.

Fiedler, Jeannine, ed. *Photography at the Bauhaus*. Exh. cat., Bauhaus-Archiv. Cambridge, Mass., 1990.

Fineman, Mia. "Ecce Homo Prostheticus: Technology and the New Photography in Weimar Germany." PhD diss., Yale University, 2001.

Forgács, Éva. *The Bauhaus Idea and Bauhaus Politics*. Trans. John Bátki. Budapest and New York, 1995.

Franciolli, Marco, Giovanni Battista Martini, and Alberto Ronchetti. *Florence Henri: Fotografie 1927–1938*. Exh. cat., Museo Cantonale d'Arte. Lugano, 1991.

Frevert, Ute. *Women in German History: From Bourgeois Emancipation to Sexual Liberation*. Trans. Stuart Mckimmon-Evans et al. New York, 1989.

Ganeva, Mila. "A Forgotten History of Modernity: Fashion in German Literature, the Illustrated Press, and Photography in the Weimar Republic." PhD diss., The University of Chicago, 2000.

Gassner, Hubertus, ed. *Wechselwirkungen: Ungarische Avantgarde in der Weimarer Republik* (Interactions: Hungarian Avant-garde in the Weimar Republic). Exh. cat., Neue Galerie Kassel. Marburg, 1986.

Gay, Peter. *Weimar Culture: the Outsider as Insider*. New York, 1968.

Glüher, Gerhard. *Licht, Bild, Medium: Untersuchungen zur Fotografie am Bauhaus* (Light, Image, Medium: Research on Bauhaus Photography). Berlin, 1994.

Göltz, Klaus E., ed. *Hans Finsler: Neue Wege der Photographie* (Hans Finsler: New Paths in Photog-raphy). Exh. cat., Staatliche Galerie Moritzburg. Leipzig, 1991.

Hake, Sabine. "Faces of Weimar Germany." In *The Image in Dispute: Art and Cinema in the Age of Photography*, 117–147. Edited by Dudley Andrew. Austin, 1997.

Hallen, Andreas, and Diethart Kerbs. *Revolution und Fotografie: Berlin, 1918/19.* Exh. cat., Neue Gesellschaft für Bildende Kunst. Berlin, 1989.

Hardt, Hanno. "Pictures for the Masses: Photography and the Rise of Popular Magazines in Weimar Germany." *Journal of Communication Inquiry* 13, no. 1 (Winter 1989): 7–29.

———. "The Site of Reality: Constructing Photojournalism in Weimar Germany, 1928–33." *Communication Review* 1, no. 3 (1996): 373–402.

Herf, Jeffrey. *Reactionary Modernism: Technology, Culture, and Politics in Weimar and the Third Reich.* Cambridge, 1984.

Herzogenrath, Wulf, ed. *Frühe Kölner Kunstausstellungen: Sonderbund 1912, Werkbund 1914, Pressa USSR 1928; Kommentarband zu den Nachdrucken der Ausstellungskataloge* (Early Exhibitions in Cologne: Sonderbund 1912, Werkbund 1914, Pressa USSR 1928; with a Volume of Commentary on the Reprints). Cologne, 1981.

———, and Stefan Kraus, eds. *Bauhaus Utopien: Arbeiten auf Papier* (Bauhaus Utopias: Works on Paper). Exh. cat., Magyar Nemzeti Galéria. Stuttgart, 1988.

Hils, Claudio. *Von Königskindern und anderen: Friedrich Pöhler, ein Photograph in Wilhelmsdorf 1909–1910; Bemerkungen zur Betrachtung historischer Photographie* (On Children of Royalty and Others: Friedrich Pöhler, a Photographer in Wilhelmsdorf 1909–1910; Comments on Viewing Historical Photography). Salzburg, 1997.

Holstein, Jürgen, and Peter Nils Dorén. *Blickfang: Bucheinbände und Schutzumschläge Berliner Verlage 1919–1933* (Eyecatching: Book Bindings and Dust Jackets of Berlin Publishers 1919–1933). Berlin, 2005.

Honnef, Klaus, et al. *Heinz Hajek-Halke: Form aus Licht und Schatten* (Form from Light and Shadow). 2 vols. Göttingen, 2005.

———, Rolf Sachsse, Karin Thomas, and Volker Albus. *German Photography 1870–1970: Power of a Medium.* Exh. cat., Kunst- und Ausstellungshalle der Bundesrepublik Deutschland. Cologne, 1997.

Hopfengart, Christine, and Christiane Stahl, eds. *Alfred Ehrhardt: Fotografien.* Exh. cat., Kunsthalle Bremen. Ostfildern-Ruit, 2001.

Jennings, Michael. "Agriculture, Industry, and the Birth of the Photo-Essay in the Late Weimar Republic." *October* 93 (Summer 2000): 23–56.

Kerbs, Diethart, and Walter Uka, eds. *Fotografie und Bildpublizistik in der Weimarer Republik.* Bönen, 2004.

———, Walter Uka, and Brigitte Walz-Richter, eds. *Zur Geschichte der Pressefotografie, 1930–36: Die Gleichschaltung der Bilder* (On the History of Press Photography, 1930–1936: The Homogenized Image). Berlin, 1983.

Kleineüschkamp, Werner, et al. *Hannes Meyer, 1889–1954: Architekt, Urbanist, Lehrer.* Exh. cat., Bauhaus-Archiv. Berlin, 1989.

Koepnick, Lutz. "Face/Off: Hitler and Weimar Political Photography." In *Visual Culture in Twentieth-Century Germany: Text as Spectacle,* edited by Gail Finney, 214–234. Bloomington, 2006.

Koshar, Rudy. "The Antinomies of Heimat: Homeland, History, Nazism." In *Heimat, Nation, Fatherland: The German Sense of Belonging.* Edited by Jost Hermand et al., 113–136. New York, 1996.

———. *Germany's Transient Pasts: Preservation and National Memory in the Twentieth Century.* Chapel Hill, 1998.

Kühn, Christine. *Neues Sehen in Berlin: Fotografie der Zwanziger Jahre* (New Vision in Berlin: Photography of the 1920s). Edited by Bernd Evers. Exh. cat., Kunstbibliothek. Berlin, 2005.

Lavin, Maud, et al. *Montage and Modern Life, 1919–1942.* Edited by Matthew Teitelbaum. Exh. cat., Institute of Contemporary Art Boston. Cambridge, Mass., 1992.

Lessmann, Sabina, and Marion Beckers. *Gertrud Arndt: Photographien der Bauhaus-Künstlerin.* Exh. cat., Das Verborgene Museum. Berlin, 1994.

Luft, Friedrich, and Alexander von Baeyer, eds. *Facsimile Querschnitt durch die Berliner Illustrierte* (Facsimile: Cross-section of the Berlin Illustrated Press). Munich, 1965.

Lugon, Olivier. "La photographie mise en espace: Les expositions didactiques allemandes." *Études Photographiques* 5 (November 1998): 97–118.

———. "Photo-Inflation: La Profusion des Images dans la Photographie Allemande, 1925–1945." *Les Cahiers du Musée national d'art moderne* 49 (Fall 1994): 91–113.

Maas, Ellen, and Barbara Grimm. *Frauen im Bild 1920–1930: Eine deutsche Photogalerie* (Women in the Picture 1920–1930: A German Photo-Gallery). Exh. cat., Spessartmuseum. Lohr am Main, 1997.

Magilow, Daniel H. "The Space between the Pictures: Photography, Literature, and the Late-Weimar Photo Essay." PhD diss., Princeton University, 2003.

Margolin, Victor. *The Struggle for Utopia: Rodchenko, Lissitzky, Moholy-Nagy, 1917–1946.* Chicago, 1997.

Mehring, Christine. "Siegfried Kracauer's Theories of Photography: From Weimar to New York." *History of Photography* 21, no. 2 (Summer 1997): 129–136.

Meskimmon, Marsha. *We Weren't Modern Enough: Women Artists and the Limits of German Modernism.* Berkeley, 1999.

———, and Shearer West, eds. *Visions of the "Neue Frau": Women and the Visual Arts in Weimar Germany.* Aldershot, England, and Brookfield, Vt., 1995.

Molderings, Herbert. "Überlegungen zur Fotografie der Neuen Sachlichkeit und des Bauhauses" (Reflections on Photography in New Objectivity and at the Bauhaus). *Kritische Berichte: Mitteilungsorgan des Ulmer Vereins Verband für Kunst- und Kulturwissenschaften* 5, no. 2/3 (1977): 67–88.

Oelker, Simone, and Otto Haesler. *Otto Haesler: Eine Architektenkarriere in der Weimarer Republik.* Hamburg, 2002.

Paret, Peter. *German Encounters with Modernism: 1840–1945.* New York, 2001.

Pauseback, Michael. *Felix H. Man: 60 Jahre Fotografie.* Exh. cat., Kunsthalle Bielefeld. Bielefeld, 1978.

Petro, Patrice. *Joyless Streets: Women and Melodramatic Representation in Weimar Germany.* Princeton, 1989.

Peukert, Detlev. *The Weimar Republic: The Crisis of Classical Modernity.* Trans. Richard Deveson. New York, 1993.

Philipp, Claudia Gabriele. *Deutsche Volkstrachten, Kunst- und Kulturgeschichte: Der Fotograf Hans Retzlaff, 1902–1965* (German Folk Costumes, Art and Cultural History: The Photographer Hans Retzlaff, 1902–1965). Exh. cat., Freilichtmuseum Hessenpark. Marburg, 1987.

Pohlmann, Ulrich. "Die vergessenen Fotomuseen: Zur Geschichte realisierter und unausgeführter Vorhaben in Deutschland" (The Forgotten Photography Museums: On the History of Realized and Unrealized Projects in Germany). *Fotogeschichte* 10, no. 35 (1990): 14–21.

———, and Simone Förster, eds. *Die Eleganz der Diktatur: Modephotographien in deutschen Zeitschriften 1936–1943* (The Elegance of Dictatorship: Fashion Photography in German Magazines 1936–1943). Exh. cat., Münchner Stadtmuseum. Munich, 2001.

———, and Rudolf Scheutle. *Lehrjahre Lichtjahre: Die Münchner Fotoschule 1900–2000* (Learning Years, Light Years: The Munich Photo School 1900–2000). Exh. cat., Münchner Stadtmuseum. Munich, 2000.

Rocco, Vanessa. "Before Film and Foto: Pictorialism to the New Vision in German Photography Exhibitions from 1909–1929." PhD diss., City University of New York, 2004.

Rollins, William. "Heimat, Modernity, and Nation: In the Early Heimatschutz Movement." In *Heimat, Nation, Fatherland: The German Sense of Belonging.* Edited by Jost Hermand et al., 87–112. New York, 1996.

Roters, Eberhard. *Berlin, 1910–1933.* New York, 1982.

Sachsse, Rolf. "Eloge de la reproduction: La photographie dans les écoles d'arts appliqués allemandes" (In Praise of Reproduction: Photography in German Applied Arts Schools). *Études Photographiques* 8 (November 2000): 44–67.

Schmölders, Claudia, and Sander L. Gilman, eds. *Gesichter der Weimarer Republik: Eine physiognomische Kulturgeschichte* (Faces of the Weimar Republic: A Physiognomic Cultural History). Cologne, 2000.

Schneider, Katja. *Burg Giebichenstein: Die Kunstgewerbeschule unter Leitung von Paul Thiersch und Gerhard Marcks 1915 bis 1933* (Burg Giebichenstein: The Arts and Crafts School under Paul Thiersch and Gerhard Marcks, 1915 to 1933). 2 vols. Weinheim, 1992.

Sichel, Kim. *Germaine Krull: Photographer of Modernity*. Cambridge, Mass., 1999.

Soden, Kristine von, and Maruta Schmidt. *Neue Frauen: Die zwanziger Jahre*. Berlin, 1988.

Toepfer, Karl Eric. *Empire of Ecstasy: Nudity and Movement in German Body Culture, 1910–1935*. Berkeley, 1997.

Weise, Bernd. *Fotografie in deutschen Zeitschriften, 1883–1923* (Photography in German Magazines, 1883–1923). Exh. cat., Institut für Auslandsbeziehungen. Stuttgart, 1991.

———. "Pressefotografie III. Das Geschäft mit dem aktuellen Foto: Fotografen, Bildagenturen, Interessenverbände, Arbeitstechnik; Die Entwicklung in Deutschland bis zum Ersten Weltkrieg" (Press Photography III. The Trade in Topical Photography: Photographers, Photo Agencies, Professional Associations, Working Methods; Development in Germany until World War I). *Fotogeschichte* 10, no. 37 (1990): 13–36.

West, Shearer. *The Visual Arts in Germany, 1890–1937: Utopia and Despair*. New Brunswick, N.J., 2001.

Westheider, Ortrud. *Die Neue Sicht der Dinge: Carl Georg Heises Lübecker Fotosammlung aus den 20er Jahren* (The New Vision of Things: Carl Georg Heise's 1920s Photo Collection at the Lübeck Museum). Exh. cat., Hamburger Kunsthalle. Hamburg, 1995.

Wick, Rainer. *Das Neue Sehen: Von der Fotografie am Bauhaus zur Subjektiven Fotografie* (The New Vision: From Photography at the Bauhaus to Subjective Photography). Munich, 1991.

———. *Teaching at the Bauhaus*. Ostfildern-Ruit, 2000.

Wiethoff, Dorothee. *Lotte Errell: Reporterin der 30er Jahre*. Exh. cat., Museum Folkwang. Essen, 1997.

Zervigón, Andrés Mario. "The End of Dada: Charting the German Avant-garde's Move from Dada Photomontage to Figurative Realism." PhD diss., Harvard University, 2000.

Hungary

PERIODICALS

A fény (Light), 1904–?

Dokumentum (Document), 1926–1927

Érdekes Újság (Interesting News), 1913–?

Fényképészeti Lapok (Photography Magazine), 1882–1888

Fotoélet (Photo Life), 1931–1944

Fotoművészet (Art Photography), 1914

Fotoművészeti Hírek (Art Photography News), 1921–1936

MA (Today), 1916–1925. Reprint, Budapest, 1980–?

Magyar Fotografia (1921–1938)

Munka (Work), 1928–1939

Pesti Napló (Pest Diary), Sunday photography supplement, 1925–1938

ANTHOLOGIES

Albertini, Béla. *A magyar fotókritika története 1839–1945* (History of Hungarian Photocriticism). Budapest, 1987.

———, ed. *Szemelvények a szociofotó forrásaiból* (Extracts from Sources on Social Photography). 2 vols. Budapest, 1984–1985, 1989.

Bán, András. *Fotográfozásról* (About Photography). Budapest, 1982.

Csaplár, Ferenc, ed. *Lajos Kassák: The Advertisement and Modern Typography*. Budapest, 1999.

PRIMARY BOOKS AND ARTICLES

Angelo. "A Modern Fotográfia Problémái" (Issues in Modern Photography). *Fotoművészeti Hírek* 10, no. 8–11, no. 5 (November 1929–May 1930).

Balogh, Rudolf. *Hungarian Pictures: A Pictorial Series from the Life and Work of the Hungarian People*. Introduction by Ladislaus [László] von Szabó. Budapest, 1938 (originally published as *Ungarnfibel: Eine Bilderreihe aus dem Leben und Schaffen des ungarischen Volkes*, Budapest, 1938).

Bayer, Herbert. "Tipográfiai és propaganda eszközök" (Typographic and Propaganda Tools). *Munka*, no. 1 (September 1928): 19–20.

Bozsek, Rezső József. "A fényképeyés lélektana" (The Psychology of Photography). *Fotóművészeti Hírek* 11, no. 6 (June 1930): 165–170.

Brogyányi, Kálmán. *A fény művészete* (The Art of Light). Bratislava, 1933. Reprint, 2004. Introduction by Béla Albertini.

Gró, Lajos. "Az M.T.E. fotócsoportjának melléklete" (Supplement of the M.T.E. Photo-group). *Munka*, no. 14 (June 1930): 425.

———. "Brogyányi Kálmán: A fény művészete" (Kálmán Brogyányi: The Art of Light). *Munka*, no. 28 (May 1933): 815–816.

———. "Riportázs és művészet" (Reportage and Art). *Munka*, no. 28 (May 1933): 788–791.

Hevesy, Iván. "A foto reneszánsza" (The Rebirth of Photography). *Magyar Fotografia* 6 (1931): 6–7.

———. *A magyar fotoművészet története* (The History of Hungarian Art Photography). Budapest, 1958.

II. *Nemzetközi Művészi Fényképkiállítás / 2nd International Exhibition of Photographs*. Exh. cat., Műcsarnok. Budapest, 1927.

Inoue, Seiichi, and Francis Haar. *Hangariya / Magyar képeskönyv* (Hungarian Picture Book). Tokyo, 1941.

Jenő, Ondrejovich. "Alkotás a fényképezésben" (Creation in Photography). *Fotóművészeti Hírek* 10, no. 6–8 (September–November 1929).

———. "Daguerre-től Moholy-Nagy-ig" (From Daguerre to Moholy-Nagy). *Fotoművészeti Hírek* 10, no. 4 (July 1929): 4–8.

Kálmán, Kata, Zsigmond Móricz, and Iván Boldizsár. *Tiborc*. Budapest, 1937.

———, and Virag Móricz. *Tiborc új arca* (The New Face of Tiborc). Budapest, 1955.

Kankowsky, Ervin. "A Fotokritikus" (The Photo Critic). *Fotoművészeti Hírek*, no. 3 (1928): 6–8.

Kassák, Lajos. *MA-Buch*. Introduction by Andreas Gáspár. Vienna, 1923. Reprint, Budapest, 1999.

———. *A mi életünkből: a munka első fotókönyve / Aus unserem Leben: Fotobuch der Munka* (From Our Lives: Munka's First Photobook). Trans. Georg László. Budapest, 1932.

———. [Introduction]. *Munka*, no. 1 (September 1928): 1–3.

Kinszki, Imre. "A kiállítási kép esztétikája" (The Aesthetics of the Exhibited Picture). *Fotoművészeti Hírek* 15, no. 9 (September 1934): 183–184.

Paulini, Béla, ed. *The Pearly Bouquet* (Gyöngyösbokréta). Budapest, 1937.

Pécsi, József. *Fotó és reklám: szöveg és kép; Pécsi József, a fotográfia professzora* (Photo and Advertisement—Text and Image: József Pécsi, Professor of Photography). Berlin, 1930. Reprint, Budapest, 1997.

Révész, [Imre], and [Judit] Biró. Foto-Reklam. Budapest, c. 1932.

Szélpál, Árpád. "Megalakítottuk a Munkásfoto-muzeumot" (We Have Established the Worker Photography Museum). Népszava (21 March 1931): 7.

Tábori, Kornél. Egy halálraítélt ország borzalmaiból: Razzia a nyomortanyákon (From the Horrors of a Country Condemned to Death: Inspection-Tour through the Misery of Budapest). Budapest, 1920.

Vydareny, Iván. "A Ma fotográfiája" (Today's Photography). Fotóművészeti Hírek, no. 7 (1929): 5–6.

———. "Új Irányok" (New Directions). Fotóművészeti Hírek, no. 7 (1928): 4–9.

SECONDARY BOOKS AND ARTICLES

Albertini, Béla. A fotószakíró Brogyányi Kálmán (Kálmán Brogyányi, Scholar of Photography). Bratislava, 2003.

———. A magyar szociofotó története: a kezdetektől a második világháború végéig (The History of Hungarian Social Photography: From the Beginnings until the End of World War II). Budapest, 1997.

———. A Sarló szociofotós vonulata (The Social Photography Strata of Sarló). Bratislava, 1993.

———. Szélpál Árpád, a szociofótos (Árpád Szélpál, Social Photographer). Kecskemét, 2005.

Bajkay, Éva R., et al. Avant-garde hongroise, 1915–1925 / Hongaarse avant-garde, 1915–1925. Trans. Margit Szoboszlai et al. Exh. cat., Banque Bruxelles-Lambert. Brussels, 1999.

Baki, Péter. "A Neue Sachlichkeit fotóművészetben" (New Objectivity in Art Photography). Fotóművészet 48, no. 1–2 (2005): 115–120.

Bakos, Sylvia Dora. "The Emergence of the Hungarian Avant-garde, 1900–1919." PhD diss., Rutgers University, 1989.

Baum, Peter. Ungarn: Avantgarde im 20. Jahrhundert (Hungary: Avant-garde in the Twentieth Century). Exh. cat., Neue Galerie der Stadt Linz. Linz, 1998.

Beke, László, Gábor Szilágyi, Klára Tőry, and Colin Ford. The Hungarian Connection: The Roots of Photojournalism. Exh. cat., The National Museum of Photography, Film, and Television. Bradford, West Yorkshire, 1987.

Bodri, Ferenc. "Trauner Sándor tárlatának élménye és tanulságai" (Experiences and Lessons from Sándor Trauner's Exhibition). Művészet 23, no. 6 (1982): 46–47.

Botar, Oliver A. I. "From the Avant-garde to 'Proletarian Art': The Emigré Hungarian Journals Egység and Akasztott Ember, 1922–23." Art Journal 52, no. 1 (1993): 34–45.

Bourgoing, Catherine de, Anne Cartier-Bresson, and Károly Kincses. Photographies hongroises: des romantismes aux avant-gardes / Hungarian Photographs: Romanticism to Avant-garde. Exh. cat., Musée de la Vie Romantique. Paris, 2001.

Csaplár, Ferenc. "A Munka-kör képzőművészeti tevékenysége" (Artistic Activities of the Munka Circle). Művészettörténeti értesítő (Art History Bulletin) 21, no. 2 (1972): 133–140.

Csorba, Csilla E. Magyar fotográfusnők (Hungarian Women Photographers) Budapest, 2001.

Daranyi, Georges, Emmanuel Guigon, Krisztina Passuth, and Mariann Gergely. Lajos Kassák y la vanguardia húngara (Lajos Kassák and the Hungarian Avant-garde). Exh. cat., IVAM Centre Julio González. Valencia, 1999.

Di Castro, Federica. Nel raggio dell'utopia: l'esperienza fotografica ungherese tra le due guerre (In the Sphere of Utopia: The Experience of Hungarian Interwar Photography). Exh. cat., Istituto Nazionale per la Grafica, Rome. Venice, 1987.

Hegyi, Lóránd. "A Munka-kör képzőművészeti tevékenysége" (Artistic Activities of the Munka Circle). Ars Hungarica 21, no. 2 (1983): 282–295.

Kieselbach, Tamás. Modern Hungarian Painting. 2 vols. Budapest, 2003–2004.

Kincses, Károly. Angelo. Exh. cat., Magyar Fotográfiai Múzeum. Kecskemét, 2002.

———. Fotógrafos made in Hungary: los que se fueron; los que se quedaron (Photographers Made in Hungary: Those Who Left, Those Who Stayed). Trans. Maria Ferencz et al. Exh. cat., Caja San Fernando. Seville, 2002.

———. A fotográfus, építész, festő Vydareny Iván (Iván Vydareny: Photographer, Architect, Painter). Exh. cat., Magyar Fotográfiai Múzeum. Kecskemét, 2000.

———. A két Reismann (The Two Reismanns). Exh. cat., Magyar Fotográfiai Múzeum. Budapest, 2004.

Kopócsy, Anna, ed. Magyar kollázs: a magyar kollázs / montázs történetéből, 1910–2004 / Hungarian Collage: From the History of Hungarian Collage / Montage, 1910–2004. Exh. cat., Városi Művészeti Múzeum. Budapest, 2004.

Kunt, Ernő. Foto-Anthropologie: Bild und Mensch im ländlichen Ungarn der ersten Hälfte unseres Jahrhunderts. Edited by Edith A. Weinlich. Würzburg, 1990.

Mansbach, Steven A., and Richard V. West. Standing in the Tempest: Painters of the Hungarian Avant-garde, 1908–1930. Exh. cat., Santa Barbara Museum of Art. Santa Barbara, Calif., and Cambridge, Mass., 1991.

Nádas, Peter. Seelenverwandt: Ungarische Fotografen 1914–2003 / Kindred Spirits: Hungarian Photographers 1914–2003. Trans. Akos Doma et al. Exh. cat., Martin-Gropius-Bau. Berlin, 2005.

Plank, Ibolya, Virág Hajdú, and Pál Ritoók. Fény és Forma: Modern építészet és fotó / Light and Form: Modern Architecture and Photography 1927–1950. Trans. László Boros et al. Budapest, 2003.

Reismann, János. Nyugtalan évek: Reismann János fotóművész munkássága (Restless Years: The Work of Art Photographer János Reismann). Budapest, 1982.

Simon, Michael. Összehasonlító magyar fotótörténet (A Comparative History of Hungarian Photography). Trans. Magdolna Kolta. Budapest, 2000 (unpublished ms. in English as "A History of Photography in Hungary").

Szántó, Tibor, et al. Lengyel Lajos: könyvtervező fotográfus oktató és humanista (Lajos Lengyel: Book Designer, Photographer, Educator, and Humanist). Budapest, 1995.

Szilágyi, Gábor, and Sándor Kardos. Leletek a magyar fotográfia történetéből (Findings from the History of Hungarian Photography). Budapest, 1983.

Tőry, Klára. Ungarische Fotografie von 1900–1945. Exh. cat., Museum für Kunst und Kulturgeschichte. Dortmund, 1987.

Wanaverbecq, Annie-Laure. Photographies hongroises, 1919–1939: Regards nouveaux / az Új Tekintet (Hungarian Photography, 1919–1939: A Fresh Look). Exh. cat., La Maison Robert Doisneau de Gentilly. Paris, 2004.

Poland

PERIODICALS

As (Ace), 1935–1939

Blok, 1924–1926

f.a. (Art Film), two issues, 1937

Fotograf Polski (Polish Photographer), 1925–1933

Ilustrowany Kurier Codzienny (Illustrated Daily Courier), 1910–1939

Kurier Literacko-Naukowy (Literary-Educational Courier), 1925–1939

Miesięcznik Fotograficzny (Photography Monthly), 1924–1931

Na szerokim świecie (Out in the World), 1928–1939

Nowości Fotograficzne (Photographic News), 1929–1939

Polski Przegląd Fotograficzny (Polish Photography Review), 1925–1930

Praesens (Presence), two issues, 1926 and 1930

Przegląd Fotograficzny (Photography Review), 1935–1939

Światowid (Eye on the World), 1924–1929

Sygnały (Signals), 1933–1939

Tajny Detektyw (Secret Detective), 1931–1934

ANTHOLOGIES

Bocheńska, Jadwiga. *Polska myśl filmowa: antologia tekstów z lat 1898–1939* (Polish Film Theory: Anthology of Texts 1898–1939). Wrocław, 1975.

Gerould, Daniel Charles, ed. *The Witkiewicz Reader.* Evanston, Ill., 1992.

Piwowarski, Jerzy. *Słownik technik i tendencji stylistycznych stosowanych w polskiej fotografii artystycznej przed 1939r* (Encyclopedia of Techniques and Stylistic Tendencies in Polish Photography before 1939). Częstochowa, 2001.

PRIMARY BOOKS AND ARTICLES

Baliński, W. Ł. *Propaganda: Jej metody i znaczenie* (Propaganda: Its Methods and Meaning). Warsaw, 1930.

Bednarczuk, Władysław, ed. *Pierwsza wystawa fotografii robotniczej w Polsce* (First Worker Photography Exhibition in Poland). Lviv, 1936.

Bobrowski, Tadeusz. "O czynnik społeczny ruchu fotograficznym" (On the Social Factor in [Our] Photography Movement). *Fotograf Polski* (December 1935).

Bułhak, Jan. "Amerykanizm a Fotografja Ojczysta" (Americanism and Homeland Photography). *Przegląd Fotograficzny* (July 1938): 124–128.

———. "Dyskusja w obronie fotografiki" (Discussion in Defense of Art Photography). *Myśl Narodowa*, no. 1 (1931): 14–15.

———. "Dziesięcioletnie 'splendid isolation' Niemieckiej Fotografiki" (A Decade of "Splendid Isolation" in German Art Photography). *Polski Przegląd Fotograficzny* 6, no. 2 (February 1930): 25–27.

———. "Emancypacja fotografji artystycznej w Polsce" (The Emancipation of Art Photography in Poland). *Fotograf Polski* 10 (1927): 202–205.

———. "Jak daleko może fotografia odejść od Malarstwa?" (How Far Can Photography Stray from Painting?). *Przegląd Fotograficzny* 2, no. 5 (1936): 89–95.

———. *Polska Fotografia Ojczysta* (Polish Homeland Photography). Poznań, 1939.

———, ed. *Almanach fotografiki polskiej 1934 / Almanach de la photographie pictoriale de Pologne 1934.* Vilnius, 1934.

———, Tadeusz Cyprian, and Antoni M. Wieczorek. *Fotografja w szkole* (Photography in the Classroom). Poznań, 1934.

Cyprian, Tadeusz. *Fotografia na boisku Sportowym* (Photography on the Playing Field). Poznań, 1939.

———. "Fotomontaż." *Polski Przegląd Fotograficzny*, no. 4 (1930): 89–91.

———. "Normalizacja sztuki?" (Normalization of Art?). *Fotograf Polski*, no. 18 (1933): 161–162.

———. "Nowoczesna fotografja artystyczna" (Modern Art Photography). *Światłocień*, no. 4 (1923): 35–36; 47–48.

———. "Pod znakiem groteski" (Under the Sign of the Grotesque). *Fotograf Polski*, no. 6 (1928): 125–127.

———. "Splendid Isolation." *Fotograf Polski* (April 1934).

Dederko, Marjan. "Szkolnictwo fotograficzne w Polsce" (Photography Education in Poland). *Fotograf Polski*, no. 5 (1936): 16–18.

———. "W obronie fotonizmu" (In Defense of Fotonizm). *Polski Przegląd Fotograficzny* 6, no. 4 (1930): 73–75.

———. "Wystawa fotografiki sowieckiej" (Exhibition of Soviet Art Photography). *Fotograf Polski*, no. 2 (1934): 43.

Henryk Streng [Marek Włodarski]. "Walczymy o żywą sztukę" (We Are Fighting for a Living Art). *Sygnały*, no. 17 (1936): 8.

Hoffmann, Konrad. "Fotomontaż." *Fotograf Polski* 3 (1933): 51–52.

———. "O nadprodukcji w fotografice" (On Photographic Overproduction). *Fotograf Polski* 6 (1933): 126–128.

Lutyk, Leon. "Fotografika w kształceniu estetycznym techników" (Art Photography in Aesthetic Creations Using Technology). *Życie Techniczne*, no. 9 (November 1936): 191–195.

Mierzecka, Janina. *Całe życie z fotografią* (A Life in Photography). Kraków, 1981.

Miezeryczer, L. "Kierunki i prądy w fotografice sowieckiej (I–II)" (Directions and Currents in Soviet Photography). *Fotograf Polski*, no. 5–6 (1934): 105–106; 125–126.

Minich, Marjan. "Wystawa zrzeszenia artystów plastyków 'Artes' (II)" (Exhibition of the Arts Group 'Artes.'" *Kurjer Lwowski* 336 (4 December 1931): 5.

Romer, Witold. "Fotografia pod wodą" (Underwater Photography). *Nowości Fotograficzne*, no. 2 (1937): 24–28.

Schönfeld, Stanisław. "Pierwszy międzynarodowy salon fotografji artystycznej w Warszawie" (First International Art Photography Salon in Warsaw). *Fotograf Polski* 12, no. 5 (1927): 87–88.

———. "Szkoły a fotografja." *Polski Przegląd Fotograficzny* 5, no. 9 (1929): 155–157.

Strzemiński, Władysław. "Foto Auge" (Photo Eye). *Europa*, no. 4 (7) (1930): 223–224.

———. "Fotomontaż wynalazkiem polskim" (Photomontage, a Polish Invention). *Europa*, no. 1 (1929): 29.

———. "Jan Tschichold: Eine Stunde Druckgestaltung (Typography in One Hour). Verlag Fritz Wedekind. Stuttgart." *Europa*, no. 10 (13) (1930): 477.

Świtkowski, Józef. "Fotografika i Fotonizm" (Art Photography and Fotonizm). *Polski Przegląd Fotograficzny* 6, no. 7 (1930): 139–141.

Themerson, Stefan. *The Urge to Create Visions.* Amsterdam, 1983.

Unkiewicz, T. *Uwagi o propagandzie* (Reflections on Propaganda). Warsaw, 1937.

Vishniac, Roman. *Polish Jews: A Pictorial Record.* Introduction by Abraham Joshua Heschel. New York, 1947.

Vogel, Deborah. "Genealogija fotomontażu i jego możliwości" (The Genealogy of Photomontage and Its Possibilities). *Sygnały*, no. 12–13 (October–November 1934).

Wieczorek, Antoni M. "Almanach fotografiki polskiej." *Przegląd Fotograficzny*, no. 8 (1937): 148–149.

———. "Fotografja polska wczoraj i dziś" (Polish Photography Yesterday and Today). *Fotograf Polski* 20, no. 4 (1935): 79–81.

———. "Fotonizmowi do pamiętnika" (Fotonizm, an Obituary). *Polski Przegląd Fotograficzny* 6, no. 11 (1930): 221–222.

———. "Narodowość a fotografika" (Nationhood and Art Photography). *Miesięcznik fotograficzny*, no. 140 (August 1931): 122–125.

———. "O 'Nowej Rzeczowości'" (On New Objectivity). *Fotograf Polski* 7 (June 1932): 107–108.

———. "Prawda w fotografji" (Truth in Photography). *Fotograf Polski* 10 (1933): 169–170.

Witkiewicz, Stanisław (sr). *Sztuka i krytyka u nas, 1884–1898* (Art and Criticism in Poland). Lviv, 1899.

SECONDARY BOOKS AND ARTICLES

Bartelik, Marek. "Between Spirituality and Nationalism: Expressionism in Polish Art, 1917–1922." PhD diss., City University of New York, 2000.

Bartnik, Krystyna. *Mieczysław Berman.* Exh. cat., Muzeum Narodowe we Wrocławiu. Wrocław, 1990.

Bocheńska, Jadwiga. *Polska myśl filmowa do roku 1939* (Polish Film Theory until 1939). Wrocław, 1974.

Borowiec, Piotr. "Kształtowanie się wydawnictwa i koncernu prasowego Ilustrowany Kurier Codzienny w Krakowie (1910–1939)" (The Creation of the Publisher and Press Conglomerate *Illustrated Daily Courier* in Kraków, 1910–1939). PhD diss., Uniwersytet Jagielloński. Kraków, 2000.

Cavanaugh, Jan. *Out Looking in: Early Modern Polish Art, 1890–1918*. Berkeley, 2000.

Czartoryska, Urszula. "Fotografia polska." *Studio International* 195, no. 993 / 994 (1982): 40–48.

———. *Masterpieces of Polish Photography, 1912–1948*. Exh. cat., Muzeum Sztuki. Łódź, 1992.

Czekalski, Stanisław. *Awangarda i mit racjonalizacji: fotomontaż polski okresu dwudziestolecia międzywojennego* (The Avant-garde and the Myth of Rationalization: Polish Photomontage between the World Wars). Poznań, 2000.

———. *Fotomontaż polski w dwudziestoleciu międzywojennym* (Polish Photomontage between the World Wars). Exh. cat., Zachęta Państwowa Galeria Sztuki. Warsaw, 2003.

Danecka, Tatiana, Adam Sobota, and Danuta Dziedzic. *Fotografia we Lwowie do roku 1939* (Photography in Lviv until 1939). Exh. cat., Muzeum Narodowe we Wrocławiu. Wrocław, 1991.

Fotografia polska. Exh. cat., International Center of Photography. New York, 1979.

Garztecki, Juliusz. "Przyczynki do historii fotografii w prasie polskiej (I–XI)" (Contributions to the History of Photography in the Polish Press). *Fotografia* (1968–1970).

Giżycki, Marcin. *Awangarda wobec kina: film w kręgu polskiej awangardy artystycznej dwudziestolecia międzywojennego* (The Avant-garde Relation to Cinema: Film in Polish Interwar Avant-garde Art Circles). Warsaw, 1996.

———. *Walka o film artystyczny w międzywojennej Polsce* (The Struggle for Art Films in Interwar Poland). Warsaw, 1989.

Gresty, Hilary, and Jeremy Lewison, eds. *Constructivism in Poland 1923 to 1936*. Exh. cat., Kettle's Yard, Cambridge, and Muzeum Sztuki, Łódź. Cambridge, England, 1984.

Haltof, Marek. "Film Theory in Poland before World War II." *Canadian Slavonic Papers* 40, no. 1 / 2 (March–June 1998): 67–69.

Hölscher, Petra. *Die Akademie für Kunst und Kunstgewerbe zu Breslau: Wege einer Kunstschule 1791–1932* (The Academy for Art and the Applied Arts in Breslau: Paths of an Art School, 1791–1932). Kiel, 2003.

Jabłońska, Teresa, Anna Liscar, and Stefan Okołowicz. *Tatry: Fotografie Tatr i Zakopanego 1859–1914 / Photographs of Zakopane and the Tatras, 1859–1914*. Lesko and Zakopane, 2004.

Jackiewicz, Danuta. *Sztuka fotografii: portret, pejzaż, reportaż w fotografii polskiej XIX wieku* (The Art of Photography: Portrait, Landscape, Reportage in Polish 19th-Century Photography). Warsaw, 1990.

Jackowski, Jan Maria. "The Beginnings of Polish Political Photography." *History of Photography* 15, no. 1 (Spring 1991): 1–12.

———. "Marian Fuks (1884–1935)." *Foto*, no. 9 (1983): 266.

Jurecki, Krzysztof. "The History of Polish Photography to 1990." In *Essays on Polish Culture*, www.culture.pl (accessed 19 December 2004).

Keller, Ulrich. *The Warsaw Ghetto in Photographs: 206 Views Made in 1941*. New York, 1984.

Lukaszewicz, Piotr. *Zrzeszenie Artystów Plastyków Artes: 1929–1935* (The Arts Group 'Artes,' 1929–1935). Warsaw, 1975.

Morawińska, Agnieszka, and Alain van Crugten. *L'Avant-printemps: Pologne 1880–1920* (Before the Spring: Poland 1880–1920). Exh. cat., Palais des Beaux-Arts. Brussels, 2001.

Nawrocki, Konrad. *W Kazimierzu nad Wisłą* (In Kazimierz on the Vistula). Warsaw, 2001.

Parlagreco, Silvia. *Costruttivismo in Polonia / Konstruktywizm Polski*. Exh. cat., Il Filatoio, Caraglio. Turin, 2005.

Piwowarski, Jerzy. *Fotografia artystyczna i jej wystawiennictwo w Polsce okresu międzywojennego* (Art Photography on Exhibition in Interwar Poland). Częstochowa, 2004.

Plater-Zyberk, Małgorzata. *Spojrzenia na Wilno: fotografia wileńska 1839–1939* (Remembering Vilnius: Vilnius Photography 1839–1939). Exh. cat., Muzeum Narodowe w Warszawie. Warsaw, 1999.

Płażewski, Ignacy, and Jerzy Płażewski. *Dzieje polskiej fotografii 1839–1939* (A History of Polish Photography 1839–1939). Warsaw, 2003, 1st ed., 1982.

Podgórska, Ewa. "Koncern wydawniczy 'Ilustrowany Kurier codzienny' i ozostała po nim spuścizna fotograficzna" (The IKC Publishing House and Its Photographic Legacy). *Archeion* 67 (1979): 129–153.

Présences polonaises: Witkiewicz, constructivisme, les contemporains. Exh. cat., Centre Georges Pompidou. Paris, 1983.

Schuler, Romana, and Goschka Gawlik, eds. *Zwischen Experiment und Repräsentation: Der neue Staat; Polnische Kunst 1918–1939* (Between Experiment and Representation: The New State; Polish Art 1918–1939). Exh. cat., Leopold Museum. Vienna, 2003.

Schwarz, Arturo. *Mieczysław Berman: cinquant'anni di storia nei fotomontaggi di Berman*. Exh. cat., Galleria Schwarz. Milan, 1973.

Słomińska, Halina. "Aleksander Minorski: Fotografia walcząca" (Aleksander Minorski: Photography as Weapon). *Fotografia* 8, no. 169 (1969): 177–185.

Sobota, Adam. "Art Photography in Poland, 1900–1939." *History of Photography* 4 (1980): 18–34.

———. *Polska fotografia artystyczna do roku 1939*. Exh. cat., Muzeum Narodowe we Wrocławiu. Wrocław, 1977.

———. *Szlachetność techniki* (The Nobility of Technology). Warsaw, 2001.

———. *Sztuka reportażu z historii fotografii polskiej* (The Art of Reportage in Polish Photography History). Exh. cat., Muzeum Narodowe we Wrocławiu. Wrocław, 1980.

Sochańska, Małgorzata. "A Forgotten Muse: The Life and Work of Deborah Vogel." M.A. thesis, University College London, 2003.

Szymanowicz, Maciej. "Dylematy Piktorializmu, o polskiej fotografii artystycznej lat trzydziestych" (Dilemmas of Pictorialism: On Polish Art Photography in the 1930s). *Pismo Artystyczne Format*, no. 41 (2002).

———. "O sanacyjnej propagandzie i heroizmie sportu" (On Sanacja Propaganda and the Heroism of Sports). In *Przestrzenie fotografii. Antologia tekstów*, edited by Krzysztof Makowski et al. Łódź, 2005.

———. "Miejsce Piktorializmu w historii polskiej fotografii dwudziestolecia międzywojennego" (The Place of Pictorialism in the History of Interwar Polish Photography). PhD diss., Uniwersytet im. Adama Mickiewicza, 2004.

———. "Śląska idylla: O przemyśle, folklorze i fotografii lat 30. / Silesian Idyll: On Industry, Folklore, and Photography of the 1930s." *Fotografia*, no. 14 (2004): 96–103; 129–132.

Turowski, Andrzej. *Budowniczowie świata: z dziejów radykalnego modernizmu w sztuce polskiej* (Builders of the World: From the History of Radical Modernism in Polish Art). Kraków, 2000.

———. "Utopia biomechaniki czyli maszyna ciałem obleczona" (Biomechanic Utopia, or The Machine Dressed in Flesh). *Kresy* (1995): 179–186.

Żakowicz, Aleksander, ed. *Dawna fotografia lwowska: 1839–1939* (Photographs of Old Lviv, 1839–1939). Lviv, 2004.

———, and Jolanta Firek-Suda. *Nauczanie fotografii w Polsce w latach 1839–1980* (Photographic Instruction in Poland, 1839–1980). Częstochowa, 1982.

Zdanowski, Edmund. "Fotograficzne środowisko wileńskie: wspomnienia i refleksje" (The Vilnius Photography Circle: Remembrances and Reflections). Paper presented at the I Sympozjum Historii Fotografii, Lublin, 8–10 October 1971.

INDEX

272

Every effort has been made to locate the copyright holders for the photographs used in this book.

CATALOGUE

Cats. 1, 2, 15, 18, 23, 31, 35, 38, 40, 48, 51, 56, 65, 68, 70–72, 78, 84, 86, 92–95, 101, 103, 105–109, 114–118, 120, 122, 126, 129, 131–134, 141–145, 154, 157, 158, photographs Daniel Šperl; cats. 3, 24, 26, 44, Photography © The Art Institute of Chicago; cats. 5, 17, 19, 163, 164, 165, © Karel Teige—the heirs c/o DILIA; cats. 6, 29, 52, 73, 121, Bauhaus-Archiv, Berlin; cats. 7, 25, 30, 32, 61, 64, 74, 83, 91, 94, 128, 130, 139, 146–148, 156, Image © 2006 Board of Trustees, National Gallery of Art, Washington, photographs Lorene Emerson; cat. 8, Courtesy of Ars Libri Ltd., photograph Kaz Tsuruta; cat. 9, © 2006 Artists Rights Society (ARS), New York/VG-Bild-Kunst, Bonn; cat. 10, photograph Wolfgang Morell; cats. 11, 16, 17, 22, 33, 67, 75, 76, 87, 88, 90, 100, 113, photographs Lee Stalsworth; cat. 12, Akademie der Künste, Berlin, Kunstsammlung; cats. 13, 28, 46, 54, 63, 80, 89, 112, The J. Paul Getty Museum, Los Angeles, © 2006 Artists Rights Society (ARS), New York/VG Bild-Kunst, Bonn; cat. 19, photograph Hana Hamplová; cat. 20, © National Gallery in Prague 2005; cats. 21, 37, 45, 55, 119, 125, 136, 137, Museum Folkwang, Essen; cat. 24, © 2006 Artists Rights Society (ARS), New York/Beeldrecht, Amsterdam; cat. 27, © 2006 Artists Rights Society (ARS), New York/VG Bild-Kunst,

Bonn; cat. 31, © Estate of Jaromir Funke; cats. 34, 153, 165, photographs Jürgen Liepe; cat. 35, National Museum in Warsaw; cat. 39, © 2005 The Metropolitan Museum of Art; cats. 41, 53, © 2004 The Metropolitan Museum of Art; cat. 42, Courtesy Gallery Kicken Berlin, Copyright Phyllis Umbehr/Gallery Kicken Berlin; cats. 43, 127, 149, 151, Albertina. Wien; cat. 47, The Granger Collection, New York; cats. 49, 99, 104, 123, photographs Becket Logan; cat. 50, © 1994 The Metropolitan Museum of Art; cat. 54, © 2006 Die Photographische Sammlung/ SK Stiftung Kultur-August Sander Archiv, Cologne/ ARS, NY; cat. 55, Copyright Eva Besnyö/MAI; cats. 57, 59, 62, 63, © 2006 Artists Rights Society (ARS), New York/VG-Bild-Kunst, Bonn; cats. 66, 160, 161, photographs Martine Beck-Coppola; cat. 70, © Miloš Dohnány (heirs)/LITA, Bratislava/Artists Rights Society (ARS), New York; cat. 77, National Museum in Warsaw; cat. 79, A.N.L., picture archives, Vienna; cat. 80, © Joan Munkacsi, Courtesy Howard Greenberg Gallery, NYC; cat. 81, photograph Jürgen Liepe; cat. 82, © The Art Institute of Chicago, photograph Robert Lifson; cat. 85, © 2006 Albert Renger-Patzsch Archiv/Ann und Jürgen Wilde, Zülpich/Artists Rights Society (ARS), New York; cat. 89, Courtesy Robert Mann Gallery; cats. 96, 138, photographs Jürgen Liepe; cat. 98, Digital Image © The Museum of Modern Art/Licensed by SCALA/Art Resource, NY; cat. 110, photograph Kaz Tsuruta; cat. 114, © Dan Wlodarczyk; cat. 119, bpk/Berlinische Galerie; cat. 129, © Karol Aufricht (heirs)/LITA, Bratislava/Artists Rights Society

(ARS), New York; cats. 129, 143, 144, Artwork is from the collection of the Slovak National Gallery, © Artists Rights Society (ARS), New York/LITA, Bratislava; cat. 135, Estate Helmar Lerski, Fotografische Sammlung, Museum Folkwang; © 2006 Die Photographische Sammlung/SK Stiftung Kultur-August Sander Archiv, Cologne/ARS, NY; cat. 143, © Sergej Protopopov (heirs)/LITA, Bratislava/Artists Rights Society (ARS), New York; cat. 144, © Karel Plicka (heirs)/LITA, Bratislava/Artists Rights Society (ARS), New York; cat. 146, © Estate of André Kertesz; cat. 150, A.N.L., picture archives, Vienna; cat. 152, San Francisco Museum of Modern Art, © Mara Vishniac Kohn, courtesy International Center of Photography; cat. 159, photograph Ben Blackwell, © 2006 Artists Rights Society (ARS), New York, ADAGP, Paris

COMPARATIVE ILLUSTRATIONS

Demetz introduction, Hajo Rose, © 2006 Artists Rights Society (ARS), New York/VG Bild-Kunst, Bonn; figs. 1.4, 2.7, 3.3, 5.5, 5.6, 7.3, photographs Becket Logan; figs. 2.1 and biographies, Erich Salomon, photographs Markus Hawlik; fig. 2.2, © 2006 Estate of Gustav Klucis/Artists Rights Society (ARS), New York; fig. 2.6, Photography © The Art Institute of Chicago; figs. 3.5, 8.2, Rheinisches Bildarchiv Köln; fig. 3.7, photograph Robert Lifson

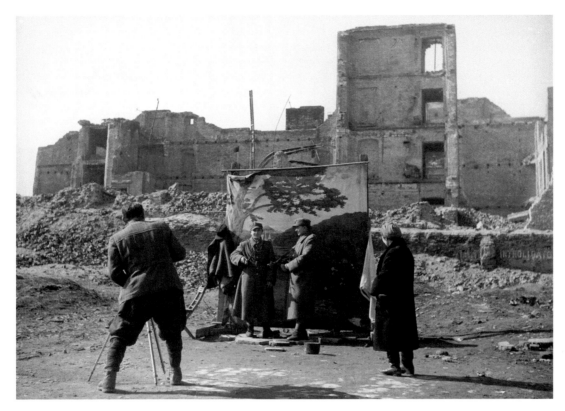

166

JINDŘICH MARCO (Czech,
1921–2000), *Souvenir (Souvenir)*,
from the series *Springtime
in Poland (Jaro v Polsku)*, 1947,
printed later, gelatin silver
print, 29.2 × 38.7, On loan from
the Melvin and Lorna Rubin
Family Collection